# Ansel Adams

*and the*

# American Landscape

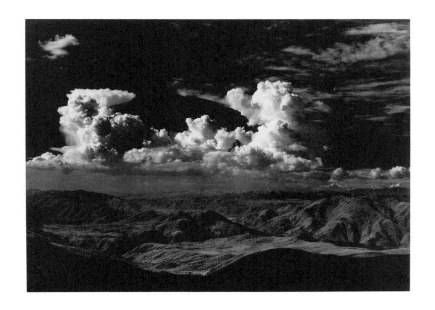

*Thunderheads, Anza-Borrego Desert.* Contemporary print from original negative by Ansel Adams, California Museum of Photography, Sweeney/Rubin Ansel Adams *Fiat Lux* Collection, University of California, Riverside.

# ANSEL ADAMS

## *and the*

# AMERICAN LANDSCAPE

## A BIOGRAPHY

*Jonathan Spaulding*

UNIVERSITY OF CALIFORNIA PRESS

BERKELEY LOS ANGELES LONDON

Permissions to quote from copyrighted material can be found on page 515.

University of California Press
Berkeley and Los Angeles, California

University of California Press
London, England

Copyright © 1995 by Jonathan Spaulding

Library of Congress Cataloging-in-Publication Data

Spaulding, Jonathan, 1957–
    Ansel Adams and the American landscape: A biography / Jonathan
    Spaulding.
        p.   cm.
    Includes bibliographical references (p.    ) and index.
    ISBN 0-520-08992-8 (acid-free paper)
    1. Adams, Ansel, 1902–1984.   2. Photographers — United States —
    Biography.   I. Title.
    TR140.A3S63   1995
    770'.92 — dc20
    [B]                                                  95-1601
                                                            CIP

Printed in the United States of America
    2   3   4   5   6   7   8   9

The paper used in this publication meets the minimum requirements of
American National Standard for Information Sciences— Permanence of
Paper for Printed Library Materials, ANSI Z39.48-1984 ♾

*to my parents*

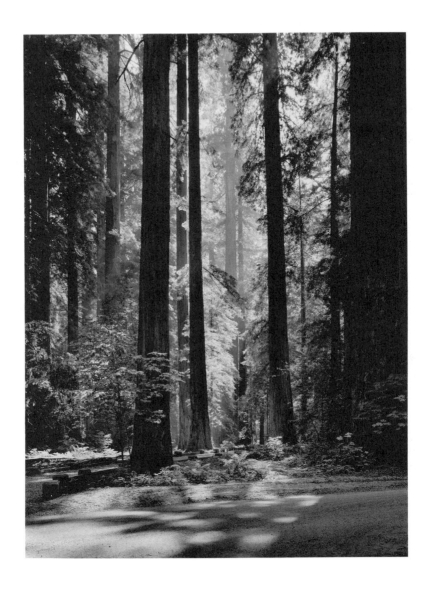

Ansel Adams, *Redwood Forest, Founders Grove, Avenue of the Giants, Redwood National Park*, California, 1966. Contemporary print from original negative by Ansel Adams, California Museum of Photography, Sweeney/Rubin Ansel Adams *Fiat Lux* Collection, University of California, Riverside.

A CALIFORNIA *song*,

*A prophecy and indirection, a thought impalpable to breathe as air,*

*A chorus of dryads, fading, departing, or hamadryads departing,*

*A murmuring, fateful, giant voice, out of the earth and sky,*

*Voice of a mighty dying tree in the redwood forest dense.*

Farewell my brethren,

Farewell O earth and sky, farewell ye neighboring waters,

My time has ended, my term has come.

*Along the northern coast,*

*Just back from the rock-bound shore and the caves,*

*In the saline air from the sea in the Mendocino country,*

*With the surge for base and accompaniment low and hoarse,*

*With crackling blows of axes sounding musically*
*driven by strong arms,*

*Riven deep by the sharp tongues of axes, there in the*
*redwood forest dense,*

*I heard the mighty tree its death-chant chanting.*

*The choppers heard not, the camp shanties echoed not,*

*The quick-ear'd teamsters and chain and jack-screw men heard not,*

*As the wood-spirits came from their haunts of a thousand years
to join the refrain,*

*But in my soul I plainly heard.*

*Murmuring out of its myriad leaves,*

*Down from its lofty top rising two hundred feet high,*

*Out of its stalwart trunk and limbs, out of its foot-thick bark,*

*That chant of seasons and of time, chant not of the
past only but of the future. . . .*

For them we abdicate, in them ourselves ye forest kings!

In them these skies and airs, these mountain peaks,
Shasta, Nevadas,

These huge precipitous cliffs, this amplitude, these valleys,
far Yosemite,

To be in them absorb'd, assimilated.

---

*from* WALT WHITMAN,
"Song of the Redwood-Tree"

# Contents

Preface  xi

*one*
Land's End  1

*two*
Sierra Nevada  20

*three*
Modernism  56

*four*
Art in the Great Depression  92

*five*
The Power of Images  116

*six*
New Beginnings  146

*seven*

WAR AND NATURE'S PEACE 184

*eight*

WILDERNESS AND THE POSTWAR WEST 217

*nine*

THE AMERICAN EARTH 267

*ten*

DISSONANCE AND HARMONY 318

ACKNOWLEDGMENTS 369

NOTES 373

SELECTED BIBLIOGRAPHY 461

INDEX 499

# PREFACE

IN THE LATE AFTERNOON of November 1, 1941, Ansel Adams was driving south along Highway 84 in northern New Mexico. With him in the big Pontiac station wagon loaded down with camping supplies and camera gear were his eight-year-old son, Michael, and his good friend, Cedric Wright. Adams was working at the time for the U.S. Department of the Interior, which had hired him to produce a series of photographic murals for its offices in Washington, D.C. After a frustrating day along the Chama River, he had given up and was heading back toward Santa Fe.[1]

The sun was traveling a low arc across the sky on that fall afternoon, creating long shadows on the mesas of the Rio Grande Valley. As the trio rolled south approaching the village of Hernandez, Adams glanced to his left and saw the moon rising above a band of cirrus clouds and the snow-covered peaks of the Sangre de Cristo range. In the foreground were the town's church and graveyard, their crosses brilliantly illuminated by the setting sun. He pulled off the road in a swirl of dust and flying gravel and rushed to the back of the car to unload his equipment. He quickly had the tripod out, the unwieldy $8 \times 10$ view camera set up, and the image framed on the ground glass. He knew immediately what

he was after. Envisioning a darkened sky beyond the glow of the village, he slipped a deep yellow filter into the holder before the lens. The crucial decision now was to determine exposure and development, but in his haste to set up his camera he had left his light meter in the car. While his companions went searching, Adams grew desperate. The sun was edging toward a bank of clouds in the west, and he feared that at any moment the shadow would fall across the glowing crosses.[2]

Years of experience came to the rescue, however, as he recalled that the luminance of the moon in a clear sky is approximately 250 candles per square foot. Using the exposure system he had recently developed, Adams placed this value on Zone VII, toward the white end of the ten-step scale but not so bright as to wash out the details of the lunar surface. He was concerned that the brightness range of the scene might be too extreme and consequently made a note to process the negative by a diluted "water bath" method to compress the density range and preserve detail in the dark areas of the foreground.[3]

Adams realized immediately that he had made an important photograph and decided to expose a duplicate negative for safety's sake. He reversed the film holder, pulled the shielding slide from in front of the film plane, and looked up in anticipation of releasing the shutter, only to see that the bright sunlight had vanished from the crosses. The magical instant had passed.

In his early prints of the now classic *Moonrise, Hernandez, New Mexico*, Adams left the sky a middle gray with several bands of light clouds in the upper portions of the frame. In later years he increased the exposure to these areas to render the sky a deep velvet black. *Moonrise* represents the product of a series of conscious interpretive decisions by the photographer, not simply a record of a beautiful scene. At each stage of the process Adams applied his technical mastery of the medium to create an image that would convey the emotions he felt on that highway in New Mexico in the fall of 1941.[4]

It is a photograph that sums up his art, both in its form and its content. Perhaps most powerful is the visual intensity of the image, its hard-edged clarity and brilliance, made all the more striking by its emergence from a cosmic blackness. But its formal qualities gain their power from the way they emphasize the cultural associations of the subject. It is an idealization of the American landscape, not as a place of exploitive conquest and violence, but as a place of spiritual union between human society and an embracing nature. As the village stands amid the immense distances of the desert landscape, the glowing crosses infuse the scene with a sense of the divine, a transcendent spiritual force immanent in the natural world, its presence felt in an enveloping light that suffuses both nature and human culture.

For all of its remarkable power, *Moonrise* is clearly not a complete image of the American West. Missing are the darker aspects of the national legacy. Where, for example, are the slaughtered buffalo, the dispossessed Indians, the sweating gangs of underpaid immigrant laborers, the scarred earth of the open pit mines? Although Adams preferred to focus on the ideal, in other less celebrated photographs he recorded a more mundane American landscape for a variety of commercial clients. On this same trip in which he made his sublime *Moonrise*, he also carried out a commercial assignment for the U.S. Potash Company in Carlsbad, New Mexico, rendering with the same powerful style its huge processing plants, belching locomotives, and underground mines.[5]

In the course of a life from 1902 to 1984, Ansel Adams created some of the most influential photographs ever made, contributing more than any other photographer to the public acceptance of the medium as a fine art. Perhaps his greatest legacy, however, was his role as one of the twentieth century's leading exponents of environmental values. His photographs have become icons of the conservation movement, conveying to millions a vision of an ideal America where nature's grand scenes

and gentle details live on in undiminished glory. Yet, as his work for a variety of western industries demonstrates, the vision he presented was becoming increasingly rare in the twentieth-century West. The untrammeled lands he memorialized had become overrun with highways, housing tracts, and vacationing tourists.

To some, this avoidance of the reality of commercial and industrial development in his fine art images is a crucial flaw, making his art little more than a pleasant daydream. At a more sophisticated level, some critics have seen his work as an unwitting embodiment of the false dichotomy between humanity and nature, a dichotomy at the root of our continuing legacy of environmental destruction.[6] Such criticisms raise important questions about Adams's creative vision, its origins and its impact.

Adams's photographs, like all landscape art, reflect and reinforce broader ideas about the world and humankind's place in it. The remarkable popularity of his vision suggests that his work speaks to deeply held beliefs. As modern societies struggle to create a sustainable future, it is worthwhile to investigate the origins and meaning of Adams's art. To do this, it is necessary to explore the broader environment in which he lived and worked. Adams's career evolved in the context of his personal emotional life, movements in photography and the arts in general, economic factors of the photographic market, and the changing ideas and tactics within the conservation movement. This investigation of Adams's life and work will therefore cast a wide net, considering his photographs as expressions of both a personal vision and a society's changing response to the natural world.

Throughout his life, Adams pitted his faith in nature, in art as the expression of an orderly beauty, and in progressive civic action against the tumultuous currents of the twentieth century. Adams offered reassurance in his images of a natural world whose power and beauty prevailed undiminished and in his vision of America as an idealistic nation

with its roots in the sacred earth. As his great popularity shows, he was by no means alone in his hope that the citizens of the world could yet build "the new society at last, proportionate to Nature."[7] All those who have been moved by his art might consider why that new society is yet unborn.

# LAND'S END

THE EARLIEST MEMORY that Ansel Adams would recall in later years was of lying in a perambulator, what people today call a stroller, on a warm San Francisco afternoon looking up at the blue sky, watching fingers of fog move in off the Pacific Ocean. Soon the sky had clouded over completely. His nanny gathered him in her arms and carried him to a crib inside.[1]

The Adamses lived near Baker Beach and Land's End, the aptly named westernmost point of the San Francisco peninsula. Like the great basalt prow of a ship, the cliffs of Land's End plunge into the sea and fall back against the greater force of the wind and the waves. The area at that time was undeveloped. The residential suburbs of the city were just beginning to extend out toward the western reaches of Golden Gate Park. If the Adamses were seeking solitude, they came to the right place.

The product of continental masses jammed together over millennia, the rugged cliffs along the ocean's edge were sparsely covered with scrub pine and chaparral. Behind them lay broad sand dunes and rolling hills. In streambeds and dark coves the young Adams would explore for hours. It was a lonely place to grow up but full of a stark beauty.

For the young Adams, nature was not a remote abstraction. It was a

vast and powerful physical presence. It was also a playground of seemingly infinite dimensions. "I've got all these memories," he recalled nearly seventy years later, "the wild country and the beautiful flowers and Lobos Creek, and the fog horns, and Baker's Beach right down below. . . . [T]hat whole western part of the city . . . profoundly influenced me; the storms and the fogs and all this open space. Why I didn't get killed a hundred times on those Golden Gate cliffs I don't know. I used to go out to Land's End and climb all over without knowing how to climb and all alone. I got into some tight situations."[2]

Although the area around the Adams home seemed wild and open, by the time of Ansel's birth on February 20, 1902, San Francisco was anything but a wilderness. Over the course of the preceding half-century, the city had changed from a sparsely populated outpost of Mexico to frontier boomtown to the established seat of a commercial empire. By the turn of the century, the social and economic fluidity of the gold rush had been left behind. In its place were firmly established social classes and an economic network as advanced as any in the world. San Francisco in 1900 had a population of approximately 350,000, eighth among U.S. cities. Building on its unequaled natural setting and resources, it had emerged as the economic capital of the Far West. The harbor controlled both the local trade of its surrounding counties and the international trade of the Pacific slope states, Latin America, and Asia.[3]

The city's position as an international crossroads made its population unusually diverse, even by the standards of nineteenth-century America. The lure of gold had drawn people from around the world, and a generally booming economy continued to draw newcomers through the latter decades of the century.[4] The city contained at least seven distinct residential areas. The clearest division ran along the center of Market Street, the main commercial thoroughfare.

Between the iron rails of the streetcar lines ran a metal slot. In the

popular language of the day, "the Slot" served as a metaphor for the physical and class divisions of the city, divisions that its expanding industrial economy seemed to be hardening into an unbridgeable gulf. "South of the Slot" were the factories, the railroad yards, the tenements and boardinghouses of the working class. "North of the Slot" were the banks, the hotels, the theaters, and the residential neighborhoods of the middle and upper classes. Ansel Adams, raised in the far northwestern corner of the city, was unequivocally "north of the Slot."[5]

The social geography of San Francisco was more complex than this division suggests. North of Market Street there were also the immigrant communities of Chinatown and North Beach, each just a stone's throw from the mansions of Nob Hill. Downtown in the early morning, by the Ferry Building and the embarcadero, dock workers, fishermen, and wharf rats shared the streets with bankers and merchants on their way to new steel and cement offices. Bleary-eyed revelers made their way home from the Poodle Dog or one of the other well-known "French restaurants" that catered to a variety of pleasures. Though San Francisco was becoming increasingly like other modern commercial and industrial cities, it still retained some flavor of its gold rush youth, a tradition most of its citizens embraced with a certain ambivalence, as not only their colorful frontier legacy but also a lingering source of social decay.[6]

### The Argonauts

Like the city in which he was born, Ansel Adams had the frontier and the gold rush experience in his blood. In venerable New England tradition, his grandfather, William James Adams, had run away from home in Thomaston, Maine, at the age of fifteen, heading to sea on a merchant schooner. He worked the Atlantic seacoast, where his Yankee instincts for trade were nurtured, and he rapidly progressed to positions of

greater authority. By the age of nineteen he found himself in the port of New Orleans where he took work as a pilot on a Mississippi steamboat. It was there on the river in 1849 that he heard the news of gold in California.[7]

He traveled by ship to Panama and overland across the isthmus via the Chargres River. Adams must have had better luck than most, because he made his way through the malarial swamps unharmed and quickly found passage on a ship bound for San Francisco. Like the rest of the gold-hungry hordes, he went directly to the hot Sierra Nevada foothills to scour the streams and sift the dry riverbeds for their ancient deposits.[8]

It did not take the shrewd Adams long to realize the real money to be made in California was not by toiling over a sluice box but by selling to the miners, who were paying outrageous prices for basic tools, food, and clothing. Like the future railroad barons—Collis Huntington, Mark Hopkins, and Leland Stanford—who were his neighbors, Adams opened a dry goods and grocery store in Sacramento and prospered. By 1856 he had turned from retail to wholesale, and with his fortune assured, he sold the store and returned to Maine to bask in local glory.[9]

There he noticed Cassandra Hills, the daughter of a country doctor. She had married a sea captain at fifteen and been widowed a year later. By the time of W.J.'s arrival, she was twenty years old and ready for a new life in the West. They married and returned to San Francisco, where W.J. immediately opened another grocery store.[10]

The gold rush and the first years under U.S. rule gave San Francisco a distinctive culture that flavored its subsequent development and helped to shape the ideas and values of the young Ansel Adams. The city's first history, *The Annals of San Francisco*, reflected the popular image of a rollicking New World Babylon—cosmopolitan, exuberant, expansive, and democratic.[11]

But this image of San Francisco and California told only one side of the story. Underneath lay an inner anxiety born of materialism, violence, and competitive greed. The gold rush let out twin genies, the best and the worst in the American experiment. The rootless masses of young men, drawn by stories of easy wealth, more often than not found only poverty, drudgery, and loneliness. While most writers, artists, and boosters of the "Golden West" liked to focus on the elegance of the city's hotels or the opera and theater that blossomed seemingly overnight in the cash-rich mecca, they could not ignore the trash-strewn streets, the rags that came far more often than the riches, the awareness that the whole gaudy spectacle masked a pervasive desperation. The city's suicide and murder rates were symptomatic of a burden of violence, frustration, and failure.[12]

Like most in California, W. J. Adams experienced its vagaries firsthand. His dry goods store burned to the ground twice in the periodic fires that swept through the wooden buildings of the city. Like most, he had no insurance: at that time it cost as much as the property itself. Like most, he simply rebuilt and started again. In Adams's case, the booming economy and its inflated prices soon had him back in the fray. Seeing the huge demand for timber that San Francisco's meteoric growth and regular fires fueled, Adams invested in Washington timberlands. He built a chain of sawmills under the banner of the Washington Mill Company and a fleet of ships to carry the milled lumber down the coast to California.[13]

W. J. and Cassandra eventually had five children to care for and with their increasing wealth were able to purchase fifty-four acres on the rolling coastal foothills south of the city. The Adamses built a twenty-three-room home, which they called Unadilla, in the Atherton area, a wealthy enclave of Bay Area gentry.[14]

Ansel's father, Charles Hitchcock Adams, was the youngest of the

five children. Like many of the offspring of the new merchant and industrial elite, he and his brother and sisters were more interested in literature, the arts, and the sciences than in carrying on their father's burgeoning empire. The eldest son, William, was a physician, a diagnostician, a specialty that was in great demand. He was also a dedicated linguist and bibliophile who translated French poetry in his spare time. With his medical career established, he had no desire to assume control of the family business. The middle three children were daughters who, as was expected at the time, married and established families of their own. The business therefore fell to the youngest son, Charles. Although his true love was the natural sciences, astronomy in particular, Charles represented his father's last hope to keep the business in the family. Reluctantly, he assumed his duties.[15]

Perhaps partly as consolation for his disappointing career, Charles sought out the "high culture" of San Francisco. In that pursuit he met his future wife, Olive Bray, whose family had come across the plains in a covered wagon in 1856. The Brays opened a business in Sacramento and subsequently moved to Carson City to take advantage of the silver boom in the area. They established a livery stable and a freight hauling business and were active in Carson City's small "respectable" social circles. Olive played piano, performed in amateur theatricals, and painted china by hand. Olive's sister, Mary, belonged to the Carson City Browning Society, which met in local homes to read the poetry of their namesake as well as the efforts of society members. While they tried to maintain and nourish a semblance of genteel culture in the rowdy and uncouth mining town, the real highlights of their social year were the visits to San Francisco. It was there that Olive Bray met Charles Adams and their romance bloomed. The two were married in Carson City in 1896. They returned to San Francisco to settle into what they assumed would be a comfortable life.[16]

By the late nineteenth century, the United States was deep in the throes of its industrial revolution. The resulting social and economic changes challenged the most fundamental assumptions of the nation. While Ansel's grandfather was the quintessential Jacksonian man, a self-made entrepreneur of the American frontier, Ansel's father came of age in an entirely different era. Economic growth had set the lines of wealth and poverty into increasingly clear divisions. The journalist Henry George had noted as early as 1868 that men with "established businesses" would "become richer for it and find increased opportunities; those who [had] only their own labor [would] become poorer, and find it harder to get ahead."[17]

The Jeffersonian ideal of a virtuous yeomanry living self-sufficiently on the land was clearly only a fantasy for the new industrial work force of the late nineteenth century. Violent confrontations between labor and capital arose with disturbing regularity. Cities took on a frightening aspect, their growing slums densely packed with the "dangerous classes" of immigrant workers. Fluctuating business cycles threatened economic chaos, while armies of the unemployed seemed harbingers of its social equivalent. Henry George was moved to ask,

> When, under institutions that proclaim equality, masses of men, whose ambitions and tastes are aroused only to be crucified, find it a hard, bitter, degrading struggle even to live, is it to be expected that the sight of other men rolling in their millions will not excite discontent? . . . The political equality from which we can not recede, and the social inequality to which we are tending, can not peacefully coexist.[18]

San Francisco's social and political turmoil was typical of many American cities at the end of the nineteenth century. The idealism that

had propelled the republic across the continent now seemed lost in the industrial empire it had built. One particularly trenchant observer of the changing social and economic landscape was Henry Adams, great-grandson of John Adams and grandson of John Quincy Adams. His pessimistic assessment of the nation's present condition and future prospects was published as *The Education of Henry Adams* in 1904. Ansel's father read the book with alarm. The gloom it expressed seemed to him a harbinger of decline as well as an example of the type of intellectual morbidity he hoped his son could avoid.[19]

Henry Adams was only expressing the feelings of his class in emphatic terms. He saw the new social, economic, and intellectual landscape as one in which the established civic elite and the values they clung to had no place. At the Paris Exposition of 1900, Henry Adams sensed in the mysterious forces unleashed by the huge electric dynamos the intimation of impending chaos in the new century. Humanity's moral and political development had failed, he thought, to keep pace with its acquisition of technological power. Like many others of his class, he found what refuge he could in what he perceived as the simpler world of centuries past.[20]

The majority of Americans at the turn of the century were unwilling to accept this dour prognosis. Reform currents, arising predominantly from middle-class professionals and small-business owners, surfaced throughout the nation. The disturbing effects of industrialization and urbanization could be controlled, they said, with a renewed commitment to "moral order" and rational planning. Coalescing under the banner of Progressivism, the movement represented a heterogeneous mix of ideas and impulses. At its core was an effort to combine the democratic traditions of the early republic with the technological and economic power of the twentieth-century empire—precisely the combination Henry Adams believed impossible to sustain.[21]

Ansel Adams was born at the height of the Progressive movement.

Its legacy would form the basis of his later political beliefs and of liberal politics in general throughout the rest of the century. As an adult, Ansel did not, like Henry Adams, see himself as the last of a dying line of defenders of an eighteenth-century sense of civic virtue but rather as part of a new spirit of twentieth-century reform. Although he would reject the pessimistic resignation of Henry Adams, Ansel came to share the idea that the problems of the twentieth century demanded a reconnection with a spiritual stability. He found its source not in Catholicism and the image of the Virgin—as Henry had—but in nature and the image of wilderness.

The great figurehead of Progressive reform on the national level, Theodore Roosevelt, passed through San Francisco on a campaign loop in the spring of 1903, a year after Ansel Adams was born. Roosevelt was stirring up the emotions and the fears of his middle-class constituents as he railed against the "loss of vitality" among the white race, the true foundation, he felt, of the nation's greatness. In Roosevelt's thinking, races proceeded through an "evolutionary" pattern from savagery and barbarism to military and social efficiency, then, languishing in their success, to softness and materialism and finally to decadence and death. The Anglo-Saxon race was at a crossroad, he felt, and only the most vigilant preservation of the "martial virtues" and the invigorating contact with the forces of nature could delay its eclipse.[22]

Speaking a few days earlier at the dedication ceremony of the St. Louis World's Fair, Roosevelt took the opportunity to discuss the legacy of the frontier in American life.

> The old pioneer days are gone, with their roughness and their hardship, their incredible toil and their wild half-savage romance. But the need for the pioneer virtues remains the same as ever. The peculiar frontier conditions have vanished, but the manliness and stalwart hardihood of the frontiersmen can be given even freer scope under the conditions

surrounding the complex industrialism of the present day. . . . The old days were great because the men who lived in them had mighty qualities; and we must make the new days great by showing these same qualities.[23]

Roosevelt's views were widely shared. The nostalgia for the frontier and life on the land was especially strong in the urban West. One manifestation was the growing trend toward suburban living. In April 1903, when Ansel was fourteen months old, the family moved out of their flat in the Western Addition to their newly built home west of the Presidio. It was a fairly spacious two-story structure with commanding views of the Pacific, the harbor entrance, and the headlands of Marin. W. J. Adams supplied the lumber to double specification. It was a solidly built home, even for the day.[24]

The Adamses were part of a nationwide movement of the middle and upper classes away from the central city.[25] The family had the best of both worlds. Ansel's father would take the cable car from his downtown office at the Merchants Exchange to the end of the line at Presidio Avenue. From there he would take a horse-drawn carriage to his home. There were so few structures on that western edge of the city that Ansel could see the carriage coming more than a mile away across the rolling dunes.[26]

## Unadilla

In the first years of Ansel's life, the Adamses enjoyed the comforts and security of his grandfather's wealth. Particularly memorable were the frequent visits to Unadilla, his grandparents' estate in Atherton. The spacious and stately Victorian mansion was set on extensive and well-tended grounds scattered with large valley oaks. A wide staircase led up

to the porch surrounding the house, where the Adamses could sit on rocking chairs under the awnings on a hot summer day. Inside, the decor was in the standard mode, the high-ceilinged rooms filled with heavy furniture and the walls adorned with dark-hued oils in gilded frames. Servants prepared and served the meals; gardeners tended the grounds.

At the peak of the house was a tower reached by a winding staircase. This was Ansel's favorite haunt. He loved to sit and gaze out across the oaks to the redwood-covered Coast Range or eastward across the tidal marshes to the San Francisco Bay. Best of all was to climb the winding staircase to the tower as dark winter storms blew down across the peninsula. There he would stand enthralled by the wind and the rain.[27]

Storms of another sort were crowding down on the family, one upon the other. A series of calamities had struck soon after Charles Adams assumed control of the family business operations. Between 1897 and 1907, twenty-seven ships were lost to fire or at sea and three mills burned to the ground. One disaster was not confined to the Adamses alone. On the morning of April 18, 1906, at 5:14 A.M., about three years after the Adamses had moved into their new home on 24th Avenue, the ground underneath San Francisco began to rumble.

Ansel was asleep in his room, with his nanny, Nellie, in another bed nearby. His mother was asleep down the hall, and his father was out of town on business. The house began a violent shaking. With Nellie holding tight, they were both hurled back and forth across the room along with the furniture. The west window shattered with a crash and the chimney came tumbling down, leaving a broad view of the Golden Gate.[28]

There was severe damage throughout the city. The unreinforced brick and cheap wooden tenements were the hardest hit. But the worst destruction began when fires broke out at several points around town. By that afternoon they were out of control. New steel skyscrapers be-

came flaming towers. Parts of the city would burn for three more days. The army, called in to fight the fire and enforce martial law, began to dynamite broad swaths of buildings to prevent the fire's spread.[29]

On the first afternoon one of the many aftershocks hit while four-year-old Ansel was on the garden path. The force of the tremor sent the boy headfirst into the pavement, giving him the distinctive, Lombard Street–shaped nose he retained all his life.[30]

Ansel's father, who was attending a conference in Washington, D.C., tried desperately to contact the family. He heard rumors of vast devastation in the city and feared the worst. He took the first available train west, sending telegrams home from stops along the way. Finally he heard from his brother, Will, and from Olive's brother, Charles Bray, that his family was fine and their home more or less intact. The city had not fared as well.[31]

A good part of it was left in ashes. The western end of town, where the Adamses lived, was the least damaged. Some tens of thousands of refugees poured into the tent cities erected in Golden Gate Park, the Presidio, and other smaller sites. The city showed its best side as a cooperative spirit flourished in the breadlines and the encampments.

Although the Adamses survived the earthquake and fire, their financial troubles remained serious. W. J. Adams died in 1907. The following year Unadilla burned to the ground.[32]

Charles Adams had not wanted to take over the business, and now he had seen it come crashing down around him. In an attempt to recoup the family fortune, he invested in an operation suggested by his brother-in-law, Ansel's namesake, Ansel Easton, and his good friend and attorney, George Wright. They leased the American rights to a process to convert sawdust into ethyl alcohol. They incorporated as the Classen Chemical Company and built a modern facility near the site of one of the Adams mills. With the ready supply of cheap raw materials, the operation seemed ideal.[33]

Unknown to Charles, the Hawaiian Sugar Trust, realizing the potential competition to its own alcohol process, had contacted Ansel Easton and George Wright, offering to buy their shares for a substantial sum. With their controlling shares of the operation, the Trust purposely undermined the business until it was closed at a substantial loss. The resulting debts forced Charles to sell what little remained of his father's timber holdings and kept him near the brink of bankruptcy for the rest of his life. What made the situation particularly difficult was the apparent betrayal by two of his closest friends.[34]

With the family fortune gone, Charles was forced to look for work as an accountant. He took it all stoically, but it clearly hurt. His life, he said, had been an utter failure. He found solace in his astronomy, continuing his involvement with the Astronomical Society of the Pacific and serving as its secretary for many years. His greatest solace was his only son. He wanted to nurture Ansel's talents and free spirit, to see him attain the fulfillment he had been denied.[35]

Although Ansel's father bore the financial calamities reasonably well, his mother, Olive, seemed to slip into a lasting depression. Her sister Mary, who along with her father lived with the family, joined in the sorrow and condemnation. They blamed Charles for the disastrous turn of events. Home became a kind of prison. The family's "fall" clearly had a strong effect on all its members, producing tensions and bitterness only barely concealed beneath the veneer of Victorian decorum. An only child, Ansel was buffeted by the conflicting emotions and unspoken animosities. He turned inward for refuge.[36]

Charles's disappointment made him all the more resolved that Ansel would not suffer the same fate. He supported Ansel's every new interest with remarkable devotion and patience. Ansel was a precocious child. His doting parents encouraged the growth of his talent but also magnified his hyperactive and overly emotional nature. He suffered from frequent colds and flus and debilitating depressions. In his youth, as

throughout his life, Adams would keep up a frenetic pace until his body could take no more and he was forced into bed.[37]

Adams wanted to explore, to try new things, but he lacked the discipline to see them through. He had problems in school almost from the beginning. His odd behavior was too much for most of his teachers. His father, always patient, tried various schools, public and private, but to no avail. Although his indulgence had much to do with Ansel's unbridled and erratic behavior, Charles did not want to stifle his creative spark. At the age of twelve, after his final expulsion, Ansel ended his classroom education. Henceforth he studied at home.[38]

It was a remarkable decision, given the family's severe financial pinch. His father instructed him in arithmetic and accounting techniques, and private tutors provided instruction in languages and science. Ansel was a lackadaisical student, however. He was more interested in what he could discover for himself. Around the age of ten, for example, he had taken to visiting the field office of a local building contractor, S. A. Born, who was constructing many of the new houses that were filling in the open space around the Adamses' property as the residential areas of the city moved relentlessly outward. Born took an interest in the inquisitive boy and allowed him to watch the architects and draftsmen at work. They showed him how they created the plans, how to draw the elevations and render correct perspective. Born set Adams up with a little desk and some drafting tools, and the boy would sit for hours working on imaginary projects.[39]

Ansel's greatest interest was music, which he also came to of his own initiative. At first he merely banged haphazardly on the keys of the family's parlor upright. By the age of twelve, he had managed to construct his own one-boy orchestra. Kicking vigorously at a drum on the floor with his left foot and blowing with all his might on a harmonica held in his left hand, Ansel pounded out weird chords and frantic trills on the piano with his right hand, while applying full pedal with his right

foot to sustain the ringing cacophony. His grandmother Adams sat by at his insistence, nodding appreciatively.[40]

Although his first efforts were hardly euphonious, Ansel made remarkable progress. Within a matter of months after his first serious efforts, he was, according to his father, able to sight read virtually any piece of music put before him and to play with a genuine sensitivity to touch and tempo.[41] Seeing his son's natural aptitude, Charles encouraged his formal training. His first teacher was the stern Miss Marie Butler, formerly of the New England Conservatory of Music. Under her demanding regimen, Ansel's frenetic and "scatterbrained" behavior—this was Miss Butler's initial assessment—slowly found a focus.

Miss Butler demanded perfection. "There was no compromise," Adams recalled. Every piece assigned to him had to be performed precisely before he could go on to another. "I'd get so damn sick of that thing that I'd just go out of my mind. But finally, by feeling obligated, I just did it."[42] Slowly Adams learned to direct his effort toward a long-term goal. For the rest of his life he continued to apply the same kind of discipline to all his endeavors.

### The Panama Pacific International Exposition

Not long after he began his piano instruction, Adams was provided with yet another outlet for his relentless energy and inquisitive mind. On February 20, 1915, his thirteenth birthday, the Panama Pacific International Exposition opened its gates to the world in celebration of the newly completed Panama Canal. After the devastation of the 1906 earthquake and fire, the civic leaders of San Francisco saw the exposition as a symbol of the city's resiliency and its return as an even grander metropolis.

San Franciscans in general believed the exposition marked the beginning of a new era. Ben Macomber, writing for the *San Francisco*

*Chronicle*, expressed the consensus. "Changes in trade routes have overwhelmed empires and raised up new nations, have nourished civilizations and brought others to decay. . . . Huge as was the canal as a physical undertaking alone, it is not less stupendous in the vision of the effects which will flow from it."[43]

Charles Adams saw the exposition as the perfect opportunity to unleash his son's relentless energy in a relatively safe environment. Ansel was given a year's pass to the grounds. Although he continued his piano lessons as well as his studies of language and literature at home, for a good part of each day he was free to roam the fair. The exposition was more than an incredible wonderland to the boy. It was an indoctrination into the grand ideals of the age.

Like the great international fairs that preceded it, the Panama Pacific International Exposition was intended to display the triumphant march of modern civilization. The overriding theme of the event, the canal's linking of East and West and the new era of international prosperity and progress it portended, was broadcast everywhere. San Francisco was the end of the frontier, the terminus of European civilization's westward push toward Asia, and the gateway to the waiting riches of the East.[44]

Among the most popular sculptural pieces at the exposition were the statues, *The End of the Trail* and *The Pioneer*. These two works were intended to be read in conjunction. James Earl Fraser's *The End of the Trail* depicted "a great chapter in American history," according to one official guide. "The dying Indian, astride his exhausted cayuse, expresses the hopelessness of the Red Man's battle against civilization." Solon Borglum's *The Pioneer*, in contrast, presented a "triumphant American frontiersman marching indomitably to the winning of the West . . . a telling contrast to his doomed opponent."[45]

Perhaps because such cultural indoctrination was so pervasive at the fair, it seemed unremarkable to Adams. His later recollections focused

instead on what were already his overriding interests: technology and the arts. Because music had so quickly become his passion, Ansel spent each noon hour in the huge domed Festival Hall to hear the organist Edwin Lamar perform. Particularly memorable were Lamar's daily improvisations on themes suggested by the audience. The boy was clearly fascinated with the enveloping sound of the magnificent instrument and was finally given the chance to play it briefly. After that he added the organ to his musical studies.[46]

The exposition also housed one of the more significant exhibitions of international contemporary art held in the United States at that time. Adams repeatedly viewed the works of expressionism, cubism, and futurism on display in the Palace of Fine Arts. Here he encountered a radically new kind of artistic language—one that moved beyond the world of appearances to portray in visual terms the uncertainty and relativity that modern physics was discovering in the universe; the speed, precision, and ceaseless change that modern technology made possible; and the surreal and fantastic realms of the unconscious mind that were being explored in the new science of psychology.

For Adams, it was an important introduction to new ideas and visual forms, yet he was more impressed with the technological marvels on display. One of these, the Dalton Adding Machine Company exhibit, was managed by a friend of his father. Seeing Ansel's fascination with the device, the man offered to show him how it worked. Ansel picked up the technique immediately and was soon spending an hour or two a day demonstrating the machine's various functions to the spectators who gathered to watch this odd young boy, his fingers whirring over the keys as he explained excitedly in his high-pitched voice all the many computations of which it was capable.[47]

His other favorite was the Underwood typewriter exhibit. Here a large stage set of movable dioramas presented the history of office writing in dramatic tableaus. From an eighteenth-century bookkeeper with

quill pen to the modern office of 1915, a series of shifting scenes appeared, one dissolving into the next in an apparently magical fashion. The technician behind the display was a man named Tom Mooney, who offered to divulge the secrets of the illusion to Adams, provided he keep it strictly confidential.[48]

The boy took a great liking to Mooney. Two years later he received a shock when, a few days after the 1917 Preparedness Day bombing on Market Street in San Francisco, he saw a photograph of Mooney in the paper along with the news that he had been charged with a major role in the events. A radical anarchist group opposed to the war was deemed responsible, and Mooney, a member of the group, was found guilty. The kindly man Ansel had met at the fair was sentenced to life in prison. He was too young to fully understand the forces behind the growing "Red hysteria" and political violence of the times, but the fate of his friend gave young Ansel an intimation that the world was less benign than he had been led to believe.[49]

Although the fair was created as a tribute to the triumph of modern civilization, the political turmoil and social instability that motivated the reformers of the Progressive Era could not be banished from its grounds. Adams was already gravitating to a world of beauty and order in his music and in his roaming of the dunes and beaches around his house, yet the harsh realities of the world had a way of making their presence felt.

Wandering home through the alleys behind the amusement area known as the Joy Zone one late afternoon, Adams came across a group of ragged men sitting against a wall. One of them looked up with sunken eyes as he injected the contents of a large syringe into his arm. Badly frightened, Ansel ran for the street and the nearest streetcar, which happened to be heading in the wrong direction. He was late getting home that night, and when his father asked him the cause, Ansel told

him of the disturbing scene. Charles explained that the men were most likely drug addicts, more deserving of sympathy than fear.[50]

Another frightening experience came on the closing day of the exposition. Adams made his way onto the grounds early to visit his favorite displays one last time. By that afternoon the crowd had become enormous, filling the plazas from edge to edge. Wandering into their midst, Adams soon found himself trapped within the close-pressing mass. A sense of panic seemed to seize the crowd, yet no progress could be made. Pressure waves rippled through the sea of bodies. Women standing nearby had fainted only to be held upright, unable to fall. Terrified and trapped, Adams was carried along by the crowd until he finally reached the gates and made his escape.[51]

The exposition offered Adams a far better education than he would have received in the classroom. It was an education in the ideals and myths of the age and a glimpse into the disturbing forces that threatened to give those ideals the lie. The themes of the perfectibility of mankind, the march of progress, the superiority of Western and especially American culture were driven home in every way imaginable, from the heroic sculpture to the vast and overpowering layout of the grounds to the mesmerizing displays of technology. The nighttime fireworks, the bewildering array of searchlights and floodlights in the sky, created a scene that Adams and others recalled as a "fairyland," a wonderful dream. That sense of the promise of American life, the luminous potential of a technology harnessed to the best ideals of the Western humanistic tradition remained deeply embedded in Ansel Adams's mind and spirit as he grew to maturity, yet they remained set in combination with the frightening uncertainty of the twentieth century.

# SIERRA NEVADA

IN THE SPRING OF 1916, the fourteen-year-old Ansel was in bed with a cold. To cheer his spirits during another of his many illnesses, his aunt gave him a copy of James M. Hutchings's *In the Heart of the Sierras*, published in 1886 and one of the classic travel accounts of the region. The boy lay mesmerized by Hutchings's romantic tales of adventure among the towering walls of the Yosemite Valley.[1] The family had been discussing where to spend their upcoming summer vacation. In years past they had gone to Puget Sound or down the coast to Santa Cruz, but for Ansel there was now no option. They simply had to go to this incredible place called Yosemite. His parents were reluctant at first: neither had been to the Sierra, and Aunt Mary refused to go without the cat. In the end the boy had his way. Aunt Mary and her cat stayed behind as Ansel and his parents boarded the train in Oakland on the first day of June.

They crossed the Coast Range at Altamont Pass. In the distance they could see the outline of the Sierra, over a hundred miles to the east. The grasses and wildflowers of early spring had given way to the dried golden brown of summer. The air in the San Joaquin Valley was hot and dry as the train chugged toward the agricultural town of Merced. There they

transferred to another train bound up the Merced River valley to El Portal, the gateway to Yosemite. From his seat by the open window Adams felt the hot wind in his face and heard the roar of the locomotive echoing from the canyon walls. They arrived that evening at El Portal and made their way to the Hotel Del Portal. Despite the heat and the long ride, Ansel was energized by the new surroundings. The roar of the nearby Merced, the smell of pine, the towering granite walls of the canyon, and the ridges beyond promised further mysteries; he could hardly wait.[2]

The next morning Adams was up at dawn and down to the river to scout the area. After breakfast, the family boarded an open bus bound for the valley. Dust and exhaust fumes mixed with the smell of pine and mountain laurel as they climbed the steep gravel road. On one side were rugged walls of broken rock with sage and manzanita clinging to precarious footholds; on the other side were nearly vertical dropoffs to the canyon below. Ansel took it all in, bouncing in his seat like a caged squirrel. He could not understand why some of the passengers closed their eyes as the bus rounded turns that threatened to send them into the yawning abyss.[3]

After a two-thousand-foot elevation gain in only ten miles, the bus emerged at Valley View. They beheld the panorama of the towering cliffs, plunging waterfalls, and tree-lined valley floor of Yosemite. As they twisted and turned down the narrow road, Adams sat transfixed, rapturously taking in the sights and sounds and smells of the valley.[4]

They arrived at Camp Curry to the effusive greeting of its proprietor, David Curry, shouting and waving his arms, helping with baggage, directing his customers toward their tent cabins. Ansel and his parents piled their luggage into tent number 305. Throughout the rest of his life Adams recalled this day as a defining moment; he felt a deep psychic connection had been made.[5]

Soon after their arrival, Ansel's parents gave him a Kodak No. 1 Box

Brownie camera. After a brief lesson on its simple controls, he was off to explore the area. On foot, camera in hand, he traversed the valley with characteristic hyperkineticism. He took snapshots with no conscious artfulness, only a desire to record what caught his eye.[6] At one point he clambered atop a rotting stump to shoot across the valley floor to the cliffs above. As he leaned back to take the picture, the stump gave way, sending him plummeting to earth. On the way down he managed to trip the shutter.

The next day he took the film into the valley's local camera shop, Pillsbury's Pictures, Inc. When he came back to pick it up, Arthur Pillsbury himself presented him with the processed photos. Pillsbury inquired about one shot on the roll in particular. How had it happened to be made upside down? Had Adams held the camera inversed over his head for a better angle? Ansel explained his airborne photograph, adding that it was just a matter of luck that it had been shot at a perfect 180 degrees. Pillsbury gave the boy a skeptical look; here was an odd one indeed.[7]

The family spent four weeks in Yosemite and the surrounding area, visiting all the required tourist spots. They hiked to the Little Yosemite Valley and up the Yosemite Falls trail and took the bus to the Big Trees, the ancient groves of giant sequoias in the mountains west of the valley.[8] Although it was a revolutionary event for Ansel, the Adamses' summer vacation fit the standard patterns of middle-class leisure for the era.

In California, a love for outdoor life had been woven into the cultural fabric of the region since its Spanish and Mexican colonial days. Under American rule, the practice of holiday migrations began in the late 1860s among San Francisco's upper middle class, who ventured south into the Coast Range or northward to the Russian River.[9]

Owing to its remote mountain location, Yosemite was slower to become an important tourist destination. It is generally agreed that

Yosemite was first seen by Euro-Americans in 1833, when the fur trapper Joseph Walker led a reconnaissance party across the Sierra in the fall of that year. Walker and his men, near starvation, looked enviously down at the valley floor, with its wide meadows and the curving Merced River. Finding no route down the nearly vertical slopes, they were forced to push toward the lower foothills in search of game.[10]

The Ahwahneeche Indians who inhabited the valley saw no more strangers until 1849, when the foothills were suddenly and, for them, inexplicably filled with thousands of gold-hungry, gun-toting miners. The native inhabitants of California's mountainous interior regions had generally avoided contact with the Spanish and Mexican colonists of California and were ill prepared for the onslaught that followed the U.S. conquest of the region and the discovery of gold. Miners brought with them the racism and violence of frontier America. In the Sierra foothills volunteer battalions routed the native populations who were believed to stand in the way of civilization and profit-making.[11]

On March 25, 1851, the Mariposa Battalion, one such unit of mounted volunteers, entered Yosemite Valley. Lafayette Bunnell, who chronicled the event and gave the valley the name by which it has since been known, sensed the aesthetic power of the spot.

> None but those who have visited this most wonderful valley can even imagine the feelings with which I looked upon the view that was there presented. The grandeur of the scene was but softened by the haze that hung over the valley—light as gossamer—and by the clouds which partially dimmed the higher cliffs and mountains. This obscurity of vision but increased the awe with which I beheld it, and as I looked, a peculiar exalted sensation seemed to fill my whole being, and I found my eyes in tears with emotion.[12]

Few in the Mariposa Battalion shared his romantic tastes. Others would follow who did.

James Hutchings, the author of the travel adventure that sparked Adams's original curiosity about the place, was the proprietor of the principal tourist hotel as well as the valley's biggest booster in the popular press. In 1855, just four years after the Mariposa Battalion's arrival, Hutchings led the first party of tourists into Yosemite. Accompanying the group was the painter Thomas Ayres, whose sketches of Yosemite Falls and the towering cliffs of the valley aroused great public interest when they were reproduced as engravings in the eastern press. The following year Hutchings started *Hutchings' Illustrated California Magazine*. He was editor and principal author of the monthly, which, with its well-reproduced engravings and earnest text, urged Californians to take notice of their natural environment and to see it as part of their emerging regional identity. The premier issue featured an article on Yosemite.[13]

In 1859, Hutchings introduced the first photographer to the valley, Charles Weed. His Yosemite work went on display in Sacramento at the Fifth Annual Fair of the State Agricultural Society. With increasing publicity came increasing tourism, though the numbers remained small. The difficult trip on horseback and foot was made, according to one report, by a total of 653 visitors in the first nine years following Hutchings's first tour.[14]

Despite the fact that few had actually witnessed them in person, within a few years the wonders of the valley and the nearby Mariposa grove of giant sequoias had become widely publicized in the national press. In 1864, Congress took the unprecedented step of granting this land to the state of California in order that it be protected for "public use, resort, and recreation." In the decades to come, Yosemite became one of the lasting symbols of California and an icon of the western landscape.

With the rapid construction of railroads in the 1870s and 1880s,

western tourism became an affordable possibility for most of the middle class. This newly accessible West offered a strange new environment to easterners as well as the thrill of real or imagined dangers of travel through territories that had only recently been "subdued."[15] The first carriage roads into Yosemite Valley opened in 1874 and 1875. Tourism remained slow, however, until the 1880s, after which it began to increase substantially each year.

By 1907 the railroad ran as far as El Portal, and in 1913 the automobile began to replace the railroad. The English visitor Lord Bryce warned Californians about the dangers of automobiles in Yosemite, which he likened to letting the "serpent in the Garden of Eden." The automobile's impact was immediate: the number of visitors to the park doubled in each of the next two years, from 15,000 in 1914 to more than 33,000 in 1915.[16]

### Back to Nature

When Charles and Olive Adams brought their son to Yosemite Valley in 1916, they were like many Americans looking for a pleasant vacation in the great outdoors. Yet for the Adamses, as for many of their fellow nature lovers, there were deeper motivations as well. In the decades following the Civil War, just as America's rise to industrial power and territorial consolidation of the continent were being achieved, there arose a broad popular sentiment that something was being irrevocably lost as the nation succeeded in its conquest of the wilderness. The cult of the frontier and the rise of tourism went hand in hand. Although transportation was the key to mass access, other forces acted to bring tourists to the famed spots of the West. Among these were intellectual currents that sensed in the passing of the frontier and the rise of a new industrial and urban nation challenges to the very foundations of Amer-

ican society and culture. With the shift toward an urban culture, many felt the beneficial contact with wilderness that had been such an essential factor in American life would disappear.[17]

In 1893 at the Chicago Columbia Exposition, the historian Frederick Jackson Turner gave emphatic shape to such ideas. His paper, "The Significance of the Frontier in American History," presented to a meeting of the American Historical Association at the exposition, argued that democratic traditions in the United States emerged as a result of the influence of the frontier. As "settlement" moved west, inherited social forms were discarded under the necessities of wilderness existence. The opening of new lands and the building of new communities encouraged democracy and self-reliance. Now those qualities and much of the nation's democratic character were threatened as the frontier disappeared.[18]

Theodore Roosevelt did as much as anyone to popularize these ideas. For Roosevelt, the experience of "the rugged life" was central to maintaining the qualities that had made the nation great. Like the Progressive reform movement, the "back-to-nature" movement at the turn of the century marked the attempt of Americans to come to terms with the new social and economic landscape of the modern world.

Americans in the twentieth century found themselves confronted by a new society and economy dominated by powerful corporations, impersonal cities, and warring factions of capital and labor, rich and poor. An urbanized industrial economy with its standardization and regulation of life and work seemed to offer little room for the independence and self-motivation that had supposedly characterized American culture through the nineteenth century. As a replacement for lost freedoms, there arose what some historians have called a "therapeutic" orientation, in which individuals sought self-fulfillment through physical challenge and personal growth.[19] With the continent thoroughly conquered, Americans increasingly viewed the wilderness not as an obstacle

to be overcome but as a recreational and spiritual resource that allowed them to keep the "frontier" alive within themselves.

For young Ansel Adams, Yosemite proved to be just such a release, offering freedom from the confines of his family's gloomy sense of failure and its stifling Victorian restraint. Yosemite would remain the symbol of health, freedom, and renewal throughout his life. The sense of liberation and vitality he found there was at the core of his creative vision and his message to the world.

## Darkroom Monkey

When the Adamses returned to San Francisco, Ansel continued to use his camera. Mechanical devices had always fascinated him, and his experience at the Panama Pacific International Exposition had heightened his curiosity. Even before he received his Kodak Brownie, he had seen his father shooting photographs around the house. Charles owned a Kodak Bullseye box camera and used it to make family snapshots and records of their travels, their home, and the surrounding area. Ansel and his father were two of millions who learned to press the button and let Kodak "do the rest," as the company's advertising motto put it. George Eastman, the founder of Eastman Kodak Company, had pioneered the mass marketing of small-format roll films and automated processing, the two key developments in the rise of simple and affordable amateur photography. Eastman's lightweight, handheld Kodak cameras ushered in a new era in photography. Once the exclusive province of professional photographers who had mastered the alchemical mysteries of the medium, now amateurs by the millions were making their own images with the press of a button.[20]

Adams began in much the same way, wandering through his local haunts with camera in hand. His photographs from these years were standard enough. They depicted his house, Baker Beach, and the nearby

dunes—all, in his words, simple records of the things that interested him. Yet, typically, the boy was soon burning with the desire to learn everything he could about this new device. He went to work part-time for a neighbor, Frank Dittman, as a "darkroom monkey." Dittman had a photo-finishing operation in the basement of his home where he set Adams to performing a variety of tedious chores. Ansel got up early and was at Dittman's by 7:00 A.M. to pick up the previous day's processed negatives and prints. He then made his rounds of the local drugstores by streetcar, to drop off the finished work and pick up the new orders. Back at Dittman's by around 10:30 A.M., he would head to the darkroom to develop and help print the new film.[21]

Adams learned the rudiments of photographic chemistry, such as it was generally practiced in that day, but their methods were crude. Dittman and his crew did not concern themselves with maintaining fresh solutions, controlling processing times and temperatures, or thorough washing of negatives and prints. As a result their work was doomed to a limited life span. Nonetheless, Adams made the most of his opportunities. With no formal schools for photography in San Francisco at that time, the best path to photographic education was apprenticeship.[22]

Adams received two dollars a day, not a bad sum then for a fifteen-year-old working part-time. He began in 1917 and continued at the job through the following year. What was significant about his work for Dittman was his early immersion in the technical aspects of the medium. Ansel shared his father's scientific interests. As he had gravitated to the Palace of Machinery at the exposition, as well as to the Palace of Fine Arts, so, too, in his photography his interests were technical as well as aesthetic. This early orientation presaged Adams's lifelong interest in mastering all aspects of darkroom chemistry and photographic technique in general. Technical excellence was always Adams's forte and a major contributor to the power of his images.

Ansel was well received by Dittman, the three printers, and the

six delivery boys, although his odd ways provoked some ribbing. The skinny, hyperactive Ansel, with his crooked nose, his long words, and his stories about Yosemite, seemed an amusing character. They called him "Ansel Yosemite Adams." He took it all well, Dittman remembered, and appeared to find the pranks played on him funny, too. He "picked up cussing real fast," and Dittman thought the job was a good antidote to the music lessons he believed were just another example of the coddling the boy got at home. Dittman recognized that Ansel was in his element in the darkroom. "It came natural to him. I could see right off he was good. Whatever the kid done was done thorough."[23]

Adams was fascinated by photographic equipment and began to prowl the local camera shops to investigate the rows of lenses, tripods, lights, chemicals, printing papers, cameras, and film. He read the amateur photographic magazines and whatever technical handbooks he could find. At a local camera club he met W. E. Dassonville, a manufacturer of fine printing papers and an accomplished photographer. Dassonville knew many of the Bay Area photographers and gave Adams an introduction to the practice of the medium as a fine art.[24]

## Music

Ansel's approach to photography was influenced by his central passion of the time—music. He adopted the rigorous discipline of his classical training and perhaps also the moods and structure of the works he was learning.[25] Although Ansel's enthusiasm for photography was growing, music continued to be his main concern, and by the age of eighteen he had determined to become a professional pianist.

His first teacher, Marie Butler, felt that Adams had learned all he could from her and urged him to move on to more advanced studies. His next teacher was Frederick Zech, an eighty-year-old German émigré with a thick accent and thicker mustache. Zech had been an assistant to

Hans von Bulow, one of the great German pianists and conductors of the nineteenth century. He realized immediately that Adams had a solid foundation. If the boy was willing to work hard, he could go far. Zech demanded that each day his student spend one hour on finger work, one hour on Bach, one hour on Beethoven, and two hours on another composer.[26] The neoclassical order and precision of Bach and the romantic grandeur and emotion of Beethoven had been woven into Adams's mind from the age of twelve. Throughout his life these composers profoundly influenced his creative vision.[27]

After many years with Zech, Adams went on to study with Benjamin Moore, who emphasized the refinement of touch and expressive skills. The relationship of technique to creative expression and interpretation was central to Moore's approach.[28] Throughout his career, Adams reiterated that technical skill was an essential means to the goal of creative expression, not an end in itself. The emphasis on a never-ending search for technical perfection that Adams learned in his musical studies affected his approach to photography profoundly, yet equally important was the application of that technique to the expression of a personal vision.[29]

## Yosemite

Although most of the year was given over to intensive studies, summers were reserved for the Sierra. After Adams's first visit to Yosemite in 1916, he returned every year for the rest of his life. In the summer of 1917, Charles was unable to go along, so Ansel went with his mother. She wrote regularly about their activities. Her son's inexhaustible energy was a frequent refrain. On a typical day, Ansel was up before seven o'clock and out the door, bound for Pillsbury's camera shop. After dropping off his prints back at the tent, he set out for a swim in the chilly

Merced, then a hike to Happy Isles and on to Vernal Falls. He returned for lunch, then he and a boy he met on the train went off to explore some more around the valley.

His father hoped his photography was progressing, that he would make a serious effort of it. Amused but pleased with Ansel's prodigious photographic output, he urged the boy to take his time with each image, to think out his compositions before snapping the shutter.[30]

That year Ansel and his mother had been introduced to Francis Holman, a retired mining engineer, who knew the Yosemite area intimately. Ansel and "Uncle Frank" took an immediate liking to each other. His mother was pleased to have some reliable supervision for the boy, someone who could introduce him to all the trails of the valley and the adjacent country.

Holman was a member of the Sierra Club, the San Francisco–based conservation and mountaineering organization founded by John Muir in 1892. He told Adams stories about club outings to the high Sierra backcountry above Yosemite Valley, an area Adams was determined to see for himself someday. As Holman was the summer custodian of the LeConte Memorial Lodge, the Sierra Club headquarters in the valley, Adams took to visiting there regularly to read from its small collection of mountaineering books and journals and to pore over snapshot albums of club excursions.[31]

The sixteen-year-old Adams returned to Yosemite by himself in the summer of 1918. He went on several short excursions with Holman to the mountains above the valley. On one typical trip they started out for Mount Starr King at 5:00 A.M., as the first light of dawn was just beginning to show in the east. Holman led the way up the steep trail out of the valley. Soon they were making their way cross-country through stands of yellow pine and Douglas fir, across swift-running streams, and over rocky outcroppings of glacial moraine, steadily upward to the base

of the peak. They arrived around midday, and, after a quick lunch, Holman led the way up the big snowfield, looking for a route to the top. The best option seemed to be on the northern side, up a snow-filled chute that led nearly all the way to the summit. Adams and Holman agreed that it would be wise for Adams to remain below. He watched as Holman began to climb the final five hundred feet of nearly perpendicular snow, cutting footholds with his ice ax as he went. About an hour later he was at the top, the first ascent, to Holman's knowledge, of the mountain via that route. Although Adams had not made the summit, he was excited to have gotten as far as he did.[32]

On most days Adams spent his time at far less precarious activities. He liked to hike in the valley and spent a good part of his time photographing the wildflowers he found on his rambles. Along with his other scientific interests, Charles Adams was an avid amateur botanist. Ansel sent him his wildflower photographs in the spirit of a naturalist's documentation. Although the photographs were admittedly mediocre, they were certainly adequate for identifying the specimens.[33]

The next year, in the spring of 1919, Adams was having another of his regular bouts with illness. He had contracted a dangerous strain of flu from which many had died that year. Ansel recuperated, but while he was laid up in bed, he read a book about the life of Father Francis Damien, the priest who cared for the lepers at the colony on the Hawaiian island of Molokai. It was, perhaps, an unfortunate choice.

He became convinced that the fate of the lepers could be his. He feared physical contact and contamination in public places. If forced to touch such potential germ sources as doorknobs or streetcar railings, he would immediately run to wash his hands. For months he agonized about this imagined assault on his health. Above all he wanted to return to Yosemite, where surely no leprosy lurked. His parents, disturbed by

their son's strange compulsion, agreed that the mountains might do him some good.[34]

That summer Adams learned there would be an opening for the job of caretaker at the Sierra Club's LeConte Memorial Lodge the following year. He applied for membership and wrote to the club's president, William Colby, asking to be considered for the position. Adams was looking for a way to continue to spend his summers in Yosemite; this seemed the perfect opportunity. Although he was just eighteen, Colby hired him.

Adams arrived in Yosemite in mid-April of 1920 to begin his duties at the lodge, actually a small stone cottage designed in a vaguely neo-Gothic style by an associate of the California architect Bernard Maybeck. The building had been broken into over the winter. Whoever had done it had made a general mess of things and burned all the firewood.

Adams was less than pleased with his cold, damp, and dirty surroundings. He found the water had been turned off and that his bed consisted of an old army cot and a single thin blanket. But as spring progressed to summer, he made it a comfortable and cozy place to live. Adams's duties included greeting visitors, answering their questions, and leading hikes around the valley. Through his work at the lodge he became acquainted with many Sierra Club members and began to forge the friendships that would last throughout his life.[35]

Adams felt the mountain life and regular exercise were doing him a world of good. His physical and mental health were both remarkably improved. On an excursion to the top of Vernal Falls, he kept careful track of his heart rate and respiration, noting with satisfaction that his pulse had risen to only ninety-five beats per minute by the time he reached the top. His strength was improving as well; hauling his Graflex view camera, glass plates, and wooden tripod up backcountry peaks was becoming routine.[36]

Adams spent most of his free time away from the lodge working on his photography. He was now trying to move beyond his early snapshots to serious artistic work. He took his time, looking for just the right scene and studying his subjects carefully. Rather than straightforward records, he was determined to make "impressionistic" photographs. To capture the mood and scale of the great mountain chain required careful selection and interpretation. He sent his father a print he considered particularly successful and provided a detailed analysis of the techniques employed.[37]

He had come across an intriguing cascade in Tenaya Canyon on one of his hikes and vowed to return with his camera to photograph it. He had assumed that the morning light would be most propitious, but on arriving at 9:00 A.M., he was disappointed to find the water in deep shade. He sat down among the rocks at the river's edge and waited patiently for the sun to strike the cascade. Finally at 1:00 P.M. the lighting was ideal, and he set about his work.

He sought some way to convey in visual terms the feeling of the scene—the powerful flow of water, the sparkling sunlight, and the floating spray. He chose a triangular composition to convey the sense of dynamic movement, the water rushing in two vigorous diagonals across the frame. He achieved the impression of brilliant sunlight through careful attention to lighting conditions. His patient wait for the correct position of the sun resulted in an intense print, the luminous waters of the foreground set against the deep shade beyond.[38]

In seeking a creative approach, Adams self-consciously tried to emulate the standards of contemporary art photography. From its inception in the mid-nineteenth century, photography was considered a useful tool to the artist, but, because it was assumed to be a merely mechanical procedure that expressed no artistic sensibilities, it was not

generally held to be a fine art. However, there were soon champions of the medium's artistic potential.

Among the most influential was the Englishman Peter Henry Emerson. In articles, speeches, and his book, *Naturalistic Photography*, published in 1889, Emerson described a method for producing artistic photographs that was based on principles of vision similar to those advanced by the impressionist painters. Human vision, Emerson explained, does not perceive the world in sharp focus; therefore, neither should the photograph render it that way. Emerson's visual style as well as his choice of outdoor scenes and still lifes reflected the continuing interaction of painting and photography. Adams's impressionistic rendering of the Diamond Cascade and his description of the concepts behind it show the influence of these ideas and marked his first serious attempt to create works of art with his camera.[39]

His use of the phrase "pictorial photography" demonstrates his awareness of what was then the predominant style among the photographic salons in the first decades of the twentieth century. The pictorialists used soft focus and the diffused textures of the platinum and gum bichromate printing techniques to mask photographic precision and produce a more painterly effect. It was felt that if their photographs were to be taken as legitimate works of art, they must not be seen as mere mechanical transcriptions of reality but as subjective interpretations.[40]

In his early photographic efforts around Yosemite, Adams was absorbing and responding not only to the relatively recent ideas in art photography but also to older traditions of landscape art in Europe and in the United States. The popularity of landscape as an artistic genre had waxed and waned with the changing social and intellectual environment. In the European tradition, landscape emerged in the Renaissance after a period of neglect during the Middle Ages. The medieval Christians, for the most part, viewed nature as a fallen world, divorced from God's

kingdom of heaven. Art should concern itself with the spiritual realm. To contemplate the beauty of the landscape was at best a waste of time, if not positively sinful. In the Renaissance, however, the rise of secular empiricism encouraged a renewed interest in the world of nature. Artists of the Renaissance saw the landscape as part of a well-ordered universe governed by rational law. Yet empiricism and rationalism led to the effort not only to record nature but also to control and reshape it for human purposes.[41]

By the eighteenth and nineteenth centuries, the industrial revolution was radically transforming European society and its landscape. The Renaissance ideal of the scientist/artist, typified by Leonardo da Vinci, gave way to the romantic artist who rejected science and rationalism and the industrial world they were creating. Artists began to view nature with an elegiac nostalgia, seeing it as the antipode of mechanized order. Its "wildness" was a source of inspiration and relief from what they considered the ugliness and inhumanity of the new industrial society and the machines it worshiped.[42]

Throughout the nineteenth century, artists in the United States absorbed the ideas and stylistic trends developed in the centers of European culture, brought them to America, and adapted them to the New World scene. Many American artists, however, sought to move beyond the European tradition to create a more truly indigenous art.[43]

The painter Thomas Cole was a case in point. Working mostly in the vicinity of the Hudson River and the Catskills in upstate New York, Cole was steeped in the romantic tradition and envisioned nature as a source of wisdom and religious inspiration. A characteristic landscape, *In the Catskills*, shows a solitary hunter gazing across a tranquil lake to distant rugged hills infused with a radiant light. Cole and the other artists of the Hudson River school shared the widely held belief that the North American wilderness offered a unique contribution to American

life and art—a vigor and purity that, to some extent, made up for its relative lack of established cultural and historical traditions.[44]

Yet despite the romantic pull of wilderness, Cole, like most Americans, remained committed to civilization, industrialization, and American expansion. In an article entitled "Essay on American Scenery," he predicted that "where the wolf roams, the plough shall glisten, on the gray crag shall rise the temple and tower, mighty deeds shall be done in the new pathless wilderness."[45]

Ansel Adams shared this ambivalent embrace of both wilderness and "American progress." Over the course of Adams's lifetime, the contradictions would become increasingly difficult to sustain. In the twentieth century, as remaining wilderness areas rapidly disappeared before the mechanized plow and the steel tower, the assumption that America could be an indefinitely expanding technological society while simultaneously remaining "nature's nation" became ever more doubtful. For Adams, it was a question that would never fully be resolved.

While nineteenth-century landscape photographers borrowed heavily from their easel-wielding brethren, photography's ambivalent status as both an artistic and a scientific medium gave their work some unique characteristics. As the United States pushed westward, government-sponsored expeditions, the railroads, and promoters of tourism hired artists to record and interpret the newly conquered lands. Photographers were particularly in demand among those who wanted to convince viewers that the wonders of the western landscape were not mere figments of the imagination or the product of romantic exaggeration.[46]

These photographers, therefore, had to combine scientific, promotional, and creative goals. The documentation of the exploratory surveys and the geologic formations of the West was only part of their job. Their ability to convince their audience—Congress, private corpora-

tions, and the public—of the grandeur and national significance of these regions not only kept their various enterprises funded and operational but also added to the growing sense of the western landscape as a national resource of aesthetic as well as economic value.

William Henry Jackson's photographs for the Ferdinand Hayden survey, for example, helped convince Congress to set aside Yellowstone National Park in 1872. Later, his work for the western railroads helped to fill their cars with tourists bound to witness for themselves the wonders they had seen in his photographs. Carleton Watkins's mammoth-plate images of Yosemite contributed to the preservation of the valley in 1864 and attracted an ever-growing stream of visitors to the park, filling the coffers of those who catered to the tourist market.[47]

The simultaneous pursuit of federal patronage, commercial clients, and fine art ideals evident in the careers of Jackson, Watkins, and other nineteenth-century landscape photographers in the West would play a defining role in Adams's own photographic career.[48] The friction between his creative, commercial, and environmental concerns would later become a source of great conflict in his life and art. For now, however, he was able to pursue his art with an unburdened spirit.

## High Country

By midsummer 1920, Adams felt like an old Yosemite hand and was eager to go on an extended trip into the wild country above the valley rim. He soon had his opportunity. Francis Holman, Elizabeth and Charles Pond, and two other friends were planning a trip up the Little Yosemite Valley to Merced Lake. Adams was able to take time off from his duties at the LeConte lodge to join in the excursion. He packed up the burro he had purchased earlier that spring and started out.

The trip began in a soaking rain that continued as they camped alongside Merced Lake. It cleared up during the night, and the next

morning Adams climbed up the ridge behind the lake just as dawn glimmered in the east. He sat facing into the gentle breeze that flowed over the eastern escarpment of the Sierra, watching as Mount Clark and the surrounding crags were slowly bathed in golden light. If the first experience of Yosemite Valley had been a revelation to him, here was its confirmation. Adams scrambled back down to camp, where Uncle Frank was fixing breakfast. Seeing Adams's breathless excitement, he gave a knowing smile. The Sierra had found another convert.[49]

In the following summers Adams went on even more frequent and extended trips with Holman and a number of other companions. Among these was Elizabeth Adams, the young widow of Ansel's uncle, William. Ansel and his Aunt Beth became close friends, corresponding regularly in those years. As they were both aspiring poets, their letters invariably contained some new bit of verse. Adams's poetry was in the romantic mode, full of nature imagery and spiritual yearning. Aunt Beth was apparently the first person with whom he was willing to share these personal thoughts. It was one more way in which his mountain excursions brought a new confidence and openness into his life.[50]

Adams's Sierra outings with Holman and other companions generally followed a predictable routine. They packed most of their supplies on burros, as was common practice in high country travel at the time. Each morning they would rise at dawn, fix a quick meal, and get an early start on the trail. They walked all day, covering an average of ten to fifteen miles. Arriving at a stopping point in the late afternoon, they would set up camp quickly. At that time equipment was simple and primitive, with none of the creature comforts of the modern back-packer. Wool blankets over a bed of pine branches or meadow grass sufficed for sleeping. Coffee cans with a hoop of wire through the top served as kettles, and an iron skillet performed all other cooking tasks. Dinner was "a mixture of ants and cinders and hash or whatever it was."[51] Adams was prone to boast about his early spartan approach. To

those few who ventured in the Sierra backcountry, making do with simple materials was the sign of the true devotee.

On layover days Adams and his friends would climb nearby peaks. What they lacked in climbing technique they made up for in a combination of enthusiasm and good luck. They possessed none of the equipment employed by later generations of climbers. Their only "safety" devices were an old World War I trench pick and a length of window sash, the sturdy cords used to hold window counterweights. This latter item was potentially deadly. Rather than ensuring their safety, the cord more or less guaranteed that if one fell, all would go together. Furthermore, being only an eighth of an inch thick, the cord offered little shock absorption and potentially deadly lacerations.[52]

On one excursion among the Merced peaks east of Yosemite Valley, Adams and Holman had a quick ride down the mountain. They were working their way up a broad snowfield, roped together with the window sash cord. Holman was cutting steps in the hard-packed snow with the trench pick. About a thousand feet of snow and ice lay between them and the peak. Eight hundred feet up, Adams slipped and started to slide down the sixty-degree slope, pulling Holman along with him. "Keep your feet front," Holman yelled. "Don't roll!" They were sliding face down and going so fast that they were unable to dig their ice axes in to slow themselves. A big pile of snow and rocks was below them at the bottom of the hill. Somehow they missed the rocks and plowed into the snowbank unharmed. Holman sat up slowly, rubbing the snow from his face. "Well, we'll go right up again," he said. And up they went.[53]

## Growing Up

Adams continued to look after the Sierra Club's LeConte lodge each summer for the next several years. He began to gain a certain perspec-

tive, to realize how fortunate he had been and continued to be. His adventurous, carefree summers stood in bold contrast to the cold winters and disciplined training back home in San Francisco. With his growing self-reliance came self-awareness and maturity.

Because his family rarely discussed such things openly, he was hesitant to express his feelings, but with a self-conscious formality, he made the effort. He wrote to his father in the summer of 1921, apologizing for his infrequent correspondence and its distant tone. The lack of warmth was not intended, he said. He hoped somehow to find a way to express his true feelings. Adams apparently began to feel some guilt for his summer freedom. He feared that he was being hopelessly selfish, enjoying an idyllic life while his father toiled in the city. He felt that he should be contributing to the family's income and helping to lighten, rather than add to, the burden his father carried. He realized that it was his father's efforts that made it all possible. Although his mother and aunt offered his father little support, Ansel wanted him to know that he was appreciated. He vowed that someday he would prove his admiration by fulfilling the high expectations his father held out for him.[54]

Although Ansel's letter expressed a growing maturity and sense of responsibility, there was also a considerable naïveté. He assured his father that he had absorbed the high moral ideals his parents sought to instill. These values were only strengthened, he said, by contact with those who were less virtuous. While he admitted that he was far from perfect himself, he expressed shock at the hypocrisy he had seen in others, the "unprincipled" lives so many ostensibly upstanding citizens lived. He vowed to hew to a higher standard. He would always uphold the dignity of the family name and the high moral standards he had been taught.

Charles was clearly pleased with his son's letter. He admitted that they had seldom sat down for a good honest talk. While they had always

been close, their feelings had characteristically remained unspoken. Charles assured Ansel that he was the axis of his parents' lives. They wanted to share, if he would let them, all of his thoughts and emotions and all of his plans for the future. As their only son, he was the most precious part of their lives.[55]

Charles, however, rejected the notion that Ansel should feel any pangs of conscience. Charles suffered stoically, answering the demands of failing business ventures and uninspiring office work as an accountant while he wished for nothing more than to pursue his astronomy. It made him determined to give his only son every chance to avoid such a fate. The high-minded life of the artist was what he wanted for Ansel and what he gave him every opportunity to achieve.[56]

He was pleased that his son had developed such a strong sense of moral purpose. But he warned Ansel that many young men who begin their lives in a virtuous way soon fall prey to unsavory influences. Having no experience with such dangers, they are susceptible to characters and circumstances that may lead them astray.[57]

His father had little cause to worry. Adams's regimen during the winters in San Francisco in these years was a busy and disciplined one. In addition to intensive practice and instruction on the piano, he was also studying Greek with a retired minister, Dr. Herriot, and learning business practices and accounting from his father.[58] Ansel's music was progressing rapidly, and although he loved his annual mountain trips, one drawback to his Yosemite stay was the lack of a piano. Adams could not afford to get rusty. He inquired among the valley's residents to see if he could find a piano on which to practice. It did not have to be a particularly good one, just something to exercise his fingers. The Yosemite National Park ranger-naturalist, Ansel Hall, suggested he visit Harry Best, one of many landscape painters drawn to Yosemite but one of the few who lived there full time during the summers. Best kept a

studio and shop open to the public. Hall told Best that he was sending over his "namesake." Best's daughter, Virginia, thought he was sending one of his relatives and was surprised when a young man named Ansel Adams showed up. The Bests had an old square Chickering piano that had seen a lot of use, but Adams was pleased to have any instrument.

He began to visit every afternoon. It slowly dawned on Virginia that Ansel was interested in more than their piano. While she was flattered by the attention, she was hesitant to venture beyond a bantering friendship. She felt emotionally unprepared for a serious relationship.[59] Virginia was a shy but lively girl, an enthusiastic hiker who was training to be a singer, all of which appealed to Ansel. Her mother had died the year before, and Virginia now had the added responsibilities of looking after the home for her father.

It is easy to see why Ansel would find Virginia attractive. She was seventeen years old when they met, two years younger than he, a beautiful and intelligent young woman with a lithe body and bright blue eyes. What Virginia saw in Ansel is harder to imagine. She recalled him as a tall, awkward young man.[60] Ansel still had much of the hyperactive personality of his childhood, and his recent growth spurt had left him all spindly arms and legs. What Ansel may have lacked in physical appeal he made up for in sheer energy and enthusiasm. He was full of dreams for the future and grand visions of a life dedicated to art and music.

Ansel and Virginia had a traditional and restrained courtship. He wrote to her regularly as their friendship grew, giving advice and confiding in her about his uncertainties. His first letter to her, written from his campsite at Merced Lake in the late summer of 1921, was mostly a friendly note, with news of the weather, a description of the country and his itinerary, and an expression of thanks for the use of the piano.[61]

The following summer Ansel was willing to reveal a bit more of his emotions, telling Virginia of the beauty he found in the alpine country

and the wonderful sense of community among the group. It was a return, he said, to simple, ancient pleasures of life, free from the bonds of too much civilization.[62]

It was earlier that summer that Ansel first broached the subject of Virginia to his parents. He felt a bit awkward at the prospect.[63] He began by offering his appreciation for the new openness in their communications and promising that he would not hesitate to share all of his thoughts. The thought foremost in his mind was Virginia, and in the best Victorian terms, Ansel told his parents of her kind and generous nature, her practical sensibilities, and her unshakable virtue. He was deeply smitten, he said, but he assured them that his emotions would precipitate no rash or impetuous behavior.[64]

The following summer, 1923, Ansel and Virginia's love ripened through warm Yosemite days. He was now twenty-one and she nineteen. Both began to feel they were destined for one another. Back in San Francisco that fall, Ansel was already lonesome. He had been keeping very busy since his return, with both music and photography. He wrote often to Virginia. He was giving piano lessons, which, he explained, were not only a source of income but also a means of establishing his reputation in the city. He was also pursuing photographic work, securing occasional portrait commissions and commercial assignments. Although pleased with the progress he was making in his photography, it was decidedly secondary to his music, a means of incidental income until his musical career was firmly established. After that, he said, photography would be a hobby only. Music would remain his life's work.

Despite this avowal, for the rest of the letter, he mused on his direction in photography. He would concentrate on only the highest-quality work. Although his clientele would be more limited, he would be able to command a higher fee and a greater satisfaction, both for himself and

his clients. He hoped that with such a strategy, he could establish a steady income from which to continue his music and to provide for Virginia.[65]

Adams had been trying his hand at commercial photography in San Francisco, with disastrous results. Around 1920 his next-door neighbor hired him to photograph her kindergarten class at the Baptist Chinese Grammar School. Adams gladly accepted the commission and arrived at the school with his view camera, tripod, and flash equipment. At that time, photographic flash units used magnesium flash powder. Adams was still a little unsure of the proper quantities. He decided to be on the "safe" side and use a bit more than the tables in the instructions indicated; the walls of the classroom were rather dark, and he did not want to have the negative underexposed. Overcompensating to the extreme, he used about fifteen times the recommended amount of powder.

He had the children line up. The teacher told them to look at Mr. Adams and smile. Adams raised the flash gun above his head, opened the view camera's shutter, and fired the flash. With a blinding light and a loud explosion, Adams's arm holding the flash gun was thrown back. In the billowing smoke he nervously closed the shutter and looked about the room. There was a shocked silence and no one to be seen. Then, from under the desks where students had dived for cover, came a chorus of wails. The teacher threw open the windows and tried to calm the children. The fire department arrived with sirens blaring as smoke poured from the classroom. Told it was only a photographer, they returned to their station. When the children had recovered sufficiently, Adams suggested they try again, this time outdoors with natural light.

His next job was a wedding. He was careful this time to use a more prudent quantity of flash powder. The bridal party had assembled in a small room, so he set up in a doorway to get the entire group within the frame. He pulled the shutter and fired the flash. All seemed well until he

looked at the lintel above the doorway and saw the flash had scorched the paint four feet around. Adams agreed to pay for the repainting and wound up with a net loss on the assignment.[66]

## Summer in the Sierra

Although Adams's early commercial work was not highly successful, his mountain photography was progressing well. In the summers of 1925 and 1926 he joined the LeConte family on hiking excursions to the Kings River region in the southern Sierra, approximately one hundred miles south of Yosemite. Professor Joseph N. LeConte II was the son of the eminent geologist Joseph LeConte, chief of the U.S. Geological Survey in the West and himself a leading authority in the field. LeConte (called "Little Joe" by his fellow Sierra Clubbers) and his family knew the spectacular and seldom-traveled Kings Canyon area well.[67]

Adams was ecstatic at this opportunity to explore new regions of the Sierra and determined to bring a full panoply of photographic equipment. He wrote to Virginia that he was collecting everything necessary for the coming trip, including a plate-changing bag, two red filters, and a special box for his plates and film. With three cameras, five lenses, six filters, and a generous array of accessories, he concluded that any failure to secure good negatives could not be blamed on a lack of equipment.

After six or seven weeks of traveling with the LeContes, he returned to Yosemite to develop his plates. Although the trip itself had been an immense pleasure, this was even better. He was finally beginning to produce the kind of images he envisioned, photographs that gave a sense of the place he loved so much. He sent a few of his prints off to the *Sierra Club Bulletin*, and they were included in the annual issue, along with his report on his duties at the LeConte lodge.[68]

When time permitted, Adams took short side trips into the backcountry above the valley. Those two- and three-day excursions were

devoted entirely to photography. On one excursion, after making all the necessary preparations, he set out in the early morning with a pack on his back and his mule Electra loaded down and following behind. He made his way through stands of yellow pine and Douglas fir in the crisp morning air and brilliant sunlight, letting his mind wander. He was in no particular hurry to search out photographs. Miles went by before he came on a scene that excited his interest.

Then around a bend in the trail, the view opened: towering thunderheads above a jagged granite peak; a blue lake gleaming below. As Electra nibbled some meadow grass, Adams rummaged through the pannier for his 5 × 7 view camera, thinking all the while about how to achieve a satisfying photograph. Should he select the wide-angle lens and emphasize the broad sweep of sky? Or should he use a telephoto lens to isolate and emphasize the peak and thunderheads? And what filter should he use? The red seemed most appropriate to darken the sky and render the clouds a brilliant white. The filter would demand a long exposure, however. Would it blur the effect of sparkling water? Framing the scene on the ground glass, he found it uncooperative. Perhaps if he moved to the left and forward a bit, the line at the water's edge would begin to work in conjunction with the stand of trees leading up to the ridge beyond.

Electra moved on to a new patch of green as Adams picked up the camera and tripod, walking slowly across the spongy meadow grass. Moving up toward the lake, he saw the composition slowly come together. Shifting a little more to the right, he found exactly the vantage point he sought and pushed the legs of the tripod down firmly into the soft grass. The wind was starting to pick up now as warm lowland air raced upward above the peaks, fueling the massive thunderheads. That wind might make the long exposure troublesome. Adams decided to use a yellow filter, a shorter exposure, and a longer development for the negative. This, he thought with satisfaction, would both give the dramatic sky he wanted and keep the exposure to a reasonable length. After

framing the image, tilting the film plane slightly to emphasize the dark thunderheads, making his final focus adjustments, and selecting his aperture and shutter speed, he removed the dark slide and released the shutter.[69]

This was what Adams lived for: the simple satisfactions of roaming at will through the Sierra high country with only his cameras and Electra for company, letting his mind and body be absorbed in the creative process. Part explorer, part pilgrim, he was never happier than at this moment.

### Thoughts of the Future

Although Adams was pleased with the progress of his photography, he remained convinced that his future lay in music. Progress on that front remained slow, however, and Adams was concerned about what that meant for his relationship with Virginia Best. He wrote to her in the fall of 1925, expressing his doubts and pleading for her understanding. He felt that he was far from achieving real professional status as a musician. He assumed that it would take six to ten years before he became truly accomplished. Supporting himself, let alone a family, through this period seemed difficult at best. If he had to take on a heavy teaching load to support a family, this would only slow his progress further. He feared that on such a course he would end up a mere "neighborhood teacher," earning a precarious living and filled with regret over missed opportunities and the mediocrity of his life. Thinking perhaps of his own family's situation, he felt that this would be a miserable fate.[70]

Given this situation, Ansel felt that they must delay any plans for marriage. Instead he would try to fulfill what he saw as his destiny, dedicating his life to art, giving his whole soul and all his energy to his work.[71]

Virginia was crushed, yet remarkably patient with his decision. She

admired the fact that Ansel was completely dedicated to the life of an artist, but she was bewildered by his presumption that such a dedication had to preclude a family life. He had been urging her to develop her own musical talents. He assumed that she, too, should immerse herself in art. He urged her to give more time to improving subjects, reading and studying the classics, absorbing the ennobling spirit of the finest art. Ansel felt that Virginia did not appreciate her own powers. But Virginia did not want a musical career. She wanted a home and a family, and she was willing to wait for both.[72]

## Edward Carpenter

Adams's decision to pursue the "pure" life of art may have been influenced by his summer reading while traveling with the LeContes. On the Kings Canyon trip of 1925, he had brought along a copy of Edward Carpenter's *Toward Democracy*, written in 1883. Ansel sent a postcard to Virginia via some hikers they encountered near Marion Lake, telling her of the inspiration he had found in Carpenter's ideas.[73]

Edward Carpenter was an Englishman active in the late nineteenth-century British Socialist movement. His ideas on social reform followed in the tradition of Thomas Carlyle, John Ruskin, and William Morris, who believed modern industrial culture to be destructive of aesthetic values. They called for the reestablishment of the physical and spiritual links that had once existed between nature and society.[74]

Carpenter, like Morris, pursued an actively reformist agenda, seeking a new working-class culture based on a closeness to nature and a cooperative, small-scale craft economy. To counteract the damaging effects of pleasureless work in the factories and the poverty and unemployment seemingly endemic to the capitalist economy, Carpenter advocated small communities of limited wants that would demonstrate the benefits of the "simple life."[75] He pointed to the Americans Walt Whit-

man and Henry David Thoreau as examples of the spiritual revitalization brought about by a life close to nature. Scientific discoveries and the materialism of the capitalist industrial system had fatally undermined the authority of orthodox Protestantism, he believed. For Carpenter, the only true source of spiritual insight was nature itself.[76]

When Ansel Adams read Carpenter among the granite peaks of the Sierra Nevada, it was the perfect combination of a time and a place, a set of ideas and a receptive mind. Reading Carpenter helped to confirm his growing sense of the spiritual power of nature and its potential for the redemption of society.

## Defenders of Wilderness

Along with Carpenter, John Muir was probably the most significant influence in the development of Adams's thinking concerning the role of nature in the modern world.[77] After five summers at the Sierra Club's LeConte lodge, Adams had become well acquainted with the life and conservation legacy of the most ardent and eloquent spokesman for California's wild country. There was an emotional as well as an intellectual connection. The sense of joyous release Adams felt on his Sierra trips paralleled Muir's own experience. Wilderness was to Muir, as it was to Adams, a realm of liberation. Yet Muir, like Adams, had his Protestantism too well ingrained not to see the wilderness experience as something beyond immediate gratification. It became the great source of spiritual insight, its sermons in stone making the time spent among the mountains not sinful idleness but a pilgrimage to the font of wisdom.[78]

Muir's thinking and writing did not set boundaries between science and art, between a communion with nature and a careful investigation of it. Muir combined his scientific investigations with a born-again rapture in the sensuality of the natural world. "It is a blessed thing to go

free in the light of this beautiful world," he wrote to his daughter later in life, "to see God playing upon everything, as a man would play on an instrument. His fingers upon the lightning and the torrent, on every wave of sea and sky, and every living thing, making all together sing and shine in sweet accord, the one love-harmony of the universe."[79]

His articles in the popular press described the natural history of the western forests, extolled their beauty, and decried their rapid despoliation. These pieces found a responsive audience and contributed to the growing sense that for both aesthetic and practical reasons the resources of the West needed federal protection.

By the time Muir's articles began to appear in the popular press, the Sierra had been subject to intensive assaults for nearly half a century. In the first decades of American occupation, the gold rush and especially the more technologically sophisticated hydraulic mining that followed led to widespread environmental degradation. The high-pressure hoses of hydraulickers washed away mountainsides and sent tons of sediment into northern California rivers, destroying plant and animal life, creating navigational hazards, and inundating low-lying farmlands. Huge tracts of forest were clear-cut to supply the timber demands of the growing state. Coast redwoods, like those cut by the Adams family's Washington Mill Company, were the prime targets for the construction needs of new population centers. The most heavily logged in the Sierra were the pine and fir of the middle elevations, at four to seven thousand feet, just above the gold-bearing foothills. Californians seemed engaged in a frenzy of environmental destruction. "Nature here," wrote the visiting journalist Bayard Taylor, "reminds one of a princess, fallen into the hands of robbers who cut off her fingers for the jewels she wears."[80]

Perhaps the most brazen assault was suffered by the giant sequoias of the Sierra Nevada. These ancient trees, some of the largest over three hundred feet tall and over two thousand years old, seemed even to those who cut them down symbols of the majestic power of nature.

One tree, dubbed the Mother of the Forest, had its bark stripped off to the height of 116 feet for an exhibition tour in the East and Europe. The tree died not long after. For Henry David Thoreau, these assaults revealed a primal urge to destroy reminders of human insignificance. The grand and venerable sequoias were an affront to the puny conquerors of California.[81]

The onslaught stood out all the more clearly against the background of the state's tremendous natural beauty. The public appreciation of that beauty and concern for its preservation were slow in arising, but early voices of protest began to find an audience toward the turn of the century, when the state had a more firmly established economy and a public ready for renewal in tourism and outdoor leisure.

In 1889, Muir took Robert Underwood Johnson, an editor of *Century Magazine*, on a camping trip into the high country above Yosemite. Sitting by a campfire at Tuolumne Meadows, they agreed to initiate a national campaign to expand the boundaries of the park to include the entire surrounding watershed and place all under federal protection. The creation of the Yosemite and Sequoia national parks in 1890 marked the beginning of a fertile period in conservation legislation. A year later, in 1891, Congress empowered the president to create the first forest reserves. These soon led to the establishment of federally regulated national forests where, for the most part, careful management would replace wanton exploitation.[82]

In 1889, the year Muir and Johnson embarked on their campaign for Yosemite's enlargement and national park status, Muir met with a group of like-minded Californians interested in protection of the Sierra. Attending were his friend, the painter William Keith; Warren Olney, a lawyer active in Bay Area Progressive politics and later mayor of Oakland; and a group of professors from the University of California and Stanford, including Joseph LeConte, J. Henry Senger, William Armes,

Cornelius Bradley, and Stanford president David Starr Jordan. Johnson had written to Muir earlier that year suggesting he start an association of friends of the Sierra. The suggestion dovetailed with the interest at the University of California in establishing an alpine outing club. It was agreed at that meeting to form a new organization, which they named the Sierra Club. By May 1892, the organization had grown to twenty-seven, and at a meeting held on June 4, they formally endorsed the club's articles of incorporation in which they stated their purposes: "to explore, enjoy, and render accessible the mountain regions of the Pacific Coast; to publish authentic information concerning them; to enlist the support and cooperation of the people and the government in preserving the forests and other natural features of the Sierra Nevada." John Muir was unanimously chosen as president, and by the following winter there were 283 charter members.[83]

It was Muir's hope that the Sierra Club would bring people to the mountains to experience nature for themselves. In 1901, Muir had expressed the essence of the national park idea: "Thousands of tired, nerve-shaken, over-civilized people are beginning to find out that going to the mountains is going home; that wilderness is necessary; and that mountain parks and reservations are useful not only as fountains of timber and irrigating rivers, but as fountains of life."[84]

Direct contact with wilderness, he felt, was the most effective means to build a constituency for the parks. The most important aspect of this effort was the club's annual High Trip, a monthlong excursion into the Sierra Nevada backcountry. Adams had his first exposure to the Sierra Club High Trip in 1923. Although his duties at the LeConte lodge prevented him from joining the outing for its entire duration, he was able to go along for the first week. The party climbed out of the valley via the Yosemite Falls trail and headed up Yosemite Creek northward, bound for the Pate Valley, a seldom traveled area in the far northern

region of the park. It was Adams's first full immersion in the culture and ideals of the Sierra Club.[85]

In 1927, having given up his position as custodian of the lodge, Adams was able to go on his first full-length High Trip. The destination that year was Sequoia National Park in the southern Sierra. They stayed first at Redwood Meadows among the giant sequoias. Around the campfire they received conservation instruction and heard tales of mountain exploits. In the morning, they moved on to higher elevations and camped near Black Rock Pass and Columbine Lake. Here they stayed for several days, setting up a base camp along the lake. Newcomers to the mountains learned basic skills from the old hands.

Although Adams was a relative newcomer to the club, he was by now an experienced mountaineer. He quickly took an active role in leading scrambles up nearby peaks and teaching the basics of mountain photography. His most important function was his role as "camp master." On travel days, he would rise at 4:30 A.M. to get a head start on the mules and hikers. At the designated stopping place eight to ten miles up the trail, Adams would locate an appropriate spot and begin preparations for the arrival of the mule train. Around the evening campfire, Adams took center stage. From off-color limericks to the staging of mock Greek tragedies—"Exhaustus," "O Rest Your Fannies," and "The Trudgin' Women"—he was the group's prime prankster.[86]

Adams was frequently aided and abetted in these efforts by his good friend, Cedric Wright. Cedric was about twelve years older than Ansel. He had been to college in Germany and was an accomplished violinist, a devoted amateur photographer, and a lover of the mountains. With this mutuality of interests, it is clear why they became close friends. Adams took in many of Wright's ideas—his sense of nature as a source of inspiration in art, his love of pranks, and his gregarious ways.[87]

It was Wright who had introduced Adams to the writings of Edward

Carpenter. Wright, like Carpenter's inspiration, John Ruskin, emphasized the fact that the beauty and lessons of nature were to be found as much in the small and unnoticed details as in the grand scene.

> No one's writing, no one's pictures, ever tell the intimate spirit of a camping trip in the Sierra. They are too much in love with the *big mountain* and the *big tree*, and with what *they did*. But when we see the exquisite charm of little intimate rivulets, their moss gardens and little separate worlds, is it any wonder to feel the need of being closer in spirit to this sort of thing, to collect into ourselves all the intimate touches of a mountain trip—the pictures that have never been taken—and to try to translate the phrasings of mountains into the phrasings of music and human life? To love this beauty so that one becomes it![88]

Here was someone who understood what Adams was trying to achieve in his photography. By his early twenties Adams had absorbed the ideas and experienced the emotions that would direct all of his subsequent life in photography and conservation. On a personal level he had felt the healing power of nature, much as his Sierra Club forebear, John Muir, experienced it a half-century earlier. Adams's early years in the Sierra Club provided him with an introduction to Muir's ideas and the principles of the conservation movement. At the same time he had come to believe he was destined for a life as a creative artist. He had the good fortune to combine great natural talent with tremendous energy and capacity for hard work. Adams entered his adult life dedicated to art and the ideals of conservation, but he was still seeking a way to bring them together creatively.

# Modernism

Back in San Francisco each fall, after his High Sierra summers, Adams took to visiting Cedric Wright's redwood home in the Berkeley hills, a frequent gathering place for Bay Area artists, musicians, and assorted eccentrics. Adams found the free-spirited atmosphere liberating. Here his abundant energy and idiosyncrasies were accepted, even admired. These creative contacts were a tonic to him, thawing the sense of isolation remaining from his solitary childhood and providing access to those who shared his creative interests. Evenings featured food, conversation, and music; Adams had a prodigious appetite for all three. Wright would fix a big pot of spaghetti with fresh salad and bread— "Sierra food," he called it—and provided liberal quantities of wine to wash it down. After dinner Adams would sit at the piano and Wright would get out his violin for an impromptu concert. Others were welcome to join in as their talent or inebriation allowed.[1]

## Albert Bender

At one such party in the spring of 1926, Wright pulled Adams aside, picked up a box of his prints, and presented them both to a dapper man

seated on the couch. This, Adams discovered, was Albert Bender, a charming bon vivant in the old San Francisco style and one of the city's leading patrons of the arts. He was the owner of an insurance agency, not the largest in the city but having among its clients many of the prominent figures in business, society, and the arts. Although he was not extremely wealthy, Bender, of Irish and Jewish descent, used his network of contacts among the Bay Area elite, especially in the Jewish community, to promote and support the work of young artists he admired.[2]

He suggested they find some better light to view the prints. Adams sat nervously as Bender went through a stack of photographs of Yosemite and the Sierra. Adams was aware of Bender's reputation and realized this might be a crucial opportunity. After viewing each print carefully, Bender looked up and smiled. It was fine work, he said, very promising. Perhaps Adams could come by his office the next morning so they could talk at greater length.[3]

Adams was ecstatic. At ten o'clock the next morning he was waiting at Bender's office in downtown San Francisco. Shown inside, he found Bender seated behind a desk piled with papers, magazines, books, and memorabilia. From behind this mass of clutter, Bender smiled broadly and rose to greet his guest. Adams produced his prints and Bender sat down at a small table nearby to study them carefully once more. When he was done, he turned to Adams with great enthusiasm, saying that they must present the prints as a portfolio. Although Adams tried to appear calm, he was electrified by the unexpected development.[4]

In Adams Bender felt that he had found an important new talent. He did not waste any time promoting his work. He suggested they arrange with Jean Chambers Moore to publish the portfolio; the Grabhorn Press would do the typography and the announcement. At Moore's suggestion, they decided to call the group *Parmelian Prints of the High Sierras*, on the assumption that referring to them as photographs would

make their status as fine art more doubtful. It was a decision Adams regretted in later years.[5]

Bender wanted the finest work possible, which meant the portfolio would not be cheap. They estimated the costs of production and arrived at a price of fifty dollars for the group of eighteen prints. At the time, this was a steep price for a collection of photographs, but Bender was confident in Adams's work and in his own promotional skills. He began by ordering ten for himself and presented Adams with a check for five hundred dollars. Next he got on the phone to some of his friends. His first call was to Rosalie Meyer Stern. Stern was the daughter of the banker Eugene Meyer and the wife of Sigmund Stern, the nephew of San Francisco pioneer and jeans manufacturer, Levi Strauss. The Sterns were among the leading patrons of San Francisco artists. Bender explained that he had met a young photographer with some very fine work. He described the plans for the portfolio and informed her that he was purchasing ten copies. Mrs. Stern said she would take ten also. Bender made more calls, and by noon he had sold over half the issue, sight unseen.[6]

### California Legacy

Bender decided that Adams ought to be exposed to a wider range of influences, and he took it upon himself to bring that about. Altruism was not the sole motivation: Bender liked to travel, and Adams could act as his driver. Through Bender, Adams was introduced to San Francisco's community of artists and writers and the heritage of California's regional culture. It was a heritage on which he would both consciously and unconsciously build his own career.

One of their first visits was to the home of the poet Ina Coolbrith. At that time she was living in a small rented apartment with her cat and two other elderly women. Bender always brought along a bottle of port

to keep Coolbrith in good spirits on cold, foggy San Francisco nights. Having heard Bender refer to Ansel as Dr. Adams (Bender had given him an honorary Ph.D., Doctor of Photography), one of Coolbrith's compatriots, eager for the good doctor's access to medicinal liquor in the era of Prohibition, asked if he might be able to prescribe more port, since the bottle that Albert brought never seemed to last for long.[7]

Coolbrith was a legendary figure on the city's literary scene. She was born in 1841 and originally named Josephina Smith, in honor of her uncle, the Mormon prophet Joseph Smith. Her father died of pneumonia three months later. Her mother eventually remarried, and in the summer of 1851 Ina accompanied her family on the overland trail to California. Coolbrith became a well-known figure of San Francisco's literary scene, contributing regularly to the *Golden Era*, the *California*, and the *Overland Monthly*. The dowdy old woman Adams met in the late 1920s had once been a mysterious and romantic young poet and rumored lover of many of the city's early writers—Bret Harte, Charles Warren Stoddard, Samuel Clemens, and Joaquin Miller. As she tactfully put it on refusing to write her autobiography, "Were I to write what I know, the book would be too sensational to print, but were I to write what I think proper, it would be too dull to read."[8]

The gold rush nurtured writers and artists of international caliber who forged an image of the state as a frontier carnival with a cast of colorful, rowdy, but essentially lovable characters. It was an enduringly popular image, if misleading and incomplete, one that neglected or romanticized the violence and social turmoil that accompanied the high adventure.[9]

With the financial chaos and political turbulence of the 1870s came a new emphasis on the state's darker side. Toward the turn of the century, California writers like Frank Norris and Jack London were part of a movement throughout America and Europe questioning the assumptions of the "genteel tradition."[10] Although London worked in the tra-

dition of western adventure writing established by an earlier generation of frontier authors, he presented the relationship between humans and the natural world in a much different light. He showed a violent world, in which the only morality was that of strength. It was a post-Darwinian vision of nature in its ruthless indifference to human wishes. But nature's violence was inside as well, as Norris revealed in *McTeague*, whose title character, an unassuming San Francisco dentist, was subject to ungovernable forces of lust and murder. McTeague's was a post-Freudian mind of powerful, instinctual drives that bourgeois decorum could not repress.[11]

California and the world had changed dramatically since the days when Ina Coolbrith crossed the Sierra on horseback. The sense of optimism and endless opportunity that fueled the gold rush was rapidly eroding in the face of a violent and chaotic century. As an artist, a Californian, and a citizen of the modern world, Adams would grapple throughout his life with the issues of nature and human nature, never fully satisfied with the visions offered by either romantic optimism or modernist despair.

### Tor House

In June 1926, Adams and Bender headed south on the narrow, winding coast road bound for Carmel, a town with an international reputation as an artist colony and the home of the poet Robinson Jeffers.

For Adams, that visit with Jeffers felt like something of a pilgrimage. He had admired his work for some time and was nervous about meeting the literary celebrity (Jeffers had recently graced the cover of *Time* magazine, as rare for a writer then as it is now). Adams and Bender approached the simple wooden gate to find a sign reading "Not At Home Before Four O'Clock." The other side said simply "Not At

Home." Considering themselves lucky, they waited patiently until, promptly at four, his wife Una Jeffers appeared, removed the sign and chain, and greeted them cordially. Bender was an old friend of the family.

Una led them up the path to the stone house as the afternoon fog began to blow in from the sea. As Jeffers greeted them at the front door, Adams was immediately struck with the quiet strength of the man. Overwhelmed, Adams sat by while Bender carried on loquaciously. Jeffers mostly listened, adding a comment here and there.

As the afternoon wore on, Bender suggested that Adams play something on the Jeffers's beautiful Steinway grand piano. Adams was somewhat nervous at this impromptu recital, but he obliged, choosing a section of a Bach partita and a Mozart sonata. He recalled it as a "creditable" performance. Bender beamed with pride as Una offered generous praise. Jeffers said, "Good." He produced a copy of *Roan Stallion* and presented it to Adams, with his inscription. As the evening fog enveloped the coast, Adams and Bender said their good-byes and began the journey back to San Francisco.[12]

Meeting Robinson Jeffers gave Adams his first real contact with a leading figure of modernism. Jeffers's quest to pare his lines to a functionalist simplicity was an example of a fundamental principle of modernism in all the arts. In architecture, painting, and poetry, for example, the goal was a "truth to materials," to strip away the Victorian edifice of gentility to reveal the stark but honest bones of the work: the steel beams of buildings, the stroke of the painter's brush, the plain word/sound of the poet. In photography, too, artists were beginning to emphasize rather than disguise what they considered the essential characteristics of the camera image, its optical precision and clarity, its ability to capture an instant and make it timeless. As Adams became more familiar with modernist aesthetics, he began to reas-

sess his own photographic approach, which at that time was still predominantly influenced by nineteenth-century romanticism and pictorialism.

Jeffers taught Adams the grandeur possible within a spare realism. His lines embodied the sharp-edged power of the coast. Their slow-measured rhythms rolled across the page like the swells of winter storms. His poetry was far different from the work of the English romantics of whom Adams was so fond in his youth. Instead of their sentimental lyricism, Jeffers practiced a stark simplicity. His work often focused on human tragedies set against the vast cyclic flow of nature and the universe in which humanity is only a transitory form. The wild Big Sur coast fit his themes perfectly, and his poems were constructed on a precise imagery of its plant and animal life and its violent meeting of land and sea.[13]

Jeffers directly addressed the issues of humanity's relationship to nature, issues that were central to Adams's creative development. The nineteenth-century notion of nature as a mirror of human ideals gave way to the notion forcefully expressed by Jeffers that the rise and fall of individuals and civilizations were mere moments in the vast movement of the universe. Jeffers felt that modern poetry must not only be in tune with the ancient forces of nature but must also be true to contemporary life. He based his ideas on the scientific discoveries of earth's geological time, on the principles of evolution, and on theories of the cyclical nature of the universe. "We cannot take any philosophy seriously," he wrote, "if it ignores or garbles the knowledge and viewpoints that determine the intellectual life" of the time.[14] For Jeffers, poetic truth required an awareness of mankind's minor role in the grand drama of the cosmos.

The modernist view of nature, evolving on the West Coast in concert with international movements, did not feel entirely comfortable to Adams. His intellectual and physical environments had encouraged a

view of nature more like that of Ralph Waldo Emerson or John Muir, a view in which the scientist's empiricism was combined with the mystic's rapture. He remained convinced of nature's inherent "goodness." The apparent pessimism of Jeffers was difficult for him to accept.

## New Mexico

Adams's introduction to modern art continued in the spring of 1927 when he and Bender, along with Bertha Pope, an author and collector of southwestern art, set out across the deserts east of California, bound for the art colonies of Santa Fe and Taos, New Mexico. The twelve hundred miles was hard going, mostly over narrow dirt roads, rutted to a washboard surface. But the difficulty of the trip was part of the region's allure. In the 1920s, northern New Mexico was still almost completely rural, and there was a sense of isolation from the twentieth-century world. Three cultures—Indian, Hispano, and Euro-American—existed side by side, yet each largely retained its own identity.[15]

The "harshness" of the land had been its primary impediment to economic development; it was also its greatest attraction for artists and writers. On the high mesas above the Rio Grande, between the San Juan and Sangre de Cristo mountain ranges, the dry air and 7,000-foot elevation gave the sunlight a crystalline clarity. Summer thunderclouds towering into the sky glided in slow procession, creating vast patterns of light and shade across the desert floor. It was a landscape in which the elemental forces of nature seemed close and powerful.

In the increasingly urban America of the 1920s, an art based on images of the "old West" was rapidly losing interest for contemporary artists. But the western landscape and its inhabitants still had a strong pull on the imagination. Part of this attraction lay in the persistent image of the West as a land of freedom and new beginnings, unencumbered with the weight of traditional social conventions. As the pressures

of urban life mounted and Europe unraveled into world war, urban bohemians from New York, Chicago, San Francisco, and other American cities found low-cost living, social freedom, and creative inspiration in New Mexico, far from the contemporary nightmare.

For the modernist exiles of the 1920s, the Southwest was not a "New World" or a "great frontier" with all the optimistic and ethnocentric notions of conquest and manifest destiny that accompanied that image. For them, it was a place more ancient than the "Old World" crumbling around them. By rediscovering "primitive" societies and raw, elemental nature, they hoped not to impose their own culture but rather to learn from the example of others.[16]

While the activities at these art colonies had serious motivations, much of the agenda was devoted to having fun, a radical concept in itself. Once they arrived safely in Santa Fe, Adams, Bender, and Pope made the rounds of Bender's many acquaintances in the area. Among them was the writer Witter Bynner, known to his friends as "America's greatest minor poet."[17]

One typical evening, Bynner invited them to dinner at his home. With Adams at the wheel of Bender's now dust-caked Buick touring sedan, they headed north, past the Santa Fe River. Pope was sure the house was somewhere out there, yet before long they were thoroughly lost. They made their way back to the hotel and gave Bynner a call.

Bynner told them not to worry. They could meet at a party he knew of on Canyon Road, in the foothills just east of town. After dark, on empty stomachs, they arrived at the spot, only to find a bacchanalia in progress. Several of the revelers lay passed out on the floor. Bynner greeted them gaily, with drinks in hand. Finally around nine, they left for Bynner's house. There was more partying there and finally dinner at ten. By then, the food hardly mattered.[18]

During Prohibition, all-night drinking parties fueled by potent bathtub gin and other concoctions were standard forms of amusement.

Bynner used the parties as inspiration for his work. He would carouse until one o'clock in the morning and then sit down to write. The party often raged on until dawn, with Adams an active participant, as usual. The others could sleep it off. Adams, however, had to be up with the dawn, in search of the best light. Although the festivities took their toll, Adams enjoyed it all immensely. That serious artists could have this much fun was reassuring and liberating.[19]

## *Virginia*

Given the relative stagnation of his musical career and the blossoming of his photography, Adams was naturally beginning to alter his priorities. He *had* made some progress in music since 1925, when he had broken his engagement to Virginia. In 1926 he formed his first professional group, the Milvani trio. In addition to Adams on piano, the group featured Mildred Johnson, a violinist, and Vivienne Wall, a dancer. They had some reasonably successful performances and some lukewarm reviews, but Adams was disillusioned.[20]

Perhaps most decisive was the fact that his photography allowed him to work in the mountains, whereas music demanded an urban life. He had no desire to stay in San Francisco, but for now he had no choice. What he wanted above all was to get back to his beloved Sierra. He was envious, he told Virginia, she in that wondrous valley and he in the miserable city.[21]

After all the posturing and egotism of the music world, Virginia was a breath of fresh air, simple and calm, like the mountains. She seemed to represent the same qualities that Adams found in Yosemite; in his mind she was part of his summer freedom and the beauty of the mountains. He had had some brief relationships since they had broken off their engagement, but as he grew disillusioned with professional music and his life in the city, he felt himself drawn strongly to her once more.[22]

Adams made a short trip to Yosemite in April 1927 to visit Virginia and to make some photographs. Now that he was achieving some artistic success with his photography he was determined to create more expressive work, images that would convey the personal vision he felt was stifled in his musical career. It was on this visit that Adams made the photograph he consistently referred to as among the most crucial of his life.[23] Early one morning, Ansel, Virginia, and several friends, including Cedric Wright, started out on a hike to the Diving Board, a granite projection located on the west shoulder of Half Dome, the huge granite monolith whose sheer face rises majestically over four thousand feet above the valley floor. Adams had been to the spot several years before and had had it in mind as a good location from which to photograph.

They made their way up the steep LeConte gully. Adams was carrying a forty-pound pack loaded with a view camera, several lenses and filters, and six holders containing twelve glass plates. He made several exposures en route, leaving only two plates for the view of Half Dome. They arrived at the Diving Board around noon, at which time the face of Half Dome was still shaded from the sun. They sat down on a ledge overlooking the valley and ate their lunch while they waited for the light to make its way around the corner.

By 2:30 P.M. the sun had moved far enough west that the light fell across the face of Half Dome at an oblique angle, highlighting the texture of its surface. Adams positioned his camera near the edge of the precipice, framing the view so that the huge granite face filled the right side of the image, receding at a sharp angle toward the background from right to left. Adams may have reduced this convergence and recession of lines by swinging the film plane of his view camera so that it lay more parallel to Half Dome's face, a movement that would also serve to improve the depth of focus.

He chose to include a portion of the snow-covered foreground rocks and trees in the right corner of the image and the upper reaches of

Tenaya Canyon in the distant background on the left. The bright values of the sunlit snow and distant peaks served to frame Half Dome's darker granite rock. To get the uppermost portion of the monolith into the frame, Adams raised the lens plane of the camera, an action that served the same purpose as tilting the entire camera upward yet reduced the convergence of parallel vertical lines in the image. Such a vertical convergence would make the foreground trees seem to lean excessively inward and would reduce the viewer's sensation of being pulled into the horizontal depth of the picture, thereby lessening the visual impact of the broad granite face.[24]

On his first exposure Adams placed a moderate yellow filter over the lens, one he used regularly to darken the film's rendering of the blue sky. He calculated the exposure and released the shutter. Almost immediately, he had second thoughts. As he replaced the slide and reversed the film holder for his final exposure, he considered whether the finished print would convey the emotional quality he perceived in Half Dome's massive granite face. In his mind's eye, Adams envisioned the print he sought, with the looming cliff outlined against a dark sky, the snow-covered Tenaya Peak sharply etched in the distance. He realized that only a deep red filter would produce the dramatic interpretation he was after.

The filter reflected virtually all blue light, producing a nearly black sky and darkening all shadows on the rugged face of the dome. He had only one plate left, so he carefully calculated the necessary increase in exposure to compensate for the new filter. He felt satisfied with his interpretation and execution of the image but did not realize the full extent of his accomplishment until he developed the plate that evening. Pulling the glass negative from the final rinse, he was elated to see the powerful results, exactly as he had envisioned. Throughout his life, he would recall the thrill of this, his first successful visualization.[25]

"Visualization" was the term Adams used to describe the conscious

control of the medium to produce a preconceived result. Rather than simply snap the picture and hope for the best, Adams felt that the photographer should think through each stage of the process, from the exposure and development of the negative to the presentation of the final print, so that each stage would reflect his interpretation of the scene. His objective was not to duplicate reality. The art of photography, he argued, came in the departure from reality. The placement of the camera; the selection of lense, film, and filters; and the choices of exposure, development, and printing were all steps toward achieving the photographer's unique visualization of the scene before the camera.[26]

With the success of his first portfolio and a few portrait commissions in San Francisco and Santa Fe, Adams began to gain some financial security. More important, he was gaining confidence in his work. His photography was now sufficiently advanced to deserve the world's attention, he announced a bit grandly to Virginia. He was filled with plans and new ideas—and a new clarity of purpose.[27]

That summer, he was once again in Yosemite. The highlight was the Sierra Club's annual High Trip. Ansel and Virginia shared the long summer days, the music and antics around the campfire, and, when they could find time alone, their dreams for the future. Back in San Francisco that fall, Ansel was lovesick once again. This time he decided to do something about it. He wrote to Virginia just before Christmas, suggesting that he come up to the valley for a visit. They could walk together and talk of the future. For some time now, he told her, he had felt as though they were destined to be together. After years of indecision on his part and Gibraltar-like patience on hers, Ansel was now ready to share his life with Virginia.[28]

On January 2, 1928, Ansel and Virginia were married. The headline in the *San Francisco Chronicle* read, "Couple Hikes to the Altar." It was a small wedding at Best's Studio in Yosemite, with Ansel's parents, Vir-

ginia's father, and a few friends in attendance. Ansel's friend Ernst Bacon played an Austrian wedding march on the Chickering piano; Cedric Wright was the best man. With a tweak to formality, Ansel wore knickers and his high-top basketball shoes with his coat and tie. Because of the spur-of-the-moment decision, Virginia did not have time to buy a wedding dress. She wore the best outfit she had, which happened to be black. Ansel's mother, increasingly distraught in these years, wept at the "ill omen."[29] But Ansel's father was very pleased. His happiness seemed almost unreal after all the pain he had suffered since his financial collapse. Although he was convinced his life was a failure, he wanted Ansel and Virginia to have the kind of life together that he had been denied, to fulfill their dreams and, vicariously, his own.[30]

### Mary Austin

With his marriage, Adams was especially eager to develop a successful career. Although he had not abandoned the pursuit of music, he was turning increasingly to his photography. In the spring of 1928 he began his most important project yet. Adams had met the writer Mary Austin in Santa Fe at one of Witter Bynner's parties in 1927. With characteristic insight and business savvy, Albert Bender felt that Adams and Austin shared a similar style and feeling for the western landscape. He suggested the two collaborate on a book.

At first glance the suggestion might have seemed unrealistic. Austin was a well-established writer with an international reputation. Adams was a relative novice with no recognition to speak of. Furthermore, their personalities were virtual opposites. Austin, sixty years old and in failing health, was a gruff perfectionist, cantankerous and demanding. Adams was a bit intimidated by the woman.[31]

Despite their differences, Adams and Austin had much in common. Austin was a midwesterner by birth who had emigrated with her family

from a small Methodist town in Illinois to California in the late 1880s. Like many coming to California for the first time, Austin was overwhelmed by its beauty. In her first published article, "One Hundred Miles on Horseback," Austin described the physical and spiritual renewal she experienced in her journey through the state.

Married in 1891, she moved with her husband to the Owens Valley at the eastern base of the Sierra Nevada. Here she found her greatest subject. In this high desert country lying in the shadow of the Sierra, she felt mystical forces in the land and its native inhabitants. Austin claimed that her work throughout her career arose from a mysterious inner voice, a spiritual muse that she referred to as "I-Mary." To let this voice speak was her literary goal, and it seemed that it emerged most powerfully in natural settings.[32]

Austin found confirmation in the new theories of the unconscious that were gaining adherents around the turn of the century. Sigmund Freud pointed to the power of the unconscious mind to influence and direct all aspects of life; his theories suggested to many the futility of the Victorian effort to control the unruly passions, to perfect society and the individual through rationality and self-control. Whereas Freud emphasized the shaping of the psyche in early childhood, his colleague Carl Jung pointed to the universality of the unconscious mind.

In the arts the mysterious, frightening, and liberating forces of the irrational were celebrated in the rise of expressionism, abstractionism, and surrealism. Artists living in the age of technological marvels turned increasingly to indigenous cultures for their inspiration, cultures they assumed to be more in touch with the instinctual forces of life and the well of creative inspiration. African, Polynesian, African-American, and Native American sources were mined for the creation of an art more attuned to primal instincts unconstrained by the inhibitions of modern civilization.[33]

After her departure from Carmel and San Francisco, Austin had moved to Santa Fe while working on her study of American poetry, *American Rhythm*. After Bender introduced them, Adams and Austin corresponded over the course of the year, trying to settle on a subject for their collaboration. Adams was particularly taken with the Ácoma pueblo. Its ancient structures set atop a high mesa above the desert seemed like something out of legend. In the brilliant southwestern light the colors of the pueblo—the warm browns of the earth, the cool blue-green sage, the glowing reds, yellows, and blacks of the painted dancers—took on a luminous intensity. Adams was mesmerized by that light and determined to interpret it on film.[34]

In the spring of 1928, Adams suggested that Ácoma be their subject.[35] Austin was receptive to the idea but warned that the documentary filmmaker Robert Flaherty was attempting to obtain permission to photograph the pueblo as well. Austin doubted his success. "He may not be able to make the necessary arrangements with them. He tried the Hopi and failed. . . . He seems to know very little about Indians."[36]

Austin understood the intricacies of obtaining permission to study the lives of the Pueblo tribes, who guarded their religious practices from the prying eyes of white tourists, artists, and documentarians. They had become shrewd bargainers in the process. Austin wrote again to Adams in early July, telling him that Flaherty had been turned down and that the film rights that year had been given to the Famous Players, a Hollywood studio. She feared the influx of Hollywood money might make their negotiations more difficult. "They may connect the idea of large payments with photographs in the minds of the Acomas."[37] They decided to consider other pueblo sites.

In the meantime, Austin departed on a lecture tour of the East. On an earlier visit to New Mexico, Adams had made several portraits of Austin. When she asked if he might have something she could use for a

publicity photograph, he sent along a selection of prints in the hope that she would be "utterly pleased" with them. Austin was not; in fact, she found them "impossible" to use. "I dare say you can take away that dreadful smirk, and the drawn look around the mouth," she wrote, "but the carriage of the head, with the face thrust down and forward, and the slumped shoulders are not only not characteristic of me, but contradict the effect it is still necessary for me to make on my public." Adams was learning that portraits are seldom pleasing to the subject, and in this case the stern visage in the photograph seemed to convey more of the photographer's trepidation than "the personal drive, the energetic index, the impact of the whole personality" that Austin felt her public needed to see.[38]

Undaunted, Adams forged on in working out the details of their planned collaboration. It was April 1929 before he was able to begin a serious and concerted effort at photographing the area. On this, his fourth trip to New Mexico, Adams was accompanied by Virginia and a friend of Albert Bender named Ella Young. Born in northern Ireland, Young began her career as a lawyer and became active in Irish revolutionary politics. She lived for a time with Maude Gonne and William Butler Yeats in Dublin and participated in the 1916 uprising against British rule. Like Yeats, Young developed a strong interest in native Celtic culture; she spoke Gaelic fluently and felt the force of mystic powers. On their way east to New Mexico, she insisted they stop at each state border to offer a bit of bread and wine to the spirits of the land.[39]

Austin had planned to be away on a lecture tour of the East that spring, so she offered to let Ansel and Virginia stay in her guest quarters while she was gone. Bender wrote ahead to alert her to their special needs. He assured her that "these young people have practically every virtue in the catalogue of righteousness," but he felt obliged to warn her about their appetites. "They need food every hour in large quantities,"

he noted, "and if you have no mortgage on your house now, you will have at the time of their departure." It was unfair to include Virginia in this, since Ansel did most of the eating. Bender did, however, single Ansel out when it came to beverages. "If the circulatory system permits, I think a special pipe should connect with Ansel's room, through which a cup of coffee could be furnished day or night."[40]

When Austin returned to Santa Fe in mid-April, they agreed that the subject of their collaboration should be Taos Pueblo, the ancient Indian community near which the small town and art colony of Taos had grown up. They appear to have settled on Taos for practical reasons. Mabel Dodge Luhan, an old friend of Austin, had a home nearby. Most important, perhaps, Mabel's husband, Tony, a native of Taos Pueblo, remained an influential figure in the Taos community and a member of the tribal council, despite the controversy surrounding his marriage to Mabel. With Tony Lujan's intercession, Adams was given the rare privilege of complete access to the pueblo.[41]

As Adams spent more time with Austin, he found her to be an impressive personality. She undertook each activity with great skill and attention and applied her perfectionism and disciplined energy to each task at hand, whether gardening, cleaning, cooking, or writing. She wasted little time and fewer words, and she expected those around her to do the same.[42] Austin's health, precarious for many years, had taken a turn for the worse by the time they began their collaboration. *Taos Pueblo* would be one of her last books.

Adams launched into his photography with an intensity worthy of Austin herself. He found Taos full of photographic potential. The weather seemed even more dramatic there than it did to the south in Santa Fe. One afternoon thick clouds moved in from the north. By dawn the storm had moved on, leaving a cloudless sky from horizon to horizon and a fresh carpet of snow across the land. Adams set out, camera in hand, to photograph in the strong morning light.[43]

Adams could not have found a better place to continue his education in modern art than Mabel Luhan's rambling Taos adobe, Los Gallos. Born Mabel Ganson in Buffalo, New York, in 1879, Luhan had been married three times before her final marriage in 1923 to Antonio Lujan. Prior to her move to the Southwest, Luhan had lived in Italy, Paris, and New York, where she was hostess to the leading figures in radical politics and the artistic avant-garde.[44]

In 1917, at the suggestion of her husband at the time, the painter John Sloan, Luhan left New York in search of tranquillity in the Far West. Arriving at Taos Pueblo, she heard the sound of singing and drumming in the distance. "I ran hurriedly toward it with my heart beating . . . [and] all of a sudden I was brought up against the Tribe, where a different knowledge gave a different power from any I had known, and where virtue lay in wholeness instead of in dismemberment."[45]

As Luhan settled into her new life in Taos, she began to reestablish her role as hostess to the avant-garde. In the plainest terms, she simply liked the company of creative individuals. Yet many, including Adams, thought that her interests in this direction bordered on the neurotic, that she collected the famous and the artistic like so many trophies for her mantle.[46]

Perhaps her most famous attempted conquest was that of the British writer D. H. Lawrence. Luhan chronicled her efforts to attract the renowned author to the Southwest in her book, *Lorenzo in Taos*. Ostensibly, she was interested in his creative talents. But as an advocate of "free love" and a crusader against bourgeois sexual repression, she found Lawrence, the champion of the orgasm as a pathway to spiritual insight, fascinating for reasons beyond mere intellectual stimulation.[47]

Despite the pettiness of much of the goings-on at Taos, there was also a great deal of serious work done. In this atmosphere of creative exchange, Adams absorbed many ideas and attitudes that would remain central to his intellectual and artistic outlook throughout his life. Perhaps one of the most powerful ideas he absorbed in New Mexico was the idea of the avant-garde as a separate and crusading entity, existing somehow above and beyond the conventional patterns of bourgeois life, dauntlessly charting new paths of creative liberation and artistic achievement. This romantic vision of the artist fit well with Adams's already exalted ideal of the creative life.

The first decades of the twentieth century were a period of intense ferment in the arts. Proponents of modern art felt that they were not merely responding to the new society but were an active force leading the way to a new vision, creating a revolutionary social language that would liberate the creative spirit. In America young artists rebelled against the entrenched academicism of such arbiters of taste as the National Academy of Design. Among these were a group of artists, led by Robert Henri and John Sloan, who sought a greater realism in both style and subject matter. They were dubbed the "Ashcan school" for their audacity to depict urban life with uncompromising directness.[48]

At the same time that Henri's group, "The Eight," held their first controversial exhibition in New York, the photographer Alfred Stieglitz began to publish the work of European modernists in his periodical, *Camera Work*. Stieglitz also provided exhibition space at his gallery at 291 Fifth Avenue, both for the innovative painters of Europe and for a group of American artists working in the modernist vein. As early as 1909 he had published the work of Cézanne and Matisse. There were discussions of the new movements in European painting, including fauvism, cubism, and futurism. *Camera Work* was the first American magazine to publish the writing of Gertrude Stein; Henri Bergson's theories were presented; the writings and paintings of the expressionists

Wassily Kandinsky and Franz Marc appeared, as did the pioneering cubist works of Pablo Picasso and Georges Braque.[49] Adams, eager for an introduction to the latest ideas in art and the best in contemporary photography, no doubt read the copies of *Camera Work* in Luhan's library with avid interest.

While staying with Mabel Luhan and working on the photography for *Taos Pueblo* in the spring of 1929, Ansel and Virginia met two painters, John Marin and Georgia O'Keeffe, who were part of the Stieglitz circle. Both Marin and O'Keeffe, Stieglitz's very independent wife, were to become close friends of Adams and important influences on his photography. Their work embodied many of the ideas prominent among the Stieglitz circle, especially the interest in nature and indigenous American sources and subjects for their art.[50]

For Georgia O'Keeffe, the trip to New Mexico marked a return to the wide vistas of the West. She was born in the Midwest and had spent several years as a teacher in west Texas. The dry, windy plains had been an early inspiration, so her visit to Taos in the summer of 1929 was in many ways a homecoming. She felt an immediate sense of recognition, a sense that she had found her natural subject. O'Keeffe eventually became a permanent resident of New Mexico and the artist most closely identified with it.

Adams was a bit put off by the severe and aloof O'Keeffe when he first met her in 1929. By 1930 he had gotten to know her better, but she still seemed difficult to approach.[51] While her imperial cool was hard for Adams to take, her painting was unmistakably brilliant. Her celebration of the spiritual in nature as well as her clarity of line and simplicity of design were qualities he was moving toward in his own work at the time.

Adams felt a more immediate rapport with Marin. They spent a morning together working in the desert. Marin, though quiet and unobtrusive, was among the most sophisticated artists in the United States

at that time, incorporating the lessons of Cézanne, expressionism, and cubism to create startlingly original interpretations of the New Mexico landscape. Adams recognized his greatness immediately and was charmed by his simplicity and unaffected good humor. Marin would wander with apparent purposelessness, absorbing the shapes, colors, and moods of the land. Back at his easel, a few brisk watercolor strokes would distill the essence of his perception.[52]

Marin was not at first impressed with Adams. He recalled the arrival at Los Gallos one day of "a tall, thin man with a big black beard." In he came,

> laughing, stamping, making a noise. All the other people crowded around him. Made even more noise. I said to myself, I don't like this man. I wish he'd go away. Then all the other people hauled him to the piano—and he sat down and struck one note. *One* note. And even before he began to play, I knew I didn't want him to go away. Anybody who could make a sound like that I wanted for my friend always.[53]

Like their antiacademic predecessors in the Ashcan school, Marin, O'Keeffe, and others of the Stieglitz circle believed that artists should be true to their own time and place, not slavishly follow the rules and subject matter of the established canon. It was an attitude to which Adams was highly receptive as he became increasingly involved with Stieglitz during the 1930s. Stieglitz was determined to see modernism grow in the United States, but he, like many others in the 1920s and 1930s, was looking for an American modernism, one that would look to the indigenous culture for its inspiration.[54]

In the nineteenth century, "cultural nationalism" had spurred the celebration of wilderness and contributed to the creation of the first national parks. Nature continued to be a central concern of these twentieth-century artists. The painters of the Stieglitz circle worked

extensively with landscape, and Marin and O'Keeffe were no exception. Yet some of the proponents of a focus on American culture and society criticized their interest in natural forms.

Waldo Frank, for example, in the influential book, *The Re-Discovery of America*, charged Marin with escapism. Marin's uninhabited still lifes and landscapes lacked a crucial human element, he claimed. Frank pointed to the work of the Mexican muralists Diego Rivera, José Clemente Orozco, and David Siqueiros as examples of more politically correct painting. Marin's friend and fellow member of the Stieglitz circle, the photographer Paul Strand, came to his defense in the *New Republic*.

Marin did indeed possess an "American consciousness," Strand argued, although it was one without the obvious sentimental and political manifestations Frank seemed to demand. Marin was authentically indigenous in his roots, Strand claimed. "Perhaps more than anyone in painting, Marin is related to the American pioneer. But where the latter wanted only to possess the body of the continent, Marin is revealing its spirit." This was at the core of Adams's art as well.[55]

### Taos Pueblo

By the end of May 1929, Adams had completed most of his photography at Taos Pueblo. He and Virginia were back in California by early June, preparing for the Sierra Club's High Trip. This time more than two hundred members journeyed through the central Sierra, up the San Joaquin River, and eastward to the high alpine country. After several days in Humphries Basin, they headed northward toward Yosemite. On the five-day layover at Garnet Lake, Adams led a party of forty to the top of Banner peak, while the more daring climbers scaled the highest Minaret. The party continued north over Donohue Pass and down Lyell Canyon to Tuolumne Meadows, then climbed Cold Canyon into

the seldom-traveled high plateau region beneath Mount Conness. After several days among the peaks, they headed down toward Yosemite Valley to revel in hot showers and feast on fresh vegetables.[56]

On their return to San Francisco, Adams got his first taste of dealing with temperamental authors and the intricacies of publishing. He, Austin, and their mutual friend Frank Applegate were continuing to develop their ideas for a book on Hispanic arts and architecture in New Mexico. Austin had sent some of Adams's photographs to Yale University Press to see if they would be interested in the project. Adams had apparently requested the return of the photographs from Yale before a decision had been made. When Austin learned of this, she launched an angry and condescending letter. Such an unauthorized move on his part had caused her considerable embarrassment, she told him. She reminded him coldly of the "illustrator's" secondary role in any book. Austin's scolding missive was followed soon after by a telegram warning, "Don't send anything to Yale or write to them."[57]

A week later she wrote again. Adams, it seems, had not followed her orders.

> As for your writing again to Yale, after receiving my letter, that is utterly inexcusable. You were told not to do so on any grounds whatever. You were told it was none of your business, and that you were to let it alone. You were told that your doing so prejudiced the whole project, *and you were not offered any discretion in the matter.* . . . I have not the slightest intention of putting my whole professional prestige in your hands to make use of, and unless you learn that promptly there will be an end to the whole business.[58]

Austin's next letter resumed a friendly tone. "I have neglected to acknowledge your portrait of Juan, which is very fine—the only Indian

portrait I ever had which I feel willing to put up in my house. I hope the others are as successful." Austin went on to say that her health had improved—perhaps this was one reason for her more amiable mood—and that she had made good progress with her writing on the pueblo. "So far as I have got with it, it is very good." She planned to finish the work while staying with Mabel Luhan in Taos. "I very much want the inspirational mood of the place."[59]

Austin stayed a week in Taos and visited the pueblo daily. She had the manuscript ready by the end of her stay and mailed it soon after to San Francisco, where Adams was overseeing the production of the book under Bender's experienced guidance. Bender was active in the Book Club of California, a group of bibliophiles dedicated to the art of fine printing. He and Adams agreed that the Taos book should have the finest possible production.

The financial success of his first portfolio convinced Adams of the practical advantages of a high unit cost. More fundamental was his dedication to technical perfection regardless of expense. For Adams, art was an uncompromising quest for excellence—a quest most likely to be appreciated only by a select few. This attitude had been reinforced by his introduction to the leading contemporary artists. Adams shared with most artists he had encountered in California and New Mexico the assumption that his audience would be a limited and elite one.

Adams and Bender decided on an edition of one hundred, with eight additional authors' copies. The bindings were of linen and hand-finished leather. Adams's friend W. E. Dassonville prepared a special photographic emulsion that he applied directly to the paper. Each book contained twelve original photographs printed personally by Adams. Mary Austin was aghast at the proposed price of the volume. "A hundred copies at seventy-five dollars a copy leaves me gasping," she told him. "You will have to make your own decisions."[60]

Despite the high price, the book sold well. Thanks in large part to Bender's wide circle of friends, within two years all copies had been purchased. Adams presented a copy to the people of Taos, to whom Austin wrote the dedication. It was wrapped in deerskin and placed in one of the sacred kivas at the pueblo.[61]

Austin's text and Adams's photographs were produced separately, but they showed remarkable similarities. Austin's prose was characteristically spare, with carefully structured rhythms that mirrored the sturdy repetitions of pueblo architecture. Adams's photographs also incorporated this angular architecture into their graphic design. In *Woman Winnowing Grain*, Adams chose a strong sidelight to break the image into blocks of varying value that mirrored the physical structure of the pueblo.[62]

Adams learned much from Austin's lean and rhythmic prose and her hardworking professionalism. Most important, through Austin, he discovered in the native cultures of the Southwest examples of societies for which the natural world was a living presence. Adams's photographs of Taos capture the human qualities evoked in Austin's description of pueblo life. Like Austin, Adams emphasized Taos culture as "taprooted," enduringly ancient and deeply connected to the cycles of nature.

The photographs in *Taos Pueblo* marked a transitional phase in his work. They retained much of his earlier pictorialist style in their rather soft focus and warm-toned printing. However, their simplified, geometric graphic organization and their unsentimental realism show the early signs of his move to a more modernist approach. Although Adams and Austin did not see each other's work until the book was ready for printing, their similar treatment of the subject illustrates their artistic sympathies. Like Austin, Adams had a romantic streak despite his movement toward the modernist's spare realism.

*Taos Pueblo* was a critical success, and much of the attention focused on Adams's photography. "These photographic studies are really a joy for the beholder," effused the reviewer for *California Arts and Architecture*. "Ansel Easton Adams has had great success in showing the striking effects of alternate blocks of light and shade shooting the buildings." The reviewer went on to praise Austin's contribution as well. "Never has this lady done a finer piece of interpretation."[63]

When Adams sent the finished book to Austin in the winter of 1931, she admitted that it was an impressive volume. "I was naturally much excited to receive it. I agree with you that it is a superb piece of workmanship."[64] She continued, however, to express her interest in seeing a less expensive edition appear.

> I discussed the matter with the man who does the buying for the Fred Harvey news stands and he said that they did not make a point of carrying expensive books on the news stand because of the handling which they receive and because the class of people who buy them does not care much for fancy book making. He thought $3.00 would be as much as would be paid by the kind of people to whom he would expect to sell the book.[65]

Adams and Bender remained convinced that the expensive edition would do well, despite the worsening depression in the national and international economy. Bender's generosity aided the financial success of the book: he took ten copies. Once again, Adams realized that he owed his friend a profound debt of gratitude. The past five years had produced a remarkable flowering in Adams. *Taos Pueblo* was the summation of the progress he had made. He realized that none of it would have come about without Bender, who had brought him from isolation into an expanding world of creative relationships and supportive patrons. He vowed to show his gratitude by the constant refinement of his art.[66]

## Paul Strand

Mabel Luhan's guest cottages were all filled when Ansel and Virginia arrived in the summer of 1930. Paul Strand and his wife, Rebecca, offered to share their guest bungalow. Strand was another of the many artists associated with Alfred Stieglitz who visited New Mexico regularly. He had developed a sharp-focus style and a powerful sense of design influenced by the abstract painters. As a frequent visitor to Stieglitz's gallery, Strand was familiar with contemporary issues in the visual arts. "I, as a photographer, was in the middle of it—fascinated," he recalled. "All the abstract things I did were consciously directed at finding out what those fellows were talking about, and seeing what relationship it had to photography." Rather than rely on pure abstraction, Strand soon moved to a more representational style, but one that incorporated the lessons of abstraction. "All good art is abstract in its structure," he said.[67]

Adams was curious about the quiet and diligent photographer and asked to see what he had been producing over the course of the summer. Strand did not have any prints with him, but he showed Adams a selection of his negatives. Even in this form, Strand's vision was clear and impressive. With a subtle control of values, mysterious, liquid shadows and luminous highlights, a masterful sense of design, and a coiled energy within a classical calm, Strand transformed the objects before his lens into images of tremendous power.

In Strand's work Adams saw that photography could equal the emotional intensity and formal originality that he had seen in the work of other visual artists in New Mexico. It was a revelation to him, confirming his sense that photography could be an avenue of forceful and significant creative work. With the publication of *Taos Pueblo* and Strand's example, Adams left behind any lingering doubts about his commitment to photography.[68]

Although his mother and aunt both thought it foolish to abandon a promising career as a classical pianist for his "hobby" of photography, warning him that photography could not express the human soul, Adams felt that photography would, in fact, better allow him to express his deepest emotions. He never abandoned his music in creative terms. In their effort to reach beyond the realm of surface appearances, twentieth-century visual artists sought to cross the boundaries of the various artistic media and establish a common vocabulary of expression. The members of the German expressionist group, the Blaue Reiter, especially Kandinsky, employed the musical analogy often, as did many of the painters associated with Stieglitz. To think of visual art in musical terms would help to free artists from the bonds of representation, to explore the formal qualities of abstract design, and to explore the unconscious mind.[69]

For Adams, it was a natural association. His musical training had shaped his creative sensibility in endless ways. Perhaps most important, it taught him to think in abstract terms, to convey emotion through the relationships of tone, volume, rhythm, and phrasing. Everything from his intensely disciplined work habits to his insatiable quest for technical excellence to his sense of visual mood and composition arose, at least in part, from his long years of study at the piano. It was precisely because he felt that photography gave him the ability to express himself individually and originally that he turned to it now with his full energy.

## Edward Weston

Adams's decision cleared away the lingering ambiguity in his career. He hung his shingle outside the small studio he and Virginia occupied next

door to his parents. Above the fireplace of their new home they carved a motto from Edward Carpenter, "O Joy Divine of Friends!" They brought with them the open sociability of the art colonies: Ansel and Virginia both loved to have people around, to share ideas, music, and good food.

Many of the friends who came to visit were photographers. They would sit around the small living room long into the night, talking about their work, what it was and what it could be. Photography was undergoing a renaissance at the time, a period of international growth and experimentation. Photographers in San Francisco eagerly discussed the latest movements and ideas. With his professional career now firmly under way, Adams began to consider more seriously how he wanted to proceed in the medium.

He began writing photography reviews for a local journal of the arts, the *Fortnightly*. His debut piece, in 1931, was on an exhibition by his fellow California photographer Edward Weston, whom he had met in 1928 at a gathering at Albert Bender's home in San Francisco. Weston had shown some of his prints to the group and afterward Bender had taken Weston and his son, Brett, also a photographer, aside to show them some of Adams's work.[70]

Weston recalled Adams's music as far more memorable than his photography, which he thought "promising but immature." "The thought that in this young musician, with such a future before him, we'd have one of the greatest photographers we've ever had, never so much as crossed my mind." For his part, Adams was not particularly impressed with Weston's work, finding it cold and overly intellectual.[71]

By 1931, however, Adams's growing awareness of modernist principles in photography gave him a better understanding of Weston's art. In his review of Weston's first one-man show at San Francisco's M. H. de Young Memorial Museum, Adams displayed considerable understand-

ing of and sympathy for Weston's purpose: his quest for essential form through clear and direct examination, isolating and heightening the viewer's perception of ordinary things.

Adams considered Weston's landscapes, the rocks and tree details, his finest work. He was less taken with the vegetables, especially the cabbage and onion cross sections. Adams objected, as did Weston, to the common assumption that the curvaceous peppers Weston repeatedly photographed were some sort of edible nudes. It is the shared structure of organic form, Adams argued, that gives the pepper its sensual aspect, not the conscious intention of the artist.

Weston's emphasis on small details taken from the everyday world and examined in precise, sharply focused images soon became particularly influential in Adams's own work. Under the influence of modernist principles, Adams was moving steadily away from his broader landscape views, choosing instead smaller subjects in which he could emphasize formal qualities of graphic design: the relationship of tonal values and the effects of light, texture, and line.[72]

Weston was pleased with the sympathetic and insightful review. He wrote to Adams soon afterward: "Your article I appreciated fully, it was an intelligent consideration, by far more so than most I get, because it was a subject close to your own heart." Intelligent writing on photography was rare at that time, and Weston appreciated the opportunity to discuss some significant issues. Among the most pertinent was the question of abstraction in photography and modern art as a whole. "No painter or sculptor can be wholly abstract," Weston argued.

> We cannot imagine forms not already existing in nature—we know nothing else. Take the extreme abstractions of Brancusi: they are all based upon natural forms. I have often been accused of imitating his work—and I most assuredly admire, and may have been "inspired" by it. . . . Actually, I have proved, through photography, that Nature has

all the "abstract" (simplified) forms Brancusi or any other artist can imagine. With my camera I go direct to Brancusi's source. I find *ready to use*, select and isolate, what he has to "create."[73]

## Group f/64

In 1931, Weston agreed to lend his support to a group of young San Francisco photographers who were affirming, as Weston had done years earlier, the value of the sharply focused negative and the unmanipulated print. The members of the group were Weston, Adams, Imogen Cunningham, Willard Van Dyke, Sonya Noskowiak, Henry Swift, and John Paul Edwards. They called themselves Group f/64 after one of the smallest aperture settings common on the lenses of that time. The name was indicative of their quest for clarity and depth of focus in their images. Group f/64 became a vehicle not only to encourage ideas and support the work of its members but also to carry their beliefs into the photographic press.

Adams wrote a series of articles in which he carried on a debate with the well-known Laguna Beach photographer William Mortensen. Adams attacked Mortensen's extravagant version of pictorialism, particularly his penchant for romantic soft-focus images of lurid tableaus. Adams, like most members of Group f/64, tended to favor simple, everyday subjects photographed in natural light. He produced sharply focused and highly detailed images, printed on glossy paper to accentuate the full range of values, from pure white to deepest black. Adams felt, as did Weston, Strand, and Stieglitz, who pioneered this approach, that these techniques were truer to the fundamental characteristics of the medium: its precision and unaffected directness. He felt that the soft-focus techniques of the pictorialists reflected an effort to disguise their photographs as paintings, a ploy he believed undermined the recognition of photography as a viable medium of art in its own right.[74]

In the early decades of the twentieth century, photography was undergoing a shift similar to that which occurred in poetry through the influence of Ezra Pound and the imagists. Like these poets, American photographers were rejecting the excesses of nineteenth-century romanticism for a more precise realism. Weston was among those leading this trend. His often stated photographic credo, "To see the *thing itself* is essential; the quintessence revealed direct, without the fog of impressionism," paralleled the dictum of the American poet William Carlos Williams, "No ideas but in things."[75]

Adams and his cohorts in Group f/64 were part of an international movement reshaping photography in the twentieth century. The spirit of experimentation in the arts was especially manifest in European photography of the 1920s and early 1930s. A variety of artistic currents swirled through the medium, all contributing to what they hoped would be a "new vision," using camera images to break through old ways of seeing the world. In France and Germany, cubism, dadaism, and surrealism pushed photography beyond its representational traditions with new techniques of collage and montage. Images were cut, cropped, and combined in startling new ways with both serious and humorous intent.

While the dadaists made their social and political commentary in visual and verbal puns and directed jabs at both the bourgeoisie and the emerging Fascist movements, the constructivists, futurists, and precisionists employed photography as part of a broad utopian reform ideal. The German Bauhaus school epitomized such efforts. For Bauhaus photographers like László Moholy-Nagy, the camera was one of many tools to liberate industrial life, to infuse it with a creative spirit.

In the United States, artists were also responding to the new demands of the "machine age." Like the European proponents of the new vision, Paul Strand felt that photography could serve to reconcile the increasingly disparate realms of science and art. The photographer, he wrote in 1917,

in establishing his own spiritual control over the machine, the camera, reveals the destructive and wholly fictitious wall of antagonism which these two groups have built up between themselves. . . . Are they not both vital manifestations of energy, whose hostility turns the one into the destructive tool of materialism, the other into anemic phantasy, whose coming together might integrate a new religious impulse? Must not these two forms of energy converge before a living future can be born of both?[76]

Strand turned his lens to closeup studies of mechanical creations, such as the interior of his new Akeley movie camera, turning its gears and levers into an object of formal beauty.[77]

Most members of Group f/64 worked in this precisionist mode. Weston and Cunningham both began their respective moves away from pictorialism with studies of industrial subjects, Weston with his *Armco Steel, Ohio* in 1922 and Cunningham with her *Shredded Wheat Water Tower* in 1928. Although both considered the new industrial landscape of America a suitable subject for their camera, they, like most members of Group f/64, gave their greatest attention to the forms of nature. By the time Adams became aware of their work, organic forms were their predominant subject.

The change to a modernist approach affected Adams's work in the Sierra, as well as in the Southwest. In the late 1920s, he experimented with a more tightly composed rendering of the Sierra, using the telephoto lens to great advantage. His work from the 1928 Sierra Club High Trip to Canada, such as the photograph of Mount Robson featured in the *Sierra Club Bulletin* the following year, shows the growing strength of his composition. The telephoto view of the peak and its surrounding glaciers framed the scene to emphasize the graphic qualities of the dark masses of rock jutting up from the white bands of snow.[78]

The telephoto lens produced a flattening of pictorial space, which

reduced the sensation of depth and emphasized the two-dimensional relationship of values in the print. In this Adams was moving toward the emphasis on the pictorial surface characteristic of modernist painting. His images of the Southwest made in these years were also generally compact and forceful compositions, their simplified, angular geometry showing many parallels to the abstractionism of the painters he met in Taos and Santa Fe.

Although he was adopting modernist compositional ideas by the late 1920s, Adams had not yet abandoned the old-fashioned look of his prints. He continued to use the warm-toned, textured printing papers favored by the pictorialists, and he continued to produce prints dominated by middle values. They had the soft, warm glow of romanticism, not the cool, hard edge of modernism.

In 1931, in his first one-person show outside the Sierra Club, a group of Adams's photographs appeared in Washington, D.C., at the Smithsonian Institution, under the title *Pictorial Photographs of the Sierra Nevada Mountains by Ansel Adams*. It was the last time he allowed the word "pictorial" to be used in conjunction with his work. Seeing the photographs of Strand and Weston convinced him to adopt a radically new approach to the printing and presentation of his photographs. By 1932, he was an active participant in Group f/64 and a vocal exponent of the group's philosophy. In contrast to the soft-focus impressionistic rendering of his subjects, he was now producing prints of greater clarity and brilliance. In particular, Adams began to use smooth-coated glossy printing paper to give his prints a greater sharpness and an expanded range of values.

In 1932 on a Sierra Club trip to the Kaweah and Kern River watersheds in the southern Sierra, Adams made a photograph that sums up his style of these years. *Frozen Lake and Cliffs* reflected his adoption of the Group f/64 philosophy and his growing awareness of contemporary movements in the visual arts. Adams balked, however, at referring to

such images as abstraction. He preferred to speak of them as "extracts," pointing out that they were derived from actual scenes, selected and manipulated in the process, not synthesized purely from the imagination.[79]

Within the constraints imposed by the photographic medium, Adams exerted considerable control over the image. He framed the scene to eliminate any references to its specific location, selecting a small portion that served not simply as a record of a spot on the trail but as a subjective interpretation of the look and feel of the entire region, the cold beauty of stone, water, and ice.

This approach was apparent in much of his work during these years. One cold, crystalline winter day he was out on the outskirts of San Francisco with his 8 × 10 view camera, his mind open to the visual possibilities around him. A patchwork of weathered boards on the side of an old barn caught his eye, their texture highlighted by bright morning sidelight. A patch of thistles gave a sharp counterpoint to the strong lines of the boards. The resulting photograph, *Boards and Thistles*, demonstrated Adams's growing graphic sophistication and his ability to organize images with a musical sensibility.[80]

Adams's contact with the latest ideas in contemporary art pushed his photography in new directions that sometimes left his friends in the Sierra Club perplexed. They wondered why he would picture rocks and leaves and old boards and such. The photograph was about its subject, they assumed. What was the point of these things?[81]

It was a question Adams would be asked with growing frequency in the coming years as the Great Depression made the theoretical and formalist concerns of the avant-garde seem irresponsible in that time of social turmoil and human suffering.

*four*

# ART IN THE GREAT DEPRESSION

ADAMS ENTERED THE 1930s with a clear commitment to photography. Albert Bender's support over the previous six years had given him a crucial introduction to the leading figures in modern art and to its ideas and techniques. Although his influences were now international, his identity remained firmly regional. Like California's turn-of-the-century writers, the photographers of Group f/64 were sometimes dismissed as a "cosmic" West Coast coterie, out of touch with world events and far behind the artistic cutting edge.

Despite the label, Adams's work grew rapidly more sophisticated. His focus on the world of nature was not simply a product of his idyllic days in the Sierra or the relative isolation of California from the main currents of contemporary art. His intuitive response to the landscape and the principles of conservation that he had learned through his association with the Sierra Club were given a further dimension by his introduction to the ideas of writers and artists who saw in the western landscape access to timeless forces, an avenue to the spirit, the unconscious, the primitive, and the elemental.

Adams would continue his relationship with these artists in the coming years, not only in the Southwest but also in his increasingly frequent

visits to New York. It was in New York that he would establish what were probably the most important artistic relationships of his career: with Alfred Stieglitz and with Beaumont and Nancy Newhall of the Museum of Modern Art. Yet as he was broadening his horizons and establishing contacts that would keep him abreast of contemporary movements in art, he was about to experience a crucial reassessment of his values.

By the time Adams began to establish himself in the art world, American modernism was in a generally individualistic and apolitical phase, more concerned with formal issues and self-exploration than with social reform or political agendas. He had been a boy when the Armory Show seemed part of a revolutionary moment. His friend Tom Mooney, the kindly man who ran the Underwood typewriter exhibition at the Panama Pacific International Exhibition, was in jail for the Preparedness Day bombing before Adams was old enough to know the causes of such violence. In the seemingly endless space of the Sierra and the heady atmosphere of New Mexico, the disturbing forces of modern life seemed a million miles away. Yet those forces would soon intrude again.

## Sublime Amusements

Although the onset of the Great Depression, following the stock market crash in the fall of 1929, limited private patronage for artists, Adams was able to carry on during the early 1930s more or less as he had in previous years, pursuing the life of a fine artist in his serious personal work while supporting himself precariously through book projects, print sales, lectures, writing, and various commercial assignments. He was certainly not getting rich, but he and Virginia managed to get by. His most secure source of income in these years was his work for the Yosemite Park and Curry Company, known simply as the Curry Company.[1]

The Curry Company had been formed a few years previously from

the merger of the two largest Yosemite concessionaires, the Yosemite National Park Company and the Curry Camping Company. The two concerns had been antagonistic for years. In 1925, Secretary of the Interior Hubert Work became thoroughly fed up and insisted they silence their endless bickering through consolidation. Henceforth the new entity would possess a virtual monopoly on the tourist trade of the park. By the mid-1920s, this constituted a considerable business as an average of half a million visitors made their way to the valley each year.[2]

Tourism in Yosemite had come a long way since 1899 when David and Jennie Curry, former schoolteachers from Indiana, pitched a number of tents near the base of Glacier Point and opened their Curry Summer Camp to park visitors. David Curry, the freewheeling and exuberant entrepreneur Adams had witnessed in action on his first visit to the park in 1916, was ever vigilant for promotional opportunities. He hit on an enduringly popular entertainment when he revived an earlier Fourth of July tradition in the valley, the "firefall" of burning logs pushed over Glacier Point's edge to plunge over three thousand feet in a cascade of glowing embers.[3]

Curry's promotional stunts were part of a general tendency to lure visitors not through an emphasis on the quiet contemplation of wilderness but rather through the creation of a tourist resort and amusement park in the middle of the valley's spectacular physical setting. The crowds that poured into Yosemite each summer were taken by the National Park Service as a sign of their success. But many preservationists felt that the aesthetic experience of the park was becoming increasingly compromised.

"Yosemite Valley is getting to be an awful place," wrote Charles W. Michael, Yosemite's assistant postmaster and an amateur ornithologist, to the University of California biologist Joseph Grinnell in the summer of 1927. "We have crowds all season and right now camps are very much crowded. The air is filled with smoke, dust, and the smell of gasoline."

The next year Michael wrote again. This time he was worried that the crowds would soon not simply be confined to the spring and summer months but would discover the virtues of the more peaceful fall and winter seasons, and "then there will be no rest at all for those who like peace and quiet."

In the late 1920s the newly formed Yosemite Park and Curry Company engaged in an extensive expansion program. The most conspicuous result of that effort, the luxurious Ahwahnee Hotel, opened its doors on July 14, 1927. At Camp Curry a new ice-skating rink was installed, and plans were under way for a ski lift and lodge at Badger Pass, above the valley rim near Glacier Point. Key to the viability of these new winter sports facilities was the All-Year Highway, which opened in 1926. The Curry Company president, Donald Tresidder, even proposed the construction of a cable car tramway running from the valley floor to the top of Glacier Point. The tram would be an attraction in itself and convey skiers quickly from the Curry Company accommodations in the valley to the lifts at Badger Pass.

The tramway was turned down by the Park Service, but most park officials looked favorably on the other "improvements." One who did not share their attitude was Frederick Law Olmsted, Jr., who carried on his father's legacy both as a noted landscape architect and as a leading voice for Yosemite's preservation. On hearing of the completion of a nine-hole golf course on the grounds of the Ahwahnee Hotel in April 1930, Olmsted remarked with disgust, "So it goes, nibble by nibble!"[4]

Although Adams was certainly no advocate of commercial exploitation of the wilderness, he soon found himself lending his talents to the promotion of just such an eventuality. By the mid-1920s, Adams had become a fixture around Yosemite, noted for his eccentric antics. As part of the winter activities planned by Donald Tresidder, a theatrical Christmas dinner was begun at the Ahwahnee Hotel, with a group of his

friends from San Francisco's Bohemian Club providing a pageant featuring a chorus, processions, and a traditional English yuletide feast.

The dinner's director cast Adams to type as the Jester, and Adams carried out his part with enthusiasm. After several rounds of drinks at the singers' party beforehand, he arrived at the hotel. He asked the director for some suggestions, having had no rehearsals. The director suggested he act like a jester.[5] After preparing for his role with a few more drinks, he made his appearance in the Ahwahnee's grand dining hall. Prancing gaily and jangling his bells, he made his way to one of the massive stone pillars rising more than forty feet above the assembled guests. Clinging like a fly to the rock-faced column, Adams ascended deftly toward the rafters, to the gasps and cheers of the crowd below.[6]

In 1929, Adams and Jeannette Spencer, who in partnership with her husband, Ted, was an architectural design consultant to the Curry Company, took over the Christmas dinner. They brought a more serious and professional approach to the production and dubbed the annual event the Bracebridge Dinner, modeling it on Washington Irving's account of an English squire's Christmas entertainment in *Christmas Dinner at Bracebridge Hall*. Adams arranged the music, organized the choir and soloists, and wrote the speaking roles. Both Ansel and Virginia took part in the performance, with Virginia one of the featured soloists. The Adamses and the Spencers collaborated on the dinner annually for nearly fifty years, finally retiring from their duties in 1975.[7]

Following the well-received dinner in 1929, Tresidder learned that Adams was a photographer and offered him a job illustrating winter activities around Yosemite. The Curry Company wanted to launch an all-out campaign promoting Yosemite's winter recreational opportunities. Tresidder hoped that Adams could supply the necessary photographs. They signed an agreement in which Adams would work for a daily fee of $20, plus expenses, for a period of eight weeks. Adams would retain all negatives, supplying prints as needed at cost.[8]

The promotional efforts of the Curry Company were part of two significant trends that accelerated greatly during the 1920s and would be crucial factors in Adams's subsequent career: the growth of advertising and of mass recreation. By the 1920s advertising had become a crucial element in expanding markets for the new technologies and consumer goods of the twentieth century. Along with the tremendous economic growth of that decade came greater leisure time for both white-collar and blue-collar workers. The automobile became affordable and put Americans on the road. A variety of sports became national obsessions. Professional baseball, college football, golf, and tennis were the favorites, but in the West, the wilderness sports of hiking, mountaineering, and skiing were growing in popularity.[9]

The Sierra Club's orientation in this period mirrored the national trend. Members were active in a broad range of outdoor recreation.[10] Adams, for example, contributed a glowing account of Nordic skiing to the 1931 annual *Sierra Club Bulletin*, in which he described the magical transformation of the Sierra backcountry under a blanket of winter snow.[11]

Although many, including Adams, were beginning to question the rising pressures on the wilderness from commercial activities and public use of the national parks, the opposition between preservation and public enjoyment of the parks that became a serious issue following the Second World War was not strongly felt at that time. The National Park Service and the Sierra Club both continued to support greater public use of the parks. Adams shared this point of view, finding no conflict between his work for the Curry Company and the Sierra Club.

The depression slowed the rate of growth in Yosemite's annual visitation, but the number of visitors remained fairly stable throughout the 1930s. Tresidder hoped that his promotional efforts would keep the

people coming. Adams's work for the Curry Company provided a crucial source of steady income as he and Virginia struggled to stay financially afloat. Tresidder and the advertising department were pleased with Adams's photographs, and he was hired on a part-time basis each year through 1938.

While Adams was working for the Curry Company, another future conservation leader joined the organization. In the summer of 1936, David Brower, a twenty-three-year-old rock climber and Sierra Club member, secured a job in the accounting department of the Curry Company and soon advanced to publicity manager. In this capacity he was often in contact with Adams as they worked on the promotional efforts of the park concessionaire. It is perhaps no coincidence that Brower and Adams later became two of the leading figures of the Sierra Club's public outreach campaign in the 1950s and 1960s. Their training in the power of advertising taught them important lessons that they would put to use in later years.[12]

### Stieglitz and New York

In the winter of 1933, the depression was at its lowest ebb. Ansel and Virginia were on their way across the country, bound for the East Coast. Virginia was three months pregnant when they started out that March. Her father had given them a thousand dollars as a gift, suggesting they take the opportunity to see the country and visit the art centers of the East before their first child arrived. They had taken along a stack of traveler's checks but found them useless as financial panic gripped the country. In an effort to control the situation, President Franklin Delano Roosevelt declared the first of the "bank holidays" immediately after his inauguration that month.

Initially Adams took it all with good humor. They had put off the trip for months. Now, on the second day of their journey, they discov-

ered that banks would be closed nationwide. With only thirty dollars in cash on hand, they found themselves stranded in Santa Fe. They stayed with Frank Applegate and made the most of the situation by looking up old friends and meeting new ones at the usual round of parties.[13]

Behind Adams's optimistic front lay gathering doubts. Like many Americans at the time, he feared financial panic might portend a broader social collapse. He admitted in a letter home to his parents that he and Virginia were both glad to be among good company in New Mexico rather than in the urban centers. He urged them to take precautions, suggesting that they head up to Yosemite if panic set in in San Francisco.[14]

They enjoyed the serenity of Santa Fe for a week or so, but repeated telegrams and letters from Albert Bender urging them to continue their trip finally prevailed. When the bank agreed to cash their traveler's checks, Ansel and Virginia resumed their cross-country trek.[15]

Their next stops were in Detroit and Chicago where some of Adams's San Francisco patrons had friends among the wealthy art collectors there. Armed with letters of introduction, Ansel and Virginia made the rounds of local high society. Ansel was not unacquainted with social niceties, but he could not seem to resist the opportunity to tweak the refined sensibilities of his pompous hosts. At one dinner in Chicago, Adams struck up a conversation with the cultured guests around the table. They assumed that any serious artist had made at least an obligatory visit to the art capitals of Europe and were surprised to hear that Adams had never been. Adams, always a bit of a nativist in matters of culture, felt that Europe's importance was much overrated. He was willing to admit, however, that he would enjoy seeing the Gothic cathedrals. Yes, they were simply marvelous, the matron seated next to him agreed. She wondered what aspect of the Gothic style he found most appealing. The flying buttocks, he said, were strangely fascinating. His little joke was not well received.[16]

Adams liked to make fun of social pretensions, but he had his own form of social climbing in mind. As a young artist on the make, he was concerned with the reaction of the photographers he planned to visit when he and Virginia arrived in New York. At that time the city was the undisputed center of American art. Above all, Adams wanted to show his work to Alfred Stieglitz, the man he considered, with much justification, the greatest photographer of the day.[17]

It was natural that Adams should gravitate toward Stieglitz. Since the turn of the century, Stieglitz had been the most important figure in establishing photography as a fine art in the United Sates. Through his own photographs, as well as through his magazine, *Camera Work*, he had been the prime force behind the move to a modernist approach known as "straight" photography. Adams was eager to meet the legendary figure and to see how he would react to his work.[18]

When they arrived in New York City several days later, Ansel and Virginia were greeted with typical late winter weather: cold, damp, and miserable. From Grand Central Station, they made their way to East 51st Street and the Pickwick Arms Hotel. A haven for retired radio and theatrical employees, the threadbare hotel brought home the harsh realities of depression life for the city's masses.[19]

Later that afternoon, they visited the Museum of Modern Art and the Julien Levy Galleries. They also stopped at the new Rockefeller Center, the huge complex rising above the city despite the depression. They were hoping to find Diego Rivera, whom Adams had met previously in San Francisco. Rivera was painting a mural for the center's lobby, a complex narrative composition on the rise of modern industrial society. Prominently featured was the heroic figure of Vladimir Lenin. Outraged at Rivera's audacity in placing such "Communist propaganda" in the citadel of American capitalism, the corporation's manage-

ment had it painted over. Adams had little interest in overt political themes, but he loved Rivera's sense of humor.[20]

He and Virginia were disappointed to find him not about, so they returned to the hotel. Donald Tresidder was in town and had invited them both to dinner. Virginia wrote home to Ansel's parents the next day, pleased with their venture in New York's high society. Tresidder had taken them to 21, the most famous speakeasy in the city. With Tresidder footing the bill, they enjoyed the plush decor, the elegant food, and the smooth liquor—which before long would be legal once more.[21]

The next day Adams ventured forth with his portfolio. With his unruly beard and rumpled suit, he looked the part of the "serious" artist. "Quite Rive Gauche," remarked a friend of his father.[22] His first stop was Stieglitz's gallery, An American Place, on Madison Avenue. It was another bleak day in Manhattan. A freezing rain fell on the dirty streets lined with garbage cans awaiting collection. Traffic roared through the gray canyons of steel and glass. As Adams rushed along the sidewalk, he bumped another harried pedestrian. His proffered "Excuse me" was met with a hostile glare.[23]

Finally arriving at 509 Madison Avenue, Adams took the elevator to the seventeenth floor and found the door to An American Place open. He entered the main gallery, which was filled with a cool, late winter light. There was no one to be found, so he ventured around the corner to the doorway of a small room from which issued the sound of rustling papers. There he found an elderly man, his small frame wrapped in a large black cape. Wisps of silver hair fell across his broad forehead and an abundant mustache bristled beneath his boxer's nose. He was bent over the desk, engrossed in a book.[24]

He looked up with a scowl. Adams explained his mission as simply as he could and presented a letter of introduction from Mrs. Sigmund

Stern, one of his patrons in San Francisco. Stieglitz glanced at it briefly. The woman had nothing but money, he said with a dismissive wave of his hand, and if the depression continued much longer, she would not have even that. Adams was mortified by this callous dismissal of his kind and generous friend. He explained that he simply wanted to show him his work. Stieglitz waved him off. "Come back at two-thirty," he said, and went back to his papers.[25]

In a silent rage, Adams went outside to the street. He felt like abandoning the whole idea. Who did this man think he was? This so-called avatar of American modernism, this "greatest living photographer," seemed like nothing more than an old crank. When Ansel met Virginia for lunch he told her he wanted to go back to California. He did not need this humiliation, and he could not stand New York. Virginia calmed him down and urged him to give Stieglitz another chance.[26]

Adams returned to An American Place at the appointed time to find the old man's mood thoroughly improved. Greeting him cordially, Stieglitz took the portfolio and sat back down at his desk to study each print carefully. As there was no other chair in the gallery, Adams took a seat on the radiator by the window. Stieglitz lingered over each image. When he was finished, he carefully tied the laces of the portfolio and looked up at Adams with a searching gaze. Then he untied the portfolio and studied each photograph as carefully as before.

With the radiator clanking away, Adams felt himself literally on the hot seat as he nervously awaited the old man's opinion. Finally Stieglitz looked up once more. "You are always welcome here," he said. "These are some of the finest photographs I have ever seen." He praised Adams's "straight" approach to the medium and the sensitivity of his vision.[27]

Adams wrote excitedly to Albert Bender to report the news of Stieglitz's warm response. Bender, who recalled him as "an intellectual talking machine," was perhaps a little jealous of Stieglitz's possible usurpation of his role as Adams's artistic benefactor. He warned Adams of

coming too much under the great man's shadow. "It is far better for you to be independent instead of a protégé of his. Through being independent you will go farther and develop yourself to rely on your own resources." Yet Bender acknowledged the crucial role that Stieglitz had played in American photography. "He is the chief man in America to have raised photography to a high plane. . . . You[,] among others who come after him, owe him a great deal for leading the way."[28]

Adams paid visits to several other prominent photographers, including Edward Steichen, once Stieglitz's closest associate. It was Steichen who had introduced Stieglitz to the work of many of the groundbreaking European modernists featured in *Camera Work* in the first decades of the century. During the 1920s, however, Steichen had turned to a lucrative career in portrait, fashion, and advertising photography. Stieglitz felt that Steichen had sold out.[29]

Adams knew immediately that he and Steichen would not hit it off. After making an appointment to see him at ten o'clock one morning, Adams waited patiently for Steichen's arrival. Finally Steichen rushed into the studio, preoccupied. He told Adams that he was busy now. Maybe he would be free next week. With that he disappeared through a doorway to carry on with his business. It seemed clear to Adams that Steichen was not the least bit interested in him or his work. Hoping that perhaps he had caught him on an unusually busy day, Adams returned later in the week but was again unable to gain a meeting. He felt an arrogance in the man—a flaunting of power and prestige. In the coming years, his antipathy toward Steichen would only increase.[30]

After the Second World War, Steichen muscled his way into the position of director of the Department of Photography at the Museum of Modern Art, forcing out Adams's good friend Beaumont Newhall. Steichen brought with him a theatrical approach to exhibitions that Adams found inappropriate to an art museum but proved immensely popular with the general public. Steichen came to symbolize all that

Adams disliked in the art world. His animosity may have arisen in part because he was closer to Steichen than he liked to admit. Although he would never go as far as Steichen, Adams felt the pull of a successful commercial career and a populist approach to art. Stieglitz and Steichen, two early giants of American art photography, formed twin poles between which Adams oscillated in the coming years.[31]

Although Steichen brushed him off, Adams's confidence remained high. One of his primary goals was to secure a gallery exhibition in the city. He visited the Delphic Studios, one of the few galleries in New York that exhibited photographs, and met with the owner, Alma Reed, who liked what she saw and offered him a one-man show that fall. Things were definitely going well on his first visit to the capital of American art.[32]

Adams was now willing to grant that New York was not so bad after all. In fact, he admitted to his parents, he was beginning to like it. There was an intensity, a sense of being at the center of the action. While San Francisco's isolation had its creative advantages, in New York he felt in touch with contemporary ideas. They seemed to make more sense here.[33]

Despite this more positive view of New York, Adams still championed his West Coast colleagues and their artistic point of view. Albert Boni, editor of *Creative Art*, asked Adams to review Edward Weston's first book, *The Art of Edward Weston*, which had been published the previous fall. Adams used the opportunity to speak up for his friend and his native region.

> The physical environment of the California Coast has left an impressive mark on Edward Weston. In the whirl and social vortices of the huge craters of civilization, it is easy to forget the simplicities of stone and growing things. . . . Weston has dared more than the legion of brittle sophisticates and polished romanticists ever dreamed. . . . Recording

actualities of the natural world[,] . . . simple things which, through his presentation, assume the qualities of elemental necessities.[34]

By May, Ansel and Virginia were back in San Francisco. Adams continued to think of Stieglitz. According to one friend, "It was Stieglitz this and Stieglitz that."[35] Adams decided to express his thoughts directly. He wrote to Stieglitz in June, explaining that he had been planning to write for some time but had been unable to find the words to fully express the deep impression their meetings had made. Stieglitz had shown him what photography could be, what the life of an artist could be. Above all, he had given him confidence in his creative intuitions and the courage to express them in his work.[36]

Stieglitz's encouragement pushed Adams, like an excited electron, to a new level of energy. The most immediate manifestation of this was the experiment Adams undertook on his return to San Francisco. He rented a small space in downtown San Francisco for use as a combination studio/gallery. It was a very simple arrangement but fairly spacious and well-lighted. Adams was aware of Stieglitz's influence in the decision to include a gallery. Yet he claimed that the venture was not intended to imitate An American Place: such a goal would be impossible to achieve.[37]

Adams asked Stieglitz if he would send a selection of prints for an exhibition at the new gallery. Stieglitz replied in a friendly but definite way. "I have often had you in mind and frequently regretted that I was unable to show you really a good lot of my work—But I knew you understood. I have had your own work in my mind too—Been thinking quite a lot about it." Sending exhibition prints, however, was not possible. For one thing, he was at his family vacation home at Lake George in upstate New York. "Even if I were in town I don't know whether I could respond to your request—You see I am a stickler in presentation of everything." Although Stieglitz turned down the request, he wanted

to assure Adams of his support. "I'd like to send you a good print of mine for yourself as a token of appreciation for your purpose. . . . I know your 'Experiment' will be a good one. I know well it won't be an imitation of anything else—I wish you every success in your work and with the gallery."[38]

### Sierra Club Directors

In addition to his responsibilities at the studio and gallery, Adams had his hands full that summer with Sierra Club business. He had become increasingly active in the club over the years. He joined the editorial board of the *Sierra Club Bulletin* in 1928 and worked closely with the editor, Francis Farquhar. Farquhar was already an advocate of high-quality reproductions, and Adams encouraged this direction. The 1929 issue, for example, included a gravure frontispiece of Adams's *Mount Robson* and well-reproduced halftones throughout.[39]

Since 1930 he had been active in organizing the annual High Trip. He was part field marshal, organizing each encampment; chief photographic guru, leading camera excursions and delivering inspirational lessons; and court jester, cracking bad jokes, loosing a constant stream of puns, and organizing impromptu theatrical spoofs for the evening campfires.[40] He left on the High Trip of 1933 in early July; Virginia stayed in Yosemite, their first baby due any week. Although Virginia had told him not to miss the trip, he felt a certain guilt at enjoying himself in the mountains while she labored in the valley. Sensing that the time had come, Ansel left the last encampment of the trip a day early, hiking down over Bishop Pass to the Owens Valley where he stopped to send a telegram telling Virginia that he was on his way. From there he traveled by car over the Tioga Road to Yosemite Valley. He arrived in the late evening at Best's Studio and rushed in to ask how things were. Her father replied laconically that all was fine. Ansel hurried to the local

hospital to find Virginia and their new son, Michael, born two days earlier, both healthy and in good spirits.[41]

With the birth of their first baby and a daughter, Anne, two years later, Virginia became busy with the new tasks of parenting, especially since Ansel's photographic assignments frequently took him on the road. Her duties made it difficult for her to continue as a member of the Sierra Club board of directors, a position she had held since 1931. She recommended Ansel as her successor. Ansel felt she deserved to remain on the job. They were both nominated in the 1934 election, and, as the San Francisco Chronicle reported, "Thus they campaigned, she for him and he for her." Virginia's campaigning proved the more successful: Ansel was elected. He continued to serve on the board for the next thirty-seven years.[42]

For Virginia, the idea of pursuing a professional singing career, always more Ansel's idea than hers, became impractical now. After her father's death in 1936, she took over the management of Best's Studio in Yosemite Valley. She made every effort to stock the studio with high-quality merchandise rather than the cheap trinkets commonly sold by Yosemite concessionaires. She purchased a variety of books and Indian crafts to complement the photographic supplies and Ansel's original prints and oversaw the day-to-day operation of the business. In the coming years they divided their time between their home bases in Yosemite and San Francisco.[43]

## Art and Life

When Adams returned to San Francisco that fall, he was asked to help the curator of the de Young museum select and borrow a representative collection of historical and contemporary international photography for a major exhibition that was being planned. He wrote to Stieglitz asking for advice on the selection of artists and contacts in Europe from whom

to obtain exhibition prints. Although he was learning quickly, Adams's knowledge of historical and contemporary photography was actually fairly limited at the time.[44]

Stieglitz had been drawing increasingly away from the movements of contemporary photography and the official "art world" in general. Always distrustful of museums and curators, he may have feigned ignorance to avoid the whole topic. "I have no idea," he wrote, "who is who in the New World of Photography—that is from the print for exhibition point of view. . . . I am living in a world which I feel at times seems millions of miles away from all that's official—institutional—and all that these terms signify."[45]

After several more exchanges over the course of the summer of 1934, Adams felt an increasing openness with his new mentor. He perceived in Stieglitz's work and attitudes toward art a quality that his own recent strident emphasis on "purist" technique had overlooked. Although he still demanded the finest possible craftsmanship, as did Stieglitz, he realized now that technique was meaningless without deeper motivation and expression. Above all, there must be an emotional element. Stieglitz called it tenderness—an engagement with life that extends beyond surface into essence. Making a photograph then becomes part of an ongoing relationship between artist and environment, the expression of a passionate immersion in the world.[46]

Stieglitz's dedication to art as a deeply spiritual activity prodded a continuing sore point with Adams, the matter of art and moneymaking. While he vowed to resist the subjugation of his art to the demands of commerce, he pointed out that rent and grocery bills wait for no one. He would limit himself to only the most significant work and do it as he saw fit. Bills could not be paid with good intentions, however. He hoped to find commercial assignments that would allow at least a modicum of creative challenge and artistic integrity. A few pending assignments for

local merchants seemed to offer good prospects, and he promised to send Stieglitz prints of the best images.[47]

While Adams struggled to stay afloat in the stormy economic seas of the depression, his creative powers were ripening into full fruition. Having expanded his social, intellectual, and geographic horizons immensely over the last five years, he was now beginning to reassert his own personal vision and sense of place. He realized that for all he had learned in the centers of the avant-garde, such places were not his true spiritual home. New York seemed like an intellectual hothouse. New Mexico seemed almost too beautiful, so that it fell into the merely picturesque. The transplanted sophisticates were an imposition on the land, aliens amid the indigenous cultures they sought to emulate.[48]

In his search for the essence of his art, a search that meeting Stieglitz had sharpened and clarified, Adams saw that the real roots of his photography lay in his own emotional heartland, the Sierra Nevada. In those mountains, with his simple camera, wornout clothes, and trusty mule Electra, he had traveled for weeks on end through timeless landscapes of rock and sky. There was no purpose to it—no patrons or projects or ulterior motives—just a simple communion of a mind and spirit with the world. It was from those experiences that his art was born, and so it would always remain.[49]

Although Stieglitz's support gave him the confidence to follow his own muse, Adams worried whether he could hew to the stringent ideals that Stieglitz embodied—the uncompromising pursuit of the creative life. Adams's concerns highlighted a continuing tension not only in his own work but in modern art as a whole, a tension that Adams would feel with increasing force as the 1930s progressed. Social mission and commitment to the public good were important components in the work of many modernist pioneers. In the first decades of the century, modern-

ism in the arts and radicalism in politics were closely allied. In Europe, the Soviet constructivists, the Italian futurists, and the German Bauhaus school all saw art as a crucial tool in the construction of a new social order, although the art and the social order envisioned differed considerably among them.

In a similar way, many of the artists associated with Alfred Stieglitz sought to revitalize American art through the development of a truly American modernism—an art based on the unique qualities of American society, a celebration of its industrial power and urban dynamism as well as its natural landscape and indigenous cultures. Yet with Stieglitz and his circle, as with most European modernism of the time, it was an artistic revolution from above. However much these artists and theorists might celebrate native culture, the spirit of modernism was essentially an elitist one in which a vanguard of the enlightened would lead the masses to the new vision and the new society.[50]

Stieglitz provided a good illustration of this elitism. "Integrity of endeavor means nothing to the American people," he wrote to Adams. "Nothing whatever. Still I fight on and shall till I drop." Stieglitz's negative view of the American people applied particularly to the institutional art world from which he self-consciously held himself apart. "The racketeering in the so-called world of art becomes more & more brazen & engulfing.—The sordidness of it all is appalling."[51]

Adams had on several occasions diplomatically requested a Stieglitz and/or O'Keeffe exhibition for his new gallery in San Francisco. Stieglitz continued to decline. "The O'Keeffes are needed here," he claimed. "I dare not risk them out." Furthermore, he felt the entire process of exhibition had become little more than a form of mass entertainment. "You know I hate the very idea of all exhibitions for exhibitions as such are rarely true.—Have no fundamental significance—Are 'entertainers' & not enlighteners. I know my America and know the American character."[52]

This attitude struck Adams as harsh, and he once again raised the question that was bothering him more and more in these years. He was feeling open enough to venture a criticism and suggested that perhaps Stieglitz had insulated himself too much from the world. The armor erected against a largely philistine public may also prevent contact with those elements of society that could genuinely respond to meaningful work.[53]

Adams agreed that a true appreciation of art was a rare quality, but he questioned whether that necessarily implied that a public orientation and a democratic attitude were naive. Although Adams's sympathies were democratic, he remained elitist—at least for the time being—in his assumption that art was a rarified realm appreciated by only a few. Although only a "handful" truly understood or even cared what art could be, he felt that it was therefore the artist's duty to seek out such receptive minds.[54]

The question of the proper role of art in society was hotly debated as the depression forced artists to reexamine the meaning of their work. The crisis accelerated the turn toward American popular culture begun in the 1920s and prompted an effort to discover a solid core of American culture, a "usable past" within the life of "the people." The majority of American artists turned their attention from stylistic innovation to the social and political issues of the day. The new bywords in intellectual circles were social commitment and political activism.[55]

Adams had entered the art world at a time when the avant-garde thought of itself as a distinct subculture. In the 1920s, the era of the "lost generation," most artists retreated from society in expatriate exile or gathered at bohemian colonies like those of Santa Fe and Taos, seeking independence from what they viewed as the crassly materialistic and spiritually anesthetized America of that decade. Meanwhile, for their part, most of the public viewed the avant-garde with distrust. The stylistic innovations of modernism in all media left most people perplexed, if

not outright hostile. The avant-garde, Adams among them, generally relied on the support of a limited circle of cognoscenti and affluent patrons.[56]

Coming into the art world at the height of America's early period of modernism, Adams adapted well and flourished with the support of affluent patrons such as Albert Bender, Rosalie Stern, and Mabel Luhan. The collapse of the American economy made this specialized art market difficult to sustain. Some artists continued to fare reasonably well—as, for example, did the more recognized members of the Stieglitz circle such as John Marin and Georgia O'Keeffe—but most found the market for their work, always tenuous at best, now almost entirely dried up. Under the circumstances, the age demanded a reassessment of the usually adversarial relationship of modern artists and the general public, if for no other reason than the economic survival of the artist. Under the federal patronage that came with the New Deal, many formerly abstract painters found financially lifesaving work on various projects of federally sponsored art.[57]

By 1935 Franklin Roosevelt's New Deal had inaugurated the Federal Art Project branch of the Works Progress Administration (WPA). Its director, Holger Cahill, summarized the views of many artists working for the WPA: "The emphasis upon the universal and eternal in art too often has meant that our interest has become attached to fragments lost from their contexts in time and human society." Cahill condemned the modernist tendency of art to "feed on itself" and the artists' obsession with "art for art's sake." He emphasized that the Federal Art Project was not concerned with producing masterpieces, which he felt was "a collector's idea." Rather, the goal should be a collective effort to encourage a creative atmosphere throughout society. Artists of various degrees of competence were invited to participate on projects directed toward the widest public audience. Art should belong to everyone, not merely the

Anonymous, *The End of the Trail and the Tower of Jewels.*
Courtesy Bancroft Library.

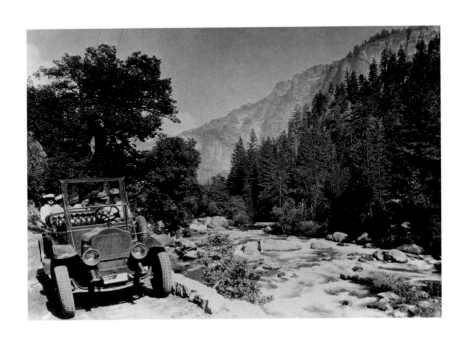

Anonymous, *Autostage on the El Portal Road, Yosemite National Park, 1916.*
Courtesy Yosemite National Park Research Library.

Joseph LeConte, *Ansel Adams and the LeConte Family
Crossing Cartridge Pass, King Canyon Region, 1926.*
Courtesy Bancroft Library.

*Junction Peak, Sierra Nevada.*
Courtesy National Archives.

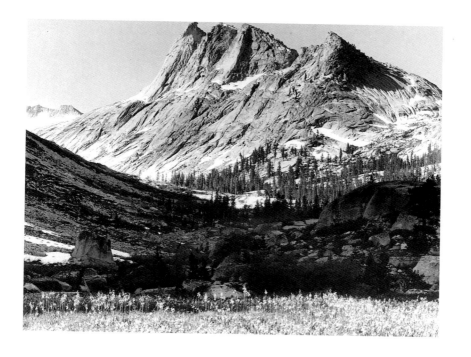

*Roaring River, Sierra Nevada.*
Courtesy National Archives.

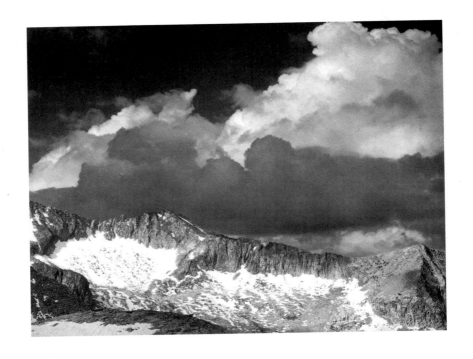

*Clouds, White Pass, Sierra Nevada.*
Courtesy National Archives.

*Curry Company Brochure*, ca. 1935.
Courtesy Yosemite National Park Research Library.

John Marin, *Mountain Forms, New Mexico*,
watercolor with black chalk over pencil, 1930.
Alfred Stieglitz Collection, 1949.570. Photograph © 1994,
The Art Institute of Chicago. All rights reserved.

Paul Strand, *Church, Ranchos de Taos, 1931.*
Copyright © 1971, Aperture Foundation, Inc.,
Paul Strand Archive.

Edward Weston, *Pepper #30, 1930.*
Courtesy and Copyright © 1981 Center for Creative Photography,
Arizona Board of Regents.

*Detail, Bristlecone Pine Wood.*
Contemporary print from original negative by Ansel Adams,
California Museum of Photography, Sweeney/Rubin Ansel Adams
*Fiat Lux* Collection, University of California, Riverside.

Dorothea Lange, *White Angel Breadline, San Francisco, 1933*.
Copyright the Dorothea Lange Collection, The Oakland Museum,
The City of Oakland. Gift of Paul S. Taylor.

affluent patron. Indicative of this spirit were the numerous mural projects undertaken in public buildings: post offices, schools, libraries, and the like.[58]

Others chafed against the demands of mass taste to which the federal art seemed to kowtow. The WPA employed a number of abstract and surrealist painters. Among these was Stuart Davis, who, although based primarily in New York, had been a frequent visitor to Santa Fe and Taos. Davis managed to retain a modernist's concern with abstraction and formal inventiveness in his federally sponsored work. Feeling the need to justify his continued use of avant-garde styles, he sturdily maintained the importance of formalist concerns. "Art values are social values," he explained, "not by reflection of other social values, but by direct social participation. . . . Art is one of the forms of social expression and must change as society changes." Davis railed against the regionalists, social realists, and American Scene painters whom he felt represented a reactionary rejection of the progressive European influences inherent in American modernism. He felt that the realist painters were employing outmoded techniques while attempting to achieve progressive ends. "The expression remains static even in the class-struggle variety of domestic naturalism because although the ideological theme affirms a changing society, the ideographic presentation proves a complete inability to visualize the reality of change."[59]

### Dorothea Lange

Like Davis, Adams was committed to carrying on his modernist principles, despite the trends of the moment. His photography had gained recognition during the early 1930s as his artistic vision and technique became more assured. Yet by 1932, the year that he and his fellow California photographers began Group f/64, the depression had revealed

itself as an overwhelming catastrophe for America, Europe, and much of the world. Photographers, like people everywhere, felt the weight of contemporary events.

Among Adams's friends, the artist most identified with social concerns was Dorothea Lange. In 1929, Lange had been a portrait photographer living in San Francisco. As the depression worsened in the early thirties, she began to pass the breadlines of the unemployed as she walked to work each day. Looking out the window of her studio, she saw destitution that stood in stark contrast to the genteel images she was creating for her customers. In a change of direction typical of many artists of that time, she was no longer willing to isolate herself from the human tragedy going on around her. She decided to take her camera out into the streets. Her resolve to photograph the victims of the economic collapse provided a sense of purpose and commitment that she had previously felt was missing in her work.[60]

In 1932, more than fourteen million across the nation were unemployed. Near Lange's studio, a wealthy woman known as the "White Angel" had set up a breadline. Lange ventured out one day, determined to photograph the scene. As she wandered through the gathered crowd, she noticed a grizzled old man leaning against a railing, a crumpled hat pulled low over his eyes, a banged-up soup cup between his arms, his hands clasped together as though in prayer. Standing with his back turned to the crowd behind him, the old man personalized the bitter resignation and alienation of the nation's unemployed. His unconscious prayerful gesture spoke directly to the viewer in a call for humanitarian response.

In this, her first effort at social documentary, Lange achieved one of her finest photographs and one of the classic images of the Great Depression. It typifies the best of her documentary work, combining a simplicity and strength of composition, a journalist's eye for the detail that embodies the larger situation, and a powerful human appeal that

carries the image beyond its particular context to speak to universal emotions. Lange knew as she framed the photograph that she was seeing something significant.

> I can only say I knew I was looking at something. You know there are moments such as these when time stands still and all you do is hold your breath and hope it will wait for you. And you just hope you will have time enough to get it organized in a fraction of a second on that tiny piece of sensitive film. Sometimes you have a sense that you have encompassed the thing generally.[61]

Lange's photographs attracted the attention of Group f/64. Adams was impressed with her work, seeing in her a remarkable artist as well as a compassionate social observer. Although critical of her technique, he praised her uncanny perception and intuition. Her photographs, he said, conveyed not only the substance but also the spirit of the times. They were powerful emotional documents that grew from strong personal convictions yet never fell into mere propaganda. He was certain that her work would be recognized as among the most important and enduring of the age.[62]

His prophecy proved correct. Lange's photographs were soon universally praised as among the most powerful records of the human costs of the Great Depression; they would continue to be so regarded for decades to come. The success and the significance of the photographs made by Lange and other documentarians during the 1930s forced Adams to reassess the meaning of his own work. What did it really stand for? What did he want to say with his art, and how was he to communicate that to his audience? In the coming years Adams would wrestle with these issues continually.

*five*

# THE POWER OF IMAGES

THE DECISION OF ADAMS'S friend Dorothea Lange to turn her attention from the studio to the streets was part of a widespread change of direction in the arts during the 1930s. The movement among artists to address the political issues and social drama of the depression gave a tremendous boost to the genre commonly known as documentary. Although in the early years of photography the category did not exist as such, images that could be classified as documentary had been made since the earliest days of the medium. It was not until photographers began to identify their work with fine art that the more prosaically reportorial work, images that sought to provide a straightforward record of a particular situation, became differentiated into a separate category.[1]

The term "documentary" was coined in 1926 in a review of Robert Flaherty's *Moana*. The British filmmaker John Grierson described the film as "a visual account of events in the daily life of a Polynesian youth" and praised its "documentary value." Grierson used the term in its literal sense, suggesting that the film presented a factual record of Polynesian life that was valuable to the anthropologist and sociologist as well as to the general public.[2]

In the United States, documentary photography grew in significance

with the introduction of *Life* and *Look* magazines during the mid-1930s. Henry Luce, the publisher of *Life* as well as the already well-established *Time* and *Fortune* magazines, described the concept behind the new venture in his prospectus of 1934: "To see life, to see the world, to eyewitness great events; to watch the faces of the poor and the gestures of the proud; to see strange things—machines, armies, multitudes, shadows in the jungle and on the moon . . . ; to see and be amazed; to see and be instructed."[3]

The photograph, mechanically reproduced at low cost and available to a wide public, seemed to offer a window to the world. A great many people agreed with the writer James Agee who claimed in 1936 that the camera was "the central instrument of our time." Amid the turbulence of those years, photography offered the public a vehicle to understand the rapidly changing world. The people wanted "facts," and the camera offered, or appeared to offer, them. "The camera can do what nothing else in the world can do," Agee continued. It can "perceive, record, and communicate, in full unaltered power, the peculiar kinds of poetic vitality which blaze in every real thing and which are in great degree . . . lost to every other kind of art."[4]

The precision and apparent objectivity of photography lent itself to recording the events and appearance of the world. Yet there was also the subjectivity inherent in the human control of the camera. Art photographers had for years emphatically pointed out that it was a manipulated process, from the framing of the image on the ground glass to its rendering as a finished print. This subjectivity was an aspect of the medium that documentarians also manipulated.

Social reformers in the Progressive Era had discovered the potential of the camera to bring the "realities" of contemporary problems to their middle-class viewers. "Whether it be a painting or a photograph," wrote the great documentary photographer Lewis Hine, in 1908, "the picture is a symbol that brings one immediately into close touch with real-

ity. . . . The photograph has an added realism of its own; it has an inherent attraction not found in other forms of illustration. For this reason the average person believes implicitly that the photograph cannot falsify." While popular faith in the truth of photographs was central to their power as social documents, Hine was well aware that they were not as objective as they appeared to be. "Of course, you and I know that this unbounded faith in the integrity of the photograph is often rudely shaken, for, while photographs may not lie, liars may photograph."[5]

The rapid growth of the documentary form, not only in photography but also in painting, writing, and a variety of arts, during the 1930s created new topics of artistic debate. As photographers and other artists turned their attention to the social issues of the day, questions of art and propaganda became part of the political battlefield of those ideologically polarized times. In practice the division between art and propaganda was often blurred beyond recognition. As Lange put it, "Everything is propaganda for what you believe in, isn't it?"[6] Adams was adamant in his opposition to this point of view. While he respected much of the documentary work of the period, he criticized those aspects that he felt undermined photography as a branch of the fine arts, turning it into a tool of particular social and political agendas.[7]

## The Significance of Rocks

With so many of his friends and associates turning to documentary work and so much of the momentum of art and literature moving toward political engagement and social activism, Adams experienced continuing doubts concerning his own devotion to personal expression and "insignificant" subjects.[8] He did not object to "sociological" uses of photography, that is, the use of photography as a method for gathering evidence on contemporary society. Furthermore, he felt several contemporary documentarians went beyond this role to create true works

of art. He pointed to Dorothea Lange, Willard Van Dyke, Margaret Bourke-White, and Walker Evans as examples. However, he felt that his interest in nature was also legitimate, and he was sensitive to criticism of his continued dedication to that subject. As the French photographer Henri Cartier-Bresson later put it, "The world is going to pieces and people like Adams and Weston are photographing rocks!"[9]

Adams wrote to Weston in 1934 defending his work and his belief that a rock could be just as socially significant as an unemployment line, that attention to the primal aspects of the earth—rocks, plants, water, and sky—could have an important value in times of social turmoil. He realized that such "bourgeois" attitudes would relegate him to the dustbin of history, come the revolution, yet he refused to abandon those beliefs under political pressure. He admitted that he and Weston had different ways of working and different interests, yet he believed they shared the same basic objective: to follow their creative intuition as to what was truly significant in art and to realize that beauty has a legitimate role in society.[10] Weston replied soon after.

> I agree with you that there is just as much "Social Significance in a rock" as in "a line of the unemployed." All depends on the *seeing*. I must do the work that *I* am best suited for. . . . There is much talk of the artist getting down to the realities of life. But who is to say which are the realities. Obviously they cannot be the same for everyone. . . . If I saw an interesting battle between strikers and police I might be tempted to photograph it—if aesthetically moved. But I would record the fight as a commentator, regardless of which side was getting licked.[11]

Weston had dealt with a similar situation in Mexico when he was living there from 1923 to 1925 during the Mexican Revolution. In those years he created some of his finest work and counted as his close friends both Diego Rivera and José Clemente Orozco, the Mexican muralists who inspired many American muralists of the 1930s. Weston, however,

did not at that time apply his photography to overtly political themes. The atmosphere of the revolution encouraged his artistic growth and spirit of experimentation, but he continued to follow his own personal aesthetic.[12]

Paul Strand, whose work had such a profound impact on Adams when he saw it in New Mexico in 1930, had a different reaction. The social turmoil of the depression years brought a change in his attitudes. Strand had had radical sympathies for many years and was a supporter of the Communist party. Like many of the pioneer modernists in the years before the First World War, Strand felt no qualms about the formalist orientation of his work at that time. His precisionist abstractions and still lifes seemed part of a revolutionary movement that reached across the boundaries of art and politics. By the 1930s, however, he felt the need to abandon his aesthetic theories for a more direct involvement. "Yes these are critical years," he wrote to Adams in 1933, "for anyone who is alive—aware—has not insulated himself in some 'esthetic' rut—away from the world. The world itself is in profound process of change—social change, as it appears to me."[13]

Strand had moved to Mexico to lend his efforts to revolutionary social ideas being tested there, working on government-sponsored documentary films. "I have worked hard here," he continued, "started new problems and have taken up lines of work started way back in 1915. Now I have been made director of motion picture work in connection with the Department of Fine Arts—Secretária of Education and that offers me the greatest problems to solve—We hope to begin work soon."[14]

The following year Strand completed the film *Redes*, a documentary on the life and economic problems of a fishing village near Veracruz. Following an unsuccessful attempt to work in the Soviet Union with the director Sergei Eisenstein, Strand returned to the United States where he joined Pare Lorentz in making *The Plow that Broke the Plains* for the

Farm Security Administration (FSA). Joining Lorentz on his next film, *The River*, was Adams's friend Willard Van Dyke.[15]

Like Strand, Van Dyke felt the events of the decade demanded a more socially activist art. As a protégé of Edward Weston and one of the founding members of Group f/64, Van Dyke had championed the "purist" aesthetic of the group. Yet in the mid-1930s, he wrote, "I believe that art must be identified with contemporary life. I believe that photography can be a powerful instrument for the dissemination of ideas, social and personal. I believe that the Photo-Document is the most logical use of the medium."[16]

It was the work of Dorothea Lange that had the greatest impact on Van Dyke's artistic sea change. In 1934, he had offered her a show in his small gallery at 683 Brockhurst in Oakland, where Group f/64 regularly gathered. In a review of her exhibition, Van Dyke made it clear that Lange's photographs provided an example of the direction he felt his own work should take. "Dorothea Lange has turned to the people of the American Scene with the intention of making an adequate photographic record of them. These people are in the midst of great changes—contemporary problems are reflected on their faces, a tremendous drama is unfolding before them, and Dorothea Lange is photographing it through them."[17]

## Making a Photograph

Although many of Adams's fellow photographers were turning wholeheartedly to social issues and documentary, he remained a champion of his purist aesthetics and "socially insignificant" subjects. In the burst of energy that followed his return from New York and his meeting with Alfred Stieglitz in the fall of 1933, Adams began supplementing his income with lectures, teaching, and writing. These activities contrib-

uted to his growing reputation as an articulate advocate of Group f/64's purist concepts and a photographic technician of the highest order. The San Francisco-based photographic periodical *Camera Craft* offered him a series of articles in which to explain his philosophy and working methods. The series ran from January to May 1934.

The first place included a statement of his principle of visualization. Precise control of the technical process was essential to creative expression in photography, he argued. Visualization was the means by which the photographer maintained that control. The key step was to visualize the completed photograph before releasing the shutter and to carry out the necessary controls of exposure, development, and presentation to translate that vision into a finished print. The vision that prompted the image should guide each phase of the process to ensure that the work fully expressed the artist's intention.[18]

His second article dealt with landscape photography. Landscape, he felt, represented one of the most difficult subjects since the photographer's point of view was often dictated by the terrain. With a limited range of vantage points, compositional options were frequently narrowed. Light, too, was difficult to control: either the photographer adapted to the conditions or waited for them to change. He criticized the mundane records of scenery that commonly passed for landscape. It was expression and interpretation that transformed "scenery" into meaningful art, he argued. The unthinking approach that characterized much of what passed for landscape had stigmatized the genre and hindered the creative development of photography as a whole.[19]

For Adams, the essential element in photographic expression was control of process, from visualization to final print. The photographer, like the composer, must organize the visual components into a harmonious whole. For the photographer working in black and white, Adams said, the gray scale is like the musical scale; within each "key" certain

harmonies ("chords" of value) exist. The photographer must be aware of these and control them for their expressive potential. To achieve this goal he recommended a precise command of the exposure and development process. At the time he had not articulated his famous zone system, yet his technical approach was clearly headed in that direction, as he described his working method of translating subject light intensities into specific values in the finished print.[20]

His third piece was devoted to portraiture and the explication of his personal approach to that genre, an approach distinctly at odds with the direction in which contemporary portraiture was moving. While the handheld camera and faster films allowed photographers of the 1930s to capture movement and expression in their subjects, Adams purposely avoided these characteristics. He claimed to photograph a head or a figure as if it were a piece of sculpture, an object, or a specimen.[21] For precisely this reason Adams's portraits of this era were not generally well received. As Lange's son, Daniel Dixon, reportedly put it, "Adams makes rocks look like people and people look like rocks."[22]

In his fourth and final article of the series, Adams offered advice on various forms of "applied photography." He felt that commercial photography was mired in shallow clichés and slick imagery. He urged professionals to seek "honest" concepts and high standards of craft.[23]

Adams continued his forays into the press in a piece, "The New Photography," for the London Studio's annual *Modern Photography*, *1934–1935*. In it he offered his views on the evolution of the medium, an evolution leading to the "Photographic Renaissance" he saw emerging at that time. Central to this renaissance, according to Adams, were the principles of so-called straight photography: truth to the "inherent" characteristics of the medium, practiced unselfconsciously by the pioneering photographers of the mid-nineteenth century, abandoned in the late nineteenth century by the pictorialists in their imitation of

other graphic arts, but reestablished within art photography by such leaders as Stieglitz, Strand, and Weston. Although he hailed the purist principles of Group f/64 as the leading edge of contemporary photography, he acknowledged the value of documentary photographers, mentioning Dorothea Lange and Walker Evans in particular, whose images, he felt, combined formal beauty and photographic precision to move beyond their function as simple records into the realm of art.[24]

The London Studio's editor, C. P. Holme, was impressed with Adams's ability to combine clear explanations of technical matters with a well-defined approach to photographic aesthetics. He hoped Adams would be willing to contribute a short technical manual to the press's "How-To-Do-It" series. Adams jumped at the opportunity. In his prospectus, he described the book as an examination of the basic properties of the medium and a guide to their control for the purposes of creative expression.[25]

Using his *Camera Craft* articles as his starting point, he rewrote and condensed to fit the 16,000-word limit imposed by the publisher. He added a brief introduction and asked Weston to supply a foreword. When the book, *Making a Photograph*, appeared in April 1935, it was well received by critics and the public. The first printing sold out so rapidly that a second run was rushed through the next month. It went through three editions and continued to sell well for many years to come. Adams eventually revised and expanded it into his five-volume *Basic Photo Series*, which first appeared in the 1950s.[26]

He sent a copy of *Making a Photograph* to Stieglitz, hoping the old man would appreciate its emphasis on the principles of straight photography and the high quality of its reproductions. "I have often had you in mind," Stieglitz replied. "I must let you know what a great pleasure your book has given me. It's so straight and intelligent and heaven knows the world of photography isn't any too intelligent—nor straight, either. But

why single out photography?"[27] Adams was pleased Stieglitz liked it. He had feared that Stieglitz might think he was wasting his time on words when he ought to be making photographs. He had hesitated, he said, to accept the publisher's offer to undertake the project. He decided that it would be valuable if it remained "simple and direct," true to the principles both he and Stieglitz supported.[28]

## Labor and Capital

At the same time that Adams was laying out the principles of his purist aesthetics and techniques, conflicts spawned by the depression were beginning to erupt across the nation. In San Francisco, tensions between labor and capital were heating to the boiling point. Despite the vigorous response of the Roosevelt administration, the economic situation continued to worsen. With it came a growing bitterness among the legions of the unemployed and the working class who saw their wages cut repeatedly. With the economies of capitalist nations shattered, radicalism entered a new period of growth in the United States and throughout the world, attracting the unemployed, the labor unions, and the alienated intellectuals. In San Francisco the focus of labor activism was on the harbor docks.

Union strength in San Francisco had fallen rapidly since the First World War. From 1921 to 1933, the port operated with little union organization. At the same time the Bay Area's share of the ocean trade diminished as other Pacific Coast ports, particularly Los Angeles, Portland, and Seattle, took over an increasingly large percentage of the trade. When section 7-A of the National Recovery Act (NRA) facilitated collective bargaining, San Francisco's waterfront workers aligned themselves with the International Longshoreman's Association (ILA) under the leadership of Harry Bridges, an Australian-born longshore-

man who had emerged from the rank and file. In May 1934, the ILA made a series of wage and working condition demands. The port operators rejected all points and charged that the union was under Communist control. Despite the efforts of President Roosevelt, Senator Robert Wagner, and members of the national and regional boards of the NRA, no settlement could be reached. On May 9 a strike began, effectively closing all the ports along the Pacific Coast.[29]

On July 5, 1934, strikebreakers under police escort tried to unload cargo on San Francisco docks. Strikers responded by overturning trucks, dumping goods into the streets, and setting them ablaze. When police launched tear gas, the strikers retaliated with rocks and bottles. As police moved in, two strikers were killed and more than a hundred were seriously injured. Labor leaders organized a funeral procession one hundred thousand strong up Market Street in a dramatic illustration of their solidarity. Republican Governor Frank Merriam, fearing further conflict, called out the National Guard. In response, the ILA called for a general strike among all the city's workers. Beginning on July 16, the general strike succeeded in paralyzing the commerce of the entire city. Conservative union leaders relented, however, in response to government and business pressure and the prospect of further violence. By July 19 they withdrew their involvement. Although the longshoremen were back on the job by the end of the month, the union eventually won control of hiring under an arbitration agreement and began a period of growing power.[30]

Troubles like those in San Francisco were occurring across the nation. A radical takeover seemed possible in some cities. In Denver, Colorado, for example, on the eve of a threatened cutoff of Federal Emergency Relief Act monies (due to the state's failure to provide matching funds), an angry crowd assembled and Communist leaders "seized control of the mob." They stormed the capital, and the panic-stricken senators fled. There followed "a genuine Communist meeting" in the cap-

itol chambers, the first Communist-controlled meeting ever held under the dome of any state capitol in the United States.[31]

Middle-class San Franciscans like Adams's father began to worry that the events might lead to the "class war" the Communist organizers were advocating. Charles wrote with alarm to his son soon after the San Francisco strike had subsided. He was worried about Ansel's association with some radical artists. He felt that "loyal" citizens needed to band together in these times and told Ansel of his plans for an anti-Communist group, "moderate and law abiding" but unyielding in its defense against "the abhorrence of Communism and its vile servants who are working to destroy." He expected Ansel's support for the cause.[32]

Adams was on the annual Sierra Club High Trip, camped at Tuolumne Meadows. He had heard of the strike over the shortwave radio packed in for emergencies. Since the membership of the club included some of the city's most powerful political and business leaders—the very sort of people the "class war" was intended to take on—Adams had made an effort to keep them abreast of events back in the city.

Adams took a more moderate and cool-headed stance than his father toward the supposed Communist threat. He felt that labor had "real grievances" that should be settled through arbitration. He doubted the strike represented any deeper conspiracy. Communist groups used the grievances of labor to achieve their own ends; the Communists did not invent the conditions. He predicted that the strike would produce a conservative reaction, but he felt that people of goodwill should defend the rights of labor.[33]

This position was very much in line with that of Franklin Roosevelt. Like the president and most of his administration, Adams was a moderate liberal raised on the ideals of the Progressive Era. He remained a solid Democrat throughout his life, a classic New Dealer in his dedication to an active government in the service of humanitarian goals and liberal principles. His political centrism caused a certain amount of

tension in his life, however, as many of his friends felt that the time for moderation had long since departed.

Although Roosevelt had promised a New Deal, there was little evidence of any real improvement in the years immediately following his inauguration. Radicalism on both the Left and the Right grew rapidly as the decade progressed. The Communist party had a fairly strong organization in San Francisco, including many prominent artists, writers, and intellectuals. Among Adams's friends, Van Dyke was very sympathetic to the party, though it is not clear whether he ever joined. Strand was both a supporter and a member of the party. Lange was approached by local Communist party members who hoped she would lend her talents to their cause. She gave the suggestion serious consideration, but, always leery of submitting to any party line, Lange never joined. She felt increasingly compelled, however, not only to photograph the human turmoil of the times but also to try to put her photographs to work to make a genuine contribution toward improving the world she lived in.[34]

Perhaps the most famous of Adams's radical friends was Diego Rivera. Although he strongly supported the Communist movement, Rivera was opposed—as were many others—to Joseph Stalin's perversion of the socialist dream. In 1940 he was working on a mural in San Francisco. While Adams was visiting him at his rooms at the St. Francis Hotel, the bellboy arrived with a telegram. Rivera opened and read it with growing terror, exclaiming "I'm next! I'm next!" Leon Trotsky, who was staying in Rivera's Mexico City home, had been assassinated. Fearing the worst from Stalin's operatives, Rivera asked for and received police protection. Rivera, like Trotsky, defended the freedom of artists allied with the Communist movement to pursue their own direction and strongly criticized the crushing of artistic freedom under Stalin's totalitarian regime and the lockstep attitudes of many in the international Communist parties.[35]

While many of his friends were turning to social documentary and political action, Adams remained committed to his wilderness subjects. But he did begin to realize that his images of the "natural scene" could serve social and political purposes as well as aesthetic ones. In the fall of 1935, the Sierra Club board asked him to act as its representative at a conference on the national and state parks to be held in Washington in January 1936. In attendance would be Secretary of the Interior Harold Ickes, Secretary of Agriculture Henry Wallace, the former director of the National Park Service, Horace Albright, and the current director, Arno Cammerer. Adams went armed with his photographs and with the knowledge that the photographer Carlton Watkins had helped to establish Yosemite as a state park in 1864 and the photographer William Henry Jackson had helped to establish Yellowstone as the first national park in 1872.[36]

The 1930s were crucial years in the history of conservation in the United States. Franklin Roosevelt was conscious of the Progressive tradition of federal activism in conservation and the legacy of his cousin, Theodore Roosevelt. As governor of New York, FDR had initiated an extensive reforestation program based on the sustained yield practices he had witnessed in Germany's Black Forest during his student days. "President Roosevelt . . . is forest-minded," observed Congressman Martin Smith of Washington, "and possesses a more comprehensive knowledge of timber growing as a crop and its varied uses, including those of industry, than any President we ever had." But FDR's interests extended beyond resource conservation and a strictly utilitarian approach to the public lands. He was also a solid supporter of wildlife and wilderness protection.[37]

Once he gained the White House in 1933, Roosevelt appointed two highly able, if not always cooperative, figures in the two key federal posts

in charge of the public lands: Henry Wallace at the Department of Agriculture and Harold Ickes at the Department of the Interior. The Forest Service was a part of Wallace's domain, while the National Park Service was under the supervision of Ickes.

At that time the long-standing rivalry of the Forest Service and the National Park Service was reaching new heights. The former generally continued its utilitarian policies forged under the leadership of Gifford Pinchot. As Irving Brant, the future aide and speechwriter for Ickes and FDR, put it, the Forest Service "thinks of all trees in terms of board feet" and "obstructs every effort to preserve scenic areas which contain merchantable trees." The National Park Service, for its part, was "so completely cowed by the Forest Service that it dares not call its soul its own." This timidity led it to avoid efforts at "a legitimate park expansion measure in one locality for fear of reprisals [from the Forest Service] in another."[38]

Ickes's appointment to the Interior brought the Park Service into a period of greater power, though not without vociferous objections from Wallace and the Forest Service. Perhaps most galling to the Forest Service was Ickes's proposal to merge the Forest Service, the National Park Service, and all other federal agencies dealing with the public lands into one Department of Conservation under his control. The idea never came to fruition, however. The rivalry between the two federal agencies had a significant impact on a proposal dear to the heart of Adams and his fellow members of the Sierra Club. A year after the establishment of Sequoia National Park in 1890, John Muir, who had been instrumental in that victory, proposed the extension of the park to include the High Sierra country of the Kings Canyon region, north and east of Sequoia. His call went unanswered in Washington, but the idea remained popular with the Sierra Club and other advocates of wilderness preservation. The proposal resurfaced on several occasions over the next decades. In

1935 and again in 1938, bills were introduced to create Kings Canyon National Park.[39]

Because the Forest Service had instituted a new wilderness area policy with the encouragement of Aldo Leopold and Robert Marshall, many members of the Sierra Club believed that the Kings Canyon region had a better chance of being preserved as a wilderness area under Forest Service jurisdiction than under the National Park Service. Many preservationists were fed up with the Park Service's attempts to attract tourists with an "amusement park" orientation. As Joel Hildebrand, president of the Sierra Club from 1937 to 1940, recalled, "We wanted a national park that would not be another Yosemite with an Ahwahnee Hotel." Adams went to Washington with the goal of convincing Congress and federal agencies that Kings Canyon should be a *wilderness* park, regardless of which branch of the government administered it.[40]

Adams left for Washington in January 1936 to lobby for the park bill. Joining him on the eastbound train was Willard Van Dyke, who was about to begin his work for the FSA's film unit. As they rolled through the dry western basins and across the Rockies to the plains, they talked about the different directions their photography had taken. Adams urged Van Dyke not to underestimate his artistic gifts and not to subordinate his creative talent to any party line.[41]

For his part, Van Dyke felt an artist's talent must be directed toward the cause of humanity. Individual genius was wasted if it was not contributing to the struggle for freedom and social justice. Adams had heard the argument many times by now and remained as ready as ever to defend his point of view. Yet a change was already taking place in his own orientation. With his portfolio in hand, Adams was on his way to Washington to rally support for the preservationist cause. In many ways his mission was not that different from Van Dyke's. Slowly, in his commitment to wilderness preservation and his increasingly active role in

the campaigns of the Sierra Club, Adams was beginning to bridge the gulf between Van Dyke's ideal of the artist as a worker in the cause of humanity and his own ideal of the artist as a visionary in search of eternal beauty.

Before reaching his final destination, Adams planned a stop in New York to visit several conservation and mountaineering societies and to show his latest work to Stieglitz. Soon after he arrived in the city, he went to see a movie in a theater on Union Square. At the end of the film, as the house lights were going up, he noticed Georgia O'Keeffe and a friend making their way up the aisle. As he jumped up to offer his usual effusive greeting and bearhug, O'Keeffe's friend intervened in alarm, uncertain whether this crazy bearded man was a fan of the artist or someone intending to do her harm. O'Keeffe laughed at the two men's conflicting chivalry and offered introductions.

Her friend, David Hunter McAlpin, was a cousin of the Rockefellers, a banker by profession, and a devotee of modern art. He had taken to visiting Stieglitz's gallery regularly and had struck up a friendship with O'Keeffe. While Stieglitz remained somewhat aloof and refused to sell him any of her paintings, telling him "You aren't ready for one yet," O'Keeffe was happy to act as his guide to the world of modern art. McAlpin became active not only as a collector but also as a member of the board of directors of the Museum of Modern Art, where he would take a major role in the establishment of the new department of photography in 1940. He and Adams soon became close friends.[42]

After introductions they went uptown to the Shelton Hotel, where Stieglitz and O'Keeffe had an apartment on the thirtieth floor. Adams brought along a portfolio of his latest work. There, on the top floor of a steel tower in Manhattan, they looked over the prints. His work at this time represented the apogee of his Group f/64 style—tightly framed images of luminous intensity and microscopic precision. Even though

Group f/64 had been officially disbanded for over a year, his photographs reflected its modernist style. In his closeup views one could especially see similarities to the work of his colleagues Edward Weston and Imogen Cunningham and also to O'Keeffe's paintings of the time. To be sure, Adams had a unique style. He was more concerned with a straightforward representation of his subjects than Cunningham or O'Keeffe, who at this time often framed the flowers they worked with so tightly that the abstract forms of the image predominated, and his interests were less conceptual than Weston's quest for essential form in the structures of nature. Yet Adams shared with them a fascination with the natural world and a belief that precisionist realism offered the best avenue to its portrayal.

For all his intense focus on nature, Adams worked extensively with subjects drawn from the modern urban, industrial world. As Stieglitz, O'Keeffe, and McAlpin looked over his recent work, they saw not just pine cones, rocks, and weathered fences but factory buildings, scrap iron, and skyscrapers.

Stieglitz was impressed with what he saw that night and offered Adams a show at An American Place for the coming fall. It would be the first solo exhibition for a photographer at the gallery since Paul Strand's show in 1917. Adams's years of patient waiting had paid off. He wrote ecstatically to Virginia, who as usual was home taking care of the children. A show at Stieglitz's gallery was, to his mind, the height of photographic achievement and the greatest moment of his career.[43]

Adams had little time to rest on his laurels. He was scheduled to visit Capitol Hill in a matter of days, and there was much to prepare. He studied the record of earlier Kings Canyon park proposals and the arguments of the various groups contending over the issue. He visited conservation organizations in New York to line up support for the Sierra Club position and prepared his presentation, including perhaps

his most persuasive evidence, his photographs of the Kings Canyon region.

Arriving in Washington two days later, he spoke to a conference on state and national parks; met with California Senator Hiram Johnson, who seemed quite sympathetic to the park proposal; and received a request from Eugene Meyer, editor of the *Washington Post*, for an article on the park and photographs of the region.[44]

Although no decision was made on the Kings Canyon bill that year, Adams achieved some personal success: he sold two freestanding photographic screens, one to Meyers's wife and one to Ickes, who placed the work in his Interior Department office. The screens featured a mural-sized print mounted on three hinged panels. Adams had been experimenting with such large photographic murals since the Curry Company had commissioned him to provide several for their exhibit at the 1935 San Diego World's Fair. Now he wanted to see what he could do with the concept in his personal work. He chose the folding screen as a way to integrate the large print into the room and emphasize the image's abstract forms.[45]

The sale to Ickes marked the beginning of what would prove to be an important relationship for Adams's career. Soon after his return to San Francisco, Adams received an unexpected letter from the secretary's office requesting he stop by the Interior Department to discuss producing a photographic mural for the new Interior building in Washington. Adams was pleased with the offer and vowed to follow it up. For the time being, however, he had his hands full with other projects.[46]

His most pressing task was to return to Yosemite for another season of winter photography for the Curry Company. While the company remained pleased with his work, they suffered the pinch of the depression and wanted to make sure they were getting their money's worth. Donald Tresidder felt that Adams should "be relieved of routine Yosemite shots, newspaper publicity pictures," and the like. Furthermore, he

was "dissatisfied with the use made of the many photographs." Since "literally thousands had been taken and relatively few actually used," Tresidder wanted greater control exerted over the type of work Adams was assigned "to cut down the cost of his labor and his supplies; in other words to make his work cost us less in the future, rather than more."[47]

Tresidder had taken an active role in directing Adams's work in previous years as well. In 1931, for example, when the company was lobbying heavily for Yosemite to be named the site of the 1932 winter Olympic Games, Tresidder had given Adams specific instructions for the images he had in mind. He was to show only snow-laden trees and only accomplished skaters in the Curry Village rink. The photographs were to avoid capturing "some awkward beginner in a position which immediately attracts attention, promotes mirth, and causes a loss of value." He suggested hiring professional skaters for the occasion.[48]

Adams was used to clients' requests in advertising assignments and did not seem to begrudge Tresidder's requirements. As the years went on, however, he chafed more and more at the constraints of commercial attitudes. He objected to what he saw as the tastelessness of much of the Curry Company's advertising and merchandising approach. In an effort to encourage a more aesthetically and environmentally aware direction, Adams urged the Curry Company to see itself as an ally of the National Park Service and conservation organizations such as the Sierra Club.

In the summer of 1935, for example, he had organized the Conservation Forum, also known as the Wildflower Festival, in Yosemite and invited organizations and concerned individuals to come together in an effort to forge a united strategy for the preservation of California's scenic resources.[49] On the sponsoring committee were the director of the National Park Service, the superintendent of Yosemite, the presidents of Stanford University and the University of California, and representatives of the Forest Service, the State Parks Department, the Federal and State Highway commissions, the California Conservation League,

the Save-the-Redwoods League, the Garden Club of America, the Boy Scouts and Girl Scouts, and other organizations. The program was divided into five sections: legislation, education, landscape, highways, and the Pacific Crest trail, the latter dealing with a proposed trail from the Mexican border north to Alaska.[50]

The conference had many beneficial effects in bringing together these organizations concerned with conservation issues, yet it also served to highlight the continuing rifts within the movement. One who illuminated these conflicts was Tresidder, who expressed his disagreement with groups who placed "intangible" wilderness values above all others in the national parks. As the operator of park concessions, he felt it his duty to make the parks available to everyone, not just a few thousand nature lovers and mountaineers willing to forgo the creature comforts most of the public demanded. How could park concessionaires expand and improve their facilities to serve the public when conservationists barred their way with calls for wilderness preservation and appeals to "intangible values"? Roads made the park accessible to the public; hotels made it possible for the less hearty visitors to appreciate its beauty; ski slopes provided recreation for tens of thousands. Surely wilderness lovers did not want to bar others from enjoying the mountains.[51]

Adams was outraged at his friend's speech. He felt Tresidder's argument used populist rhetoric to mask a quest for greater profits. As his own preservationist activism grew, cracks began to develop in his relations with the Curry Company. Although he remained friendly with Tresidder, he was growing increasingly disturbed by the commercialism of the company's marketing approach. He was concerned that his photographs be used to further public appreciation of the park's natural beauty, not simply to lure tourist dollars. For the time being, however, he pressed on with his assignments for the company.

By 1936, his complex and often contradictory feelings about "progress," technological change, and economic growth were in a state of flux. As a child of the Progressive Era, Adams felt that technology and rational planning *could* provide avenues to social improvement. He supported such New Deal projects as the Tennessee Valley Authority and Boulder Dam. He remained fascinated with the latest scientific theories and the engineering marvels of the day. Yet at the same time he worried about the blight that such advances seemed too often to bring in their wake.

His mixed feelings were evident in his response to the construction of the two massive steel bridges spanning the San Francisco Bay. He could see the twin towers of the Golden Gate Bridge from his window. To the east, the Bay Bridge was nearing completion as well. Soon the city would be directly linked to its surrounding counties across the bay. He admitted that the bridges were spectacular feats of technology and in many ways the embodiment of the age. Nonetheless, he feared that they would only bring new regions within the reach of relentless urban sprawl.[52]

As Adams pursued his work in both art and conservation, the various lines of his life and thought were beginning to converge, revealing both the unity and the disjunction of his ideas. Could he reconcile his love of wild nature with his fascination with science and technology? Could he maintain a life dedicated to art, yet achieve a successful commercial career and a degree of financial security? The submerged tensions of his life called for some resolution, some sorting out of his true priorities.

In the spring of 1936 Adams wrote to Van Dyke, who had begun his work for the FSA film unit. Van Dyke was still trying to convince Adams that he was misusing his talents. In his absorption with nature and the perfection of technique, Adams was not pursuing the more important goals for which photography could be used. Adams admitted that his friend had a point. He had been raised to believe that art was an essen-

tially religious experience, an intensely personal and lonely process. Looking back he realized that there was a certain detachment from the world in this devotional attitude. He admitted that art must have its roots in the whole experience of life.[53]

## Family Man

By summer Adams found himself facing several approaching deadlines. In addition to his show at An American Place for Stieglitz, he had two other solo exhibitions scheduled that fall, at the Katherine Kuh Gallery in Chicago and at the Arts Club in Washington, D.C. Before he could get to any of this, however, he was off to the High Sierra.

That summer Adams was again responsible for helping to organize the Sierra Club's High Trip. Virginia was going as well, thankful for a break from taking care of Michael, who was just about to turn three, and Anne, who had been born that spring. Ansel invited a young model named Patricia English, whom he had met while working on a commercial assignment for the Southern Pacific Railroad, to join the outing as well. Over the course of the monthlong trip, their romance bloomed.[54]

By August Adams had returned from the mountains. Pat English became his assistant in preparing for the upcoming exhibitions. A month later, he had produced a set of forty-five prints for Stieglitz, mostly 8 × 10s with a few 11 × 14s—the distillation of his work up to that point and all as close to perfection as he could make them. He included a short biography and introductory statement and sent the collection off to New York.[55]

At the height of his tension over the exhibitions, his personal life, so relatively quiet and orderly up to this point, began to unravel. Whether he unconsciously sought it or not, Adams was immersed in a deeply wrenching emotional experience that threatened to overturn his marriage, his family, and all the safe harbors of his life. The intensity of the

experience fueled an incredible outpouring of creative effort. If, as he earlier admitted to Van Dyke, his art lacked "contact with life," it certainly had it now.

He could not or would not keep the truth of his new relationship from Virginia. Deeply wounded but determined to maintain her dignity, she told him to make up his mind one way or the other. Ansel had caused her pain before by breaking off their engagement for two years, then deciding to take her back. She was not going to sit by while he decided now. She gave him an ultimatum: he must choose soon.[56]

It is clear that Adams felt a certain ambivalence toward his life as a family man. In their first years together, Ansel and Virginia shared the dream of a life dedicated to art. As his early letters to her attest, Ansel urged Virginia to devote herself to her singing, envisioning their life together unencumbered by the usual trappings of a middle-class life. Virginia, however, wanted something more settled: she wanted a home and a family.[57]

Ansel wanted that too, and he prided himself in being able to support his family. Yet he also longed for the pure pursuit of art, free from mundane demands. Now that he was thirty-four years old and a father with two young babies, that possibility seemed increasingly remote. He had seen his own father become a "three-dimensional martyr" to his family and financial struggles. The thought of repeating that fate was no doubt a frightening one.

As that fall went on, things just got worse. Virginia's father, Harry Best, was visiting. One night, as he was helping put his newborn granddaughter to bed, he slumped across the little cot she slept on and slid to the floor, dead of a massive stroke.[58] It was not the time to leave on an extended trip, but Adams could see no alternative. His exhibition at An American Place opened October 27, and the show at the Katherine Kuh Gallery was scheduled to open on November 2. On his way out he received a postcard from Stieglitz: "Will be glad to see you. — Visitors

not numerous.—Show looks very swell.—I'll be very glad to see you & am glad to have you see your things on our walls."[59]

He arrived in Chicago the following week to find that Kuh had done a considerable amount of work on his behalf, arranging meetings with potential clients, publishers, editors, and patrons. There were lectures, portrait sittings, receptions, and dinner parties. It was a whirlwind visit. He had not managed to get to bed before 3:00 A.M. since his arrival in the city, and there was no letup in sight.[60]

After another virtually sleepless night on the train, Adams arrived at New York's Grand Central Station and went directly to An American Place to view the exhibition. On entering the gallery, he was over-whelmed with the impact of Stieglitz's treatment of the work—the selection and ordering of the prints, the way they looked on the walls of the room. It was, he said, an uncanny summation of his art, a magical combination of Stieglitz's spirit and his own, a once-in-a-lifetime experience.[61]

It was the culmination of his dreams to have such an exhibition in New York, in Stieglitz's gallery. It was to remain one of his most satisfying moments. The simplicity of his work at this time and its presentation on the spare walls of An American Place gave the exhibition a gemlike intimacy that his later, grander exhibitions never equaled.[62]

The show was a financial success as well. Adams was pleasantly surprised to find that seven prints had already been sold at prices averaging thirty dollars; one, *The White Tombstone*, sold for one hundred dollars. At that time it was a substantial sum for a photograph, but Stieglitz was known for getting top dollar for the artists he represented. Adams felt that he had now become part of the Stieglitz circle.[63]

Adams was kept as busy in New York as he had been in Chicago. He was going on pure adrenaline now as he made the most of his moment in the limelight. He kept a frenetic pace of meetings and social engagements, from morning to midnight.[64] One of these many meetings was

with Horace Albright, the former director of the National Park Service, now vice president and general manager of the U.S. Potash Company in New Mexico. Adams met to share thoughts on the state of the national parks and to discuss a possible commercial assignment for the corporation. The easy transition for Albright from Park Service chief to head of a major extractive industry in the West was indicative of the generally friendly relationship of business and conservation leaders in these years.[65]

Adams likewise felt no real conflict. Commercial work was his bread and butter, and if he could accomplish it with a sympathetic figure like Albright, so much the better. Clearly, neither felt the antagonism that would develop between business and environmental interests in the decades following the Second World War. For now, he was happy to have the work and took it with no pangs of conscience.

Adams left for Washington about a week later for the Arts Club show and his meeting with the current Park Service assistant director, Arthur Demaray. Virginia had inherited Best's Studio from her father, but their operating permit was now up for review. Adams made it clear that it was primarily Virginia's operation and that she wanted to do something worthwhile with it—to contribute to the overall quality of the parks by setting an example of what could be done with park concessions. She was particularly critical of the cheap curios sold throughout the national park system and wanted to present a range of merchandise, from small mementos to high-quality works of art, consistent with the spirit of the parks. Demaray was favorably impressed and renewed the permit immediately.[66]

There was also the matter of the photomural idea proposed by Secretary Ickes. As a beginning, Demaray hired Adams to photograph Carlsbad Caverns National Monument in New Mexico. It worked out well, since Adams was headed that way anyway to carry out his assignment for U.S. Potash.

Adams arrived in New Mexico a week later. After completing his work at U.S. Potash, he moved on to Carlsbad Caverns. He took an elevator down into the bowels of the earth and photographed dutifully as the guide led groups of visitors through the caverns, theatrically illuminated to heighten the drama of the surreal limestone formations. The visitors oohed and aahed appropriately. Soon the guide had the group stop; the lights were dimmed and the assembled asked to contemplate the darkness and silence. A trio of singers began to sing "Rock of Ages." As the lights slowly rose and the strains of the final verse faded, the elevators conveyed the crowd into the sunlight.[67]

For Adams, it was the national parks at their worst—a tasteless underground amusement park. He found it as appealing as a tour of the lower intestine. He was glad to have the work, but the job solidified his feeling that the parks needed to emphasize their original role as preserves where nature predominated, where the public could experience the timeless landscape of America, not some overblown carnival.[68]

### Self-Portrait in a Victorian Mirror

All in all, it had been the most difficult and draining four months of his life. By early December, on his return to San Francisco, the accumulated emotional stress and physical exhaustion led to serious collapse. Within a week both Ansel and Virginia fell severely ill. They entered Dante Hospital around December 9. Ansel was suffering from a severe chest infection, possibly pneumonia.[69] There seems to have been a strong psychological component as well. In his letters to Virginia and to Stieglitz from Carlsbad, little more than a week before he entered the hospital, his vivid descriptions of the tortuous interior of the caverns might be read as a portrait of his own internal state. The imagery of repressed sexuality is particularly striking, especially the "phallic stalagmites and stalactites, reaching and meeting, boiling and dripping, hard, crystal-

line, and terribly silent." In this dark cavern, he added, "things are seen (which should never be seen)."[70]

By December 22, he and Virginia were released to recuperate at home. On his arrival he found a letter from Stieglitz, who had some welcome news. Among those most impressed with the show was David McAlpin.

> McAlpin has taken three more large ones & one of the small ones. I "priced" the small one somewhat lower than the large ones. So I enclose [the] check. He gave Dorothy Norman [Stieglitz's assistant and an accomplished photographer] $49.00 for the Place. So you see you are helping to pay rent for the Place. Works all around. I hope you are pleased as well as surprised. I am. Its all too wonderful. But Lord you deserve it. . . . I know your head won't be turned. And remember just go your own way. Don't let the Place become a will-o'-the-wisp. So many have done that. And that's awful all around. Destructive in the worst sense.

But Stieglitz seemed to think Adams was sufficiently independent to avoid that trap; at any rate, it was not an issue on which he chose to dwell. He continued, "Well Adams it has been a great experience for me to have had your prints here & to have you here. A great one truly.[71]

Adams wanted to thank Stieglitz immediately, so he resorted to his usual activity during periods of enforced bedrest. Propping himself up with pillows, he pounded out a letter on his portable typewriter, trying to explain the forces behind his collapse. He admitted that he had been pushing too hard for years—taking on too many responsibilities—until his body simply refused to take anymore. All the unresolved issues of his life—his career, his marriage, his entire sense of self—were at stake. He had come finally to the breaking point.[72]

His collapse that winter was cause for a deep reassessment of his life. He wrote to his oldest friend, Cedric Wright, confiding the depth of his

malaise. Everything in his life had lost its meaning, he said. He had no sense of purpose. He had reached the pinnacle of photography with his exhibition for Stieglitz. He had said all he had to say, had given all that was in him to give. In its aftermath, he was left with an emotional void.

It was only the emotional intensity of his affair that had given him the energy to create that exhibition. He was sure that he could not produce such a body of work now, no matter how hard he tried. Adams longed to go off with his old friend on a mind-clearing, spirit-refreshing trip to the desert. He realized, however, that he was not as free as in the old days. His responsibilities were piling up—Virginia and the children, Best's Studio, his parents, and his Aunt Mary. He suspected that they could all manage well enough without him, but he could not or would not break free.[73]

It was around this time that Adams made one of his most revealing self-portraits. He called it *Self-portrait in a Victorian Mirror, Atherton, California, 1936.* Trapped in the gilded metal frame of the fish-eye mirror, a morose-looking Adams, in coat and tie, stands in the dining room of a Victorian mansion in Atherton, the same wealthy community in which his grandparents' mansion had stood. The photograph sums up his confinement within social and domestic expectations, the prison of his presumed role and inherited inhibitions.[74]

Adams was ultimately unwilling or unable to leave his responsibilities behind. Most important, he realized that he loved Virginia and his children very much. He resolved, though not without a great deal of pain, to abandon his new love and remain with his family.

He and Virginia agreed that they needed a rest and a change of scene. Adams vowed, in response to his doctor's demands, to cut back on his work and to concentrate on those projects that meant the most to him. He would refrain from all photography entirely for several months. When he resumed his photography, he would take no commercial work

other than selected "honest" projects. He and Virginia would take a leisurely trip, perhaps an ocean cruise, as his doctor suggested.[75]

In a letter to Stieglitz, Adams quoted several lines from Robinson Jeffers that summed up his feelings and his new resolve.

> Does it matter whether you hate your . . .
> self? At least
> Love your eyes that can see, your mind that can
> Hear the music, the thunder of the wings.[76]

# New Beginnings

Ansel and Virginia left for Yosemite around Christmas for the holidays and a change of scene, but by February, after their return to San Francisco, Ansel had come down with infectious mononucleosis. This relapse had everyone worried, no one more than Ansel. He and Virginia decided to leave their studio on 24th Avenue. The wind and fog had come to seem a gloomy presence in their lives, and living next door to Ansel's parents and Aunt Mary did little to improve the mood. The city, once a comfortable distance away, had now surrounded them. They both felt it was time to look for another place to live. They decided to move across the bay to the sunnier climes of the Berkeley hills. They rented a house shaded by eucalyptus and laurel trees, with canyons and ridges nearby waiting to be explored. The children would love it, and Ansel and Virginia were looking forward to it too.[1]

Like his father before him, Adams felt it was better to raise his family outside the city. Although he had earlier complained of "the fungus" of suburban sprawl brought on by the Golden Gate and Bay bridges, he was willing to take advantage of the convenience they brought and to participate in the suburban exodus. Now that he was among those it

served, he praised the newly completed Bay bridge as a marvelous contrivance, making San Francisco no more than thirty minutes away by car.[2]

Adams followed his doctor's orders and refrained from all photography and from work of any kind. To the Curry Company, he suggested a replacement who would carry out his photographic duties for that winter. As he was recovering emotionally and physically, a letter came from the Museum of Modern Art. It was from a young man named Beaumont Newhall, who was organizing what he described as "a large retrospective exhibition integrating the technical development of photography with its growth as a creative medium and outlining its modern uses in technology and communication."[3] Newhall planned to call the comprehensive exhibition *Photography 1839–1937*, and he invited Adams to participate. He had already been offered the loan of three Adams prints, *Boards and Thistles*, *The Golden Gate*, and *Pine Cone and Eucalyptus*, all recently purchased from An American Place by Mrs. Charles Liebman, the sister of Adams's loyal patron, Rosalie Stern. Did Adams approve, and did he have three other prints he would like to submit, preferably from his recent work in the 35mm format?[4]

Adams was honored by the invitation. He responded immediately, agreeing to send the requested prints. In addition, he offered an album of original prints by Timothy O'Sullivan, the pioneering nineteenth-century photographer of the American West. Newhall was more than happy to accept this unexpected bonus. These letters marked the beginning of a close friendship and working relationship that would extend throughout the rest of Adams's life and expand his photographic horizons dramatically.

Newhall had studied art history at Harvard University and curatorship with Paul Sacks at Harvard's Fogg Museum. On graduation he worked briefly as a lecturer at the Philadelphia Museum before moving

to New York's Metropolitan Museum as curator in residence at the Cloisters, a collection of sculpture and architectural stoneworks. He lost his job after only a year and a half as a result of an administrative change at the museum but soon found work as the librarian at the Museum of Modern Art. It was 1935 when Newhall arrived. On entering the museum for his first day on the job, he encountered Alfred Barr, the museum's director, putting up a van Gogh exhibition. "Take off your coat," Newhall recalled him saying, "and help me hang these pictures."[5]

In those first years he supplemented his meager income as librarian by photographing artworks, such as the cubist sculpture declared "hardware" by U.S. Customs on its arrival in New York from Europe. His interest in photography went well beyond this type of record keeping, however. Since 1932 he had been contributing articles and reviews on photography to various journals. As his output and reputation grew, so too did his photographic responsibilities at the museum.

"Alfred [Barr] could see I was really keen on photography," Newhall recalled, "and one fine day he stopped me in the corridor and asked me, 'Would you like to do a photographic show?' I said I most certainly would." Barr had an ambitious vision of a comprehensive survey of the medium, showing its historical development and its current directions, a grand show along the lines of the museum's recent exhibitions *Cubism and Abstract Art* and *Fantastic Art, Dada and Surrealism*. He provided Newhall with a $5,000 budget, "very good in those days," and astounded him further by adding, "You'll have to travel to Europe."[6]

Newhall called his fiancée, Nancy Wynne Parker, with the news of his good fortune and suggested that they get married. Nancy had been trained in painting at Smith College in Massachusetts and the Art Students League in New York and soon came to share Beaumont's interest in photography. In the coming years, she became a leading writer on photography and an innovative designer of photographic books and

exhibitions. She also became Adams's closest collaborator for more than thirty years.[7]

Meeting the Newhalls marked a crucial point in Adams's artistic development. Beaumont in particular had a wide-ranging interest in photography and was familiar with traditions in the medium both in the Americas and in Europe. Furthermore, he was receptive to new ideas and generally undogmatic in his approach to exhibitions and criticism. These were all qualities from which Adams benefited. His often strident and dogmatic attitudes on matters of art and photography were tempered and broadened by Newhall's more cosmopolitan outlook. At the same time, Adams exerted a strong influence on the Newhalls, particularly Nancy, who came to share his love of the western landscape and his dedication to the conservation movement.

Another fortuitous offer came that winter as Adams recuperated: Walter Starr, a member of the Sierra Club since its earliest days, wrote that he wanted Adams to produce a book, a photographic interpretation of the Sierra Nevada. He was willing to pay for the entire project, whatever the cost. The book was to be a memorial to his son, Walter Starr, Jr. The younger Starr had been a lawyer and a passionate explorer of the Sierra backcountry. As he was nearing completion of a guidebook to the region in the summer of 1933, he was killed in a fall while climbing alone among the Minarets. The guidebook was published posthumously by the Sierra Club as *Starr's Guide to the John Muir Trail and the High Sierra Region* and became the standard resource for high country travelers.[8]

Walter Starr, Sr., wanted Adams to produce a photographic monument to his son and the mountains he loved. He left the details of the book entirely to Adams and told him to produce the finest edition possible. This was music to Adams's ears and he immediately set about outlining his ideas. Many of the necessary photographs could be culled

from his files, but he longed to travel again through the Sierra, photographing as he had in the old days. It was a project that would have to wait, however, at least for the time being, as Adams had promised his doctor to abstain from all photography for the next several months.

Although Ansel and Virginia enjoyed the house in Berkeley, it was costing them extra money they did not have. With Ansel out of work, finances were getting very tight. The relaxing ocean cruise to Europe was canceled; they could not afford it, and the deteriorating situation created by the rise of Nazi Germany made a voyage unwise. They chose instead a less expensive option. That spring they moved into Best's Studio on a full-time basis. They hoped that the studio could become a welcome source of income, and Virginia wanted to give the operation her full attention. For his part, Ansel was eager to make the move. As in his youth, he felt that if any place could restore his health, Yosemite would. They both believed the change of scene from the Bay Area would do them good. Michael and Anne could go to the local school; there was certainly no more ideal place for them to grow up.

As Adams recuperated that spring, his spirits improved. With his enforced rest from work, he had a chance to reflect on his life and what mattered in it. He wrote to Cedric Wright in early June in an optimistic frame of mind. In Yosemite he regained a sense of peace with the world and a new appreciation for the people he loved. He felt that he truly understood love for the first time. It was not mere pleasure—not simple personal gratification—but joy, a deeper emotion that comes from giving and accepting all aspects of life. After the emotional turmoil of his affair and breakdown, he had arrived at a new sense of the importance of the people he loved, above all, the importance of Virginia and the children. Rather than an impediment to his creative freedom, he now realized that his family was a source of strength and inspiration. To look beyond the self, to live for others, was true liberation.

He realized as well how important his friends were. To be able to share his deepest feelings and to be accepted without reservation was the truest form of friendship. He wanted Wright, his oldest friend, to understand how much he meant to him.[9]

Adams's rejuvenation continued that summer as another of his closest friends, Edward Weston, came to visit. Weston had recently been awarded a Guggenheim Fellowship, the first ever to a photographer. He was given $2,000 to carry out a year's travel and photography throughout the West. As his future wife Charis Wilson put it in the text to *California and the West*, the book they produced together on the grant, they soon discovered "the limited elasticity of two thousand dollars. As the most casual amateur swiftly learns, photography is expensive." To make their money go as far as possible, they "distributed and redistributed the dollars and cents until they made for a maximum of photography and travel."[10]

This approach led them to abstain from hotels, motels, and restaurants, opting instead to camp out and rely on canned food augmented with dried fruits and nuts. They also realized the advantage of relying on friends for the occasional warm bed, shower, and home-cooked meals. Adams had been urging Weston for years to visit Yosemite and to photograph the Sierra. Now Edward and Charis were coming up for a trip through the high country that summer. As far as Adams was concerned, nothing could recharge his creative juices more than to go back into the mountains and share the excitement he felt there, to see how Weston would react to his photographic turf.[11]

Charis and Edward arrived in Yosemite in late July 1937. "There," Charis wrote, "we were enthusiastically welcomed, nobly housed and fed. Plans were laid for a week's pack trip to Lake Ediza." Edward and Charis had grown used to roughing it on their travels, but with Adams it was going to be even more spartan.

We speculated on what gastric adventures lay before us. Back at the start of our travels we had written Ansel to ask if he knew where we could get dehydrated vegetables. He had answered no, but anyway they were an insult to the taste buds; years of camping had taught him the needs of outdoor diet were few and simple: salt, sugar, bacon, flour, jelly beans, and whiskey.[12]

Adams invited his assistant, Ron Partridge (son of Imogen Cunningham and Roi Partridge), and two friends from the Sierra Club, David Brower and Morgan Harris, along as well. Brower, who had recently begun working for the Curry Company publicity department, was always eager for the chance to get into the backcountry. Virginia had to stay behind, as usual, to tend to the children and the store. However much he was now committed to her and the family, it was her strength and patience that made his art possible.

Instead of sleeping peacefully, they spent the night before the departure with "a rousing party that kept its momentum well past midnight." They were up at six o'clock to make a bleary-eyed start on the long drive across the range to the Owens Valley and back up the eastern flank to Agnew Meadow, above Mammoth Lakes. "I'm afraid none of us looked our best," Charis recalled.[13]

As they made their way up the eastern escarpment of the Sierra, they found themselves surrounded by swarms of hungry mosquitoes. Adams assured his friends that they would dissipate in the higher elevations. That did not turn out to be the case, but they bravely endured. Charis posed for Edward fully swathed in an impromptu turban, while Ansel hovered nearby to swat any lingering bugs. Despite the circumstances, Edward and Charis collaborated to produce one of their subtlest and most sexually charged portraits.

It was the kind of photograph that Adams never attempted. He could photograph women as strong-willed and heroic, as in his portraits of

artists like Mary Austin and Georgia O'Keeffe. He could photograph them as sensitive souls, as in his portrait of Carolyn Anspacher. Yet he seemed unable to photograph a woman as a sexual being.[14] As much as he was inspired by Weston's approach to art and life, Adams seems to have realized that he and his friend remained fundamentally different individuals.

Adams could not adopt Weston's life of the liberated ascetic. He followed the dictates of his own needs. Yet well into the 1950s, his path firmly carved out, Adams continued occasionally to wonder if he was wasting his talents on the endless duties he had taken on. His friend Edwin Land reassured him, however. "Weston lives in a shrine, you live in the world." It was what Adams liked to believe. At the core of his "worldliness" was the centripetal dynamism of his multitalented personality and his desire for the social and economic success his father had so disastrously lost. Weston remained an inspiration, yet he also represented a path from which Adams self-consciously, perhaps self-righteously, held himself apart.

The fact that they were insect food did not diminish the impact of the magnificent alpine scenery for Adams and his friends. Arriving at the base of the Minarets, they set up camp at Lake Ediza. "We were camped in a fringe of hemlocks at the edge of a terrace that overhangs the south end of Lake Ediza," Charis wrote.

> The grassy smoothness of the terrace is broken here and there by heaps of polished granite and cut by a dozen meandering little streams that join in groups for the rush down hill. Volcanic Ridge, a dark forbidding mass, closes off the east; south, the Minarets—a line of jagged black spires, patched with snow that looks like cut-out bits of paper—tower in the sky; to the west Mt. Ritter and Banner Peak, both around thirteen thousand feet—story-book mountains, neatly cut triangular masses of snow and rock. Only northward the view opens out; above the lake and

the wall of forest and cliff that shuts it in, we can look away over miles of curving mountaintops whose outlines grow softer and softer in the distance.[15]

As they explored the areas surrounding their base camp, Adams was pleased to find Weston enthusiastically making photographs. It was a confirmation of sorts for Adams to see his friend respond so completely to the high country. "Rich hunting grounds for Edward," Charis noted. "He worked away like mad, on icebergs, lake, minarets, tree stumps, snow and rocks. . . . For the first time on any trip he used up all the holders (made twenty-four negatives) in one day."[16] Adams volunteered to reload the film holders each night, as he had grown used to performing the tricky operation in the small changing bag barely large enough for the $8 \times 10$ film holders Weston employed. With a fresh batch of film each day, Weston and Adams continued to make photographs in profusion for the rest of the week.

Weston's photographs on this trip and throughout his travels on the Guggenheim Fellowship showed a new emphasis on broader landscape views. This was no doubt partly due to the nature of his project, photographing the landscape of California and the West. Moving out from the studio to the highway, dirt road, and trail, Weston inevitably expanded his vision.[17] His images were by no means devoid of people or human artifacts. They included roadside scenes, small towns, desert truck stops, billboards dwarfed by the desert expanses, even a fresh corpse—a lost wanderer of the depression highways.

The changes occurring in Weston's photography had some interesting parallels to the direction Adams's work was taking at that same time. Adams's style was moving from the more compact and simplified formalism of his Group f/64 work toward broader landscapes with a more complex graphic organization. Significant differences remained, however. Adams did not tend to focus as much as Weston on human/nature

interactions in his landscape work, and whereas Weston emphasized the earth, pointing his camera downward, Adams began to point upward, filling his frame with wide expanses of sky and dramatic light. For Adams, the shift would become even more pronounced in the 1940s as his work took an increasingly expansive and dramatic turn.

Both artists were responding in their own ways to a greater engagement with the world. The early period of modernism had faded in the 1930s as the delineation of social realities took increasing precedence over formalist invention throughout the arts. Weston made it clear, however, that the photography on his Guggenheim project was not documentary in the popular sense of the word. "I have not attempted to make a geographical, historical or sociological record. My work this year as in the past has been directed toward photographing Life. . . . I have tried to sublimate my subject matter, to reveal . . . Life through it."[18]

Weston remained resolutely committed to aesthetic interpretation and the symbolic subtext of his imagery, the revelation of the "life force" through natural form. Yet like other artists of the period, Weston had left the isolation of his studio and taken to the road. His travels throughout California and the West launched him into a period of refreshed creative energy. With Adams, it was much the same. Emerging from his debilitation of the previous fall and winter, he was now back in his element.[19]

After their descent to the Owens Valley and a stop to photograph at Mono Lake, they returned to Yosemite and Adams's studio late in the evening. To celebrate the completion of their trip, they feasted on cold roast chicken as they told Virginia about all the highlights, "laughing uproariously at the feeblest suggestion of a joke, . . . swept on by the wild hilarity fatigue produces." In the midst of their revelry they saw a face appear in the window, shouting, "The darkroom's on fire!"

Racing outside, they found a crowd of people rushing around for hoses and fire extinguishers. Clouds of smoke billowed from the dark-

room next door. "The negatives!" Adams yelled as he ran toward the building. With help from the assembled onlookers, they soon had the fire out. Their work that night was not finished, however. To save as many of the charred negatives as possible, they filled the bathtub with water and rinsed and hung up to dry all those they could salvage. The undamaged ones were put in new envelopes. Luckily, most of those destroyed were his commercial photographs for the Curry Company. All told, Adams estimated that he lost about a third of his life's work that night. Yet, as Charis Weston recalled, "of the group, Ansel looked least like a ruined man. When we had had a well-earned drink he became positively gay, sat down at the piano and rendered an extensive Bach concert. At three in the morning we finally staggered off to bed."[20]

Adams refused to be defeated. In one sense, the fire was a blessing. Like the trip with Weston from which he had just returned, it marked a fresh start and called for renewed energy. Adams had not exactly rested that spring and summer, as his doctor had ordered, but for him the perfect remedy was to be in the mountains again and to be in the company of an artist as close and as talented as Weston.

Adams's physical, emotional, and creative recovery was further aided by an invitation from Georgia O'Keeffe to come to New Mexico. Her friend and patron, David McAlpin, would foot the bill. Adams was happy to accept the offer. He wrote to Stieglitz soon after his arrival. In the vast space and brilliant sun his mind turned outward, away from self-doubts and nagging problems. Here he could merge with the timeless landscape, free of the trials and tribulations of the past year.[21]

In the course of the visit, the group—Adams, O'Keeffe, McAlpin, McAlpin's cousin Godfrey Rockefeller, Rockefeller's wife Helen, and the head wrangler at O'Keeffe's Ghost Ranch, Orville Cox—headed west through the mesa country to Canyon de Chelly. Adams brought along a small 35mm Contax camera to continue the experiments he had re-

cently begun with this new tool that was becoming so important to documentary photographers. With the handheld camera Adams was able to abandon the stiffly posed look of his earlier portraits and achieve one of his most animated and revealing images, catching O'Keeffe as she gave Cox a sly grin. The 35mm format did not automatically lead to spontaneity, however. More typical of his usual style was another portrait he made of O'Keeffe that day, standing majestically in her black hat and cape in the late afternoon light, the mesas stretching beyond her to the horizon.

Over the course of the trip, Adams proselytized about the wonders of Yosemite and the Sierra. They succumbed to his salesmanship and agreed to make a visit the following summer.

### The "Resort Photographer"

Adams could enjoy these respites only so long. Finances demanded that he soon return to his commercial obligations back in Yosemite. Although he had not been making new negatives for the Curry Company that winter, the company was actively using those images they already possessed. Back in Yosemite, he found that in their latest publishing venture, *The Four Seasons in Yosemite*, they had used a large number of his photographs. He was irate. He sent off an impassioned, three-page letter to Donald Tresidder announcing his decision to suspend any further work for the company. As he saw it, the brochure was the worst example yet of cheap, banal commercialism.[22]

He felt that, at the least, such a publication ought to have had his approval and to have included a royalty agreement, assuring him some of the profits derived from it. He had heard nothing about it until he saw it for sale in Yosemite shops. On top of that, photographs from the brochure were reproduced in *Life* magazine without permission or compensation. To make matters worse, the biographical blurb described

Adams as a "resort photographer." Nothing could have been a greater blow to his vanity. He reminded Tresidder of his association with Alfred Stieglitz, his worldwide reputation, and numerous exhibitions. He felt that the company had used his professional standing for their own benefit and had demeaned the integrity of his work in the process. It was the last straw in his growing frustration with the commercial mentality of the Curry advertising department.[23]

It was a difficult situation for Adams. The Curry Company job was crucial, providing a reliable income through the difficult years of the depression. Now that he was living full-time in Yosemite, it was all the more logical and practical to continue the arrangement. But he simply could not bring himself to stand by and see his photographs put to such use. The crux of the issue for him was that the Curry Company felt compelled to present Yosemite as nothing more than a tourist resort. In the competition with other western "vacation" areas, the park's intangible values were all but ignored.[24]

Adams had been trying for several years to encourage the company to adopt a subtler promotional approach, more in keeping with the natural beauty of the park. But he had found little sympathy. With this latest affront, he felt the time had come to take a stand. Describing his battles against the commercial mind-set in a letter to Stieglitz, Adams vowed to make a clean break. He could not continue in good conscience to degrade his vision for the sake of the almighty dollar.[25]

With his uncompromising dedication to "pure art," untainted by commercialism in any form, Stieglitz presented a nearly impossible model to emulate. In this case, Adams felt that he could take the moral high ground alongside Stieglitz. On other matters, Adams could not or would not go as far. The photography retrospective at the Museum of Modern Art, for example, had been a great success, and he was pleased to have been included in it. Stieglitz, however, continued to want noth-

ing to do with the institution or its representative, Beaumont Newhall. "It is almost impossible," Stieglitz wrote, "for a man like Newhall to grasp the spirit underlying all I do & all I have done the past fifty years or more." For Stieglitz, Adams represented someone wonderfully free of the social and political infighting of New York. "It's good for me to know that [there] is Ansel Adams loose somewhere in this world of ours."[26]

Adams appreciated the compliments and valued Stieglitz's opinion above all others, but he could not bring himself to share his view of Newhall and the museum. Adams wanted to participate in an undertaking of such potential moment for serious photography. He felt that when an institution as significant as the Museum of Modern Art offered to support photography, it was the duty of all those associated with the medium to encourage it and to direct the museum's efforts toward developing the best possible program.[27]

That summer Adams reiterated his offer that O'Keeffe, McAlpin, and the Rockefellers visit him in Yosemite. As he became more active in New York through his continuing contacts with Stieglitz and his growing involvement with the Museum of Modern Art, Adams wanted to share his world with the artists and patrons he met there, to show them the country that inspired him. He looked forward to watching O'Keeffe respond to the high country, whose clear and intense light, windswept trees, and jagged granite seemed ideally suited to her art.

He urged her to come out several weeks early and stay in Yosemite with his family. She would have time to get to know the land, to explore the valley at her leisure, and to paint as she saw fit. He and Virginia would be very glad to have her. Although they loved their Yosemite friends, they hungered for the company of serious artists. He knew it would be difficult to entice Stieglitz out as well, as he hardly ever left the

confines of Manhattan, except for his annual trip upstate to Lake George, but he thought it worth a try. Adams offered the unhampered use of his darkroom and 8 × 10 camera.[28]

As expected, Stieglitz declined the offer, but O'Keeffe arrived in early September and was soon followed by the entire entourage. Adams had arranged for an extensive array of equipment, including fourteen mules and a packer, a guide, a cook, and large supplies of food, bedding, and clothing. These extensive logistics were more akin to the Sierra Club High Trips than to Adams's usual ideal of light traveling. He no doubt suspected that his wealthy patrons would prefer to travel in more comfort.

Adams met O'Keeffe at the train station in Merced and drove her up the narrow road from the San Joaquin Valley into the Sierra foothills. As they passed through the golden rolling country, O'Keeffe pointed out weathered barns, old oaks, and lichen-covered granite outcroppings, fascinated with the pictorial possibilities. They climbed through dense stands of pine and fir into the higher elevations until at last they rounded the curve and saw the valley spread below them bathed in sunset glow. Entranced by the magnificence of the scene, O'Keeffe had by now abandoned her usual restraint and was virtually raving at the beauty of it.[29]

Adams had encouraged the group to hire a cook to leave as much time free for painting and photography as possible. He explained that the best light for photography was in the morning and evening. They should not waste such moments preparing and consuming meals. He recommended that dinner be served well after sunset, so that they could work until the last of the light had faded. He suggested a leisurely pace to give plenty of time for creative endeavors and scheduled a number of layover days at various points along the way to give the group more time for exploration.[30]

Adams was disappointed to find that O'Keeffe had not brought painting supplies. Nonetheless, he was invigorated by her presence.

She brought an entirely individual sensibility to the place, an approach completely free of the usual clichés. Adams was so impressed that he vowed to climb out of his advertising ruts and see the valley afresh.[31]

## The Photographic Book

Over the course of the summer Adams had begun to assemble a selection of negatives from his files for the book sponsored by Walter Starr. He also added several images from his recent trips. By that fall the book, *Sierra Nevada: The John Muir Trail*, was ready for the printers. The first run of plates by the Lakeside Press of Chicago proved disappointing. Adams wanted reproductions that would come as close as possible to matching the tonal richness and optical precision of his original prints. He went to Starr with the difficult recommendation that they start again. Starr proved entirely sympathetic. The second run was worth the effort: placing the reproductions next to the originals, many of Adams's friends could not tell which were which.[32]

Adams rushed a copy to Stieglitz and awaited his reaction. "You have literally taken my breath away," replied the old master, who was not prone to exaggeration.

> Congratulations is a dumb word on an occasion like this. What perfect photography. Yours. And how perfectly preserved in the "reproductions." — I'm glad to have lived to see this happen. And here in America. All American. And I'm not a nationalist. I am an idolater of perfect workmanship of any kind. And this is truly perfect workmanship. I am elated.[33]

Stieglitz's compliments were revealing. For him, Adams seemed to combine all the qualities he had been seeking in an American modernism. Stieglitz saw Adams, as he saw O'Keeffe, building on the interna-

tional principles of modernism but firmly rooted in the native landscape of America. Adams was "a breath of real fresh air from the mountains" blowing through the steel canyons of Manhattan.[34]

Adams appreciated the compliments, but he had heard many less favorable reactions. Stieglitz's adulation of "perfect workmanship" was not entirely shared by artists and intellectuals who had come of age in the class-conscious 1930s. Many thought it ostentatious and boringly conventional. According to them, Adams was producing precious keepsakes for the rich, rather than pushing the boundaries of the form and contributing to the struggle for a meaningful art.[35]

Illustrated books were becoming the most important new avenue for photographic expression by the late 1930s. Unlike Adams's painstakingly crafted limited editions, however, the most widely praised books were based on contemporary issues and aimed toward a wide audience. In 1937, Margaret Bourke-White collaborated with Erskine Caldwell on a documentary book, *You Have Seen Their Faces*, that combined photographs, captions, and text to chronical the conditions of Southern tenant farms. It was immediately hailed as "a new art," the first example of a novel form of documentary reportage and persuasion.[36]

The form was not without precedent, however. In addition to earlier examples such as Jacob Riis's *How the Other Half Lives* (1890), the recent success of photographic journalism in mass circulation periodicals had established the combination of words and images as an effective and popular format. Documentary films, such as those produced for the United States Film Service by Pare Lorentz (with the assistance of Paul Strand and Willard Van Dyke), had similarly contributed to the growing interest in the genre.

*You Have Seen Their Faces* was a substantial commercial and critical success and led to an outburst of documentary books in the next several years. In 1938, the poet Archibald MacLeish wrote the text (what

he called a "sound track") to accompany eighty-eight Farm Security Administration photographs assembled in the book *Land of the Free*. MacLeish's book was a strident call to action in support of the nation's dispossessed farmers. Whereas Bourke-White's farmers were merely pitiful, MacLeish's were presented as confused, bitter, yet, in the final images of the book, galvanizing into collective action.[37]

*Land of the Free* helped to bring the work of the New Deal's Farm Security Administration to the attention of a wider public. The photographic division of the FSA, officially called the Historical Section, was commissioned to document the conditions on the nation's farms and to build public support for New Deal agricultural policies. This group included (in the still photography division) Walker Evans, Arthur Rothstein, Carl Mydans, Ben Shahn, Russell Lee, Marion Post Wolcott, and Dorothea Lange. Together with the other photographers working for the federal government, they produced some of the most important and influential images of the decade.[38]

The success of the documentary books that appeared in the late 1930s encouraged Adams's own growing interest in books as a vehicle for his photographs. As his *Sierra Nevada* neared completion, he wrote to David McAlpin full of enthusiastic plans. With his renewed health and energy, Adams was eager to take on new creative challenges. He wanted above all to take on a sustained project, as many of his friends had done. If, by some incredible stroke of luck, he were to be fully funded by some beneficent angel and left free to do as he pleased, he was sure he could produce some excellent photographs.

Yet he feared that too much freedom might produce a haphazard body of work, "effete and inconsequential." He hoped that his long years of work in Yosemite could form the basis of a significant project, although so many of his efforts there were perverted by the demands of the Curry Company advertising department. He felt *Sierra Nevada* rep-

resented the first step in a new direction. Books not only promised a vehicle by which to tackle meaningful, long-term projects but might also turn out to be a reasonable source of income as well.[39]

## The Critics

Although Adams was impressed by the commercial success of certain photographic books, he held to his long-standing reservations about many practices within the documentary genre. Above all, he was alarmed to see that the growing use of photography as a medium of social documentary made many question its continued validity as a medium of fine art. The critic and Museum of Modern Art (MoMA) trustee James Thrall Soby, for example, felt that his collection of photographs by the European modernist Man Ray no longer held much significance.

> The non-objective photography—the "rayographs," the odd-angle shots, the composite prints, have one by one been filed away against the time when they may have some value as a commentary on the aspirations of certain frustrated artists in the 1920s. This is of course merely a personal experience, but it is apparently not unique. The men who ten years ago sold me these photographs were art dealers, proudly advertising their intention of selling photographs along with paintings, drawings, and sculpture. Today hardly an art dealer in the country handles photographs; as one of them recently said to me, "you can't sell a photographic print as a work of art because people soon find out it isn't one."[40]

Soby felt that the best use of photography was as a simple medium of recording. He accused many documentary photographers of seeking the status of artists through a romanticization of their subjects. "Are the present-day documentary photographers really humble, have they really

renounced the pose of being artists for the less glamorous one of being reporters?"[41]

Such talk from art critics gave Adams real cause for concern. His alarm was heightened by the Walker Evans exhibition and book, *American Photographs*, sponsored by the Museum of Modern Art. He granted that the book contained some excellent photographs, but they seemed to be lost within the context of social criticism. He found the accompanying essay by the critic Lincoln Kirstein especially infuriating. The man, Adams complained, was just another fatuous aesthete, using criticism as an outlet for his peevishness.[42]

Kirstein's essay contained a number of points bound to strike a sensitive nerve for Adams. According to Kirstein, the photographer's most significant purposes, those

> which take the greatest advantage of his particular medium and invoke its most powerful effect[,] are social. The facts of our homes and times, shown surgically, without intrusion of the poet's or painter's comment or necessary distortion, are the unique contemporary field of the photographer. . . . It is for him to fix and show the whole aspect of our society, the sober portrait of its stratifications, their backgrounds and embattled contrasts.[43]

For some time Adams had been sensitive to critics who saw social documentary as the only legitimate use of photography. That the Museum of Modern Art was now publishing such views was particularly galling to him since he saw the museum as a potential bastion of support for photography as a fine art, independent of any sociopolitical agenda. Adams was not entirely sure what agenda and what vision of America Evans had in mind, but he was plainly upset by Kirstein's interpretation. Kirstein spoke of "the disintegration of chaos" evident in Evans's photographs. "The eye of Evans," Kirstein wrote, "is open to the visible effects, direct and indirect, of the industrial revolution in America, the

replacement by the machine . . . of the work and art once done by individual hands and hearts." Those effects, he said, could be seen in the modern era as depicted by Evans, "an epoch so crass and so corrupt. . . . Here are the records of the age before an imminent collapse. His pictures exist to testify to the symptoms of waste and selfishness that caused the ruin and to salvage whatever was splendid for the future reference of the survivors."[44]

Kirstein's assumptions concerning the nation's "imminent collapse" seemed to make Adams even angrier. The "left-wing" vision of America as a nation rotten at the core only encouraged cynicism, Adams said, at a time when all Americans needed to tap the faith and resiliency that had made the nation great. These critics had no contact with the land and the "real people" who lived on it. As far as Adams was concerned, America remained a joyous place, beautiful and strong, despite the troubles that threatened.[45]

Adams wanted to present a positive alternative to the critiques emanating from both the Left and the Right in the late 1930s. He felt that his greatest contribution to the ongoing documentation of America would be to illustrate the relationship of humanity to the earth, to demonstrate the healing power of nature that he himself had experienced.[46]

Although many intellectuals continued to speak in revolutionary and apocalyptic terms, the radicalism of the mid-1930s was in rapid decline on many fronts by the end of the decade. With the rise of fascism throughout the world, the militant tone of former radicals toward the liberal values of "bourgeois" America became distinctly more moderate. In the face of the rising threat from the far Right, a new spirit of cooperation and coalition building replaced earlier calls for proletarian revolution. The Moscow Show Trials had put an end to many radicals'

idealistic image of the Soviet Union. Philip Rahv wrote in "Trials of the Mind," published in the *Partisan Review* in 1938, that "the failure of capitalism had long been assumed, but the failure of communism was a chilling shock and left the intellectual stripped of hope and belief in progress, with only himself and his own talents to rely upon."[47]

If more evidence was needed, it came the following year, in the summer of 1939, when the Nazi-Soviet Pact was announced. The reaction of the editors of the *New Republic* was typical of that of many liberals in the United States, once sympathetic to the ideals of the Popular Front: "People must have something in which to repose hope and confidence; it is more likely that with the collapse of Russia's moral prestige they will turn more and more to this country—the last great nation to remain at peace under democratic institutions."[48]

With the gathering prospect of war, the tone of documentary books began to change. The catalog of America's ills that characterized the documentary books of 1937 and 1938 gave way to a celebration of liberal values and American traditions—a trend very much in concert with Adams's own political sensibilities. It was in these patriotic terms that Adams sought to convince the public of the importance of wilderness.

Although the principal objects of his scorn during the 1930s had been "left-wing propagandists" in the documentary realm and corporate-minded manipulators in advertising, these two forms, both clearly effective in advancing their various agendas, provided him with models that he adapted to his own ends. He had felt for some time that the radicals had made better use of the tools of popular persuasion than had the liberals.

He discussed the subject with Tresidder during the winter of 1938. Adams was attempting to mend some fences following his angry departure from the Curry Company the previous fall. He tried to explain to his friend and former client his feelings about advertising. He began in

a less than conciliatory vein, denouncing it as a shallow and pompous profession, lacking any genuine creative impulse despite its continuous protestations to the contrary. Nonetheless, he realized its importance to his work. He had studied the field of advertising carefully, he said, in an effort to adapt its strengths to his own purposes.[49]

Adams explained that he wanted to communicate to the public what he saw as the essence of Yosemite. His photographs would convey the wonder and renewal he found there, all the moods of nature—from quiet details of the forest to the sublime power of the thunderclouds above the valley walls. The persuasive power of documentary "propaganda productions" and advertising techniques could be incorporated into something, to his mind, more spiritual and profound.[50]

Adams soon put his plan into action. In the projects he undertook in these years, he sought to merge his landscape art and his nationalistic feelings, to create a body of work that would demonstrate the crucial role of the natural world in sustaining human life. To achieve this goal, he allied himself with powerful elements in the federal government.

### Kings Canyon

The Kings Canyon bill had been reintroduced in Congress in 1937, but agricultural interests in the San Joaquin Valley combined with the opposition from the Forest Service to block the legislation. In 1938, Secretary Ickes lobbied actively for passage of a revised bill designed to mollify the water interests of California agriculture and the wilderness interests of the Sierra Club. Ickes had in fact come to San Francisco that fall to meet with the Sierra Club board. The club had dragged its feet on the 1937 bill, believing that the Forest Service might administer the land better than the Park Service. Through the arrangements of Francis Farquhar, Ickes met with all fifteen members of the board at San Fran-

cisco's Bohemian Club in October 1938. Duly impressed by Ickes's arguments on behalf of the Park Service and its bill, the directors agreed to give the measure their full support.[51]

Adams saw the Kings Canyon bill as an opportunity to continue the photographic lobbying he had begun on his first visit to Washington, D.C., in 1936. He sent a copy of his recently published *Sierra Nevada* to Arthur Demaray, who was now director of the National Park Service. Adams was pleased with Demaray's stated desire to preserve Kings Canyon as a wilderness park. He hoped to reinforce that commitment by showing the bureaucrats in Washington the natural beauty of the region, to help them appreciate the area as a physical entity rather than a mere policy abstraction.

In January, Adams received a letter from Demaray.

> Recently we transmitted to Secretary Ickes the complimentary copy of your new Sierra Nevada portfolio which you sent to the National Park Service. Yesterday the Secretary took it to the White House and showed it to President Roosevelt, who was so impressed with it that the Secretary gave it to him. In later discussion Secretary Ickes expressed his keen desire to have a copy for his own also.[52]

Adams was more than happy to supply the requested additional volume. Obviously his efforts were bearing some fruit. It no doubt had crossed his mind that his career might benefit as well from these contacts with the federal government. Soon after he received another letter, this time from Ickes himself. "I am enthusiastic about the book— *The John Muir Trail*—which you were so generous as to send me. The pictures are extraordinarily fine and impressive. I hope that before this session of Congress adjourns the John Muir National Park in the King's Canyon area will be a legal fact."[53] Ickes's prediction proved correct. The bill was signed into law by Roosevelt on March 4, 1940.

Although Adams was beginning to orient himself to an audience beyond the usual one for fine art photography, he was still very much concerned with his career in that realm. With Stieglitz's warm response to his latest book, Adams hoped that he might be offered a second exhibition at An American Place. He did not want to ask directly, however. He knew Stieglitz would request a show if he wished to have one. McAlpin was not so reticent. He lobbied Stieglitz directly, suggesting that Adams's latest work deserved an exhibition. He was disappointed to find Stieglitz unresponsive to the idea.

According to McAlpin, Stieglitz later said, "I'd like to give Adams another show but I can't do it until he brings me another group of fine prints which are better than the 1936 show. He may never produce a finer group than that. . . . Perhaps it was the freshness of his response which produced such a remarkable group."[54] McAlpin suspected that Stieglitz's reluctance had more to do with Adams's relative independence. "S. requires dependence on him of people," McAlpin wrote to Adams. "He would probably deny it and doubtless honestly but he likes to have them more or less helpless. In that state he will do anything to help them but he is insanely jealous of success."[55]

Although McAlpin exaggerated, Stieglitz was noted for his protective attitudes toward the artists in his circle. "He thrives on the psychic power of turning people down," McAlpin went on. "He has to say 'NO.' . . . So if he thinks you want a show or feel you rate one, his instinctive reaction would be not to offer one. . . . [C]ompared to Marin you live on much too ritzy a scale—your car runs & gets places. . . . [Y]our children have at least one pair of shoes . . . and you have sold commercial prints. You have trafficked with Mammon."[56]

In the next several years Adams continued to manifest that indepen-

dence and energy. Prime examples of this were the teaching positions he took the following year. In the summer of 1940 he began a workshop in Yosemite Valley sponsored by *U.S. Camera* magazine.[57] In the fall he began teaching at the Art Center School in Los Angeles. The school had a well-deserved reputation as a training ground for commercial artists. Although financial necessity was no doubt at the core of his decision to take on these teaching duties, he also was motivated by a desire to further his crusade for better photographic technique. Since the appearance of his 1935 publication, *Making a Photograph*, and numerous articles, he was widely acknowledged as a master of the camera and darkroom.

Adams stressed precision and control in each phase of the image-making process. He left aesthetics to his students, urging them to explore the visual world creatively, to "keep the camera-eye going," as John Marin used to say to him. Rather than impose a vision, Adams asked only if the photograph said what the student wanted it to say. And he taught the principle of visualization as the means to achieve that statement in the finished print.

He had been trying for years to increase his control over the photographic process, to achieve a rational and repeatable system to obtain the values in the final print that he visualized as he made his initial exposure. Once he began teaching at Art Center, he set about devising a system that would enable him to pass that skill on to his students so that they would gain command of what he termed their photographic "scales and chords." The musical analogy was apt. The rigorous musical training of his youth remained the guide in his teaching approach. He felt that discipline and technical mastery were the foundations from which creative expression emerged.[58]

Working in conjunction with a fellow instructor at Art Center, Fred Archer, Adams devised a practical method for achieving that control.

He called it the "zone system," for its division of the gray scale of final print values into ten zones from pure white (Zone X) to pure black (Zone I), with middle gray as Zone V.

Using a narrow angle of view ("spot") exposure meter, Adams would select a portion of the subject that he wished to render in the print as middle gray and note the shutter speed and aperture (lens diaphragm setting) called for on the meter to render this value at "normal" exposure. With this median guide, Adams could then measure the light in each part of the scene and predict how, with normal exposure and development, each part of the image would appear in the final print. A bright portion of the subject—a white patch of snow on a mountainside, for example—might reflect sixteen times as much light as the portion placed at Zone V. Since a one-zone increase is produced by each doubling of the light intensity, Adams could predict that this portion would be rendered as Zone IX. He could then choose to alter the various parameters of exposure and development to effect the final outcome, exposing for specific values and compressing or expanding the contrast scale to tailor the negative to his wishes.[59]

This quantitative approach gave Adams precise control of his photography. Rather than merely hope for the best, he could visualize the effects he desired and take the steps necessary to achieve them. He could produce the brilliantly luminous prints for which he is best known or quiet somber prints of a limited range of values, a mood at which he was equally adept.

Adams's range of photographic activities expanded further in the summer of 1940. San Francisco's Golden Gate Exposition had opened its doors the previous year in celebration of the completion of the Golden Gate Bridge, the new symbol of the city. As self-appointed champion of art photography, Adams was disappointed to find no photography exhibition. He spoke to Timothy Pfleuger, the organizer of the art exhibi-

tions. Pfleuger suggested that Adams take on the responsibility of organizing such a show himself. He offered Adams office and exhibition space, a secretary, and reimbursement for all expenses, but no salary.[60]

Although the offer promised a great deal of work for very little reward, Adams found it a challenge he could not refuse. He gathered materials from across the United States and Europe and assembled a large historical survey of photography, from early daguerreotypes to the latest experiments of Man Ray and Moholy-Nagy. An entire room was devoted to color photography and an impressive display of huge photographic mural enlargements of scientific images, including Eadweard Muybridge's studies of animal locomotion, Harold Edgerton's high-speed photographs, and astronomical photographs from various observatories. In addition, he organized a series of group exhibitions—including shows by FSA photographers, the Photo League of New York, and *Life* magazine photographers—and a series of solo exhibitions—opening with Edward Weston and including shows by Berenice Abbott, Eugène Atget, Margaret Bourke-White, László Moholy-Nagy, Paul Outerbridge, Charles Sheeler, Paul Strand, Brett Weston, Cedric Wright, and Adams himself.[61]

### The Newhalls

That summer Beaumont and Nancy Newhall made their first trip to the West Coast to visit Adams and see the exhibition. They came with mixed feelings. They found Adams a fascinating character but were a bit put off by his western exuberance and his endless praise of the wonders that awaited them. "Adams sounded too often like Hollywood and the super-colossal," Nancy recalled. "We had the easterner's built in resistance to bombast, to superlatives— 'the biggest,' 'the newest,' 'the best.' "[62]

The trip west was an entirely new experience for the Newhalls. Raised in New England and well traveled in Europe, they were used to

a landscape where the hand of human culture predominated. But by 1940, as Nancy recalled, "France had just fallen, the last of the continent; England was under heavy bombing; there was no Europe to go to anymore."[63] Against the backdrop of that horror and the apparent descent of society into chaos, the wide-open distances of the western landscape seemed part of another universe.

At first they viewed it all with a certain ambivalence. The "beauty of nature" seemed suspect in a world where Adolf Hitler was the man of the hour. Yet at the same time, especially in Nancy, came an inkling of an idea that Adams articulated again and again, that the primordial landscape offered a stable and enduring source of wisdom, inspiration, and renewal—a way out of the madness of the twentieth century. As they worked more closely together in the coming years, Nancy came to share Adams's view of the redemptive power of nature. As the United States gathered its forces for war, they both began to articulate a vision of landscape as a national resource for the spirit.

For the time being, however, the Newhalls were still trying to figure out who this character Adams was. They were duly impressed with his *Pageant of Photography*. "It was huge and comprehensive," Nancy wrote,

> immaculate in installation, perfectly lighted, though to us the design was monotonous, with the endless succession of black and white rectangles on pallid walls. The photomurals he had made from astronomical negatives, especially the Pleiades and the corona of the sun during a total eclipse were breathtaking. . . . The show as a whole, we thought, represented a breadth of mind and heart unusual among creative artists with such strong personal dedications as Adams.[64]

Adams wanted to give the Newhalls a personal introduction to California. He began by taking them for a drive across the bay over the newly completed Golden Gate Bridge to the headlands of the Marin peninsula, along the wild and windswept coastline that still retained the

mood of the elemental encounter of land, sea, and sky that Adams recalled so vividly from his childhood.

Next he took them south along the coast highway. The tour could not be complete without a visit to Carmel and Edward Weston's newly finished cabin on Wildcat Hill. There they witnessed firsthand the photographer's simple lifestyle and single-minded devotion to his art. The visit marked the beginning of a long friendship between Weston and the Newhalls.

On their return north they stopped along a section of the road near Pacifica where the cliffs dropped vertically to the rocky shoreline. With his camera mounted on a tripod extended horizontally out over the precipice, Adams made several images as the incoming surf washed abstract patterns in the sand. He conceived and exhibited them as a sequence or group, the changing designs like a composer's variations on a theme.

The camera's vertical point of view was similar to that employed by Moholy-Nagy and other European practitioners of the "new vision." The sequence also bore a strong resemblance to Weston's several images, each titled *Surf, Orick*, that were made on his Guggenheim travels and which Adams may have seen on his visit that weekend. Perhaps the most important influence behind his *Surf Sequence* was the presence of the Newhalls. In four decades of close collaboration with Adams, their wide-ranging photographic interests and spirit of experimentation would be a crucial factor in his creative growth.

Adams capped the West Coast education of his eastern friends with a visit to Yosemite. Sitting outside over drinks one afternoon in the valley, Newhall reminded Adams of the suggestion he had made in 1935 in *Making a Photograph*. Adams had stated then that photography had become sufficiently mature both as an art form and as a medium of communication that it warranted an institution dedicated to exhibiting the best work and supporting future growth. Newhall agreed whole-

heartedly and believed the Museum of Modern Art offered the best potential home. As Newhall recalled it, Adams "threw his drink into the bushes and said, 'We'll call Dave McAlpin right now.' "[65]

McAlpin's interest in photography had grown steadily, largely as a result of his friendship with Adams. He was determined to do something to establish photography's place at the museum on a permanent basis. As a cousin of the Rockefellers and a successful stockbroker in his own right, McAlpin clearly had the financial wherewithal to carry out his ideas. He made a specific demand in conjunction with his support for the new department: he wanted Adams to be a member of the managing committee.

> Newhall and I both feel it essential for you to be here for six months to a year as a member of the committee and special advisor in launching the Photo Dept. I have accepted the chairmanship *provided* you would come and stay here and devote as much time as necessary and serve as advisor, organizer and policy director. I have offered to underwrite your retainer. So it's in the bag if you can be induced.[66]

Adams was quick to accept.

The following week a letter from Beaumont Newhall arrived. "Things have been happening fast during the last few days! The creation of a Department of Photography is a fact; the Trustees have approved of the plans I submitted to them last July and have appointed me Curator. Dave McA has accepted chairmanship of the committee." Adams was to be vice chairman. He agreed to work at the museum for six weeks, as that was all that his schedule allowed and seemed sufficient to make a significant impact on the organization of the department. Newhall was pleased at the prospect. He had come to appreciate Adams as a kindred spirit and someone who could help his effort to establish links with the photographic world. In particular, he hoped that Adams might help build a bridge of communication to Alfred Stieglitz. In a postscript,

he added, "I have written Stieglitz about the plans in general and have appealed to him for advice and counsel. I want him to feel that he is *in* on the work from the very foundation."[67]

Although he had gradually warmed to Newhall, the old man continued to hold a grudge against the museum as an institution. "I have nothing against the Museum of Modern Art," he had told Adams in 1938, "except one thing & that is that politics and the social set-up come before all else."[68] Unlike the irascible and intransigent Stieglitz, Adams was eager to be a part of the museum.[69] Such an association would not only help him influence the direction of photography as a fine art but would also clearly be of significant benefit to his career.

The first exhibition organized by the new department was called *Sixty Photographs: A Survey of Camera Esthetics*. It was a much smaller show than the 1937 retrospective and, in Beaumont Newhall's later estimation, "not nearly so good."[70] Adams, an active participant in its planning, was not completely pleased with it either. He was discovering that although he was very much in sympathy with the Newhalls, there were other forces governing the direction of the department with which he was much less sympathetic.

Edward Steichen, Tom Maloney (editor of *U.S. Camera*), and Willard Morgan (a leading photographic publisher and the husband of photographer Barbara Morgan) all more or less shared the view that the Department of Photography, in this exhibition at least, was too aloof in its presentation of what they considered the most democratic of media. As Nancy Newhall told Adams, "The prevalent opinion is that the museum devitalizes creative work, puts it in a setting of grandeur and expense. Many people are actually afraid of the place."[71]

Adams could not agree. He felt that photography deserved the sanctification of high art status.[72] Adams found his ideas at odds not only with many outside the museum but with many within it as well. A typical reaction was that of the museum's director, Alfred Barr. As Barr made

his way around the exhibition, he looked at the nature studies by Stieglitz, Strand, Atget, Weston, and Adams. Turning to Nancy Newhall, he asked, "Why do all the photographers have to photograph bushes?"[73]

James Thrall Soby and Lincoln Kirstein, both on the museum's photography committee, antagonized Adams with what he considered their "anti-art" attitudes. He was especially leery of the museum's apparent acceptance of their preference for documentary photography. His concern was further inflamed by much of the European photography on display. As Nancy Newhall recalled, Adams wondered why the museum would exhibit these photographers' "infantile experimentation and downright bad, even deliberately bad, technique."[74]

Beaumont Newhall tried to explain the ideas behind the work, the Europeans' revolt against prevailing notions of high art. Adams thought this counterproductive, to say the least. To see the Department of Photography embracing such ideas struck him as contrary to all they had fought for in their efforts to establish the department in the first place.

Furthermore, Adams could not understand the dark tone of much of the work. "Why the emphasis throughout the museum on the death-in-life twitches of Europe," Nancy Newhall recalled him wondering, "on the decadent, the satiric, the macabre? Why not stress the pure, the vital, the revelations of beauty . . . [,] what Stieglitz called 'the affirmation of life'?"[75]

Adams's reaction put into sharp relief the distance that separated California and the American West from the horrors engulfing Europe in the late 1930s. Secure amid the physical beauty and relative social stability of California, Adams naturally had a difficult time understanding the origins of the European art he saw in New York. Although the West certainly had its share of social and political turmoil in the 1930s, the immense physical scale and enduring beauty of the region seemed to confirm Adams's belief that nature's timeless rhythms would outlast the human follies of the moment.

As war engulfed the world and the United States was drawn inevitably into it, nationalism was growing throughout the country. A number of photographic books published in these years continued the turn toward a more conservative documentary style that had begun in the late 1930s. These books, such as Erskine Caldwell and Margaret Bourke-White's *Say, Is This the USA*, published in 1941, and Eleanor Roosevelt and Francis MacGregor's *This Is America*, published a year later, were sentimental patriotic odes to American virtue that featured stereotypical scenes: a New England town, Kansas wheatfields, a Pacific beach, and a variety of ethnic types—all cheerful, optimistic, and working together.[76]

The tenor of these books was part of a general trend. Public support for the war was strong, and criticisms of the American social and economic structure were generally left behind in the belief that only a concerted national effort could assure the successful defeat of totalitarianism.[77] Not the least of the elements in this pro-America spirit was a glorification of the American landscape. In 1941, Kate Smith captured the public mood with her hit recording of Irving Berlin's "God Bless America," with its refrain "From the mountains / to the prairies / to the oceans white with foam" reinforcing the traditional assumption that the national landscape was the embodiment of American virtue.[78]

The new mood in the nation helped to push Adams further along lines of thought he had already begun to pursue. Throughout the 1930s, the calls for social and political activism among artists had rubbed against the grain of his vision of the artist. Perhaps most essentially, he could not accept the assault on liberal ideals that most activist artists seemed to be waging. With the shifting sentiments among artists, intellectuals, and the nation at large, Adams felt a greater willingness to lend his efforts to "the cause." His work at the Museum of Modern Art and for the Sierra Club combined to set the parameters of his crusade: the

"affirmation of life" and the role of nature in American society were his themes.

In the winter of 1941 he wrote to Nancy Newhall outlining his ideas for a photographic exhibition to be called *Image of Freedom*. A competition, sponsored by the Museum of Modern Art, would invite photographers from around the nation to participate in "a sweeping, many-sided interpretation of what America means to Americans." Newhall was excited by the idea and composed a statement explaining the purpose of the project.

> We have seen searching photographic studies of the waste of life and land due to abuses that we allowed to accumulate, and we have seen the beginnings of a reclamation. Now let us see, with a vision equally exact, the power that can remedy these faults . . . [,] the vast, unconscious power of millions of us living on the American earth. . . . Let us look at the earth, the sky, the waters. Let us look at the people—our friends, our families, ourselves. . . . What are our resources and our potential strength?[79]

Adams thought Archibald MacLeish should write the introduction to the show, something along the lines of his *Land of the Free*. MacLeish read Newhall's statement of the exhibit's purpose and felt he could not improve on it. To promote a "democratic" selection of images, Newhall and Adams requested that the submissions be anonymous, so that the fame or obscurity of the photographer would not influence the selection process.[80]

While Adams was working on the *Image of Freedom* competition in the summer of 1941, he received a letter from E. K. Burlew, assistant to Secretary of the Interior Ickes, requesting a meeting, at Adams's convenience, with the secretary. Adams wrote back wondering what the meeting might be about. Burlew replied in a few days.

Secretary Ickes asked me to have you come in and discuss with him the possibility of making one or more photographic murals to be placed in the Interior Department. He has the very beautiful screen which you made some time ago in his office, and while we have quite a number of murals painted on the walls of our corridors, we would like to have some made by the photographic process.[81]

The offer seemed too good to be true. Characteristically enough, Adams immediately envisioned a grand project documenting all facets of the Interior Department and the lands under its jurisdiction. By August he had worked up a detailed outline. The request for mural-sized prints would require both a technical and aesthetic treatment appropriate to that large scale. Adams specified the particular films, chemicals, and enlarging papers he would need to create prints to his exacting standards. Here was an undertaking perfectly suited to his talents. Few, if any, photographers of the day were better prepared to carry out the task in all its technical, logistical, and creative dimensions. While he relished the prospect of a challenging new assignment, his greatest interest was in the impact his images might have. At the very least, he felt that his photographs in the corridors and offices of the Interior Department might make the officials in Washington think twice about their land use policies.[82]

The Interior Department mural project marked the beginning of what was arguably Adams's most productive and creative period. "You seem so hard at it in so many ways," wrote Stieglitz in the fall of 1941. "It all sounds very hectic to one like me—a derelict. But we are living in such a hectic age. Even the minutes, I fear, do not recognize themselves. They are pushed along so fast that they have become part of the mob spirit, and the mob spirit certainly rules the world in one way or another ever more today."[83]

Stieglitz realized, not without a certain self-satisfaction, that he had

no part in the new world taking shape around him. He knew that Adams was now making his own way. Adams had indeed come into his own in the years since his first show at An American Place and the breakdown that followed it. The year 1941 marked the beginning of a new phase of Adams's life and career.

One event in particular marked the passage of time and the end of an era. In March 1941, his old friend and first patron, Albert Bender, passed away. Adams had not written to Bender much after Stieglitz took over the mentor role that Bender had once held. Adams received the news by telegram at his Yosemite studio. He and Virginia left immediately for San Francisco where they found that Bender was receiving a fitting sendoff, an Irish wake followed by funeral services at Temple Emmanuel. Adams was selected to watch over the body on the final evening, from midnight until dawn. As he talked with all those who came to pay their last respects, people from all walks of life, he was struck again by the legacy of Bender's generous spirit.[84]

Although Adams was entering a new phase of his life, the foundations laid down in his youth remained the source of all he would do in the coming years. His belief in the healing power of nature and his dedication to art remained constant. Behind his creative and physical renewal lay, as always, the landscape of the West. His return to Yosemite and his travels through the Sierra, along the California coast, and through the Southwest were the elixirs of his well-being. The importance of nature in his own life convinced him of its importance for society as a whole.

The turmoil of the 1930s had affected him strongly, as it had all artists. Adams remained scornful of much of the art produced in those years, yet he had gradually absorbed the principle of an activist art and had begun to make it a guiding force in his own work. Several trends converged in these years to define the future direction of his photographic and conservation career: the rise of photography as a medium

of mass communication and mass persuasion, his involvement with the Sierra Club, and his association with the Museum of Modern Art. In particular, his photographic and conservation careers, always linked through their common source in his love for the natural world, now began to converge.

# WAR AND NATURE'S PEACE

IN LATE AUGUST 1941, Adams made his way down from New York to Washington by train to meet with the Interior secretary. Ickes proved cordial and generous. He agreed to hire Adams at the highest rate then paid to government consultants, $22.22 per day, plus $5 for meals and reimbursement for train fares or car mileage at 4 cents per mile. He asked Burlew to draw up a contract spelling out these details and to get it processed and approved as soon as possible. He then drafted a letter of introduction to ensure that Adams received full cooperation at the various sites he would be visiting. "Mr. Adams should be given every possible opportunity to take photographs of scenery and structures of reclamation projects, Indian reservations, national parks, and other places under the jurisdiction of this Department."[1] With Burlew pulling the appropriate strings, the contract was approved and signed on November 3 and backdated to October 14, when Adams began his work.

The *Image of Freedom* exhibition opened in the fall as Adams was returning to Yosemite to begin preparations for his mural project. As the MoMA press release described it, the show included "a wide variety of subjects each of which interpret a facet of the American spirit as seen by the individual photographer." David McAlpin commented on the

photographs selected by the panel made up of himself, Alfred Barr, Monroe Wheeler, Beaumont Newhall, James Thrall Soby, and Adams.

> Some chose to represent freedom by portraying (in landscape) the vast natural resources of our country. Others felt that the key to freedom is to be found in the betterment of living conditions by a benevolent government. To others freedom of expression seemed most important: freedom to protest, freedom to live the way one wants to, freedom to work with pride of craftsmanship, and to enjoy leisure hours without regimentation.[2]

The photographers, both amateur and professional, were paid twenty-five dollars per image for up to a maximum of five photographs. Not surprisingly, the final selection included a number of photographs by professionals, including four by Brett Weston, two by André Kertész, Aaron Siskind, and Ron Partridge, and one by Imogen Cunningham and Eliot Porter. Three prints by a young photographer named Minor White were also selected. It was his first contact in what would become a close working relationship with Adams and the Newhalls. The museum had arranged an international tour for the exhibition, sponsored by the federal government. Such touring exhibitions were to become an increasingly common arrangement during the war as the government sought to promote a positive image of the United States to the world.[3]

*Image of Freedom* was not the only war-related exhibition at the museum, nor was it the first. That spring the museum had sponsored *Posters for National Defense*, a competition offering $2,000 in prizes for work in two categories, the U.S. Air Corps and the National Defense Savings Bonds. According to the MoMA *Bulletin*, the museum felt that "in a time of national emergency the artists of the country are as important an asset as men skilled in other fields."[4] Preceding the showing of the winning posters was a large exhibition, *Britain at War*, that went up in May.

Meanwhile, Adams spent the early part of October preparing for the upcoming trip at his home base in Yosemite. He telephoned Cedric Wright and invited him along, took his son, Michael, out of school for the fall term, and began to gather the necessary camping and photographic equipment. The year before he had bought a new Pontiac station wagon to haul all the paraphernalia he liked to take on the road, but the car had not an inch to spare by the time they were ready to go.[5]

They left Yosemite in mid-October, bound for the Southwest with stops in Death Valley and Hoover Dam. At that impressive example of modern engineering and New Deal spending, Adams received his first experience of working with the government bureaucracy. In his quest for the dramatic, he put the dam's administrators to a test of their tolerance. Adams described the grand image he had in mind—a wide-angle view below with the spill gates opened and the plumes of water pouring forth. The dam's director clutched his head in growing distress. It was out of the question, he said. It would take a month's worth of paperwork. Notices would have to be sent to every water user from there to the Mexican border, with precise calculations of the water released and plans made at every dam below them to release sufficient water to take the overflow. He said it would cost at least $50,000. He suspected the secretary would change his mind if he knew that. Adams agreed to scale back his Cecil B. DeMille scheme and settled for a dry spillway.[6]

They traveled north to Zion and then back down to the Grand Canyon, with rich photographic rewards all along the way. Continuing eastward, the group encountered some difficult traveling. After a night spent at the Hopi pueblo on Walpi Mesa, storm clouds began to gather as they arrived in Canyon de Chelly. It had been the worst season of fall thunderstorms in twenty-five years, and the roads were in unusually bad shape. By late afternoon thunderclouds had rolled in, unleashing flashes

of lightning and torrents of rain. With wheels spinning and mud flying, the overloaded Pontiac struggled ahead.

After two days of slow going through axle-deep mud, they found their way blocked by a fast-flowing river in Butler Wash. Adams estimated the depth at no more than fifteen inches, deemed it passable, shifted into low, and plowed ahead. Just as the front wheels arrived at the far bank, the engine died from water thrown back by the fan. He got the motor started again but found he could make no progress up the embankment. With the wheels spinning wildly, Adams gunned it in reverse back into the stream, where the car stalled once again. This time the ignition was dead. Now the water was up to the floorboards. Two inches more and it would reach the cameras and film. The thunderclouds above threatened more rain. With a good downpour, the wash could be swept by several feet of water within fifteen minutes, taking the car and all its contents with it.

Adams and Michael began unloading the fifteen hundred pounds of equipment, while Wright started the seven-mile hike to the nearest town. When the tow truck arrived, they connected the winch and broke the wheels free as the rain started to fall. Within ten minutes the wash was a roaring torrent. Towed the seven miles to town, they spent the next day getting mud and sand out of the bearings and replacing the burned-out clutch. They reached pavement just over the Colorado border, thankful, with four thousand miles ahead of them, to be back on solid ground.[7]

A few days later they arrived safely in Santa Fe, where they stayed with friends, making it their base of operations for the next several days. For Adams, it was much like old times as he photographed by day and enjoyed the camaraderie by night. Since he was not as young as he used to be, he took some precautions against the effects of the festivities. Just before the party was to begin, he brandished a small bottle of olive oil, took several hearty gulps, and urged Wright to do the same. He said

that, according to legend, it would line their stomachs and reduce the absorption of alcohol into the bloodstream. The not-so-tasty antidote worked surprisingly well. After a particularly bibulous party, Adams and Wright were up with the sun, feeling no ill effects.[8]

While in Santa Fe, Adams took the opportunity to explore the surrounding country, both for potential mural subjects and for his personal work. It was on one such excursion that he made what was to become his most famous photograph, *Moonrise, Hernandez, New Mexico*. Although his visit to Santa Fe was much like old times, *Moonrise* clearly demonstrated the distance he had come, both technically and aesthetically, since his stays there in the late 1920s.

By this stage in his career, his work encompassed both the lyrical detail and the grand panorama. It was with the latter that he achieved his most distinctive images. Certainly no other photographer has matched his skill with these subjects. By the early 1940s, Adams had moved away from the more typically modernist style he had perfected over the previous decade. The direction his work had begun to take in the late 1930s, the move toward a wider horizon and more dramatic light, continued and grew more pronounced during the years leading up to the war.

The expansive and dramatic turn of his photographs in these years was not simply a response to his technical facility. At its heart was his desire to relate his vision of the "Natural Scene" to his vision of American society and its wilderness heritage, to show that nature could strengthen the national spirit in time of war.[9]

Adams portrayed the landscape as vast, powerful, touched by the hand of God—all the qualities then being invoked as the nation geared up to join the global conflict. The images he made in these years were Adams fortissimo: rousing nationalistic choruses linking nature, spiritual inspiration, and national purpose. In this they recalled the huge canvases of the nineteenth-century romantic landscape painters Albert

Bierstadt, Frederick Church, and Thomas Moran. These painters, whose popularity was at its height in the 1860s and 1870s, created works that expressed the mood of expansionism and growing national power behind the spirit of manifest destiny.[10]

That Adams should echo the imagery of these nineteenth-century romantics in his efforts to convey the grandeur of the American landscape and enlist public support for conservation was in part an expression of the times. With the coming of the Second World War, the isolationism of the 1920s and 1930s was left behind. In its place was a reinvigorated spirit of American mission, expanded now to an international scale. Americans conceived of themselves as battling the forces of barbarism and bestowing the virtues of democracy and capitalism not simply across their own continent but throughout the world.

In 1932, at the height of his Group f/64 "purism," Adams had scoffed at the theatricality of American mass taste and its lack of appreciation for the beauty of simple, ordinary things.[11] His wartime imagery, however, was nothing if not theatrical. The stirring tone of these photographs verged on the bombastic approach he would soon criticize in the work of Edward Steichen and other wartime propagandists. Yet Adams had a different vision, even if he shared their tenor.

Adams's work in these years portrays inspiration and national identity in the vast and timeless forces of nature rather than in industrial might or marching columns of infantry, like most wartime imagery. The social vision expressed in these images recalled his collaboration with Mary Austin on *Taos Pueblo* in 1930. Austin argued that the southwestern environment had contributed to the creation of indigenous communities rooted in the land and characterized by the kind of social equality and stability that "would fill the self-constituted prophets of all Utopias with unmixed satisfaction." For Austin, "here, not in the cafés of Prague or the cellars of Leningrad, is the stilly turning wheel on which the fair new shape of society is molded."[12]

While the essential concepts embedded in Adams's imagery reflected the influences of his early years, the form in which that vision was presented grew out of his experience as an artist in the 1930s. The spirit of social and political activism in art characteristic of that decade had, despite his protests, made a profound impact on his approach to photography. It had changed the type of audience he sought out—from his earlier limited circle of Sierra Club members and affluent patrons to the federal government and soon the public as a whole. And it had changed the form his photographs took—from subtle formal compositions reproduced in expensive limited editions to dramatic images designed for reproduction as huge photographic murals in Washington's corridors of power.

Like the mural art of the 1930s, Adams's photographs from these years invoke archetypal American imagery to encourage a sense of participation in a larger national identity. They were Adams's version of "art for the millions," public rather than private in orientation, large in scale, and heroic in mood. In these years Adams reached his artistic maturity, moving beyond his earlier borrowing from his principal photographic inspirations, Stieglitz, Strand, and Weston, to create his most original and characteristic work.

### Home Front

Following America's entry into the war, the Museum of Modern Art sought ways to support the armed forces and the war effort in general. James Thrall Soby was named director of the newly inaugurated Armed Services Program, a multifaceted effort to provide domestic and overseas exhibitions as well as education and therapy for the troops on leave in New York. One of these shows, organized for overseas distribution with the help of Nancy Newhall, was a collection of photographs by Adams.

In late December 1941, Adams had written to Burlew asking for permission to use a selection of his mural project negatives for an exhibition he was planning, titled *Photographs of America by Ansel Adams*. In addition, the exhibit would include a variety of his other photographs from personal and commercial work in the Sierra, the Southwest, and the East as well as industrial subjects and a number of portraits of people of various races, presumably living together in harmony thanks to American democracy and opportunity. Like the other material sponsored by the Office of War Information (OWI), it was pro-American propaganda designed to bolster Allied morale.[13]

Although Adams was too old for military service (he was forty years old in 1942), he was eager to make some genuine contribution to the war effort. Many of his friends and associates had joined the ranks or were employed in some capacity by the military. His Sierra Club friends Richard Leonard and David Brower were involved in the training of the first United States Mountain Division, which saw active duty in the Italian campaigns. Beaumont Newhall was working in Europe as a photointerpreter for aerial reconnaissance missions. He wrote to Adams in August 1942 telling him of his excitement at being a part of the Allied war effort.[14]

Adams searched for a way to lend his talents to "the cause." His hopes were raised when he received a telephone call from Edward Steichen, who was in charge of the navy's photographic unit. Steichen told him that he needed someone to run his laboratory in Washington, D.C. Excited by the prospect, Adams awaited the further details Steichen had promised to send along. Over a month later he read in a photographic magazine that Steichen had appointed someone else to the position. For Adams, it was yet another example of Steichen's cavalier attitude, and his animosity toward the man rose another notch.[15]

With Beaumont in Europe, the Museum of Modern Art appointed

Nancy Newhall acting curator of photography. Adams offered to go to New York to assist her. As vice chair of the Committee on Photography, he was expected to make regular visits to the museum anyway. Adams was glad for the opportunity. Not only did he enjoy working with Nancy but he also had a strong desire to make his presence felt in New York. Although issues of prestige and the advancement of his career figured prominently in this, his personal need for social and creative contacts played at least as much a part.

To make his stays in the city more enjoyable, he had a piano installed in the Newhalls' apartment on 53d Street, opposite the museum. He still practiced often, squeezing in an hour or two after dinner as best he could. After the landlord's 10:00 P.M. musical curfew, he would walk down to 44th Street and his room at the Algonquin Hotel.[16] He did not spend much time there, however. Adams stayed in constant motion.[17]

Typical of his socializing were the visits he and Nancy made to Charles and Musya Sheelers' Sunday afternoon parties. Ansel and Nancy would drive up along the Hudson River to the Sheelers' home in the old gatehouse of a river estate. After a long icy winter, they savored the pleasures of warm sunshine and blooming flowers as they talked with old friends in the Sheelers' garden. Tea and vodka flowed. In typical fashion, Adams chose the vodka.[18]

Although Sheeler was nearly twenty years older than Adams, they were both dedicated to the precisionist legacy of photography's high modernist phase in the years between the two world wars. Now that new trends were coming to the fore in documentary and photojournalism, they shared a certain misgiving. Adams recalled Sheeler's reaction to an exhibition they viewed around this time. "Isn't it remarkable," Sheeler said, "how photography has advanced without really improving."[19]

For all his pleasure in the company of like-minded artists he was continually overtaken by disgust with the urban scene. For every day of spring sunshine, there were months of freezing rain and sweltering heat.

For every moment of friendly chatter, there was the constant pressure of conflicting egos and hidden agendas. Despite his professional ambitions and need for creative exchange, Adams was always uncomfortable in New York and eager for the first opportunity to escape westward.[20]

With Pearl Harbor and the U.S. entry into the war in December, the prospects for the continuation of Adams's mural project had dimmed. He had written to Burlew on December 28, trying to lobby in patriotic terms, arguing that his project contributed to the war effort by presenting the landscape of America and the values it embodied—what Americans were fighting for. Ickes and the Interior Department could not be persuaded, however, to extend his contract beyond the fiscal year ending June 30, 1942. With this approaching deadline, he hurried to complete as much of his project as possible.

Adams left New York for California in May 1942. In early June he began his final round of mural project photography. It was proving to be an arduous enterprise. He was inflicting considerable punishment on himself, he admitted to Nancy Newhall, taking on a project of this scope while juggling all of his other commitments, but he seemed to thrive on it.[21]

His trip to Yellowstone was typical. Government rationing of tires and gasoline forced him to travel by train. The train arrived in Billings, Montana, at 6:00 P.M.; he waited there for the train to Livingston, which left at 11:00 P.M. and arrived at 2:15 A.M. Having no Pullman sleepers, he caught what naps he could sitting up. At the station he slept on a bench, with his baggage and camera cases piled nearby. Early the next morning he caught a bus to Gardiner, where he was met by a government car for the final leg to Yellowstone.

With all the logistical nightmares, he felt as if he were back in the previous century. He urged Nancy to relate his adventures to William Henry Jackson, the photographer employed on the original government

surveys of the Yellowstone region, who was then in his nineties and living in New York City. He was sure the old surveyor would appreciate his troubles. While Jackson had to carry a huge 57 × 118-inch plate camera and a portable darkroom on his western travels, Adams thought he had that topped with 280 pounds of cameras, tripods, typewriters, and assorted baggage all lugged from train to bus to roadside without the benefit of mules.[22]

Despite the inconvenience, Adams felt in his element here in Yellowstone. It was a wonderful, invigorating feeling to be in the vast spaces of the West, optimistic and relaxed. None of the intellectual squabbles and intrigue of the Manhattan intelligentsia seemed to matter much under the Wyoming stars. He urged Nancy and Beaumont to come see it for themselves.[23]

### The Road to Victory

By the first of July, Adams had completed his second round of travels. He had made hundreds of negatives, but the immense job of proofing them all and producing a set of master prints from which the Interior Department could make its selection for murals lay before him. After much negotiation Adams managed to stay on as a consultant to the department with no salary but with his printing expenses paid for.[24]

By November he had produced a set of 225 prints. On the fifth he mailed them to Washington, where they were to gather dust on the shelves of the Interior Department until 1962, when they were transferred to the National Archives. With Ickes's departure as secretary of the interior after the war, Adams's prospects for the renewal of his project faded. The murals had been Ickes's idea, and under the new administration there was little enthusiasm for them. With funding for additional travel unlikely, Adams did not make much of an effort to pursue the matter. He now sought a broader public audience.

Although this was a direction in which he had been moving for some time, Adams felt a new and significant impetus from an unlikely source. In the summer of 1942, while Adams was at work on his final round of mural project travels, Edward Steichen organized *The Road to Victory: A Procession of Photographs of the Nation at War*, a gigantic exhibition at the Museum of Modern Art. He had been invited to curate the exhibition because of both his established reputation as a crowd-pleaser and his newly acquired role as the chief of the U.S. Navy's photographic unit. The *Road to Victory* was inspired by the earlier *Image of Freedom* and *Photographs of America* exhibits, but Steichen carried the propagandizing to an extreme.

The *Road to Victory* was conceived while the *Image of Freedom* was still on the walls. The museum's director of exhibitions, Monroe Wheeler, explained the origins of the show. "Although the *Road to Victory* was planned in October 1941, America's entrance into the war immediately charged it with a new significance. Lieutenant Commander Edward Steichen, U.S.N.R., was especially assigned by the Navy to assemble the exhibition."[25] The entire second floor of the museum had been rebuilt to house the show. As the MoMA press release explained, "Although approximately 150 photographs have been used as the basic material, the exhibition is not one of photography in the ordinary sense, huge free-standing enlargements, many of them life-size or over, are juxtaposed dramatically with one another or with the murals—one of them 12 feet × 40 feet—affixed to the walls."[26]

The installation designer was the former Bauhaus member Herbert Bayer. Together Bayer and Steichen devised a show of spectacular visual impact. The installation itself and the sequence of images, rather than the individual photographs themselves, contained the message. The exhibition brought the concept of the photoessay, so influential in magazines and books of those years, into a museum setting. In addition to its obvious connection to the political mural art of the 1930s, the show

carried the flavor of Hollywood was well. Steichen, who had done frequent work for the studios, brought the visual impact of the big screen and the dream factory's penchant for sensationalism to the once staid gallery.

The display began with images of the land, with text supplied by Steichen's brother-in-law, Carl Sandburg. Entering the exhibition the viewer would have seen panels of buffalo and Indians followed by the first of the series of murals, an immense 12 × 16-foot view of Bryce Canyon, Utah. On the panel nearby was the first block of Sandburg's text: "In the beginning was virgin land and America was promises. . . ."[27]

Next were panels showing farms and ranches, corn and wheat fields to the horizon, cattle herds, and combine harvesters. Following these were images of industrial America and huge murals of government reclamation projects—Shasta Dam, Hoover Dam, the TVA. The natural forces of the land had been harnessed by decent, hardworking folk. Americans possessed the strength to defend their virtuous nation. Now the "arsenal of democracy" was at work.

After witnessing this stirring of the slumbering giant, the viewer would move to a panel of an isolationist "America First" meeting that quoted their slogans, "It can't happen to us" and "We've got two oceans protecting us." Immediately following was a dramatic photograph of the U.S. destroyer *Shaw* at Pearl Harbor exploding in a tower of flame, shrapnel, and black smoke. Hanging in front of this picture was one of the Japanese ambassador, Kichisaburo Nomura, and the Japanese peace envoy, Saburo Kurusu, "rocking with laughter." Opposite, seeming to stare grimly at them, was an image of an old Texas farmer, who was quoted as saying, "War—they asked for it—now, by the living God, they'll get it."

There followed a series of panels of the gathering American forces, fighter and bomber formations, and a huge mural enlargement of the battle for the Marshall Islands, with the text, "Smooth and terrible birds

of death—smooth they fly, terrible their spit of flame, their hammering cry, 'Here's lead in your guts.' Loads of death, tons on tons of annihilation, out of the sky and down down on the enemies of the free world."

The exhibition came to a close with "a final mighty climax," a mural, 12 feet by 40 feet, of a vast sea of armed and marching men. Accompanying it were panels showing mothers and fathers from different parts of the country: "America, thy seeds of fate have borne a fruit of many breeds, many pages of hard work, sorrow and suffering—tough strugglers of oaken men—women of rich torsos—they live on—the fathers and mothers of soldiers, sailors, fliers, farmers, builders, workers—their sons and daughters take over—tomorrow belongs to the children."[28]

In its overheated rhetoric and heavy-handed imagery, the show was typical of the wartime propaganda that began to issue from both the public and private sectors. The strange combination of sentimentality and vicious war fever evidenced in the *Road to Victory* was hugely appealing to the public and drew unprecedented crowds from the first days of its opening. It was not simply the general public that was impressed. Reviews from across the journalistic and political spectrum chimed in their praises. The *New York Times* hailed it as "the season's most moving experience." The New York *Herald Tribune* called it "a show of inspiring purposes . . . a declaration of power and an affirmation of our will to win the war." Even the *Daily Worker* found it "the most sensational exhibit of photographs that ever was shown in these parts. What a country to fight for!"[29]

Beaumont Newhall, on whose turf Steichen was treading none too lightly, was less ecstatic. As he reported to Adams,

> the Steichen shebang got up on the walls in time for the opening by nothing short of a miracle. The public finds the show very exciting, and we have been showered with praise about it. Between you and me the show, for all its spectacular timeliness, has nothing whatever to do with

photography, and may be more harmful than good. It's like a Stokowski orchestration of a Bach fugue: very spectacular, very tuneful, very popular but it ain't Bach and it ain't good taste.[30]

Adams agreed completely. He thought the exhibition belonged in Madison Square Garden rather than in the Museum of Modern Art. Steichen, he felt, was more concerned with theatrics and attracting a huge crowd than with photography as a serious art form. Steichen's liberties with photographic print quality were a particularly irksome point to Adams. He thought the huge enlargements were amateurishly produced, with a grainy texture and a limited range of values, all muddy grays. He felt the exhibition was not about photography at all; it was a bombastic harangue that happened to use the medium of photography to achieve its goals.[31]

For all his ranting against it, Adams was profoundly influenced by the success that Steichen had achieved. Just as he had learned from the prevailing photographic practices in the 1930s, Adams now absorbed crucial lessons from Steichen's accomplishment even as he criticized it. That kind of public outreach had, after all, become his highest ambition. He wanted to achieve it on his own terms, however, on terms that would be true to the art of photography as he understood it. He wanted to achieve an emotional impact without sacrificing the integrity of the photographic print. He wanted to communicate ideas and persuade public opinion without falling into sentiment and propaganda.

### Manzanar

After he had completed the printing of the mural project photographs in the fall of 1942, Adams continued to search for ways to make a meaningful contribution to the war effort. His first war-related assignment was in Yosemite. The valley was being used as a practice destination for

mobile artillery companies. After hauling their field cannons across the San Joaquin Valley and up the winding roads to Yosemite, the troops were given time off for rest and recreation. Adams was assigned the task of escorting them around the valley and photographing their excursion. The colonel in charge of one of these artillery units asked him to come to Fort Ord, outside of Monterey. It seems that the repair and maintenance unit he commanded was not receiving adequate photographs from the Signal Corps, so the colonel wanted his men to learn to provide their own photographs. This brief assignment led to another at the San Francisco Presidio, where Adams printed top-secret negatives of Japanese military installations in the Aleutian Islands.[32]

At Art Center in Los Angeles, where he continued to teach on a part-time basis, Adams instructed photographers from the army Signal Corps. He taught technical basics as well as skills suited particularly to wartime situations. In one test, he placed the students in the basement while he stood at the school's street-level entrance. As a streetcar approached, he yelled down the stairs, "Attack!" The students rushed upstairs, as yet unaware of their subject. Adams told them to photograph the streetcar before it reached the corner. As the students raced into the street, no doubt to the surprise of any passersby, they whipped their cameras from their cases, focusing and setting the shutter and aperture controls on the run. After getting the best shot they could manage, they ran back to the basement to process the film as rapidly as possible and presented the results to Adams.

Another, less enjoyable, training exercise was for the city of Los Angeles and its civil defense program. Fearing the worst, the city wanted to devise a system for identifying corpses in case of a major civil disaster. Adams devised a method for making rapid mug shots: by placing a mirror close to the victim's head, one could get a single photograph of both the profile and the full face. He took his Art Center students to the county morgue to practice.

By the end of spring semester, Adams was thoroughly fed up with his duties in Los Angeles. After his final class at the morgue, he loaded his car and drove all night up the coast to Carmel. Edward Weston greeted him as he pulled in not long after dawn. After his usual bearhug, Weston stood back a step or two. What was that nasty smell? Adams explained his duties in the morgue as Weston shook his head, amazed at what his friend put himself through in the name of earning a living.

That day Weston made a portrait of the smelly artist, still in his Los Angeles suit. Later when Weston sent him prints, Adams was full of praise for the photography but less enthusiastic about his face. Fatigue and formaldehyde had clearly taken a toll. Also, he had shaved his beard a few years earlier, perhaps to present a more professional image now that he was on the advisory board at MoMA and a commercial photographer of some repute. Now he was reconsidering. There was also the matter of the nose, but that, unfortunately, could not be changed. He admitted that Weston had captured his state of mind, but it was not something he cared to be reminded of. Particularly interesting was Adams's pose. Weston had framed the image so that the portion of the wooden gate Adams was holding looked as if it was a cross he bore. Weston's wry commentary on his friend's self-imposed martyrdom may not have been the most flattering portrait of Adams, but it was certainly among the most revealing.[33]

Adams was working too hard, as usual. But he still felt that he was not making any real contribution to the war. He continued to look for a meaningful project. He had tried all available means to become involved in a serious way, he reported to Stieglitz in August 1943, with no real success. For all his efforts to contribute, he was not a blind supporter of the war. The tragedy of the war was not simply the obvious costs in lost lives but the hidden toll on the survivors: the ugliness and brutality would scar their minds for the rest of their lives.[34]

The wartime propaganda filling the press, the airwaves, and the

museums seemed to him to be missing the point. He was growing very tired of the sentimental patriotism it relied on. The orchestrated crescendo of hype seemed to trivialize the American spirit it set out to glorify. Adams felt the "pure" artist had more to say about that spirit. John Marin's simple and incisive paintings and Stieglitz's serene photographs were, he argued, examples of the kind of art that spoke to the deeper realities of life, not the bombast of the moment. A society in which such art could flourish was something worth fighting for.[35]

The opportunity Adams sought came in an unexpected form. In the immediate aftermath of Pearl Harbor, Americans of Japanese ancestry had come under intensive social and governmental pressure. Adams first heard about the situation from his parents' gardener in San Francisco, Harry Oye. Born in Japan, Oye had lived in the city for years and was an important figure in the local Nichiren Buddhist temple. In March 1942, he was notified to appear at the San Francisco assembly center. There was no time to put his affairs in order. He was only allowed to bring what luggage he could carry.

Oye's case was echoed throughout the Japanese-American community. Despite being a clear violation of the Constitution, the internment law was signed by President Roosevelt in February. Military leaders, western congressmen, and the American public generally supported the move to eliminate the threat these Americans were thought to pose. Although no actual or planned acts of disloyalty had occurred, as far as the army was concerned "the very fact that no sabotage had taken place to date is a disturbing and confirming indication that such action will be taken." By the end of March, 110,000 Japanese Americans had been forced into concentration camps. Of these 70,000 were citizens born in the United States.[36]

Among those interned was Toyo Miyatake, a Japanese-American photographer living in Los Angeles. Miyatake and his family were assigned to the Manzanar Relocation Center in the Owens Valley, at the

eastern base of the Sierra Nevada. A photographer, he felt compelled to record what he found there. Using a lens and film holder he smuggled into the camp with the few belongings prisoners were allowed, Miyatake built a rough box camera from scraps of wood and plumbing he found around the camp. He attached his single 4 × 5-inch film holder to the back and fitted his lens into a length of threaded drainpipe. For some time Miyatake successfully managed to photograph the life of the camp with this strange-looking device. After nine months his camera was discovered. Luckily, the camp's newly appointed director, Ralph Merritt, proved sympathetic to Miyatake's aims. To bypass military regulations forbidding any Japanese American to make photographs, Merritt assigned a white camp worker to release the shutter after Miyatake had positioned his camera. As soon as military restrictions eased, Miyatake sent to Los Angeles for the studio and darkroom equipment he had stored there at the time of internment.[37]

Merritt was a member of the Sierra Club and a friend of Adams. One day in the late summer of 1943, not long after he had taken over at Manzanar, Merritt stopped by Adams's home and studio in Yosemite. Adams told him of his frustration at not making a real contribution during the war. As Adams recalled it, Merritt urged him to appreciate his good fortune and to continue his photography of the natural world, for such images contributed to the national defense in their own subtle way. Adams was not satisfied with this. Perhaps the criticisms of his aloofness from social issues, the suggestions that he was merely submerged in a pleasant dream world of natural beauty, seemed especially biting at this time of global catastrophe. He told Merritt he wanted a human story to tell. "I do have a project that might interest you," Merritt replied. He told Adams about his new assignment at Manzanar and asked whether he would be interested in documenting the lives of those interned there.[38]

Adams immediately recognized the importance of the project. He

had been angered at the injustice of the operation since hearing of the fate of Harry Oye. Now he would have the opportunity to address an issue beyond the empty rhetoric of wartime propaganda, one that might awaken Americans to a realization that while the nation spoke of securing freedom throughout the world, there remained deeply rooted injustices at home. He accepted no official sponsorship, since he feared it might be used to manipulate his work or open it to accusations of being government propaganda. While Merritt gave him free rein at the camp, Adams supplied his own equipment, film, and labor.[39]

Adams's approach was sympathetic and upbeat. He tried to stress that the prisoners at Manzanar were loyal American citizens (the War Relocation Authority [WRA] had segregated "loyal" from "disloyal" on the basis of citizenship and signed oaths) and that they were engaged in productive work in the camp—creating small businesses and farms, gaining confidence and a sense of self-sufficiency that, he felt, would enable them to successfully integrate with the general society after the war. He was eager to illustrate their perseverance under trying circumstances and their success at turning the camp at Manzanar into a relatively harmonious and thriving community. Although Adams did not emphasize it, these middle-class values of industry and entrepreneurship were already strongly ingrained in the Japanese Americans. In fact, it was their considerable success in the California economy that had so irritated many of those who supported the internment.

Adams and Miyatake met at the camp. While their situation and backgrounds were clearly different, they were surprisingly similar in their photographic approach to Manzanar. Above all, they shared a positive interpretation, showing the internees actively working to turn adversity to their advantage. Miyatake tended to choose images of order and beauty—a small Buddhist shrine, a well-tended garden—and images of good times—a baseball game, a Christmas celebration, a picnic. Adams emphasized the various work activities—farming, the camp's news-

paper, dressmaking, electrical repair—all facets of the spirit of energy and competence he found there.

Adams and Miyatake shared a positive emphasis in their portraiture as well, showing the residents of the camp as stoic, proud, and cheerful. Adams made a large number of individual portraits, generally shot from slightly below the subject's eye level (thereby giving a heroic and powerful aspect to the face) and from straight ahead in direct sunlight or with a single direct light source (giving a simple, solid, and forthright appearance). The people in these portraits appear friendly and honest, strong and confident—all qualities at odds with the prevailing racial stereotypes of the day.

Miyatake was less likely to make individual portraits, choosing instead to portray group activities. Not only was this indicative of a cultural emphasis on community over the individual but it also gave his images a more natural, unposed character. While Miyatake generally showed the hard work and resiliency of the internees, he also made powerful images revealing Manzanar as the concentration camp it was. This was not something Adams was willing or able to do. WRA restrictions prevented the depiction of the barbed wire and guard towers that ringed the camp, and his own inclinations led him to stress the "positive."

Adams and Miyatake were not alone in photographing the camp at Manzanar. Soon after the internment process began under the direction of the WRA, a number of photographers, including Dorothea Lange, were hired to record the various phases of the operation.[40] Lange went to work for the WRA in the spring of 1942 and remained on its staff for the next year and a half. Her project was far more inclusive than Adams's. She visited a majority of the assembly and relocation centers around the western states. Furthermore, she photographed the entire internment process, not simply its latter, relatively more tranquil, stages. Adams arrived at Manzanar only after the camp had been in operation for some

time. The neat community he found and recorded had not begun that way. Lange photographed the dusty, ramshackle conditions of the initial stages and the efforts of the internees to make a home in what she viewed as an extremely harsh environment.

Although they both photographed the camp at Manzanar, Lange and Adams carried out separate projects and approached their subjects from different perspectives and with different goals in mind. Whatever the government's purpose in photographing the internment, Lange was motivated by her outrage over the injustice of the entire operation and her sympathy with the captives. She did not share Adams's view about the inspirational qualities of the site or the social benefits of life in the camps.[41]

A comparison of the three photographers' approaches to farming at the camp gives a sense of their different conceptions of life at Manzanar. In *Field Workers Hoeing Corn, Manzanar Relocation Center, July 1942*, Lange shows the agricultural labor as harsh backbreaking work. Her low angle of view and bleached-out whites convey a sense of drudgery in the hot desert sun. Adams's *On the North Farm at Manzanar, 1943*, presents a grand panorama of orderly rows and industrious workers against a backdrop of magnificent Sierra peaks. In *Chrysanthemum Specialist*, Miyatake takes a closer view, showing the beauty the people had created amid their incarceration.[42]

Unlike Lange, Miyatake and Adams both did a good deal of landscape photography around the camp. While Miyatake's images of cloud-enshrouded peaks drew on traditional Asian landscape styles, Adams photographed wide vistas filled with dramatic light, in a modernist version of the sublime.[43]

In the text to the book Adams eventually made of his experiences at Manzanar, *Born Free and Equal*, he emphasized his belief that the natural environment of the Owens Valley had helped to sustain the optimism of those at Manzanar and had contributed to their perseverance in the

midst of a difficult situation. It was his clearest statement to date of his attempt to portray the natural landscape in social terms—its role in the nation's history and culture and its potential as a spiritual resource in the contemporary world.[44]

Adams made two of his best-known landscapes while working at Manzanar, *Mount Williamson, the Sierra Nevada, from Manzanar, California, 1944*, and *Winter Sunrise, the Sierra Nevada, from Lone Pine, California, 1944*. For both photographs, Adams consciously sought out the most sweeping point of view and the most dramatic light. In the case of *Winter Sunrise*, he had been waiting for the right combination of light and weather conditions for some time. He knew he wanted the low-angled light of sunrise to put the peaks into bold relief. When a December storm laid down a fresh dusting of snow, he decided the time was right.

He and Virginia, who was staying with him in a barracks quarters in Manzanar, got up before dawn, prepared a thermos of coffee, and headed south to Lone Pine. They pulled off the road just north of town at a spot from which Adams had made several earlier attempts. In the front seat of the Pontiac, sipping their coffee in the cold winter air, they watched as the sun ascended the horizon, turning the snow-covered range a glowing pink. As the sun climbed higher, the peaks turned a dazzling white. Big clouds left by the passing storm moved through the sky, projecting shadows on the pasture and low rolling hills in the foreground and middle distance.

Adams climbed up onto the roof platform of his station wagon where he had set up his 8×10 camera, feeling that the right moment would soon be at hand. As the cloudscape drifted past, sunbeams shone down on the cottonwood trees in the foreground, just as he had hoped. Adams wanted to release the shutter, but the horse grazing in the pasture was facing away from the camera. At that moment it obligingly turned to profile and Adams made the photograph.[45]

In *Born Free and Equal,* Adams spoke of the "huge vistas and the stern realities of sun and wind and space [that] symbolize the immensity and opportunity of America." Here was the image to convey those ideas. Throughout the rest of his career, Adams would use *Winter Sunrise* and a handful of other grand landscapes as symbols of the role that wilderness played in American culture.[46]

The power of *Winter Sunrise* comes from its strong graphic organization as well as its symbolic associations. Its sharp juxtaposition of values, brilliant whites against deep black, interspersed with bands of middle grays gives the image an immediate impact. The photograph is made up of four distinct planes, the middle grays of the foreground, the dark values of the middle ground, the light values of the peaks, and the middle grays of the sky and clouds. This horizontal banding is broken up only slightly by the highlighted line of cottonwood trees leading diagonally into the frame, drawing the eye into the picture's depth.

The interplay of romantic and modernist styles characteristic of Adams's work in these years shows itself clearly here. The two-dimensional series of horizontal bands gives the image its modernist simplicity and strength, while the vast three-dimensional space and enveloping light give it the romantic grandeur he often sought out in the war years.[47]

It is appropriate that *Winter Sunrise* has become one of Adams's best-known photographs. Like *Moonrise, Hernandez, New Mexico,* it combines the various strands of his art and ideas into a unified and powerful statement. It was his belief that nature's enduring beauty had "strengthen[ed] the spirit of the people of Manzanar." He felt it could do the same for the entire nation.

The Manzanar project attracted a great deal of attention and controversy. Adams wrote to Nancy Newhall soon after he completed his photography at the camp. He explained that the project was bound to be

controversial and for that reason he hoped to keep it confidential for the time being. He described the atmosphere of intense racial animosity in California toward all persons of Japanese descent, citizens and aliens alike, which he attributed to reactionary elements and to agricultural and business groups jealous of the success Japanese Americans had achieved. He felt the project was among the most significant of his career and an important contribution to the war effort.[48]

Newhall thought Adams's photographs deserved an exhibition at the Museum of Modern Art and immediately began working out the details. In her press release announcing the show, she emphasized the racial issues at its core. "With the coming of peace, photographers will undoubtedly play an increasingly significant role interpreting the problems of races and nations one to another all over the world." Considering the controversy surrounding the internment, Newhall's direct reference to the race issue was daring. Perhaps most controversial for the museum's board of directors was the inclusion of a panel quoting the Fourteenth Amendment, guaranteeing due process of law to citizens of all races, and a letter written by Abraham Lincoln in 1855.

> As a nation we began by declaring that "all men are created equal." We now practically read it as "all men are created equal except Negroes." When the Know-Nothings [a short-lived, but widely supported third party] get control, it will read "all men are created equal, except Negroes and foreigners and Catholics." When it comes to this, I shall prefer emigrating to some country where they make no pretense of loving liberty. . . . Where despotism can be taken pure, and without the base alloy of hypocrisy.[49]

This was too much for the MoMA board, even if the words came from the revered former president. The exhibition was canceled twice

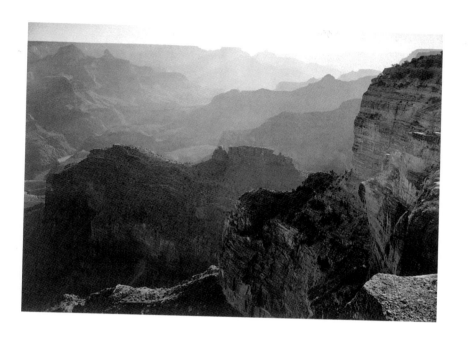

*Grand Canyon National Park.*
Courtesy National Archives.

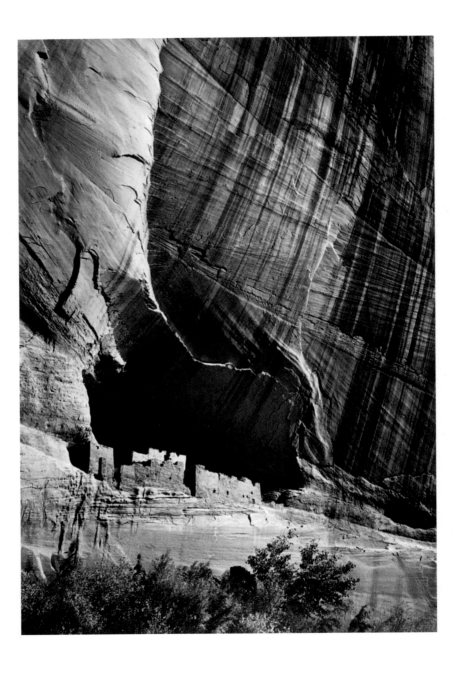

Left: *White House Ruin, Canyon de Chelly.*
Courtesy National Archives.

Above: *Mother and Infant, Canyon de Chelly.*
Courtesy National Archives.

Left: *Tower at Cliff Palace, Mesa Verde National Park.*
Courtesy National Archives.

Above: *Walpi, Arizona.*
Courtesy National Archives.

Left: *Leaves, Glacier National Park.*
Courtesy National Archives.

Above: *Cloud Covered Mountain, Glacier National Monument.*
Courtesy National Archives.

Above left: Anonymous, *Road to Victory, Installation View, 1942.*
Courtesy Museum of Modern Art, New York.

Left: *Margaret Fukuoka, Manzanar Relocation Center.*
Courtesy Library of Congress.

Above: Toyo Miyatake, *Children, Manzanar Relocation Center.*
Courtesy Miyatake Studios, San Gabriel, California.

Dorothea Lange, *Mother and Baby Await
Evacuation Bus, Centerville, California.*
Courtesy National Archives.

Dorothea Lange, *Fieldworkers, Manzanar Relocation Center.*
Courtesy National Archives.

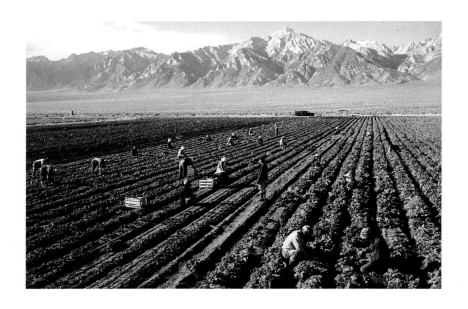

Above: *On the North Farm at Manzanar.*
Courtesy Library of Congress.

Above right: Toyo Miyatake, *The Chrysanthemum Specialist,*
*Manzanar Relocation Center.*
Courtesy Miyatake Studios, San Gabriel, California.

Right: *Tom Kobayashi, Manzanar Relocation Center.*
Courtesy Library of Congress.

Above: Ansel Adams and Dorothea Lange, *Freedom of Speech.*
Courtesy National Archives.

Right: Ansel Adams and Dorothea Lange, *Freedom of Religion.*
Courtesy National Archives.

Dorothea Lange, *End of the Shift, Richmond, California.*
Copyright the Dorothea Lange Collection, The Oakland Museum,
The City of Oakland. Gift of Paul S. Taylor.

until it was finally accepted with the offending panel removed and the title changed from *Born Free and Equal* to *Manzanar: Photographs by Ansel Adams of Loyal Japanese American Relocation Center*.[50]

Despite these compromises, Nancy Newhall reported that "photographers were full of praises" when the exhibition opened in the fall. "Some, as I expected, tempered their praise of your technique with the comment, variously phrased, according to intelligence, 1: that it was 'static,' 2: that you were too kind, too courteous, toward people (Roy Stryker and his gang), 3: (Paul [Strand]) that its guts had been removed by the museum's censorship."[51]

The show was well received by the general public, and its run was extended several weeks. The Office of War Information was interested as well. In late November, Adams received a letter expressing the OWI's desire "to use the superb collection of pictures which you took of the Japanese Relocation Center at Manzanar, California. Pictures showing American kindness to Japanese have been urgently requested from our Pacific outposts to combat Japanese propaganda which claims our behavior is monstrous."[52]

It is highly unlikely that the government included the offending reference to the Fourteenth Amendment or the letter by Lincoln.[53] Nevertheless, Adams was pleased to comply and sent a number of additional prints was well.[54] His eagerness to help the government's overseas propaganda campaign to paint an inaccurate picture of the internment for the Asian audience may seem inconsistent with his personal feelings. Yet Adams's loyalties to the war effort went beyond any desire to debate the fine points of interpretation. Such a position did not satisfy Dorothea Lange. Although Lange later remarked that Adams's treatment of Manzanar was "far for *him* to go," she felt that he had not gone far enough in his condemnation. He seemed to her to be supporting the government view.[55]

It was a sentiment echoed by some in the Japanese-American community in later years. Reiko Gaspar, a former chapter president of the Japanese American Citizens League, told a reporter covering a revived exhibition of the photographs in the 1980s that "Ansel Adams was a stranger. The Japanese Americans . . . only showed their best, . . . they were not ready to show their sorrow or their anguish." Yet others felt that the image of the camp that comes through in both Adams's and Miyatake's photographs was true to the spirit of the people in the camp. Ben Omaha, who was interned in Arizona during the war, felt that "the photos really show the joy in our faces that we had made those places livable and pleasant."[56]

Adams sought to present the collection as a book. *U.S. Camera* offered to publish it, but, like the Museum of Modern Art, its editors were wary of the potential controversy.[57] Adams prevailed on them to include the text removed by the MoMA board—the Fourteenth Amendment and the letter by Lincoln—and went so far as to open the book with it. Following that was a foreword by Secretary Ickes, which read in part, "It is my prayer that other Americans will fully realize that to condone the whittling away of the rights of any one minority group is to pave the way for all of us to lose the guarantees of the Constitution."[58] It was a strong statement coming from a member of FDR's cabinet and the head of the department under whose jurisdiction the War Relocation Authority operated.

Adams was impressed with Ickes's ability to cut to the heart of the issue and the political bravery he showed in associating himself with the project. Adams urged Newhall to vote Democratic in the upcoming election. He wondered if those who supported liberal values, as Ickes so clearly did, really understood how those values would be challenged in the coming years. As the Cold War began and anti-Communist hysteria rose, Adams would find that question prophetic.[59]

Adams was well aware of his reputation for being unconcerned with people and social issues. He hoped that he was beginning to prove his critics wrong. His recent ventures into the documentary field demonstrated, to his satisfaction at least, that he was not an antisocial aesthete, aloof in an ivory tower. They represented an important transformation in his work, he told Stieglitz, and a new phase in his career.[60]

His satisfaction with this new work encouraged him to attempt other documentary projects. Manzanar had made him sensitive to the issue of race in America, and he suggested to Nancy Newhall that they undertake an exhibition and book on that theme. In the interest of manageability, they agreed that the topic should be narrowed to a study of African-American education. In October 1945, he reported to Nancy that "the Negro book" was moving ahead.[61] They continued to work on this amid their many other projects for several years. Adams met with a variety of leaders in the black community, including W. E. B. Du Bois, from whom he received encouragement and advice. He and Nancy wrote to many photographers, explaining the plan and requesting their participation in the project. After four years of intermittent work, they abandoned it for lack of support from any publishers.[62]

Although Adams and Lange had not worked together at Manzanar, they soon had the opportunity to collaborate on a series of assignments for the Office of War Information. In her FSA years, Lange had established her reputation for sensitive handling of human subjects. She was also known for being temperamental on occasion and for the varying technical quality of her work. Adams, however, was known for his workmanlike reliability and his unexcelled technical proficiency. While he was not considered a great documentarian, he was the one to call

for any technically demanding subject. The two complemented each other well.

Their assignment was to photograph minority groups in California for use in the agency's magazine, *Victory*. It was a large-format publication, first published in the winter of 1943, featuring articles, photo-essays, and paid advertising, much like any commercial pictorial magazine. *Victory* had a wide circulation overseas, where it was distributed among the Allies and several neutral nations as well. In addition, copies of various issues were dropped from planes over enemy territory to encourage public support for the Allied cause by promoting an image of the equality and opportunity given to European minorities living in the United States.[63]

Beaumont Newhall, who was stationed in Italy as the Allies made their push up the peninsula, came across an Italian-language edition of *Victory* in the town of San Severo. He was particularly struck by the group of photographs depicting Roosevelt's "Four Freedoms" as they were supposedly enjoyed by Italian Americans in San Francisco. He sent the article to Nancy, telling her that "the handling of the Four Freedoms theme is the best which I have seen."[64]

The series contained four images. *Freedom of Speech* showed a group of men talking on a street corner. Its caption read in part, "[As is] the custom of Americans of Italian origin in San Francisco, Sunday after Mass, the men stay behind to talk politics and the war." *Freedom of Religion* portrayed churchgoers exiting the church of Sts. Peter and Paul in North Beach after Sunday Mass: "Like very many Italian-Americans, the inhabitants of the Italian quarter of San Francisco are deeply religious." *Freedom from Want* showed a farmer in overalls standing among grapevines on a rolling hillside, its caption informing the Italian villagers that "California is one of the richest agricultural regions of America, and Italian-Americans have greatly contributed to make it so." In the final image, *Freedom from Fear*, eight children walk hand in hand

across a city street, escorted by a smiling policeman. "The Italian-American kids know that policemen are friends and protectors of the public."[65]

"I wonder who made these photos?" Beaumont asked. "I wouldn't be surprised if we found that they were taken by someone we know." Nancy wrote back telling him of Lange's and Adams's work for the OWI in San Francisco. Beaumont's suspicions had proven correct.[66]

Lange and Adams undertook other similar assignments for the OWI, photographing Hispanic farmworkers in the Central Valley and Italian Americans in Los Angeles. They tried to show their life and work in a positive light and to convey an idea of the freedom they had found in America. They tried not to paint too rosy a picture, however, so that, as Lange recalled, it would not "look as though during the war we had a surfeit and plenty [in these photographs destined] to go to people who were suffering the ravages of war."[67] *Victory* presented a carefully culti-vated image to the world. There was no mention of the hardships and unequal wages endured by the Hispanic workers under the Bracero pro-gram, the segregation enforced on the black shipyard workers, or the internment of the Japanese Americans.

All of the photographs Adams and Lange made on assignment for *Victory* were turned over to the Office of War Information, whose staff wrote the articles, did the layouts, and composed and translated the captions in various languages. The photographers were not credited. All in all, it was a surprising switch for both Adams and Lange, who were particularly adamant about preserving control over their work. For Lange, an added departure was the upbeat tone that glossed over so many of the social problems she tended to focus on in her own work. That she accepted this so willingly illustrates the extent to which artists of all political persuasions were submerging their personal beliefs out of support for the Allied cause. Although Adams may have had less distance to travel in aligning himself with the government's purposes, he too

adapted his usual mode to the demands of the moment. In so doing he entered new areas of work in the documentary realm that he would otherwise have been unlikely to explore.

Adams had received no pay while pursuing his Manzanar assignment and only a moderate day rate while working for the OWI. There were still bills to be paid, which forced him to continue to seek out commercial assignments. Among his most rewarding projects in these years were those from *Fortune* magazine. As a leading business periodical, and at the time having a strong interest in photojournalism, *Fortune* sponsored a series of photographic essays on the effects of the wartime economy in the West. *Fortune*'s editors commissioned Adams and Lange to cover the booming wartime shipyards in Richmond, California, on the shores of San Francisco Bay.[68] FDR's reluctance to prepare for the war contributed to a huge industrial demand in the wake of Pearl Harbor. Since the Pacific was to play a key role in the naval war, the West Coast became a principal site for military shipbuilding efforts, with California the focal point. West Coast shipyards accounted for 52 percent of all vessels built during the war, and San Francisco by itself produced more than a third of the total tonnage.[69] The town of Richmond, the Bay Area site of shipyards owned by the Kaiser and Permanente corporations, experienced a 400 percent increase in its population between 1940 and 1944 as workers flocked to take advantage of the boom.[70]

The huge expansion of population and industry brought new social pressures to the community. Although it was a blessing to those who had suffered through the hard times of the depression, the workers arriving at the shipyards and other wartime industries found new kinds of hardship to endure. Housing in the surrounding areas was extremely tight. For blacks, many of whom were recent immigrants from the rural South, housing shortages were exacerbated by racial discrimination and segregation.[71]

For Adams, it was an immersion in a world he usually liked to avoid.

As he and Lange followed their assignment into the lives and living conditions of the workers, they saw many "things that were not too pleasant." Most workers made the best of what was available to them. Some gathered in trailer camps on the mudflats on the edge of the bay. Adams and Lange walked over fifty feet of wooden planks in the mud to photograph them. Working with Lange, Adams seemed to absorb some of her style. In these camps he made some of his most sensitive human documents, with a more intimate style than his typically rather stiff and formal portraiture.[72]

The trailer camps were comfortable compared to the sleeping arrangements of some. Adams recalled crossing the bay on the Richmond ferry with workers who had gotten off the day shift at factories on the San Francisco peninsula. He found them stretched out near the ship's boilers, trying to catch whatever sleep they could before working another eight-hour shift in Richmond.[73]

Lange tried to capture what she saw as the "new California" taking shape in these wartime cities. One of the photographs she considered most successful was made at the end of a shift at the Richmond shipyards. "It was a mass of humanity," she recalled, "from all parts of the country. They had their tin hats on and they came down in this *river*. But what made the photograph so interesting was that they were all looking different directions. They were *not* a group of people united on a job. It showed so plainly."[74]

The teeming crowds and lack of social cohesion that Lange found in the shipyards would appear throughout the state in the postwar era, raising questions about whether the environmental, economic, and social qualities that drew people to California could be preserved in a period of unprecedented growth.

For Adams, the postwar years would present similar opportunities and challenges. As the war drew to a close, his art was in many ways at its defining peak. The first decade of his professional career in photog-

raphy, during the 1930s, had seen him translate his youthful experiences in the wilderness and the world of modern art into photographs of formal elegance and technical brilliance. The turmoil of the late 1930s and early 1940s convinced him of the importance of applying his art to the crucial issues of contemporary life and to reaching a wider audience. In the postwar decades, Adams would continue to reach out to a mass audience, bringing his vision of nature to a world beset by tension and conflict.

# WILDERNESS AND
# THE POSTWAR WEST

IN THE WINTER OF 1945 it looked as if the war would soon be ending. Adams considered applying to the Department of the Interior to renew his mural project, but the prospects had dimmed with the resignation of Harold Ickes in 1944. He decided instead to expand and reshape his national parks photographs into a book. He saw this as an opportunity to take a new approach. While he was admittedly unsure of what form the book would take, he knew for certain that he would address his photographs not simply to the bureaucrats in Washington but to the entire American public.[1]

He explained his ideas in an article for the *Sierra Club Bulletin* in December 1945. The appreciation of nature had taken root in America, he said. Though fragile and threatened by overwhelming forces, a conservation ethic was beginning to grow. Despite the illusions and distortions of commercial interests that exploited the natural world for their own benefit, despite the threats of development and degradation, much of the primordial landscape endured. To protect this irreplaceable national treasure, the public must be made aware of what was at stake, to understand why wilderness mattered. In this effort the photographer could play a vital role, raising awareness and inciting action. He saw this

as his personal mission; he believed it should be the mission of the Sierra Club as well.[2]

For Adams, the focus of this effort was his extended project in the national parks. With a new administration in Washington and Ickes no longer running the Interior Department, Adams realized that funding from the federal government was unlikely. He applied instead to the Guggenheim Foundation, which had earlier provided fellowships to Edward Weston and Walker Evans. A project as idealistic as the one he had in mind seemed a good prospect for support.

## Teaching

While Adams awaited word from the Guggenheim Foundation, another opportunity presented itself. His friend Ted Spencer, architect and consultant to the Yosemite National Park and Curry Company, was serving as president of the San Francisco Art Association in 1946. One of his duties involved overseeing the operation of the California School of Fine Arts. Formerly a relatively small program, the school was entering a period of expansion as the GI Bill brought a stream of returning veterans into the ranks of the nation's higher education system. Spencer suggested that Adams inaugurate a department of photography.[3]

Adams had quit his job at Art Center several years earlier, but he still felt the desire to teach. While this desire was partially a matter of financial necessity, it also stemmed from his belief that professionalism included not only a complete dedication to the field but also an obligation to pass on one's knowledge to others.[4] It is not surprising, therefore, that he accepted the offer.

Spencer and the school's director, Douglas McAgy, provided him with a spacious studio for his classes and helped him design a new darkroom area in the basement of the main campus building. Adams was given the task of raising the $10,000 necessary for its construction. After

considerable effort, he obtained a grant from the Columbia Foundation and construction began. Once the new facilities were in place and his classes were under way, he found unexpected hostility to his presence. The artists of other disciplines protested that photography did not deserve its own department, Adams recalled, and many questioned whether it could be an art at all.[5]

Perhaps he exaggerated their resistance because the program remained and was soon flourishing. Nevertheless, he continued to feel somewhat out of step with the artistic direction of the school, which was becoming in those years the West Coast center of abstract expressionism—a new development in the arts with which he felt little sympathy.

As he had at Art Center, Adams emphasized technical excellence in his teaching. This, he believed, was the key to the liberation of creative vision. He based his instruction on two fundamental principles. First was the practice of visualization. Trial-and-error methods and rapid-fire shooting were inimical to his ideal. Second was the zone system, which he had developed some years before. While the methods of quantification required left some students perplexed, for Adams it was a necessary part of achieving command of the medium.

Adams's return to teaching got him thinking about an expanded edition of his technical guide, *Making a Photograph*. He especially wanted to explain the principles and techniques of visualization and the zone system, as he had developed and refined these since the publication of the book in 1935. It soon became clear that the in-depth guide he had in mind would require several volumes. After securing an agreement with the photographic publishers Morgan and Lester, he began work on the first volume of what he would call the *Basic Photo* series. Always eager to play the evangelist, Adams hoped that his books would help to raise the level of quality among both amateur and professional photographers.

Two years later, in 1948, he published *Camera and Lens*, which of-

fered a detailed discussion of the characteristics and operation of a wide range of equipment, with a particular emphasis on the large-format view camera. He followed with *The Negative* later that year and *The Print* in 1950, laying out in exhaustive detail the principles of his zone system. No matter how involved his technical discussions, however, Adams always reminded his students that expression and communication were the ultimate goals of art.[6]

## Changes

After the war, Beaumont Newhall had returned to New York and what he assumed would be the resumption of his job as curator of the Museum of Modern Art's Department of Photography. That did not turn out to be the case. In December 1945, Stieglitz had warned Nancy to "watch out for Steichen. He wants to take over the department."[7] Reportedly, the idea was first suggested by Henry Allen Moe, director of the Guggenheim Foundation and an important figure in the New York art world. He asked Tom Maloney, editor of *U.S. Camera*, if Steichen would be interested. Maloney suspected that he would and put the question to him directly two days later. Steichen enthusiastically agreed. Moe reported Steichen's willingness to the museum's board of trustees, who supported the idea given that his salary would not result in an increase to the museum's budget. What may have convinced them was Maloney's plan to raise $100,000 from a number of photographic manufacturers to expand the department's program (and to pay Steichen's higher salary). The Advisory Committee on Photography was not consulted at all. David McAlpin first heard about it at a trustees' meeting sometime after the fact and reported the news to Newhall.[8]

"As near as I can make out I'm being screwed," Beaumont reported to Adams on hearing of the plan.[9] Steichen had hoped that Newhall would be willing to stay on as curator of photography under his direc-

tion. Newhall considered the proposal but realized he could not play second fiddle to Steichen. Steichen's inflated ego and showmanship were not compatible with his own scholarly approach to photography. Having built the department from the ground up, he was unwilling to assume the position of someone else's assistant.

McAlpin and Adams were outraged. Adams considered Steichen "the anti-Christ of Photography."[10] Soby and the entire photography advisory committee expressed their anger with the move by resigning en masse. As Mariam Willard, chair of the advisory committee, recalled, "This was the first time that commercial money, I believe, came into the museum in such a way." This and the cavalier treatment accorded Newhall "got us concerned about the direction the museum was taking."[11]

For Newhall, such concerns were too late in coming. He had already decided it was time to leave. "The Rubicon is passed. The die is cast," he informed Adams in early March. "After these months of indecision, after Nancy and I had talked ourselves out about the whole matter, I have at last come to a final and irrevocable decision. The Museum cannot have me if they have Steichen."[12]

With Newhall's departure and his own connections to the Museum of Modern Art severed, Adams began to spend less time in New York. He did, however, continue his regular correspondence with Stieglitz. By the end of the war, having fallen victim to a series of illnesses, Stieglitz was feeling old and tired. The war had reduced the number of visitors to An American Place and left him feeling out of touch, a relic of an earlier era. "The Place should be called The Sarcophagus wherein I lie entombed," he wrote Adams wearily, "with the glory of the Marins, O'Keeffes, Doves, your photographs as well as mine."[13] Adams tried to cheer him up. He reminded Stieglitz of the crucial contributions he had made, from *Camera Work* to his first gallery at 291 Fifth Avenue to An

American Place. The impact of those efforts, Adams assured him, would continue long after he had gone.[14]

Although things were not going well for Stieglitz, they were beginning to go very well indeed for Adams. In April 1946, he received some good news from the Guggenheim Foundation. They had agreed to support his proposal. He would have two years of funding to carry out his photography in the national parks and monuments. Adams wrote immediately to Weston and Stieglitz, thanking them not only for their recommendations but more for the encouragement they had given to his work through the years.[15]

On hearing the news, Stieglitz wished him well. "If anyone ever earned the Guggenheim you did."[16] It was the last he would hear from Stieglitz. In July, Nancy Newhall dropped by An American Place on a Saturday afternoon to continue her interviews with Stieglitz for a projected biography and retrospective exhibition. She found him alone, laying on the bed in his office in pain, his heart racing. He had called the doctor moments before. He felt better later that week. Aware that he had little time left, he wanted to talk and dictate letters. On Wednesday he suffered a stroke and did not regain consciousness. He died the following Saturday.

Georgia O'Keeffe came as quickly as possible from New Mexico, only to continue her feuding with Dorothy Norman, who had assumed the role of Stieglitz's protégé and protector. Nancy and Beaumont put aside their animosity toward Steichen to help him organize Stieglitz's papers and photographs. Paul Strand was there, finding the simmering animosities "strange and sad."[17]

Adams had expected the news. He knew he was supposed to be upset, but he honestly was not. He was by no means unaffected by Stieglitz's passing, however. He wrote to Dorothy Norman later that summer. He had been driving in the mountains, he said, when he felt Stieglitz's spirit speaking to him, reminding him to concentrate on the forces that sus-

tain life: the sun, the earth, the green living world. Humanity's pain, so forcefully manifest over the last years, was brought on by its self-imposed exile from the rest of creation. The role of art was to reforge those broken links.[18]

For Adams, Stieglitz provided a sustaining faith. No one had exerted a greater force on his art, yet he had absorbed the lessons and grown increasingly independent. His ties to New York were almost entirely cut. Adams now turned his attention fully to the West and to the work he had before him.

As he began his preparations for his Guggenheim travels, Adams realized that the project would severely limit his time for teaching. He called the Newhalls seeking their recommendations for someone to take over his classes at the California School of Fine Arts. They suggested Minor White. The Newhalls had first become aware of White when they selected three of his photographs for the *Image of Freedom* exhibition.[19] After serving in the army, White had moved to New York, where he studied art history at Columbia and worked part time as a photographer for the Museum of Modern Art. When Steichen took over, he encouraged White to stay on, but out of friendship with the Newhalls, White refused. The offer of a teaching position in California came as a welcome opportunity. Since Ansel and Virginia were based in Yosemite, they offered the use of their home and studio next to Ansel's parents on 24th Avenue in San Francisco. His parents were getting on in years, and it seemed like a good idea to have someone around to look after things.

White recorded his impressions of his first meeting with Adams in his journal. "Ansel met me at the train yesterday. This morning in his class . . . the whole muddled business of exposure and development fell into place." Working with Adams, particularly learning the intricacies of the zone system, gave White a new appreciation for the creative potential of technical mastery. "This afternoon I started teaching his

Zone System. Ansel did not know it, but his gift of photographic crafts-manship was the celebration of a birthday."[20]

Despite his appreciation for Adams's craft, White had an independent point of view. Even before embarking on his teaching at the California School of Fine Arts, his approach to photography emphasized personal psychic and spiritual exploration. He first developed this approach while teaching photography at a Portland YMCA before the war: "For myself, the importance of this kind of teaching was in becoming conscious of an activity done for larger purposes than proficiency in technique, or even exercise in creative ability, but related to a person's adjustment to living."[21]

This direction in White's art and teaching would eventually provoke some criticism from Adams, but for now he was satisfied. He told White that he had promised McAgy that he would not leave without finding a replacement competent to take over the program. Adams was fully confident that White was up to the task.[22]

It was with a sense of liberation and the beginning of an important new phase of creative energy that Adams began the preparations for his departure. Edward Weston was on hand to see his friend off. It was a nostalgic moment for him, as he recalled the excitement that had surrounded the beginning of his own Guggenheim travels nine years earlier. For him, however, those days seemed far in the past.[23]

The recent years had been difficult for Weston. His troubles began soon after the war's end, when he and Charis had divorced. Only two months earlier Adams had made one of his regular visits to the Westons' cabin on Wildcat Hill, south of Carmel, to enjoy the relaxed pace and warm feelings he always found there. On that occasion everything seemed blissful enough. But in mid-November Adams received a note: "You will never see Charis and Edward together on Wildcat Hill. Divorce."[24]

Adams had offered whatever support he could. He knew that Weston

did not need the usual trite response. Edward and Charis had shared a deep relationship—deep enough to know and to admit when the time had come to part. Adams reminded Weston of his past achievements, calling him the greatest of photographers and one of the finest artists of the century in any medium. Above all, he offered his friendship. The world was out there waiting. He wished they could both go off together on another adventure like their Sierra trip ten years earlier.[25]

Weston appreciated the kind words. His break with Charis came as he was in the midst of preparing his upcoming retrospective exhibition at the Museum of Modern Art, one of the last exhibitions the Newhalls would oversee there, and printing as many of his as yet unprinted negatives as possible. The combination of events left him physically and emotionally drained. The conflicting emotions attending a major retrospective exhibition could only have added to the void that divorce brings in its wake.

Was anything achieved? Was there any meaning to the struggles of life? "Men should retain the right to weep when occasion demands," Weston replied to his friend. "I will not protest your appraisal of me, my work; I *want* to believe everything you say!—even though I don't think *there ever is a 'greatest.'* You are right, neither Charis nor I want or need sympathy. We remain to each other best friends."[26]

Weston's health began to deteriorate over the course of the next several years. In April 1946, he underwent surgery to repair a hernia and in the fall had another operation. By the following winter, as Adams prepared to begin his Guggenheim travels, it had become apparent that his physical decline had a more fundamental cause: the doctors diagnosed his condition as the onset of Parkinson's disease, a congenital neurological disorder that produces a gradual loss of motor control.

Despite his failing strength, Weston continued to pour all his energy into creative photography. Unable to travel far, he concentrated his attention on the nearby coastline at Point Lobos, long one of his favorite

subjects. Weston's Point Lobos photographs from these years express a resolution and acceptance of the intermingled forces of life and death. They continued the trend begun in his Guggenheim years toward more open compositions, the controlled order of his work during the years of Group f/64 having given way to what the curator John Szarkowski described as "a looser, gentler rein. A sense of the rich and open-ended asymmetry of the world."[27] That formal change paralleled what his friends saw as a beatific acceptance and transcendence of his fate.[28] His last photographs stand as a coda to his life, continuing his search for spiritual meaning in natural forms and finding there an affirming grace.

Adams and Weston—these two artistic comrades dedicated to the precision of the large-format view camera and to the vital spirit in nature—could not have led more different lives. The gregarious and hyperactive Adams was typically involved in half a dozen simultaneous projects, chasing down commercial assignments, rushing off to Sierra Club meetings, worrying about family bills, evangelizing in the photographic press, all the while traveling throughout the nation, from Maine to Texas, from Alaska to Hawaii, with his vast array of equipment in tow. Meanwhile, Weston slowly made his way around the rocks and kelp of Point Lobos, his fading strength intently focused.

## National Parks

Adams's first stop on his tour of the national parks and monuments was at Death Valley—one of Weston's favorite photographic hunting grounds. From there Adams planned an extended loop through the Southwest. He would head south to Joshua Tree, then east to Arizona to photograph Organ Pipe and Saguaro national monuments, then on to Big Bend National Park in Texas and returning home via Shiprock National Monument and Grand Canyon National Park. Adams was

excited by the possibilities and eager to be on the road. He had purchased a new Cadillac station wagon, outfitted like his earlier model with a roof-mounted camera platform and stocked with provisions and his usual array of photographic equipment.[29]

Out in the desert country Adams felt a renewed commitment to the western landscape. Others, however, could not see the value in it. An article in the photography periodical *Minicam* typified the negative critical reaction he was receiving in certain quarters at that time. The author, Christina Page, who had earlier written captions for the Office of War Information photoessays by Adams and Dorothea Lange, described Adams as a "photographer who limits the scope of his subject matter to one area. His emphasis is on natural scenes in an era when the world is almost completely interested in human values, and social and political influence. It is the old ivory tower question. The work of an artist in relation to the time in which he lives must enter into an appraisal of his work."[30] Page thought the times demanded something other than images of nature.

Although Nancy Newhall noted that Adams was hurt by the article when it appeared, out in the desert such criticisms seemed to fade from his mind. The earth looked as beautiful as ever, he reported to Minor White from a stop outside of Joshua Tree National Monument. Nature's forms, organized within the camera's magic frame, were completely satisfying. Looking into the infinity of the desert night, Adams found it difficult to remain overly concerned with aesthetic debates and modern crises.[31]

It was not that he was oblivious to such issues. On the contrary, he explained to Ted Spencer, it was precisely his concern for the social good that prompted his focus on nature. Societies, like individuals, are sustained both physically and emotionally by the sun, the earth, and all forms of life. Most contemporary art reminded him of a lost soul, weak

and bewildered, with a pallid and pockmarked face. The sickness of contemporary art and contemporary society came in their separation from the ancient wellsprings of inspiration and life.[32]

On his return to San Francisco, Adams renewed his offer to the Newhalls. Maybe a good trip out West would improve their artistic complexions. Beaumont and Nancy were both eager to go, and, putting aside their various projects, they headed for California in the spring of 1947. After their arrival and festivities at Ansel and Virginia's, they squeezed into Ansel's overstuffed station wagon bound for Zion National Park in southern Utah. They mostly camped but visited the occasional motel for showers and soft beds. The Newhalls received a first-hand initiation into Adams's photographic mode of operation.

"We all had cameras," Beaumont recalled, "and we just went where Ansel took us." They had no choice but to adapt to a sleeping bag on the ground and a predawn wake-up call. "He'd bray like a donkey to wake us up," Beaumont laughed at the recollection, but it might not have been so funny at the time. They would photograph in the early morning light, then pile into the car to scout new locations. With the windows down and dust billowing behind, they bounded along the narrow dirt roads through the mesas and dry washes, their eyes peeled for potential photographs. On finding a promising spot, they would stop and haul out the cameras, often waiting for the late afternoon to soften the glare and deepen the shadows. They would return to camp when the light had gone and prepare a typically spartan Adams meal as night came on.[33]

While both Newhalls enjoyed the new experiences and magnificent country, Nancy was definitely the more enthusiastic of the two. The trip marked the beginning of her conversion to the conservation cause. In the coming years she would become a major voice in that movement and frequently remind Adams of the larger crusade, of their duty to evangelize the public on nature's behalf. Beaumont liked the wilderness too, but he had his limits. As they made their way from Zion to Bryce

Canyon, with the Grand Canyon yet to come, Beaumont began to feel a surfeit of scenery.

After a long, dusty day of bad roads and blazing sun, they arrived at the edge of Bryce Canyon. Before settling down to another canned dinner in the dark, Adams urged them out to the canyon precipice to glory in the twilight view. Nancy was enchanted. Beaumont was less enthused. "Oh God," he muttered, "more nature."[34]

Beaumont may have grown tired of roughing it, but he continued to be fascinated with Adams the photographer. He recalled the making of one photograph as particularly revealing. Adams was on the lookout throughout the trip for appropriate subjects for his latest commercial client, the Eastman Kodak Company. He had maintained contacts with the company since his first visit to Rochester in 1933. In the mid-1940s Kodak commissioned several fine art photographers of note, including Adams, Weston, Strand, and Sheeler, to experiment with their new 8 × 10 color sheet films. The resulting photographs were used for various advertising promotions. Adams was more than happy to accept the challenge of working in color for the first time, especially considering the handsome fee they had promised. They wanted waterfalls, preferably with rainbows, and they were paying $250 per 8 × 10 Kodachrome transparency.[35]

Kodak decided to promote its new line of color films with a huge display in New York's Grand Central Station. They called it the Colorama—a color transparency eighteen feet high and sixty feet long, mounted on a vast bank of fluorescent lights high above the milling crowds in the station's vaulted central lobby. Adams was hired to produce a number of coloramas over the years.[36] On this trip he was making test shots, what he called sketches, exploring potential colorama ideas.

As he and the Newhalls stood on the rim of the Grand Canyon at sunset, Adams had the inspiration for a surefire crowd pleaser. Knowing that a full moon would be rising soon after sunset, he began by framing

an image of the sunset afterglow and setting his exposure parameters for a slight underexposure. He marked the horizon line on the ground glass after releasing the shutter, then he swung the camera 180 degrees, changed his normal focal-length lens for a telephoto, and awaited the moonrise. When the glowing orb had risen to the appropriate angle marked on his ground glass, he made his second exposure on the same sheet of film, producing an image of what appeared to be a huge harvest moon illuminating the vast chasm of the Grand Canyon.[37]

This type of double exposure, though carefully planned and flawlessly executed, was not the sort of thing he considered artistically legitimate as it was a manufactured image. For his personal work, Adams felt the found objects and arrangements of the world provided all the artistic possibilities he needed; camera-based "tricks" were not consistent with the Stieglitzian "honesty" he strived for. Adams regularly manipulated his photographs, however, via methods of exposure and development, lens selection, and view camera adjustments to produce prints often markedly different from the original scene before the lens. This he considered a legitimate and necessary aspect of artistic interpretation.

Such aesthetic distinctions did not concern the people at Kodak. While they were impressed with his spectacular color moonrise, they could not use it for the Colorama. "It was not the kind of subject Kodak wanted," Newhall recalled. "They had to have pretty girls."[38] Adams reluctantly obliged, often using his assistants as models and occasionally using professional models hired by Kodak.

While it may not have been up to his usual fine art standards, Adams's work for Kodak proved quite lucrative. A few years later, in 1951, for example, he had a large schedule of work, including six 8 × 10 color transparencies, six black-and-white mural prospects, one sunset colorama, and a variety of smaller-format color work of possible colorama subjects. All told, it represented nearly $3,400 worth of work—a godsend to his beleaguered bank account.[39]

The financial aspect was certainly the primary appeal, but Adams continued to maintain the ambivalent and often contradictory attitudes toward commercial photography that he had displayed throughout his career. While he scoffed at the advertising mind-set and longed for the day when he would be free of its demands, he continued to accept commercial assignments throughout his career. However much he desired a life dedicated to art, he refused to live in bohemian poverty. Weston's life of simple austerity seemed too precarious.

He and Virginia had expenses to meet. Their children, Michael and Anne, had graduated from the Yosemite schools, and the nearest high school—a forty-five-mile bus ride to Mariposa—did not seem academically challenging. Michael went instead to the Wasatch Academy in Utah, a boarding school popular with the employees of the National Park Service. When the family moved back to San Francisco in the early 1950s, Anne attended the "rather posh" Hamlin School there. Adams liked to point out that he was not the typical parent. He recalled one wet winter morning when he helped Anne out to the school car waiting on the street. The other girls took in the worn Levis, the plastic darkroom apron, the battered Stetson over the bald dome, off-kilter nose, and unruly beard. Surely this strange character was not Anne's father![40]

Adams loved playing the eccentric artist and cultivated his western outdoor image, but as the chronic sacrifice of his art on the altar of commerce attests, he also wanted very much to make the kind of money it took to be a member of the Bay Area upper middle class—to maintain the links to the family position established by his grandfather and clung to, against all odds, by his father.

While financial considerations drove Adams's constant commercial work, so too did his pride of craft. He knew he could deliver what the clients wanted. And despite his frequent rants against his service to Mammon, he continued to harbor the hope that his commercial images might occasionally convey, in addition to their specific corporate pur-

pose, a sense of the beauty of the world. It is difficult to know exactly how viewers reacted to his commercial photographs. The reaction his clients at Kodak wanted was probably put best by a writer for *Time* magazine in the summer of 1951. Under the banner "Realism with Reverence" were two color photographs by Adams. "No artist has pictured the magnificence of the western states more eloquently than photographer Ansel Adams," asserted the unnamed author. "This summer thousands upon thousands of tourists will follow Adams's well-beaten trail up and down the National Parks fixing the cold eyes of their cameras on the same splendors he has photographed—and hoping, somehow, to match his art."[41] While Adams's photographs were certainly valuable to Kodak for their sales boost, it cannot be denied that they also contributed to a growing public appreciation for the aesthetic values of nature.

Consider one typical early colorama made in the form of a triptych: on the left was a vertical composition of tourists pointing their cameras (presumably Kodaks) at Yosemite's Vernal Falls; in the center a horizontal composition of the dramatic view from Inspiration Point with the huge panorama of Yosemite Valley beyond; on the right another vertical composition, this of tourists with cameras standing below the towering Yosemite Falls. Together the three images formed an altarpiece dedicated to Yosemite's sacred image—now worshiped by Kodak-wielding pilgrims. For thousands of commuters jammed together on their way to work, the vision of enraptured tourists enjoying their Kodaks in the wide-open spaces of the West no doubt presented an appealing prospect—and sold more than a few cameras and rolls of film when the commuters took their cues from the models in the pictures and headed for Yosemite on their vacations.

Once they were there some of these consumers might have also become conservationists. This was always John Muir's dream, and the

idea was carried on by each later generation of Sierra Club leaders, including Adams. "Go to the mountains and get their good tidings," Muir had said. That he was a spokesman for western tourism (strongly supported, for example, by the Southern Pacific Railroad president E. H. Harriman) did not strike Muir as a contradiction because he believed that conservation depended on public contact with nature. While it is easy to dismiss Adams's commercial work as a sellout and another example of the "commodification" of nature, Muir may have had a point. It was an issue that would become increasingly difficult for the Sierra Club and other conservation organizations in the coming years, however, as a rising tide of tourism threatened to overwhelm nature's sanctuaries.[42]

### New Lands

Adams, like a latter-day Daniel Boone, was always searching for new wild lands—keeping one step ahead of the crowds he helped to bring. It was an old and continuing story in America as "lighting out for the territories" Huckleberry Finn–style was never escape for long. One area that remained relatively untouched and unthreatened by development or excessive tourism was Alaska, the last of the U.S. territories. Adams had visited Glacier National Park in Montana and Olympic National Park in Washington on his mural project before the war. Seeing in that country the gateway to a whole new realm of exploration, he was determined to return and venture even farther north. Perhaps in the vast expanses of Alaska he could find his wilderness ideal.[43]

He left with Michael, who was now fourteen, in the summer of 1947. After taking the inland passage from Seattle to Juneau by ship, they boarded a plane for the Alaskan interior. The territorial governor, Ernest Gruening, offered them a place on the first wildlife and fishing

patrol flight of the season. Adams was not particularly fond of flying. Several of his friends had died in air crashes, convincing him that flight was best left to the birds. Michael, however, found it a great adventure.[44]

As the amphibious twin-engine Grumman Goose roared to life, bounced across the choppy water, and swooped off over the mountains, Adams sat immobilized by fright, strapped to his seat and awaiting his fate.[45] Despite his intimations of doom, the day proceeded smoothly as they scouted the coastal waters, checking fishing licenses and catch limits of the commercial boats. Toward the late afternoon they headed for the airport at Ketchikan. This was to be a ground landing rather than the water landings they had been performing all day. As they approached the airport the pilot discovered that the right-hand landing gear was malfunctioning. Ordering everyone over to the left side of the plane, he brought it in on one wheel, balancing as long as possible until it settled down onto the right wingtip and scraped to a stop. Unable to find the necessary parts to repair the plane, they were forced into a one-wheeled takeoff. With all the baggage and Ansel and Michael pressed against the left side of the cabin, they bounced along, the right wingtip skipping along the runway until they arose up into the air.[46]

After their harrowing air tour, Adams and his son were given the ranger's cabin at Wonder Lake, near the base of Mount McKinley, where they stayed for several days. Their location by the shore of the lake gave them a panoramic view of the mountain, rising 18,000 feet above the plain to an altitude of 26,600 feet. In that far northern latitude summer's twilight lasted through much of the night. Over the next several days Adams energetically photographed in the changing light and weather.

His images from these days demonstrate his taste for the powerful and sublime vision of nature that dominated his work at this time of his career. *Moon and Mount McKinley*, made on the first evening of his arrival, presents a scene of primordial splendor. By darkening the values

of the sky and increasing the contrast scale of his negative, Adams accentuated the drama of the swirling clouds and three-quarter moon rising above the snow-covered peak thirty miles distant. Those who consider Adams a twentieth-century romantic, a Bierstadt of the camera, can certainly find evidence here.

As the sun rose at about 1:30 A.M., he found the mountain bathed in a pink glow. Before him Wonder Lake shimmered with the iridescent reflection of the dawn. He visualized a starker image than his moonrise of the previous evening, more in a modernist vein, simplified and somewhat abstracted in its exaggerated tonal scale and flattened perspective. This latter quality was achieved by the use of a telephoto lens (23-inch focal length on an 8×10 format camera), which reduced the apparent distance of the mountains, some thirty miles across the middle ground plain, diminishing the sense of perspectival depth and increasing the emphasis on the value relationships in the print.

As usual, Adams carefully thought out and controlled his print values, providing an example of his principle of visualization and its realization through zone system techniques in action. The most striking element of the print—its immediate juxtaposition of near black and white in the eastern shore of the lake—was enhanced by his use of a deep yellow filter, which lowered the foreground shadow values while raising the values of the waters of the lake. The filter also served to darken the blue sky, framing the peak and keeping the viewer's eye focused on the gleaming waters.[47]

In exposing the negative, Adams placed the snow on the mountainside in the middle range of the exposure scale—producing print values around middle gray—when "normal" exposure would have rendered them much lighter. This "underexposure" and the compensatory above-normal development produced an expanded contrast range and resulted in the shores surrounding Wonder lake and portions of the distant plains falling into near blackness, while the brightly lit waters of

the lake occupied the highest values of the scale, from middle gray to almost pure white.[48]

The photograph was not only a technical tour de force but also a good indication of the various creative influences at work in his photography at this time. Mountain landscapes, his favored subject since his earliest days in photography, continued to dominate his work. Likewise, the modernist roots of his Group f/64 period—his dedication to the precision of the large-format view camera and the simplifying, abstracting compositions typical of his work in the early to mid-1930s—were still strongly in evidence. Also clearly present was the grand scale and heroic tone his photographs had begun to take on in the late 1930s. The Sturm und Drang of the world in those years continued unabated into the postwar period and found expression in the romantic drama of his imagery.

Yet for all his love of the grand scene, Adams maintained a strong interest and great skill in rendering the small details of nature. In Alaska weather conditions forced him to spend the majority of his time on these subjects, as clouds, which had so majestically parted for his images of Mount McKinley, socked in the peaks for virtually the entire remaining portion of his trip. He made the best of the situation with photographs like *Detail, Interstadial Forest, Glacier Bay National Monument*. Its calm and balanced design exemplified an important aspect of his work that was often overshadowed by the more strident qualities of his panoramas. While Adams was emphasizing the spectacular to a greater extent than at any other time in his career, he continued to excel at the quiet still life—what he preferred to call "extracts" from nature. In these photographs his affinities with his friend Weston were more abundantly clear.

Although they shared much in the way of form and content, neither Adams nor Weston appreciated the fact that they were frequently lumped together by critics and curators as exemplars of a supposed

"West Coast" approach to photography. Nancy Newhall, who understood these two artists better than any other critic of the day, tried to clarify the situation. At that time she was continuing to research her biography of Adams as well as edit Weston's diaries for publication. She found the simultaneous projects illuminating.[49]

Newhall quoted for Adams a passage from Weston's travels in Mexico: "Both places were quite too beautiful," he wrote. "The element of possible discovery was lacking, that thrill that comes from finding beauty in the commonplace." Newhall felt that this attitude indicated the basic difference between Weston and Adams. While Weston sought to elevate the commonplace into the realm of the elemental, Adams consciously sought out the places of extraordinary beauty. Weston, Newhall said, was "the sculptor—it's his use of the material that interests him." With Adams, she felt the emphasis was not so much on transformation as revelation. "You, more than anyone, even Stieglitz and Paul [Strand], have consistently tackled the extraordinary problem of conveying and interpreting actual beauty. Plus its often tremendous spiritual overtones."[50]

Adams always appreciated Newhall's insight and agreed with her assessment. The essence of his work, he said, was something akin to Beethoven's "The Adoration of God in Nature."[51] He was well aware that he was in the midst of a crucial and defining project with his work on the national parks. It was a project much in tune with Newhall's definition of his art, one that sought to encompass his recurring subject matter and themes—the wilderness landscape and its cultural and spiritual dimensions.

He was also well aware that his creative impulses were carrying him away from the main currents of contemporary art. His association with the painters at the California School of Fine Arts gave him a fairly representative look at those currents. He was not impressed. Adams, who had once felt privileged to join in avant-garde circles in San Fran-

cisco, New Mexico, and New York, now felt that the subjectivity embraced by postwar abstract expressionism was an abdication of the artist's role in society. The inbred concerns and unintelligible symbolism were typical, Adams felt, of the abrogation of cultural leadership among contemporary artists. Painters, like philosophers, writers, and so many others in society, seemed to inhabit their own isolated worlds with no sense of shared values and unifying concerns.

It was this connecting thread between his art and the social good that he had been pursuing since the late 1930s. His social commitment and growing conservation activism had converged in his art, leading him to his quest to illustrate for the American people the importance of nature in their national culture.

The postwar world, however, seemed hostile to his point of view. Politically, the New Deal coalition that he had enthusiastically supported was falling apart, its leadership coming under attack as "un-American" and "Communist sympathizers." Environmentally, the progress made under the leadership of FDR and Harold Ickes was threatened by the postwar boom of commercial, industrial, and population growth. Over all these hung the dark cloud of the bomb.

Maybe it would take the unthinkable to bring society—or what was left of it—back to its senses, Adams wrote to Newhall. Amid the confusion and dire potentials of the moment, the earth and its imperturbable rhythms were the only source of hope, and even this, he said, was threatened. He closed with a note of thanks and a plea for continued communication. He needed her beacon light to help show the way.[52]

He had no need to worry. His correspondence with Nancy Newhall grew steadily in the coming years as they tackled a wide variety of projects, exchanging ideas and feelings in an endless stream of letters. Adams had often collaborated well with women, beginning with Mary Austin and continuing with Dorothea Lange. Newhall was proving to

be his most empathetic colleague of all. With Stieglitz gone and Weston fading, Adams needed new compatriots and soulmates. Between them, Beaumont and Nancy were just the kind of friends he needed. From his new position as curator of photography at the George Eastman House, Beaumont provided a link to the world of museums and photography as a fine art. Nancy's freelance status and her writing and curatorial skills made her an ideal collaborator for Adams as he plunged into a variety of publishing efforts.[53]

Adams had decided to spread his Guggenheim funds over a two-year period. After attending to his various duties in Yosemite, San Francisco, New York, and elsewhere, he prepared for another round of travel in the spring of 1948. His destination was the islands of Hawaii and Hawaii Volcanoes National Park. In early April he wrote to Edward Weston from aboard the SS *Matsonia*, admitting a hunch that he would not care for the place once he arrived. Raised on the fogbound coast of San Francisco and the clear cold peaks of the Sierra, Adams had little interest in the tropics. Like his trip to Maine, he went mostly out of an obligation to encompass all the national parks in his project.[54]

It was also another trip away from home. His constant travels and frenetic work pace left him little time with Virginia. Although their relationship was strained by these absences, Virginia was an independent woman, busy with the operation of Best's Studio and the joint publishing venture she and Ansel had recently arranged with the Houghton Mifflin Company. She was also a selfless person, willing to remain in the background and to let Ansel's work come first.[55]

For his part, although he regretted the separations, Ansel's incessant drive and creative and commercial ambitions made staying home physically impossible. These separations had their sexual as well as emotional drawbacks. As he steamed across the Pacific bound for Hawaii, he told

Weston that he was trying to recover from "Lackanookie!" Exactly what sort of therapy he had in mind is unclear. Most likely it was a strong dose of sublimation and his usual hectic schedule of work.[56]

Sublimation seems to have been the rule as Adams's sex life became rather uneventful after his reconciliation with Virginia in 1937. He had apparently decided that sex was an emotional burden he could do without. His Puritan Yankee heritage was probably at the root of this. Sexual matters were only discreetly hinted at by his parents. He was certainly not socially prudish himself: the liberated free lovers of the California and New Mexico avant-garde had made sure of that. He could trade rude limericks with gusto, and he found Weston's energetic romancing wryly amusing. In his own life, however, sexuality seemed to have a fairly low priority.[57]

Other than the affair in 1936, which contributed to his physical collapse later that year, evidence of any serious extramarital relationships is hard to find. His intimate but from most indications thoroughly platonic collaboration with Nancy Newhall was a typical—if particularly intense—example of his relationships with women. It seems that he was more interested in creative partners than sexual partners. Weston liked to combine the two. Adams found that difficult. As he sublimated his sex drive into work, so too he seems to have sublimated his eroticism into nature, finding in the earth's body the essential beauty so many artists have found in the human body.

Although eager to expand his audience by pursuing new publishing outlets, Adams continued to act within his established fine art world. In the fall of 1948 he immersed himself in the printing of his *Portfolio I.* While it was technically his second portfolio, the first being his *Parmelian Prints of the High Sierras*, published in 1927, it was the first collection of fine prints he had issued as a mature artist. Fittingly, he dedicated the portfolio to Alfred Stieglitz. The photographs were each exquisitely

hand-printed by Adams to standards even the perfectionist Stieglitz would have approved of. As a group they represented Adams's homage to his friend and mentor. Each image, he informed Nancy Newhall, expressed some aspect of Stieglitz and his impact on Adams's art. Paul Strand, who had known Stieglitz quite a bit longer than Adams had, felt that while Stieglitz the artist would have been moved by the photographs, Stieglitz the gallery owner would not. At one hundred dollars for the set of twelve prints, Adams's portfolio was seriously underpriced, Strand argued, and would devalue fine photographic prints generally.

"Either a photograph as an art work is worth something or it is worth nothing," he wrote. "I well remember the time when people said no water color was worth more than $100 and Stieglitz made them pay as high as $6000 for a Marin." The same principle applied to photography. "Stieglitz tried and to some extent succeeded in giving a photograph its rightful value as an art commodity." Adams would "not increase either respect for, nor understanding of, photography as a medium of expression" by underpricing his work.[58]

Adams valued Strand's opinion highly, and, given his dedication of the portfolio to Stieglitz, no criticism could have been more effective. Yet Adams's pricing decision was another indication of his movement away from the rarified fine art world that Stieglitz represented toward a broader market among the middle class. He was charging what he thought that market would bear. He would be happy to sell his fine prints for $1,000—provided there was a large audience willing to pay that much. Until that time, however, he would keep his prices within the range "average" people could afford to pay. He was pleased that some of his students had purchased the portfolio on the installment plan. These were the kind of people he wanted to reach—those who really appreciated it for what it was—rather than wealthy collectors with an eye only for the marketplace.[59]

Adams's decision also reflected a shrewd—or at least fortuitous—

business sense. The postwar era saw a dramatic increase in the art market as the newly affluent beneficiaries of the economic boom entered those realms that were once the exclusive preserve of the established elite. Artists like Adams no longer depended on patrons like Mrs. Sigmund Stern and the Rockefellers. The change would become even more apparent in Adams's publishing ventures, as book (and later postcard, calendar, and poster) reproductions of his photographs became not only his primary outlet to the public but the primary source of his income as well.[60]

## The Young Turks

The economic changes of the postwar years affected more than the marketing of Adams's photographs. The rapid growth experienced in the San Francisco Bay area during and after the war occurred in varying forms all across the western states. The Second World War transformed the West from a quasi-colonial region—exporting raw materials to the urban centers of the East—and propelled it rapidly into its own period of industrial growth. Manufacturing, research, and service industries, fueled by wartime demand, continued to grow after the war as the "military-industrial complex" and demographic movements from "rustbelt" to "sunbelt" gathered momentum.[61]

The economic transformation of the West during and after the war was accompanied by several parallel developments. The most obvious change was the surge of population and housing. The suburban sprawl that Adams had complained of in the 1930s reached explosive levels as formerly outlying agricultural areas surrounding San Francisco and Los Angeles were bulldozed for endless miles of new housing tracts. With the surge in population and the economic prosperity of the postwar years came a dramatic rise in visitation to the parks and wilderness areas. Americans took to the road with their new cars and new families, look-

ing for recreation in the open spaces of the West. Adams could hardly have failed to notice the change in Yosemite. From a low of 119,515 in 1944, tourist travel to the park rose nearly 600 percent to 641,767 in 1946 and continued to climb each year thereafter, topping the one million mark in 1954.[62]

Adams and others in the Sierra Club had always been of two minds on the question of public travel to the national parks and wilderness areas. On the one hand, they joined the Park Service in supporting the concept of open access, feeling that high visitation would ensure the survival of the parks. Among the members of the Sierra Club, John Muir's words to his successor as club president, William Colby, were well known. In 1908, as they stood on the brink of Glacier Point overlooking the Yosemite Valley, Muir remarked, "Bill, won't it be glorious when a million people can see what we are seeing now?"[63]

Forty years later, as nearly that many people arrived in the valley each year, the club continued to foster the goals of its original bylaws: "To enjoy, preserve, and render accessible the mountain regions of the Pacific Coast." Yet by that time some of the younger members of the Sierra Club board of directors, including Adams, began to view the effort to "render accessible" an outmoded relic of an earlier age.[64]

When the Park Service announced plans to build a major new road into Kings Canyon, these leaders rose up in opposition. The Park Service had, after all, vowed to protect the area as a wilderness park; it now appeared to be contradicting that policy. Richard Leonard, David Brower, Charlotte Mauk, Harold Bradley, and Ansel Adams—the core group of the new generation of Sierra Club leaders dubbed the Young Turks—convinced enough of their fellow board members to oppose the plan and managed to work out a compromise with the Park Service that shortened the distance the new road would extend into the park.[65]

Colby, the older generation's leader and the self-appointed guardian of the Muir tradition, did not agree. A graduate of the University of

California's Hastings Law School, he was one of the West's most influential mining attorneys and secretary of Sierra Club from 1900 through 1946, except for the years 1917–1919, when he served as president. He had run the High Trip for twenty-nine years, from the first outing in 1901 through 1930, and he continued to attend each trip for many years thereafter. Colby supported the road and reminded the younger generation that Muir had felt everyone should be able to see the mountains. As Leonard recalled it, "Dave [Brower] and I felt that Muir was an intelligent enough man—although we had never known him—that he would have recognized that sixty years later there were already so many people enjoying the mountains that they were overloading them and beginning to damage the beautiful country."[66]

Colby realized that a new era was beginning for the club and for conservation as a whole. "We have a new crop of very zealous conservationists growing up who have taken over," he informed his fellow old-timer, Horace McFarland.[67] Colby decided it was time to retire. The Young Turks had no hard feelings. "All of us loved him deeply," Leonard recalled, "and elected him honorary President of the Sierra Club until his death in 1964."[68]

The question of public access and its impact on wilderness preservation continued to confront the club as more tourists, more cars, and more roads appeared every year. Particularly galling were the Park Service plans to widen the Tioga Road through Yosemite National Park. Originally a nineteenth-century mining road, it wound through the alpine landscape above Yosemite Valley to the eastern border of the park, over the 9,000-foot elevation of Tioga Pass, and down a narrow and precipitous canyon to the Owens Valley. It had deteriorated badly until it was purchased in 1915 by Stephen Mather (with contributions from the Sierra Club). Mather had it repaired and reopened and then donated it to the National Park Service, of which he was the first direc-

tor. The new road mostly followed the twists and turns of the original and gave motorists a slow but intimate encounter with the high country.

During the 1930s, the Park Service drew up plans to widen and reroute it for high-speed travel. On consultation with the Sierra Club, they agreed to abandon the plans to move the road north of Mount Hoffman into the undeveloped Ten Lakes region. With this compromise the club was willing to support the plans, which would "enable travelers to reach Tuolumne Meadows and the eastern portions of the park readily and with comfort."[69]

The modifications were begun in the late 1930s but were delayed with the coming of the war. When construction resumed in 1946, the last remaining section to be completed—and one of the most technically difficult—was to skirt the glacially polished granite at the edge of Tenaya Lake. Adams joined with fellow directors Bradley, Brower, and Leonard in crying foul at what they saw as an infringement on one of the most beautiful of all Sierra lakes.[70]

Bradley pleaded with his fellow directors to support "the preservation of this section of our High Sierra in its present semi-primitive nature in summer and in its winter wildness." The old road, he thought, discouraged "the mere restless driver and the speed addict" and kept the high country relatively uncrowded compared to the hordes arriving in the valley each summer. "Changes of this sort," he warned, "have a way of breeding more changes. . . . There is indeed no obvious terminal point to the forces which destroy wilderness, once you introduce them in a region such as this."[71]

To the older members of the board, such a reversal of their earlier agreement with the Park Service seemed a dangerous precedent and counterproductive. They valued their good relations with both the Park Service and the Forest Service and did not approve of endangering them for what they saw as a relatively minor issue. Furthermore, several criti-

cized the basic premise on which the opponents of the wider road based their objections—that access to the high country ought to be relatively difficult and limited. Bestor Robinson, for example, felt that such an attitude implied "that wilderness areas are for enjoyment by those with leisure and financial ability to go to them for more than weekend trips."[72]

The club decided not to alter its earlier agreement with the Park Service, and plans for the road went forward. The issue of public access and wilderness preservation intensified in the following years as pressures for improved public access mounted. Eventually even the older members of the board agreed that efforts "to . . . render accessible the mountain regions of the Pacific Coast" were now out of date. In 1951, the club voted to alter the wording of its bylaws to reflect the new situation. From now on they would work "to explore, enjoy, and preserve the Sierra Nevada and other scenic resources of the United States."[73]

Although he was beginning to question its implications for the preservation of wilderness, Adams was a direct beneficiary of increased tourism. One of the most immediate effects was the rising number of customers at Best's Studio. Virginia's efforts to keep the business afloat during the depression and the war began to pay off as tourists flocked to the valley after the war. Since inheriting her father's concession in 1937, Virginia had been looking for high-quality items with which to stock the store and was particularly interested in the idea of teaming up with Ansel to produce books designed for the Yosemite visitor. Their first collaboration, published in 1941, was a children's book, *Michael and Anne in Yosemite Valley*, using their children as protagonists in prototypical adventures around the valley. The publisher made a number of changes in the manuscript, which Ansel felt brought a commercial sentimental-

ity that undermined the grace of Virginia's simple text. It proved to be a commercial success, however. Their next collaborative venture, *An Illustrated Guide to Yosemite*, which appeared in 1946, continued that trend.[74]

These publishing ventures were not the only examples of Adams's access to the expanding market brought by postwar tourism. Several years later, in 1954, the Standard Oil Company distributed a series of "Scenic Views" through its service stations around the West. Adams contributed two images— *Vernal Falls, Yosemite National Park*, and *Mount McKinley National Park, Alaska*—to the set of fifteen. Customers were told, "You'll want to collect the whole thrilling series—to frame for your home, as souvenirs of your western travels, as reminders of scenic highlights to visit on your next trip."[75] Adams fueled their imaginations while Standard Oil fueled their cars. With this new democratic twist, the old connections of art and commerce in western exploration continued in the twentieth century.

It may seem contradictory that Adams was among those leading the call to limit roads and other forms of public access to the Sierra at the same time that he was promoting tourism for clients like Eastman Kodak and Standard Oil, profiting from his own publications aimed at the tourist market, and making an effort to take his conservation message to the widest public audience. Did he want more business and more conservation voters but not more campers clogging the landscape? His attitude was clearly ambivalent. It was a problem that many in the Sierra Club and throughout the conservation movement shared.

Adams himself had noted in 1945 that the ever-growing travel industry was perhaps more dangerous to wilderness than the usual adversaries in grazing, timber, oil, and mining. Although he was clearly participating in the growth of this industry, he saw his participation as, at least in part, an effort at revolution from within—to redirect the tourist mind through images, to clarify the true purpose of the national parks and

wilderness areas. Instead of marketing the parks as resorts and amusement zones, he wanted to show them as places for spiritual renewal and contact with the nation's ancient landscape. The Sierra Club should encourage the incorporation of these deeper values into definitions of the character and mission of the parks. This was not antidemocratic, he argued. Rather, it was part of freeing the parks from the grasp of commercial interests.[76]

While Adams supported limitations on wilderness development and access, he was strongly opposed to any exclusivity within the ranks of the Sierra Club. At the board of directors meeting in December 1945, he had presented a motion to abolish the Los Angeles chapter on the grounds that it was no more than a social group, giving dances and hikes but doing no significant conservation work, and that the chapter allegedly screened out blacks, Hispanics, Asians, and Jews. While the board unanimously denounced any racial exclusion in club membership, the motion to abolish southern California's Angeles chapter was not passed. The issue resurfaced several years later during the anti-Communist hysteria of the mid-1950s. This time the Angeles chapter proposed that all prospective members sign an oath of loyalty to the United States. Adams was among those leading the defeat of the proposal.[77]

His criticisms may have reflected his own uneasiness about the character and mission of the club as a whole in these years. His work on Manzanar and on African-American education had heightened his awareness of social and racial issues. The Sierra Club, while having no policy of racial exclusion, was overwhelmingly made up of white Anglo-Saxon Protestants of the professional classes and was largely Republican in its politics. Adams had grown increasingly democratic (and Democratic) during the New Deal and the war. The club's narrow membership and timid conservation policies began to seem outdated and unsuited to the challenges that lay before it. Adams and others within the club began an

effort to reach out, to send the message of wilderness into the wider world. His Guggenheim project represented his own personal effort toward that goal, but he felt the Sierra Club and all those concerned with conservation needed to expand the circle of wilderness appreciation.

## Cold War

The narrow-mindedness of certain members of the Sierra Club was only part of a much wider and deeper phenomenon in postwar America. Beneath the surface of the economic boom and apple pie domesticity of the late 1940s and early 1950s ran strong currents of suspicion and fear. Events on the international front were especially disturbing. Tensions between the Soviet Union and its Western allies had been building throughout the war. With victory assured, suspicion boiled over into open hostility as the Soviet Union, under the leadership of Joseph Stalin, worked both overtly and covertly to expand its sphere of influence across Europe and Asia. The alarm was sounded by Winston Churchill in a speech given in Fulton, Missouri, in March 1946. "From Stettin in the Baltic to Trieste in the Adriatic," intoned the West's elder statesman, "an iron curtain has descended across the Continent. . . . I do not believe the Soviet Union desires war. What they desire is the fruits of war and the indefinite expansion of their power and doctrines."[78]

In the United States, the threat of Communist expansionism and the apparent leaks of classified information, especially in regard to the atomic bomb, created a mood of fear within the government and the nation at large. As the Iron Curtain fell across Europe, a veil of secrecy and suspicion descended in the United States. Constitutional rights of free expression and political association were often cast aside. All branches of the federal government contributed to the repression of

political dissent, including the White House, the FBI, and the Supreme Court. Perhaps the greatest damage was done by Congress, whose House Un-American Activities Committee, led by Senator Joseph McCarthy, undertook a wide-ranging investigation of American citizens from all walks of life. Those in the arts were among the primary targets.

Among those placed on the "Red List" of suspected Communist organizations was the Photo League, a New York–based organization of socially concerned photographers. Adams had first spoken before the league in 1940 as part of his effort to reach out to the photographic community of the city when he was beginning his work at MoMA. Adams joined the league in July 1947, perhaps as a way to maintain some contact with the New York photographic world following his resignation from MoMA's photography committee. That fall he gave a lecture to the league, presenting his views in typically strident fashion. In particular, he voiced his long-standing doubts about documentary photography, the prevailing approach among the members of the league, and its impact on photography's acceptance as a fine art. Adams stressed the importance of photography as a creative process and the fine print as the highest expression of the photographer's vision. Too many journalistic photographers, he claimed, ignored these aspects of their work.[79]

Afterward, Philippe Halsman, a noted portrait photographer, wrote Adams asking for further explanation. "I don't know whether you are conscious of the fact that you created the impression of belonging to the people who can be called 'Holders of the Truth.' It seemed to me that in your opinion there was only one kind of photography that was legitimate and meaningful: yours and that of people sharing your views." Halsman went on to add, however, that some of his friends assured him "that in reality you are interested in every branch of photography. But you didn't give this impression in your lecture!"[80] Adams was never one

to take well-intentioned criticism badly. In fact, he welcomed Halsman's opinion. He certainly never claimed to be the "Holder of Truth," he said. He was not shy, however, about stating his convictions.[81]

Soon after his lecture Adams learned of the government investigation. He urged the league to affirm a policy of nonalignment with any particular political organization. This, he felt, would not only clear the air of any suspicion but would also help photography. It was more or less the same argument he had been making since the 1930s to those who wanted to use the camera as a tool for social change. Art must come before political agendas if photography was to achieve its full recognition and potential as a creative medium.

That Adams maintained this position at this time in his career may seem ironic, considering the distinctly political turn his own work had taken. The crux of the matter seemed to lie in *which* political agenda photographers were advancing and their method for doing so. If a political message was communicated through creative expression, if it was an adjunct of art, that seems to have been acceptable. This explains his early praise of Dorothea Lange as being both a humanitarian and an artist. Adams's zeal to see photography recognized as a legitimate fine art may have, as Halsman suggested, given him a narrow definition of what was a valid use of the medium. In his own case, he felt his political message was compatible with his art because his message was that the land was beautiful—and valuable to the nation for that reason.

The majority within the league did not share his views. The prevailing feeling was that the league must take a stand against McCarthyism and in support of the Bill of Rights. When the league would not publicly disavow Communist affiliation, Adams resigned.[82]

While Adams strongly opposed McCarthy, believing him more dangerous than the supposed subversives, he was also convinced that the Communist threat was real. In fact, he felt that it was now clear that the

Communist conspiracy had been a serious matter—far more so than he or his artist friends had realized. To Beaumont Newhall, who was himself denied access to classified government documents because of connections with the league, Adams admitted that he—as many others—had been naive, but mostly because their good friends were in the grip of forces beyond their understanding. Although he had been bothered by the few ideologues he knew, he had personally thought of socialism and communism in benign generalities, as idealistic movements in the tradition of Emerson or the Pueblo tribes of New Mexico.[83] The postwar situation changed all that. A liberal and a dedicated New Dealer, Adams felt that American democracy was threatened from both the Left and the Right. He tried to rally the members of the Photo League to hold firm to the vital center.

As he saw it, the ideals of the nation were being smeared by the very people who claimed to be upholding them. He called for a renewed patriotism and a return to democratic principles. He urged his fellow photographers to study again the ideals of Whitman, Paine, Jefferson, Lincoln, and Franklin Roosevelt, to regain an understanding and confidence in America and its values. Photographers should turn their attention, he said, to the great accomplishments of the American people and the magnificent land that made those accomplishments possible.[84]

## Wilderness and the Postwar West

Adams's vision of America was deeply rooted in national tradition. Yet as its industrial empire continued to grow, the "accomplishments" of modern America threatened to overwhelm the land that sustained them. Most leaders within the conservation movement continued to share his ideal, assuming that economic growth and wilderness preservation could coexist. The coming years, however, would cause many to wonder whether that could continue.

Already voices of warning were being raised. From his desk at *Harper's* magazine, Bernard DeVoto wrote for a nationwide audience. In the summer of 1946 he took a tour of the region in which he was born. DeVoto had not been West for years. It was a journey much like the one Adams would begin the following year, an extended tour through a dozen national parks and forests. Some 13,580 miles later, he emerged an ardent conservationist and proceeded to bring his formidable talents and wide readership to the issues of the postwar West.[85]

DeVoto, much like Adams, lined up a variety of freelance assignments to offset the costs of his travels. One of these jobs was an article on the national parks for *Fortune* magazine. Accompanying the piece were photographs and illustrations by several artists, including Adams. DeVoto felt that the national parks represented one of the federal government's most benign legacies to the West—a legacy of responsible stewardship.[86]

Back in 1934 DeVoto had described the West as a "plundered province," giving voice to a widespread resentment of the eastern capitalists who controlled the region's economy, extracting its natural resources for their own enrichment. Twelve years later, he felt that the threat to western resources was no longer coming from outside; now, as the title of his 1947 article for *Harper's* proclaimed, it was "The West Against Itself."[87]

Since the war, western business interests had been pushing for greater access to the vast areas controlled by the federal government. According to DeVoto, it had taken a concerted policy of federal regulation "to save western natural resources from total control and quick liquidation by the absentee Eastern ownership." Now that western landowners and business interests had grown powerful they wanted to be free of the federal regulation that, DeVoto argued, had enabled the region to prosper. Their attitude could be summed up as "get out and give us more money." To prevent the supplanting of one set of absentee

"liquidators" with an indigenous one, DeVoto felt that federal control must remain in place and the economy of the West "must be based on the sustained, permanent use of its natural resources." He realized that such an economy would represent a major break with the past.[88]

"We need a mid-twentieth century Pinchot," DeVoto later asserted, referring to the U.S. Forest Service founder and champion of rational, sustainable use of natural resources. Yet many within the conservation movement were beginning to question the basic conception of humanity's relationship to nature embedded in the concept of the natural world as a collection of "resources" for human use. Many began to see a dangerous hubris in the assumption that the world was made for people to do with as they pleased. The horrors of the Second World War and the atomic bomb made frighteningly clear humanity's destructive potential. Many began to look for alternative visions of the world, visions based on the sanctity of all forms of life, regardless of their potential utility.

Among conservationists one of the early champions of this view was John Muir. Although Muir had continued to be revered by members of the Sierra Club after his death in 1914, his ideas had fallen from prominence within the conservation movement. In the postwar years, his ideas and reputation underwent a significant revival. One of the early indications was the warm reception of Linnie Marsh Wolfe's biography of Muir, *Son of the Wilderness*, published in 1945 and awarded the Pulitzer Prize. Another was the publication of *Yosemite and the High Sierra* in 1948, featuring selections from Muir's writings and photographs by Ansel Adams. Adams had long been an admirer of Muir and perhaps more than anyone else had carried Muir's message forward. As the historian and Muir biographer Stephen Fox pointed out, "In its major phases his career paralleled Muir's: a shock of recognition on first seeing the [Yosemite] valley, followed by a period of residence and then a reputation as the artistic voice of the Range of Light."[89] The book, edited

by fellow Sierra Club board member Charlotte Mauk, was published by Houghton Mifflin and received wide distribution, favorable reviews, and satisfying sales.

One of those who was impressed was DeVoto. "I doubt if you are ever going to get me to do a book with you," he wrote. "The moral of the Yosemite one is all too painfully clear. In the face of your pictures Muir is just some unnecessary rhetoric. . . . I wish to God that more of your stuff were available. I am going to evangelize Houghton Mifflin about it."[90]

Although it is not clear whether DeVoto's evangelizing had a role in it, Virginia and Ansel soon worked out a co-publishing agreement with Houghton Mifflin. Over the course of the next two years they published three books, *My Camera in Yosemite Valley*, *My Camera in the National Parks*, both by Adams, and *My Camera on Point Lobos*, by Edward Weston. In addition, Adams provided photographs for Houghton Mifflin's reissue of Mary Austin's *Land of Little Rain*, her account of the Owens Valley and its native cultures, first published in 1903.

Of these books, *My Camera in the National Parks*, the product of Adams's Guggenheim work and the most direct expression of his conservation ideals, was his most significant effort.[91] The national parks, he explained in his introduction, are symbols of America, its history and its culture. He hoped that the book would encourage readers to seek such beauty in their own lives—wherever they may be. He opened the book with a quotation from his early source of inspiration, the English poet, essayist, and social reformer Edward Carpenter: "Only that people can thrive that loves its land and swears to make it beautiful."[92]

Adams thought of the book as an important step in bringing the conservation message to the people. He felt, however, that it was only a beginning. He had been active in the field of conservation for many years, he explained to the National Park Service director of information,

William Dougherty. Unfortunately, most of the movement's literature and photography was unbearably boring. He urged the Park Service and all those concerned with conservation issues to make a new start with words and images that would catch the public's attention and galvanize it to action. The arts could play a leading role in this effort, but contemporary directions in the arts did not seem to offer much hope of that. The self-absorbed art of the day would never change anything, he said. What was needed was a return to the spirit motivating the art of the Middle Ages, when religious values permeated the work, inspiring the viewer to a higher vision.[93]

## Art in the Postwar World

The movement of modern art toward the abstract and the subjective in the postwar years occurred simultaneously with the conservation movement's emergence as a national political force. Adams chose to accept the challenge of leading the conservation charge into public awareness even if it meant wearing the label "outmoded" in art circles. His continuing divergence from the prevailing directions of contemporary art only strengthened his resolve to direct his photography toward a popular audience rather than the specialized realm of critics, museums, and other custodians of the avant-garde.

He had no interest in being an artist, he told Nancy Newhall in the winter of 1950, if that meant being one of the fraudulent clique of the latest thing. A visit to an exhibition at the San Francisco Museum of Art of Bay Area artists working in the abstract expressionist mode confirmed his feelings. He was not impressed.[94] The internal psychic exploration and mythic reconstruction of abstract expressionism seemed to him an ostrichlike avoidance of the real issues of the day. He found most of the work firmly caught in European concepts. The real break had yet to occur.[95]

This was not the prevailing opinion. For its proponents, it represented the forceful return of abstraction following realism's temporary ascendancy during the 1930s. Much like Adams at that time, many painters had felt confined by the narrow demands of social realism, regionalism, and American Scene styles and their often overt political messages. In 1938 an article by the exiled Communist leader Leon Trotsky, the surrealist artist André Breton, and Adams's friend Diego Rivera appeared in the favored journal of radical intellectuals of the day, *Partisan Review*. In reaction to the stifling of creative life under Stalin's regime and the lockstep attitudes of many fellow travelers overseas, the authors proclaimed the right of all artists to be free of ideological demands.[96]

This rejection of overt politicism in the late 1930s led the way to a distinct turn inward after the war. Artists like Arshile Gorky, Willem de Kooning, Jackson Pollock, Mark Rothko, and Clifford Still turned to the act of painting itself, seeking a connection with the ancient forces of life that lived on in the inner wilderness of the subconscious. While this direction owed much to the influence of a number of European surrealists who arrived in America in the late 1930s and early 1940s, including Breton, abstract expressionism developed a distinctly American form in its raw energy, its massive scale, its combination of brutality and lyricism.[97]

Adams was correct in his assumption that the majority of abstract expressionists had abandoned any effort to reform society through political means. In the face of worldwide violence and the threat of instantaneous atomic doom, these artists rejected the liberal political idealism to which Adams and Newhall committed themselves. For Adams, the war led to an increased social activism; its liberal crusading spirit was closer to his own political views than was the radicalism of the 1930s. Such was not the case with most artists of the postwar avant-garde, who had lost whatever faith they had in government or social movements to

realize their ideals. Their attitudes closely resembled the existentialist philosophy of Jean-Paul Sartré, who portrayed the human condition in terms of an extreme individualism. In a world without transcendent order, human life was a process of self-definition, in which the individual heroically carved meaning out of chaos and the absurd.[98]

The existential condition was embodied, on a more concrete level, in a new style of photojournalism. Among the most recognized of this group was Cartier-Bresson. Although they did not come in for the kind of vituperation reserved for Steichen, Cartier-Bresson's images seemed, to Adams, to embody the despair and chaos of the postwar world. It was, he said, the flip side of the National Geographic vision of smiling faces and universal harmony. Both, he thought, were equally false. He wanted to find a middle way, neither despairingly tragic nor ignorantly blissful. He simply wanted to give what he called an "honest" picture of the world—one that left the viewer elevated rather than depressed. He was grateful that Nancy Newhall understood and shared his views.[99]

"That you don't click with the cliques is, I think, a matter for humble thanks to God," she assured him.

> This civilization has the art it deserves, and its art accurately mirrors our diseases and distortions and our gropings.
>
> It is terrifying to be living in what may be the last days of the world. . . . Did you read the E. B. White story, "The Day They Did IT," in the *New Yorker*. Terrifying because only a few quite logical steps further. Instant and complete destruction is enough to mourn for—the end of man, of beauty, and poetry, and all love and promise—destroyed by his own evil-impelled inertia. . . . I think there are only two ways we can be stopped—catastrophe so horrible that people will rise and change our whole direction, or—or perhaps with—a new Christ.
>
> And our job is to prepare a way for that new faith and that new world. I don't think we can do it fighting bits and pieces of the old negativity—

tackling art cliques, for instance. I think we do it . . . by powerful words and images. Man has still immense capacity for faith and action; it is up to us to rouse it, concert it. . . . [W]ith your usual psychic insight or instinct, you have sensed the deep needs of our time, and what's more can express and help answer them—Why else the response you get from such masses of all kinds of people?[100]

Newhall provided the encouragement Adams needed and fed his messianic streak. Her apocalyptic vision was not unfounded. The year before, the Soviet Union had conducted its first successful test of a nuclear weapon. Now the American nuclear trump card had been matched and the world stood between two hostile powers, each rattling their sabers of mass destruction.

At the same time more personal emotions added to Adams's sense of urgency. His mother, Olive, had been physically ill and severely depressed for many years. She never recovered from the family's repeated financial debacles and became increasingly withdrawn and sullen. According to Ansel, she blamed Charles for their misfortunes. For that Ansel never seemed to forgive her.[101] She had developed arthritis before the age of sixty. Later, after two severe falls, she was confined to a wheelchair. She held on for many years, however. In Ansel's eyes she was yet another burden his father was forced to bear. She finally slipped into a coma in 1950, at the age of eighty-seven. Ansel hoped the end would come soon. He hired a full-time nurse so that his father could get some rest, a particularly difficult additional expense, especially with Michael and Anne both in private schools and a large backlog of volunteer work for the Sierra Club.[102]

Ansel was immensely relieved when she died a month later. Indeed, he felt a certain secret pleasure in having her gone. His father accepted her passing and adjusted well. His health was failing rapidly, however. Ansel and Virginia moved back to San Francisco to help care for him.

He steadily worsened over the next year, and in August 1951, he died as well.[103]

Ansel had always loved and respected his father deeply. His death only reinforced those feelings. While he had never been close to his mother, he thought of his father as a saint. He wrote with deep emotion to Beaumont Newhall, vowing that someday he would attain the greatness his father had always believed was in him. He was sorry he had wasted so much time along the way.[104]

For a man who, when forced into bed by exhaustion and overwork, sat typing long letters on a portable typewriter or poring over technical manuals until dawn, wasting time seems the least of his faults. His father's death did nothing to placate whatever demons drove him. He had been working at a furious pace since the end of the war—seven books, two portfolios, endless commercial assignments—yet he continued to feel driven to do more. Although his father was an inspiration, he was also a ghost that haunted him with failures and unfulfilled dreams. Just two weeks after his father's death, he told the Newhalls that he wanted to take a break, spend some time thinking, perhaps do some printing. It was out of the question, however. "Pure escapism," he said.[105]

Nancy felt he deserved to give himself a break and wondered what prevented his ever doing so. "There are times in people's lives," she told him, "when it is *necessary*—how can I make it strong enough?—to stop being hounded by the little necessities."[106]

Nancy found it strange that he could not give up his frenetic pace. "Why should you still be Orestes with the Furies after him? They have never conquered you, but they harry you and they are driving you to burn yourself out." She knew enough from researching her biography of him to realize the impact of his solitary childhood and the silent tensions of his family. "I think I know something of the pain, the fears

and boredom from which they sprang, but I know no reason why they should still haunt you. Why should you not sleep? . . . The nightmares are waste, so is the drive that will not let you take the rest you need, but hurls you exhausted and exasperated on the barricades."[107]

"My dear Ansel," she announced, "WILL YOU PLEASE REALIZE THAT YOU HAVE A JOB TO DO *in the next ten years* WHICH IS PERHAPS THE MOST IMPORTANT ANYBODY AT THIS PERIOD OF TIME HAS TO DO? Stop and think about THAT for a minute. It implies a time for a . . . PSYCHIC gathering of forces."[108]

Nancy wondered if he could make the time for "that quiet seminal, growing year."[109] It was plain that he could not. It was not that he would not like to; it was just not in his nature. He pressed ahead with his endless stream of projects and assignments, but her words must have echoed in his mind.

### David Brower and Dinosaur

Adams and Newhall were not alone in their sense of the urgency of the moment. One who shared their feelings was David Brower. Brower had worked closely with Adams in 1935 and 1936 when he was on the editorial board of the *Sierra Club Bulletin* and when he served as publicity manager for the Curry Company. While they commiserated about the banalities required by the Curry Company advertising department and its manager, Stanley Plumb, they both absorbed important lessons about the tools and techniques of public outreach. The Sierra Club as a whole had been in the business of public persuasion since the days when John Muir's influential articles in the national press helped create a groundswell of support for the national parks and forest reserves.

By the 1930s, the club recognized the rising importance of photog-

raphy and film in mass communications and formed the visual education committee. Its first chair was Nathan Clark. The second was Brower. When the club was lobbying for Kings Canyon, Brower and Richard Leonard collaborated in making a 16mm color motion picture, an ultra-low-budget silent piece called *Sky-Land Trails of the Kings*. Brower set up his projector in the halls and offices of Congress alongside Adams's photographs.[110] Following the success of the Kings Canyon campaign, the club continued to produce other films for showings to various groups and officials as an important adjunct to its publishing and lobbying efforts.

When Brower lost his job at the Curry Company in 1937, Adams wrote to Francis Farquhar, editor of the *Bulletin* and secretary of the club, on his behalf. He suggested the club hire Brower as an assistant secretary and editor to perform office tasks, dispense information, arrange activities, and promote membership. Not only would it help the club but it would also give Brower the chance to carry out the writing and conservation efforts he was eager to pursue.[111]

With its limited budget, there was only money for a part-time position. Brower soon found a steadier source of income as an editor for the University of California Press, which allowed him, in his off-hours, to continue his work for the club. In 1946, following his return from Europe and his service as an officer with the Tenth Mountain Division, Brower inherited the job of editor of the *Sierra Club Bulletin* from Farquhar who began a two-year term as the club's president. An accountant by profession and one of the club's early rock-climbing pioneers, Farquhar had edited the *Bulletin* since 1926. Under his direction it became a highly respected mountaineering journal, combining lively accounts of outings and first ascents with scholarly reports on the history and natural history of the Sierra Nevada. Brower's training in the Curry Company publicity department served

him well as he tried to bring a new activism to the club and its publi-
cations. He did not have to wait long for an issue on which to test his
new ideas.

The growth of the West in the postwar years rested, in part, on a foun-
dation of massive hydraulic engineering projects. Continued expansion
in the arid lands depended on a ready supply of water and power. To
meet those needs the federal Bureau of Reclamation sponsored a plan
for a billion-dollar Colorado River Storage Project (CRSP), a massive
complex of dams to harness the flow of the Colorado and its tributaries.
One of the proposed dams would flood the canyons of Dinosaur Na-
tional Monument in southeastern Utah. The conflict reopened wounds
left by the construction of the Hetch Hetchy dam thirty years earlier.
The victory of utilitarian water interests over preservationist forces led
by John Muir had been a serious blow to the Sierra Club and wilderness
lovers throughout the nation. The National Park Service, founded one
year after the decision on Hetch Hetchy, was created in part to protect
the parks from any further compromise of their integrity.

In the case of Dinosaur National Monument, the Park Service was
unwilling, or politically unable, to oppose the dam. The fight therefore
fell to the conservation organizations. They began by voicing their ob-
jections to Secretary of the Interior Oscar Chapman. Irving Brant, the
former confidant of Harold Ickes, spoke for all when he described the
plan as "one more move in the incessant drive to break down the
national park system by subordinating all values not measurable by
dollars."[112]

The first public charge was sounded by Bernard DeVoto in a *Satur-
day Evening Post* article published in July 1950 and subsequently re-
printed in *Reader's Digest*. That summer seventeen conservation orga-
nizations banded together to carry on the fight. They won a temporary

victory in 1951 when Chapman ordered further studies before he would consider submitting the CRSP to Congress.

The CRSP, including its proposed dam at Echo Park in Dinosaur, was enthusiastically embraced, however, by the administration of Dwight Eisenhower, who came into office in the winter of 1953. The decidedly prodevelopment tone of Eisenhower's policy toward the public lands was exemplified in his appointment of Douglas McKay, an automobile dealer from Oregon, as Secretary of the Interior. Dubbed "Giveaway McKay" by those in conservation, he opened the doors of the public domain to gas, oil, timber, and mining interests.[113]

During the 1930s the Bureau of Reclamation and the National Park Service had managed to peacefully coexist under the auspices of the Department of the Interior. Yet as the population and economy of the West expanded, the underlying conflicts in the federal government's commitment to both dam building and wilderness preservation grew increasingly apparent. It was a choice paralleling that faced by the leaders of the Sierra Club. The fight over the Echo Park dam would bring these conflicts into the open and propel the club not only into a period of national notoriety and rapid growth but also into a period of profound internal conflict.

Like other leaders within the club, Adams faced these issues in his own work. For example, one of the industries supporting the CRSP (for the cheaper power it was supposed to produce) was the Kennecott Copper Corporation. Adams photographed Kennecott's huge Bingham mine—over one and a half square miles of strip mine in the Utah desert, the largest of its kind in the world—for *Fortune* in 1951. Later Kennecott used the sweeping panoramic views (similar in their power and scale to his grand evocations of wilderness) for the front cover of the *Kennecott Corporation, 1951* annual report and in a print advertising campaign ap-

pearing in the *Saturday Evening Post, Newsweek, Business Week, Fortune,* and *Time* in the fall of 1952.[114]

The text of the ad, perhaps taking its cue from the heroic scale of Adams's photograph, likened the gaping scar in the Utah desert to an enormous football stadium, where—with all-American teamwork—the corporation was doing its part in the drive for national economic and military supremacy.

> They're rolling up the score in the "Copper Bowl"—It looks like a stadium for giants. Its "seats" are 65 feet wide, 70 feet high. It stretches a mile and a half across. It is the largest open-pit copper mine in the world—the Kennecott Utah Mine.
>
> And in this "Copper Bowl" a team of drillers, dynamiters, shovel operators, locomotive engineers and other workers all pull together to get out the ore. Together they produce about thirty percent of all the copper mined in the United States—more than one-half billion pounds a year. That's a "score" Kennecott is proud of. And it means a lot to a nation that depends so greatly on copper for industry and for defense.[115]

As was generally the case with such work, Adams had viewed his original assignment for *Fortune* as a necessary annoyance.[116] His righteous indignation at the banalities of advertising and commercial photography succumbed to the financial opportunities available in the thriving postwar economy. He found himself in demand with a number of corporate clients. In 1954 alone his work was featured in the annual reports of the Yosemite Park and Curry Company, the Bank of America, Pacific Gas and Electric, and the Polaroid Corporation. Each of these, with the exception of Polaroid, was based in the West and used Adams's reputation as the premier interpreter of the western landscape to link their company with the region and its mythic qualities of grandeur, endurance, and abundance.

Adams did not think of his commercial work as a contradiction to his love for the natural world. On the contrary, he thought of it as a tool that allowed him to carry out his own "assignments from within." Like most conservationists of his generation, Adams believed that economic growth and prosperity were not incompatible with preservationist goals. Adams's connections with a variety of enterprises that profited from western resources, industry, and recreation were not unusual among the club's leadership. Most were, as director Joel Hildebrand explained, "men of influence" who used that influence to "alert all their friends . . . to apply pressure" for specific conservation goals.[117]

As important figures in business, the professions, and academia, these were people firmly in the mainstream of America's industrial society. Club presidents included mining lawyer William Colby, real estate developer Duncan McDuffie, petroleum engineer Alex Hildebrand, dam builder Walter Huber, and paper products manufacturer Walter Starr.[118] Adams shared with these men a commitment to economic growth and the technological engines of that growth. At the time few saw their dual allegiance to wilderness preservation and industrial civilization as a contradiction, but in the years ahead Adams, like many in the conservation movement, would feel increasing pressure to choose sides as antagonisms between the more militant environmental movement and western business escalated.

*nine*

# THE AMERICAN EARTH

IN THE SUMMER OF 1952, Ansel and Virginia were back in Yosemite Valley, minding the store at Best's Studio and conducting summer photography workshops. There was time for a camping trip and making new photographs in the high country and around the valley. Amid the relative calm, Adams stopped to reassess. The seven years since the war had been full of intense activity and emotion. Now he felt physically drained. He surveyed his interior landscape in a letter to his old friend and benefactor, David McAlpin. Adams appreciated the opportunity to chart his creative psyche with someone who had followed the full trajectory of his career with a sympathetic eye.

Looking back, he saw a series of distinct phases of change and activity followed by "static" periods of recovery and gathering of new energy. His initial creative phase, as he saw it, came during the course of the 1920s and his "complex" transition from music to photography. The next two decades had seen cycles of creative waxing and waning. There were bursts of energy: Group f/64; *Making a Photograph*; the Stieglitz exhibition; the founding of the Department of Photography at the Museum of Modern Art; the mural project and the war years; the Guggenheim travels; the national parks, Yosemite, and technical books. Between

each burst of energy and creative output had come periods of exhaustion and recharging. He was in such a period now, he knew, but he was afraid it was proving to be a particularly long and dreary one. He hoped desperately for some new round of movement and productivity.[1]

His sense that a new phase was in the offing proved correct, as his move toward a publicly oriented art coincided with the blossoming of the conservation movement into a significant force in national politics. The movement needed powerful words and images, and Adams was eager to supply them. For the time being, however, a seemingly endless array of projects and commercial assignments absorbed his time and energy.

## Aperture *and Aspen*

Among these was the launching of *Aperture* magazine. Since the days of Group f/64, Adams had called for a high-quality journal devoted to the art of photography. He had tried unsuccessfully to garner support for the idea at the Museum of Modern Art. While many within the photographic community had expressed an interest in the project, nothing came of it until the early 1950s when Adams enlisted a number of his friends to personally underwrite and launch the venture.[2]

The idea was born at the first, and only, Aspen Conference on Photography in the fall of 1951. For ten days about 150 amateur and professional photographers met in the town high in the Colorado Rockies, sponsored by the Aspen Institute for Humanistic Studies. Adams and a score of leading figures from the world of photography presented papers, participated in panel discussions, and gathered informally to explore the social role of their medium. All agreed to ban technical shoptalk. The topics instead centered on philosophical issues of art and journalism and the effort to make meaningful contributions in their

work. There was a strong consensus that photography had an important role to play in the postwar world, that photographers should seize the opportunities of their growing influence as artists and social observers.

"Nothing as intense or as inspiring has ever happened to a group of persons in and around photography," declared Beaumont Newhall after it was over. *Aperture* was the most tangible outcome of the conference.[3] The core group of volunteers was made up of Adams, Milton Ferris, Dorothea Lange, Ernest Louie, Beaumont and Nancy Newhall, Barbara Morgan, Dody Warren, and Minor White. In the first issue, published in 1952, Adams offered an original fine print to anyone sending in a $25 subscription. Approximately sixty people took him up on the offer. The most important financial support came from the Polaroid Corporation.[4]

Although Adams generated much of the initial momentum, the person who brought *Aperture* to fruition was Minor White. Deeply involved in exploring the issues of creative photography, White enthusiastically supported the journal idea and offered to serve as its editor and production manager. As time went on, Adams frequently found White's editorial direction aggravating. The journal, he felt, became too often bogged down in theory and obfuscated by White's mysticism. Much as he liked and admired Adams, White refused to capitulate and remained true to his ideals. "I get slightly peeved at the root of all evil being considered as the 'personal,' subjective, clinical and psychological. We very simply live in an age when these matters are constantly under consideration, to bypass them is to leave a hole."[5]

Adams was caught in a conflict of his own making. Having promoted a journal of creative photography and a critical forum, he could not legitimately complain when *Aperture* followed those goals. Unable and unwilling to devote more of his time, he was left mostly to carp on the sidelines. The fundamental problem was that Adams did not really care for many of the directions in which photography was moving during the

1950s. He brushed the theoretical disputes aside. There was no time to waste on café chatter, he said. Better to spend that energy making a decent photograph.[6]

## Polaroid and the Wizards

One of Adams's most important contributions to the economic survival of *Aperture* was his role in bringing the Polaroid Corporation on board. As a technical adviser to the company and a close friend of its founder, Edwin Land, Adams had developed strong ties to the organization. Adams's connection with Polaroid was as important to his own finances as it was to *Aperture*'s. As always, he could not afford to continue his various creative and volunteer efforts without a steady commercial income. The association proved one of his longest and most satisfying, the only commercial affiliation of his career that he enjoyed on all levels, financial, creative, and personal. Much of that was due to the innovative nature of the company and Land himself.[7]

During the early 1930s, while still an undergraduate at Harvard, Land developed the idea and technique for producing polarizing filters made of finely ground crystals aligned and embedded in a sheet of synthetic plastic. He dropped out of school one semester short of graduation and set about finding markets for his new product. His first major customer was the giant Eastman Kodak Company, which requested the material sandwiched between two discs of optical glass for resale as an adjustable lens-mounted polarizing filter.[8]

After lucrative agreements with the American Optical Company and Bausch and Lomb Optical Company to supply polarizing materials for their sunglasses, Land attracted the attention of Wall Street, and in August 1937 the Polaroid Corporation was born. That same year, as Adams was casting around for commercial clients in a letter to McAlpin,

he inquired about the new company, wondering if they might be interested in a tasteful photographic promotion.[9]

Eventually much the same idea occurred to the people at Polaroid.[10] In 1945, Richard Kriebel, Polaroid's public relations director, wrote to Adams. "Ever since the first Polaroid filters were announced some years ago," he explained, "we have wanted to have a collection of photographs to show what could be done with them."[11] Adams's participation in the company grew in scope and significance when Land introduced his most important and seemingly magical invention—the instant photograph. Land had conceived of the technical means of making self-developing films during the war and introduced the new product with considerable fanfare in the winter of 1947. With its fortunes now closely tied to the photographic market, Polaroid was especially eager to seek the advice and endorsement of leading photographers.[12]

When Adams met Land at a party in 1948, the two took an immediate liking to each other. Adams became one of Land's close friends and a well-paid consultant for new product development, famous within the company for his long and minutely detailed memos outlining general goals the company should work toward and providing exhaustive specifics on how to achieve them. One of his most significant contributions was in developing Polaroid's line of 4 × 5 sheet film. Adams provided the impetus for the large-format film, convincing Land of its potential for professionals who wanted instant feedback for their studio and location work. He was convinced that the film could also become a source of fine prints in its own right. He pushed for the wider contrast scale and cooler print tones favored by most art photographers. Polaroid's sponsorship of *Aperture* was one vehicle for demonstrating the instant film's potential, as the back cover of each issue featured the work of noted photographers using Polaroid materials.[13]

While Polaroid became Adams's commercial mainstay in these

years, he took assignments from a number of regular clients, including IBM, Hasselblad, Bell Telephone, Varian Associates, and Pacific Gas and Electric, among others. It was a client list that reflected the changing economy of California and the nation. Although he continued to work with extractive resource industries in the West, such as U.S. Potash and Kennecott Copper, his newest clients were in the booming sector of high technology. Adams found these industries exciting and their technological innovations fascinating. As throughout his life, his interest in the latest advances of science and technology coexisted alongside his veneration of nature.

Other than Land, his favorite scientists and businessmen were the brothers Russell and Sigurd Varian, founders and chief engineers of Varian Associates, a leader in the fast-growing telecommunications field. The Varians were old friends of the Adamses. Ansel and Virginia had met their parents, John and Agnes Varian, in the late 1920s while traveling to Santa Fe with their friend Ella Young. The Varians and Young were residents of the Theosophical Society community at Halcyon on the central California coast near Oceano. Their son, Russell, and his wife, Dorothy, became active in the Sierra Club and close friends of Ansel and Virginia.[14]

Adams photographed the Varian brothers for a January 1954 feature in *Life* magazine celebrating America's postwar boom. Amid the articles touting the nation's prosperity was a photographic gallery of the leading figures in electrical engineering, dubbed by *Life*'s editors the "Wizards of the Coming Wonders." Adams contributed portraits of Edward Ginzton, pioneer of the high-energy linear accelerator used to explore subatomic structure, and of the Varian brothers, inventors of the klystron tube and a variety of its microwave transmission applications. Adams's own scientific and technological bent made the Varians particularly interesting, but what he enjoyed most was that the two had an impish sense of humor much like his own. Opting for a "mad scientist"

pose, they put together a strange mélange of microwave paraphernalia, impressive looking but completely useless. They stood beside it, staring intently into the camera. Following publication of the article, letters poured in from fellow engineers wanting to know the story behind their latest invention. They let their friends and competitors stew a bit before informing them of the joke.[15]

## Arizona Highways

The *Life* feature was typical of Adams's increasingly frequent excursions into the world of journalism. The most important of these, both financially and creatively, were a series of collaborations with Nancy Newhall for the popular pictorial monthly, *Arizona Highways*. From its founding in the 1920s through the Second World War, the magazine had more or less reflected its title, covering highway development appropriations and new construction projects. Its style and content changed dramatically after the war. Under the editorial direction of Raymond Carlson, it moved to a large, glossy, full-color format with articles centered not on the highways themselves but on the scenic wonders they enabled visitors to reach. Buoyed by the rising tide of automotive tourism, the state of Arizona (whose legislature funded the magazine) increased the appropriations and allowed all proceeds from subscriptions and newsstand sales to return directly to the magazine rather than go into the state's general fund. In 1951, *Arizona Highways* went nationwide; its Christmas issue sold over half a million copies. Four years later circulation had passed the one million mark.[16]

Adams and Nancy Newhall offered their services for a series of articles on the national parks and monuments of the Southwest. Carlson was naturally happy to accept these distinguished contributors and announced their arrival on the first page of the June 1952 issue. "We hope you'll like the Adams-Newhall studies of our big, old rough country,"

he wrote, promising that their collaborations would be a continuing feature in upcoming issues.[17]

The pieces Newhall and Adams supplied were far from the usual travelog and tourist hyperbole. They were after a more complex relationship of image and text, what Newhall called a synergy. Not simply an explanation of the image, the words had their own message that worked in conjunction with the image to create an additional level of meaning and emotional response. Alfred Stieglitz's idea of the photograph as an "equivalent" of subjective emotional experience, a concept that reached its highest form in his series *Music: A Sequence of Ten Cloud Pictures*, was their central inspiration. Newhall and Adams saw their collaborations as an extension of the equivalent, creating music on the printed page from the harmonies and rhythm of image and word.[18]

The style Newhall and Adams developed grew out of the extended photoessay form of the late 1930s and 1940s. MacLeish's *Land of the Free* was a particularly influential example, as was Steichen's *Road to Victory*. With *Time in New England*, her collaboration with Paul Strand published in 1950, Newhall produced an elegant expression of the form she was after. Combining quotations from seventeenth-century letters, poems, and journals with Strand's landscapes, portraits, and architectural details, she created a collage of images and text arranged in carefully planned sequences to create a dynamic flow of ideas and emotions.

After securing an agreement with *Arizona Highways* that allowed them complete editorial freedom, Adams and Newhall selected topics and arranged sequences and layouts for a series of articles. Their initial offering was "Canyon de Chelley National Monument." Among Adams's landscapes and closeup details ran Newhall's written counterpoint, describing the people and their history, the look and feel of the land. The following month's issue featured a portfolio and short interpretive text on Sunset Crater National Monument. Next came a more extensive article on the Jesuit mission at Tumacacori. Newhall described the ef-

forts of Father Eusebio Kino to establish a foothold in the "huge and mountainous desert swept by the fury of the Apaches, the Seris, the Hocomes, and other tribes unalterably opposed to white domination." The historical focus continued in the October 1953 article, "Death Valley." Describing the place, Newhall wrote, "Unearthly and immense, Death Valley so seizes the imagination that its history during the century white men have known it, is the history of illusions." The land itself, she thought, was what kept the place beyond reach. "At first sight, it seems more of an apparition than a reality." It remained a land beyond human control.[19]

The Death Valley essay was their most extensive yet for the magazine. Although pleased with the piece, Adams had mixed emotions concerning the project as a whole. *Arizona Highways* was noted for the relatively high quality of its reproductions, but Adams found them less than satisfactory. Compared to the brilliancy and extended range of his original prints, the muddy grays of the halftone plates were disappointing. He found the color even worse. In a departure for Adams, the Death Valley article featured a number of color reproductions. While *Arizona Highways* prided itself on its bright, full-color spreads, Adams found their garish hues unappealing. He preferred the more abstract qualities of black and white, which, he felt, emphasized the photographer's interpretive vision. Color photographs, especially in reproduction, seemed too saccharine, the kind of "superior postcards" some accused his black-and-white images of being. *Arizona Highways* had built its million-plus circulation on its brilliantly hued pages, and, as he had with Kodak, Adams was willing to supply color images if that was what the client wanted. Although he had mixed emotions, Adams was pleased overall. If nothing else, he and Newhall appreciated the income and the opportunity to hone their collaborative skills.

The magazine was proving a remarkable public relations boon for the state of Arizona. *Fortune*, not without some envy, noted its success

and the astute marketing behind it. "Whether by accident or design, the state of Arizona seems to have clicked as one of the truly smart promoters in the country's $10 billion dollar tourist industry." One indication of the drawing power of the images that Adams and others contributed to the pages of *Arizona Highways* could be seen in an article that appeared in the September 1954 issue. "Dream Homes by the Dozen" described the new subdivisions surrounding Phoenix. "If you want a brand new home with as much as thirty-percent more house and luxury features for the money than you'll find most anywhere else, then look at fabulous Phoenix, boom town, U.S.A." The miles of housing tracts shown in the accompanying photograph were a far cry from the desert silences that Adams portrayed, yet the two were clearly linked in the pages of *Arizona Highways*.[20]

## Three Mormon Towns

While life on the stucco frontier of the housing tracts was becoming the prevailing reality for westerners in the 1950s, small towns and traditional ways managed to hang on in the more isolated corners of the region. Adams photographed some of those outposts in collaboration with Dorothea Lange. Lange had done little photography since she had worked with Adams during the war. In 1946, after suffering for years with stomach ulcers, she underwent surgery for the condition. By 1951 she was feeling stronger and was ready to work again.[21]

After her discussions with Adams at the Aspen conference and her participation in the launching of *Aperture*, she was receptive to his suggestion that they collaborate on a photographic essay. Adams was not sure whether he or Lange's husband, the University of California sociologist Paul Taylor, suggested the Mormons of Utah. They chose to focus on three small towns in the southern part of the state: St. George,

Gunlock, and Toquerville. They sketched out their ideas for the article and offered it to *Life*.

Coming from these two eminent photographers with a proven track record, the magazine's editors quickly accepted the proposal but requested they get permission from the Mormon church. Taylor went to Salt Lake to meet with Reuben Clark, a friend who was an apostle of the church. Taylor returned under the assumption that all was cleared with the church authorities. When Adams and Lange arrived with Taylor and Lange's son, Daniel Dixon (from her first marriage to the painter Maynard Dixon), they soon discovered that such was not the case. In at least two of the three towns, church officials had apparently called ahead to warn that the photographers were unauthorized. After extensive assurances that they had only the best intentions, Adams and Lange were allowed to begin. But throughout the three weeks they spent in Utah, they encountered varying degrees of suspicion; some subjects refused to be photographed.[22]

Despite the difficulties, they found plenty of material. "We shared the work in a rather obvious way," Adams recalled. "She concentrated on the people and I concentrated on the environment, although in some instances we overlapped or worked together on a single subject." Although their styles and interests were markedly different, Adams and Lange shared a similar attitude toward the people, seeing these close-knit descendants of the Mormon pioneers as an enduring embodiment of the frontier spirit.[23]

Back in San Francisco, the two photographers processed their film and met to compare prints and shape the story. Adams invited Nancy Newhall along, thinking she might help in the selection, sequences, and layout. Lange resented the intrusion. Taken aback by her attitude, Adams and Newhall bowed out of the process, leaving Lange to work out the piece with the editors at *Life*. Although the story ran for ten pages

and included thirty-four photographs, a healthy-sized feature by *Life*'s standards, Adams felt that it had been edited into mediocrity, with little of the intellectual or emotional depth of their original vision intact.[24]

There was an angry reaction from some of the townspeople when the article appeared. In the beginning Adams and Lange had planned to mount an exhibition based on their project and thought of the article as primarily a means to finance their work. Adams felt they had misled some of their subjects into believing they only intended the exhibit, with little or no mention that their photographs would be seen by millions of *Life* readers. A woman whose photograph was used in the piece demanded a thousand dollars, claiming that the photographers had misrepresented themselves. Taylor marshaled evidence against her allegations and the suit was dropped. Despite the outcome, Adams felt they had not been completely forthright. He later visited some of the families and tried to explain what had happened. He felt some guilt at having at least given the impression of being just another intrusive and manipulative city slicker.[25]

Adams genuinely admired the inhabitants of these Mormon towns. But he encountered others in his travels around the West who were less appealing. It was his frequent experience in the sublime wilderness, he informed Nancy Newhall on his return from Utah, to realize with some chagrin that those who actually dwell in the bosom of nature were on the whole "a bunch of narrow, grasping, insensitive, stupid asses." The worst offenders, he said, were the workers at the Moab mine. They were the true heirs of the argonauts, "a sorry-looking bunch of boozy, brutal muckers." Thank God, he said, for the farmers and good Mormon families.[26]

Adams had similarly mixed emotions about those pouring into Yosemite each year. Discussing the best time to visit California with his editor from Houghton Mifflin, Paul Brooks, he recommended careful timing to avoid the teeming masses. Yosemite Valley was beautiful in

the spring, but by mid-June the invading hordes arrived in full force. Thankfully, the "infestation" of "hoi polloi" was confined to the valley floor. The high country was still fairly peaceful.[27]

Although heartfelt, these were not the kind of sentiments the Sierra Club would want as part of its conservation campaigns. Clearly, Adams had his contradictions, admiring the "wizards" of nuclear power while sneering at those who worked the uranium mines, wanting parks preserved for "the people" and then bemoaning their "infestation" with the same. In all fairness, such elitist outbursts were rare and did not reflect his fundamental beliefs. Yet they illustrate the tensions within the preservationist camp. Such tensions continued to grow as conservation emerged into the national spotlight.

## Dinosaur

The vehicle for that emergence was the Sierra Club's first nationwide campaign. Under Eisenhower's administration, the Bureau of Reclamation was going forward with its plans for the Colorado River Storage Project, including the proposed dam at Echo Park in Dinosaur National Monument. The Sierra Club and other conservation organizations prepared to remount the barricades to fend off what they saw as a dangerous assault on the integrity of the national parks and monuments. The club was ready and willing to accept the challenge of a national campaign. In December 1952, David Brower had been named the Sierra Club's first executive director. He welcomed the creation of the new position as "another milestone in the growth and progress of the club."[28] The following May, Richard Leonard began a two-year term as president. The "younger generation" was now firmly in the driver's seat.

Adams was pleased with the new activism. At a directors' meeting that year, the board discussed the questions raised by the club's growth. How far, Brower asked, should its concerns and cooperation with other

organizations extend? As Adams saw it, the club's interests were national in scope. Its strength derived from public enlightenment. More publicity was essential.[29]

Brower and Leonard and others agreed that the time had come to expand their sights beyond California and the Pacific Coast, to recruit new members from around the country, and to actively publicize their message. Yet many older members had serious doubts about the club's growth. When Marjory Farquhar resigned from the board that year, many took it as an expression of her disapproval of the new policies and her nostalgia for the simpler days of the past. Leonard agreed some twenty years later that her predictions had proven correct. "Her club is lost," he said. "It is now a powerful, impersonal political force. It is not a club of people gathered together, it is a political force."[30]

Although he later had mixed emotions about the changes, at the time Leonard was eager to see that political force materialize. The Dinosaur campaign demanded an immediate test of their strength. Leonard felt the board must take a no-compromise stand in support of the national park principle and reiterate its complete opposition to any dams within Dinosaur National Monument. Brower was responsible for mounting the campaign. He and the allied conservation groups would be as hard-hitting as their limited treasuries would allow, using books, pamphlets, and movies to spur a public letter-writing movement and to lobby Congress directly.[31]

Brower's finest hour came in his testimony before the House Interior and Insular Affairs Subcommittee on Irrigation and Reclamation. "I have not seen Goliath today," cabled Howard Zahnizer, the Wilderness Society point man at the hearings, to the Sierra Club headquarters, "but David is on his way to what should be return in triumph. Salute him well. He certainly hit the giant between the eyes." Brower's stones were taken from the giant's own arsenal. Conservationists had urged Congress to support an alternate plan that eliminated the need for a dam at

Echo Park by increasing the capacity of the proposed dam at Glen Canyon. The Bureau of Reclamation claimed that a larger dam downstream at Glen Canyon would result in greater net loss of water from evaporation. Brower and others suspected that the bureau's figures were incorrect.[32]

As he studied the data the night before his testimony, he noted a crucial error. The bureau's figures for evaporation from the higher Glen Canyon dam alternative neglected to subtract the evaporation losses from the eliminated dams at Echo Park and Split Mountain. Brower demonstrated that the bureau's estimate of 165,000 acre-feet per year lost would actually amount to no more than 70,000 acre-feet. Although bureau representatives protested this "amateur" analysis, Brower had clearly made a significant impression on the committee. It would be "a great mistake," he concluded triumphantly, "to rely upon the figures presented by the Bureau of Reclamation when they cannot add, subtract, multiply, or divide."[33]

Brower had not only undercut the Bureau of Reclamation on its own turf but had also impressed the congressional committee with his calm and rational tone and his willingness to offer an alternative plan that would allow the project to proceed while preserving the integrity of Dinosaur National Monument. Far from being a group of wild-eyed radicals, the conservationists seemed reasonable, moderate, and willing to work toward compromise solutions.

While he was appearing surprisingly congenial on Capitol Hill, Brower gathered forces for the public relations campaign. Although the House subcommittee that had heard Brower's testimony recommended removing the dam at Echo Park, the Senate had approved the CRSP in its entirety. As the vote neared, the Sierra Club and its allies turned up the political heat. One project was a pamphlet and short film on the fate of Yosemite National Park's Hetch Hetchy Valley, recalling John Muir's impassioned but losing crusade to protect the valley and the integrity of

the parks. Particularly effective were photographs showing the glacially carved canyon before construction of the dam, looking much like a smaller version of nearby Yosemite Valley, with pastoral meadows and a wide meandering river. Juxtaposed to the idyllic scenes were views of the flooded valley, its granite walls ringed with drowned trees and other detritus.[34]

Meanwhile Brower brought together a talented team of writers and photographers to put together *This Is Dinosaur: Echo Park Country and Its Magic River*. When he turned to enlisting photographers for the project, one of his first inquiries went to Adams. Surprisingly enough, Adams declined to participate. He had a number of pressing commitments and felt that the area around Dinosaur had little creative potential. He may also have hesitated because this was a project he could not personally control. Would Brower make it simply a partisan broadside? Would it be hastily produced? Would the illustrations be poorly printed? Adams was more than willing to lobby with his photographs, as he had shown in his work for Kings Canyon, but he wanted to lobby on his own terms.

Adams suggested that Brower contact a young photographer named Philip Hyde, who had been his student at the California School of Fine Arts. Hyde had told Adams that he wanted to lend his photographic talents to conservation and the Sierra Club. "Because I have a particular love and appreciation of nature," he had said, "I believe I can best use the tools I have in the interpretation of nature."[35]

In advice that sounded like it was as much directed toward himself as to his former pupil, Adams encouraged Hyde not to abandon subjective interpretation entirely but to direct his interpretations toward awakening the spiritual impulse in his audience, using the symbolic power of wilderness to convey his message. Adams reminded him that nature in itself is often a very dangerous place, unconcerned with human life and ideals. Wilderness was a social creation, he said, through which people,

individually and collectively, could reconnect with the beauty of the world. To communicate the message of wilderness, clear statements were needed. Although he welcomed Hyde's eagerness to lend his hand to the conservation cause, he urged him to avoid hyperbole and distortion. Clarity and honesty demanded that the artist be informed and balanced in his presentation.[36]

At the same time, Adams sent a telegram to Bernard DeVoto to encourage his participation in the proposed book.[37] DeVoto responded that he was optimistic that "the God damn stupid bastards currently known as the Administration" would not have much legislative success that year. "They certainly won't get the Upper Colorado Storage Project through Congress." He thought the campaign so far had been a major success. "This time we have really raised the country. Brower's stuff in particular has been magnificent."[38]

## The Theme and the Vehicle

Despite his reluctance to participate directly in the Dinosaur campaign, the energy and ferment within the Sierra Club and the conservation movement as a whole propelled Adams into a new phase of creative output. Rather than a narrow propaganda piece about the dam, he wanted to offer a broader vision of the parks and of wild lands in general. For Adams, the issues and the message went far beyond Congress and the fate of a particular piece of legislation to fundamental questions of humanity's place in the world. For him, the issues of art and conservation were essentially the same. He wanted to find the appropriate creative vehicle to bring them together and get them across to the public.

Although his ventures into the pages of national monthlies had been a welcome source of income and a chance to refine his collaborations with Nancy Newhall, Adams felt as if he was treading water creatively at a time when the world and the nation were at a crucial juncture. He felt

the stirrings of a powerful undercurrent of hope. He felt the stirrings of a powerful undercurrent of hope within himself and the world at large trying to find expression.[39]

As an antidote to the immediate background of political and military confrontation, the apparent self-destructive march of society toward its own oblivion, and the self-absorption of contemporary artists, he called for a renewed attention to the earth and its eternal forces. He wanted to speak for these in his art. The articles, he felt, were trial runs. He wanted to find a grander vehicle.[40]

Beaumont Newhall urged him to join Nancy in searching for a worthy project.

> What you and [Nancy] can do, in words and pictures, is even more important now than ever . . . something positive in this most negative era. The Arizona Highways formula . . . is a most extraordinary one. . . . These things hit people emotionally, and make them think. It is a great deal to be able to do this. I always feel that to *move* people is the mark of the artist. This is an oversimplification, of course, but to put them in such a frame of mind that they will accept the eternals as all-pervading and ever indispensable is, today of all days, of the most extreme importance. . . . With your great gifts you have a task. You have a message to bring to all of us . . . . It does not matter what the medium may be, and you are right in questioning the emphasis on the medium. The days of f/64 are gone, the days of the gospel of the functional esthetic are gone. These are days when eloquent statements are needed![41]

Adams found his opportunity by returning to the scene of his earliest contact with the Sierra Nevada and conservation ideals. Yosemite's LeConte Memorial Lodge had belonged to the Sierra Club for decades, but in 1954 the National Park Service requested that it be put to a more

public use. He suggested that the building be used to house an exhibit that would illustrate conservation principles and wilderness ideals—an inclusive and inspiring summation of what the Sierra Club stood for. Thirty-five years earlier the eighteen-year-old Adams had spent his first full summer in the Sierra as caretaker of the lodge. Now it would be the site of what was arguably the most important exhibition of his career.

At first Nancy Newhall did not seem to recognize this as the opportunity they were seeking. Even after hearing of his plans, she continued to believe that "all you or I need is the theme and the vehicle, and I think we are on the verge of finding really great ones, both alone and together!" Soon she came to see that the grand project they were after might be right under their noses. She suggested they expand the show to include not simply the national parks but the entire panorama of human relations with nature.[42]

## Wilderness Conferences

In their discussions concerning the scope and themes of the exhibition, Adams and Newhall reiterated many of the issues raised in the Sierra Club's biennial wilderness conferences. The first wilderness conference, sponsored jointly by the Wilderness Society and the Sierra Club, had been held April 8–9, 1949, in Berkeley, California. It brought together conservation groups; federal agencies; timber, mining, and livestock interests; and recreational outfits, from river rafters to mule packers. Although the discussions began with issues of limited scope, they soon grew into fundamental philosophical questions about land-use policies and practices. In the process they brought the range of thinking about wilderness into sharp relief. As expected, these groups often had conflicting interpretations of what wilderness was and what it was good for. Even within the Sierra Club, views differed sharply from those who felt

that "the sole function of wilderness is to contribute to the inspiration and well-being of people" to those who saw wilderness as a biological community that "should be preserved for its own sake."[43]

These two views, later dubbed anthropocentric and biocentric, respectively, grew out of fundamentally different visions of humanity's relationship with wilderness and with the world as a whole. At that time most members of the club favored the anthropocentric point of view. Wilderness was primarily a recreational area—a place for escape from urban pressures, for rest and renewal in beautiful surroundings. If many conservationists had little sympathy for biocentric views, most of the government administrators and economic interests had even less. They called for the application of the Forest Service's "multiple-use" policy in wilderness areas to prevent the "lockup" of valuable resources.[44]

At wilderness conferences in the mid-1950s the biocentric point of view found a growing number of advocates, especially among scientists and the younger conservationists. Where earlier generations of activists had confined their efforts to preserving limited segments of nature as "natural resources" and "scenic wonders," conservation after the Second World War began a transition to environmentalism—the effort to protect the health of biological systems as a whole.

Perhaps the most important factor in this transformation was the development of ecological concepts within biology. Ecology as a scientific practice grew out of Charles Darwin's theories of evolution. Darwin described biological change as the product of the dynamic relationship of organisms and their environment and portrayed evolution as a process of increasing diversity and complexity within species and the biosystem as a whole. This dynamic equilibrium through which evolution worked formed the basis of ecology. Ernst Haeckel, a German biologist familiar with Darwin's work, coined the term "ecology" in 1866 from the Greek root, *oikos*, meaning household or living relations (the word "economy" shares this same etymology). Haeckel defined

ecology as "the whole science of the relations of the organism to the environment." The field of ecology confirmed John Muir's insight: "When we try to pick out anything by itself, we find it hitched to everything else in the universe."[45]

Adams and others within the conservation movement discovered ecology primarily through the ideas and writings of a wildlife biologist named Aldo Leopold, whose most influential work, *A Sand County Almanac*, was published in 1949, the year after his death. The collection of essays on ecology, aesthetics, and ethics representative of his lifelong work in game management and wildlife conservation was reviewed by Harold Bradley (a former colleague of Leopold's) in the *Sierra Club Bulletin* in 1951. Brower, who later claimed that reading Leopold changed his outlook from recreational to ecological, published excerpts in the *Bulletin* and stocked the book for sale at the Sierra Club office.[46]

Leopold began his career at Yale's school of forestry, where he absorbed the utilitarian ideals of the U.S. Forest Service founder, Gifford Pinchot. On graduation he took a job in the Forest Service's Southwest District, supervising the Gila National Forest of New Mexico. Leopold became active in wildlife conservation organizations, including serving as secretary of the New Mexico Game Protective Association. He championed the prevailing practices of wildlife conservation of the day, stressing protection and improvement of habitat. He led the Forest Service's effort to establish wilderness areas during the 1920s. At the same time he urged the control of predators to maximize the abundance of game. To him, as to most hunters and ranchers, wolves and coyotes were merely "varmints" to be wiped out.[47]

In the coming years, however, Leopold's attitude began to change. As he continued his work in game management, he discovered that the preservation of life in all its forms was the key to the health of each individual species. The selection of "good" and "bad" species and the protection of the former at the expense of the latter only disrupted the

fragile equilibrium between them. Throughout the 1920s and 1930s, he watched as the success of predator elimination efforts brought overpopulation of deer, overgrazing of food supplies, and subsequent starvation. His experiences with deer and wolves led him to an appreciation of biological diversity and nature's self-regulating mechanisms.

Key to the new ecological attitude was what Leopold termed "a biotic view of the land." Whereas traditional resource management sought to maximize those species deemed useful and minimize those deemed harmful or useless, ecology envisioned the land and its life as a single system "so complex, so conditioned by interwoven cooperations and competitions that no man can say where utility begins or ends."[48] The best management was that which preserved the greatest possible diversity of species and left them alone, so that natural controls could maintain their own balance. In his essay "The Land Ethic," the capstone to *A Sand County Almanac*, he explained the philosophical and social ramifications of an ecological perspective. He called for a land ethic founded on the realization that the environment was a community to which humanity belonged rather than a commodity that it possessed.[49]

Leopold became an activist for the protection of wild areas in their full biotic diversity. In 1935 he joined with Robert Marshall in establishing the Wilderness Society. Leopold and Marshall explained the purposes of the new national organization in ecological terms. The preservation of wilderness, they argued, had to do with fundamental issues of biological health, not simply with recreation per se. It represented "one of the focal points of a new attitude—an intelligent humility towards man's place in nature."[50]

It should be noted, however, that Marshall represented what might be called the more traditional conservation outlook. His interest in wilderness was less biological and more human centered than Leopold's.

Marshall saw wilderness as a recreational and spiritual resource increasingly important for an urban society. As far as he was concerned, "the enjoyment of solitude, complete independence, and the beauty of undefiled panoramas is absolutely essential to human happiness."[51] The two founders of the Wilderness Society exemplified the transition beginning among conservationists in the postwar era. While Marshall's ideas remained important, Leopold's biocentric ones would find increasing support as human impact on the environment increased.

For the time being, however, most conservationists remained committed to the human-centered approach typified by Marshall. Fred Grunsky, editor of the *Sierra Club Bulletin*, warned that a biocentric position would be difficult to sell to the public at large. Public relations expert William J. Losh agreed and recommended that wilderness supporters stress the scarcity value of wilderness and its traditional place in American culture, emphasizing it as an irreplaceable part of a "vanishing America" rather than as a biological refuge or laboratory. He also warned preservationists to beware charges of elitism that could be brought against efforts to limit access and use of wilderness areas.[52]

### The Exhibition Takes Shape

In the summer of 1954, as Adams and Newhall developed their plans for the LeConte exhibition, these issues became recurring themes in their discussions. Beaumont wrote from their home in Rochester:

> Nancy is conserving our natural resources like mad. More nature here at 7 Rundel Park now than ever. Inside: natural specimens. Outside: natural specimens. Books on conservation piled high here and there. Even got me reading about forestry—and darned if it didn't seem interesting to me. I always thought that conservationists were the

people who get up at 4 A.M. to see birds and stuff. Never realized there was a practical side to it, fascinating bibliographies to read, and research to be done.[53]

Nancy worked intently through the summer, finally announcing in early September,

Finished the magnumopus at quarter past midnight last night. To think I once thought it would only take three WEEKS! I DID warn you that I HAD to write a book! . . . DO make it clear to everybody that this is *not the show!* Nobody in his right mind could possibly stand on his hind legs and read all this. . . . I have some suggestions for you to think over: 1) the Sierra Club might consider this as a picture book. I would then recast it in that form; even at this length, it is designed to flow across panels from image to image.[54]

Deeply immersed in the literature of conservation and biology, Nancy had begun to realize its potentially revolutionary implications. In the process of writing the text for the exhibition, she became an apostle of ecology and the new environmentalism. "Man is a part of Nature," she concluded. "If we are, so far as we can perceive or judge, the highest expression of Nature—a postulate that might be doubted—why does that imply that therefore everything from atom to universe must revolve around us to our benefit alone? It seems to me we are just the contemporary heirs to the position held in past eons by trilobites and dinosaurs—and may well be treading on our successors."[55]

Adams did not agree. Conservation was, for him, an effort by humanity for humanity. Their efforts, he said, were for the material and spiritual benefit of human society. Wilderness was a source of inspiration, a manifestation of God in the most basic form.[56]

Newhall was unwilling to accept Adams's emphasis on "pure" wilderness and the distinction between humanity and nature that it im-

plied. She felt that Europe, in which Adams had little interest, offered an important example of "the earth passionately loved and still fertile after two thousand years or more." "The wonderful places—the crags, the pinnacles, the valleys where man with a daring imagination has extended their wild beauty," proved, she said, that

> man CAN live with nature and Nature can still stand majestic, potent, primeval. And Man's works can appear so integral with Nature that they seem an outcropping, a field of flowers, a nest of birds. I think a lot of this is due to the European feeling before Columbus that *there was no more land*; the earth stopped at the Atlantic. Well, America stops at the Pacific. There is no more land to waste and ruin. To me, there are immense potentials in this.[57]

Newhall sent proofs of the text to a number of conservation leaders, including DeVoto, who seemed to come down somewhere between the views of Newhall and Adams.

> People and their societies are part of the order of nature, though only the new crop of ecologists are willing to recognize that fact. . . . The job of conservation is not to exalt nature over man, but to teach man how to conduct his societies in harmonious accord with nature. . . . I suggest you scrutinize carefully every passage which might suggest that birds and glaciers are more important than people.[58]

Adams was distressed by DeVoto's response. He suspected that Benny had had too many martinis again. Obviously their work was about people. What else could it be about? He felt that the exhibition should remain focused on the national parks and wilderness areas and their role as resources for the human spirit.[59] They discussed images and sequences, choosing from one to three photographs by thirty-two photographers to complement Adams's work. The exhibition and the refurbishing of the LeConte Memorial was financed by Walter Starr, who

had earlier supported the publication of Adams's *Sierra Nevada: The John Muir Trail*. A Sierra Club director for many years, Starr was then serving as chairman of the board of directors of the Yosemite Park and Curry Company. Meanwhile Ted and Jeanette Spencer made plans for the physical layout of the exhibition, including lighting fixtures and furniture for the small LeConte interior. Over the course of the following winter, the exhibition gradually came together.[60]

When the show opened in the spring of 1955, it proved an immediate success as crowds packed the small building throughout the summer. It featured a large selection of Adams's work from throughout his career, with a particular emphasis on his photographs from the Interior Department mural project and his Guggenheim Fellowship. Newhall's text was an environmental manifesto in free verse, a plea for public awareness of mankind's interdependent relationship with the natural world and a call to action to ensure the survival of life on the planet.[61]

Adams and Newhall both continued to hope that the exhibition would grow into a book. Although Nancy had suggested they publish it through the Sierra Club, Adams worried that the club might not have the resources to produce the high-quality edition he had in mind. He was well aware of the factors at work in producing a book of that kind. In 1954, he and Virginia had teamed up with the Newhalls and Phillip Knight, a photographer and assistant at Best's Studio, to form a publishing company called the 5 Associates. They began by issuing *Death Valley* and *Mission San Xavier del Bac*, expanded versions of two of Ansel and Nancy's collaborations for *Arizona Highways*.[62] They soon followed with a variety of guidebooks to Yosemite and the Sierra, including *Yosemite Valley*, which, like the first two books, was a large-format paperback with reasonably good reproductions at an affordable price.

Their experiences with 5 Associates brought home the difficulties of producing the type of book they hoped *This Is the American Earth* would

be. Creativity, quality, workmanship, and profitability were often incompatible, yet they hoped that with the right subject and the right balance of quality and price, a broad audience could be found.[63] Realizing that they needed some outside financial support to help defray the publication costs, Adams proposed the idea to a number of his wealthy and influential friends. He had approached Henry Allen Moe, director of the Guggenheim Foundation, the previous year, while just beginning work on the exhibition.[64]

Adams and Newhall also took their ideas directly to several publishers. One of their first contacts was with Alfred Knopf, an ardent conservationist with a strong interest in western history, who ran one of the most prestigious publishing houses in the industry. Richard Leonard informed Newhall that Knopf would be visiting Yosemite in August 1955. Leonard promised to encourage him to consider the LeConte show for publication. Meanwhile, Newhall reported that in New York most of those she spoke with recommended they send the manuscript to Simon and Schuster. She took the advice but added that "Knopf was always the heavy second" choice.[65]

A short time later she received a kindly worded rejection note from Richard Simon. "To do the book justice physically," he wrote, expressing the basic dilemma Adams had already pointed out, "we would either have to sell many thousands of copies or else publish it at a retail price far beyond the border of reasonability."[66] Newhall and Adams, who remained convinced that the book *could* sell "many thousands," continued their search.

While *This Is the American Earth* was drawing a steady stream of visitors in Yosemite, Brower was pushing ahead with his public relations campaign and the planned book on Dinosaur National Monument. DeVoto, who had provided so much of the literary dynamism in the postwar conservation movement, was set to edit the volume but died suddenly in

November 1955. Editorial duties passed to DeVoto's friend, the fellow writer and Utah native, Wallace Stegner. Novelist, director of the creative writing program at Stanford University, and biographer of the Colorado River explorer John Wesley Powell, Stegner soon became one of the leading voices in conservation. Alfred Knopf offered to finance the printing of the book and write its concluding chapter, "The National Park Idea."[67]

Although the contents were of high quality, the book's hasty production showed. Sales were slow, only five thousand copies. Nonetheless, every member of Congress received a copy. Perhaps the most effective single piece of propaganda, however, was a full-page advertisement that appeared in the *Denver Post* in the spring of 1956, days before the final vote. The first of its kind for a conservation organization, the ad urged the public to pressure Congress to accept the compromise bypassing Dinosaur, saving the Colorado River Storage Project as a whole while preserving the integrity of the park.[68]

When the votes came in, Congress agreed to drop the Echo Park dam, and Secretary of the Interior McKay, the plan's staunchest advocate, resigned. The campaign had been a remarkable success. It was clear to all sides that the national conservation movement had come of age. As the leader of the antidam coalition, David Brower was the man of the hour. "Dave changed the whole course of the political effectiveness of the Sierra Club in this campaign," Richard Leonard recalled. "It was at that time that the Sierra Club became a truly national organization."[69]

## Mission 66

The director of the National Park Service during Eisenhower's second administration, Conrad Wirth, felt that the rise in automotive tourism in the parks called for a new approach to management and infrastructure. People in cars needed different facilities than those who, as in

earlier decades, came by train or bus. Wirth announced a massive construction and refurbishing program to begin in 1956 with scheduled completion on the fiftieth anniversary of the Park Service in 1966. He called the program Mission 66.

In the best bureaucratic rhetoric, he described the plan as "a comprehensive and integrated program of use and protection." As Wirth was well aware, "use" and "protection" were increasingly incompatible goals. They reflected the fundamental conflicts embedded in the Park Service mandate of 1916: "to conserve the scenery and the natural and historical objects and the wild life therein and to provide for the enjoyment of the same in such manner and by such means as will leave them unimpaired for the enjoyment of future generations."[70] The vague generalities of this statement left a lot of room for interpretation; questions of how to leave parks "unimpaired" while providing for public "enjoyment" were never clearly answered. The high-speed highways, motels, stores, and restaurants envisioned in the Mission 66 plan clearly leaned more to the "enjoyment" side of the equation.

Those members of the Sierra Club who had opposed earlier road-building plans were angered that they had not been consulted about Mission 66. While the older directors, Alex Hildebrand (who was serving as club president) and Bestor Robinson, urged cooperation with the Park Service, the younger directors, who were generally opponents of roads and development in the parks, were unwilling to accept the traditional stance of compromise and cooperation. Adams was particularly outraged and called for an immediate effort to halt the plan. He was in no mood for cooperation.

For Adams, the most pernicious aspect of Mission 66 was the plan to widen Yosemite's Tioga Road. He had accepted the tabling of discussion on the road in 1952 after the Sierra Club board evenly split in its vote on the issue. Now plans went forward for blasting the glacially polished granite along the edge of Tenaya Lake to make way for a highway with a

lakeside view. Unwilling to support the club's equivocal stance, he offered his resignation from the board of directors and fired off an angry telegram to the secretary of the interior, the secretary of commerce, and the director of the National Park Service.[71]

After making it clear that he was speaking as an individual, not as a representative of the Sierra Club or any other conservation organization, Adams launched into an impassioned denunciation of the "desecration" of Tenaya, calling the plan a violation of the National Park Service Act bordering on criminal negligence. His wire provoked an immediate response. Four days later he left San Francisco for Yosemite and a meeting with the park superintendent, looking forward to the battle.

Adams relished the opportunity to lock horns with the Park Service, which under the Eisenhower administration was beginning to remind him of the Curry Company. Both seemed to view the parks as little more than federally owned tourist resorts. The Park Service, he complained to Horace Albright, was made of good people trapped in a system they could not control.[72]

Adams felt it was his responsibility to speak up for aesthetic values in the parks, to take a stand firmly on the preservation side of the national park equation. While the Sierra Club board was unwilling to come out as strongly as Adams, they were also unwilling to accept his resignation. Brower, Leonard, and Bradley persuaded him to return, claiming that his "purist" voice was needed to keep the club true to its ideals.[73]

Aware that his role in the club provided the best avenue to affect the conservation agenda, he agreed to rejoin. There is certainly a good chance that he never intended to leave permanently. His primary motives were to make his point as emphatically as possible and to avoid any embarrassment for the club in his contradiction of its official position.[74] Back in the club's ranks, he continued to express his views emphatically. The forces of development and preservation were headed for a show-

down, he thought. The pressures coming from increased visitation and infrastructure "improvements" in the parks showed no signs of slowing. Adams knew his views did not make him popular with the Park Service, but the parks were too important, he said, to be left to the Park Service.[75]

The growing pressures not just on the parks but on all the open lands of the West convinced Adams of the need for a comprehensive program of wilderness protection. That is why he joined other conservationists in support of the proposed Wilderness Act.[76] Throughout the nation, conservationists found themselves fighting rearguard actions, trying to block an endless array of development schemes. What was needed was a legal framework for wilderness that could preserve areas before they became objects for commercial development. The chief strategist of this campaign was Howard Zahniser, executive director of the Wilderness Society. Zahniser worked tirelessly to coordinate the work of conservation organizations, including the Sierra Club, and to lead the lobbying program in Washington, D.C.

Adams felt he could best contribute by calling attention to the aesthetic aspects of wilderness. Wild lands had an intrinsic value in themselves, he argued, like the art in the National Gallery. Conservationists needed to promote this. The biennial wilderness conferences seemed little more than the mouthing of noble platitudes. They were simply more preaching to the converted. What about the unconverted? Had the club really tried to reach out to them and get them involved?[77]

Adams was not alone in his belief that conservation groups needed a public relations campaign of broad dimensions. *Sierra Club Bulletin* editor Fred Grunsky urged Brower to give such a campaign the highest priority.

You and others have heard me say, with so much repetition that I am tired of it too, that the prime need in our field of conservation is for the kind of promotional and educational publicity that is not only truthful

and accurate but also wins attention. Our ace-in-the-hole, I am convinced, is the eye-catching appeal of good photography—whether in the form of illustrations in publications, posters, panel displays or movies. A thousand words about scenery will never do the work of one good picture, in getting the attention and good will of an "average reader" who is not a convert already.[78]

Brower, of course, fully agreed and was making every effort to see that become a reality. Having seen *This Is the American Earth* in Yosemite, he had grown more convinced that a general appeal for public appreciation of the parks and wilderness areas such as Adams and Newhall had mounted might be at least as effective as the more specific efforts like the Dinosaur campaign.

"You bring kudos to the club," Brower wrote to Adams in the fall of 1956, "which we could never afford to buy and couldn't have bought elsewhere even if we had the price." He admitted that he had been slow to grasp what the exhibition could be and do. "Your own faith in an idea made it work." He hoped that "we and our successors will find ways to administer the club in such a way that there will always be a fertile place for seeds of ideas like yours to grow."[79]

## I Hear America Singing

While Adams and Newhall continued their efforts to find backing for the publication of *This Is the American Earth*, they carried on with the many other projects on their agenda. Among these was their long delayed book on African-American education, a topic made especially significant by recent events. In 1954 the United States Supreme Court overturned the doctrine of "separate but equal" derived from the 1896 case of *Plessy v. Ferguson*. In *Brown v. the Board of Education of Topeka*,

*Kansas*, the Court outlawed racial segregation in schools and other public facilities. When the decision was put to the test in Little Rock, Arkansas, the national guard had to be called in to enforce it.

It seemed to Adams in the spring of 1956 that the ignorant, intransigent whites were the ones most in need of education. Expressing a common fear, he worried that some disaster awaited, an explosion of violence, unless moderate leaders came together to bring about a peaceful resolution. He hoped his tribute to black educational achievements would help in that cause. He was aware, however, that prejudice was not easily overcome. It was one thing to make a collection of uplifting pictures and text; it was quite another to actually achieve something with it.[80]

Nancy Newhall's working text emphasized the international leadership of the United States in the protection of freedom and human rights. She suggested the nation practice at home what it preached abroad.

> We, a democracy, sprung from most of the nations of the earth, have proclaimed all men created equal, regardless of race, color, creed, or class. By our own words the world judges our acts. . . . CAN WE OVERCOME PREJUDICE as we have overcome other diseases? Can we solve through life and faith what death and terror never could? The answer is Yes! And one proof lies in the progress Negroes have made in America during the last hundred years.[81]

As in the past, they could not find a publisher willing to take on such an "uncommercial" topic. The issues they raised continued to be important, nevertheless. Despite, or perhaps because of, the simmering tensions in American society and abroad, a new spirit of idealism and activism began to emerge in the mid-1950s. Since the end of the Second World War, an internationalist spirit had flourished in many quarters, a hopeful counterpoint to the cold war terrors. Amid superpower con-

frontation and postcolonial revolution throughout the globe, the vision described in Wendell Wilkie's best-seller, *One World*, and tentatively begun in the United Nations charter gave hope of a better future.

At the Museum of Modern Art, Edward Steichen organized a block-buster exhibit that championed these ideals in characteristically senti-mental style. He called the show *The Family of Man*. Steichen accurately, if less than humbly, described it as "the most ambitious and challenging project photography has ever attempted," intended to "mirror . . . the universal elements and emotions in the everydayness of life . . . the essential oneness of mankind throughout the world."[82] For Steichen's brother-in-law, Carl Sandburg, the subject was "People! flung wide and far, born into toil, struggle, blood and dreams . . . [,] one big family hugging close to the ball of Earth for its life and being."[83] The exhibi-tion was an unprecedented success and broke all attendance records at the museum. Published later that year, the book became a phenomenal best-seller, with over five million copies sold worldwide.

The 503 photographs, selected from over 10,000 submissions, were made by 273 photographers, amateurs and professionals, from sixty-eight countries. Steichen asked Adams for a mural print of *Mount Wil-liamson from Manzanar*. Always skeptical of any undertaking in which Steichen was involved, Adams had been hesitant to accommodate his request. He asked whether he could personally make the huge print Steichen had in mind. According to Adams, Steichen refused on the grounds that Adams's perfectionist printing would be inconsistent with the rest of the show. Adams thought Steichen was afraid of real photo-graphic quality. Unwilling to risk his original negative, Adams sent a copy negative along with a warning that, like the original, it contained a large fingerprint in the sky, acquired while loading the film in his cramped quarters at Manzanar during the war. Careful burning-in was required to prevent this from being glaringly apparent. Adams's fears

were confirmed on seeing the exhibition print. Steichen and his staff had turned one of his most important images into overpriced wall covering.[84]

As far as Adams was concerned, many of the photographs in the exhibition were essentially snapshots, appropriate for this colossal "family album" but inappropriate for a museum of art. He admitted it was a worthwhile effort and a powerful expression of a global ideal. There were certainly many fine photographs. Nonetheless, the show mainly confirmed his belief that for Steichen, photography was only a vehicle for an overblown theatricality and the aggrandizement of an equally overblown ego.[85]

Steichen, he said, was doing photography a disservice by contributing to the general belief that its real validity was only in social reportage and journalism. Pure expression, subtlety, spirituality—the true qualities of art—were dismissed as inconsequential. He contrasted the museum's exhibition policy under Beaumont Newhall, designed he said to emphasize photography as an expressive art form equal to the other arts, with Steichen's approach, in which photography was simply a vehicle for illustrating subjects and conveying social messages in a popular visual form.[86]

Adams was essentially correct in this assessment. Steichen had said himself that under his direction the museum would mount exhibitions in which "photography is not the theme but the medium through which great achievements and great moments are graphically presented." Whatever else it may be, Steichen argued, photography was above all "a great and forceful medium of mass communication."[87]

Adams's condemnation of *The Family of Man* illuminates the contradictions in his own mind about photography at the time. As had been the case during the war, he criticized Steichen for taking a direction in which he himself was increasingly moving. Although completely dedi-

cated to his role as a fine artist, Adams had more than a bit of the showman in him as well. The same could be said of Nancy Newhall, who joined with Adams in undertaking popularly oriented exhibitions.

Several of those exhibitions were sponsored by the United States Information Agency (USIA), the cold war offspring of the Office of War Information. The USIA provided news and cultural exports for the frontlines of the global standoff, battling the Communist bloc for the hearts and minds of the nations caught in the middle of their international confrontation.[88] The Newhalls had established connections with the agency during their tenure at the Museum of Modern Art.

Aware of the agency's desire for exhibitions that could bring a positive vision of American culture to a broad public, Nancy contacted the USIA's director of exhibitions, Michael Barjansky, suggesting that the agency circulate *This Is the American Earth* overseas to show the beauty of the American landscape and its role in the formation of the American character. She confided to Adams that she was well aware that the show was not the USIA's usual fare: "I hope it doesn't give Barjansky a nervous breakdown!"[89]

Surprisingly enough, the agency accepted the idea with enthusiasm and sponsored a worldwide tour the following year. Meanwhile, the Smithsonian Institution Traveling Exhibition Service circulated the exhibition within the United States. Encouraged by the warm reception the show was receiving, Nancy wrote again to Barjansky, hoping to convince him and the USIA to accept another exhibit, something "pure and serene," perhaps "simply the growth and change of an American artist. Sans Propaganda!" She suggested that this less ideological approach "might be the most convincing thing we, in our sphere, could do for international relations."[90]

Barjansky did not seem to agree, offering instead to sponsor a project more in line with the agency's usual stance. Nancy described the offer to Ansel and Virginia. "Latest from the USIA is the treatment of what

might well be the most important job yet: a statement of democracy—the dignity of man; the interaction of individuals—and especially during the last ten years." She thought that it was "right up Ansel's alley."[91]

Newhall suggested an exhibition combining Adams's photographs (as well as photographs by a variety of others) with the poetry of Walt Whitman to portray the spirit of American democracy. Both Newhall and Adams had long been admirers of Whitman's poetry. Adams had begun reading him through the influence of Cedric Wright in the early 1920s. Whitman was also one of the principal heroes to the artists of the Stieglitz circle. He gave voice to the optimistic faith in America that Adams had always maintained.

Originally titled *I Hear America Singing*, the name was changed to *Nation of Nations* for the overseas tour. The exhibition opened in the Berlin Kongresshalle in West Berlin, the epicenter of the cold war. It is an indication of how closely their ideas and tastes had become aligned that Newhall would produce an exhibition so much in concert with Adams's own style and ideals. It also showed the degree to which they had both been influenced by their rival, Edward Steichen. Like *The Family of Man* and his wartime exhibitions, *I Hear America Singing* was organized as an extended photoessay, a series of photographs illustrating a unified concept—in this case, the character of American democracy. The exhibition also shared the same designer, former Bauhaus member Herbert Bayer. Bayer's trademark hanging and freestanding panels heightened the visual impact of the photographs, confronting the viewer directly rather than resting demurely on the walls in traditional museum fashion.[92]

Yet the dedication of Newhall and Adams to the photographic print as a fine art object came through clearly. Adams personally printed each photograph, bringing his trademark forceful style, with its extended tonal range from deep velvet blacks to brilliant whites. He took pains to avoid enlarging any image beyond the point where grain structure and

blemishes in the negative became obtrusive. While both Newhall and Adams wanted a show of strong emotional impact, they were determined to make it an exhibition of fine photographs whose individual integrity was not sacrificed.

The show opened with a group of three images, *Sea and Clouds, the Pacific*, by Adams, *Portrait of Walt Whitman* credited to Mathew Brady, and *Grass and Sea* by Edward Weston. Between them were these lines from Whitman's *Leaves of Grass*:

> I heard that you'd ask'd for something to prove the
> Puzzle of the New World,
> And to define America, her Athletic Democracy.
> Therefore I send you my poems that you behold
> In them what you want.

On an adjacent panel was the text by Nancy Newhall.

> Walt Whitman spoke for the young America, which during his lifetime, 1819–1892, swept across half a continent, fought a civil war to free Negroes from slavery, and went on, tumultuous, turbulent, to build a civilization based on the belief in the equal rights and dignity of every individual. Of this epic Whitman became the poet and prophet, seeing democracy as a force rising with the force of every individual it liberates—as an ascending spiral whose goals are no less than solving the great problems and achieving the still greater dreams of humanity.[93]

After panels on the democracy of the New England towns, the quest for religious freedom, and the influx of immigrants from across Europe and the world, the story moved west in the third panel. Beneath a mural-sized print of Adams's *Thunderstorm, the Teton Range*, ran these lines from Whitman:

> As in a dream they change, they swiftly fill
> Countless masses debouch upon them—

*Yosemite National Park.* Kodak Colorama. Courtesy and Copyright Eastman Kodak Company.

## They're rolling up the score in the "Copper Bowl"

It looks like a stadium for giants. Its "seats" are 65 feet wide, 70 feet high. It stretches a mile and a half across. It is the largest open-pit copper mine in the world — the Kennecott Utah Mine.

And in this "Copper Bowl" a team of drillers, dynamiters, shovel operators, locomotive engineers and other workers all pull together to get out the ore.

Together they produce about thirty percent of all the copper mined in the United States — more than one-half billion pounds a year. That's a "score" Kennecott is proud of. And it means a lot to a nation that depends so greatly on copper for industry and for defense.

**COPPER CORPORATION**

*Fabricating Subsidiaries:*
CHASE BRASS AND COPPER CO.
KENNECOTT WIRE & CABLE CO.

*Kennecott Copper, Bingham Mine.*
Advertisement from *Fortune* magazine, November, 1952.
Courtesy and Copyright Kennecott Corporation.

*Snags, Northern California.*
Contemporary print from original negative by Ansel Adams,
California Museum of Photography, Sweeney/Rubin Ansel Adams
*Fiat Lux* Collection, University of California, Riverside.

*West from the "Big C" (late into Sun).*
Contemporary print from original negative by Ansel Adams,
California Museum of Photography, Sweeney/Rubin Ansel Adams
*Fiat Lux* Collection, University of California, Riverside.

*Barns, Fence, Near South Entrance,*
University of California, Santa Cruz.
Contemporary print from original negative by Ansel
Adams, California Museum of Photography,
Sweeney/Rubin Ansel Adams *Fiat Lux* Collection,
University of California, Riverside.

*Tidepool.*
Contemporary print from original negative by Ansel Adams,
California Museum of Photography, Sweeney/Rubin Ansel
Adams *Fiat Lux* Collection, University of California, Riverside.

*Rock Detail.*
Contemporary print from original negative by Ansel Adams,
California Museum of Photography, Sweeney/Rubin Ansel
Adams *Fiat Lux* Collection, University of California, Riverside.

Above: *Santa Rosa Road, View East Over Desert.*
Contemporary print from original negative by Ansel Adams,
California Museum of Photography, Sweeney/Rubin Ansel Adams
*Fiat Lux* Collection, University of California, Riverside.

Right: *Desert Plants, First Overlook, Sunrise.*
Contemporary print from original negative by Ansel Adams,
California Museum of Photography, Sweeney/Rubin Ansel Adams
*Fiat Lux* Collection, University of California, Riverside.

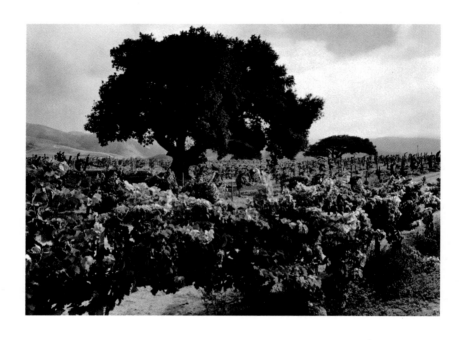

*Paul Masson Vineyard at Soledad.*
Contemporary print from original negative by Ansel Adams,
California Museum of Photography, Sweeney/Rubin Ansel Adams
*Fiat Lux* Collection, University of California, Riverside.

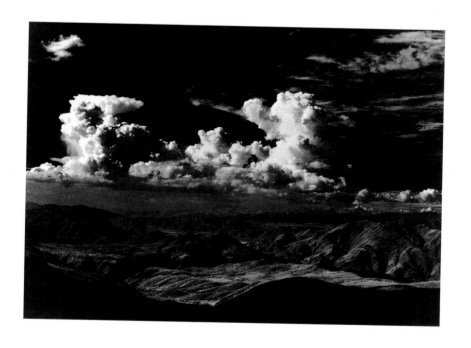

*Thunderheads, Anza-Borrego Desert.*
Contemporary print from original negative by Ansel Adams,
California Museum of Photography, Sweeney/Rubin Ansel Adams
*Fiat Lux* Collection, University of California, Riverside.

*Roots.*
Contemporary print from original negative by Ansel Adams,
California Museum of Photography, Sweeney/Rubin Ansel Adams
*Fiat Lux* Collection, University of California, Riverside.

Through the passes, up the mountains steep, conquering,
holding, daring, venturing the
Unknown ways,
Pioneers! O Pioneers!

Surrounding Adams's primal landscape were historical photographs of U.S. expansion: homesteading, farming, and mining in the great reaches of the West. Newhall included a variety of material artifacts as well, from miners' pans to saddles and spurs.

From images of the land's material wealth, the show turned to its spiritual dimension, with Adams's photographs of Mission San Xavier, Indian dances, and, floating above them, his classic *Moonrise, Hernandez, New Mexico.*

The following panels portrayed the nation's pull for immigrants from around the world:

Here is not merely a nation but a teeming nation of nations—
Here is what moves in magnificent masses—
Here the crowd, equality, diversity, the soul loves.

The images of everyday life that followed—home and family, work, education, holidays, sporting events—became, in Whitman's embrace, archetypes of the nation's democratic promise. Newhall closed the exhibition with a call for those in other nations to join in America's democratic quest, quoting Whitman's lines,

This moment yearning and thoughtful, sitting alone
It seems to me there are other men in other lands yearning and
    thoughtful,
And it seems to me that if I could know these men, I should
become attached to them as I do to men in my own lands—
I know I should be happy with them.

Although they were sponsored as a part of the USIA's cold war effort, Newhall and Adams used their opportunity to express a somewhat radical message. Accompanying daguerreotypes of a former slave, Massachusetts Chief Justice Lemuel Shaw,[94] and a contemporary courthouse were Whitman's words,

> Justice is in the soul
> It is immutable. Majorities and what not, come at
> last before the same passionless and exact tribunal.

Symbolic of what that justice might bring was a portrait of Ralph Bunche, U.S. Ambassador to the United Nations, and the highest-ranking black man in the federal government. Following a closeup of door hinges was the poet's revolutionary call,

> Unscrew the locks from the doors!
> Unscrew the doors themselves from their jambs!
> By God! I will not accept that which all cannot have
> their counterpart of on the same terms.

Newhall and Adams's next images were of a union meeting and gathering stormclouds and the words

> I will therefore let flame from me burning fires
> that were threatening to consume me.
> I will lift what was too long kept down these smoldering
> fires.

Around these lines were photographs of nineteenth-century tenements on New York's lower east side, a Lewis Hine photograph of child labor, and a contemporary redevelopment project called the "New East Side." They closed with Whitman's rally cry

To thee, old cause!

Thou strong, remorseless, sweet idea.

Deathless through the ages, races, lands—

These chants for thee, the eternal march of thee!

and two photographs by Adams: *Clearing Storm, Mount Williamson*, and *Burnt Stump and New Grass, Sierra Nevada*. From the ashes of the Second World War and the dark clouds of nuclear terror, they implied, a resurgent hope was rising from the deep springs of America's democratic traditions.[95]

## The American Earth

The combination of idealism and nationalism expressed in *I Hear America Singing* strongly influenced the evolution of *This Is the American Earth* as it grew from exhibition to book. In close consultation with Adams and Brower, Nancy Newhall expanded the text of the show into a free verse epic. The nationalism of the USIA exhibitions and the biocentrism of the wilderness conferences came together in a powerful combination.[96]

In the fall of 1958, Newhall struggled to fuse her wide-ranging themes into a coherent whole. "I am a woman being devoured by a poem!" she told Adams. "Just said I'll make a typethrough of the 'American Earth' text incorporating Dave Brower's suggestions (some of them) and new thoughts I've had or come across during the last 3 years." That was proving difficult: "every morning . . . the typewriter and the stuff in it stares me in the face saying this is NOT all you mean or need to say. And then the voices—your ghosts—come up with a word or a phrase." Somewhat surprised herself at the dimensions the project had taken on, she warned Adams that she "might rewrite the Creation and the Apocalypse. Well, no one gal is going to do that, but I seem pro-

pelled towards making a stab at it." What she wanted most was some feedback and encouragement. "I NEED THEE! Brother and love and friend and colleague, come to me! Tell me if I got to go on like the Delphic Oracle . . . or if this is off the beam and I should, if possible, stop."[97]

Only a few days later Adams was there in person to look over the manuscript. In the midst of a typically whirlwind trip through the East, he made a weekend stopover in Rochester to visit the Newhalls and Minor White, who had left San Francisco in 1953 for a job at the George Eastman House.[98] En route to San Francisco the following Monday, he typed out what was for him a brief letter—two single-spaced pages—on his trusty portable machine, expressing gratitude for the pleasures of good company, midnight steak, and 6:00 A.M. coffee. Apparently he had been unable to offer more than general comments. He assured her that he was deeply interested in the text. His lack of specific criticism was more a reflection of her brilliant writing than any displeasure or disinterest on his part. Nancy was a true genius, as far as he was concerned. He was worried, however, that she was burning herself out with intense efforts and too much liquor. He urged her to take it easy.[99]

Considering the source, the advice was more than a bit ironic. Adams himself was feeling tired and frayed but as usual would not allow himself to let up. He felt he must keep working, that he should get his huge backlog of negatives printed while he was still able. His thoughts on mortality were perhaps spurred by the death the previous winter of Edward Weston, whose long bout with Parkinson's disease finally ended on New Year's day 1958.[100]

Weston's last years had been painful. As he grew increasingly weak, he passed the printing of his negatives on to his son, Brett, a well-respected photographer in his own right. Later Brett turned the job over to his brother, Cole, an established photographer as well. Observing Weston's demise and his inability to personally print some of his

most significant negatives, Adams vowed to devote himself to the printing of his own vast body of images.[101]

Adams was also becoming increasingly aware of his physical limitations. He had kept the lean physique of his mountaineering youth well into his forties, but by the late 1950s, he had developed a fair-sized gut. Decades of midnight steaks and evening cocktails could not help but take their toll. His back was the first to go. Regular visits to a local doctor offered temporary relief, but the aches and pains piled up.[102]

As Newhall struggled over the text for *This Is the American Earth*, she received considerable input from David Brower. He recalled bringing her a number of books and talking with her a great deal. While Newhall was eager to receive help on environmental topics and conservation history, once she had organized her thoughts on paper, she was less receptive to suggestions. "I'd say, '. . . but could we change this word,'" Brower recalled. "She'd look at it and she'd put her hand in her hair, then she'd get up and . . . ,'" acting out Newhall's response, Brower paced pensively, then swung around, shouting "'No!'" It is safe to say that Newhall's text was essentially her own.[103]

By 1959, Newhall and Adams were satisfied and Brower was convinced that the Sierra Club should publish the book. He agreed that it should be of the highest possible quality, an enduring and beautiful summation of the club's philosophy expressed in positive terms. He was aware that it would be an expensive undertaking and followed Adams's suggestion that he search for financial underwriting. They found it from the estate of the former Sierra Club board member Marion Randall Parsons and from the industrialist and conservationist Max McGraw and the McGraw Foundation.[104]

When the book finally appeared in 1960, it fulfilled the highest expectations of its authors. Beautifully bound and printed, it had the look

and feel of a fine limited edition. The generous 14 × 11-inch dimensions gave Adams's photographs a wide-screen impact, especially when laid out across a double-page spread, as many of his more dramatic images were. In his foreword, Brower proudly called it "by far the most important work the club has published." It was just the first of what would be called the exhibit format series, bringing conservation philosophy and nature photography to coffee tables across the nation.

The opening pages featured a large two-page spread of Adams's *Winter Sunrise—The Sierra Nevada from Lone Pine, California* (1944), with the caption by Newhall: "This, as citizens, we all inherit. This is ours, to love and live upon, and use wisely down all the generations of the future." Here was the book's essential message.[105]

Newhall's text began with the modern condition: "an age whose hopes are darkened by huge fears . . . frantic with speed, noise, complexity[,] . . . an age when the closed mind, the starved eye, the empty heart, the brutal fist, threaten all life upon this planet." Juxtaposed to that fear and uncertainty were Adams's images of nature's grandeur and tenderness, from the light-filled *Winter Sunrise* to the soft textures of *Fern in Rain, Mount Rainier*. Among these images ran a series of rhetorical questions: "What is the price of exaltation? . . . What is the value of solitude? . . . What is the cost of freedom?"

When Newhall said she was trying to rewrite the Creation and the Apocalypse, she was not far from the truth. In the first chapter, "Brief Tenant," she traced the rise and fall of civilizations from the ancient roots of human consciousness. "Out of the vast depth of time past," she began, "man comes like a meteor's flash. In myth, in dream, this living dust remembers chaos, the drift through endless night, the longing to cohere—the shock, the winds, the vast light of Creation. Was it only a million years ago . . . we first stood upright? . . . Was it only a hundred thousand years ago when, with fire and tools . . . we began to change life's balances?" The domestication of animals, the first agriculture, the

rise of cities all followed, yet every civilization that arose eventually succumbed. Beneath a nineteenth-century photograph by Francis Frith of colossi in the Nubian desert, fallen, eroded, slowly engulfed in the sand like Shelley's Ozymandias, Newhall reminded the reader that "across the continents Man's record of ruin lies very old."[106]

Mesopotamia, Egypt, Greece, and Rome fell in their turn as the earth that gave life was repeatedly abused. "In Israel . . . Jeremiah cried, 'The whole land is made desolate because no man layeth it to heart!' Isaiah warned all ages: 'Woe unto them that join house to house, that lay field to field, till there be no place that they may be placed alone in the midst of the earth!'"[107]

In the achievements of Europe, the Renaissance, and the rise of science, humankind found the keys to the powers of nature, learning "to harness the invisible, the intangible, the forces known by Satan, prince of the powers of the air. . . . We remember Faust, and dread his bargain as our own." Driven by their belief that "the only hope of freedom lay in conquest," Europeans sailed across the oceans to America.[108]

The second chapter, "New World," illustrated the "Eden" they found with Adams's visions of a primordial North America, from a storm off the Atlantic coast to thunderheads above Yosemite Valley. In these fertile lands, Newhall claimed, new ideas of democracy and freedom were born out of the frontier experience. "Here any man with ax and gun could live, clear his own fields, hew his own home, win for himself a long-forgotten birthright—independence." Something else was born as well. Amid the wonders of the North American continent, a small but growing number awakened to natural beauty. Opposite Adams's *The Tetons and the Snake River*, Newhall quoted the seventeenth-century New England theologian Jonathan Edwards: "Alone in the mountains or some solitary wilderness. . . . Divine glory seemed to appear in everything; in the sun, the grass, in the water and all nature. I felt God, if I may so speak, at the first appearance of a thunderstorm."[109]

From these beginnings, Newhall argued, the sentiment for wilderness preservation emerged. She quoted the artist George Catlin who, in 1832, had called for "some great protecting policy of government" so that the Indians, the buffalo, and all the life of the plains might be "preserved in all their pristine beauty and wildness in a magnificent park—a nation's park."[110]

Against this incipient movement ran much stronger currents of technological power and environmental destruction. Not until the end of the nineteenth century, with the frontier a vanishing legacy, did the nation as a whole begin to awaken to the need for a new approach. The third chapter, "The Machine and the New Ethic," outlined the twin strands of twentieth-century conservation: the utilitarian goals of rational and sustainable resource policy and the preservationist quest for an emotional reunion with the spirit of the wild. She saw the rising popularity of wilderness recreation as an expression of a deep-seated longing. "Confined by our own artifice, borne up on vast abundance and colossal waste, restless, disconsolate . . . we course across this dwindling globe that once seemed infinite . . . seeking somewhere, in some last far place, our birthright: the wild majesty, beauty, freedom through which for a million years Man grew."[111]

The key to a reconnection between humanity and nature, Newhall argued, lay in the insights of biology and ecology: "Shall we not learn from life its laws, dynamics, balances? . . . Learn at last to shape a civilization in harmony with the earth?" All forms of life are connected in a vast web of interaction and mutual sustenance. Only by recognizing that whole web of life could humanity discover the wisdom and "the forces of renewal" for a new and sustainable relationship with the natural world.[112]

In the concluding chapter, Adams's images and Newhall's text urged the reader to venture into the wilderness and experience its mystical

embrace. "Shall we not come as pilgrims to these sanctuaries [and] leave behind, below, tensions and frenzies." This was the Sierra Club's core message, the ideals of John Muir presented to a new generation.

## Redefining the Frontier

*This Is the American Earth* was an immediate success. Prominent conservationists such as Supreme Court Justice William O. Douglas hailed it as the finest statement on conservation ever made. NBC's "Today" show featured the book on its morning broadcast. Much to everyone's satisfaction, it sold approximately twenty-five thousand hardcover copies. The paperback edition released several years later sold around fifty thousand. The success of *This Is the American Earth* "changed Dave's whole way of looking at the conservation moment," recalled Edgar Wayburn, who was serving as club president at the time it came out. "He saw what a book could do."[113]

The book was effective both as art and as propaganda. Perhaps the key to its effectiveness in the latter realm was its linkage of the conservation movement with romantic and nationalist traditions. Newhall, Adams, and the conservation movement as a whole drew on the long-standing belief that the process of westward expansion had been the nation's defining experience, an idea that found its most enduring expression in Frederick Jackson Turner's paper, "The Significance of the Frontier in American History," presented to the annual meeting of the American Historical Association in 1893.

In her text, Newhall described the wilderness in Turnerian terms, as the source of American freedom and democracy. Yet she saw in the "passing of the frontier" the need for a new relationship with nature rather than a continuation of old ways. She emphasized the folly of conquest, the dead-end of a policy of exploitation. Rather than the

dichotomies of civilization versus savagery and humanity versus nature, she pointed to the unity and interdependence of life.

One way that Newhall and Adams subverted Turner was by bringing Walt Whitman's optimistic embrace of the whole sweep of the American experience into their conservation message. Franz Kafka noted that Whitman "combined the contemplation of nature and civilization, which are apparently entirely contradictory, into a single intoxicating vision of life." This could also be said of Adams and Newhall. Rather than a Turnerian conquest of nature, they offered Whitman's vision of America as "nature's nation," in which American culture gains its strength from the power and beauty of the continent.[114]

In *Winter Sunrise*, Adams presented the landscape in these terms. Wilderness is a realm of glorious light and divine inspiration, standing majestically above civilization. While the juxtaposition of nature (in the form of the wild Sierra peaks) and culture (in the form of the pastoral scene below) echo nineteenth-century traditions, this is not the meeting ground between "savagery and civilization" that Turner described. Progress is not defined as the conquest of wilderness but as benign coexistence with it.

By incorporating Whitman and Turner into their vision of conservation, Adams and Newhall helped to enlarge the definition of the movement and bring a new constituency to its ranks. Far from a narrow special interest, a fringe element of bird-watchers and tree-huggers, they portrayed conservation as an effort to save the core values of the nation. Yet at the same time they were also engaged in a reinterpretation of those values.

Although Adams and Newhall revised the frontier myth and the relationship to nature that it implied, much of the old paradigm remained. The title of the book itself carried a tone of triumphant nationalism that seemed to contradict the biocentrism of Newhall's text. As Brower recalled, some younger environmentalists later complained

about it. "It isn't the American earth," they said, "it's the earth's earth."[115]

The phrase seemed to echo the "American Century" rhetoric of the postwar period and its "manifest destiny" subtext. Campaigning for the presidency in 1960, John F. Kennedy called his plan to revitalize America's leadership to the world the "New Frontier." Yet in the swamps of Vietnam, it was no longer clear on which side of the line between "savagery and civilization" America stood. While the equally horrific wars of the nineteenth and twentieth century were sanctified in the assumption that light was prevailing over darkness, the debacle in Southeast Asia would undermine America's faith in its inherent virtue, superiority, and destiny.

## Silent Spring

Another article of faith at the core of the old frontier and the new—that progress was defined as unceasing growth and was made possible by the technological conquest of nature—would also receive mortal wounds in the coming years. In 1962, Rachel Carson's best-seller, *Silent Spring*, delineated in frightening terms the biological hazards of the modern chemical industry, in particular the highly toxic pesticide DDT. Carson had worked for the U.S. Fish and Wildlife Service, observing the effects of these toxins on wildlife populations for many years and documenting their impact. She had witnessed firsthand the effects of humanity's war on nature.

The use of these pesticides, Carson argued, was based on a biologically disastrous and morally indefensible attitude. "The 'control of nature' is a phrase conceived in arrogance . . . when it was supposed that nature exists for the convenience of man. The question is whether any civilization can wage relentless war on life without destroying itself, and without losing the right to be called civilized."[116]

Perhaps the most compelling aspect of Carson's book was that it brought these issues home to readers in forceful, personal terms. This was not an abstract philosophical debate; it was not about what was happening in some remote wilderness. It was about what was in the air, what came out of the kitchen faucet, what was in the food on the dining room table. Carson made the issue of environmental health a matter of personal concern for the ordinary citizen.

The rising importance of broad-based environmental issues forced the Sierra Club to confront basic assumptions about its mission and the values of modern society as a whole which their earlier recreational focus had allowed them to ignore. Many in the club were not pleased. Thomas Jukes, a professional chemist with American Cyanimid, defended the record of pesticides in fighting diseases like malaria and increasing crop yields to feed the people of the world. He considered the position of Carson and people like her a surrender to humanity's old enemies of disease and starvation and a retreat from the progress made possible by science. Alex Hildebrand agreed. As a professional engineer, he criticized what he saw as the growing tendency of the club's leaders to venture into areas "they weren't technically qualified to understand. . . . [T]hey became too broad, and not selective enough in their criticisms." His father, the University of California chemist Joel Hildebrand, resigned from the club, angered over the increasing "antiscience" bias he found in Brower and other club leaders.[117]

Despite such objections, the Sierra Club continued to expand its attention beyond the parks. The 1963 Wilderness Conference was a milestone. Wallace Stegner expressed the public concern: "I certainly cannot speak from scientific knowledge," he said, "but I *can* speak from fear. I am running scared." Stewart Udall, President Kennedy's secretary of the interior, questioned the assumptions "that man must destroy nature in order to conquer it" and that "science alone can solve all our problems."[118]

Over the course of the 1960s, the Sierra Club would ride to national prominence on a groundswell of environmental concern. Despite the club's dramatic growth, Adams, like many others in the organization's ranks, began to experience some doubts about the direction the club was heading. While he supported the growing national power of the group and its aggressive public campaigns in favor of parks and wilderness, he felt uneasy about the antitechnological, antigrowth elements that were emerging in the club and in the environmental movement as a whole.

*t e n*

# DISSONANCE AND HARMONY

ADAMS WAS SIXTY-ONE YEARS OLD in February 1963 and feeling
more rickety with each passing season. He could not escape the suspi-
cion that his best years and most important creative work were now
behind him. It was not simply a matter of declining physical strength;
there was also the sense that he was merely stirring the coals of his
earlier creative fires. In part, this was the product of his own success. A
relatively small group of his images, repeatedly exhibited and repro-
duced, had made him famous. Most of the public, however, did not
appreciate the full range of his art.[1]

While Adams's success as the artistic voice of the American land-
scape had typecast him in a particular role, his style had not stagnated
to the extent some critics suggested. The grandly dramatic scenes that
brought him fame did occasionally reappear in his photographs of the
late 1950s and after, but they were increasingly rare. Quieter images and
a more intimate scale prevailed; closeup details and landscapes with a
more restrained tone and a greater emphasis on abstract design replaced
the stridency of his most famous work.[2] Feeling, perhaps, a certain mel-
lowing with age, he was returning to his purist roots.[3]

His best-known photographs from these years, both titled *Aspens,*

*Northern New Mexico*, exemplify the trend. Adams made them while on a trip to the Southwest with Virginia and his two photographic assistants of the time, Geraldine Sharpe and Don Worth. It was an autumn afternoon in the Sangre de Cristo mountains east of Santa Fe, and the aspens were at the height of their color. As they drove up a narrow road, Worth caught sight of a grove with a beautiful sidelight on the trunks. He pointed out the scene to Adams, who agreed to stop on the way down the hill. On their return later that afternoon, they pulled off the highway and unloaded their equipment. Although there are no signs of people in the photographs, Adams and his compatriots were in fact only a few steps off the road. Affixing a telephoto lens to his 8 × 10 field camera, Adams compressed the distance and isolated portions of the grove.[4]

Adams made two different photographs of the scene. One was a vertical composition of the trunks, which seemed to radiate a translucent glow. Here Adams's zone system and filtration mastery were clearly evident. From the luminous brilliance of the foreground, the line of trees receded in cadences of deepening value toward a deep black background. Classically modern in its elegant simplicity, the image has a quiet strength typical of his best work of this period.

The other image was a horizontal composition. Here Adams included two young aspens in the foreground, their glowing leaves a soft counterpoint to the vertical lines of the surrounding trunks.[5] Worth saw the horizontal *Aspens* as a symbolic image of youth and age. Adams, however, was always averse to explicit interpretation of his photographs. Whatever its specific associations, the horizontal *Aspens* was a clear example of the spirit of affirmation and tenderness that his old mentor Alfred Stieglitz repeatedly called the key message of art.

For David Brower, the photograph was a beautiful symbol of the environmental movement. He remembered going to visit Adams while they were working on *This Is the American Earth*, looking at big prints for the book up on the studio walls. "When I got to the 'Aspens . . . ,' I

cried," he said. For the rest of his career at the Sierra Club, Brower used the image at the top of his letterhead as a visual statement of the club's ideals.[6]

## *Carmel*

Meanwhile, Adams's physical frailties continued to mount. His vision was getting worse; so were his gout and arthritis. The spirit was still willing, but the body was questionable.[7] He thought perhaps a change of scene would reinvigorate him. He considered moving to Santa Fe, but Virginia pointed out that they both continued to have important business in California. Ansel's commercial and Sierra Club duties and Virginia's management of Best's Studio all demanded close attention. Their friend Dick McGraw (a former student of Adams and the son of Max McGraw, one of the sponsors of *This Is the American Earth*) owned a parcel of land on the coast at Carmel Highlands. He invited the Adamses to buy a piece of the property and construct a home there.[8]

It was a difficult move in some ways. Most difficult was selling the house his father had built in 1903. It was home to him, despite the mixed emotions it conjured up: the memories of lonely fog-shrouded afternoons from his childhood and his parents' long decline. It may have been those mixed emotions, however, that prompted the move and the sale. Ansel and Virginia had seen their children grow up and start families of their own. The house was fairly quiet now, or as quiet as it could be with Ansel around, friends dropping in, and every night open house at cocktail hour and dinner time, the usual din of activity.

The move to Carmel set the stage for a new phase. Despite his physical complaints and fears of creative decline, Adams was still a dynamo of energy by any standard. He saw the new house as the scene of his final round of creative effort. Above all, he wanted to give his full attention to printing the huge backlog of negatives from forty years of

photography. When he asked Ted Spencer to design the structure, the first requirement was a top-of-the-line darkroom with plenty of space for sinks, storage, and enlargers—including the huge horizontal behemoth he used in making his mural-sized prints. Mounted on tracks like a railroad car and illuminated by thirty-six high-output lamps, it could make prints up to 40 × 78 inches from an 8 × 10-inch negative. At this time, however, Adams was concentrating on more manageable sizes, from 8 × 10 to 16 × 20, which he could produce in quantities sufficient to keep up with the growing demand for his work.[9]

The rest of the house was designed to take advantage of the spectacular site. Inside, redwood posts and beams supported a high ceiling and allowed for large areas of glass with views of the ocean, the rocky coastline, and the inland mountains. Above the stone fireplace Ansel and Virginia mounted a huge fifteenth-century Chinese drum they had bought many years earlier from their friend William Colby. Six feet in diameter, its round head was adorned with an intricately painted dragon. On appropriate occasions Adams would give the drum a whack with the big cloth-covered mallet, sending out a low rumble like distant thunder through the house. Of course, his instrument of choice remained the piano. He had his prized Mason and Hamlin grand installed in the gallery, just off the living room and adjacent to the darkroom. Despite his increasingly arthritic fingers, he still played, sometimes late into the night as the ocean pounded a slow rhythm on the rocks below the house.

### The Eloquent Light

Although he continued to make new negatives and to accept selected commercial assignments, Adams cut back in both of these areas to devote as much time as possible to printing negatives from his existing inventory. This process added to the feeling that he was entering the final phase of his creative life. Another and perhaps even more impor-

tant factor in this was the publication of the first volume of Nancy Newhall's projected multivolume biography of Adams and a huge retrospective exhibition, both titled *The Eloquent Light*.

Newhall had been working intermittently on the manuscript since the late 1940s. The first volume carried the story from Adams's boyhood in San Francisco through the publication of his *Sierra Nevada: The John Muir Trail* in 1938. Their close friendship and intensive working relationship were the source of the book's greatest strengths and greatest weaknesses. For her, Adams was the embodiment of the heroic modern artist and a prophet for nature in a world dangerously estranged from its beauty. While she was hardly dispassionate in her judgments, Newhall's closeness to Adams gave her an insight into his character, his emotional life, and his artistic values that no other writer could match. Published by the Sierra Club in 1963, the book was the seventh in the exhibit format series and, like the others, printed and bound to the highest standards.

For a more inclusive look at Adams's career, fans could visit the huge retrospective exhibition that opened in the fall of 1963 at San Francisco's M. H. de Young Museum. The show covered forty years and included more than 450 photographs as well as books, portfolios, and mural screens that filled nine spacious rooms. It was the largest exhibition of a single photographer's work ever held. Nancy Newhall's exhibition design demonstrated her usual good taste and empathy with Adams's art. Entering the gallery, the viewer was greeted by *Monolith, the Face of Half Dome*, Adams's seminal image from 1927, in a grand 4 × 5-foot print made especially for the exhibition. Beneath it, freestanding on the polished wood of the gallery floor, was a sculptural arrangement of Sierra granite and bristlecone pine.[10]

The simple combination of hard-edged granite and storm-blasted wood said more about the wellsprings of his art than could any number of words. These sculptural pieces running throughout the exhibition

included not only the Sierra rock and wood but also Indian pottery and basketry from New Mexico and California, Hispanic santos, and old gravestones from San Francisco cemeteries, all elements of the cultural dimensions behind his work.

Walking through the nine rooms, the viewer encountered the full range of Adams's photography. There were galleries devoted to his early photographs of San Francisco, the Sierra, and the Southwest; one was entirely hung with images of Yosemite, and his work on the rest of the national parks filled another; photographs made with Polaroid materials—from instant prints to murals enlarged from Polaroid negatives—took up yet another. An extensive selection of portraits, architectural studies, commercial advertising, and photojournalistic work belied the popular impression that Adams was exclusively a nature photographer.

It was an impressive display of a lifetime of total dedication to his chosen field. Coming on the heels of *This Is the American Earth* and Newhall's biography, the exhibition provided a major boost to Adams's rapidly growing fame. The show's stop at the Boston Museum, for example, was particularly well publicized. On arriving in town, Adams hailed a cab, only to discover his name and "The Eloquent Light" in banner headlines across its miniature rooftop billboard. It was a strange feeling, this realization of celebrity status, but not altogether unwelcome.[11]

While the tour was a hit with the public, the critics had mixed reactions. Typical of the negative comments he received in certain quarters was the review by Alexander Fried, writing in the *San Francisco Examiner*. Fried remarked on Adams's "peculiarly orderly temperament." "The orderliness," he felt, "becomes a limitation—or let us say a special characteristic—when Adams's disposition to arrange things well makes his style too consistently clean and controlled."[12]

It was a criticism that had hounded him throughout his career, a

reflection, some thought, of a certain coldness and inhumanity. In a typical example, Lincoln Kirstein looked over the Newhalls' shoulders at the Museum of Modern Art in 1938 as they studied the elegant compositions of rock, water, wood, and sky flawlessly reproduced on the pages of *The Sierra Nevada*. "Doesn't anybody *go* there?" he asked.[13]

Whatever one could say about his art, there was certainly nothing cold about Adams himself. As another critic, objecting to these charges, pointed out, "Personally, he is as friendly, twinkly-eyed, excitable, and enthusiastic as a warm puppy."[14] Anyone who knew Adams could not help but agree. Still, the critiques raised serious issues at the heart of Adams's artistic vision. While his idealistic and emotional art was, like its creator, intense in its motivation and its engagement with the world, many found the technical perfection of his prints, his elegant and orderly sense of design, the perfect and undiminished beauty of his subjects all *too* perfect, the expressions of a temperament out of touch with the realities of modern life.

### Strange Crusade

Since the Second World War photography had been moving away from the high modernist style of Adams and his fellow "purists." Young photographers like William Klein, Robert Frank, Diane Arbus, and Garry Winogrand who photographed the "social landscape" of the city streets had little interest in either the fine print tradition of the art photographers or the all-American optimism of Steichen and commercially successful documentarians. Adams had found Cartier-Bresson's "anti-art" stance difficult to accept, but this was even worse! Their apparently haphazard compositions, harsh grainy prints, and jaundiced look at "mainstream" America were about as far from Adams's "controlled" and "orderly" Edenic visions as any photography could be.[15]

The young Swiss photographer Robert Frank was probably the most

influential of this group. Traveling around the United States by car in 1955 and 1956 on a Guggenheim Fellowship, Frank created a photographic portrait of the country that was published in book form as *The Americans* in 1959. Like a modern-day Lewis and Clark, he made his way over endless miles of highway, exploring truck stops, parking lots, and city streets. His camera recorded the social and cultural geography of the nation, its deep racial chasms, and the televised mirage that hovered over the land. While many criticized the book, others saw it as a truthful look behind the facades projected by the era's consensus politicians and cheerful mass culture.

According to the Beat writer Jack Kerouac, "With that little camera that he raises and snaps with one hand [Frank] sucked a sad poem right out of America onto film, taking rank among the tragic poets of the world." Despite his sense of alienation in the land of Joe McCarthy and Mickey Mouse, Frank's tragic vision of America carried echoes of a lost innocence. Like his beatnik friends and that wanderer of an earlier century, Walt Whitman, Frank held out the hope that redemption was still out there on "the charging restless mute unvoiced road."[16]

With others, like the photographer Diane Arbus, the alienation ran deeper. Her matter-of-fact images of physical deformity, social deviance, and psychic neurosis mirrored a growing sense of irony, a hollowness at the core of the American Dream. When the Museum of Modern Art exhibited three of her images in 1965, one of the museum's staff had to come in early each morning to wipe the spit off them. "People were uncomfortable—threatened—looking at Diane's stuff," he recalled, putting it mildly.[17]

As far as Adams was concerned, most contemporary photography seemed interested only in social decay, the shock value of the bizarre, and experimentation for its own sake.[18] He was less critical of the landscape and nonobjective photography of the period. With his established standing in the field, Adams was frequently called on to offer his opinion

of young photographers working in those areas. For example, as a member of the advisory committee to the Guggenheim Foundation, he reviewed applications in photography. His response demonstrated that while he may have privately criticized many contemporary trends, he remained a strong supporter of innovative work. His highest praise generally went to those whose photography was clearly in the fine art mode, whose debts to modernist traditions were more clearly visible.[19]

Adams appreciated younger artists who carried on those aspects of modernism that emphasized high ideals and positive change. As ever, Adams found refuge and renewal in an idealistic art, dedicated to what Stieglitz called "the affirmation of life." When Wallace Stegner was asked to summarize Adams's career, he stressed the photographer's debt to Stieglitz and his constant search for perfection. Throughout his life, said Stegner, Adams "re-asserted the Stieglitz position as if forty years of artistic nihilism, experimentation, iconoclasm, cynicism, spiritual muckraking, and the arrogance of fashionable despairs had never intervened."[20]

Stegner felt a kinship with Adams because he too felt himself to be a holdout against the social and artistic chaos of the mid-twentieth century. As head of one of the nation's top programs in creative writing at Stanford University, Stegner saw the experimental and iconoclastic spirit of the age mirrored in his students. Perhaps no pupil embodied it better than Ken Kesey. Following the success of his first novel, *One Flew over the Cuckoo's Nest*, published in 1962, Kesey became the center of a quixotic band who called themselves "Merry Pranksters" and helped to usher in the hippie era. Among other things, Kesey and the Pranksters staged a series of "acid tests," free-form events in which psychedelic chaos was given every opportunity to bloom.[21]

While Kesey and others in the so-called counterculture embraced the liberating potential of this chaos, his old professor, Wallace Stegner, found it all very troubling. "What really shocked me," he recalled, "was

the occasional instance of a young writer who seemed to have from my point of view an absolute kind of moral idiocy, who along with his emancipation into another lifestyle had lost his sense of values, his sense of what is or is not good, what is or is not sympathetic."[22]

While Adams shared with his friend Stegner a rejection of the irrationalism bubbling up all around, he was often more appreciative of its youthful partisans. For example, he encouraged the work of a young photographer and environmentalist named Stewart Brand, who later went on to organize the Trips Festival, an outgrowth of Kesey's acid tests, and to publish several editions of *The Whole Earth Catalogue*, the bible of the counterculture's back-to-the-land movement, and, later, a journal of environmental philosophy, *Co-Evolution Quarterly*.

In 1963, Brand visited Adams to discuss the potentials of photography in the environmental movement. Adams saw that Brand and many others of his generation were searching for positive alternatives. At the time Brand was living with the Warm Springs tribe in Oregon. He felt that Native American cultures exemplified a benign relationship with the natural world—in marked contrast to the rapacious attitude brought by European settlers to North America.[23]

The next winter Brand sent portfolios of his Warm Springs photographs to the directors of the Sierra Club in the hope of interesting them in an exhibition and book on the subject. Adams was very much impressed with what he saw, calling the photographs extraordinary. He urged the Interior Department to support Brand's work, perhaps remembering the importance of his own Interior Department project to the progress of his career. Adams clearly admired the young photographer's energy and idealism.[24]

In many ways, Adams found the free-spirited atmosphere of the 1960s very congenial. He had no doubt seen members of the hippie "tribes" trooping up and down Highway 1, past his home in Carmel Highlands, headed to Big Sur in painted buses, old Volkswagens, or on

foot with thumb extended. He was fascinated by this "strange crusade" and its quest for self-realization and communal transformation. Unlike many among the older generation, he found the movement an encouraging sign of a renewed spirituality and compassionate social values.[25]

However, Adams found the counterculture and its back-to-nature idealism somewhat naive. He viewed the young people crowding into the Sierra backcountry each summer with mixed emotions. While he envied their adventures and recalled his own nostalgically, he pointed out that it was dangerous to confuse the wilderness image with nature's often harsh reality. When their nice freeze-dried food ran out and the weather turned harsh, the flower children's romp could turn into a fiasco.[26]

## Wildness *and Wilderness*

Encouraged by the success of *This Is the American Earth*, David Brower moved quickly in the early 1960s to expand the Sierra Club's exhibit format series. *Words of the Earth*, a collection of photographs and verse by Adams's old friend, Cedric Wright, was the first to follow. Published posthumously, the book was the summation of Wright's creative life. He and Adams had drawn apart somewhat in their later years, after a stroke left him embittered and irascible. Adams supported the publication of Wright's book as an expression of his friend's spirit at its idealistic best.

Adams's *These We Inherit: The Parklands of America*, a reissue of *My Camera in the National Parks* with several new plates and a revised text, was the next offering in the series. In this edition Adams gave particular attention to the problems of commercialism and overcrowding in the parks, problems that had grown steadily in the intervening years. As a whole the book lacked the emotional intensity and creative interplay

between words and images that marked *This Is the American Earth*, and its mediocre sales reflected that fact.

So far none had matched the success of *This Is the American Earth*. That changed with the club's first full-color exhibit format book, *In Wildness Is the Preservation of the World*. Published in 1962, it featured selections from the journals of Henry David Thoreau and Eliot Porter's photographs of the New England landscape. Porter had given up a career in medicine to pursue his photographic interests full-time following the exhibition of his early black-and-white work at Stieglitz's gallery in 1939. He turned to color in the 1950s, combining the precision of the large-format camera with semiabstract design and a subtle palette.[27]

While Adams had remained skeptical of color, generally employing it only for commercial assignments, Porter had quickly adapted to the new medium. He worked hard to achieve the precise control that enabled him to render the scene according to his personal interpretation. The subtly nuanced color of his prints was a far cry from the garish hues that characterized most color photography of the day. Adams was impressed but remained personally committed to what he saw as the more austere and expressive qualities of black and white.[28]

Porter had created the book over the course of a decade. It was rejected by a succession of publishing houses, who balked at the cost of producing the volume, so he turned the book into an exhibition titled *The Seasons*. After showings in several cities, it was selected by the Smithsonian Institution as one of its nationally circulated exhibits. The first stop on the tour was in Rochester, at the George Eastman House. When Nancy Newhall saw the show, she felt immediately that it should become the next in the Sierra Club's exhibit format series. When Brower saw it, he agreed and vowed "to see it published even if [he] had to take up a life of crime to get the funds for it." That proved unnecessary when the Belvedere Scientific Fund (a philanthropic arm of the

giant international construction firm, Bechtel Corporation) agreed to sponsor the publication.[29]

With the rapid improvements in color offset printing throughout the 1950s and early 1960s, Brower felt that a color book could be made to the exacting standards of the exhibit format series. When combined with the writings of Thoreau, Porter's visually pleasing imagery created an immensely popular package. While Adams and Newhall had achieved a solid success with hardcover sales of *This Is the American Earth*, the club hit paydirt with *In Wildness*, selling over 70,000 hardcover copies. Under a joint agreement with Ballantine Books, a paperback edition appeared five years later and became the best-selling trade paperback of the year, with more than 250,000 copies sold in its first year.[30]

Wilderness, at least as an image and idea, was clearly popular with a large segment of the public. In mounting its campaign for the wilderness bill pending before Congress, the Sierra Club tried to capitalize on this fact. Rather than a negative critique of economic "progress," they offered a positive vision of wilderness as a refuge for the human spirit in a mechanized world and a crucial part of the nation's physical and cultural heritage.

Wallace Stegner, then serving as a special adviser to Interior Secretary Stewart Udall, argued that "something will have gone out of us as a people if we ever let the remaining wilderness be destroyed." For Stegner, it was the knowledge that such refuge still remained that was essential. "We simply need that wild country available to us, even if we never do more than drive to its edge and look in. For it can be a means to reassuring ourselves of our sanity as creatures, a part of the geography of hope."[31]

This symbolic appeal of the wilderness idea was crucial in the successful passage of the Wilderness Act in 1964 after years of hard work and lobbying. Yet at the moment of its public and legislative success,

this vision was undergoing challenges from within the environmental movement itself. Several speakers at the 1963 Wilderness Conference presented views that threatened to throw a monkey wrench into the popular appeals of wilderness advocates. The most controversial lecture was by Stephen Spurr, dean of the School of Natural Resources at the University of Michigan. He urged scientists and conservationists to recognize wilderness as part of wider biological systems, changing along with the rest. "Stability is only relative," he argued. "Natural succession will never recreate an old pattern." The effort to preserve wilderness was doomed to failure if it saw wilderness as a changeless museum piece.[32]

This was a position contrary to the views of club member A. Starker Leopold, the son of Aldo Leopold, who along with several other biologists had produced the Leopold Report on wildlife management in the national parks. It urged the Park Service to recognize and preserve the integrity of ecosystems within the parks and surrounding areas, to sustain or re-create conditions as they were before European contact. The report seemed to support the symbolic role of wilderness as a timeless refuge from the modern world, a zone free of human impact.

Adams realized that the natural world was not simply a refuge for the modern urbanite, and he was aware that it was often anything but pretty. Nevertheless, like most of those within the Sierra Club leadership, he shared a dedication to a humanistic tradition. For Adams, the ultimate goal was the preservation of the human spirit. These issues reverberated in the growing debate over the identity of conservation as it transformed into the new environmentalism.

In 1964 the Sierra Club continued its exhibit format series with *Not Man Apart*, a book pairing photographs of California's Big Sur coast with the poetry of Robinson Jeffers. The image of nature in Jeffers's poetry disturbed some in the club's ranks. When George Marshall, brother of the Wilderness Society founder Robert Marshall, received

one of the club's new "Eloquent Light Notes," with Jeffers's lines "A little too abstract, a little too wise, / It is time for us to kiss the earth again," he wrote to Wallace Stegner complaining about the selection. It reminded him of "the over-sentimentalized anti-intellectualism which I encountered in Germany . . . in 1933. . . . Much of Jeffers's writing strikes me as being anti-human or a-human." Stegner agreed. As he saw it, if the club really accepted the implications of some of the poems, "we wouldn't be trying to conserve a coast, we'd simply wade out and breathe deeply."[33]

Adams had a more ambivalent stance. He admired Jeffers for the spare modernist rigor of his lines and the dark intensity of his imagery, yet he shared Stegner's concern about the apparent pessimism of his message.[34] Throughout the twentieth century the romantic ideal of nature as a benign reflection of man's highest aspirations, or a benevolent deity's well-ordered plan, had faded in the face of the post-Darwinian view of nature as a violent, chaotic, and Machiavellian realm. While Jeffers's poetry presented the world in these terms, the "anti-human" label was misleading.

Jeffers was not a nihilist or a worshiper of the *Übermensch*; he gave his allegiance to the whole web of life. He preferred to call his attitude "Inhumanism," which he described as "the rejection of the human solipsism and recognition of the transhuman magnificence." In "The Answer," from which the title of the club's book was taken, Jeffers explained his views in positive terms. "The greatest beauty is organic wholeness, the wholeness of life and things, the divine beauty of the universe. Love that, not man apart from that."[35]

Conflicts within the Sierra Club, ideological and otherwise, were amplified by its success. It had grown from a small group of friends into a powerful national organization. In 1945, there were about 4,000 mem-

bers in five local chapters, all in California. In the early 1950s, the
Atlantic chapter (to which Nancy Newhall belonged) and the Pacific
Northwest chapter were added. In 1956, after the victory at Dinosaur
National Monument, the ranks swelled to over 10,000 members. By
1967, there were more than 50,000 members in twenty-one chapters
nationwide. William Siri, who served as president from 1964 to 1966,
noted the trend with satisfaction. At the close of his term he pointed out
that, at the current rate of growth, the club's membership would exceed
the population of the United States by the year 2093. In the year 2562,
its membership would be three times the population of the world.[36]

Barring visitation from environmentally concerned travelers from
another planet, this was, of course, an impossible prospect, yet Siri's joke
had serious implications. The club's influence was growing even faster
than its membership, primarily on the strength of Brower's publishing
program. Yet publishing, like the rest of the club, experienced new
tensions over philosophy, finances, and organizational power. While
Brower went ahead full steam, certain members of the publications com-
mittee began to question both the necessity and the economic rational-
ity of his ambitious goals. August Frugé, director of the University of
California Press and a member of the club's publications committee, was
familiar with the economics of publishing and complained vocally about
Brower's practices.

In 1963, Frugé called for a serious reassessment of the program. He
worried that publications threatened to become the club's primary mis-
sion, turning it into a "smaller and less commercial version of *American
Heritage*." He questioned the utility of "general nature propaganda"
such as *This Is the American Earth* and Porter's *In Wildness* and the high
cost of their lavish production. He recommended instead that the club
concentrate on more affordable vehicles such as pamphlets and maga-
zine articles.[37]

Adams vehemently disagreed. He wondered if Frugé really under-stood that the club's publishing program was an attempt to expand their usual constituency and to promote a broad-based environmental ethic by tapping into the realm of ideas and emotions. Art watered the roots of environmental action, he argued, by addressing the basic questions of humanity's relationship to life and the world at large. The exhibit format books laid the groundwork on which specific conservation campaigns could be built. As for money, the program had done well so far, despite the risks. In the end, books contributed far beyond their individual profit or loss by bringing new dues-paying members to the club. Above all, Frugé must realize that times were changing and the club needed to change with them. They must seize the opportunity that the ground-swell of environmental concern provided and act with boldness rather than retreat to the safety of their old ways.[38]

Stegner, also a member of the publications committee, sided with Adams, though he agreed with Frugé that the club should proceed with care in what could be a costly business. He echoed Frugé's call for a clear policy but recommended they continue the publishing program, "right up to the edge of the club's financial possibilities."[39]

Brower had encouraged oversight of publications, but criticism of his policies fed his rising suspicion that traditionalists within the club who disapproved of his aggressive tactics were attempting to rein him in. Several directors later recalled that around this time Brower devel-oped a "paranoid streak."[40] Despite, or perhaps because of, his suspi-cions, Brower pushed ahead full speed. The more aesthetic and philo-sophical works like *This Is the American Earth*, *In Wildness*, and *Not Man Apart* were joined by books in the *This Is Dinosaur* tradition, aimed at specific legislative goals. Between 1963 and 1965 the club published a series of books focused on its leading conservation campaigns. *The Last Redwoods* (1963), which featured photographs by Philip Hyde, Adams,

and others, led its campaign for a Redwood National Park on California's northern coast. *The Wild Cascades* (1965) called attention to the campaign for a national park within the Forest Service lands of Washington state's North Cascades.

<center>*An Era of Confrontation*</center>

Although Adams was actively participating in the club's growing publishing efforts, he had his own career to worry about. He certainly would have preferred to devote all his energy to projects like *This Is the American Earth*, but economic reality demanded he continue to pursue commercial assignments. In 1963 he was offered the biggest assignment of his career, a three-year project photographing the entire University of California system.

California's postwar population explosion was felt particularly strongly in the state's university system as the baby boom progeny began to reach college age. Determined to maintain the ambitious goals of the state's master plan for higher education, the university began a massive expansion program to meet the rising demand. Between 1958 and 1966, construction on three new campuses was begun, and the six established campuses initiated building programs of their own. Over the course of those eight years, enrollment in the statewide system grew from 43,000 to 88,000; faculty, from 4,000 to 7,000. In the midst of its growth spurt, the university was also celebrating its centennial anniversary in 1968. To commemorate the event and to record the remarkable transformation the system was undergoing, the board of regents commissioned Adams and Nancy Newhall to produce a photographic and written portrait of the university.[41]

Adams got to know the university system well. He felt that it was a remarkable institution, with broad programs of significant research and

a vital spirit of intellectual freedom. He could not, however, fail to notice the growing tensions on the campuses as student protests led to repeated clashes with university authorities and local police. The focal point of the conflicts was at Berkeley, the university's oldest and largest campus. The civil rights and free speech movements of the early 1960s had contributed to the formation of a number of radical student organizations. The escalation of the war in Vietnam and the rise of the counterculture propelled these organizations into a spirit of revolutionary confrontation with "the establishment" in all its forms.

Adams observed the polarization of the campuses with alarm. The atmosphere of shared purpose and free inquiry that he found so appealing was rapidly being replaced by one of militancy and reaction. Photographing one day around Berkeley's Sather Gate, he encountered a noisy demonstration in progress. He stopped one of the slogan-chanting protesters, hoping to engage him in an amiable discussion. The young radical was in no mood for talk. The only way to change things, he said, was to "trash something, man!"[42]

The state government seemed no more open-minded than the campus radicals. In response to the mounting protests, the governor had ordered an investigation of the university. On reading the Burns Committee report and its findings of infiltration by subversive groups, Adams wrote immediately to Governor Edmund G. Brown, offering an impassioned defense of the university and denouncing the implication that support of free speech had become a violation of the law. He urged Brown to back the embattled University of California president, Clark Kerr, and to reject the findings of the report.[43]

The tensions mounting on the University of California campuses and around the nation in the late 1960s affected Adams deeply, shaking, but not toppling, his essentially optimistic faith in humanity. The bitter antagonisms of the decade would find their way, in a variety

of forms, into the Sierra Club in the coming years. Adams, who had always preached compromise, was forced to decide exactly where he stood.

The stage for the schism within the club was set by a series of intensely fought conservation battles. The club's highest priorities at the time, the Grand Canyon and the Colorado River, were the subject of two books, *The Place No One Knew* (1963) and *Time and the River Flowing* (1964). The first of these was a requiem for Glen Canyon, the area "sacrificed" in the compromise solution to the Dinosaur controversy. Although the club had agreed to the building of a higher Glen Canyon dam as a means to save the national monument upstream, Brower later expressed deep regret over that decision. In his foreword to the book, he wrote, "Glen Canyon died in 1963, and I was partly responsible for its needless death. So were you. Neither you nor I, nor anyone else, knew it well enough to insist that at all costs it should endure." The compromise solutions that had made the victory at Dinosaur possible now seemed to Brower and many others like a lack of will.[44]

For Brower and board member Martin Litton, there was never any question of compromise on the Grand Canyon. This was not an obscure tributary; this was one of the crown jewels of the national park system and, perhaps even more than Yosemite or Yellowstone, the symbol of the primordial North American wilderness. "If we can't save the Grand Canyon," Brower asked, "what the hell can we save?"[45]

The proposed dams on the lower Colorado were part of the federal government's Southwest Regional Water Plan. The Interior Department claimed the project was needed to relieve an increasing water shortage and support the rapidly growing population of the region. Thanks to a U.S. Supreme Court decision in 1963, the state of Arizona won a significant share of the water rights to the lower Colorado. The

thirsty suburbs of Phoenix and Tucson would soon be drinking from waters supplied by the Central Arizona Project. The Sierra Club and other environmental organizations argued that the proposed dams, though outside the actual bounds of the park, would have a disastrous impact on the entire lower Colorado, including the Grand Canyon itself.

Not everyone within the Sierra Club agreed with this dire prognosis, however. Bestor Robinson, one of the remaining directors from William Colby's generation, felt that compromise was possible. Prohibiting all dams would be unrealistic, he argued, and the economic losses "staggering." Furthermore, lakes behind the dam would provide access and recreation to many more visitors than ever enjoyed the river in its wild state.[46]

One who agreed with him was Floyd Dominy, commissioner of the Bureau of Reclamation. Taking on the conservationists at their own game, Dominy put together a glossy book of photographs and poems called *Lake Powell: Jewel of the Colorado*. It contained verses like the following:

> Dear God, did you cast down
> Two hundred miles of canyon
> And mark, "For poets only"?
> Multitudes hunger
> For a lake in the sun.

The dam would not only be a monument to democracy but an engineering marvel as well, taming a wild river and making it "a servant to man's will."[47]

The arguments in favor of the dam, that it would bring both recreation and economic development, were ones about which the club had traditionally been ambivalent. To those inside the club and out who argued that a lake would help tourists see the canyon more easily, Adams

suggested that on the basis of such logic the Vatican ought to "fill the Sistine Chapel about ⅔ full of water so that visitors can float around and see the ceiling paintings to better advantage!"[48]

Brower, who later claimed the line had come from a member in New Jersey, liked it so much that he used it in a full-page advertisement that ran in the *New York Times*, the *Washington Post*, the *Los Angeles Times*, and the *San Francisco Chronicle* in the summer of 1966. "Should We Flood The Sistine Chapel So Tourists Can Get Nearer The Ceiling?" asked the banner headline. The ad drew a tremendous response: letters poured into Congress and the White House, and membership applications flooded the Sierra Club.[49]

Adams was later chagrined to have contributed to what he saw as the hyperinflated rhetoric of the club's campaign. "I'd rather dams were stopped," he said, "but I think they could have been stopped by logical methods as well as [by] what I call 'aggressive public opinion dynamite.'"[50]

That "dynamite" had created some problems for the club with the Internal Revenue Service. A few weeks earlier that summer the club had run another ad regarding the Grand Canyon. Its banner headline proclaimed "Now Only You Can Save the Grand Canyon from Being Flooded . . . for Profit."

The day after the ad appeared, a man from the IRS turned up at the club's office in downtown San Francisco. The IRS had decided that the ad constituted "significant" lobbying and was therefore grounds for suspending the tax-deductible status of contributions to the club. Many felt that the IRS had moved after prodding from someone high up in the federal government angered at the club's opposition to the Grand Canyon dams. If it was intended as punishment, the action backfired badly as the IRS ruling produced a shower of public sympathy and new membership for the club. "The threat to the Sierra Club was headline news all over the country," Brower recalled. "People who didn't know

whether or not they loved the Grand Canyon knew whether or not they loved the IRS."[51]

The ruling freed the club to increase its direct political action. Yet as they enjoyed the glow of the spotlight, Adams, for one, was feeling increasingly uneasy about the direction in which Brower and the younger environmentalists were moving. With the success of the club's conservation campaigns and his own role in that success, Brower's missionary persona seemed to many increasingly strident, projecting an aura of invincibility and self-righteous zeal. "He definitely changed after the Echo Park victory," recalled Richard Leonard. According to Joel Hildebrand, Brower became "a sort of fair-haired boy or knight in shining armour and got carried away with his own self-importance."[52]

By the mid-1960s, Brower and his activist coterie had abandoned the strategy of accommodation with federal and state bureaucracies and private commercial interests. Friendly persuasion gave way to aggressive criticism. The confrontational attitude angered many of the traditionalists in the club and even some of Brower's own generation. Adams, for example, favored aggressive campaigns but was concerned with Brower's tactics. "David Brower and his particular group are so antagonistic and so uncompromising that the Forest Service and the Park Service and the lumber people, who used to talk to us—we used to come sometimes to very reasonable, balanced conclusions—would no longer have anything to do with us." As far as Adams was concerned, "You don't get anywhere by kicking people in the shins when you should be sitting down around the table."[53]

## The Brawl

The shin-kicking intensified when the club's focus shifted to the issue of nuclear power. In the early 1960s, the Pacific Gas and Electric Company had begun plans to develop a nuclear power plant on the central Califor-

nia coast. The original site proposed by PG&E was called the Nipomo Dunes, near the town of Oceano. The dunes had been a favorite of artists, including Adams and Edward Weston, for years; its supporters had on several occasions recommended its preservation as a park. The Sierra Club urged PG&E to consider an alternative site. With the San Francisco–based organization, Conservation Associates, acting as an intermediary, club leaders held private negotiations with PG&E, ultimately convincing it to move the project to Diablo Canyon, a remote area approximately fifteen miles to the north.[54]

It was the sort of agreement the club once prided itself on—a gentlemanly compromise that left both parties satisfied and no feathers ruffled. Times and attitudes had changed considerably, however. For the younger and more radical elements in the club, the cozy nature of the deal was unacceptable. "I never felt comfortable with the way that was done behind closed doors," recalled Michael McCloskey, who was the club's conservation director at the time. "The fact that there was no collective judgment employed on the club's side bothered me considerably."[55]

When the matter came up at the May 1966 board meeting, Brower registered his disapproval of the swiftness of the agreement and urged more on-site study to see just exactly what they were giving away. Frederick Eissler reminded the board of the club's stated policy disapproving "construction of power plants along the ocean and natural shorelines of high recreational or scenic value." Despite these objections, the board passed the resolution supporting the agreement, provided that marine resources of the area were protected, power lines were kept out of sight, and air pollution and radiation kept within legal limits.[56]

Adams considered the compromise agreement an important achievement and gave it his full support. He accepted PG&E's assessment of the need for the plant. It was safe to assume, he said, that they would not be spending millions on an unnecessary project. Coopera-

tion, he told Brower, had a better chance of success than doctrinaire intransigence.[57] Adams felt that nuclear power, if done properly, presented a clean and efficient solution to energy needs and a superior alternative to the use of high-polluting fossil fuels such as oil and coal.

Brower did not agree. While he once supported nuclear power as an alternative to hydroelectric dams on the Colorado, he had come to view it as a fundamentally unsafe technology. Adams "was always waiting for some new high tech to save us," Brower said later. "He thought nuclear would and I thought nuclear would, but I got over it and he didn't."[58]

Martin Litton, who along with Eissler was the most active opponent of the Diablo agreement, felt that if the club was seriously committed to environmental protection, it must work to limit growth. Citing the advice of the University of California ecologist Raymond Dasmann, Litton argued that the way to stop growth is not to prepare for it. Providing the power resources necessary for twice the current population of the state would allow that growth to occur and with it the state's scenic character would be destroyed.[59]

There was more at stake than scenery. The connections of nuclear power to atomic weaponry and the military-industrial complex made it an especially sensitive topic for both its supporters and its detractors.[60] As the "police action" in Vietnam escalated, the credibility of government and industry plummeted for much of American society. Younger environmentalists generally shared this distrust, expressing their disdain for the collegial relationship conservationists once cultivated with government and business. Grant McConnell, Brower's adviser on relations with the Forest Service, warned that the Progressive Era ideals on which the conservation movement was founded were outmoded. Appeals to an amorphous public interest could not control the power of corporations. The assumption that friendly relationships and appeals to the common good could take the place of power politics had proven to be a fallacy, he argued.[61]

For the time being, most of the club's leadership rejected this analysis and its implications. Leonard, for example, condemned the tendency of the "young folks" to assume "that corporations are immoral, that business is immoral, and that corporations and businesses will deliberately pollute to save dollars and will deliberately harm the environment needlessly. I don't believe that at all." Leonard, like his friend Adams, felt that the adversarial approach to government and industry practiced by younger environmentalists was breaking down the lines of communication older club leaders had worked hard to establish. He believed that radicalizing the club would diminish rather than increase its effectiveness.[62] The membership seemed to agree. In the election of 1967, a referendum on whether the board's agreement with PG&E should be sustained passed by a vote of 11,341 to 5,255.[63]

The polarization of the club's leadership over Diablo Canyon worried Adams. In an effort at conciliation, he assured his old friend Brower that he had not been "taken over" by the "Conservative Opposition." He had no interest in turning back the clock or in seeing the club retreat from an aggressive pursuit of its goals. Yet he was concerned by Brower's tendency to circumvent club policy to carry out his own agenda. Adams urged Brower to remember that he was part of a larger organization whose interests must come first, to accept criticism without assuming a conspiracy was afoot to silence him, and to subordinate his personal views to the policies of the club. It appeared to Adams that Brower was courting disaster unless he changed his approach.[64]

Aside from the Diablo Canyon issue, most of the conflicts between Adams and Brower were over publications. Looking at the list appearing in 1967, Adams found some that seemed of questionable quality. He wrote to Porter about the situation, taking Brower's recent decision to publish *On the Loose* as a case in point. Its young authors, Terry Russell and Renny Russell, extolled the joys of their backpacking rambles in a handletter text illustrated by "photographs . . . of the lowest fidelity

obtainable . . . [and] as far from the photographer's vision as cheap cameras, mediocre film, and drugstore processing could make them."[65] Adams felt the book was part of a general decline in the standards of the club's publications. Yet when it was released as a paperback and distributed by Ballantine Books, the book turned out to be among the club's all-time best-sellers.

Adams was concerned most about the fact that the publishing operation was losing money. Frugé had been raising questions since 1963; now others were beginning to join in. In the spring of 1968, Leonard pointed out that the deficits were growing at an alarming rate. Annual losses in publishing, according to the auditors' reports, had risen from $14,665 in 1963 to a peak of $119,114 in 1966 and would total an estimated $63,475 for 1967. The most dangerous aspect financially was the unreliable cash flow. Of the club's total assets of $1,623,704, $945,896 was tied up in inventory and accounts receivable at the end of 1967. With a net worth of only $447,287 (on liabilities of $1,176,417), the club was walking a tightrope. Leonard's legal opinion was that, should the club go bankrupt, the individual directors could be held liable for the debts.[66] This made Adams very nervous. Having worked hard for the modest financial security he had achieved, he did not want to see it go up in smoke. He had seen it happen to his father and did not want it to happen to him.[67]

Despite these dire warnings, in the 1968 election the membership gave Brower's supporters a majority on the board. Following their victory, Brower and Philip Berry drafted a letter to PG&E advising it that the club was planning to review its policy on nuclear power and Diablo Canyon in particular. Adams's severe distress over this move was heightened on reading the editorial in the *San Francisco Examiner* reporting the "new anti-atom majority" on the board and criticizing the "inconsistent club" for its apparent reversal of policy.[68]

The action set the stage for a serious confrontation at the September

meeting. Eliot Porter spoke for the antinuclear members of the board, arguing that the club must change with the times. Compromise with corporations like PG&E, "whose deeds belie their words, and whose interests are diametrically opposed to ours," would contradict the fundamental values of the club and do far more damage to its reputation than an admission that it had taken the wrong stand in its earlier agreement.[69]

Although he accepted the majority decision, Adams considered it the darkest day in the club's history. He urged the militants to understand that the club must face the realities of modern industrial society and channel its efforts into practical solutions. Ashamed of the club's current direction, he vowed to fight back.[70]

Less than a month later, Adams, Richard Leonard, and Richard Sill called a special meeting of the board to present their evidence against Brower. They detailed charges of fiscal irresponsibility, of insubordination, and of diverting publishing royalties to fund unauthorized publications. Adams cited Brower's development of two books on the Galápagos Islands, with photographs by Porter, despite the disapproval of the publications and executive committees.[71] Brower responded in an angry letter to Adams, with copies sent to the board and chapter officers, calling his charges "actionable, libel, and slander."[72]

Undaunted by the attacks, Brower continued to forge ahead. On January 14, 1969, he placed a full-page advertisement in the *New York Times*, at a cost of $10,500, announcing the Sierra Club's plan to publish a series of exhibit format books on the ecosystems of the world as part of "an international program . . . to preserve Earth as a 'conservation district' within the Universe, a sort of . . . 'EARTH NATIONAL PARK.' " Neither the ad nor the books had been approved by the publications committee or the directors. The day after it ran, the club's president, Edgar Wayburn, and the board of directors (by a seven to six vote) suspended Brower's financial authority. Even some of his supporters had reluc-

tantly come to the conclusion that, as Stegner put it, Brower had been "bitten by some worm of power." Sierra Club policy had to "be decided by the full board, and not by one individual, however brillint and however histrionic."[73] Brower took a leave of absence from his position as executive director and announced his decision to run for the board of directors in the spring election.

Despite the open warfare being waged within the club, 1968 had brought a string of legislative victories. Aggressive campaigns helped to stop the Grand Canyon dams, establish a redwood national park on the northern California coast and a North Cascades national park in Washington, pass the Wild and Scenic Rivers Act, and establish California's San Rafael Wilderness Area, the first area added under the Wilderness Act. The club's success, and Brower's undeniable role in those victories, was of little consolation to Adams and other disgruntled leaders. Determined to settle the issue, the opposing sides squared off for the 1969 elections. Billed by both as a referendum on the club's future, the election set a new precedent in acrimonious campaigning. Brower's supporters went by the acronym ABC, for "Aggressive Brower-type Conservationists," or for an "Active, Bold, Constructive" Sierra Club. The Adams, Leonard, Sill contingent went by the name "Concerned Members for Conservation," or CMC. The two sides, each with a full slate of candidates, presented their case to the membership in the months leading up to the election, essentially restating the positions they had staked out over the past two years.[74]

While the members had supported Brower and his policies in the 1968 election, apparently the reports of his financial misdeeds and unilateral decisions had changed their minds. The CMC slate won a decisive victory as each of its five candidates, including Adams, received more votes than Brower, the highest vote getter in the ABC bloc. With all five ABC candidates defeated, the CMC faction now had a ten-to-

five majority on the board. Realizing that he would be dismissed if he did not resign, Brower stepped down at the directors meeting in May.[75]

Adams and Leonard had achieved a victory that left a bitter taste. They were, after all, Brower's oldest and once closest friends in the club, the co-sponsors of his membership in 1933. In those early days, Leonard and Brower, both in their twenties, had scaled sheer rock cliffs throughout the West, their fates literally entwined. "My life," Leonard recalled the day before Brower's resignation, "depended on his judgment and ability for weeks at a time."[76] Those experiences forged bonds that were difficult to break. It was equally difficult for Adams. For more than thirty years, Adams and Brower had worked together to bring the Sierra Club's message to the world. Together they built an ambitious publications program and aggressive conservation campaigns. Now it seemed that the success of those efforts had driven them apart.

Brower, at a loss to explain his friend's hostility, thought it might have had something to do with Eliot Porter's rising star in the club's publishing program. Porter's color photographs had graced more and more of the exhibit format series while Adams's contributions had declined. Porter outsold Adams by a considerable margin. Brower recalled an embarrassing faux pas at a board meeting in the mid-1960s when he referred to Porter as "our most valuable property." Both Adams and Porter were at the meeting, and neither, Brower thought, appreciated the comment. "Ansel hated that because he thought he was the most valuable property and Eliot hated it because he didn't think he was our property. . . . Two birds with one stone, Brower could do it."[77]

There may have been some truth in this; Adams's ego was no small factor. But deeper issues and emotions seemed to be at play. Adams was disturbed by the entire direction of the club, and Brower became the symbol on which he focused all of his anger over the "negative" and "irresponsible" attitudes of many younger environmentalists. After the

election he wrote to the outgoing president, Edgar Wayburn, calling the vote "a mandate from the membership to clean house." Yet although Adams's group had won the election, its days of influence in the club were waning. Younger leaders, like the incoming president Philip Berry, sought to regain the club's momentum after the well-publicized struggle. "There must be dynamic movement ahead—without compromise of principle—as far and as fast as possible toward our conservation goals."[78]

While the Sierra Club worked to clarify lines of authority, rationalize its management, and improve coordination between its paid staff and the volunteer network, it retained and strengthened its commitment to the ideals associated with Brower. The new president, Philip Berry, and the new executive director, Michael McCloskey, both supporters of Brower, urged the club to expand its focus from the preservation of parks and wilderness to the preservation of the entire planetary environment. They believed that issues of population growth, environmental pollution, and species survival should head the club's agenda. The fundamental notions of "progress" and the human subjugation of nature should be reassessed. The leadership was determined not to retreat from confrontation with political and economic powers.[79]

In the coming year the "environmental revolution" brought a new level of public support and media attention, culminating in the first Earth Day on April 22, 1970. The club's inexpensive paperback, *Ecotactics: The Sierra Club Handbook for Environmental Activists*, which sold over four hundred thousand copies, boasted that "of some 28 individual contributors, only two are over 40. More than half are under 30." Adams complained that the book was "two-dimensional" and urged the club to undertake a new exhibition in the tradition of *This Is the American Earth*. Although the club would continue to publish high-quality nature photography in its monthly magazine and annual calendars, its emphasis

shifted from the fine art orientation of the exhibit format series to a new line of paperbacks in the *Ecotactics* mold called Sierra Club Battle Books.

Adams bowed to the will of the majority. The whole situation had been wearing on him. The Sierra Club was not much fun anymore. Its bitter power struggles reminded him of the 1968 Democratic National Convention. Chest pains, which he had experienced periodically for years, sent him to the doctor, who discovered a damaged heart valve and clogged arteries. Ordered to cut back his work and stress level, Adams retired from the board in 1971, one year before his term was up. He was now sixty-nine years old. It was time, he said, to bring new blood into the organization.[80]

### Malaise

Adams was feeling low, and there was little in the world at large to cheer him. The optimistic spirit of the early 1960s had turned dark in the 1970s. Assassinations and armed confrontations in the streets had overtaken rational political discourse. The spirit of experimentation in the arts and in American culture had taken a similarly negative turn. In 1967 he had seen promising signs of a resurgent spirituality among the younger generation. Now they seemed to exhibit only a violent, sullen anger. It left Adams feeling out of step and angry, too. The young photographers he saw exhibited in the galleries did not improve his mood. "The pale, weak, drug-dazed thousands" turning out "terrbill snapshots" that were hailed by critics as the "new thing" seemed symptomatic of a wider cultural malaise.[81]

It seemed that the world was suddenly plunging toward chaos, he complained to Nancy Newhall. He vowed to fight for the recognition of beauty and compassion in life and in art. Through nearly three decades Nancy Newhall had been his closest collaborator and his staunchest ally

in proclaiming, in the spirit of Alfred Stieglitz, that art was the affirmation of life. In 1970 they published the last of their collaborations, *The Tetons and the Yellowstone*.[82]

The book was admittedly not their finest effort. Since the publication of *This Is the American Earth* and *The Eloquent Light* in the early 1960s, Nancy's intense workload had begun to catch up with her. Beaumont, Adams, and other friends became alarmed as they watched her health and characteristic energy decline. On their insistence, and her doctor's orders, she agreed to take a break.[83] It was clear, though, that she thrived on creative exertion. After her enforced rest she never regained the creative spark of her earlier years.

In 1974, Beaumont and Nancy were on a rafting trip down the Snake River in Wyoming's Grand Teton National Park when without warning a tree along the river's bank fell crashing into their boat. Nancy was severely injured, but it seemed as if she would recover. Several days later she died. Beaumont asked Ansel and Virginia to hold the memorial service at their home in Carmel. After a simple ceremony, Nancy's ashes were given to the sea. In tribute to her work for photography, Ansel and Virginia gave $250,000 to the Museum of Modern Art to endow the Beaumont and Nancy Newhall Curatorial Fellowship in Photography at the museum. Beaumont was deeply touched by their generosity and the rightness of the gift. "Were I but young enough . . . I can think of nothing I would more desire to be than a Newhall Fellow!" He was sure that the fellowship would help to carry on the legacy of the department they had all "worked so hard for and with such passion and devotion."[84]

### New Directions

Despite the loss of old friends and the scars of battles won and lost, Adams moved on with his energy and optimism intact. Near the end of his last year with the Sierra Club, he had been offered a weeklong ap-

pointment at Yale University as a Chubb Fellow, a program designed to bring distinguished world leaders to the campus for seminars and informal meetings with students. The coordinator of the program was a young man named William Turnage. Adams struck up an immediate friendship with the former Oxford student and State Department employee.

When Turnage completed his master's degree in Yale's School of Forestry later that year, he came out to California to interview for a job with the Sierra Club. He called Adams, who urged him to stop over in Carmel. With their usual hospitality, Ansel and Virginia convinced him to stay for several days. On his last evening there, after the assorted dinner guests had left, Turnage and Adams stayed up late, talking and drinking. By two in the morning Adams was at the piano, his arthritic fingers sufficiently numbed and lubricated to dance over the keys. Turnage was on the floor underneath the piano, listening to him play.[85]

Adams stopped and thought a moment. Here he was about to turn seventy, with "no money" and a long list of projects ahead of him. What he needed, he said, was someone to organize his life and put his business affairs in order. He thought Turnage was just the one to do it. The salary would be low, but he offered Turnage a percentage of any income he generated. They planned to spend half their time working on environmental efforts and half on photographic projects (although photography tended to occupy the greater portion in actuality). Adams felt that Turnage would have more fun and probably more real influence working for him than he would have at the Sierra Club. Turnage protested that he knew little about business. Adams was sure that Turnage at least knew more about it than he did. That was certainly true, Turnage admitted.[86]

Turnage's first assignment was to oversee the operation of Best's Studio. By this time, Virginia was eager to reduce her role in the operation. Turnage and his wife, Charlotte, served as resident managers and reorganized the business, including renaming it the Ansel Adams Gal-

lery. After passing the administration on to Michael's wife, Jeanne Adams, Turnage returned to Carmel to serve as the first executive director of the Friends of Photography, a nonprofit group founded by Adams and several associates five years earlier.[87]

The Friends of Photography had been born at a gathering at Adams's home on New Year's day in 1967. His neighbor, Cole Weston, was managing Carmel's newly opened Sunset Center. The former elementary school served as a meeting place and cultural center. Weston thought it ought to include a photography gallery. He knew that Adams had been making noises about starting some sort of photographic organization for years. With two rooms available for exhibitions and meetings, he suggested that the time had come to act on the idea. Adams agreed and invited a number of friends to develop a plan.[88]

Joining Ansel and Virginia that day were Beaumont and Nancy Newhall, Morley Baer, Edgar Bissantz, Arthur Connell, Liliane De Cock, Rosario Mazzeo, Gerald Robinson, Geraldine Sharpe, and Brett Weston. Rather than a local mutual admiration society, they wanted to develop an organization of national and even international scope, presenting, as far as their limited resources would allow, a wide range of exhibitions, publications, workshops, and lectures. On January 30, 1967, they held their first meeting to elect a board of trustees; Adams was named president. They filed papers for incorporation as a nonprofit organization in February and held their first exhibition, featuring photographs by Adams, Edward and Brett Weston, Wynn Bullock, Imogen Cunningham, Dorothea Lange, and Minor White, at the center in June.

By the early 1970s the Friends of Photography was enjoying a healthy growth in membership and activities, but its success was putting a strain on the volunteer staff. Turnage hired a small professional staff with specific duties, instituted a more clearly defined organizational structure, and began more aggressive fund-raising efforts.[89]

Turnage's most significant contribution as Adams's business man-

ager was in the area of photographic marketing. In particular, he carefully orchestrated the release of a series of portfolios and engineered an exclusive publishing agreement with Little, Brown and Company that launched Adams into a period of remarkable financial gains. Adams rode atop the rapidly escalating market for photography in the mid- to late 1970s, the popular favorite in a medium whose relative affordability made it accessible to a broad segment of collectors. Through most of his career, Adams had struggled to see photography recognized as a fine art alongside the more established media and to make his work accessible to a wide public audience. Now those goals were being realized and Adams was reaping the rewards.

Adams had been kept busy with steadily rising print orders throughout the 1960s and early 1970s. He found himself spending more and more time in the darkroom printing the same greatest hits: *Moonrise, Hernandez, Clearing Winter Storm, Monolith, the Face of Half Dome, Frozen Lake and Cliffs, Aspens,* and a handful of others. He felt hemmed in, a prisoner of his own success and the red-hot photography market. Turnage suggested he set a deadline after which he would no longer accept print orders. Adams agreed and set the date for December 31, 1975. Also on Turnage's suggestion, he decided to charge the highest prices yet for his prints, up to $800 for a 16 × 20-inch photograph.[90]

Orders for more than three thousand prints poured in. This represented a great deal of money but also a great deal of work. His liberation from the darkroom was not at hand, after all. Adams spent the next three years filling the order. His darkroom assistant at the time, Alan Ross, was amazed at the unstoppable energy of the seventy-year-old Adams. "He could work me under the table." Arriving at the house around 9:00 A.M. to begin the day's printing, Ross would routinely discover Adams already in overdrive, writing letters, making phone calls, eager to get to work in the darkroom. Adams did all his own printing and was as much the perfectionist as ever, despite the overwhelming work before him.[91]

Meanwhile Adams's surging popularity continued unabated. As the environmental movement moved from the lunatic fringe into the media spotlight in the early 1970s, Adams became one of its patron saints, the grand old man of the American wilderness. Adams was more than happy to play the part. His principal form of public outreach was through books, as it had been since *My Camera in the National Parks* appeared in 1950. His publishing agreement with Little, Brown resulted in a spate of retrospective volumes, including *Images: 1923–1974* (1974), *Photographs of the Southwest* (1976), *The Portfolios of Ansel Adams* (1977), and *Yosemite and the Range of Light* (1979). Each sold astoundingly well considering their hefty prices (at $125, *Images* sold over 100,000 copies). By 1979, Adams had sold over a million copies of his books. As always, he pushed relentlessly for the highest possible reproduction quality. With the improvements in printing technology—especially laser scanning—Adams was able to achieve the highest fidelity while maintaining an affordable price, especially in paperback editions (the paperback edition of *Portfolios*, for example, retailed for $25).[92]

Books were proving to be such a success that Adams, Turnage, and Little, Brown decided to expand their offerings. Soon Ansel Adams posters and calendars were flooding into bookstores and out to living rooms, bedrooms, and offices across the country and around the world. For $20, for example, fans of the artist could purchase a 2 × 3-foot poster, on which was brilliantly reproduced one of Adams's greatest hits: *Moonrise*, *Winter Sunrise*, or the vertical *Aspens*. Later, other favorites were added.

Adams was achieving a level of influence on public perceptions that he had hardly dared to dream of in earlier years. For millions who flocked each year to the national parks, looking for a touch of the sacred along with their vacation, Adams's photographs were icons, "the cult images of America's vestigial pantheism," as *Time* magazine's Robert Hughes

put it. In the fall of 1979, Adams's fame was at its peak. On newsstands and checkout counters across the country, Adams's grinning face, bushy beard, and trademark Stetson looked out from the cover of *Time*. It was a first for a photographer and rare for any artist, but he was by then a larger-than-life symbol. In the post-Vietnam, post-Watergate, post-modern age, Adams stood out like an emissary from a vanishing but not perhaps entirely lost era of innocence and faith. The grandfatherly Adams seemed to embody the wilderness itself. Adams, said Hughes, was the last of the American romantics, perpetuating "a sense of paradise that continually slips away."[93]

*Time*'s big spread was occasioned by the simultaneous release of Adams's sumptuous retrospective volume, *Yosemite and the Range of Light*, and the Museum of Modern Art's grand installation, *Ansel Adams and the West*. The 153 photographs in the MoMA exhibition, all landscapes chosen by the curator, John Szarkowski, spanned Adams's career from 1920 through the 1970s. Here Adams's reputation as the voice of the wilderness received another boost, but Szarkowski presented a complex Adams. He was the maker of grand vistas—"metaphors for freedom and heroic aspiration"—yet he was also the modernist, revealing through the precision of his lens and craft the cosmic in the microcosm, the unifying patterns of nature's intimate design. Szarkowski, too, saw Adams in the elegiac mode. "He was perhaps the last important artist to describe the vestigial remnants of the aboriginal landscape in the confident belief that his subject was a representative part of the real world, rather than a great outdoor museum."[94]

Although Adams seemed to have had a privileged view of the West before the "fall," he, of course, had come after like everyone else. He had been working to fend off the pressures on wilderness precisely by picturing it as a great outdoor museum or cathedral: for him, all three were much the same. Yosemite was a sacred place but one that he wanted to share with all the world, and there was the rub. It was the same

problem shared by the National Park Service. In 1980, Yosemite Valley was visited by more than two and a half million people; by 1987, more than three million. The Park Service had tried to move away from the "resort mentality" Adams had complained of for decades in its 1980 master plan for Yosemite. After six years of public hearings and "expert" testimony, the plan called for a reduction of permanent structures and campgrounds as well as the eventual elimination of all private automobile traffic.

One of the most effective policies, begun in 1970, was the rerouting of valley roads into a large one-way loop and the introduction of shuttle buses to reduce the use of private cars. Adams was pleased with the change. Yosemite, he felt, was looking better than ever, better in fact than it had on his first visit in 1916. He was aware of the many challenges facing the park, but he remained optimistic.[95]

Yosemite, like Adams's photographs, was dedicated to the wilderness idea. There was admittedly little real wilderness left in the valley; there had not been much there for thousands of years if the most stringent definition of the word were applied. From the annual burns of the Ahwahneechee to the shuttle buses full of tourists, the valley had felt the effects of human actions for centuries. Adams saw Yosemite's function as a center for public contact with one of the great "earth gestures." Looking up at the massive granite walls carved by the slow but inexorable power of nature, people who for most of the year lived within the walls of man-made boxes, their minds filled with the numbing repetitions of urban survival, could look up in wonder and, if only briefly, catch a glimpse of the vast forces at work in the world.

Adams had made an unsurpassed contribution to public awareness of the national parks and the meaning of wilderness in American culture. Yet, as his fame and influence were reaching their peak, many young photographers sought to move beyond the vision he presented in his art. They called for a new approach to landscape photography, one

that would recognize the growing human impact on the world and the changing ideas in the environmental movement. "Ansel Adams made wonderful photographs that represent a 19th-century version of the ideal landscape we all love and cherish," wrote the photographer Richard Misrach in 1990. "But the landscape Ansel Adams photographed did not contain campers, trash cans and highways. Sadly, in the 20th century, this ideal landscape no longer exists."[96]

The ideal had not existed in Adams's day either. The debate was really more over whether the "ideal" or the "real" was the more appropriate subject and goal. The movement toward a more documentary style of landscape photography had emerged in the 1970s. In the summer of 1975, William Jenkins organized an exhibition at the International Museum of Photography in Rochester. He titled the show *New Topographics: Photographs of a Man-Altered Landscape*. Jenkins felt that the works featured in the exhibition expressed the effort of the photographers to present an objective, "topographic" record of the contemporary American landscape. Rather than dwell on idyllic views of pristine landscapes, these photographers set out to document the changes in the "man-altered landscape," the encroachment of housing developments, highways, water projects, and power lines. The *New Topographics* show received considerable attention both from critics and from photographers.[97]

Lewis Baltz, like the other photographers featured in the show, recorded the expanding human presence in the landscape. His 1980 book, *Park City*, focused on the broad swath of destruction wrought by bulldozers carving the mountainsides in preparation for vacation home developments. While Adams's images of the majestic West helped to lure city dwellers in search of nature's peace, Baltz and others showed the effects of that search on the landscape.

Adams was not particularly excited by these new directions. His complaints in many ways echoed those he had directed at "realist" pho-

tography throughout the years. Adams wanted expression, emotion, uplift; the deadpan gaze of the new landscape style seemed to him "anti-art," its subject matter uninspiring.[98]

Of all the photographers associated with the new topographics style, Robert Adams (no relation to Ansel) was probably the most concerned with the issue of beauty that Ansel Adams considered so crucial in art. In the introduction to his 1974 book, *The New West: Landscapes Along the Colorado Front Range*, he urged photographers and the public to look at the whole geography of the West, not simply untouched wilderness. "All land," he wrote in the introduction, "no matter what has happened to it, has over it a grace, an absolutely persistent beauty." To see that beauty in the everyday world, he said, was the essential first step in overcoming the tendency to relegate concerns for the aesthetics of landscape to the few areas of remaining wilderness, while the land on which people live their daily lives faced abuse and neglect.[99]

The emphasis on the intersections of humanity and nature in landscape photography of the 1970s and 1980s paralleled new directions within the environmental movement. The poet Gary Snyder noted that although wilderness areas made up only 2 percent of the U.S. landmass,

> wildness is not limited to the 2 percent. . . . [I]t is everywhere: ineradicable populations of fungi, moss, mold, yeasts, and such, that surround and inhabit us. Deer mice on the back porch, deer bounding across the freeway, pigeons in the park. Spiders in the corners. . . . Exquisite, complex beings in their energy webs, inhabiting the fertile corners of the urban world in accord with the rules of wild systems.[100]

Humans, with all their artifacts and their cultures, are as much a part of that wild world as any other creature, said Snyder. Wild nature lives through and within the human body and the human mind. These were some of the principal concepts behind the philosophy known as deep ecology that emerged in the environmental movement during the 1970s

and 1980s. It combined the biological concepts of ecology with the religious principles of compassion and altruism to reconnect humanity and nature, the civilized and the wild.[101]

Adams had mixed emotions about such developments. Raised within the humanistic traditions of Western culture, his values and beliefs were deeply embedded in the Judeo-Christian exaltation of the human spirit. Yet as a citizen of the twentieth century, he had witnessed the ravages of humanity's assault on the rest of creation and on itself. A deep believer in rationalism and science, early in his life he realized the immensity of space and the minor role that humans played in the vastness of the cosmos.

Adams did not deny that he presented a highly selective and idealized view of the world. His pristine landscapes were intended to serve much the same purpose as the national parks themselves—precious fragments, beautiful and inspiring in their distinct opposition to the destruction around them. Some environmentalists rejected the public appeals of most mainstream conservation organizations—and, implicitly or explicitly, Adams's photographic contributions as well—as a form of neoromanticism contrary to ecological principles.[102] Yet Adams's contribution to public awareness of nature and its vital role in human life and culture could not be denied.

A man in his seventies is not likely to change his way of thinking much, and Adams did not involve himself in the philosophical debates swirling through the environmental movement once he resigned from the Sierra Club board. He directed his energy and his newfound fame toward more immediate goals. Always an indefatigable letter writer, Adams sent an unending stream of correspondence toward those in power, encouraging and cajoling them into action. His chief allies were California State Senator Fred Farr (and later Sam Farr, the second generation in that position), U.S. Congressman Philip Burton, and U.S. Senator Alan

Cranston. To these and others, he wrote in support of environmental causes from Alaska to the Big Sur coast.

In 1974, Adams's east coast dealer, Harry Lunn, presented a copy of *Images, 1923–1974*, to President Gerald Ford. The president and Mrs. Ford enjoyed it so much that they ordered a print of their favorite Adams photograph, *Clearing Winter Storm*, to display in the White House. Adams delivered the print in person and took the opportunity to present the president with a memorandum titled "New Initiatives for the National Parks."

His personal lobbying continued under President Jimmy Carter. In 1979 the National Portrait Gallery had contracted with Adams to make the official portrait for the Carters, the first time ever that a photographer had been invited to do so. While he was there, aiming the 20 × 24-inch Polaroid camera at the first couple, Adams urged the president to support the efforts at protecting the Alaskan wilderness. One of President Carter's last acts in office was his personal initiative, the Alaska National Interest Lands Conservation Act, through which over 100 million acres of Alaskan wilderness received federal protection. Another of Carter's final acts was to award Adams the Medal of Freedom, the nation's highest honor.[103]

With the election of Ronald Reagan in 1980 and his appointment of James Watt as secretary of the interior, Adams made it his personal mission to unseat the former actor and his interior secretary, whom he considered among the most dangerous officials ever appointed.[104] After one of President Reagan's staff read of Adams's antipathy in an interview in *Playboy* magazine in May 1983 (Adams had expressed his desire to drown the president in his martini), Adams received a call from Reagan's chief of staff, Michael Deaver, informing him of the president's desire to meet and discuss the issues. Because Reagan had not met with any environmental leaders since taking office, Adams felt a special weight of responsibility to represent the cause.[105]

President Reagan was cordial and friendly but unresponsive to Adams's ideas. The president defended Interior Secretary Watt as "a remarkable person" who was "doing exactly what I want him to do." His Environmental Protection Agency chair, Anne Burford, who resigned under a cloud of scandal, had, Reagan asserted, been "shamefully railroaded out of her position." Between the president's defense of his administration and protestations of environmental concern, Adams had little opportunity and less hope of making any real impression on the chief executive. Describing the meeting, Adams said, "The vacuum hit the fan."[106]

Despite the president's support of Watt, Adams and the environmental community mounted a nationwide campaign to have him replaced.[107] Bowing to public pressure, President Reagan accepted James Watt's resignation in October 1983.

## The Old Leprechaun

By the early 1980s, Adams was a figure of worldwide recognition, sought after for interviews and endorsements and fawned over by an adoring public. Adams was as gregarious as ever, and he enjoyed playing host to any and all who came to visit. He and Virginia had always had an open door policy wherever they lived. There was always room for the steady stream of houseguests, evening visitors, young photographers, old friends, photographic assistants, neighbors, journalists, curators, art dealers, musicians, and whoever was passing through. After five, the cocktail cart would come out and the martinis would be poured. Virginia made everyone feel at home, inviting them to dinner or to spend the night, assuring them it was no problem at all. Adams was, as usual, the star of the show, doing his foghorn imitation ("rotating slowly on his axis, now and then emitting a low, intense foghorn moan, and at every revolution gleaming upon the company with teeth and eyeballs that

seem to project through the beard a beam visible for miles," as Wallace
Stegner once described it), reciting silly limericks, or directing every-
one's attention out the window to watch for the green flash as the sun
dropped below the ocean's horizon.[108]

Some of Adams's favorite guests were the young photographers who
came by to show him their work. While many of the new directions in
photography were not to his taste, Adams enjoyed the company of young
artists. He liked their energy and humor, and they liked the same things
in him. For those who arrived expecting an unapproachable icon, his big
kid persona could come as a surprise. The San Francisco photographer
Judy Dater recalled a typical evening in 1980.

> Everyone at the dinner that evening was noisy, cheerful and a bit
> intoxicated. Ansel, at 78, presided over his guests at the head of the long
> table. He entertained us all with an endless round of jokes. His own
> laughter bellowed and resounded in the high-ceilinged room. I was
> seated to his right, and intermittently, in moments of particular good
> humor, his gnarled hand would creep along the table and pounce on my
> arm. My startled reaction sent him into new fits of laughter.[109]

After dinner Adams showed his guests some of his new "toys," an
IBM word processor and a new 4 × 5 view camera, a recent gift from
Virginia. Dater and the others there that night were amazed at his
"boundless energy and enthusiasm. . . . We, half his age, were already
tired, Virginia had slipped off to bed, but Ansel could have gone on and
on." Heading back up the curving Highway One through the fog, Dater
and her companions laughed about the bearded party animal.

> His accomplishments could be overwhelming and intimidating until
> one had a chance to actually spend some time with the person. It was
> then that the term leprechaun, while surprising, seems apt. Webster's
> describes leprechaun this way: "a small fairy, thought of as a sly tricky

old man who, if caught, will point out a treasure." Ansel Adams seemed to possess the characteristics of a magical mythical creature. Where he got all of his energy is a mystery. He knew how to delight and to mystify. And indeed, if caught, he could point out a treasure.[110]

For all his love of good company, Adams was still hard at work. The household staff had grown to seven full-time employees, including darkroom assistant Chris Rainier and staff assistant Rod Dresser, print spotter Phyllis Donohue, chefs Fumiye Kodani and Bruce Witham, and bookkeeper Judy Siria. The task of coordinating the functions of this small army, as well as editing Adams's autobiography and looking after his health, fell to Mary Alinder. A registered nurse, an experienced editor, and the former manager of the Weston Gallery in Carmel, her background was unexpectedly right. A lifelong hypochondriac, Adams liked the medical attention. His ailments were not by any means all in his imagination. Years of rich food, martinis, and "Type A" intensity had taken their toll on his heart and circulatory system. On Valentine's Day 1979, Adams underwent open heart surgery. The doctors performed a triple coronary bypass and replaced a damaged valve with one donated by a recently deceased pig. In 1982 they added a pacemaker that kicked in whenever his heart missed a beat.[111]

Despite his declining health, his obligations, real or assumed, did not go away. His major unfinished projects were his autobiography and the Museum Set, a retrospective collection of the finest work from throughout his career intended for a select group of public and private institutions. Both were to be final statements, summations in words and images of his life in photography. With his failing strength, these unfinished projects loomed over his head. "It was like this awful cross he bore," Mary Alinder recalled. "It just weighed on him."[112]

Adams's formidable energy persisted despite his many physical complaints. The pig valve and pacemaker did their jobs well enough to keep

him on his feet through his daily rounds: mornings were spent in the darkroom, printing the Museum Sets; afternoons were spent at the word processor, working on his autobiography; evenings were saved for cocktails, guests, dinner, good talk, and late nights of reading. The insomnia Adams suffered throughout his life continued in his old age. He left a light on and the radio playing softly while he read and drifted in and out of sleep. Despite the workload, Adams did get the occasional opportunity to go out with his camera to make new photographs.

## Circle of Time

His usual companion on these excursions was James Alinder, Mary's husband and the executive director of the Friends of Photography since 1977. One winter day in 1982, not long after Adams's eightieth birthday, they traveled out to the headlands of the Golden Gate. It would be one of the last such trips Adams made. As the two photographers explored the rolling hills and steep cliffs along the ocean's edge, Adams was brought back to the "wild, free days" of his youth when he had roamed this country with camera and tripod slung over his shoulder. He felt "a bit sad" to be confined to the car and the roadside now. Yet it was a rare pleasure for him to be back in the field, on the lookout for visual possibilities, framing images in his mind's eye, setting up his camera (he was using a medium-format Hasselblad, as he had for most of his photography over the past twenty years), choosing the composition, calculating the exposure, and releasing the shutter. It was all so thoroughly ingrained as to be almost unconscious.[113]

Out on the farthest cliffs, Adams came across an abandoned concrete bunker, a crumbling remnant of two world wars. It was not his usual kind of subject, but he was immediately drawn to it. Maybe he felt a certain empathy, weathered as it was, standing out there at the edge of the sea through nearly a century of storms.[114]

Adams chose to focus on a portion of the battered facade where, amid the scratched-in names and dates, was a large letter "A" within a circle—an anarchist symbol favored by the young punk rockers of the 1980s. He was particularly intrigued by the bright white paint applied by "some contemporary primitive" which covered the circle and adorned the nearby walls in broad gestural swaths like a hooligan Franz Kline.

Setting up his camera before the bunker, Adams selected a head-on view, the right angles of its doorway and empty window creating an orderly counterpoint to the chaotic scrawls and dripping paint. Still in full command of his zone system technique, Adams carefully metered the light levels. He selected his exposure parameters to preserve the darker values of the interior wall and made a note to increase the film's development to expand the contrast scale and render the circle a brilliant white. Additional manipulation in the printing stage, including a careful dodging of the interior wall to preserve the detail of its darkened space, produced an image with the luminosity, range of value, and textural detail that were his trademarks.[115]

Adams admitted that the photograph held a peculiar emotional resonance for him. "It seems that almost anything that endures in time acquires some qualities of the natural," he wrote when recalling the image he made that day. "Bleak shapes grow into a kind of magic that, once seen, cannot easily be ignored." The camera, he said, "enables us to express what we have seen and felt in the worlds of nature and humanity." Despite the chaos and violence of the twentieth century, Adams had searched for order and harmony with an indefatigable optimism. He continued to do so right up to the end.[116]

Two years later, on Easter Sunday (and Earth Day), April 22, 1984, the pianist and conductor Vladimir Ashkenazy gave a concert in the Adamses' home. Ansel was in the hospital, fighting off another round of

heart troubles. Everyone had expected he would be there, but two days earlier he had taken a turn for the worse. He had always said that he did not want a funeral, just a small concert for friends and family. Although Adams was not physically present, his spirit was in the room as Ashkenazy played the music of Schubert, Schumann, and Chopin. Adams died later that evening, after a visit from his family and a few friends.

## Mount Ansel Adams

In August 1985, a little over one year after Adams's death, a crowd of several hundred people gathered near Soda Springs in Yosemite's Tuolumne Meadows. At the same spot in the summer of 1889, John Muir and Robert Underwood Johnson had camped under the stars and planned for the meadow's protection as a national park. Now, nearly a century later, this group had gathered to celebrate the official dedication of Mount Ansel Adams and the naming of Yosemite National Park a United Nations World Heritage Site, part of a program created to recognize places of global significance.

The peak, south of Mount Lyell on Yosemite's rugged eastern border, had been unofficially named for Adams on a Sierra Club High Trip in 1933 by the climbers who made the first ascent. Because geographic features are never officially named for living people, the U.S. Geological Survey would not sanction it until several months after Adams died. Now the secretary of the interior was there to certify the designation in person. The new secretary, Donald Hodel, acknowledged with a smile that Adams had not been fond of his former boss, James Watt. Furthermore, the State Department was, at that time, by no means an enthusiastic supporter of the United Nations. Nevertheless, the administration was apparently willing to overlook these things for the purposes of the occasion.

Among the speakers that afternoon were several of Adams's old friends. Wallace Stegner pointed out the link between John Muir and Ansel Adams.

A place is not fully a place until it has had its poet. Yosemite and the Sierra Nevada have had two great poets, Muir and Adams. In consequence I think these mountains are better understood, held worthier of respect and protection than they would be if those two had never looked on them with reverence and been delighted with spring dogwood blossoms, exhilarated by glacier pavements, dazed by half-mile cliffs, and glorified by snow peaks blossoming like roses in the dawn.[117]

Senator Alan Cranston recalled another common thread connecting Adams and Muir: a relentless political engagement. Adams, Cranston pointed out, had lobbied congressmen, senators, and presidents from FDR to Ronald Reagan. When the relationship had been a good one, as it had with Roosevelt and Ickes, Adams could energize the bureaucratic labyrinths with a sense of mission and shared vision; when the relationship was adversarial, as it was with Reagan, Adams could be the staunchest of opponents. The fact that Donald Hodel and not James Watt was there that day was evidence of that.

Also addressing the assembled company was David Brower. The two old friends had reconciled late in life. For several years after their Sierra Club brawl, Adams had refused the club's offer of an honorary vice presidency as long as Brower was also to be so honored. Time mellowed them both, however, and by 1983 they were working together again. One of their projects was a "Manifesto for the Earth," a comprehensive outline for the protection of the biological systems of the planet and the preservation of wilderness areas around the globe.[118]

Brower took the opportunity of having the ear of the interior secretary and members of the press to suggest the expansion of Yosemite to

take in the entire east-west arc of the range, from endangered Mono Lake in the Owens Valley to the Merced River's lower reaches in the foothills of the San Joaquin Valley. In its audacity, it was vintage Brower, seizing the initiative and pushing ahead even as they gathered to look back. Adams would have approved.

The climax of the ceremony was the dedication of Yosemite National Park as a World Heritage site. Yosemite, as several speakers had pointed out that day, was the symbolic home of the national park idea, one of America's most significant contributions to the world. It was fitting that Adams, Muir, and Yosemite were linked together in the ceremony. Just as Muir had been Yosemite's greatest representative to the nineteenth century, Adams had been its greatest representative to the twentieth century. No one had done more than Muir and Adams to connect the national park idea to America's vision of itself. Yet in the latter part of the twentieth century, Adams had come to see that the national park idea was more than an American idea. In an age of global threats and global communication, he realized that people of all nations needed to find nature's peace together.

In his own life, Yosemite had been his physical and emotional liberation when, as a wiry hyperactive teenager, he had bounded up its trails, across its streams, and over its meadows in joyous discovery. As he grew to maturity, Yosemite remained the homeland of his creative spirit and the photographic subject to which he endlessly returned. The photographs he made there, like the park itself, were intended as symbols of the living power and beauty of nature. It was always Adams's hope that his photographs could inspire people to discover that beauty in their own lives. He dreamed, as Whitman had dreamed, that Yosemite could "be in them absorb'd, assimilated." As the people who gathered in the meadow that day made their way back down the wider, faster Tioga Road toward their houses in the cities, perhaps some part of his dream went with them.

# ACKNOWLEDGMENTS

MANY PEOPLE HAVE HELPED me on this project, and I would like to offer brief thanks (though they deserve more) to a few of them here. Among the most enjoyable aspects of my research was the opportunity to meet and talk with many good people, including Virginia Adams, James Alinder and Mary Street Alinder, David Brower, Philip Hyde, Beaumont Newhall, Alan Ross, and William Turnage. I would like to especially thank Virginia Adams, who was most generous with her time and recollections. Her legendary warmth still glows. Beaumont Newhall also deserves special thanks. Although busy with a number of projects, he gladly spent a hot July afternoon telling some of his favorite Ansel Adams stories and setting me straight on a variety of significant points. I would also like to thank Mary Alinder for her support. Her encouragement helped me over many obstacles, and her knowledge of Adams's life kept me from many mistakes. That I have no doubt made many more is certainly no one's fault but my own.

Stanley Holwitz at the University of California Press supported this project with great enthusiasm, and I am grateful for his advice and encouragement. The press's outside readers offered useful suggestions and critiques. I am particularly grateful to John Pultz for his comments.

Michelle Nordon and Michelle Bonnice guided the manuscript through the editorial process with grace and aplomb. Sheila Berg copyedited the text with a rigorous eye. Jacqueline Gallagher-Lange gave the book an elegant design in keeping with the spirit of Ansel Adams.

Norris Hundley and Thomas Hines of the University of California, Los Angeles, supported my efforts with great wisdom, skill, and friendship. Robert Heinecken, Eric Monkkonen, Deborah Silverman, and Thomas Wortham all provided good advice and shared their knowledge generously. Alexander Saxton and Richard Weiss read my prospectus and provided many useful suggestions. The members of the Domus group read drafts of each chapter, offering helpful advice and warm friendship. Susan Neel read drafts of several chapters as well as the entire completed dissertation and pointed out some of the more significant trees in the forest of environmental history. Participants in the 1990 biennial meeting of the American Association for Environmental History and the Friends of Photography's 1992 Ansel Adams Scholars Conference listened to portions of this manuscript, offered helpful suggestions, and provided examples of how it ought to be done.

While exploring Adams's far-flung paper trail, I have had the pleasure of working in a variety of fine libraries and archives. I would especially like to thank Amy Rule and Leslie Calmes of the University of Arizona's Center for Creative Photography, who guided me through the imposing vastness of the Adams, Newhall, Weston, and other assorted photographic archives in the center's collections. I am grateful as well to the staffs of the following institutions for access and guidance: the Bancroft Library at the University of California, Berkeley; the Beinecke Library at Yale University; the Huntington Library in San Marino, California; the Department of Photography at the Museum of Modern Art, New York; the National Archives, National Park Service Collection and Office of War Information Collection; the Sierra Club's William F. Colby Library in San Francisco; the United States Information Service

Historical Collection; the Department of Special Collections at the University of California, Los Angeles; and the Yosemite Park and Curry Company archives.

I would like to thank the departments of history and art, art history, and design in the University of California, Los Angeles, for financial support. The faculty, students, and staff of both departments provided an intellectually rigorous and stimulating environment in which to work.

I could never have begun, let alone finished, this project without the moral support of my family: my wife, Dana, my daughter, Margaret, my parents, Carl and Suzanne, my brothers, Tim and Rich, and all the extended tribe. To them and to my friends who put up with me over the past ten years, I am grateful.

# ON PERMISSIONS

Unfortunately, the trustees of the Ansel Adams Publishing Rights Trust have been unwilling to grant permission for the reproduction in this book of photographs and writings by Ansel Adams to which they hold copyright. Those wishing to refer to specific images and writings should consult the notes and the selected bibliography. Most of the photographs can be found in Ansel Adams, *Classic Images* (Boston: New York Graphic Society, 1985), or in Ansel Adams, *Examples: The Making of Forty Photographs* (Boston: New York Graphic Society, 1983). Much of his most significant correspondence appears in Mary Street Alinder and Andrea Gray Stillman, eds., *Ansel Adams: Letters and Images* (Boston: New York Graphic Society, 1988).

# Notes

## Preface

1. Ansel Adams, *Examples: The Making of Forty Photographs* (Boston: New York Graphic Society, 1983), 41 (hereafter cited as *Examples*).

2. Ibid.

3. Ibid., 41–42. See also Ansel Adams, *Ansel Adams: An Autobiography* (Boston: New York Graphic Society, 1985), 271–275 (hereafter cited as *Autobiography*). Around 1948, Adams treated the lower portions of the negative with an intensifier to increase separation of values in the foreground.

4. *Examples*, 41–42.

5. *Autobiography*, 276.

6. See, e.g., Charles Hagen, "Beyond Wilderness: Between Esthetics and Politics," in *Ansel Adams: New Light, Essays on His Legacy and Legend* (San Francisco: Friends of Photography, 1993), 97–102; and Charles Hagen, ed., "Beyond Wilderness," special issue, *Aperture* 120 (Late Summer 1990). See also, Charles Traub, "Thoughts on Photography in Conquest of the American Landscape," in *Art in the Land*, ed. Alan Sonfist, 217–224 (New York: E. P. Dutton, 1983); and John Szarkowski, foreword to Robert Adams, *The New West: Landscapes Along the Colorado Front Range* (Boulder: Art Museum of the University of Colorado, 1974), v–ix.

7. The quotation is from Walt Whitman, "Song of the Redwood-Tree," in *Leaves of Grass*, by Walt Whitman (New York: E. P. Dutton, 1912), 178.

## Chapter 1

1. *Autobiography*, 2. Given the selective nature of memory, it is understandable that Adams's earliest recollection should be such a photographic one, and an Ansel Adams photograph at that. As Adams himself conceded, the

recollections contained in his autobiography were, "perhaps, willfully colored" (ix). It is a point to bear in mind as much of the information in the following pages is derived from the autobiography and other recollections of his later life. It is also important to consider what he left out. That will be one of the central tasks of this study. Whenever possible, I have relied on letters and writings of the time rather than later memory. I believe these offer more reliable, though by no means foolproof, reports of events and emotions.

2. Ansel Adams, "Conversations with Ansel Adams," interviews by Ruth Teiser and Catherine Harroun, 1972, 1974, 1975, Regional Oral History Office, Bancroft Library, University of California, Berkeley, 5, 9 (hereafter cited as "Conversations"). See also *Autobiography*, 4. For other expressions regarding the mystical influence of the area around his house on his young sensibilities, see AA to Mary Austin, August 10, 1931, correspondence file (hereafter cited as cf): Mary Austin, Ansel Adams Archive, Center for Creative Photography, University of Arizona (hereafter cited as AACCP); and AA to John Varian and Ma [Agnes Varian], cf: Adams family, n.d., AACCP (this seems to have been mistakenly placed in the Adams family correspondence file based on Agnes Varian's adopted Sanskrit name, Ma, which reflects the Varians' involvement with Theosophy).

3. William Issel and Robert W. Cherny, *San Francisco, 1865–1932: Politics, Power, and Urban Development* (Berkeley, Los Angeles, and London: University of California Press, 1986), 23. According to the 1880 census, San Francisco merchants handled 99% of the Pacific Coast's imports and 83% of its exports. The city's manufacturing output, number of employees, and value of products were greater than all the other twenty-four western cities combined. By 1900 San Francisco's economic predominance was on the wane as other West Coast port cities—Los Angeles, Portland, and Seattle—each experienced substantial growth in the last decades of the nineteenth century.

4. In 1900, 64.5% of the city's population were native-born whites; of those,

over 40% had foreign-born parents. Foreign-born whites made up 30.4% of the population; of these, the Irish predominated at 27.5%, followed by Germans (22.9%), British (10.1%), Italians (6.2%), and Scandinavians (5.9%). Chinese and Japanese made up 4.6% of the population, a marked drop that reflected the rise of exclusionary policies in that period. Blacks, who accounted for 0.5% of the population, had not yet arrived in significant numbers and would not do so until the Second World War.

5. Jack London, "South of the Slot," in *Moon-face and Other Stories* (New York: Macmillan, 1906).

6. Issel and Cherny, *San Francisco*, 53–79.

7. Nancy Newhall, *Ansel Adams*. Vol. 1, *The Eloquent Light* (San Francisco: Sierra Club, 1963), 22 (hereafter cited as *Eloquent Light*). Newhall's source was a typed manuscript by Adams's cousin, Frances Kehrlein, "A Short History of the California Pioneers in the Kehrlein Family," located in the Beaumont and Nancy Newhall Archive, Center for Creative Photography (hereafter cited as NACCP) file: *The Eloquent Light*, research notes on family history. See also *Autobiography*, 4, and "Conversations," 3.

8. For descriptions of life en route to the gold fields of California, see Rodman Paul, *California Gold: The Beginning of Mining in the Far West* (1947; Lincoln: University of Nebraska Press, 1965), 20–35; J. S. Holliday, *The World Rushed In: The California Gold Rush Experience* (New York: Simon and Schuster, 1981), 45–54; and John Haskell Kemble, *The Panama Route: 1848–1869* (Berkeley: University of California Press, 1943).

9. Newhall, *Eloquent Light*, 22; Kerhlein ms., NACCP.

10. Ibid.

11. Kevin Starr, *Americans and the California Dream, 1850–1915* (New York: Oxford University Press, 1973), 112–113, 120–125.

12. Ibid., 126–130.

13. Newhall, *Eloquent Light*, 22; "Conversations," 3; *Autobiography*, 4.

14. "Conversations," 3; Newhall, *Eloquent Light*, 22.

15. "Conversations," 4; Newhall, *Eloquent Light*, 22–23; *Autobiography*, 4–5.

16. Ibid.

17. Henry George, "What the Railroad Will Bring Us," *Overland Monthly* 1 (October 1868): 302–303. As the economy of California expanded, the distinctions of poverty and wealth became more clearly defined, making the image of California as El Dorado more illusory than ever for most. The highly volatile fortunes of San Francisco's early mercantile elite had given way by the 1870s to a more stable and closed economic system. Movement from the blue-collar world into either the white-collar occupations or the elite ranks declined significantly after the 1850s. The much-heralded opportunities of the Far West were becoming increasingly no more favorable than conditions in any other American city of the day. Peter Decker, *Fortunes and Failures: White Collar Mobility in Nineteenth-Century San Francisco* (Cambridge: Harvard University Press, 1978), 60–86, 177, 189, 239, passim. Upward mobility for male workers in San Francisco, aged 20–29, in all occupations from 1852 to 1860 was 38%; from 1870 to 1880, it was 26% (see table 9.3 in Decker, 240). The rate of blue-collar workers advancing to white-collar jobs from 1870 to 1880 was no higher in San Francisco (13%) than in Poughkeepsie (13%) and lower than in Atlanta (19%) (see table 7.6 in Decker, 194).

18. Henry George, "The Kearney Agitation in California," *Popular Science Monthly* 17 (August 1880): 443–453; quote on 452–453.

19. Henry Adams, *The Education of Henry Adams* (1907; Boston: Houghton Mifflin, 1973). Ansel's family liked to believe they shared a common ancestry with the more famous Adams line. See, for example, Newhall, *Eloquent Light*, 33; and AA to Alfred Stieglitz, October 9, 1933, Alfred Stieglitz Papers, Beinecke Library, Yale University (hereafter cited as ASAY). See also "Conversations," 2, for recollections of his grandmother's attempts to trace the family genealogy back to the presidential Adams line. In reply to inquiries from Ansel in regard to his ancestors, Charles provided a brief sketch of the family history; see Charles Adams to AA, March 25, 1944, cf: Adams family, AACCP. Charles mentioned the supposed connection with

John Adams and John Quincy Adams and adds that there were ties to Ralph Waldo Emerson and Chief Justice Melville W. Fuller "on your grandfather's side." Although the connections between the two Adams families seem obscure, Ansel's father reported a peculiar experience that seemed to confirm the theory. While standing in a crowded room, he was suddenly hailed by a man who said, "Why there's an Adams!" It turned out to be Henry Adams's brother, Charles Francis Adams; see Newhall, *Eloquent Light*, 33.

20. Adams, *Education*; Newhall, *Eloquent Light*, 33. Ansel later expressed his opinion that the disillusioned brahmin's plight was the result of an excessively detached intellectualism, an unwillingness to tackle the hard work of making a better world. AA to Alfred Stieglitz, October 9, 1933, ASAY; reprinted in Mary Street Alinder and Andrea Gray Stillman, eds., *Ansel Adams: Letters and Images, 1916–1984* (Boston: New York Graphic Society, 1988), 58–61 (hereafter cited as *Letters*).

21. See Paul Boyer, *Urban Masses and Moral Order in America, 1820–1920* (Cambridge: Harvard University Press, 1978); Robert Weibe, *The Search for Order, 1877–1920* (New York: Hill and Wang, 1967); Richard Hofstadter, *The Age of Reform, from Bryan to F.D.R.* (New York: Vantage Books, 1955). Among the most significant primary sources are Henry George, *Progress and Poverty* (San Francisco: W.M. Hinton, 1879); Edward Bellamy, *Looking Backward* (Boston: Ticknor, 1888); and Herbert Croly, *The Promise of American Life* (New York: Macmillan, 1909).

22. *San Francisco Chronicle*, May 1, 1903, 2. See also Thomas Dyer, *Theodore Roosevelt and the Idea of Race* (Baton Route: Louisiana State University Press, 1980); T.J. Jackson Lears, *No Place of Grace: Antimodernism and the Transformation of American Culture, 1880–1920* (New York: Pantheon Books, 1981).

23. *San Francisco Chronicle*, May 1, 1903, 2; May 14, 1903, 2. When Roosevelt arrived in San Francisco later that month, the *San Francisco Chronicle* reported: " 'Race suicide' theory got a black eye yesterday morning

on Van Ness avenue. Whatever fears may have disturbed the President's patriotic mind on this score as a result of his wide knowledge of the effete East, the sight of four miles of San Francisco's strenuous youngsters, cheering and screaming a frantically enthusiastic welcome to their country's chief, must have seemed to him a grateful and reassuring omen for the future."

24. Charles Adams to AA, March 25, 1944, cf: Adams family, AACCP.

25. Urban housing patterns had been shifting throughout the industrialization process. During the eighteenth and early nineteenth century, the dominant pattern was of the "walking city" in which work and living spaces were not clearly differentiated. Artisans, their families, and their apprentices lived above the shop. Merchants lived near the harbor or the riverfront. Different classes and businesses mingled together in close proximity. By the late nineteenth century, workers and employers seldom lived in the same part of town. The middle and upper classes had no desire to live among the noise, the dirt, and the immigrant workers. Improved transportation systems, especially the streetcars and the trolleys, made it possible for business owners and white-collar workers to "work in the city and live in the country," as the advertisements put it, or at least to live in some facsimilie of the country. "Streetcar suburbs" sprang up around the nation's cities, and San Francisco was no exception. Sam Bass Warner, *Streetcar Suburbs: The Process of Growth in Boston, 1870–1900* (Cambridge: Harvard University Press, 1962); and Betsy Blackmar, "Re-walking the 'Walking City': Housing and Property Relations in New York City, 1780–1840," *Radical History Review* 21 (Fall 1979): 131–148.

26. *Autobiography*, 6.

27. Ibid., 39.

28. Ibid., 7–9; Newhall, *Eloquent Light*, 23, 26.

29. William Bronson, *The Earth Shook, the Sky Burned* (Garden City, N.Y.: Doubleday, 1959).

30. *Autobiography*, 6–9; Newhall, *Eloquent Light*, 23, 26.

31. William Adams (AA's uncle) to Charles Adams (n.d., April 1906); Charles Bray to Charles Adams, April 22, 1906 (telegram); J. M. McCormack (writing on behalf of Charles Bray) to Charles Adams, April 23, 1906; all cf: Adams family, AACCP.

32. *Autobiography*, 39; "Conversations," 3.

33. R. G. Aitken, "In Memorium, Charles Hitchcock Adams, 1868–1951," *Publications of the Astronomical Society of the Pacific* 63, no. 375 (December 1951), 283–286, reprint in cf: Adams family, 1950–1951, AACCP. *Autobiography*, 39–40; Newhall, *Eloquent Light*, 27; "Conversations," 10–11.

34. Ibid. The Adams and Newhall accounts of these events vary. I have related Adams's account here. Nancy Newhall maintains that Ansel Easton persuaded Charles to sell his shares to the Hawaiian Sugar Trust, while Easton went out and "sold his own—and controlling—shares on the streets of Seattle" (27). Given the fuller treatment of the story by Adams and his personal knowledge of the events, I have assumed his version to be the more accurate. When Adams learned the facts behind this incident in the 1930s, he discontinued the use of his middle name, Easton. This incident may have also contributed to his strained relationship with his mother and aunt.

35. Charles Adams to AA, November 15, 1947, cf: Adams family, AACCP.

36. *Autobiography*, 41–42. A photograph of the Adamses in the living room of their home around 1918 provides an eerie equivalent of this mood. Grandfather Bray, Ansel's mother, his Aunt Mary, and his father stand near the fireplace. Charles is off to the side, away from the hearth, standing before the window. Although his head and arm seem solid enough, the rest of his body seems to be ghostly, transparent, as the curtain pattern behind him is visible through the dark of his coat. See *Autobiography*, 42. It is possible that Charles, a talented amateur photographer, framed the scene, released the shutter, and then moved into position during the long exposure. It is also possible that two flashes were made—one with Charles behind the camera and one with him in the scene.

37. Throughout his life Adams continued to experience regular bouts of illness brought on by physical exhaustion. In his youth doctors had suspected his difficulties resulted from an adenoidal condition, yet despite the removal of his adenoids at the age of fourteen, his health troubles continued. Poor diet and overexertion seemed to be the primary causes. In later years, Adams would use the "opportunity" to churn out letters and plow through books, magazines, and technical reports. Throughout his life, his correspondence included a regular refrain of illnesses suffered and days spent in forced bedrest, usually accompanied by a list of activities that he hoped to carry out in the meantime.

38. *Autobiography*, 16–17.

39. "Conversations," 5–6; Charles Adams to AA, March 25, 1944, cf: Adams family, AACCP.

40. Charles Adams to AA, March 25, 1944, cf: Adams family, AACCP.

41. Charles Adams to Olive Adams and Mary Bray, May 17, 1914, cf: Adams family, AACCP; Newhall, *Eloquent Light*, 28.

42. "Conversations," 6.

43. Ben Macomber, *The Jewel City: Its Planning and Achievement* (San Francisco: John H. Williams, 1915), 11.

44. Burton Benedict, *The Anthropology of World's Fairs: San Francisco's Panama Pacific International Exposition of 1915* (Berkeley: Lowie Museum/Scolar Press, 1983); Robert Rydell, *All the World's a Fair: Visions of Empire at American International Expositions, 1876–1916* (Chicago: University of Chicago Press, 1984).

45. Macomber, *Jewel City*, 82, 87.

46. "Conversations," 30; *Autobiography*, 19.

47. *Autobiography*, 18–21; "Conversations," 30–31; author interview with Virginia Adams, April 29, 1985.

48. *Autobiography*, 18–21; "Conversations," 30–31.

49. Ibid.

50. *Autobiography*, 18–19.

51. Ibid., 21.

<br>

CHAPTER 2

1. James M. Hutchings, *In the Heart of the Sierras* (Yosemite Valley and Oakland: Pacific Press, 1886); *Autobiography*, 49–50.

2. Ansel Adams, Introduction, in Ansel Adams and John Muir, *Yosemite and the Sierra Nevada* (Boston: Houghton Mifflin, 1948), xiii–xvi; *Autobiography*, 51; "Conversations," 230–231.

3. Ibid.

4. Adams, Introduction, in Muir, *Yosemite and the Sierra Nevada*, xiv.

5. "Conversations," 231. In his oral history, Adams recalled Curry as "an old fake." Perhaps this view was colored by Adams's subsequent employment with the Curry Company and his distaste for their theatrical gimmickry to wow the tourists. On the impact of Yosemite, see Adams, *Yosemite and the Range of Light* (Boston: New York Graphic Society, 1979), 8; *Autobiography*, 53.

6. Although these early photographs were, as Adams later claimed, primarily "records," rather than creative interpretations, it is clear that a fairly well-developed aesthetic sense was at work in his photography even at this young age.

7. *Autobiography*, 53.

8. "Conversations," 230–231.

9. Starr, *Americans and the California Dream*, 172.

10. Francis Farquhar, "Walker's Discovery of Yosemite," *Sierra Club Bulletin* (hereafter cited as *SCB*) 27 (August 1942): 35–49; Margaret Sanborn, *Yosemite: Its Discovery, Its Wonders, and Its People* (New York: Random House, 1981), 3–9.

11. Albert L. Hurtado, *Indian Survival on the California Frontier* (New Haven: Yale University Press, 1988), 100–124; Sherburne F. Cook, "The Ameri-

can Invasion, 1848–1870," in Cook, *The Conflict Between the California Indian and White Civilization* (Berkeley, Los Angeles, and London: University of California Press, 1976).

12. Lafayette Bunnell, *Discovery of the Yosemite and the Indian War of 1851 which led to that event*, 4th ed. (1882; Los Angeles: G. W. Gerlicher, 1911), 63.

13. Starr, *Americans and the California Dream*, 181–183; James M. Hutchings, "The Yo-ham-i-te Valley," *Hutchings' Illustrated California Magazine* 1, no. 1 (July 1856): 2–8.

14. Hutchings's first trip is described in "The Great Yo-semite Valley," *Hutchings' Illustrated California Magazine* 4 (October 1859): 145–160. See also "Charles L. Weed, Yosemite's First Photographer," *Yosemite Nature Notes* 38 (June 1959): 76–87; and Kate Nearpass Ogden, "Sublime Vistas and Scenic Backdrops: Nineteenth-Century Painters and Photographers at Yosemite," *California History* 69 (Summer 1990): 134–153.

15. Earl Pomeroy, *In Search of the Golden West: The Tourist in Western America* (New York: Alfred A. Knopf, 1957), vi–viii. Tourism and landscape art were closely allied in western America. This continued to be the case during Adams's lifetime and is important for the understanding of his photography. This relationship will be explored more fully in later chapters. On tourism in the twentieth century, see John A. Jackle, *The Tourist: Travel in Twentieth-Century America* (Lincoln: University of Nebraska Press, 1985) and Scott Norris, ed., *Discovered Country: Tourism and Survival in the American West* (Albuquerque: Stone Ladder Press, 1994).

16. Pomeroy, *In Search of the Golden West*, 150–158; James Bryce, *University and Historical Addresses* (New York: Macmillan, 1913), 399–401; *Report of the Director of the National Park Service . . . 1917* (Washington, D.C.: Government Printing Office, 1917), 190. See also Stanford E. Dumars, *The Tourist in Yosemite, 1855–1985* (Salt Lake City: University of Utah Press, 1991); and Alfred Runte, *Yosemite: The Embattled Wilderness* (Lincoln: University of Nebraska Press, 1990).

17. Roderick Nash, *Wilderness and the American Mind*, 3d ed. (New Haven: Yale University Press, 1982); Hans Huth, *Nature and the American: Three Centuries of Changing Attitudes* (Berkeley: University of California Press, 1957); Perry Miller, *Errand into the Wilderness* (Cambridge: Harvard University Press, 1956).

18. Frederick Jackson Turner, "The Significance of the Frontier in American History," in Turner, *The Frontier in American History* (New York: Henry Holt, 1920), 1–38. For background on Turner's life, the development of his "frontier thesis," and its effects on American historiography, see Ray Allen Billington, *America's Frontier Heritage*, rev. ed. (1963; Albuquerque: University of New Mexico Press, 1974); Billington, *Frederick Jackson Turner, Historian, Scholar, Teacher* (New York: Oxford University Press, 1973); and Richard Hofstadter, *The Progressive Historians: Turner, Beard, and Parrington* (Chicago: University of Chicago Press, 1968).

19. John Higham, "The Reorientation of American Culture in the 1890s," in *The Origins of Modern Consciousness* (Detroit: Wayne State University Press, 1965), ed. John Weiss, 25–48; Lears, *No Place of Grace*; Weibe, *The Search for Order*.

20. *Autobiography*, 53; Newhall, *Eloquent Light*, 29. On Eastman Kodak and the development of hand-held roll film cameras and amateur photography, see Douglas Collins, *The Story of Kodak* (New York: Harry N. Abrams, 1990); and Brian Coe and Paul Gates, *The Snapshot Photograph: The Rise of Popular Photography, 1888–1939* (London: Ash & Grant, 1977).

21. "Conversations," 7; *Autobiography*, 69; Newhall, *Eloquent Light*, 31.

22. *Autobiography*, 71; "Conversations," 7.

23. Dittman quoted from an interview with Nancy Newhall, 1950, in Newhall, *Eloquent Light*, 31.

24. Newhall, *Eloquent Light*, 31.

25. *Autobiography*, 71.

26. Ibid., 26. On Zech, see H. Wiley Hitchcock and Stanley Sadie, eds., *The*

*New Grove Dictionary of American Music*, vol. 4 (London: Macmillan, 1986), 590–591.

27. See, e.g., Adams, "Problems of Interpretation of the Natural Scene," *SCB* 30 (1945): 47–50.

28. *Autobiography*, 27. Adams began his study with Moore in 1927, following Zech's death in 1926.

29. See Minor White, Introduction, in Lilian De Cock, *Ansel Adams* (Hastings-on-Hudson: Morgan and Morgan, 1972); and Minor White, "Ansel Adams—Musician to Photographer," *Image* 6 (February 1957): 29–35. The influence of music on Adams's photographic career will be discussed in more depth in the following chapters.

30. Olive Adams to Charles Adams, June 13, 1917; Charles Adams to Olive Adams, June 13, 1917; both cf: Adams Family, AACCP.

31. *Autobiography*, 55–57. See also Adams, "Francis Holman, 1856–1944," *SCB* 29 (1944): 47–48.

32. Ansel Adams to Olive Adams, May 26, 1918; see also AA to OA, June 9, 1918. Both letters cf: Adams family, AACCP.

33. *Autobiography*, 54.

34. Ibid.

35. Ibid., 58–59; Newhall, *Eloquent Light*, 33–34; "Conversations," 234–235, 245; AA to Olive and Charles Adams and Mary Bray, April 18, 1920, *Letters*, 4. Ansel Adams, "LeConte and Parsons Memorial Lodges," *SCB* 11 (1921): 201–202. Adams's first published photographs appeared in *SCB* 11 (1922), Plate LXXV, following p. 258, and Plate XCI, following p. 314.

36. AA to Charles Adams, June 24, 1920, cf: Adams Family, AACCP.

37. AA to Charles Adams, June 8, 1920, cf: Adams family, AACCP; *Letters*, 6–8.

38. Ibid.

39. Peter Henry Emerson, *Naturalistic Photography*, 3d ed. (1899; reprinted New York: Arno Press, 1973). On the relationship of photography and the fine arts during the nineteenth century, see Aaron Scharf, *Art and Photog-*

*raphy* (London: Allen Lane, 1968); and Van Deren Coke, *The Painter and the Photograph: From Delacroix to Warhol*, rev. ed. (Albuquerque: University of New Mexico Press, 1972). For a contemporary discussion of the issue, see, e.g., an unsigned article by Lady Elizabeth Eastlake, "Photography," *Quarterly Review* 101 (April 1857): 442–468.

40. Works on pictorialist photography are numerous. Good summaries are in Beaumont Newhall, *The History of Photography from 1839 to the Present Day*, 5th ed. (1937; New York: Museum of Modern Art, 1982), 73–83; and Naomi Rosenblum, *World History of Photography*, rev. ed. (New York: Abbeville Press, 1989), 297–339. Although Adams adopted the soft-focus pictorial style in these years, he later discarded it. In the 1920s, photographers increasingly rejected the imitation of other media in favor of an approach known as "straight photography," embracing visual precision yet maintaining the control of the process essential to the expression of the photographer's subjective interpretation. For now, however, Adams remained unaware of these new ideas.

41. Kenneth Clark, *Landscape into Art* (1949; New York: Harper and Row, 1976), 1–31. See, especially, Clark's quote of Petrarch's feelings of guilt on admiring the view from a mountaintop (10). On the Christian condemnation of nature and its cultural and environmental effects, see Lynn White, Jr., "The Historical Roots of Our Ecological Crisis," *Science* 155 (March 10, 1967): 1203–1207. On the rise of rationalism and a mechanistic view of the natural world, see Carolyn Merchant, *The Death of Nature: Women, Ecology, and the Scientific Revolution* (New York: Harper and Row, 1980).

42. Robert Rosenblum, *Modern Painting and the Northern Romantic Tradition* (New York: Harper and Row, 1975); F. D. Klingender, *Art and the Industrial Revolution*, ed. and rev. Arthur Elton (New York: Shocken Books, 1970); Roger B. Stein, *John Ruskin and Aesthetic Thought in America, 1840–1900* (Cambridge: Harvard University Press, 1967).

43. Barbara Novak, *Nature and Culture: American Landscape and Painting, 1825–1875* (New York: Oxford University Press, 1980); Anne Hyde, *An American*

*Vision: Far Western Landscape and National Culture, 1820–1920* (New York: New York University Press, 1990); and Stephen Daniels, *Fields of Vision: Landscape Imagery and National Identity in England and the United States* (Princeton: Princeton University Press, 1993).

44. This attitude reflected a central dilemma among American elites concerned with their nation's cultural advancement. Conscious of their status as provincials in the shadow of Europe, they searched for something in America that would confirm their worth and make a unique contribution to Western culture. Being trained in the romantic tradition, they naturally latched on to the wild American landscape and the "noble savage" they assumed dwelled there. From John Filson's idealization of Daniel Boone to James Fenimore Cooper's Leatherstocking to Kit Carson, Deadwood Dick, and Buffalo Bill (heroes of the Beadle dime novels), the fictional western hero represented a middle ground between civilization and wilderness, a fusion of European-inspired notions of behavior with the supposed purity of the "natural man." The majority of Americans, however, thought of nature primarily as a force to be overcome. Even those who found inspiration there were ambivalent. As Thomas Cole wrote, "Man may seek such scenes and find pleasure in the discovery, but there is a mysterious fear [that] comes over him and hurries him away. The sublime features of nature are too severe for a lone man to look upon and be happy." Like Cooper's Leatherstocking, who consistently lacks sufficient cultivation and social prestige to win the hand of the fair maiden, Americans felt at a certain disadvantage in the refined world of high art. The ambiguous attitude toward wilderness reflected the uncertainty these artists felt concerning their own contribution to art: wilderness was indeed sublime and inspiring, but it was not enough to sustain them. Ultimately civilization was the superior force. Cole quoted in Nash, *Wilderness and the American Mind*, 79.

45. Ibid., 81; first published in the *American Monthly Magazine* 1 (1836): 4–5. Americans, like their European counterparts, created the landscape art of

the nineteenth century while they were engaged in rapid territorial expansion, an expansion that was based on the forcible conquest of the land, the subjugation of its native occupants, and economic exploitation of its natural resources. A particularly significant aspect of nineteenth-century landscape art was its avoidance of this reality. While popular works like Fanny Palmer's "Across the Continent" or William Gast's "American Progress" acknowledged American expansionism in celebratory terms of manifest destiny, most fine art painting depicted a pristine wilderness environment, in which humans, if present at all, were minute figures, standing still in reverential contemplation of the landscape.

This remarkable dichotomy was not unique to nineteenth-century America. The European traditions on which American artists drew exhibited parallel characteristics. The eighteenth-century British landscapes of Thomas Gainsborough, painted in an era of rapid change in the English countryside, ignore the effects of rural enclosures, in which small landowners and tenants were forced from the land, to portray instead an idealized image of quaint village scenes and bucolic pastoral landscapes. See Ann Bermingham, *Landscape and Ideology: The English Rustic Tradition, 1740–1860* (Berkeley, Los Angeles, and London: University of California Press, 1986). On the relationship of nineteenth-century American landscape art to territorial expansion, see Albert Boime, *The Magisterial Gaze: Manifest Destiny and American Landscape Painting, 1830–1865* (Washington, D.C.: Smithsonian Institution Press, 1991).

46. William H. Goetzmann, *Exploration and Empire: The Explorer and the Scientist in the Winning of the American West* (New York: Alfred A. Knopf, 1966); Weston Naef and James N. Woods, *The Era of Exploration: The Rise of Landscape Photography in the American West, 1860–1885* (Buffalo: Albright-Knox Art Gallery, and New York: Metropolitan Museum of Art, 1975); Karen Current and Richard Current, *Photography and the Old West* (New York: Harry N. Abrams, 1978); Max Kozloff, "The Box in the Wilderness," in Kozloff, *Photography and Fascination* (Danbury, N.H.: Addison

House, 1979), 60–75; Robert Cahn and Robert Glenn Ketchum, *American Photographers and the National Parks* (New York: Viking Press, 1981); Estelle Jussim and Elizabeth Lindquist-Cock, *Landscape as Photograph* (New Haven: Yale University Press, 1985); Martha Sandweiss, ed., *Photography in Nineteenth-Century America* (Fort Worth: Amon Carter Museum, 1991).

47. Nathaniel P. Langford, "The Wonders of the Yellowstone," *Scribner's Monthly* 2 (May 1871): 1–17, and 2 (June 1871): 113–128; Peter Bacon Hales, *William Henry Jackson and the Transformation of the American Landscape* (Philadelphia: Temple University Press, 1988); Peter Palmquist, *Carleton E. Watkins: Photographer of the American West* (Albuquerque: University of New Mexico Press, 1982).

48. In addition to the works cited above, see Nancy K. Anderson and Linda S. Ferber, *Albert Bierstadt: Art and Enterprise* (New York: Brooklyn Museum, 1990).

49. "Conversations," 232–237.

50. Six of Aunt Beth's letters to AA are collected in cf: Adams family, 1920–1923, AACCP; AA's letters to her are not in the archive.

51. "Conversations," 232–233; quotation on 232.

52. Ibid.; quotation on 233.

53. Ibid., 236.

54. AA to Charles Adams, June 30, 1922; cf: Adams family, AACCP; *Letters*, 9–12.

55. CA to AA, July 5, 1922, *Letters*, 13–15.

56. Nancy Newhall relates a story supporting this picture of Ansel's father. In her interviews with Charles Adams, he recalled a walk that he and Ansel took in which they discussed Ansel's future. Ansel was uncertain about his musical career and worried about the expense of a musical education. Charles recalled telling him to take twenty-five years if necessary to find out what he wanted to do. "He was not going to allow this strange and gifted son of his to be caged by business," Newhall wrote, "as he had seen many others of great promise be—and as, indeed, he himself had been.

Ansel was fully aware of what this generous attitude implied for his family's now-limited means and for his father." Newhall, *Eloquent Light*, 33.

57. Ibid.

58. "Conversations," 1, 4–5; Newhall, *Eloquent Light*, 34–36; *Autobiography*, 17–18; Ansel Adams to Virginia Best, March 1, 1922; quoted in Newhall, *Eloquent Light*, 36.

59. "Conversations," 227–228 (Virginia was also interviewed briefly in the Bancroft oral history).

60. Virginia Adams, interview with the author, April 29, 1985.

61. AA to Virginia Best, September 5, 1921, *Letters*, 9.

62. AA to Virginia Best, July 17, 1922, *Letters*, 17.

63. He had just the day before received his father's encouraging reply to his long letter opening up a more intimate dialogue and expressing his new-found sense of maturity and moral responsibility. Now he decided the time was ripe. In fact, it is possible that his first letter constituted a pre-amble to this, establishing his moral virtue before bringing up the subject of his budding romance.

64. AA to Charles Adams, July 7, 1922, *Letters*, 16. Interestingly, Ansel compared Virginia to his mother, toward whom he was decidedly ambivalent throughout his life. It appears that he intended the remark both as a form of high praise for Virginia and as an indication that his loyalty to his mother would not now decline.

65. AA to Virginia Best, September 28, 1923, *Letters*, 17–19.

66. On both of these early assignments, see *Autobiography*, 159–161, and "Conversations," 125.

67. See Helen M. LeConte, "Reminiscences of LeConte Family Outings, The Sierra Club, and Ansel Adams," interview conducted by Ruth Teiser and Catherine Harroun, Sierra Club History Committee, 1977, Bancroft Library, 9–13, 64–70. See also *Autobiography*, 148–149; Newhall, *Eloquent Light*, 42; and "Conversations," 266. Adams contributed two photographs from his Kings River trip to the *Sierra Club Bulletin*; see *SCB* XII, no. 3

(1926): facing 228, p. 237. He also had an unexpected windfall on meeting "a big pack train with a lot of rich New York bankers." They commissioned Adams to create a portfolio of his best photographs of the region and to send them copies. The $750 fee they offered seemed like a godsend to Adams, but he found that putting the portfolio together was more expensive than he had imagined. "It probably cost me $710 to do it"; "Conversations," 226.

68. AA to Virginia Best, [n.d., 1925?]; quoted in Newhall, *Eloquent Light*, 42–43.

69. This description of Adams's working technique of the time is based on Ansel Adams, untitled manuscript, n.d.; quoted in Newhall, *Eloquent Light*, 43.

70. AA to Virginia Best, September 30, 1925, *Letters*, 27–29.

71. Ibid.

72. AA to Virginia Best, October 20, 1924, *Letters*, 20–22. Newhall, *Eloquent Light*, 44.

73. AA to Virginia Best, Sunday, August 3, 1925, *Letters*, 22. See also AA to Virginia Best, September 22, 1925, *Letters*, 23–24.

74. Edward Carpenter, *Toward Democracy* (Manchester, U.K.: Labour Press, 1896). On the rise of artistic and intellectual resistance to the city and the industrial economy, see Raymond Williams, *Culture and Society, 1780–1950* (London: Chatto & Windus, 1958), and *The Country and the City* (New York: Oxford University Press, 1973).

75. On English socialism and the back-to-nature movement, see Peter C. Gould, *Early Green Politics: Back to Nature, Back to the Land, and Socialism in Britain, 1880–1900* (Sussex: Harvester Press, and New York: St. Martin's Press, 1988); on Carpenter and Morris, see, esp. 15–28. Carpenter, *Co-operative Production, with References to the Experiment of LeClaire* (1886). The pamphlet contains the text of a lecture at the Hall of Science, Sheffield, March 1883.

76. Gould, *Early Green Politics*, 18–19; Carpenter, *Toward Democracy*; and Ed-

ward Carpenter, *My Days and Dreams* (London: G. Allen & Unwin, 1921), 52–58.

77. Adams did not personally emphasize Muir's influence on his thinking and did not care for the frequent comparisons made by others between his work and that of Muir. According to Mary Alinder, his assistant and the editor of his autobiography, Adams considered Muir's prose excessively ornate and felt that it did not capture the true spirit of the Sierra. Despite these objections, it is clear that as a member of the Sierra Club and a lover of California's wild country, Adams could not help but be influenced by Muir.

78. John Muir, *The Story of My Boyhood and Youth* (Boston: Houghton Mifflin, 1913); Frederick Turner, *Rediscovering America: John Muir in His Time and Ours* (New York: Viking, 1985).

79. Quoted in a review by William Colby, *SCB* 12 (1925): 201–204; quotation on 204.

80. Bayard Taylor, *Eldorado, or Adventures in the Path of Empire*, 2 vols. (New York: G. P. Putnam's Sons, 1850). See also Robert Kelly, *Gold versus Grain: The Hydraulic Mining Controversy in California's Sacramento Valley* (Glendale: Arthur H. Clark, 1959).

81. Starr, *Americans and the California Dream*, 172–175; Henry David Thoreau, *The Journal of Henry D. Thoreau*, 14 vols. (Boston: Houghton Mifflin, 1949), 10: 89–90.

82. Holway Jones, *John Muir and the Sierra Club: The Battle for Yosemite* (San Francisco: Sierra Club, 1965); Alfred Runte, *National Parks: The American Experience*, rev. ed. (Lincoln: University of Nebraska Press, 1987); Michael Cohen, *The History of the Sierra Club, 1892–1970* (San Francisco: Sierra Club Books, 1988).

83. Jones, *John Muir and the Sierra Club*, 7–11; Cohen, *History of the Sierra Club*, 8–10; *Articles of Association, By-Laws, and List of Members* (San Francisco: Sierra Club, 1892).

84. John Muir, *Our National Parks* (Boston: Houghton Mifflin, 1901), 1.

85. "Conversations," 594. See also "The High Trip of 1923," *SCB* 12 (1924): 21–27. Included is Adams's photograph, *Pate Valley, Tuolumne Canyon*, facing p. 24.

86. Jessie M. Whitehead, "With the Sierra Club in 1927," *SCB* 13 (1928): 10–16. This annual includes eleven photographs by Adams. See also Jules M. Eichorn, "Mountaineering and Music: Ansel Adams, Norman Clyde, and Pioneering Sierra Club Climbing," an interview conducted by John Schagen, 1982, Sierra Club History Committee, 1985, Bancroft Library, 2–3, 22–23.

87. *Autobiography*, 32–37; Adams, Foreword to Cedric Wright, *Words of the Earth* (San Francisco: Sierra Club, 1960). Cedric's father, George Wright, had been Charles Adams's attorney, but they had had a falling out after the disaster of the Clausen Chemical Company, the venture in which Wright and Ansel's uncle, Ansel Easton, had apparently betrayed Charles. Despite the animosity of their parents, Cedric and Ansel became good friends.

88. Cedric Wright, "Trail Song, Giant Forest and Vicinity: 1927," *SCB* 13 (1928): 20–23.

CHAPTER 3

1. *Autobiography*, 34, 81–82; Newhall, *Eloquent Light*, 42, 47.

2. Monroe E. Deutsch, *Albert Bender* (San Francisco: Grabhorn Press, 1941); Monroe E. Deutsch, *Saint Albert of San Francisco* (San Francisco: Carroll T. Harris, 1956); Oscar Lewis, *To Remember Albert Bender* (San Francisco: Grabhorn and Hoyem, 1973).

3. *Autobiography*, 81.

4. Ibid., 82.

5. Adams, *The Portfolios of Ansel Adams* (Boston: New York Graphic Society, 1977).

6. Rosalie Stern was a prime example of the city's active and civic-minded Jewish elite. In part because of the city's rapid growth and cosmopolitan character, San Francisco's Jewish pioneers were able to begin on a rela-

tively equal footing and to achieve economic power as the city grew. In addition to Levi Strauss, such early community leaders included Anthony Zellerbach, the wholesale paper manufacturer and dealer; Aaron Fleishacker, who had the good fortune to have made loans to the developers of the Comstock mines in Nevada; and Adolph Sutro, who devised a new method of extracting silver from Comstock mine ores whereby a network of tunnels was engineered to provide greater access to deep-lying silver, and who used his huge profits to build his famous Sutro Baths near Land's End in San Francisco. Intermarriage among local families led to an interconnected and tight-knit community. Bender's membership in this community made his role as patron to artists like Adams particularly effective. On the history of San Francisco's Jewish community, see Irena Narell, *Our City: The Jews of San Francisco* (San Diego: Howell-North Books, 1981). The papers of Rosalie Stern are collected at the Judah Magnes Center for Western Jewish History, Berkeley.

7. *Autobiography*, 84.

8. Franklin Walker, *San Francisco's Literary Frontier* (New York: Alfred A. Knopf, 1939), 60–63.

9. Starr, *Americans and the California Dream*; Walker, *San Francisco's Literary Frontier*; Lawrence Ferlingetti and Nancy J. Peters, *Literary San Francisco: A Pictorial History from Its Beginnings to the Present Day* (San Francisco: City Lights Books, 1980); Jeanne Van Nostrand, *The First Hundred Years of Painting in California, 1775–1885* (San Francisco: J. Howell, 1980); Frank Marryat, *Mountains and Molehills, or Recollections of a Burnt Journal* (New York: Harper and Brothers, 1855).

10. Starr, *Americans and the California Dream*; Ferlingetti and Peters, *Literary San Francisco*; Henry F. May, *The End of American Innocence: A Study of the First Years of Our Own Time, 1912–1917* (New York: Alfred A. Knopf, 1959).

11. Jack London, *The Call of the Wild* (New York: Grosset & Dunlap, 1903); Frank Norris, *McTeague: A Story of San Francisco* (New York: Grosset & Dunlap, 1899).

12. *Autobiography*, 85–86.

13. Ibid., 86. Adams expressed this opinion of Jeffers on other occasions as well; see, e.g., Adams, "Give Nature Time," Commencement Address, Occidental College, Los Angeles, California, June 11, 1967, unpublished manuscript, activity files: Speeches, AACCP. James Karman, *Robinson Jeffers: Poet of California* (San Francisco: Chronicle Books, 1987); William Everson, *The Excesses of God: Robinson Jeffers as a Religious Figure* (Stanford: Stanford University Press, 1988); William Everson, *Robinson Jeffers: Fragments of an Older Fury* (Berkeley: Oyez, 1968); Lawrence Clark Powell, *Robinson Jeffers, the Man and His Work* (Pasadena: San Pasqual Press, 1940).

14. Jeffers quoted in Karman, *Jeffers*, 53.

15. On the history and culture of New Mexico, see Marc Simmons, *New Mexico: A Bicentennial History* (New York: W. W. Norton, 1977); Erlinda Gonzalez-Berry, *Pasó por Aquí: Critical Essays on the New Mexican Literary Tradition, 1542–1988* (Albuquerque: University of New Mexico Press, 1989); Warta Neigle, *Santa Fe and Taos: The Writer's Era, 1916–1941* (Santa Fe: Ancient City Press, 1982).

16. May, *End of American Innocence*; Frederick Hoffman, *The Twenties: American Writing in the Postwar Decade* (New York: Collier Books, 1962); Malcolm Cowley, *Exile's Return*, rev. ed. (1934; New York: Viking, 1951); Robert Goldwater, *Primitivism in Art*, rev. ed. (New York: Vintage Books, 1967); Sharyn Rohlfsen Udall, *Modernist Painting in New Mexico, 1913–1935* (Albuquerque: University of New Mexico Press, 1984).

17. *Autobiography*, 92.

18. "Conversations," 160.

19. "Conversations," 163; *Autobiography*, 92.

20. Newhall, *Eloquent Light*, 44.

21. AA to Virginia Best, March 11, 1927; *Letters*, 29–30.

22. Ibid.

23. Adams, for example, devoted nearly an entire chapter of his autobiography to the subject; see chapter 6, "Monolith," in *Autobiography*, 69–79.

24. *Examples*, 2–5; *Autobiography*, 76.

25. *Autobiography*, 76. "Monolith" was first published in the *Stockton Record* on April 16, 1927, just a few days after Adams made the photograph. Newhall, *Eloquent Light*, 44.

26. Adams, *Camera and Lens* (rev. ed.; Boston: New York Graphic Society, 1976), 14–22.

27. AA to Virginia Best, April 25, 1927, *Letters*, 30–32.

28. AA to Virginia Best, December 21, 1927, *Letters*, 34.

29. *San Francisco Chronicle*, January 9, 1928; *Autobiography*, 100–101.

30. Charles Adams to AA, January 30, 1928, *Letters*, 34–36. His father's dreams and sacrifices were both a gift and a burden to Ansel. Through them, he was free to pursue a life dedicated to art. Although his father gave him this freedom, Ansel's sense of responsibility toward that gift shackled him throughout his life. As Adams channeled his intense energy into his photographic career, he maintained the exalted ideal of the creative life that his father encouraged. Yet he was also very much a driven business-man, carrying on commercial assignments at a breakneck pace. The influ-ence of his father's own disastrous career was clearly important. However much he wanted a life devoted to art, he did not want a life of bohemian poverty. He was unabashedly concerned with making a good living from his photography, yet the conflict generated by this dual orientation to creative idealism and commercial success would continue to be a crucial factor in his life and the development of his art.

31. *Autobiography*, 87–89. Newhall, *Eloquent Light*, 47–49; the quotation is in Newhall, 48. Adams, in his oral history, described his first impression of Austin as "rather grim, [but] very nice, to me at least"; see "Conversa-tions," 162.

32. Mary Austin, *Earth Horizon: An Autobiography* (Boston: Houghton Mifflin, 1932), 51; Mary Austin, *Experiences Facing Death* (Indianapolis: Bobbs-Merrill, 1931), 25–26; Esther Lanigan Stineman, *Mary Austin: Song of a Maverick* (New Haven: Yale University Press, 1989), 17–18; Peggy Pond

Church, *Wind's Trail: The Early Life of Mary Austin* (Santa Fe: Museum of New Mexico Press, 1990); Augusta Fink, *I-Mary, a Biography of Mary Austin* (Tucson: University of Arizona Press, 1983).

33. It could be argued that the economic colonialism that made these "primitive" cultures available to European and American artists had its analog in a "cultural colonialism" that mined foreign societies for artistic raw materials, extracting the cultural forms from their social context and turning them into refined morsels for foreign consumption. Yet most artists at the time did not view the process in this way. To them it was a complex exchange in which the "conquered" often exerted a profound power on the "dominant," appropriating culture. William Carlos Williams addressed this point in his extended essay, *In the American Grain* (New York: A. & C. Boni, 1925), 39–41: "No, we are not Indians but we are men of their world. The blood means nothing; the spirit, the ghost of the land moves in the blood, moves the blood. It is we who ran to the shore naked, who cried, 'Heavenly Man!' These are the inhabitants of our souls, our murdered souls. . . . Fierce and implacable we kill them but their souls dominate us. Our men, our blood, but their spirit is master. It enters us, it defeats us, it imposes itself. We are moderns—madmen at Paris—all lacking in a ground sense of cleanliness. It is the Caribs leaping out, facing the arcebuses. . . . Their comrades bleeding, dead. . . . If men inherit souls this is the color of mine."

The English poet and novelist D. H. Lawrence agreed. "At present," he wrote in *Studies in Classic American Literature* (New York: T. Seltzer, 1923), 36, "the demon of the place and the unappeased ghosts of dead Indians act within the unconscious or under-conscious soul of the white American, causing the great American grouch, the Orestes-like frenzy of restlessness in the Yankee soul, the inner malaise which amounts almost to madness, sometimes." That restlessness could be seen in many of those who came to New Mexico looking for meaning in their lives.

Austin was one of those who found in Native American culture a conduit to the mysterious and timeless forces of the earth. Yet her exploration of Indian cultures and the landscape they inhabited was not simply a romantic projection of her own artistic and emotional needs onto a conquered people and territory. Hers was an art that combined a sense of deep spiritual connection with her subject and a precise descriptive realism. Austin was a transitional figure in western American literature, maintaining a romantic idealism and often anthropomorphized image of nature, yet working with the spare linguistic rigor of the imagists and the scientific methods of anthropology.

34. AA to Virginia Best, 1927; quoted in Newhall, *Eloquent Light*, 49.

35. AA to MA, April 22, 1928, and June 13, 1928, Mary Austin Papers, Henry H. Huntington Library, San Marino, California (hereafter cited as MAHEH).

36. Mary Austin to AA, June 17, 1928, cf: Mary Austin, AACCP.

37. MA to AA, July 5, 1928, cf: Mary Austin, AACCP.

38. AA to MA, January 31, 1929, MAHEH; MA to AA, February 23, 1929, cf: Mary Austin, AACCP.

39. "Conversations," 168–169; see also *Autobiography*, 89.

40. Albert Bender to Mary Austin, March 23, 1929, MAHEH.

41. Mabel apparently chose to spell her name Luhan to assist non-Spanish speakers in their pronunciation of it.

42. Adams to "Ma, Pa, Aunt Mary," April 10, 1929, cf: Adams Family, AACCP. See also VA to Adams family, March 28, 1929; and AA to Adams family, March 30 and March 31, 1929, all cf: Adams family, AACCP.

43. AA to Charles Adams, April 4, 1929, cf: Adams family, AACCP; *Letters*, 39. AA to Albert Bender, [n.d., spring 1929], cf: Albert Bender, AACCP; *Letters*, 40.

44. Mabel Dodge Luhan, *Movers and Shakers*, vol. 3 of *Intimate Memoirs* (New York: Harcourt, Brace, 1936); Mable Dodge Luhan, *Edge of Taos Desert: An*

*Escape to Reality*, vol. 4 of *Intimate Memoirs* (New York: Harcourt, Brace, 1937); Lois Palken Rudnick, *Mabel Dodge Luhan: New Woman, New Worlds* (Albuquerque: University of New Mexico Press, 1984).

45. Arrell Gibson, *The Santa Fe and Taos Colonies: Age of the Muses, 1890–1942* (Norman: University of Oklahoma Press, 1983), 179–224; Dodge quoted on 219.

46. *Autobiography*, 92.

47. Mabel Dodge Luhan, *Lorenzo in Taos* (New York: Alfred A. Knopf, 1935). Although Lawrence stayed only a few months, it was a productive and relatively content period for him. The heroine of his novel *St. Mawr*, set in London and Taos, is a rich American woman, Lou Witt, unhappily married to a vapid English baronet. She soon dumps her husband and moves to Taos where, withdrawn from the world of society and false ideals, she experiences a vitalistic regeneration in contact with the primal forces of the earth.

Luhan was ultimately disappointed in her object. "Perhaps I had dimly and intuitively expected Lorenzo to be the Transformer for me and had summoned him for that purpose from across the continents. Well, he had come. He had vivified my life and possibly I had done as much for his. But apparently nothing significant had come of it beyond the momentary illuminations that flashed between us and that always ended in the fretful and frustrated hours of bewilderment" (265). Also of note is the book by another of Lawrence's female admirers who was part of the Taos community, Dorothy Brett, *Lawrence and Brett, A Friendship* (Philadelphia: J. B. Lippincott, 1933). *Lorenzo in Taos* was addressed to Robinson Jeffers, whom Luhan was trying to lure to Taos in the mid-1930s. She eventually succeeded, but the visit caused such jealousy and hostility that Jeffers's wife, Una, suffered a nervous breakdown.

The combination of petty intrigue and serious creative goals was typical of Taos and Santa Fe, of Carmel, and of most bohemian colonies of the time. The fragility of the psyches of these moderns tends to cast doubts on

the validity of their ideas, their frantic search for truth a symptom of a malaise brought on by their own rootlessness, their quest to continually "make it new" destroying the possibility of establishing the rootedness they found so appealing in native cultures.

48. Robert Henri, *The Art Spirit*, 5th ed. (Philadelphia: J. B. Lippincott, 1930); Steven Watson, *Strange Bedfellows: The First American Avant-Garde* (New York: Abbeville Press, 1991); Edward Abrahams, *The Lyric Left: Randolph Bourne, Alfred Stieglitz, and the Origins of Cultural Radicalism in America* (Charlottesville: University Press of Virginia, 1986).

49. Jonathan Green, ed., *Camera Work: A Critical Anthology* (Millerton, N.Y.: Aperture, 1973).

50. Barbara Haskell, "Transcendental Realism in the Stieglitz Circle: The Expressionist Landscapes of Arthur Dove, Marsden Hartley, John Marin, and Georgia O'Keeffe," in *The Expressionist Landscape*, ed. Ruth Stevens Appelhof (Birmingham: Birmingham Museum of Art, 1987), 17–25.

51. AA to VA, August [n.d.] 1930, *Letters*, 46.

52. Ibid.

53. John Marin, interview with Nancy Newhall, 1945; quoted in Newhall, *Eloquent Light*, 60.

54. William Innes Homer, *Alfred Stieglitz and the American Avant-Garde* (Boston: New York Graphic Society, 1977); Waldo Frank et al., *America and Alfred Stieglitz: A Collection Portrait* (Garden City, N.Y.: Doubleday, Doran, 1934); Terence Pitts, *Photography in the American Grain: Discovering a Native American Aesthetic, 1923–1941* (Tucson: Center for Creative Photography, 1988).

55. Paul Strand, letter to the *New Republic* 55 (1928): 254.

56. Marion Randall Parsons, "The Twenty-Eighth Outing," *SCB* 15 (February 1930): 9–21.

57. MA to AA, August 30, 1929, and MA and AA, September 3, 1929; both cf: Mary Austin, AACCP.

58. MA to AA, September 9, 1929, cf: Mary Austin, AACCP. The Hispanic

arts book was put on hold following the unexpected death of Frank Applegate in 1931 and Yale University Press's decision that they could not take on the project for at least two to three years. Austin's death in 1934 put an end to the project and the several others she and Adams discussed in a general way. See MA to AA, February 14, 1931; March 13, 1931; and April 21, 1932; all cf: Mary Austin, AACCP.

59. MA to AA, September 18, 1929; MA to AA, September 9, 1929; cf: Mary Austin, AACCP.

60. MA to AA, April 9, 1930, cf: Mary Austin, AACCP.

61. *Autobiography*, 90.

62. Ansel Adams and Mary Austin, *Taos Pueblo* (San Francisco: Grabhorn Press, 1930), unpaginated.

63. Quoted in Newhall, *Eloquent Light*, 65.

64. MA to AA, January 2, 1931, cf: Mary Austin, AACCP.

65. MA to AA, January 13, 1931, cf: Mary Austin, AACCP.

66. AA to Albert Bender, January 15, 1931, *Letters*, 47.

67. Interview with Paul Strand, in Paul Hill and Thomas Cooper, eds., *Dialogue with Photography* (New York: Farrar, Straus and Giroux, 1979), 1–8. See also Sarah Greenough, *Paul Strand: An American Vision* (Washington, D.C.: National Gallery of Art, 1990); *Paul Strand: Essays on His Life and Work*, ed. Maren Stange (Millerton, N.Y.: Aperture, 1990); Paul Strand, *Paul Strand: A Retrospective Monograph*, 2 vols. (Millerton, N.Y.: Aperture, 1972).

68. AA to VA, August, 1930, *Letters*, 46. "Conversations," 56–57, 181; *Autobiography*, 109.

69. Quotation from Olive Adams, in Newhall, *Eloquent Light*, 62. Wassily Kandinsky, *Concerning the Spiritual in Art* (1912; New York: Wittenborn, 1955). The role of music as one of the aesthetic bases of modernist abstraction was also discussed in the pages of *Camera Work*.

70. *Autobiography*, 237–238; "Conversations," 69–72.

71. Weston interview with Nancy Newhall, 1950, quoted in Newhall, *Eloquent Light*, 68; *Autobiography*, 237; "Conversations," 70.

72. Adams, "Photography," *Fortnightly* (December 4, 1931): 25.

73. EW to AA, January 28, 1932, Edward Weston Archives, Center for Creative Photography (hereafter cited as EWACCP); *Letters*, 48–50. At the age of 13, Adams had disagreed with the idea that abstract forms necessarily had correlates in nature when he discussed similar issues with the curator at the Palace of Fine Arts exhibition in the Panama Pacific Exposition in 1915; it is interesting to speculate if his views had changed by this time; see "Conversations," 30.

74. Ansel Adams, "Photography," *Fortnightly* (November 6, 1931): 25; (December 4, 1931): 25; (December 18, 1931): 21–22; all reprinted in Beaumont Newhall and Amy Conger, eds., *The Edward Weston Omnibus: A Critical Anthology* (Salt Lake City: Peregrine Smith, 1984), 50–51. Adams, "An Exposition of Technique," *Camera Craft* 41 (January 1934): 19. Adams, "Landscape," *Camera Craft* 41 (February 1934): 72.

75. Edward Weston, "Statement" (1930), reprinted in Peter Bunnell, ed., *Edward Weston on Photography* (Salt Lake City: Peregrine Smith, 1983), 61.

76. Paul Strand, "Photography and the New God," reprinted in Alan Trachtenberg, ed., *Classic Essays on Photography* (New Haven: Yale University Press, 1980), 151.

77. Georgia O'Keeffe was reportedly inspired by Strand's closeup images to begin her own abstracting, bee's-eye flower views; see Milton Brown, "Cubist Realism: An American Style," *Marsyas* 3 (1943–1945): 155. See also Bram Dijkstra, *The Hieroglyphics of a New Speech: Cubism, Stieglitz, and the Early Poetry of William Carlos Williams* (Princeton: Princeton University Press, 1969); and John Pultz and Catherine B. Scallen, *Cubism and American Photography, 1910–1930* (Williamstown, Mass.: Sterling and Francine Clark Art Institute, 1981).

78. *SCB*, 14 (1929): facing p. 1.

79. *Examples*, 11. For an early reproduction of this image, see *SCB* 18 (February 1933): plate xiii, facing p. 47.

80. *Examples*, 30–31.

81. Ibid., 50.

CHAPTER 4

1. For an outline of Adams's finances in this period, see AA to Charles Adams, June 1, 1929, cf: Adams family, AACCP. Adams listed his income sources for the summer and fall, not including income from *Taos Pueblo*, as follows: Sierra Club, $150; Ahwahnee Hotel, $250; Yosemite Park and Curry Co., $275; Portraits, $250. These figures are indicative of the fact that Adams was beginning to develop a reasonably successful commercial career. The biggest savings Ansel and Virginia were able to achieve were in housing costs, since they lived on Ansel's parents' property in the studio Charles had built for them as a wedding gift.

2. Alfred Runte, *Yosemite: The Embattled Wilderness* (Lincoln: University of Nebraska Press, 1990), 145; visitation figure quoted on 143.

3. Ibid., 92–94.

4. Quoted in "Draft Report: Meeting of the Committee of Expert Advisors . . . April 24 and 25, 1930," File 201–11, Yosemite National Park Research Library.

5. *Autobiography*, 182–183.

6. Ibid.

7. Ibid. In his history of Yosemite National Park, Runte uses Adams as an example of well-intentioned environmentalists who nevertheless sometimes support "inappropriate" uses for the park (such as exclusive theatrical dinner parties); Runte, *Yosemite*, 187–189. Adams was indeed guilty of a certain double standard on this issue since he was a vocal advocate of reducing park concessions in general and making those that remained compatible with a wilderness experience. Yet both he and Virginia had a

strong sentimental attachment to the Bracebridge Dinner, both because of the association with their friends, the Spencers, and the outlet it provided for musical and theatrical fun. Had someone else been putting on the show each year, Adams probably would not have been so inconsistent on the subject.

8. AA to Donald Tresidder, November 1, 1929; Donald Tresidder to AA, November 18, 1929; both in the archives of the Yosemite Park and Curry Company, Yosemite National Park (hereafter cited as YPCCA).

9. Stephen Fox, *The Mirror Makers: A History of Twentieth-Century American Advertising* (New York: William Morrow, 1984); Michael Schudson, *Advertising: The Uneasy Profession* (New York: Basic Books, 1984). On advertising photography, see Robert Sobieszek, *The Art of Persuasion: A History of Advertising Photography* (New York: Harry N. Abrams, 1988).

10. On advertising, sports, and recreation in the 1920s, see Preston W. Slosson, *The Great Crusade and After, 1914–1928* (1930; New York: Quadrangle Books, 1971), 270–286, 345–371. This early example of social history provides a contemporary view of these topics. On the Sierra Club's orientation in these years, see Cohen, *History of the Sierra Club*, 73, 66–82; see also the oral histories at the Bancroft Library, University of California, Berkeley: Richard Leonard, "Mountaineer, Lawyer, Environmentalist," 7–9, 19, 21; William Siri, "Reflections on the Sierra Club, the Environment, and Mountaineering, 1950s–1970s," 13–14; and Joel Hildebrand, "Sierra Club Leader and Ski Mountaineer," Sierra Club Oral Histories, Bancroft Library, University of California, Berkeley.

11. Ansel Adams, "Ski-Experience," *SCB* 16 (1931): 44–45; see also reproductions following pp. 38 and 42.

12. David Brower, *For Earth's Sake: The Life and Times of David Brower* (Salt Lake City: Gibbs Smith, 1990), 27–29, 57–59, 187. Author interview with David Brower, July 13, 1989. David Brower, "David Brower, Environmental Activist, Publicist, and Prophet," an interview conducted by Susan

Schrepfer, 1974–1978, Regional Oral History Office, Bancroft Library, University of California, Berkeley. David Brower, "Far From the Madding Mules," *SCB* 20 (February 1935): 68–77.

13. AA to Parents [n.d., early March], 1933, cf: Adams family, AACCP.

14. Ibid.

15. Virginia Adams, in "Conversations," 329. See also *Autobiography*, 121.

16. "Conversations," 329. Another version of the story appears in *Autobiography*, 121.

17. *Autobiography*, 122. Andrea Gray, *Ansel Adams, An American Place, 1936* (Tucson: Center for Creative Photography, 1982), 13–14; "Conversations," 52, 328.

18. Homer, *Alfred Stieglitz*, 11–14; Alfred Stieglitz, "Pictorial Photography," *Scribner's Magazine* 26 (1899): 258. Ansel and Virginia made their way east from Chicago via Detroit to upstate New York, with stops in Buffalo, Niagara Falls, and Rochester, where they visited the huge facilities of the Eastman Kodak Company, later one of Adams's most important commercial clients. *Autobiography*, 122.

19. "Conversations," 329; *Autobiography*, 122.

20. Irene Herner de Larrea, *Diego Rivera's Mural at the Rockefeller Center* (Mexico City: Edicupes, 1990).

21. Virginia Adams to Adams family, March 29, 1933, cf: Adams family, AACCP.

22. Jacques [no further identification] to Charles Adams, April 17, 1933, cf: Adams family, AACCP.

23. *Autobiography*, 122; this account of the events of Adams's first visit to New York in his autobiography is a revised version of a piece, "Diogenes with a Camera," which Adams wrote circa 1935 and which was excerpted in Newhall, *Eloquent Light*, 83–85.

24. *Autobiography*, 123–124.

25. Ibid.

26. Ibid.

27. Ibid. Adams recalled that Stieglitz was particularly impressed with the copy of *Taos Pueblo* Adams showed him, remarking on the expressive quality of the photographs and the book's elegant design. AA to Andrea Gray, June 23, 1981, cited in Gray, *An American Place*, 14.

28. Albert Bender to AA, April 4, 1933, cf: Albert Bender, AACCP.

29. Carl Sandburg, *Steichen the Photographer* (New York: Harcourt Brace, 1929); Museum of Fine Arts, *Works on Paper: Edward Steichen, the Condé Nast Years* (Houston: Museum of Fine Arts, 1984). Homer, *Alfred Stieglitz*, 30–44.

30. *Autobiography*, 207.

31. This topic will be developed further in chap. 5.

32. AA to "Pa, Ma, and Aunt Mary," April 8, 1933, cf: Adams family, AACCP. In addition to the solo exhibition at the Delphic Studios, Adams placed his works in group exhibitions at the Albright Gallery in Buffalo, New York, and the Yale University Art Gallery in New Haven, Connecticut, in 1934.

33. Ibid.

34. Ansel Adams, "The Art of Edward Weston," *Creative Art* 12 (May 1933): 386–387.

35. Andrea Gray interview with Patricia English Farbman, March 1980; quoted in Gray, *American Place*, 14; see also "Conversations," 52, 328; *Autobiography*, 120–125.

36. AA to Alfred Stieglitz, June 22, 1933, ASAY; *Letters*, 50–52.

37. Ibid.

38. AS to AA, June 28, 1933, cf: Alfred Stieglitz, AACCP.

39. *SCB* 13 (1928) and 14 (1929).

40. See Cedric Wright photographs, Sierra Club Archives [hereafter cited as SCA], Pictorial Collection, Bancroft Library.

41. *Autobiography*, 101; VA to AA, August 2, 1933, *Letters*, 54; Ansel was already on his way down to the valley when this letter, telling him of Michael's successful birth, was written. See also AA to H. C. Best, August 3, 1933;

VA to Olive Adams, August 1, 1933; and VA to Adams family, August 2, 1933, all cf: Adams family, AACCP.

42. "She Won—or Maybe He Did; Anyway, He Got the Job," *San Francisco Chronicle*; quoted in *Autobiography*, 145–146.

43. Author interview with Virginia Adams, April 28, 1985; *Autobiography*, 101–104; author interview with James and Mary Alinder, July 17, 1989.

44. AA to AS, July 6, 1933, ASAY.

45. AS to AA, July 29, 1933, cf: Alfred Stieglitz, AACCP.

46. AA to AS, October 9, 1933, ASAY. Adams wrote at least two drafts of this letter. Earlier drafts can be found in cf: Alfred Stieglitz, AACCP.

47. AA to AS, October 9, 1933, ASAY.

48. Ibid.

49. Ibid.

50. Frank et al., *America and Alfred Stieglitz*.

51. AS to AA, October 20, 1993, cf: Alfred Stieglitz, AACCP.

52. Ibid.

53. AA to AS, October 23, 1933, ASAY; *Letters*, 64–66.

54. Ibid.

55. William Stott, *Documentary Expression and Thirties America* (New York: Oxford University Press, 1973), 65–73, 103, 119–120; Cowley, *Exile's Return*; Malcolm Cowley, *The Dream of the Golden Mountains: Remembering the 1930s* (New York: Viking, 1980), 1–7, passim; Warren Susman, "The Thirties," in *The Development of an American Culture*, ed. Stanley Coben and Lorman Ratner, 215–260 (Englewood Cliffs, N.J.: Prentice-Hall, 1970); Warren Susman, ed., *Culture and Commitment, 1929–1945* (New York: George Braziller, 1973).

56. Hoffman, *The Twenties*, 21–66; Udall, *Modernist Painting in New Mexico*, xv–xix, 1–16, 203–208. For a more inclusive study of the avant-garde and the culture of modernism, see Marshall Berman, *All That's Solid Melts into Air: The Experience of Modernity* (New York: Viking, 1988). For a critique

of modernism's iconoclasm, see Daniel Bell, *The Cultural Contradictions of Capitalism* (New York: Basic Books, 1976).

57. On the New Deal art programs, see Richard P. McKenzie, *The New Deal for Artists* (Princeton: Princeton University Press, 1973); Francis V. O'Connor, ed., *Art for the Millions: Essays from the 1930s by Artists and Administrators of the WPA Federal Art Project* (Boston: New York Graphic Society, 1973); Francis V. O'Connor, ed., *The New Deal Art Projects: An Anthology of Memoirs* (Washington, D.C.: Smithsonian Institution Press, 1972); Marlene Park and Gerald E. Markowitz, *Democratic Vistas: Post Office Murals and Public Art in the New Deal* (Philadelphia: Temple University Press, 1984); and Karal Ann Marling, *Wall to Wall America: A Cultural History of Post Office Murals in the Great Depression* (Minneapolis: University of Minnesota Press, 1982).

58. Cahill quoted in O'Connor, ed., *Art for the Millions*, 16–29; quotations on 17–18.

59. Stuart Davis, "Abstract Painting Today," in O'Connor, ed., *Art for the Millions*, 126–127.

60. Karin Becker Ohrn, *Dorothea Lange and the Documentary Tradition* (Baton Rouge: Louisiana State University Press, 1980), 22–24.

61. Dorothea Lange interview with Nat Herz, "Dorothea Lange in Perspective," *Infinity* 12 (April 1963): 5–11; quotation on 9–10.

62. Adams, "Unpublished Statement of Group f/64 (1934?);" quoted in Newhall, *Eloquent Light*, 82.

CHAPTER 5

1. For a general overview of documentary photography see Newhall, *History of Photography*, 85–115, 130–136, 217–225, 235–266; Rosenblum, *World History of Photography*, 155–199, 341–383, 461–489; and Maren Stange, *Symbols of Ideal Life: Social Documentary Photography in America, 1890–1950* (New York: Cambridge University Press, 1989).

2. John Grierson, quoted in Stott, *Documentary Expression*, 9; the review originally appeared in the *New York Sun*.

3. Henry Luce, "Prospectus," reprinted in *The Best of Life* (New York: Time Life Books, 1973). These magazines and others that preceded them were made possible by technical advances in halftone reproduction that improved quality and reduced cost. For a history of photomechanical reproduction and its impact, see William M. Ivans, Jr., *Prints and Visual Communication* (Cambridge: Harvard University Press, 1953).

4. Agee, quoted in Stott, *Documentary Expression*, 76.

5. Lewis Hine, "Social Photography, How the Camera May Help in the Social Uplift;" reprinted in Alan Trachtenberg, ed., *Classic Essays on Photography* (New Haven: Yale University Press, 1980), 111. Hine here refers to his famous photograph, *Newsboys, Brooklyn Bridge*, made in 1908.

6. Dorothea Lange, "Dorothea Lange: The Making of a Documentary Photographer," an interview by Suzanne Riesse, Regional Oral History Office, Bancroft Library, University of California, Berkeley, 1968, 181.

7. For expression of these views, see the letters cited below. In addition, see Adams's correspondence with Beaumont and Nancy Newhall, AACCP and NACCP. Adams's extensive correspondence with the Newhalls (often several multipage letters per week) provides an excellent and candid expression of his views on these and many other photographic topics. See also AA to Dave McAlpin, February 14, 1939, cf: David McAlpin, AACCP. On the history of propaganda, see Jacques Ellul, *Propaganda: The Formation of Men's Attitudes* (New York: Alfred A. Knopf, 1965); and Oliver Thompson, *Mass Persuasion in History: An Historical Analysis of the Development of Propaganda Techniques* (Edinburgh: Paul Harris, 1977). For more on these topics in the context of the depression, see Richard Pells, *Radical Visions and American Dreams: Culture and Social Thought in the Depression Years* (1973; Middletown, Conn.: Wesleyan University Press, 1984), 263–268, 322, 325; Stott, *Documentary Expression*, 75–91.

8. See, for one of many examples, AA to AS, May 20, 1934, ASAY.

9. Quoted in Nancy Newhall, "Controversy and the Creative Concepts," *Aperture* 2 (July 1953): 43.

10. AA to EW, November 29, 1934, EWACCP.

11. EW to AA, December 3, 1934, cf: Edward Weston, AACCP.

12. Hilton Kramer, "Edward Weston's Privy and the Mexican Revolution," *New York Times*, May 7, 1972; Nancy Newhall, ed., *The Daybooks of Edward Weston*, vol. 1 (Millerton, N.Y.: Aperture, 1961); Amy Conger, *Edward Weston in Mexico: 1923–1926* (Albuquerque: University of New Mexico Press, 1983); and Amy Conger, "Edward Weston's Early Photography, 1903–1926," Ph.D. dissertation, University of New Mexico, 1982.

13. Paul Strand to AA, October 14, 1933, cf: Paul Strand, AACCP; *Letters*, 61–62. Adams had written to Strand the previous month requesting a Strand exhibition for his new San Francisco gallery. Strand turned him down, as Stieglitz had, because he felt that exhibitions were a sham, "free entertainment" for a public that offered no real support for the artists who create them.

14. Ibid. Strand began working with motion pictures during the First World War; in 1921, he collaborated with Charles Sheeler on *Manhatta*.

15. Greenough, *Paul Strand*; Calvin Tomkins, Introduction, in *Paul Strand: Sixty Years of Photographs* (Millerton, N.Y.: Aperture, 1976).

16. Willard Van Dyke, quoted in John Paul Edwards, "Group f/64," *Camera Craft* 42 (March 1935): 107–113.

17. Willard Van Dyke, "The Photographs of Dorothea Lange," *Camera Craft* 41 (October 1934): 461–467; quoted in Newhall, *Eloquent Light*, 82; Ohrn, *Dorothea Lange*, 40–48.

18. Ansel Adams, "Exposition of Technique," *Camera Craft* 41 (January 1934): 19–20.

19. Ansel Adams, "Landscape," *Camera Craft* 41 (February 1934): 72–74.

20. Ibid., 74; Adams would develop the zone system as a teaching tool in 1940 while an instructor at the Art Center School of Design in Los Angeles.

21. Ansel Adams, "Portraiture," *Camera Craft* 41 (April 1934): 118.

22. The quotation was attributed to Dixon by Rondal Partridge, the son of Imogen Cunningham and assistant at various times to both Adams and Lange. It appears in Ohrn, *Dorothea Lange*, 141.

23. Ansel Adams, "Applied Photography," *Camera Craft* 41 (May 1934): 67–68.

24. Adams, "The New Photography," in *Modern Photography, 1934–1935* (London: Studio Publications, 1935), 9–18.

25. C. P. Holme to AA, April 20, 1934; quoted in Newhall, *Eloquent Light*, 108; AA to C. P. Holme, May 5, 1934, ibid., 108–109.

26. Adams, *Making a Photograph: An Introduction to Photography* (London: The Studio; New York: Studio Publications, 1935); Newhall, *Eloquent Light*, 111; Adams, *Basic Photo*, 5 vols. (New York: Morgan and Lester, 1948–1956).

27. AS to AA, May 13, 1935, cf: Alfred Stieglitz, AACCP.

28. AA to AS, May 16, 1935, ASAY.

29. Paul S. Taylor and Norman L. Gold, "San Francisco and the General Strike," *Survey Graphic* 23 (September 1934): 405–411. Bruce Nelson, *Workers on the Waterfront: Seamen, Longshoremen, and Unionism in the 1930s* (Urbana: University of Illinois Press, 1988).

30. Ibid.

31. Frank Cross, "Revolution in Colorado," *Nation* 138 (February 7, 1934): 152–154. William E. Leuchtenburg, *Franklin D. Roosevelt and the New Deal, 1932–1940* (New York: Harper and Row, 1963), 95.

32. Charles Adams to AA, July 21, 1934, cf: Adams family, AACCP.

33. AA to "Ma, Pa, Aunt Mary," July 21, 1934, cf: Adams family 1934–1935, AACCP. Ansel and Virginia were on the High Trip, and Michael was staying with his grandparents in San Francisco.

34. For Lange's account of the offer from the Communist party and her reluctance to join, see Lange, "Making of a Documentary Photographer," 151.

35. *Autobiography*, 197. On the Communist party of the United States and its attitudes toward art, see Lawrence H. Schwartz, *Marxism and Culture: The*

*CPUSA and Aesthetics in the 1930s* (Port Washington, N.Y.: Kennikat Press, 1980).

36. *Autobiography*, 139–151. See also A. E. Demaray to AA, January 10, 1939, cf: Dept. of the Interior, National Park Service, AACCP.

37. Irving Brant, *Adventures in Conservation with Franklin D. Roosevelt* (Flagstaff: Northland, 1988), 49, 95; quotation of Smith on 95. Francis Farquhar, a member of the Sierra Club board of directors and editor of the *Sierra Club Bulletin* during these years, was more ambivalent. In his oral history he recalled that FDR "didn't show any marked appreciation of the parks or conservation, but he was not hostile to it." Francis Farquhar, "Francis Farquhar, Sierra Club Mountaineer and Editor," an interview conducted by Ann and Ray Lage, Bancroft Library, 47. Richard Lowitt, *The New Deal and the West* (Bloomington: Indiana University Press, 1984), 78, 227–228.

38. Brant, *Adventures in Conservation*, 34.

39. Richard Leonard, "Mountaineer, Lawyer, Environmentalist," interviews conducted by Susan Schrepfer of the University of California, Regional Oral History Office (ROHO), Berkeley, 1972–1973, 46; Joel Hildebrand, "Sierra Club Leader and Ski Mountaineer," an interview conducted by Ann and Ray Lage, Sierra Club History Committee, San Francisco, 1974, Bancroft Library, 17, 22; Cohen, *History of the Sierra Club*, 82.

40. Ibid; quotation from Hildebrand, "Sierra Club Leader," 17.

41. The topics discussed on the train ride are described in Newhall, *Eloquent Light*, 124; presumably the information comes from her interviews with Adams and Van Dyke; however, she does not provide any citation or reference.

42. *Autobiography*, 221, 200–203.

43. AA to VA, January 17, 1936, *Letters*, 80–81.

44. Ibid.; Newhall, *Eloquent Light*, 124. AA to VA, January [n.d.], 1936, *Letters*, 81. See also *Autobiography*, 149.

45. See Adams, *Basic Photo*, vol. 3, *The Print* (Boston: New York Graphic Society, 1976), 104–111.

46. John Armor and Peter Wright, *The Mural Project* (Santa Barbara: Reverie Press, 1989), iv–v.

47. Donald Tresidder to Stanley Plumb, January 11, 1936, YPCCA.

48. Donald Tresidder to AA, January 19, 1931, YPCCA.

49. Ansel Adams, folder announcing the conference, quoted in Newhall, *Eloquent Light*, 114–117.

50. Ibid.; see also "Conversations," 683–684.

51. The conference and Tresidder's comments are described in Newhall, *Eloquent Light*, 117.

52. AA to AS, March 15, 1936, ASAY; *Letters*, 82–83.

53. Willard Van Dyke to Ansel Adams, March 2, 1936, correspondence, selected [photocopy, location of original unknown], Willard Van Dyke Archive, Center for Creative Photography (hereafter cited as VDACCP); AA to Willard Van Dyke, [March] 1936 [month and day not given]; quoted in Newhall, *Eloquent Light*, 126.

54. According to his friend and first biographer, Nancy Newhall, "Adams was struck as by lightning—a love so intense that during its illumination he saw the world charged with a new and profound significance." Newhall, *Eloquent Light*, 129. See also writings file: *The Eloquent Light*, research notes, NACCP. Adams's later letters seem to support Newhall's interpretation to some extent. He told Cedric Wright that he was able to complete the show for Stieglitz only because of the "emotional stimulus" of that summer and fall. Of course, this stimulus may have included a number of conflicting emotions besides love. See AA to Cedric Wright [n.d., late December, 1936], *Letters*, 92–93. Louise Hewlett, "The Outing of 1936," *SCB* (February 1937): 58–68.

55. Gray, *An American Place*, 24. AA to AS, August 12, 1936; AA to AS, September 15, 1935, ASAY.

56. Nancy Newhall, notes to her interview with Virginia Adams, May 12, 1947, writings file: *The Eloquent Light*, research notes, NACCP.

57. This interpretation is based on Newhall, *Eloquent Light*, 44; on correspondence between Ansel and Virginia in the years 1922–1928; and on author's interview with James and Mary Alinder, July 15, 1989.

58. Newhall, *Eloquent Light*, 129.

59. AS to AA, November 10, 1936, cf: Alfred Stieglitz, AACCP. See also AS to AA, October 22, 1935, same file.

60. AA to VA, November 11, 1936; quoted in Newhall, *Eloquent Light*, 129.

61. AA to VA, November 16, 1936, *Letters*, 84–85.

62. Most of his forty-five prints were 8 × 10, some were 11 × 14. For a detailed discussion of each, see Gray, *An American Place*.

63. AA to VA, November 16, 1936, AACCP; *Letters*, 84–85.

64. Ibid.

65. See Horace Albright and Robert Cahn, *The Birth of the National Park Service: The Founding Years, 1913–1933* (Salt Lake City: Howe Brothers, 1985), 312–314. For a discussion of this phenomenon in the wider conservation movement, see Susan Schrepfer, *The Fight to Save the Redwoods: A History of Environmental Reform, 1917–1978* (Madison: University of Wisconsin Press, 1983).

66. AA to VA, November 20, 1936; quoted in Newhall, *Eloquent Light*, 130.

67. AA to VA, "Saturday" [n.d., ca. November 28], 1936; quoted in Newhall, *Eloquent Light*, 130. AA to Alfred Stieglitz, November 27, 1936, ASAY; *Letters*, 85–88.

68. AA to VA, "Saturday" [n.d., ca. November 28], 1936; quoted in Newhall, *Eloquent Light*, 130.

69. AA to Alfred Stieglitz, December 10, 1936, and AA to AS, December 22, 1936; both ASAY. Adams's medical records located in the Adams archive at the Center for Creative Photography remain off-limits to researchers, so the exact nature of his illness and his doctor's response are uncertain.

70. AA to AS, November 27, 1936, ASAY; *Letters*, 85–88.

71. AS to AA, December 16, 1936, cf: Alfred Stieglitz, AACCP; *Letters*, 88–89.

72. AA to AS, December 22, 1936, ASAY; *Letters*, 90–91. See also AA to AS, December 10, 1936, ASAY; and AA to AS [n.d., January 15, 1937], ASAY.

73. AA to Cedric Wright [late December], 1936, *Letters*, 92–93.

74. See *Letters*, 92.

75. AA to AS, December 22, 1936, ASAY.

76. Ibid. Lines from Robinson Jeffers, "Love the Wild Swan," in *Solstice and Other Poems* (New York: Random House, 1935), 146.

CHAPTER 6

1. AA to AS, February 10, 1937, ASAY. Apparently their move was financed by the small inheritance Virginia received from her father.

2. Ibid.

3. "Museum of Modern Art Annex, Photography Center," *Bulletin of the Museum of Modern Art* 11 (October–November 1943): 14. This article recounts each of the photographic exhibitions held at MoMA up to that point, Department of Photography Archive, Museum of Modern Art, New York (hereafter cited as DPA-MoMA).

4. AA to AS, January, 1937; and AA to AS January 15, 1937, both ASAY. AS to AA, January 17, 1937, cf: Alfred Stieglitz, AACCP.

5. Newhall quoted in Russel Lynes, *Good Old Modern: An Intimate Portrait of the Museum of Modern Art* (New York: Atheneum, 1973), 155. Author interview with Beaumont Newhall, July 3, 1989. Beaumont Newhall, *Focus: Memoirs of a Life in Photography* (Boston: Bulfinch Press, 1993), 23–45.

6. Ibid.; see also Newhall, *Eloquent Light*, 131.

7. For a brief survey of Nancy Newhall's life and career, see Malin Wilson, "Walking on the Desert Sky: Nancy Newhall, Words and Images," in Vera Norwood and Janice Monk, eds., *The Desert Is No Lady: Southwestern Land-*

*scapes in Women's Writing and Art* (New Haven: Yale University Press, 1987), 47–61.

8. Walter Starr, Jr., *Starr's Guide to the John Muir Trail and the High Sierra Region* (San Francisco: Sierra Club, 1934). See also "The Search for Walter A. Starr, Jr.," *SCB* 19 (June 1934): 81–85.

9. AA to Cedric Wright, June 10, 1937, cf: Cedric Wright, AACCP; *Letters*, 95–97.

10. Edward Weston and Charis Wilson Weston, *California and the West* (New York: Duell, Sloan and Pearce, 1940), 14.

11. EW to AA [n.d., late May 1937], cf: Edward Weston, AACCP; *Letters*, 93. AA to EW, June 3, 1937, photocopy, cf: Edward Weston, AACCP; *Letters*, 94–95.

12. Weston and Weston, *California and the West*, 59.

13. Ibid., 59–60.

14. Perhaps the closest he came was in his snapshots of Virginia on their Sierra Club excursions; see, e.g., "Virginia Adams and Jane Paxson, Sierra Club Outing, c. 1930," *Letters*, 44. The image hardly qualifies, however, as a serious portrait.

15. Weston and Weston, *California and the West*, 61–62.

16. Ibid., 62–63. See also *Autobiography*, 245–246.

17. Weston's stylistic evolution and the period of his Guggenheim grant are discussed in Andy Grundberg, "Edward Weston's Late Landscapes," in *E. W. 100: Centennial Essays in Honor of Edward Weston* (Carmel: Friends of Photography, 1986), 93–101; and John Szarkowski, "Edward Weston's Later Work," in *Edward Weston Omnibus: A Critical Anthology*, ed. Beaumont Newhall and Amy Conger, 159 (Salt Lake City: Peregrine Smith, 1984).

18. Edward Weston, quoted in Bunnell, *Weston on Photography*, 88.

19. Andy Grundberg and Ben Maddow suggest Weston's growing preoccupation with death in these years. I tend to agree with Charis Wilson's suggestion that such an analysis is exaggerated. "The fact is . . . ," she wrote later,

"Edward had always seen death and decay—along with birth and growth—as inseparable parts of the life process." Charis Wilson, "The Weston Eye," in *E. W. 100*, 117–123; quotation on 121.

20. All quotations from Weston and Weston, *California and the West*, 65–66. See also *Autobiography*, 246.

21. AA to AS, September 21, 1937, ASAY; *Letters*, 98. See also AA to AS, November 12, 1937, ASAY.

22. AA to DT, November 15, 1937, YPCCA. See also *Autobiography*, 189–190. Adams's agreement with the Curry Company specified that he would retain the negatives he made while on assignment. See AA to DT, November 1, 1929, and AA to DT, April 4, 1930; DT to AA, April 25, 1930, all YPCC archives. Adams assumed this implied he retained rights for secondary uses of the images. The Curry Company did not agree.

23. Ibid.

24. Ibid.

25. AA to AS, November 12, 1937, ASAY.

26. AS to AA, April 8, 1938, cf: Alfred Stieglitz, AACCP.

27. AA to AS, April 18, 1938, ASAY.

28. AA to AS, July 30, 1938, ASAY.

29. AA to AS, September 10, 1938, ASAY.

30. AA to DM, July 11, 1938, photocopy, cf: David McAlpin, AACCP; *Letters*, 104–107.

31. AA to AS, September 10, 1938, ASAY; *Letters*, 107–108.

32. Brower interview in Newhall, *Eloquent Light*, 162.

33. AS to AA, December 21, 1938, ASAY (this is a copy retained by Stieglitz; the original is apparently missing).

34. AS to AA, January 12, 1940, cf: Alfred Stieglitz, AACCP.

35. AA to AS, December 26, 1938, ASAY.

36. Margaret Bourke-White and Erskine Caldwell, *You Have Seen Their Faces* (New York: Viking, 1937); quotation from Malcolm Cowley, review, *New Republic* (November 27, 1937): 78; Stott, *Documentary Expression*, 211.

37. Stott, *Documentary Expression*, 222. Archibald MacLeish, *Land of the Free—U.S.A.* (London: Boriswood, 1938); John Steinbeck's *The Grapes of Wrath*, published the following year, carried a similar tone and message. Steinbeck began his research into migrant farm labor in California in 1936 in a series of articles titled "The Harvest Gypsies" for the *San Francisco News*. The articles were illustrated with photographs by Dorothea Lange. The articles and photographs are reprinted in John Steinbeck, *The Harvest Gypsies: On the Road to the Grapes of Wrath* (Berkeley: Heyday Books, 1989). See also John Steinbeck, *Working Days: The Journals of "The Grapes of Wrath"* (New York: Viking, 1989).

38. Stott, *Documentary Expression*, 75–140, 211–289; Ohrn, *Dorothea Lange*, 26–113; F. Jack Hurley, *Portrait of a Decade* (Baton Rouge: Louisiana State University Press, 1972); David S. Peeler, *Hope Among Us Yet* (Athens: University of Georgia Press, 1987); Carl Fleishhauer and Beverly Brannan, eds., *Documenting America, 1935–1943* (Berkeley, Los Angeles, and London: University of California Press, 1988).

39. AA to David McAlpin, July 2, 1938, photocopy in cf: David McAlpin, AACCP.

40. James Thrall Soby, "Notes on Documentary Photography," *U.S. Camera* (November 1940): 37–39. Soby would have been disappointed to discover that one of Man Ray's "rayographs" was sold in 1990 for $126,500, the record price for a single photograph up to that time.

41. Ibid.

42. AA to DM, November 4, 1938, AACCP; *Letters*, 108–110.

43. Lincoln Kirstein, "Photographs of America: Walker Evans," in Evans, *American Photographs*, 187–195; quotation on 190.

44. Ibid.

45. AA to EW, November 7, 1938, quoted in Newhall, *Eloquent Light*, 163; AA to DM, November 4, 1938, photocopy in cf: David McAlpin, AACCP; *Letters*, 108–110.

46. Ibid.

47. Pells, *Radical Visions*, 292–302. The quotation appears in James Burkhart Gilbert, *Writers and Partisans: A History of Literary Radicalism in America* (New York: Wiley, 1968), 205.

48. *New Republic* 100 (September 27, 1939): 198.

49. AA to DT, January 7, 1938, YPCCA.

50. Ibid.

51. Farquhar, "Sierra Club Mountaineer"; Hildebrand, "Sierra Club Leader." T. H. Watkins, *Righteous Pilgrim: Harold Ickes* (New York: Henry Holt, 1990), 569–578.

52. A. E. Demaray to AA, January 10, 1939, cf: Dept. of Interior, National Park Service, AACCP.

53. Harold Ickes to AA, January 1939, *Letters*, 111. Ickes and the Sierra Club leadership had hoped that the park would be named for Muir, who had urged its creation for many years, but when objections were raised the idea was dropped.

54. DM to AA, December 1944, cf: David McAlpin, AACCP. For an example of McAlpin's lobbying for Adams, see DM to AS, January 7, 1939, ASAY.

55. DM to AA, January 9, 1939, cf: David McAlpin, AACCP.

56. Ibid.

57. Joining him that year was Edward Weston. Adams began his own annual Ansel Adams Workshops in Yosemite in 1955 and continued to teach there each year through 1981, when he moved the workshop down to Carmel.

58. *Autobiography*, 309–313; quotations on 310 and 311.

59. If, for example, the range of subject luminance was greater or less than desired, he could alter the normal relationship of exposure and development to expand or contract the contrast range of the negative and hence the relationship between subject luminance and the final values in the print. In addition to his control of negative exposure and development, he could also reduce or intensify silver density in selected portions of the negative through postdevelopment chemical treatments and further control values through selective "burning" or "dodging" of the print (a phys-

ical method of increasing or decreasing the exposure of selected portions of the print), the use of filters at the time of initial exposure of the negative to alter the value of certain colors, and toning of the print after development. Even after the print is finished, matting will affect the viewer's perception of print values, as will the light in which the print is viewed. For a fuller discussion of these procedures, see Adams, *Basic Photo Series*.

60. "Conversations," 389–398.

61. Adams, *A Pageant of Photography* (San Francisco: Crocker-Union, 1940); "Conversations," 387–395; *Autobiography*, 196–197.

62. Nancy Newhall, "The Enduring Moment," 91, manuscript draft for volume 2 of her biography of Ansel Adams, writings file: Enduring Moment, NACCP.

63. Newhall, "Enduring Moment," 142.

64. Nancy Newhall, unpublished manuscript, quoted in Adams, *Autobiography*, 198.

65. Newhall quoted in Lynes, *Good Old Modern*, 160. See Newhall, *Focus*, 60–61, for a more complete account of the department's formation. The concept for a department of photography evolved over several years. Newhall had drawn up a proposal, on which Adams commented in detail, before their discussion in Yosemite. See AA to David McAlpin, July 5, 1940, carbon copy, cf: David McAlpin, AACCP.

66. DM to AA, September 7, 1940, cf: David McAlpin, AACCP; *Letters*, 119–120. AA to DM, September 9, 1940, carbon copy cf: David McAlpin, AACCP; *Letters*, 120.

67. BN to AA, September 17, 1940, cf: Beaumont and Nancy Newhall, AACCP; *Letters*, 121.

68. AS to AA, April 8, 1938, cf: Alfred Stieglitz, AACCP.

69. AA to AS, April 18, 1938, ASAY.

70. Quoted in Lynes, *Good Old Modern*, 160.

71. Nancy Newhall, quoting herself, "Enduring Moment," 124. Willard Morgan's point of view is described on 111.

72. AA to AS, March 2, 1941, ASAY.

73. Barr quoted by Newhall in Lynes, *Good Old Modern*, 160.

74. Newhall, "Enduring Moment."

75. Ibid.

76. Erskine Caldwell and Margaret Bourke-White, *Say, Is This the USA* (New York: Duell, Sloan, and Pearce, 1941).

77. Stott, *Documentary Expression*, 128–257. John P. Diggins, *The Rise and Fall of the American Left* (New York: W. W. Norton, 1992).

78. Stott, *Documentary Expression*, 255.

79. "Image of Freedom," Museum of Modern Art press release, October 16, 1941, DPA-MoMA.

80. Ibid.; "Image of Freedom" contest announcement, n.d. [1941], DPA-MoMA.

81. E. K. Burlew to AA, June 18, 1941, cf: National Park Service, AACCP.

82. Ibid.; *Autobiography*, 139–151.

83. AS to AA, November 24, 1941, cf: Alfred Stieglitz, AACCP.

84. *Autobiography*, 94–95.

CHAPTER 7

1. Quoted in Armor and Wright, *Mural Project*, v–vi.

2. Press release, Museum of Modern Art, November 1941, DPA-MoMA.

3. Ibid.

4. Quoted in Lynes, *Good Old Modern*, 234.

5. *Autobiography*, 271.

6. "Conversations," 629.

7. AA to BN and NN, October 26, 1941, cf: Ansel Adams, NACCP; *Letters*, 131–133.

8. *Autobiography*, 275.

9. See Adams to Newton Drury, October 20, 1941, carbon copy, cf: Newton Drury, AACCP. For a more extensive discussion of this topic, see Jona-

than Spaulding, "The Natural Scene and the Social Good: The Artistic Education of Ansel Adams," *Pacific Historical Review* 60 (1991): 15–42.

10. For more on these artists and their cultural context, see Novak, *Nature and Culture*, 3–44.

11. Ansel Adams, "Retrospect: Nineteen Thirty-One," *Sierra Club Bulletin* 17 (February 1932): 1–10.

12. Mary Austin, "The Indivisible Utility," *Survey Graphic* 40 (December 1925): 12–15.

13. Newhall, "Enduring Moment," 169. For background on the OWI, see Allan M. Winkler, *The Politics of Propaganda: The Office of War Information, 1942–1945* (New Haven: Yale University Press, 1974); and John Morton Blum, *V Was for Victory: Politics and American Culture During World War II* (New York: Harcourt Brace Jovanovich, 1976).

14. BN to AA, August 18, 1942, cf: Beaumont and Nancy Newhall, AACCP.

15. *Autobiography*, 208.

16. Ibid., 204–205.

17. Ibid., 205.

18. Ibid.

19. Ibid. After recounting this story, he added that he considered this "a prophetic statement."

20. Ibid., 206–207.

21. AA to NN, June 11, 1942, cf: Adams, NACCP; *Letters*, 134–136.

22. Ibid.

23. Ibid.

24. Armor and Wright, *Mural Project*, vi.

25. Monroe Wheeler, "Road to Victory," *Bulletin of the Museum of Modern Art* (July 1942), DPA-MoMA.

26. Press release, Museum of Modern Art, May 1941, DPA-MoMA.

27. Ibid.

28. Ibid.

29. All quotations in Lynes, *Good Old Modern*, 236–237.

30. BN to AA, June 3, 1942, cf: Newhalls, AACCP; *Letters*, 134.

31. *Autobiography*, 207; AA to BN, March 1, 1945, cf: Adams, NACCP; this letter refers to Steichen's *Power in the Pacific* exhibition but demonstrates that Adams felt this way in those years, not simply on later recollection.

32. On these activities, see *Autobiography*, 257, 312–315, and "Conversations," 353.

33. AA to EW [n.d.] 1943, photocopy in cf: Weston, AACCP; *Letters*, 139–140.

34. AA to AS, August 22, 1943, ASAY.

35. Ibid.

36. Roger Daniels, *Concentration Camps, USA: Japanese Americans and World War II* (New York: Holt, Rinehart, and Winston, 1972). Quotation from U.S. Army Western Defense Command and Fourth Army, *Final Report: Japanese Evacuation from the West Coast, 1942* (Washington, D.C.: Government Printing Office, 1943), 34.

37. Graham Howe, Patrick Nagatani, and Scott Rankin, eds., *Two Views of Manzanar* (Los Angeles: Frederick S. Wight Art Gallery, UCLA, 1978), 9–10.

38. *Autobiography*, 257–258.

39. Ansel Adams, Manzanar Relocation Center, collection of manuscripts, correspondence, and ephemera, 1938–1944, Department of Special Collections, University Research Library, University of California, Los Angeles (hereafter cited as Special Collections, UCLA).

40. While it may seem strange that the government would want to record this inhumane action so carefully, there were several reasons the WRA chose to do so, including its desire to present the action in as humane a light as possible and to document the proceedings for bureaucratic records.

41. Ohrn, *Dorothea Lange*, 119–148.

42. Lange photo, National Archives photo no. 210-C-764. The photographs by Adams and Miyatake are in Special Collections, UCLA.

43. Some of Adams's landscapes do share an affinity with Miyatake's, indicative both of Adams's interest in Asian art and the wider debt of modernism to that tradition.

44. Adams, *Born Free and Equal* (New York: U.S. Camera, 1944), 9. See also AA to DM, January 10, 1943, carbon copy in cf: David McAlpin, AACCP; *Letters*, 141–143.

45. *Examples*, 162–165; *Autobiography*, 262–263.

46. It is clear from his description that Adams considered the horse a crucial aspect of the photograph. Such a small but significant detail was a standard element of the sublime landscape, designed to indicate the vast, overpowering scale of the scene. The horse also provided a key iconographic link to the imagery of the pastoral landscape as it grazed peacefully in the literal and figurative middle landscape between the wilderness of the Sierra peaks and the civilization of the highway where Adams stood atop his Pontiac to make the photograph. Leo Marx, *The Machine in the Garden: Technology and the Pastoral Ideal in America* (New York: Oxford University Press, 1964). On Adams's debt to the nineteenth-century tradition of the sublime landscape, see Robert Silberman, "Scaling the Sublime: Ansel Adams, the Kodak Colorama, and 'The Large Print Idea,'" in *Ansel Adams: New Light*, 33–41.

47. While his grand panoramas of these years have been called romantic by a number of critics, his work of the 1940s and after continued to embody modernist aesthetics in its forthrightly photographic precision and its simplification of form into broad graphic elements. *Winter Sunrise*, with its alternating bands of light and dark and its mysterious foreground hills, shares at least as much with the paintings of Georgia O'Keeffe as it does with those of Albert Bierstadt. Nevertheless, its grandiloquent tone differentiates it from most modernist landscape and links it with such nineteenth-century predecessors. For assessments of Adams's romanticism, see John Szarkowski, Introduction, *Ansel Adams: Classic Images*, 6; Estelle Jussim and Elizabeth Lindquist-Cock, *Landscape as Photograph* (New Haven: Yale University Press, 1985), 6, 21–22, 137, 140–141; Colin

Westerbeck, "Ansel Adams: The Man and the Myth," in *Ansel Adams: New Light*, 9–15; and Silberman, "Scaling the Sublime."

48. AA to NN [n.d., 1943], cf: Adams, NACCP; *Letters*, 143–145.

49. Abraham Lincoln to Joshua Speed, August 25, 1855; quoted in Adams, *Born Free and Equal*, 5.

50. Nancy Newhall, review of *Born Free and Equal*, *Photo Notes* (June 1946): 3–5.

51. NN to AA, November 11, 1944, cf: Newhalls, AACCP.

52. Estelle Campbell to AA, November 22, 1944; quoted in Newhall, "Enduring Moment," 233–234.

53. Since this overseas exhibition was not preserved, its exact form cannot be known for certain.

54. AA to EC, December 18, 1944; quoted in Newhall, "Enduring Moment," 233–234.

55. Lange, "Making of a Documentary Photographer," 190–191; see also 200–201.

56. Quoted in Diana Mar, "U.S. cuts short photo show on Japanese relocation camp," *Philadelphia Enquirer* [Fall 1985?]; clipping in Adams biographical file, DPA-MoMA.

57. AA to NN, October 23, 1944, cf: Adams, NACCP [note: the first page of this letter is missing].

58. Harold Ickes, Foreword, in Adams, *Born Free and Equal*.

59. AA to NN "Sunday," 1944 [no further date given], carbon copy in cf: Newhalls, AACCP.

60. AA to NN, quoted in Newhall, "Enduring Moment," 189. AA to AS, December 25, 1944, ASAY. See also Adams, "A Personal Credo" (1943), in Beaumont Newhall, ed., *Photography: Essays and Images* (New York: Museum of Modern Art, 1980), 255–256.

61. AA to NN, October 4, 1945, cf: Adams, NACCP.

62. As Adams's friend Paul Brooks, an editor at Houghton Mifflin, put it, "The whites won't buy it and the blacks can't." Quotation in Newhall, "Endur-

ing Moment," NACCP, unpaginated, in "Peregrinations of a Biographer," chap. 6 of the manuscript. For other correspondence on the project, see AA to NN, October 8, 12, and 14, 1945; April 13, 1946; March 4, 1947; March 5 and 8, 1948; and "early '49"; all cf: Adams, NACCP. NN to AA, October 8, 1945; April 27 and May 18, 1948, cf: Newhalls, AACCP.

63. [Ansel Adams and Dorothea Lange], "American-Italians," *Victory* 1, no. 4 [n.d.]: 27–35; [Adams and Lange], "Americans of Spanish Descent," *Victory* 1, no. 5 [n.d.]: 26–30.

64. Beaumont Newhall, Foreword, in Dorothea Lange, *Dorothea Lange Looks at the American Country Woman* (Los Angeles: Amon Carter Museum and Ward Ritchie Press, 1967), 7–8; author interview with Beaumont Newhall, July 3, 1989, Santa Fe, New Mexico.

65. Ibid. Translations by Beaumont Newhall.

66. Individual photographers were not credited for their work in *Victory*, so identification of which images were by Adams and which by Lange is speculative. Adams recalled that he made the photograph of worshipers departing Mass in North Beach; see "Conversations," 349. Its carefully balanced composition and use of view camera perspective controls support his contention. The photograph of the men conversing on the street is most likely by Lange. Its feel for human expression is typical of her work, and the more casual framing is characteristic of the hand-held equipment she favored.

67. Lange, "Making of a Documentary Photographer," 181.

68. Ansel Adams and Dorothea Lange, "Detour Through Purgatory" and "Richmond Took a Beating," *Fortune* 31 (February 1945): 180–184, 234–240, 262–269.

69. Gerald Nash, *World War II and the West: Reshaping the Economy* (Lincoln: University of Nebraska Press, 1990), 41–43.

70. U.S. Department of Commerce, Bureau of the Census, *Wartime Changes in Population and Family Characteristics, San Francisco Bay Congested Production Area, April 1944*, Series CA-2, no. 3 (Washington, D.C.: Government

Printing Office, 1944), 1–2; cited in Marilyn S. Johnson, "Urban Arsenals: War Housing and Social Change in Two California Cities, 1941–1954," *Pacific Historical Review* 60 (1991): 285.

71. Johnson, "Urban Arsenals," 283–308. For firsthand accounts of life in Richmond during the war, see Vera Jones Bailey, "Migration of a Working Family: From the San Joaquin Valley to the Richmond Shipyards, 1942," and Lucille Preston, "A World War II Journey: From Clarksdale, Mississippi, to Richmond, California, 1942," both in Regional Oral History Office, Bancroft Library, University of California, Berkeley.

72. "Conversations," 349.

73. Ibid.

74. Quotation in Ohrn, *Dorothea Lange*, 149.

CHAPTER 8

1. AA to BN, March 1, 1945, cf: Adams, NACCP.

2. AA, "Problems of Interpretation of the Natural Scene," *SCB* 30 (December 1945): 47–50.

3. *Autobiography*, 316–317; "Conversations," 374–375, 108; Thomas Albright, *Art in the San Francisco Bay Area, 1945–1980* (Berkeley, Los Angeles, and London: University of California Press, 1985), 16–35. Adams's teaching there began as a series of lectures and grew; see ETS to AA, September 9, 1944, and AA to ETS, September 11, 1944, cf: Ted and Jeanette Spencer, AACCP.

4. *Autobiography*, 310.

5. Ibid., 317.

6. Ansel Adams, *The Print* (New York: Morgan and Lester, 1950), v.

7. Quoted in Lynes, *Good Old Modern*, 259.

8. Ibid., 259.

9. BN to AA, February 23, 1946, cf: Newhalls, AACCP; *Autobiography*, 208.

10. AA to NN, January 7, 1946, cf: Adams, NACCP; *Letters*, 166.

11. Lynes, *Good Old Modern*, 259.

12. BN to AA, March 7, 1946, cf: Newhalls, AACCP; *Letters*, 167–168.

13. AS to AA, August 8, 1943, cf: Stieglitz, AACCP; *Letters*, 145–146.

14. AA to AS, April 15, 1945, ASAY; *Letters*, 158.

15. AA to EW, n.d. [April 1946], EWACCP; *Letters*, 169; see also EW to AA, April 12, 1946, cf: Weston, AACCP; *Letters*, 170.

16. AS to AA, April 15, 1946, cf: Stieglitz, AACCP; *Letters*, 170.

17. NN to AA, July 15, 1946, *Letters*, 175–176.

18. AA to Dorothy Norman, "late July" 1946, quoted in Newhall, "Enduring Moment," 12.

19. Author interview with Beaumont Newhall, July 3, 1989.

20. Minor White, "Memorable Fancies" [unpublished journal], July 9 [10], 1946; quoted in *Autobiography*, 318.

21. MW to AA, March 26, 1946, cf: Minor White, AACCP.

22. AA to MW, November 28, 1946, carbon copy in cf: White, AACCP.

23. AA to B&NN, January 23, 1947, cf: Adams, NACCP; *Letters*, 179.

24. EW to AA, n.d. [postmarked November 17, 1945], cf: Weston, AACCP; *Letters*, 164.

25. AA to EW, November 1945, carbon copy, cf: Weston, AACCP; *Letters*, 164.

26. EW to AA, December 1, 1945, cf: Weston, AACCP *Letters*, 165.

27. John Szarkowski, "Edward Weston's Later Work," in *Edward Weston Omnibus*, Newhall and Conger, eds., 159.

28. See, e.g., Beaumont Newhall quoted in Ben Maddow, *Edward Weston: Fifty Years* (Millerton, N.Y.: Aperture, 1979), 120.

29. AA to BN and NN, January 23, 1947, cf: Adams, NACCP; *Letters*, 179.

30. Christina Page, "The Man from Yosemite: Ansel Adams," *Minicam* (August/September 1946): 75–81.

31. AA to MW, n.d. [ca. February 1947], carbon copy, cf: Minor White, AACCP; *Letters*, 180–181.

32. AA to ETS, February 28, 1947, carbon copy, cf: Spencers, AACCP, *Letters*, 187.

33. Author interview with Beaumont Newhall, July 3, 1989.

34. *Autobiography*, 212–213.

35. AA to BN and NN, April 29, 1946, cf: Adams, NACCP; *Letters*, 171–173. This letter is a modified version of one he sent to Stephen Clark, president and chairman of the Board of Trustees of MoMA, protesting the hiring of Edward Steichen; see also *Autobiography*, 172–173.

36. The coloramas were assembled by joining together a number of parallel strips of transparency enlargements. The first coloramas were installed in 1948. From surviving evidence it appears that he produced sixteen coloramas. See correspondence with Eastman Kodak, AACCP; see also installation views, Commercial projects file, AACCP; *Autobiography*, 172–175; AA to VA, October 1958, cf: Adams family, AACCP; Silberman, "Scaling the Sublime," 33–41.

37. Author interview with Beaumont Newhall, July 3, 1989.

38. Ibid.

39. AA to NN, August 22, 1951, cf: Adams, NACCP.

40. *Autobiography*, 104.

41. *Time* 57 (June 4, 1951): 69.

42. See, for example, the criticism of Adams in Runte, *Yosemite*, 187–188, 198–200.

43. *Autobiography*, 279.

44. This may have had something to do with his enlistment in the U.S. Air Force during the Korean War. *Autobiography*, 280, 105.

45. "Conversations," 281–283; *Autobiography*, 280–281.

46. Ibid.

47. *Examples*, 74–77. In his early prints of this image, the sky and the right-hand waters of the lake are lighter (see, e.g., the reproduction in *The Print*, 20 [1950 ed.]) than in later prints, such as that reproduced in *Examples*, 74. This is typical of Adams's tendency toward more dramatic "performances" in his printing as time went on.

48. Ibid.

49. Edward Weston, *The Daybooks of Edward Weston*, vol. 1 (Rochester, N.Y.: George Eastman House, 1957); vol. 2 (New York: Horizon Press, 1961).

50. NN to AA, September 8, 1948, carbon copy, cf: Newhalls, NACCP; *Letters*, 197.

51. AA to NN, September 15, 1948, cf: Adams, NACCP; *Letters*, 198.

52. Ibid.

53. In the winter of 1948, Beaumont had been offered the position of curator of the newly created George Eastman House, founded and sponsored by the Eastman Kodak Company. He was given a generous salary and expense account to build the facilities and collections of the museum to begin a series of exhibitions on both the history of and contemporary trends in photography as a fine art. Within a short time, Newhall had built the Eastman House into one of the premier resources for the study of photography.

54. AA to EW, April 10–14, 1948, carbon copy in cf: Weston, AACCP; *Letters*, 190–191.

55. Nancy Newhall, notes to an interview with Virginia Adams, May 12, 1947, writings file: *Eloquent Light*, research notes, NACCP. Author interview with Virginia Adams, April 29, 1985. The letters referred to in chapter 3 of this manuscript, in which Ansel urges Virginia to pursue her singing (AA to VB, October 20, 1927, AACCP; *Letters*, 20–22; and AA to VA, July 1928, AACCP; *Letters*, 37–38) are early examples of Ansel's desire for Virginia to pursue an artistic career rather than concentrate, as she preferred, on home and family. Author interview with James and Mary Alinder, July 17, 1989.

56. AA to EW, April 10–14, 1948, carbon copy, cf: Weston, AACCP; *Letters*, 190–191.

57. Nancy Newhall interview with Virginia Adams, May 12, 1947, notes in writings file: *Eloquent Light*, research notes, NACCP. According to Newhall, Virginia described her relationship with Ansel as sexually disappointing.

58. PS to AA, March 21, 1949, cf: Paul Strand, AACCP; *Letters*, 206.

59. AA to PS, March 29, 1949, carbon copy, cf: Paul Strand, AACCP; *Letters*, 207–208.

60. Serge Guilbaut points out the importance of the postwar expansion in the fine art market in assuring the success of America's abstract expressionists. It is interesting to note that Guilbaut credits the depoliticization of art in the postwar years as a crucial factor in its growing acceptability and re-spectability with middle-class buyers and government sponsors. Adams seemed to follow an inverse trajectory from the one Guilbaut maps out for these painters. Rather than abandoning a radical position of the 1930s for an ideologically neutral, art-for-art's-sake introspection in the postwar years (as Guilbaut claims many of the abstract expressionists did), Adams abandoned the ideologically neutral art-for-art's-sake approach of his work in the early to mid-1930s for an activist stance during and after the war. It was not a radical activism, however, but a liberal and nationalistic one that was palatable to the public and to the federal government. I will discuss this more fully in the next chapter.

61. Nash, *World War II and the West*, xii, 1–4, passim.

62. National Park Service data compiled in Stanford E. Dumars, *The Tourist in Yosemite, 1855–1985* (Salt Lake City: University of Utah Press, 1991), 123.

63. Adams was one of those who remembered, and he related this story in his autobiography, 288.

64. Leonard, "Mountaineer"; Cohen, *History of the Sierra Club*, 89–100. New-ton Drury, director of the National Park Service at the time, discussed the problems of overcrowding in the parks in "The Dilemma of Our National Parks," *American Forests* 55 (June 1949): 6–11, 38–39. On the opening pages was a large reproduction of Adams's *Bridalveil Falls, Yosemite Valley*.

65. Cohen, *History of the Sierra Club*, 93; Fox, *American Conservation Movement*, 278.

66. Leonard, "Mountaineer," 19–20. Colby realized this himself in certain

cases; see, for example, his critique of overcrowding and overdevelopment in Yosemite Valley, "Yosemite's Fatal Beauty," *SCB* 33 (March 1948): 79–86.

67. William E. Colby to J. H. McFarland, March 10, 1948, J. Horace McFarland Papers, Division of Archives and Manuscripts, Pennsylvania Historical and Museum Commission, Harrisburg; quoted in Fox, *American Conservation Movement*, 278.

68. Leonard, "Mountaineer," 20.

69. "Relocation of Tioga Road: Report of the Executive Committee of the Sierra Club on the Proposed Relocation of the Tioga Road, Yosemite National Park," *SCB* 19 (February 1934): 85–88.

70. Sierra Club Board of Directors Minutes, September 5, 1948, Sierra Club Records (71/103c), series 2: Board of Directors/Executive Committee Records, carton 3, SCA [hereafter cited as SC Bd. minutes]; Cohen, *History of the Sierra Club*, 94–100.

71. Harold Bradley, "Tuolumne Meadows and Tomorrow," in Sierra Club Members Papers (71/295c), series 9: Harold Bradley Files (hereafter cited as Bradley files], carton 7, folder 38: Roads, Tioga Pass (Calif., 1948), SCA. Harold C. Bradley and David R. Brower, "Roads in the National Parks," *SCB* 34 (June 1949): 31–54.

72. SC Bd. minutes, December 6, 1947.

73. Cohen, *History of the Sierra Club*, 100.

74. Ansel Adams and Virginia Adams, *Michael and Anne in Yosemite Valley* (New York: Studio Publications, 1941). *Autobiography*, 104. Ansel and Virginia Adams, *An Illustrated Guide to Yosemite* (San Francisco: H. S. Crocker, 1946).

75. Collection in AACCP, Commercial projects file: AG 31:7:1:15.

76. Adams, "Problems of the Interpretation of the Natural Scene," *SCB* 30 (December 1945): 47–50; quotations on 48–49.

77. Leonard, "Mountaineer," 32–35. Philip Bernays, a former club director affiliated with the Los Angeles chapter at that time later agreed with

Adams's assessment. See Philip Bernays, "Founding the Southern California Chapter," Sierra Club History Committee, Bancroft Library, 23, 28.

78. Quoted in Eric F. Goldman, *The Crucial Decade: America, 1945–1955* (New York: Alfred A. Knopf, 1956), 147.

79. Adams letter in *Photo Notes* (July 1947): 2. For a report of Adams's 1947 visit to the league, see *Photo Notes* (November 1947): 1. Adams first wrote to the league in 1940, discussing his reactions to documentary photography and his upcoming "Pageant of Photography"; see "A Letter from Ansel Adams!!" *Photo Notes* (June–July 1940): 4–6; see also "Ansel Adams Speaks at the League!" *Photo Notes* (December 1940): 3.

80. PH to AA, December 1, 1947, cf: Philippe Halsman, AACCP; *Letters*, 185. For a detailed summary of the debate engendered by Adams's speech, see Lester Talkington, "Ansel Adams at the Photo League," *Photo Notes* (March 1948): 4–6.

81. AA to PH, December 8, 1947, carbon copy, cf: Halsman, AACCP; *Letters*, 186–187.

82. *Autobiography*, 343. On the advice of his lawyer, fellow Sierra Club director Richard Leonard, he wrote a letter to the league asking them to clarify their position. "Are you becoming politically inclined or aren't you?" he recalled asking. "I joined simply as a photographer." He sent a copy of the letter to the FBI. When he received no reply from the league, he submitted his resignation. He sent a copy of that letter to the FBI as well. "The letters got me clearance quite fast," he recalled. "Conversations," 49.

83. AA to BN, June 15, 1954, cf: Adams, NACCP. Newhall had just been denied access to classified materials unless he could prove he had not supported Communist elements as a member of the Photo League; see NN to AA, June 6, 1954, cf: Newhalls, AACCP.

84. Adams, "Letter to the League," *Photo Notes* (January 1948): 5.

85. Wallace Stegner, *The Uneasy Chair: A Biography of Bernard DeVoto* (New York: Doubleday, 1974), 294.

86. Bernard DeVoto, "The National Parks," *Fortune* 35 (June 1947): 120–133.

87. Bernard DeVoto, "The West: Plundered Province," *Harper's* 169 (August 1934): 355–364; Bernard DeVoto, "The West Against Itself," *Harper's* 194 (January 1947): 1–13.

88. DeVoto, "The West Against Itself," reprinted in *SCB* 32 (May 1947): 36–42; quotation on 38.

89. Fox, *American Conservation Movement*, 275. It should be noted that Adams's praise was tempered by his dislike for Muir's florid Victorian prose. As Mary Alinder points out, Adams felt that Muir had not captured the true qualities of the Sierra. Adams felt a modernist rigor more appropriate to its "stern realities" than Muir's romantic effusion. There is a certain irony here, as Adams's writing (and often his photography as well) was not without its own occasional florid excess.

90. BD to AA, December 23, 1948, cf: DeVoto, AACCP.

91. Adams had received a second Guggenheim grant in 1948 to complete his photography and the printing of his negatives. In addition to the book, he published his *Portfolio II: The National Parks and Monuments*, a collection of twelve fine prints.

92. Adams, "A Personal Statement" [unpaginated foreword], *My Camera in the National Parks* (Boston: Houghton Mifflin, 1950).

93. AA to WD, December 16–18, 1951, carbon copy, cf: U.S. Dept. of Interior, National Park Service, AACCP. There are two drafts of this letter in the Adams archive, one written on the 16th and one on the 18th. I have incorporated material from each. Presumably, the later draft is the one he sent to Dougherty.

94. This was probably the 69th Annual Oil and Sculpture Exhibition, which, according to Thomas Albright, was "completely dominated by the new Abstract Expressionist style." Albright, *Art in the San Francisco Bay Area*, 42. For a contemporary review of the exhibit, see Erle Loran, "San Francisco Art News," *Art News* (April 1950): 50.

95. AA to NN, February 27, 1950, cf: Adams, NACCP; *Letters*, 214–216.

96. André Breton and Diego Rivera, "Towards a Free Revolutionary Art,"

*Partisan Review* 6 (Autumn 1938): 50. Breton later claimed that the manifesto had been written by Trotsky but signed by Rivera and himself for tactical reasons. See André Breton, *Entretiens* (Paris: Gallimard, 1969), 182, and Serge Guilbaut, *How New York Stole the Idea of Modern Art: Abstract Expressionism, Freedom, and the Cold War* (Chicago: University of Chicago Press, 1983), 30–33. This attitude of Rivera's may have been one reason Adams respected Rivera, although he was generally highly critical of Communist artists.

97. Irving Sandler, *The Triumph of American Painting* (New York: Praeger, 1970); Dore Ashton, *The New York School: A Cultural Reckoning* (New York: Viking, 1973); Guilbaut, *The Idea of Modern Art*.

98. Jean-Paul Sartre, *Existentialism and Humanism* (London: Methuen, 1963).

99. AA to NN and BN, November 5, 1957, carbon copy in cf: Newhalls, AACCP.

100. Quoted in Nancy Newhall, "Controversy and the Creative Concepts," *Aperture* 2 (July 1953): 43.

101. This opinion is based on Adams's description of her life and death in his autobiography, 40–46, and his letters to Nancy Newhall, February 27, 1950, cf: Adams, NACCP, *Letters*, 214–216; and to Beaumont Newhall, March 23, 1950, cf: Adams, NACCP, *Letters*, 216. See also Charles Adams to AA, "Easter Sunday" [1948]; CA to VA, October 14, 1948; and CA to VA, April 7, 1949; all cf: Adams family, AACCP, in which Charles describes Olive's declining health.

102. AA to NN, February 27, 1950, cf; Adams, NACCP; *Letters*, 214–216.

103. *Autobiography*, 47; AA to NN, July 31, 1951, AACCP; *Letters*, 218–219.

104. AA to NN, July 31, 1951; AA to BN, August 8, 1951; both cf: Adams, NACCP; *Letters*, 221–222.

105. AA to BN and NN, August 22, 1951, cf: Adams, NACCP.

106. NN to AA, August 30, 1951, cf: Newhalls, AACCP.

107. NN to AA, December 28, 1951, cf: Newhalls, AACCP.

108. NN to AA, August 30, 1951, cf: Newhalls, AACCP.

109. Ibid.

110. Charlotte Mauk, "Conservation in Kodachrome," *The Sierra Club: A Handbook* (San Francisco: Sierra Club, 1947), 57–59; author interview with David Brower, July 13, 1989.

111. AA to Francis Farquhar, November 8, 1937, carbon copy, cf: Farquhar, AACCP; *Letters*, 100.

112. Brant quoted in Fox, *American Conservation Movement*, 281. See also Susan Rhoades Neel, "Irreconcilable Differences: Reclamation, Preservation, and the Origins of the Echo Park Controversy," Ph.D. dissertation, University of California, Los Angeles, 1990; and Elmo Richardson, *Dams, Parks & Politics: Resource Development and Preservation in the Truman-Eisenhower Era* (Lexington: University Press of Kentucky, 1973).

113. Elmo Richardson, "The Interior Secretary as Conservation Villain: The Notorious Case of Douglas 'Giveaway' McKay," *Pacific Historical Review* 41 (August 1972): 333–335.

114. Kennecott Copper Corp., *Kennecott Copper Corporation, 1951* (New York: Kennecott Copper Corp., 1951). See commercial projects activity files: Kennecott Copper, AACCP.

115. *Saturday Evening Post*, October 25, 1952; *Fortune*, November 1952; *Newsweek*, November 3, 1952; *Business Week*, November 8, 1952; *Time*, October 27, 1952.

116. AA to NN, July 31, 1951, cf: Adams, NACCP; *Letters*, 218–219. He was pleased, of course, to get the work and was even more pleased when his photographs were picked up by Kennecott. Adams mentions this fact in a letter to Kodak; AA to Dr. Albert Chapman, Eastman Kodak Company, July 1, 1954, cf: Chapman, AACCP.

117. Joel Hildebrand, "Sierra Club Leader," 24–25.

118. Schrepfer, *Fight to Save the Redwoods*, 88–89.

CHAPTER 9

1. AA to DM, June 19, 1952, carbon copy, cf: McAlpin, AACCP; *Letters*, 224–227.

2. *Autobiography*, 321–322.

3. Beaumont Newhall, *Aperture* 1 (1952): 1.

4. On the founding of *Aperture*, see AA to Dorothea Lange, March 28, 1954, carbon copy cf: Lange; and AA to BN, February 21, 1954, cf: Adams, NACCP.

5. MW to AA, June 24, 1952, cf: Minor White, AACCP.

6. AA to Wynn Bullock, December 1, 1953, carbon copy, cf: Wynn and Edna Bullock, AACCP.

7. *Autobiography*, 293–297. See also, e.g., AA to NN and BN, April 22, 1956, cf: Adams, NACCP; and AA to Harold Bradley, December 22, 1958, Sierra Club Members Papers (71/295c), series 11: David R. Brower files (hereafter cited as Brower files), carton 10, folder 1: Adams, Ansel, 1948–1963, SCA, Bancroft Library.

8. Peter Wensberg, *Land's Polaroid: A Company and the Man Who Invented It* (Boston: Houghton Mifflin, 1987), 29–45; Mark Olshaker, *Instant Image: Edwin Land and the Polaroid Experience* (New York: Stein and Day, 1978), 11–41.

9. AA to DM, November 25, 1937, carbon copy, cf: McAlpin, AACCP.

10. Whether Adams or McAlpin played any role in this is unclear from the existing record. The first correspondence in the Adams archives, cited below, was initiated by Polaroid, which made it sound as if the project was its own idea.

11. Richard Kriebel to AA, October 16, 1945, cf: Polaroid Corporation, AACCP.

12. Wensberg, *Land's Polaroid*, 86–101, 127, 130; Olshaker, *Instant Image*, 49–69, esp. 67.

13. See Adams's correspondence files, Polaroid Corporation, AACCP.

14. See AA to John Varian and Ma (Agnes Varian's adopted Sanskrit name),

[n.d.], cf: Adams family (the letter is misfiled based on the name "Ma"), AACCP.

15. "Wizards of the Coming Wonders," *Life* 36 (January 4, 1954): 93–94. *Autobiography*, 169–170.

16. Gary Topping, "Arizona Highways: A Half-Century of Southwestern Journalism," *Journal of the West* 19 (April 1980): 74–88; Kerwin Klein, "The Last Resort: Tourism, Growth, and Values in Twentieth-Century Arizona," M.A. thesis, University of Arizona, 1990, 207–211.

17. Raymond Carlson, "Up and Down Country," *Arizona Highways* 28 (June 1952): 1.

18. Paul Strand and Nancy Newhall, *Time in New England* (New York: Oxford University Press, 1950). See also Nancy Newhall, "The Caption: The Mutual Relationship of Words and Photographs," *Aperture* 1 (1952): 17–18; and Malin Wilson, "Walking on the Desert in the Sky: Nancy Newhall's Words and Images," in Norwood and Monk, *The Desert Is No Lady*, 47–61. See also Paul Strand's 1940 review of Dorothea Lange and Paul Taylor, *An American Exodus*, in which he calls for "a more active integration between image and word"; *Photo Notes* (March–April 1940): 2.

19. Ansel Adams and Nancy Newhall, "Canyon de Chelley National Monument," *Arizona Highways* 28 (June 1952): 18–27. Adams and Newhall, "Sunset Crater National Monument," *Arizona Highways* 28 (July 1952): 2–5, 34–35. Adams and Newhall, "Death Valley," *Arizona Highways* 29 (October 1953): 16–35; quotation on 16. See also Adams and Newhall, "Organ Pipe Cactus National Monument," *Arizona Highways* 30 (January 1954): 8–17; Adams and Newhall, "Mission San Xavier del Bac," *Arizona Highways* 30 (April 1954): 12–35.

20. "Understatement in the Southwest," *Fortune* 38 (July 1948): 114. Allen C. Reed, "Dream Homes by the Dozen," *Arizona Highways* 30 (September 1954): 24–29, 38–39; quotation on 25.

21. Dorothea Lange, quoted in Milton Meltzer, *Dorothea Lange: A Photographer's Life* (New York: Farrar, Straus, and Giroux, 1977), 253.

22. "Paul Schuster Taylor: California Social Scientist," interviews by Suzanne Reiss and Malca Chall, 1970–1972, Regional Oral History Office, Bancroft Library, University of California, Berkeley, 1975, vol. 1, 244.

23. Ansel Adams and Dorothea Lange, "Three Mormon Towns," *Life* 37 (September 6, 1954): 91–100; see also David Jacobs, "Three Mormon Towns," *Exposure* 25 (Summer 1987): 5–25.

24. Adams, quoted in Meltzer, *Dorothea Lange*, 291.

25. AA to NN, September 26, 1954, cf: Adams, NACCP.

26. Ibid.

27. AA to Paul Brooks, January 15, 1954, carbon copy, cf: Brooks, AACCP.

28. David Brower, memorandum to Sierra Club board of directors, November 26, 1952, Brower files, folder: Sierra Club executive director; SCA, Bancroft Library.

29. SC bd. minutes, October 17, 1953, SCA, Bancroft Library.

30. Leonard, "Mountaineer," 156.

31. Richardson, *Dams*; Neel, "Irreconcilable Differences."

32. Zahnizer, quoted in *SCB* 39 (March 1954): 30.

33. Brower quoted in House Committee on Interior and Insular Affairs, *Hearings on Colorado River Storage Project* (1954), 824. Mark W. T. Harvey, "Echo Park, Glen Canyon, and the Postwar Wilderness Movement," *Pacific Historical Review* 60 (1991): 43–67. Even Brower's calculations proved conservative; later studies suggested a probable difference of only 15,000 acre-feet per year. The erroneous nature of Reclamation's figures on evaporation was first pointed out by retired Army Corps engineer General U.S. Grant III in "The Dinosaur Dam Sites Are Not Needed," *Living Wilderness* (Autumn 1950).

34. David Brower, "Wilderness—Conflict and Conscience," in Brower, *Wildlands in Our Civilization* (San Francisco: Sierra Club, 1964), 52–74; see esp. "Once Is Too Often: *A Picture Story*, This *Was* Hetch Hetchy," 65–72.

35. PH to AA, November 15, 1952, cf: Hyde, AACCP. Author interview with Philip Hyde, July 24, 1989.

36. AA to Philip Hyde, January 10, 1953, carbon copy, cf: Philip Hyde, AACCP.

37. AA to BD, telegram, January 8, 1954, carbon copy, cf: DeVoto, AACCP.

38. BD to AA, June 3, 1954, ibid. Also worth noting is DeVoto's handwritten marginalia: "They say bedfellows make strange politics."

39. AA to NN, April 30, 1954, cf: Adams, NACCP. Note AA's praise of Shasta dam, ironic in the light of the club's campaign against Dinosaur and revealing of his ambivalent stance toward many forms of development.

40. AA to David McAlpin, June 19, 1952, carbon copy, cf: McAlpin, AACCP; *Letters*, 224–227.

41. BN to AA, May 3, 1954, cf: Newhalls, AACCP.

42. NN to AA, May 7, 1954, cf: Newhalls, AACCP. See also AA to NN, May 3, 1954, cf: Adams, NACCP. For what is apparently Adams's first outline of the proposed exhibition, see Adams, "Le Conte Lodge," typed ms. in writings file: This Is the American Earth, notes and text for display panels, NACCP.

43. Bestor Robinson quoted in Brower, *Wildlands in Our Civilization*, 146.

44. See, e.g., A. T. Spenser quoted in Brower, *Wildlands in Our Civilization*, 140.

45. The ecological aspects of Darwin's theories were lost in the heated debate over the social and intellectual implications of his portrait of humans as part of the natural world. The science of ecology remained significant only in narrow fields within biology until the middle of the twentieth century. Anna Bramwell, *Ecology in the Twentieth Century: A History* (New Haven: Yale University Press, 1989); Donald Worster, *Nature's Economy: A History of Ecological Ideas* (Cambridge: Cambridge University Press, 1977); Carl N. Degler, *In Search of Human Nature: The Decline and Revival of Darwinism in American Social Thought* (New York: Oxford University Press, 1991).

46. Aldo Leopold, *A Sand County Almanac and Sketches Here and There* (New

York: Oxford University Press, 1949). Harold C. Bradley, "Aldo Leo-
pold—Champion of Wilderness," *SCB* 36 (May 1951): 14–18. Brower's
conversion is described in Cohen, *History of the Sierra Club*, 117.

47. Susan Flader, *Thinking Like a Mountain: Aldo Leopold and the Evolution of an
Ecological Attitude Toward Deer, Wolves, and Forests* (Columbia: University
of Missouri Press, 1974); Curt Meine, *Aldo Leopold: His Life and Work*
(Madison: University of Wisconsin Press, 1987).

48. Aldo Leopold, "A Biotic View of the Land," *Journal of Forestry* 37 (Septem-
ber 1939): 727–730.

49. Aldo Leopold, "The Land Ethic," in *A Sand County Almanac*, 201–226.

50. Aldo Leopold, "Why the Wilderness Society?" *Living Wilderness* 1 (Sep-
tember 1935): 6.

51. Robert Marshall, "The Wilderness as a Minority Right," *U.S. Forest Ser-
vice Bulletin* 27 (August 1928): 5–6.

52. Panel discussion, "The Wilderness Idea: How Can We Maintain It?" in
Brower, *Wildlands in Our Civilization*, 146–151.

53. BN to AA, May 24, 1954, cf: Newhalls, AACCP.

54. NN to AA, August 2, 1954, ibid.

55. NN to AA, September 9, 1954, ibid.

56. AA to NN, September 19, 1954. See also AA to NN, September 13, 1954,
both cf: Adams, NACCP. As an artist, Adams found nature's value to be
essentially symbolic. His views and his imagery drew on the romantic
tradition in which nature was not only a source of inspiration but also a
symbolic reflection of the divine, of human emotion, and of social ideals.
Nature was set in opposition to the fallen world of man and worshiped as
the source of salvation from the sins of modern life.

57. NN to AA, February 21, 1952, cf: Newhalls, AACCP. See also AA to NN,
February 14, 1952, cf: Adams, NACCP.

58. BD to NN, September 4, 1954, cf: DeVoto, NACCP.

59. AA to NN, September 13, 1954, and AA to NN, September 19, 1954, both
cf: Adams, NACCP.

60. AA to NN, July 31, 1954, cf: Adams, NACCP.

61. See the materials in writings file: This Is the American Earth, exhibition, notes and text for display panels, NACCP.

62. Ansel Adams and Nancy Newhall, *Death Valley* (Palo Alto: 5 Associates, 1954); Ansel Adams and Nancy Newhall, *Mission San Xavier del Bac* (Palo Alto: 5 Associates, 1954). See *Autobiography*, 103, and "Conversations," 500–501.

63. See AA to BN, February 21, 1954, AACCP; and BN to AA, February 16, 1954, AACCP.

64. AA to HAM, September 29, 1954, cf: Guggenheim Foundation, AACCP. See also AA to Horace Albright, September 19, 1955, cf: Albright, AACCP, in which Adams sketches projected costs and enlists Albright's suggestions.

65. NN to AA, August 17, 1955, cf: Newhalls, AACCP.

66. RS to NN, September 8, 1955, cf: Richard Simon, NACCP.

67. Wallace Stegner, ed., *This Is Dinosaur: Echo Park Country and Its Magic Rivers* (New York: Alfred A. Knopf, 1955).

68. The advertisement, an open letter to Congress, is reproduced in *Living Wilderness* 20 (1955–1956): 24.

69. Leonard, "Mountaineer," 112.

70. U.S., *Statutes at Large* 39 (1916): 535; see also Runte, *National Parks*, 103–104, 160.

71. AA to Harold Bradley, July 12, 1958, Bradley files, carton 7, folder 40: Roads, Tioga Pass (Calif.) 1950–July 1958, SCA, Bancroft Library. AA to Fred Seaton, Sinclair Weeks, and Conrad Wirth, July 7, 1958, copy in ibid.; *Letters*, 251.

72. AA to Horace Albright, July 11, 1957, carbon copy, cf: Albright, AACCP; *Letters*, 244–246. See also AA to Harold Bradley, Bradley files, carton 7, folder 40: Roads, Tioga Pass (Calif.) 1950–1958, SCA, Bancroft Library.

73. Leonard, "Mountaineer," 67–68; AA to Harold Bradley, Bradley files, carton 4, folder 40: correspondence, Adams, Ansel, 1958, SCA; Richard

Leonard to AA, July 28, 1958, Brower files, carton 10, folder 1: Adams, Ansel, 1948–1963, SCA, Bancroft Library.

74. Considering Adams's active role in the club, it is surprising that he never served as its president. Having worked for so many years as a director, it was inevitable that his name would come up for nomination as president. In 1959 it did. There was an informal meeting at Adams's home in San Francisco to solicit nominations for the club's next president following Harold Bradley's term. According to Lewis Clark, several in attendance enthusiastically recommended Adams. Others, however, wondered whether he would have the necessary time to devote to the job and its many administrative details. His emotional resignation over the Tioga Road issue may have convinced some directors that he would not be a reliable club president. Adams declined before a vote on the matter, regretting that his workload and heavy travel demands would not permit him to take on the position. See Lewis Clark, "Perdurable and Peripatetic Sierra . . . ," an interview conducted by Marshall Kuhn, 1975–1977, Sierra Club History Committee 1982, 105–106. It was always Adams's position that his most effective work for the Sierra Club and conservation in general was through his photography. Brower makes an oblique reference to this in *For Earth's Sake*, 190.

75. AA to Paul Brooks, October 24, 1957, cf: Paul Brooks, AACCP.

76. See, e.g., AA to HA, July 11, 1957, cf: Albright, AACCP; *Letters*, 244–246.

77. Ibid.; AA to Harold Bradley, March 24, 1959, AACCP; *Letters*, 256–257. See also AA to Henry Allen Moe, April 6, 1958, cf: conservation correspondence, AACCP; AA to David Brower and others, November 19, 1956, Brower files, carton 29, folder: Sierra Club Committees, Publications Committee, SCA, Bancroft Library.

78. Fred Grunsky to David Brower, January 14, 1957 [copy supplied to Adams], cf: conservation correspondence, AACCP. Philip Hyde, pleased with the success at Dinosaur and ready for new challenges, had several suggestions, including a "Conservation Photography Clearing House"

sponsored by the Sierra Club, the Wilderness Society, and the National Parks Association. He also suggested "a Conservation Calendar, made up of a fine reproduction for each month, of simple and dignified layout, with a short conservation message." See January 9, 1957, memo to Board of Directors from Brower, cf: Hyde, AACCP; PH to AA, January 17, 1957 [same file]. Little did he know that several decades later, wilderness stock photography would be a million-dollar industry and Sierra Club calendars would be one of the club's biggest sources of revenue and new membership.

79. David Brower to AA, September 27, 1956; *Letters*, 238–240.

80. AA to Garfield Merner, March 8, 1956, carbon copy cf: Merner, AACCP. Merner was a wealthy San Francisco lumberman who was supporting the project.

81. NN, "Progress Report," April 1956, writing file, NACCP.

82. Edward Steichen, Introduction, in *The Family of Man* (New York: Museum of Modern Art, 1955), 4.

83. Carl Sandburg, Prologue, in *Family of Man*, 2.

84. *Autobiography*, 209–210.

85. AA to Alyce Haas, July 16, 1955, carbon copy, cf: Haas, AACCP.

86. Ibid.

87. Edward Steichen, quoted in Meltzer, *Dorothea Lange*, 283.

88. Wilson P. Dizard, *The Strategy of Truth: The Story of the U.S. Information Service* (Washington, D.C.: Public Affairs Press, 1961); Thomas C. Sorenson, *The Word War: The Story of American Propaganda* (New York: Harper and Row, 1966); Emily Rosenberg, *Spreading the American Dream* (New York: Hill and Wang, 1982).

89. NN to AA, September 23, 1956, cf: Newhalls, AACCP.

90. NN to Michael Barjansky, chief, development branch, exhibits division, USIA, September 22, 1956, writings file: This Is the American Earth, exhibit correspondence, NACCP. See also AA to MB, September 12, 1956, carbon copy, cf: Barjansky, AACCP.

91. NN to AA and VA, November 5, 1956, cf: Newhalls, AACCP.

92. For installation views, see AACCP, Ag31:2:3:7, folder, exhibitions, "I Hear America Singing," USIA, Berlin, West Germany-Kongresshalle. Note: It seems the show was at some point reorganized into these divisions: opening, travel, history, East, Midwest, South, West, Southwest, Northwest, races and festivals, hospitals and charities, religions, children, housing, industry, national parks, sports, artists, scientists, ending.

93. Ansel Adams and Nancy Newhall, *I Hear America Singing*, exhibition file, "I Hear America Singing," AACCP.

94. Shaw's 1842 decision in *Commonwealth v. Hunt* overturned the precedent that labor unions, by their very nature, constituted an unlawful restraint of trade. Shaw ruled that unions could serve constructive ends and that workers had a right to organize and to strike provided no laws were broken in the process. See Walter Nelles, "Commonwealth v. Hunt," *Columbia Law Review* 32 (1932): 1128–1169; and Alfred Konestsky, "'As Best to Subserve Their Own Interest': Lemuel Shaw, Labor Conspiracy, and Fellow Servants," *Law and History Review* 7 (1989): 219–239.

95. Henry Luce, publisher of *Time, Life*, and *Fortune* magazines and one of the leading proponents of the crusade for capitalism and liberal democracy in the postwar era, called it "the best show ever made on America." The exhibition did, in many ways, express the self-righteous idealism he had helped to define in his highly influential 1941 article, "The American Century." There was much in the show, however, that Mr. Luce might not have cared to see carried from the realm of art into social reality, as the last panels offer a vision of egalitarian democracy and racial equality that, if implemented, might diminish the power of men like himself. See NN to AA, September 25, 1957, cf: Newhalls, AACCP. Henry Luce, "The American Century," *Life* 10 (February 17, 1941): 61–65.

96. For the evolution of Newhall's text, see writing file: This Is the American Earth exhibit, 1955–'59—rough drafts, NACCP.

97. NN to AA, October 24, 1958, cf: Newhalls, AACCP; *Letters*, 252–253.

98. White was working as an exhibitions organizer and editor of the museum's

publication, *The Image*. In 1955 he had begun teaching photography at the Rochester Institute of Technology. Throughout these years, he continued to serve as editor of *Aperture*.

99. AA to NN, November 17, 1958, cf: Adams, NACCP; *Letters*, 254–255.

100. *Autobiography*, 253.

101. Brett Weston to AA, July 22, 1955, and July 25, 1955; AA to BW, July 22, 1955; all cf: Brett Weston, AACCP; *Letters*, 232–233. See also AA to Edwin Land, January 5, 1958, cf: Land, AACCP; *Letters*, 249–250.

102. AA to NN, June 28, 1959, cf: Adams, NACCP; *Letters*, 258–259.

103. Author interview with David Brower, July 13, 1989. See also DB to NN, November 29, 1958, writings file: This Is the American Earth book, correspondence, 1956–58, NACCP, for some of Brower's comments and suggested readings.

104. See the correspondence in Brower files, carton 30, folder 36: Sierra Club Publications, *This Is the American Earth*, 1958–1969, SCA, Bancroft Library; Acknowledgments, Adams and Newhall, *This Is the American Earth* (San Francisco: Sierra Club, 1960).

105. Adams and Newhall, *This Is the American Earth*, ii–iii.

106. Ibid., 1–4.

107. Ibid., 4–5.

108. Ibid., 8–9.

109. Ibid., 14–15.

110. Ibid., 17.

111. Ibid., 22–32.

112. Ibid., 48–49.

113. Edgar Wayburn, "Sierra Club Statesman, Leader of the Parks and Wilderness Movement: Gaining Protection for Alaska, the Redwoods, and Golden Gate Parklands," interview conducted by Ann Lage and Susan R. Schrepfer, Regional Oral History Office, Bancroft Library, Berkeley, 1985, 192. Figures for *American Earth* are from David Featherstone, "This Is the American Earth: A Collaboration, Ansel Adams and Nancy New-

hall," a paper presented to the Ansel Adams scholars conference, Carmel Valley, California, July 26, 1992. The version published in *Ansel Adams: New Light*, 63–73, does not include this information; Featherstone's figures are from royalty statements of Sierra Club Books. The combined sales for *The American Earth* in both hard- and soft cover was 75,000 before its reissue by the club in 1992.

114. Kafka quoted in Alfred Kazin, *A Writer's America: Landscape in Literature* (New York: Alfred A. Knopf, 1988), 74.

115. Author interview with David Brower, July 13, 1989.

116. Rachel Carson, *Silent Spring* (Boston: Houghton Mifflin, 1962), 95.

117. Thomas H. Jukes, interviewed by Nadzan Haron, February 1981, Sierra Club History Project, Oral History, Sierra Club Library, San Francisco, 3–4. Alexander Hildebrand, "Sierra Club Leader and Critic," interview conducted by Ann Lage, Regional Oral History Office, Bancroft Library, Berkeley, 39–40. Joel Hildebrand, "Sierra Club Leader," 31–34. Adams shared their concern; see especially his correspondence with Thomas Jukes in Sierra Club and Conservation files: general correspondence, Thomas Jukes, AACCP.

118. François Leydet, ed., *Tomorrow's Wilderness* (San Francisco: Sierra Club, 1963), 133, 211, 212.

## CHAPTER 10

1. AA to NN, December 18, 1966, cf: Adams, NACCP; *Letters*, 288–290.

2. For examples of this turn, see, among others, *Ice on Ellery Lake*, 1959; *Robert Boardman Howard*, 1960; *Tree, Stump, and Mist*, 1958; *Tree, Point Arena*, 1960; *Street Arrow, Boston*, 1960; *Moon and Half Dome*, 1960; and *Grass, Laguna Nigel*, 1962.

3. In addition to the broad stylistic shifts outlined here, there was, of course, a differing emphasis from photograph to photograph throughout his career. For expressions of Adams's return to more formalist concerns in these

years, see AA to John Szarkowski, October 14, 1962; JS to AA, October 19, 1962; and AA to JS, October 23, 1962; all cf: Szarkowski, AACCP; *Letters*, 284–288. It is interesting that Szarkowski speaks of "the idea" as the motive for a photograph, while Adams speaks of "the emotion." Szarkowski's more cerebral and conceptual orientation was typical of the prevailing one in photography in the coming decades.

4. They later discovered that Laura Gilpin and Eliot Porter were both photographing that same day a bit farther up the road. Everyone had a unique interpretation, Worth recalled. "I never saw [Gilpin's or Porter's] images, but it was rather strange to see how unlike Gerry's photographs were to mine and mine to Ansel's." Don Worth interview for audio guide to the exhibition *Ansel Adams: One with Beauty*, M. H. de Young Museum, San Francisco, 1987. For Adams's account of the day, see *Examples*, 60–64. Adams recalled that he was the one who noticed the grove; I have given Worth the benefit of the doubt.

5. *Examples*, 60–64. Adams used a dark yellow filter to raise the values of the leaves and lower the foreground and background values.

6. Worth, ibid.; author interview with David Brower, July 13, 1989.

7. AA to NN and BN, April 15, 1961, cf: Adams, NACCP; *Letters*, 272–274.

8. *Autobiography*, 329–331.

9. Adams, *Camera and Lens*, 214. Author interview with Alan Ross, July 14, 1989.

10. For a description of the show, see Beaumont Newhall, "The Eloquent Light," exhibition review, *Popular Photography* (February 1964): 92; photocopy supplied to author by Beaumont Newhall. Newhall feels that this was the best of Adams's exhibitions; author interview with Beaumont Newhall, July 3, 1989. See also *Autobiography*, 218, and exhibition files, The Eloquent Light, AACCP.

11. "Conversations," 406.

12. *San Francisco Examiner*, January 15, 1964.

13. Kirstein quoted in Newhall, *Eloquent Light*, 165.

14. George Allen Young, "The Eloquent Light," *Popular Photography* (February 1964): 93.

15. Helen Gee, *Photography of the Fifties* (Tucson: Center for Creative Photography, 1980). The emphasis on spontaneity, on chance and risk, on chaos over order, was an aspect of all forms of art emerging in the postwar era, from writing to music to painting.

16. Jack Kerouac [introduction], in Robert Frank, *The Americans* (New York: Grove Press, 1959), unpaginated.

17. Yuben Yee quoted in Patricia Bosworth, *Diane Arbus: A Biography* (New York: Alfred A. Knopf, 1984). On Arbus's vision of America, see Susan Sontag, *On Photography* (New York: Farrar, Straus, and Giroux, 1977), 27–48.

18. AA to Alvin Langdon Coburn, May 18, 1964, cf: Coburn, AACCP. See also ALC to AA, April 24, 1964 [same file] in praise of *The Eloquent Light*. Both are reproduced in *Letters*, 290–291.

19. See, e.g., AA to Henry Allen Moe, November 22, 1959, carbon copy, cf: Guggenheim Foundation, AACCP, in which he praises the work of Aaron Siskind and Paul Caponigro.

20. Wallace Stegner, Foreword, in Ansel Adams, *Images: 1923–1974* (Boston: New York Graphic Society, 1974), 7–19; quotation on 12.

21. The best-known account of Kesey's adventures in these years is Tom Wolfe, *The Electric Kool-Aid Acid Test* (New York: Farrar, Straus, and Giroux, 1968).

22. Quoted in Martin Lasden, "Wallace Stegner, On His Own Terms," *Stanford Magazine* (Spring 1989): 23–30; quotation on 26.

23. SB to AA, April 16, 1963, March 5, 1964, and March 9, 1964, cf: Brand, AACCP. The popular conception of Native American land ethics is discussed in Richard White, "Native Americans and the Environment," in *Scholars and the Indian Experience*, ed. W. R. Swagerty, 179–204 (Bloomington: Indiana University Press, 1984).

24. SB to AA, January 28, 1964; AA to SB, February 11, 1964, carbon copy, both in cf: Steward Brand, AACCP.

25. Adams, "Give Nature Time," commencement address, Occidental College, June 1967, activity files: articles, speeches, interviews, AACCP.

26. "Conversations," 605.

27. Jacob Deschin, "Eliot Porter, Medication to Conservation," *Popular Photography* (December 1967): 70, 72, 74, 84.

28. AA to Eliot Porter, July 8, 1958, carbon copy, cf: Porter, AACCP; AA to William Siri, August 12, 1965, Brower files, carton 29, folder 12: Sierra Club Publications Correspondence, 1965, SCA, Bancroft Library; author interview with Philip Hyde, July 24, 1989.

29. Eliot Porter, *In Wildness Is the Preservation of the World* (San Francisco: Sierra Club, 1962), 11. Adams, who saw the exhibition in Rochester, was extremely impressed; see AA to EP, October 4, 1960, carbon copy, cf: Porter, AACCP.

30. Figures supplied by Sierra Club Books.

31. Wallace Stegner, "Wilderness and the Geography of Hope," in Brower, ed., *Wilderness: America's Living Heritage* (San Francisco: Sierra Club, 1961), 97–102. The piece was written as a letter to David E. Pesonen of the University of California's Wildland Research Center for use in a report on wilderness for the Outdoor Recreation Resources Review Commission.

32. Stephen H. Spurr, "The Value of Wilderness to Science," in Leydet, *Tomorrow's Wilderness*, 59–74. Spurr's views so upset Brower that he wanted to offer a rebuttal in his introduction to *Tomorrow's Wilderness*, the compilation of the conference's proceedings. He considered Spurr's article "a disguised attack upon the scientific basis of wilderness preservation." Edgar Wayburn, then serving as club president, persuaded him to let the article speak for itself. See DB to William J. Losh, September 24, 1963, in Brower files, SC Committees, Publications Committee, 1963, SCA, Bancroft Library.

33. George Marshall to Wallace Stegner, with copies to David Brower, William Siri, Ansel Adams, and Martin Litton, December 23, 1964; Stegner to Marshall [cc: Adams and Brower], December 29, 1964; both Sierra Club Members Papers, series 1: Adams files (hereafter cited as Adams files), carton 2, folder 26: Sierra Club Committees, Publications Committee, Correspondence, 1961–1970, SCA, Bancroft Library. The irony here is that Nancy Newhall, who developed the idea of the "Eloquent Light Notes," found the quotation in Adams's 1936 letter to Alfred Stieglitz, in which he described his emotional depression of that winter and his vow to return to a simpler life. See AA to Alfred Stieglitz, December 22, 1936, ASAY, cited at the end of chap. 5.

34. AA to "Wally and All" [Stegner and members of the Sierra Club Publications Committee], December 28, 1964, ibid.; *Autobiography*, 86–87.

35. The first quotation is from Robinson Jeffers, Preface, in *The Double Axe, and Other Poems* (New York: Random House, 1948). Robinson Jeffers, "The Answer," in *Such Counsels You Gave to Me* (New York: Random House, 1937).

36. William Siri, "A Fractured History of the Sierra Club," *Voices for the Earth: A Treasury of the Sierra Club Bulletin* (San Francisco: Sierra Club Books, 1979), 82–83. David Brower had noted the trend in 1963: see DB to Pete Van Gorp, May 23, 1963, Brower files, carton 32, folder 1: Sierra Club Committees, Publications Committee, 1963, SCA, Bancroft Library. Data for club membership from *The Sierra Club: A Guide* (San Francisco: Sierra Club, 1989), 20, 23, 24, 29, 55–57.

37. AF, memorandum, re: Publications Program of the Sierra Club, August 9, 1963, Brower files, carton 32, folder 1: Sierra Club Committees, Publications Committee, 1963, SCA, Bancroft Library. On this, Brower's copy of the memorandum, Frugé added a note saying that he realized Brower would not likely care for the contents but that he hoped it would encourage Brower to clarify what he had in mind for Sierra Club publications. See

also Brower's reply, DB to AF, August 23, 1963, same file. Cohen, *History of the Sierra Club*, 294–299.

38. AA, memorandum, August 16, 1963, Brower files, carton 32, folder 1: Sierra Club Committees, Publications Committee, 1963, SCA, Bancroft Library.

39. WS to David Brower, August 25, 1963, ibid.

40. Wayburn, "Sierra Club Statesman," 186. For similar sentiments, see Leonard, "Mountaineer," 339; Hildebrand, "Joel Hildebrand," 29; and AA to Eliot Porter, January 24, 1967, carbon copy, Adams files: carton 1, folder 49: Sierra Club, Brower Controversies, SCA, Bancroft Library.

41. Ansel Adams and Nancy Newhall, *Fiat Lux: The University of California* (New York: McGraw-Hill, 1967).

42. Adams related this story to his photographic assistant, Alan Ross. Author interview with Alan Ross, July 14, 1989.

43. AA to the Honorable Edmund G. Brown, May 9, 1966, activities files: Sierra Club and Conservation, General Correspondence, 1966, AACCP.

44. David Brower, Foreword, in Eliot Porter, *The Place No One Knew: Glen Canyon on the Colorado* (San Francisco: Sierra Club, 1963). Adams supported the publication of both books and was one of the first to recommend a book on the Grand Canyon. See George Marshall to SC Publications Committee, "re: Ansel Adams Grand Canyon Project Proposal," Brower files, carton 29, folder 11: Sierra Club Publications, correspondence, 1958–1964, SCA, Bancroft Library.

45. David Brower, quoted in *The Sierra Club*, 30.

46. Bestor Robinson, "Suggestions for Coordinating Grand Canyon National Park and Monument into Overall Plans for Colorado River," memo to Brower et al., October 1938, General; Brower files, Grand Canyon, general, SCA, Bancroft Library. Robinson, "Thoughts on Conservation and the Sierra Club," 24.

47. [Floyd Dominy], *Lake Powell: Jewel of the Colorado* (Washington, D.C.:

Government Printing Office, 1964), ii. Although Dominy is not credited, it is generally agreed that he wrote the entire book. See Marc Reisner, *Cadillac Desert: The American West and Its Disappearing Water* (New York: Viking, 1986), 255.

48. AA to Sierra Club, attention: George Marshall and David Brower, July 2, 1966, *Letters*, 292.

49. Brower, "Environmental Activist," 148.

50. "Conversations," 597.

51. Brower, "Environmental Activist," 151. Siri, "Reflections," 48–69; Cohen, *History of the Sierra Club*, 352–365.

52. Leonard, "Mountaineer," 375; Hildebrand, "Sierra Club Leader," 29.

53. "Conversations," 596. See also AA to Hon. Fred Farr [member of the California State Senate for Monterey County], January 8, 1963, activity files: Sierra Club and Conservation, AACCP.

54. Leonard, "Mountaineer," 282–306; Cohen, *History of the Sierra Club*, 365–376. Doris Leonard (married to Richard Leonard), Dorothy Varian (widow of Adams's friend Russell Varian), and George Collins (a former member of the National Park Service) were the principals in Conservation Associates. The Varians' commitment to saving Nipomo Dunes was based in large part on their family's long association with the area.

55. Michael McCloskey, "Sierra Club Executive Director," 93.

56. Minutes, board of directors meeting, May 7–8, 1966, SC Records, series 2: BoD/Ex Com. Records, carton 4, folder 5: SC BoD: Minutes of Meetings, 1966, SCA, Bancroft Library. The earlier resolution on coastal power plants is from minutes, board of directors meeting, September 7, 1963, SC Records, series 2: BoD/Ex Com. Records, carton 4, folder 2: SC BoD: Minutes of Meetings, 1963, SCA, Bancroft Library. See also Fred Eissler to William Siri, April 29, 1966, copy to AA, Activity files: Sierra Club and Conservation: Board of Directors, 1966–'67, AACCP.

57. AA to George Marshall and David Brower, July 2, 1966, *Letters*, 292.

58. Author interview with David Brower, July 13, 1989.

59. Minutes, special meeting of board of directors, January 7–8, 1967, SC Records, series 2: BoD/Ex Com. Records, carton 4, folder 6: BoD: Minutes of meetings, 1967, SCA, Bancroft Library. Raymond Dasmann, *The Destruction of California* (Berkeley and Los Angeles: University of California Press, 1965).

60. See Spencer R. Weart, *Nuclear Fear: A History of Images* (Cambridge: Harvard University Press, 1988), 325–327, passim.

61. Grant McConnell, *Private Power and American Democracy* (New York: Alfred A. Knopf, 1966); see esp., "Quest for the Public Interest," 336–368.

62. Leonard, "Mountaineer," 24, iv–v.

63. Minutes, board of directors, May 6, 1967, SC Records, series 2: BoD/Ex Com., carton 4: folder 6: BoD: Minutes of Meetings, 1967, SCA, Bancroft Library.

64. AA to DB, November 9, 1966, Brower files, carton 1, folder 2: Adams, Ansel, 1967–1972, SCA, Bancroft Library; *Letters*, 293–295. See also AA to DB, September 2, 1966, and AA to DB, September 14, 1966, same file. Brower apparently did not reply to these earlier letters. There is, however, a rough draft of a reply from Brower (undated [ca. Dec. 1966, as Brower refers to AA letter to George Marshall of Dec. 1, 1966], same file), in which Brower argued that Adams was being misled by other directors and that the club's organizational and financial difficulties were primarily due to "growing pains" that would be overcome in time. Seven past presidents of the club, who co-signed a letter regarding Brower the following April, took a much harsher stand than Adams. "To all members of the Board and Council of the Sierra Club," from Horace M. Albright, Phil S. Bernays, Harold C. Bradley, Harold E. Crowe, Francis P. Farquhar, Clifford Heimbucher, Alexander Hildebrand, Joel H. Hildebrand, Milton Hildebrand, Bestor Robinson, and Robert G. Sproul, April 28, 1967, reprinted as an appendix to Leonard, "Mountaineer," 446–448. If there was a conservative opposition, this was it. The Adams files contain what may be the original draft of this letter, which may suggest that Adams played a role in

its creation; see Adams files, carton 1, folder 49: Brower controversies, 1967, SCA, Bancroft Library.

65. Terry Russell and Renny Russell, *On the Loose* (San Francisco: Sierra Club/ Ballantine Books, 1967), unpaginated.

66. Memorandum, Leonard to Board of Directors, April 24, 1968, Adams files, carton 1, folder 50: Brower controversies, March–July 1968, SCA, Bancroft Library. Brower disagreed with the figures arrived at by the Sierra Club controller, Clifford Rudden. His most significant suggestion was to include the income from new memberships directly attributable to publications; see DB to CR, April 29, 1968, copy in same file.

67. AA to the Board of Directors of the Sierra Club, September 1968, Adams files, carton 1, folder 52: Brower Controversies, August–September 1968, SCA, Bancroft Library; *Letters*, 298–299. See also AA to Richard Sill, September 29, 1968, Richard Sill Papers, box 49, University of Nevada, Reno.

68. *San Francisco Examiner*, June 30, July 3, and July 9, 1968.

69. Eliot Porter, "Statement of Eliot Porter at Board Meeting," September 15, 1968, Brower files, Brower Controversy, 1968, SCA, Bancroft Library.

70. AA to the Board of Directors of the Sierra Club, September 1968, Adams files, carton 1, folder 52: Brower Controversies, August–September 1968, SCA, Bancroft Library; *Letters*, 298–299.

71. Draft Minutes, board of directors meeting, October 19, 1968, Adams files, carton 1, folder 53: Brower Controversies, November–December 1968, SCA, Bancroft Library.

72. DB to AA, October 31, 1968, Adams files, carton 1, folder 51: Brower Controversies, October 1968, SCA, Bancroft Library. James E. Bryant, chair of the Rocky Mountain chapter, offered his resignation in the summer of 1968, disgusted by the infighting. "The sickness that pervades the Sierra Club is only that same sickness that pervades our society; the only difference is that so far the club has only had character assassinations."

Copy of letter in Adams files, carton 1, folder 50: Brower Controversies, March–July 1968, SCA, Bancroft Library.

73. Wallace Stegner in *Palo Alto Times*, February 11, 1969; reprinted in CMC brochure in Adams files, carton 2, folder 38: Sierra Club elections, Concerned Members for Conservation, 1969, SCA, Bancroft Library.

74. ABC brochure, Adams files, carton 2, folder 37: Sierra Club Elections, Active, Bold, Constructive Sierra Club, February–March 1969, SCA, Bancroft Library. CMC brochure, Adams files, carton 2, folder 38: Sierra Club Elections, Concerned Members for Conservation, SCA, Bancroft Library. AA to "The Public" [press release], February 4, 1969, *Letters*, 302–303.

75. In his resignation statement, Brower began by referring to a photograph by Adams that had appeared in the *San Francisco Chronicle* that morning. The famed giant sequoia known as the Wawona tunnel tree (for the tunnel that had been carved out of its trunk to allow cars to pass through it) had fallen the previous day, a victim of its own fame. Adams's photograph showed the tree in better days. "I feel a bit sympathetic about the Wawona tunnel tree," Brower said that morning. "I also let Ansel notice that I was in that photograph looking back at him at the time. I think that since that time I have gained slightly more weight than the Wawona tree." Brower seemed to imply that he had been weakened by others and brought down by forces beyond his control. "David Brower's Statement," Appendix D, Minutes, BoD meeting, May 3–4, 1969, SC Records, series 2: BoD/Ex Com. Records, carton 4, folder 8: SC, BoD, Minutes of Meetings, 1969, SCA, Bancroft Library.

76. Leonard quoted in John McPhee, *Encounters with the Archdruid* (New York: Farrar, Straus, and Giroux, 1971), 216.

77. Author interview with Brower, July 13, 1989. Although Adams defended Porter's right to royalties from Sierra Club publications as part of his professional livelihood, he may have been envious of Porter's more substantial income from Sierra Club publications. From January 1964 through Sep-

tember 1968, Adams received $11,940.50 in royalties, while Porter received $98,643.53, according to the accounting of the controller, Clifford Rudden. See CR to AA, September 27, 1968, Adams files, carton 1, folder 52: Brower Controversies, August–September 1968, SCA, Bancroft Library.

78. AA to EW, April 19, 1969, SC Members Papers, series 68: Edgar Wayburn files, carton 223, folder 23: Adams, Ansel, 1967–1984, SCA, Bancroft Library; *Letters*, 303–304. Philip Berry, quoted in "Sierra Club Annual Organizational Meeting May 3–4," *SCB* 54 (May 1969): 3.

79. See "exhibit B," included in Minutes, board of directors meeting, September 20–21, 1969, SC Records, BoD/Ex Com. records, carton 4, folder 9: SC BoD, Minutes of Meetings, 1969, SCA, Bancroft Library.

80. Adams, "Conservations," 674, 713. AA to Judge Raymond Sherwin, President, Sierra Club, September 13, 1971, *Letters*, 312.

81. AA to Nancy and Beaumont Newhall, December 9, 1971, *Letters*, 313.

82. Ansel Adams and Nancy Newhall, *The Tetons and the Yellowstone* (Palo Alto: 5 Associates, 1970).

83. See AA to David Brower, March 20, 1963, Brower files, carton 10, folder 1: Adams, Ansel, 1948–1963, SCA, Bancroft Library.

84. AA to NN and BN, June 30, 1974, *Letters*, 330–331; BN to AA and VA, July 1974, *Letters*, 332; AA to NN, July 5, 1974, *Letters*, 332–333; AA to BN, August 18, 1974, *Letters*, 334; BN to AA and VA, March 23, 1977, *Letters*, 343–344. *Autobiography*, 218–219. The Adamses made their donation in several installments beginning in 1974, when income from publishing was rising substantially.

85. Author interview with William Turnage, July 5, 1989.

86. Ibid.

87. Ibid.; AA to Marion Patterson, September 19, 1972, *Letters*, 317–318.

88. *Autobiography*, 334; Beaumont Newhall, "The Beginnings," in *Light Years: The Friends of Photography, 1967–1987 [Untitled 43]* (Carmel: Friends of Photography, 1987), 8–9; James Alinder, "The Friends: A Retrospective View," in ibid., 32–42, esp. 34.

89. James Alinder, "The Friends," 34.

90. *Autobiography*, 362–363; author interview with William Turnage, July 5, 1989.

91. Author interview with Alan Ross, July 14, 1989.

92. See William Turnage, Ansel Adams Gallery press release, September 9, 1974, announcing the publication of *Images, 1923–1974*, copy in Dept. of Photography, biographical file: Ansel Adams, DPA-MoMA.

93. Robert Hughes, "The Master of Yosemite," *Time* 114 (September 3, 1979): 3, 36–44. It is interesting to speculate whether or not the fact that Adams's publisher was a subsidiary of Time, Inc., played a role in the decision to feature him on the magazine's cover.

94. John Szarkowki, Introduction, in *Classic Images*, 5–6.

95. Adams quoted in George B. Hartzog, Jr., "Clearing the Roads—and the Air—in Yosemite Valley," *National Parks and Conservation Magazine* 46 (August 1972): 14. *Autobiography*, 190.

96. Richard Misrach, "Documenting America's Wounded Landscape," *Earth Island Journal* 5 (Spring 1990): 28–29. See also Richard Misrach and Miriam Weisang Misrach, *Bravo 20: The Bombing of the American West* (Baltimore: Johns Hopkins University Press, 1990). Misrach proposed turning the Bravo 20 bombing site into a national park. His suggestions for tourist amenities included a "Boardwalk of the Bombs" and a loop road called "Devastation Drive." For an excellent discussion of the issues surrounding landscape representation in photography and its environmental implications, see Charles Hagen, ed., *Beyond Wilderness*, special issue, *Aperture* 120 (Late Summer 1990); articles by Barry Lopez, Charles Hagen, Rebecca Solnit, Joel Connely, Wes Jackson, Gerald Halsam, J. B. Jackson, and Mark Klett.

97. William Jenkins, *New Topographics: Photographs of a Man-altered Landscape* (Rochester: International Museum of Photography, 1975).

98. Author interview with James and Mary Alinder; author interview with Alan Ross, July 14, 1989. See also Robert Hellman and Marvin Hoshino

comparing Ansel Adams and Robert Adams, *Village Voice* 20 (March 17, 1975): 90; and Grace Glueck, *New York Times*, November 12, 1976, which includes Adams's rejoinder to such critiques.

99. Adams, *The New West.*

100. Gary Snyder, "The Etiquette of Freedom," in *The Practice of the Wild* (San Francisco: North Point Press, 1990), 3–24; quotation on 14–15.

101. See, e.g., Bill Devall and George Sessions, eds., *Deep Ecology: Living as if Nature Mattered* (Salt Lake City: Gibbs Smith, 1985).

102. Even in the late 1980s, as biocentric views gained wide acceptance, environmentalists continued to employ the imagery of romanticism. As the environmental historian P. R. Hay noted, "The environmental movement's unsatisfactorily schizophrenic modus operandi involves it in a sleight of hand whereby its ecocentric goals are disguised behind acceptable homocentric political pitches, and these frequently make appeal to these romantic values which continue to possess much popular attraction." P. R. Hay, "The Contemporary Environmental Movement as Neo-Romanticism: A Reappraisal from Tasmania," *Environmental History Review* 12 (Winter 1988): 39–59; quotation on 47.

103. AA to President Jimmy Carter, November 8, 1979; President Carter to AA, November 9, 1979; President Carter to AA, February 15, 1980; AA to President Carter, July 16, 1980; President Carter to AA, August 25, 1980; AA to President and Mrs. Carter, November 6, 1980, all in *Letters*, 355–363.

104. *Autobiography*, 350.

105. Dale Russakoff, "The Critique: Ansel Adams Takes Environmental Challenge to Reagan," *Washington Post*, July 3, 1983, A1, A6; Adams, *Autobiography*, 349–351.

106. Ibid.

107. See, e.g., AA to William Turnage, [n.d.] 1981, *Letters*, 365–366 (Turnage was at that time serving as executive director of the Wilderness Society); AA to *San Jose Mercury News* [open letter printed on the editorial page,

Sunday, May 3, 1981], April 28, 1981, *Letters*, 366–368; AA to Howard Simon [managing editor, *Washington Post*], July 22, 1982, *Letters*, 376; AA to Otis Chandler [publisher of the *Los Angeles Times*], July 5, 1983, *Letters*, 380–381.

108. Adams, *Autobiography*, 374; Wallace Stegner, Foreword, in *Images, 1923–1974*. Author interviews with Beaumont Newhall, Alan Ross, James and Mary Alinder, and David Brower. Brower recalled that "more than anyone I've ever met [Virginia] could make me feel, or almost anyone feel: 'You're the person I've been waiting to see. You're the most important person I've ever run into. I'm glad you're here.' She was a great big part of Ansel's success and nobody ever quite knows that. She was the warmth."

109. Judy Dater, "Ansel Adams," in *Contemporary Photographers*, 2d ed. (Chicago and London: St. James, 1988), 8–9.

110. Ibid.

111. Author interview with James and Mary Alinder, July 17, 1989. *Autobiography*, 365–366.

112. Alinder interview. See also AA to Mary Alinder, January 24–25, 1984, *Letters*, 378–389.

113. *Examples*, 167–170.

114. Ibid., 167.

115. For a full discussion of Adams's technique in this image, see *Examples*, 167–169.

116. Ibid., 170.

117. Wallace Stegner quoted in Harold Gilliam, "Yosemite and the Twin Fires of Genius," *San Francisco Chronicle*, September 15, 1985.

118. Brower, *For Earth's Sake*, 378–382.

# SELECTED BIBLIOGRAPHY

## ARCHIVES

Bancroft Library, University of California, Berkeley
    Sierra Club Archive
        Sierra Club Pictorial Collection
        Sierra Club Records
        Sierra Club Members Papers
            Ansel Adams
            Harold Bradley
            David Brower
            Edgar Wayburn
Beinecke Library, Yale University, New Haven, Connecticut
    Alfred Stieglitz Papers
    Mabel Dodge Luhan Papers
Center for Creative Photography, University of Arizona
    Ansel Adams Archive
    Beaumont and Nancy Newhall Archive
    Willard Van Dyke Archive
    Edward Weston Archive
Department of Special Collections, University Research Library, University of
    California, Los Angeles
    Ansel Adams, Manzanar Archive
    Toyo Miyatake, Manzanar Archive
Huntington Library, San Marino, California
    Mary Austin Papers
    Edward Weston Collection

Museum of Modern Art, New York

> Department of Photography Archives

National Archives, Washington, D.C.

> Record Group 79, National Park Service Collection

> Record Group 208, Office of War Information Collection

Yosemite National Park Research Library

> Photographic Files

Yosemite Park and Curry Company

> Company Correspondence Archive

## Oral Histories

Author Interviews

> Virginia Adams, April 29, 1985

> James and Mary Alinder, July 15, 1989

> David Brower, July 13, 1989

> Philip Hyde, July 24, 1989

> Beaumont Newhall, July 3, 1989

> Alan Ross, July 14, 1989

> William Turnage, July 5, 1989

Sierra Club History Committee, Sierra Club Archive, Bancroft Library, University of California, Berkeley

> Lewis Clark, "Perdurable and Peripatetic Sierran," interview by Marshall Kuhn, 1975–1977.

> Nathan Clark, "Sierra Club Leader, Outdoorsman, and Engineer," interview by Richard Searle, 1977.

> Jules M. Eichorn, "Mountaineering and Music: Ansel Adams, Norman Clyde, and Pioneering Sierra Club Climbing," interview by John Schagen, 1982.

Francis Farquhar, "Sierra Club Mountaineer and Editor," interview by Ann and Ray Lage, 1974.

Joel Hildebrand, "Sierra Club Leader and Ski Mountaineer," interview by Ann and Ray Lage, 1974.

Helen M. LeConte, "Reminiscences of LeConte Family Outings, the Sierra Club, and Ansel Adams," interview by Ruth Teiser and Catherine Harroun, 1977.

Bestor Robinson, "Thoughts on Conservation and the Sierra Club," interview by Susan R. Schrepfer, 1974.

Regional Oral History Office, Bancroft Library, University of California, Berkeley

Ansel Adams, "Conversations with Ansel Adams," interviews by Ruth Teiser and Catherine Harroun, 1972, 1974, 1975.

Horace M. Albright and Newton B. Drury, "Comments on Conservation, 1900 to 1960," interview by Willa K. Baum, 1958.

David R. Brower, "Environmental Activist, Publicist, and Prophet," interviews by Susan R. Schrepfer, 1974–1976.

Imogen Cunningham, "Portraits, Ideas, and Design," interview by Edna Tartaul Daniel, 1961.

Newton B. Drury, "Parks and Redwoods, 1919–1971," interview by Amelia R. Fry and Susan Schrepfer, 1972.

Johan Hagemeyer, "Reminiscences of Johan Hagemeyer, Photographer," interview by Corinne Gilb, 1955.

Alexander Hildebrand, "Sierra Club Leader and Critic: Perspectives on Club Growth, Scope, and Tactics, 1950s–1970s," interview by Ann Lage, 1982.

Dorothea Lange, "The Making of a Documentary Photographer," interview by Suzanne Riess, 1968.

Joseph LeConte, "Recalling LeConte Family Pack Trips and the Early Sierra Club, 1912–1926," interview by Ann Van Tyne, 1975.

Richard Leonard, "Mountaineer, Lawyer, Environmentalist," interview by Susan R. Schrepfer, 1975.

Michael McCloskey, "Sierra Club Executive Director: The Evolving Club and the Environmental Movement, 1961–1981," interview by Susan R. Schrepfer, 1983.

William E. Siri, "Reflections on the Sierra Club, the Environment, and Mountaineering, 1950s–1970s," interview by Ann Lage, 1979.

Wallace Stegner, "The Artist as Environmental Advocate," interview by Ann Lage, 1982.

Paul Schuster Taylor, "California Social Scientist," interview by Suzanne B. Riess and Malca Chall, 1975.

Edgar Wayburn, "Sierra Club Statesman, Leader of the Parks and Wilderness Movement . . . ," interview by Ann Lage and Susan R. Schrepfer, 1985.

## Select Articles by Ansel Adams

"Anthology of Alpine Literature." Book review. *Sierra Club Bulletin* 13 (1928): 98–99.

"On High Hills." Book review. *Sierra Club Bulletin* 14 (1929): 98–99.

"Photography." *Fortnightly* (November 6, 1931): 25.

"Photography." *Fortnightly* (December 4, 1931): 25.

"Photography." *Fortnightly* (December 18, 1931): 21–22.

"Ski Experience." *Sierra Club Bulletin* 16 (1931): 44–45.

"Retrospect: Nineteen Thirty-One." *Sierra Club Bulletin* 17 (1932): 1–10.

"An Article in the Form of a Letter to William Mortensen." [1933] *Obscura* 1 (November/December 1980): 18–21.

"An Exposition of Technique." *Camera Craft* 41 (January 1934): 19.

"Landscape." *Camera Craft* 41 (February 1934): 72–74.

"Portraiture." *Camera Craft* 41 (March 1934): 118.

"Applied Photography." *Camera Craft* 41 (April 1934): 67–68.

"Letter Outlining the Objectives and Motives of Group f/64." *Camera Craft* 41 (June 1934): 297–298.

"The New Photography." *Modern Photography 1934–1935* (London and New York: Studio Publications, 1935), 9–18.

"A Personal Credo." *Camera Craft* 42 (January 1935): 110–111.

"Photography of Architecture." *U.S. Camera* (1940): 9.

"An Approach to a Practical Technique." *U.S. Camera* (1940): 11.

"Discussion of Filters." *U.S. Camera* (1940): 12.

"Photo-murals." *U.S. Camera* (1940): 13.

"Open Letter." *Photo Notes* (June–July 1940): 4–6. This and subsequent articles from *Photo Notes* are collected and reprinted in Nathan Lyons, ed., *Photo Notes* (Rochester: Visual Studies Workshop, 1977).

"Ansel Adams Speaks at the League." *Photo Notes* (December 1940): 3.

"Francis Holman, 1856–1944." *Sierra Club Bulletin* 29 (1944): 47–48.

"Problems of Interpretation of the Natural Scene." *Sierra Club Bulletin* 30 (1945): 47–50.

"An Appreciation of Yosemite Photographs by R. H. Vance." *A Camera in the Gold Rush*. San Francisco: Book Club of California, 1946.

"A Letter to the League." *Photo Notes* (July 1947): 2.

"Jacob A. Riis Exhibit." *Photo Notes* (November 1947): 1–2.

"Statement of Protest." *Photo Notes* (January 1948): 5.

"Danger Signals." *PSA Journal* 14 (November 1948): 575–581.

"The Meaning of the National Parks." *The Living Wilderness* 15 (Autumn 1950): 1–6.

"The Great Land." *Sierra Club Bulletin* 35 (1950): 12.

"Contemporary American Photography." *Universal Photo Almanac* (1951): 19–25.

With Nancy Newhall. "Canyon de Chelly National Monument." *Arizona Highways* 28 (June 1952): 18–27.

With Nancy Newhall. "Sunset Crater National Monument." *Arizona Highways* 28 (July 1952): 2–5, 34–35.

With Nancy Newhall. "Death Valley." *Arizona Highways* 29 (October 1953): 16–35.

With Nancy Newhall. "Organ Pipe Cactus National Monument." *Arizona Highways* 30 (January 1954): 8–17.

With Nancy Newhall. "Mission San Xavier del Bac." *Arizona Highways* 30 (April 1954): 12–35.

With Dorothea Lange. "Three Mormon Towns." *Life* 37 (September 6, 1954): 91–100.

"Edward Weston." *Aperture* (January 8, 1958): 23–27.

"Yosemite— 1958 Compromise in Action." *National Parks Magazine* 32 (October/December 1958): 145–166.

"Nature Spoke Simply . . . and Cedric Wright Replied." *San Francisco Sunday Chronicle*, January 22, 1961.

"The Artist and the Ideals of the Wilderness." *Wilderness, America's Living Heritage* (April 1961): 49–59.

"Conservation of Man." *American Institute of Architects Journal* 45 (June 1966): 68–74.

"Ansel Adams on Color." *Popular Photography* 61 (July 1967): 82.

With William Siri. "In Defense of a Victory: The Nipomo Dunes." *Sierra Club Bulletin* 52 (February 1967): 4, 5, 7.

"Ansel Adams on His Portfolios." *Photographic Business and Product News* 4 (February 1968): 34–35.

"Free Man in a Free Country." *American West* 6 (November 1969): 40–47.

"Eliot Porter, Master of Nature's Color." *Modern Photography* 33 (October 1969): 92.

"My Fifty Years in Photography." *Popular Photography* (August 1973): 118, 127, 142, 200.

"Nancy Newhall." *Untitled* (1976), 43–44.

"The Meaning of the National Parks." *Living Wilderness* 43 (March 1980): 14–15.

"Why We Should Oppose James Watt." *Countryside* 65 (July 1981): 8.

With Mary Austin. *Taos Pueblo*. San Francisco: Grabhorn Press, 1930.

*Making a Photograph: An Introduction to Photography*. London: The Studio; New York: Studio Publications, 1935.

*The Four Seasons in Yosemite National Park: A Photographic Story of Yosemite's Spectacular Scenery*. Los Angeles: Times Mirror Printing and Binding House, 1936.

*Sierra Nevada: The John Muir Trail*. Berkeley: Archetype Press, 1938.

*A Pageant of Photography*. San Francisco: Crocker-Union, 1940.

*The U.S. Camera Yosemite Photographic Forum*. New York: U.S. Camera, 1940.

With Virginia Adams. *Michael and Anne in Yosemite Valley*. New York: Studio Publications, 1941.

*The Complete Photographer*. New York: Educational Alliance, 1942. vol. 1. *Architectural Photography*; vol. 5. *Geometrical Approach to Composition*; vol. 7. *Mountain Photography*; vol. 8. *Printing*.

*Born Free and Equal, Photographs of the Loyal Japanese-Americans at Manzanar Relocation Center, Inyo County, California*. New York: U.S. Camera, 1944.

With Virginia Adams. *An Illustrated Guide to Yosemite*. San Francisco: H. S. Crocker, 1946.

With John Muir. *Yosemite and the Sierra Nevada*. Edited by Charlotte Mauk. Boston: Houghton Mifflin, 1948.

*Basic Photo*. 5 vols. New York: Morgan and Lester, 1948–1956. Vol. 1. *Camera and Lens*; vol. 2. *The Negative*; vol. 3. *The Print*; vol. 4. *Natural Light Photography*; vol. 5. *Artificial Light Photography*.

*My Camera in Yosemite Valley*. Yosemite National Park: Virginia Adams; Boston: Houghton Mifflin, 1949.

*My Camera in the National Parks*. Yosemite National Park: Virginia Adams; Boston: Houghton Mifflin, 1950.

With Mary Austin. *The Land of Little Rain*. Boston: Houghton Mifflin, 1950.

With Nancy Newhall. *Mission San Xavier del Bac*. San Francisco: 5 Associates, 1954.

With Nancy Newhall. *The Pageant of History and the Panorama of Today in Northern California*. San Francisco: American Trust jCompany, 1954.

*The Changing Bay*. San Francisco: San Francisco Bay Area Council, 1955.

*Yosemite Valley*. Edited by Nancy Newhall. San Francisco: 5 Associates, 1959.

With Nancy Newhall. *Death Valley*. San Francisco: 5 Associates, 1959.

With Nancy Newhall. *This Is the American Earth*. San Francisco: Sierra Club, 1960.

*These We Inherit: The Parklands of America*. San Francisco: Sierra Club, 1962.

With Edwin Corle. *Death Valley and the Creek Called Furnace*. Los Angeles: Ward Ritchie Press, 1962.

*Polaroid Land Photography Manual: A Technical Handbook*. New York: Morgan and Morgan, 1963.

With Edward Joesting. *An Introduction to Hawaii*. San Francisco: 5 Associates, 1964.

With Nancy Newhall. *Fiat Lux: The University of California*. New York: McGraw Hill, 1967.

*Twelve Days at Santa Cruz*. Santa Cruz: Images and Words Workshop, 1967.

With Nancy Newhall. *The Tetons and the Yellowstone*. Redwood City, Calif.: 5 Associates, 1970.

*Ansel Adams*. Edited by Liliane De Cock. Hastings-on-Hudson, N.Y.: Morgan and Morgan, 1972.

*Ansel Adams: Recollected Moments*. San Francisco: San Francisco Museum of Modern Art, 1972.

*Singular Images*. Dobbs Ferry, N.Y.: Morgan and Morgan, 1974.

*Yosemite Album: Fifteen Photographs*. Redwood City, Calif.: 5 Associates, 1974.

*Ansel Adams: Images, 1923–1974*. Boston: New York Graphic Society, 1974.

*Basic Photo Series*. Rev. ed. 5 vols. Boston: New York Graphic Society, 1976.

*Photographs of the Southwest*. Boston: New York Graphic Society, 1976.

*The Portfolios of Ansel Adams*. Boston: New York Graphic Society, 1977.

With Toyo Miyatake. Edited by Graham Howe, Patrick Nagatani, and Scott
   Rankin. *Two Views of Manzanar: An Exhibition of Photographs*. Los Angeles:
   Frederick S. Wight Art Gallery, 1978.

*Ansel Adams: 50 Years of Portraits*. Carmel: Friends of Photography, 1978.

*Yosemite and the Range of Light*. Boston: New York Graphic Society, 1979.

*Examples: The Making of Forty Photographs*. Boston: New York Graphic Society,
   1983.

With Mary Street Alinder. *Ansel Adams: An Autobiography*. Boston: New York
   Graphic Society, 1985.

*Ansel Adams: Classic Images*. Boston: New York Graphic Society, 1985.

*Ansel Adams: Letters and Images, 1916–1984*. Edited by Mary Street Alinder and
   Andrea Gray Stillman. Boston: New York Graphic Society, 1988.

## Select Books and Articles by Others

Abrahams, Edward. *The Lyric Left: Randolph Bourne, Alfred Stieglitz, and the
   Origins of Cultural Radicalism in America*. Charlottesville: University Press of
   Virginia, 1986.

Adams, Henry. *The Education of Henry Adams*. 1907; Boston: Houghton Mifflin,
   1973.

Adams, Robert. *The New West: Landscapes Along the Colorado Front Range*. Boul-
   der: University of Colorado Art Museum, 1974.

———. *Denver: A Photographic Survey of the Metropolitan Area*. Boulder: Univer-
   sity of Colorado Art Museum, 1977.

Aitken, R. G. "In Memorium, Charles Hitchcock Adams, 1868–1951." *Publica-
   tions of the Astronomical Society of the Pacific* 63, no. 375 (December 1951): 283–
   286.

Albright, Horace, and Robert Cahn. *The Birth of the National Park Service: The
   Founding Years, 1913–1933*. Salt Lake City: Howe Brothers, 1985.

Albright, Thomas. *Art in the San Francisco Bay Area, 1945–1980*. Berkeley, Los Angeles, and London: University of California Press, 1985.

Alinder, James. "Passing It On: Ansel Adams at 75." *Exposure* 15 (May 1977): 2–7.

——, ed. *Carleton E. Watkins: Photographs of the Columbia River and Oregon*. Carmel: Friends of Photography, 1979.

——, ed. *Light Years: The Friends of Photography, 1967–1987*. Carmel: Friends of Photography, 1987.

Alinder, Mary. *Ansel Adams: Eightieth Birthday Retrospective*. Monterey: Monterey Peninsula Museum of Art, 1982.

Alland, Alexander, Sr. *Jacob Riis: Photographer and Citizen*. Millerton, N.Y.: Aperture, 1974.

Anderson, Nancy K., and Linda S. Ferber. *Albert Bierstadt: Art and Enterprise*. New York: Brooklyn Museum, 1990.

"Ansel Adams and the National Parks." *American West* 6 (September 1969): 17–24, 41–48, 65–72.

"Ansel Adams and the Range of Prices." *Print Collector's News* 10 (November 1979).

"Ansel Adams: Arms Peddler." *Mother Jones* 12 (January 1987): 18.

"Ansel Adams: Arms Peddler?" *Time* 129 (January 12, 1987): 57.

"Ansel Adams Conducts California School of Fine Arts Course in Photography." *Architect and Engineer* 163 (December 1945): 11.

"Ansel Adams Teaches at Museum of Modern Art." *Art Digest* 19 (February 1, 1945): 14.

*Ansel Adams: New Light, Essays on His Legacy and Legend*. San Francisco: Friends of Photography, 1993.

Armitage, Merle. *Operations Santa Fe*. New York: Duell, Sloan, and Pearce, 1948.

Armor, John, and Peter Wright. *The Mural Project*. Santa Barbara: Reverie Press, 1989.

Arnheim, Rudolph. *Visual Thinking*. Berkeley, Los Angeles, and London: University of California Press, 1969.

———. "On the Nature of Photography." *Critical Inquiry* 1 (September 1974): 149–161.

Ashton, Dore. *The New York School: A Cultural Reckoning.* New York: Viking, 1973.

———. *American Art Since 1945.* New York: Oxford University Press, 1982.

Austin, Mary. "The Indivisible Utility." *Survey Graphic* 40 (December 1925): 12–15.

———. *The Land of Little Rain.* Boston: Houghton Mifflin, 1903.

———. *Experiences Facing Death.* Indianapolis: Bobbs Merrill, 1931.

———. *Earth Horizon: An Autobiography.* Boston: Houghton Mifflin, 1932.

Bade, William F. *Life and Letters of John Muir.* 2 vols. Boston: Houghton Mifflin, 1923–1924.

Baltz, Lewis, and Guy Blaisdell. *Park City.* New York and Albuquerque: Artspace Press/Aperture, 1980.

Baron, Robert, and Elizabeth Darby Junkin, eds. *Of Discovery and Destiny: An Anthology of American Writers and the American Land.* Golden, Colo.: Fulcrum, 1986.

Barth, Gunther. *Instant Cities: Urbanization and the Rise of San Francisco and Denver.* New York: Oxford University Press, 1975.

Barthes, Roland. *Image/Music/Text.* New York: Hill and Wang, 1977.

———. *Camera Lucida.* New York: Hill and Wang, 1981.

Bates, J. Leonard. "Fulfilling American Democracy: The Conservation Movement, 1870–1921." *Mississippi Valley Historical Review* 44 (June 1957): 29–57.

Baur, John I. H. *Nature in Abstraction: The Relation of Abstract Painting and Sculpture to Nature in Twentieth-Century American Art.* New York: Macmillan, 1958.

Bean, Walton. *Boss Ruef's San Francisco: The Story of the Union Labor Party, Big Business, and the Graft Prosecution.* Berkeley: University of California Press, 1952.

Bell, Daniel. *The Cultural Contradictions of Capitalism.* New York: Basic Books, 1976.

Bellamy, Edward. *Looking Backward*. Boston: Ticknor, 1888.

Bender, Albert. *George Sterling, the Man: A Tribute*. San Francisco: [privately printed], 1928.

Bender, Thomas. *Toward an Urban Vision: Ideas and Institutions in Nineteenth-Century America*. Louisville: University of Kentucky Press, 1975.

Benedict, Burton. *The Anthropology of World's Fairs: San Francisco's Panama Pacific International Exposition of 1915*. Berkeley: Lowie Museum/Scolar Press, 1983.

Benjamin, Walter. "The Work of Art in the Age of Mechanical Reproduction," *Zeitschrift für Socialforschung* V (1936). Translated and reprinted in Hannah Arendt, ed., *Illuminations: Walter Benjamin*. New York: Schocken Books, 1969.

Berman, Marshall. *All That's Solid Melts into Air: The Experience of Modernity*. New York: Viking, 1988.

Bermingham, Ann. *Landscape and Ideology: The English Rustic Tradition, 1740–1860*. Berkeley, Los Angeles, and London: University of California Press, 1986.

Bermingham, Peter. *America in the Barbizon Mood*. Washington, D.C.: Smithsonian Institution, 1975.

Billington, Ray Allen. *Frederick Jackson Turner: Historian, Scholar, Teacher*. New York: Oxford University Press, 1973.

———. *America's Frontier Heritage*. Rev. ed. 1963; Albuquerque: University of New Mexico, 1974.

———. *Westward Expansion: A History of the American Frontier*. 4th ed. New York: Macmillan, 1974.

Blackmar, Betsy. "Re-walking the 'Walking City': Housing and Property Relations in New York City, 1780–1840." *Radical History Review* 21 (Fall 1979): 131–148.

Blum, John Morton. *V Was for Victory: Politics and American Culture During World War II*. New York: Harcourt Brace Jovanovich, 1976.

Boime, Albert. *The Magisterial Gaze: Manifest Destiny and American Landscape Painting, 1830–1865*. Washington, D.C.: Smithsonian Institution Press, 1991.

Bosworth, Patricia. *Diane Arbus: A Biography*. New York: Alfred A. Knopf, 1984.

Bourke-White, Margaret, and Erskine Caldwell. *You Have Seen Their Faces*. New York: Viking, 1937.

Boyer, Paul. *Urban Masses and Moral Order in America, 1820–1920*. Cambridge: Harvard University Press, 1978.

Bradley, Harold. "Aldo Leopold—Champion of Wilderness." *Sierra Club Bulletin* 36 (May 1951): 14–18.

Bradley, Harold, and David Brower. "Roads in the National Parks." *Sierra Club Bulletin* 34 (June 1949): 31–54.

Bramwell, Anna. *Ecology in the Twentieth Century: A History*. New Haven: Yale University Press, 1989.

Brant, Irving. *Adventures in Conservation with Franklin D. Roosevelt*. Flagstaff: Northland, 1988.

Breton, André. *Entretiens*. Paris: Gallimard, 1969.

Breton, André, and Diego Rivera. "Towards a Free Revolutionary Art." *Partisan Review* 6 (Autumn 1938): 50.

Brett, Dorothy. *Lawrence and Brett, A Friendship*. Philadelphia: J. B. Lippincott, 1933.

Brewer, William. *Up and Down California in 1860–1864*. 3d ed. Berkeley, Los Angeles, and London: University of California Press, 1973.

Broder, Patricia. *Taos: A Painter's Dream*. Boston: New York Graphic Society, 1980.

Bronson, William. *The Earth Shook, the Sky Burned*. Garden City, N.Y.: Doubleday, 1959.

Brower, David. "Far from the Madding Mules." *Sierra Club Bulletin* 20 (February 1935): 68–77.

———. "A Tribute to Ansel Adams," *Sierra Club Bulletin* 69 (July/August 1984): 32.

———. *For Earth's Sake: The Life and Times of David Brower*. Salt Lake City: Gibbs Smith, 1990.

———, ed. *Wilderness: America's Living Heritage*. San Francisco: Sierra Club, 1961.

———, ed. *Wildlands in Our Civilization*. San Francisco: Sierra Club, 1964.

Brown, Milton. "Cubist Realism: An American Style." *Marsyas* 3 (1943–1945): 155.

Bryce, James. *University and Historical Addresses*. New York: Macmillan, 1913.

Bunnell, Lafayette. *Discovery of the Yosemite and the Indian War of 1851 which led to that event*. 4th ed. 1882; Los Angeles: G. W. Gerlicher, 1911.

Bunnell, Peter, ed. *Edward Weston on Photography*. Salt Lake City: Peregrine Smith, 1983.

———. *Minor White: The Eye That Shapes*. Princeton, N.J.: Art Museum of Princeton University, 1989.

Burbick, Joan. *Thoreau's Alternative History: Changing Perspectives on Nature, Culture, and Language*. Philadelphia: University of Pennsylvania Press, 1987.

Cahn, Robert, and Robert Glenn Ketchum. *American Photographers and the National Parks*. New York: Viking, 1981.

Caldwell, Erskine, and Margaret Bourke-White. *Say, Is This the USA*. New York: Duell, Sloan, and Pearce, 1941.

"Camera vs. Brush." *Time* 99 (June 2, 1947): 53.

Carlson, Raymond. "Up and Down Country." *Arizona Highways* 28 (June 1952): 1.

Carpenter, Edward. *Toward Democracy*. Manchester, U.K.: Labour Press, 1896.

———. *My Days and Dreams*. London: G. Allen & Unwin, 1921.

Carson, Rachel. *Silent Spring*. Boston: Houghton Mifflin, 1962.

Carter, Paul. *Another Part of the Twenties*. New York: Columbia University Press, 1977.

"Charles L. Weed, Yosemite's First Photographer." *Yosemite Nature Notes* 38 (June 1959): 76–87.

Church, Peggy Pond. *Wind's Trail: The Early Life of Mary Austin*. Santa Fe: Museum of New Mexico Press, 1990.

Clark, Kenneth. *Landscape into Art.* 1949; New York: Harper and Row, 1976.

Coe, Brian, and Paul Gates. *The Snapshot Photograph: The Rise of Popular Photography, 1888–1939.* London: Ash & Grant, 1977.

Cohen, Michael P. *The History of the Sierra Club, 1892–1970.* San Francisco: Sierra Club Books, 1988.

Coke, Van Deren. *Taos and Santa Fe: The Artist's Environment, 1882–1942.* Albuquerque: University of New Mexico Press, 1963.

———. *The Painter and the Photograph: From Delacroix to Warhol.* Rev. ed. Albuquerque: University of New Mexico Press, 1972.

———. *Photography in New Mexico: From the Daguerreotype to the Present.* Albuquerque: University of New Mexico Press, 1979.

Coleman, A. D. *Light Readings: A Photography Critic's Writings, 1968–1978.* New York: Oxford University Press, 1979.

Collins, Douglas. *The Story of Kodak.* New York: Harry N. Abrams, 1990.

Conger, Amy. "Edward Weston's Early Photography, 1903–1926." Ph.D. dissertation, University of New Mexico, 1982.

———. *Edward Weston in Mexico: 1923–1926.* Albuquerque: University of New Mexico Press, 1983.

Cook, Sherburne F. *The Conflict Between the California Indians and White Civilization.* Berkeley, Los Angeles, and London: University of California Press, 1976.

Cowley, Malcolm. *Exile's Return.* 1934; reprint, New York: Viking, 1951.

———. *The Dream of the Golden Mountains: Remembering the 1930s.* New York: Viking, 1980.

Croly, Herbert. *The Promise of American Life.* New York: Macmillan, 1909.

Crosby, Alfred. *Ecological Imperialism: The Biological Expansion of Europe, 900–1900.* New York: Cambridge University Press, 1986.

Cross, Frank. "Revolution in Colorado." *Nation* 138 (February 7, 1934): 152–154.

Cross, Ira. *A History of the Labor Movement in California.* Berkeley: University of California Press, 1935.

Current, Karen, and Richard Current. *Photography and the Old West*. New York: Harry N. Abrams, 1978.

Daniels, Roger. *Concentration Camps, USA: Japanese Americans and World War II*. New York: Holt, Rinehart, and Winston, 1972.

Daniels, Stephen. *Fields of Vision: Landscape Imagery and National Identity in England and the United States*. Princeton: Princeton University Press, 1993.

Dasmann, Raymond. *The Destruction of California*. Berkeley, Los Angeles, London: University of California Press, 1965.

Dater, Judy. "Ansel Adams." In *Contemporary Photographers*, ed. Colin Naylor, 8–9. 2d ed. Chicago and London: St. James, 1988.

Davis, Douglas. "Two Faces of Ansel Adams." *Newsweek* 49 (September 24, 1979): 90–94.

Decker, Peter. *Fortunes and Failures: White-Collar Mobility in Nineteenth-Century San Francisco*. Cambridge: Harvard University Press, 1978.

Degler, Carl N. *In Search of Human Nature: The Decline and Revival of Darwinism in American Social Thought*. New York: Oxford University Press, 1991.

Deutsch, Monroe E. *Albert Bender*. San Francisco: Grabhorn Press, 1941.

——— . *Saint Albert of San Francisco*. San Francisco: Carroll T. Harris, 1956.

Devall, Bill, and George Sessions, eds. *Deep Ecology: Living as if Nature Mattered*. Salt Lake City: Gibbs Smith, 1985.

DeVoto, Bernard. "The West: Plundered Province." *Harper's* 169 (August 1934): 355–364.

——— . "The West Against Itself." *Harper's* 194 (January 1947): 1–13.

——— . "The National Parks." *Fortune* 35 (June 1947): 120–133.

Diggins, John P. *The Rise and Fall of the American Left*. New York: W. W. Norton, 1992.

Dijkstra, Bram. *The Hieroglyphics of a New Speech: Cubism, Stieglitz, and the Early Poetry of William Carlos Williams*. Princeton: Princeton University Press, 1969.

Dizard, Wilson P. *The Strategy of Truth: The Story of the U.S. Information Service*. Washington, D.C.: Public Affairs Press, 1961.

Dody, Robert. "Weston, Strand, Adams." *American Photography* 45 (January 1951): 48–53.

Drury, Newton. "The Dilemma of Our National Parks." *American Forests* 55 (June 1949): 6–11.

Dumars, Stanford E. *The Tourist in Yosemite, 1855–1985*. Salt Lake City: University of Utah Press, 1991.

Dyer, Thomas. *Theodore Roosevelt and the Idea of Race*. Baton Rouge: Louisiana State University Press, 1980.

Eastlake, Lady Elizabeth. "Photography." *Quarterly Review* 101 (April 1857): 442–468.

Edwards, John Paul. "Group f/64." *Camera Craft* 42 (March 1935): 107–113.

Ellul, Jacques. *Propaganda: The Formation of Men's Attitudes*. New York: Alfred A. Knopf, 1965.

Emerson, Peter Henry. *Naturalistic Photography*. 3d ed. Reprint, New York: Arno Press, 1973.

Esterow, Milton. "Ansel Adams: The Last Interview." *Art News* 83 (Summer 1984): 76–89.

Etulian, Richard W. "The American Literary West and Its Interpreters: The Rise of a New Historiography." *Pacific Historical Review* 45 (August 1976): 311–348.

Evans, Walker. *American Photographs*. New York: Museum of Modern Art, 1940.

Everson, William. *Robinson Jeffers: Fragments of an Older Fury*. Berkeley: Oyez, 1968.

———. *The Excesses of God: Robinson Jeffers as a Religious Figure*. Stanford: Stanford University Press, 1988.

"Exhibition Review—Delphic Studios." *Art News* 32 (November 25, 1933): 8.

Farquhar, Francis. "Ansel Adams." *Touring Topics* 23 (February 1931) [unpaginated].

———. "Walker's Discovery of Yosemite." *Sierra Club Bulletin* 27 (August 1942): 35–49.

Ferlinghetti, Lawrence, and Nancy J. Peters. *Literary San Francisco: A Pictorial History from Its Beginnings to the Present Day*. San Francisco: City Lights Books, 1980.

Fink, Augusta. *I-Mary, a Biography of Mary Austin*. Tucson: University of Arizona Press, 1983.

"First New York Exhibition of Ansel Adams." *Art Digest* 8 (November 15, 1933): 7.

Flader, Susan. *Thinking Like a Mountain: Aldo Leopold and the Evolution of an Ecological Attitude Toward Deer, Wolves, and Forests*. Columbia: University of Missouri Press, 1974.

Fleishhauer, Carl, and Beverly Brannan, eds. *Documenting America: 1935–1943*. Berkeley, Los Angeles, and London: University of California Press, 1988.

Fleming, Donald. "Roots of the New Conservation Movement." *Perspectives in American History* 6 (1972): 7–91.

Fondiller, Henry. "Ansel Adams and Civil Rights . . . Uncensored Version." *Popular Photography* 92 (October 1985): 92.

Fox, Stephen. *John Muir and His Legacy: The American Conservation Movement*. Boston: Little, Brown, 1981.

———. *The Mirror Makers: A History of Twentieth-Century American Advertising*. New York: William Morrow, 1984.

Frank, Robert. *The Americans*. New York: Grove Press, 1959.

Frank, Waldo, et al. *America and Alfred Stieglitz: A Collective Portrait*. Garden City, N.Y.: Doubleday, Doran, 1934.

Gee, Helen. *Photography of the Fifties*. Tucson: Center for Creative Photography, 1980.

Geertz, Clifford. *The Interpretation of Cultures*. New York: Basic Books, 1973.

Genthe, Arnold. *As I Remember*. New York: Reynal & Hitchcock, 1936.

George, Henry. *Progress and Poverty*. San Francisco: W. H. Hinton, 1879.

———. "What the Railroad Will Bring Us." *Overland Monthly* 1 (October 1868): 302–303.

———. "The Kearney Agitation in California." *Popular Science Monthly* 17 (August 1880): 433–453.

Gibson, Arrell. *The Santa Fe and Taos Colonies: Age of the Muses, 1890–1942*. Norman: University of Oklahoma Press, 1983.

Gilbert, James Burkhart. *Writers and Partisans: A History of Literary Radicalism in America*. New York: Wiley, 1968.

Gilliam, Harold. "Yosemite and the Twin Fires of Genius." *San Francisco Chronicle*, September 15, 1985.

Goetzmann, William H. *Exploration and Empire: The Explorer and the Scientist in the Winning of the American West*. New York: Alfred A. Knopf, 1966.

Goetzmann, William H., and William N. Goetzmann. *The West of the Imagination*. New York: W. W. Norton, 1986.

Goldberg, Vicki, ed. *Photography in Print*. New York: Simon and Schuster, 1981.

Goldman, Bruce. "Kesey: Over the Border and Back Again." *Stanford Magazine* (Winter 1988): 29–32.

Goldman, Eric F. *The Crucial Decade: America, 1945–1955*. New York: Alfred A. Knopf, 1956.

Goldwater, Robert. *Primitivism in Art*. Rev. ed. New York: Vintage Books, 1967.

Gombrich, E. H. "The Evidence of Images." In *Interpretation, Theory, and Practice*, ed. Charles S. Singleton, 35–104. Baltimore: Johns Hopkins University Press, 1969.

———. "The Visual Image." *Scientific American* 227 (September 1977): 82–96.

Gonzales-Berry, Erlinda. *Pasó por Aquí: Critical Essays on the New Mexican Literary Tradition, 1542–1988*. Albuquerque: University of New Mexico Press, 1989.

Gould, Peter C. *Early Green Politics: Back to Nature, Back to the Land, and Socialism in Britain, 1880–1900*. Sussex: Harvester Press; New York: St. Martin's Press, 1988.

Graber, Linda H. *Wilderness as Sacred Space*. Washington, D.C.: Association of American Geographers, 1976.

Gray, Andrea. *Ansel Adams, An American Place, 1936.* Tucson: Center for Creative Photography, 1982.

"Great Photographs on the Block." *Life* 2 (February 1979): 84–92.

Gregory, M. "Ansel Adams: The Philosophy of Light." *Aperture* 11 (1963): 49–51.

Green, Jonathan, ed. *Camera Work: A Critical Anthology.* Millerton, N.Y.: Aperture, 1973.

Greenough, Sarah. *Paul Strand: An American Vision.* Washington, D.C.: National Gallery of Art, 1990.

Grundberg, Andy. "Edward Weston's Late Landscapes." In *E.W. 100: Centennial Essays in Honor of Edward Weston*, 93–101. Carmel: Friends of Photography, 1986.

Guilbaut, Serge. *How New York Stole the Idea of Modern Art: Abstract Expressionism, Freedom, and the Cold War.* Chicago: University of Chicago Press, 1983.

Hagen, Charles, ed. "Beyond Wilderness." Special issue. *Aperture* 120 (Late Summer 1990).

Haip, Renée. "Ansel Adams: Forging the Wilderness Idea." In *Ansel Adams: New Light*, 75–83. San Francisco: Friends of Photography, 1993.

Hales, Peter Bacon. *Silver Cities: The Photography of American Urbanization, 1839–1915.* Philadelphia: Temple University Press, 1984.

——— . *William Henry Jackson and the Transformation of the American Landscape.* Philadelphia: Temple University Press, 1988.

Hartzog, George B., Jr. "Clearing the Roads—and the Air—in Yosemite Valley." *National Parks and Conservation Magazine* 46 (August 1972): 14–17.

Harvey, Paul W.T. "Echo Park, Glen Canyon, and the Postwar Wilderness Movement." *Pacific Historical Review* 60 (February 1991): 43–67.

Haskell, Barbara. "Transcendental Realism in the Stieglitz Circle: The Expressionist Landscapes of Arthur Dove, Marsden Hartley, John Marin, and Georgia O'Keeffe." In *The Expressionist Landscape*, ed. Ruth Stevens Appelthof, 17–25. Birmingham: Birmingham Museum of Art, 1987.

Hass, Robert Bartlett. *Muybridge: Man in Motion*. Berkeley, Los Angeles, and London: University of California Press, 1976.

Hay, P. R. "The Contemporary Environmental Movement as Neo-Romanticism: A Reappraisal from Tasmania." *Environmental History Review* 12 (Winter 1988): 39–59.

Hays, Samuel P. *Conservation and the Gospel of Efficiency: The Progressive Conservation Movement, 1880–1920*. Cambridge: Harvard University Press, 1959.

——— . *Beauty, Health, and Permanence: Environmental Politics in the United States, 1955–1985*. New York: Cambridge University Press, 1987.

Henri, Robert. *The Art Spirit*. 5th ed. Philadelphia: J. B. Lippincott, 1930.

Herner de Larrea, Irene. *Diego Rivera's Mural at the Rockefeller Center*. Mexico City: Edicupes, 1990.

Hewlett, Louise. "The Outing of 1936." *Sierra Club Bulletin* 22 (February 1937): 58–68.

Higham, John. "The Reorientation of American Culture in the 1890's." In *The Origins of Modern Consciousness*, ed. John Weiss, 25–48. Detroit: Wayne State University Press, 1965.

Hill, Paul, and Thomas Cooper, eds. *Dialogue with Photography*. New York: Farrar, Straus, and Giroux, 1979.

Hine, Lewis. *America and Lewis Hine*. Millerton, N.Y.: Aperture, 1977.

——— . "Social Photography, How the Camera May Help in the Social Uplift." Reprinted in *Classic Essays on Photography*, ed. Alan Trachtenberg, 111. New Haven: Yale University Press, 1980.

Hines, Thomas. *Richard Neutra and the Search for Modern Architecture*. New York: Oxford University Press, 1982.

Hitchcock, H. Wiley, and Stanley Sadie, eds. *The New Grove Dictionary of American Music*. Vol. 4. London: Macmillan, 1986.

Hoffman, Frederick. *The Twenties: American Writing in the Postwar Decade*. New York: Collier Books, 1962.

Hofstadter, Richard. *The Age of Reform, from Bryan to F.D.R.* New York: Vantage Books, 1955.

———. *The Progressive Historians: Turner, Beard, and Parrington*. Chicago: University of Chicago Press, 1968.

Holliday, J. S. *The World Rushed In: The California Gold Rush Experience*. New York: Simon and Schuster, 1981.

Holmes, Oliver Wendell. "The Stereoscope and the Stereograph." *Atlantic Monthly* (June 8, 1859): 747–748.

Homer, William Innes. *Alfred Stieglitz and the American Avant-Garde*. Boston: New York Graphic Society, 1975.

Honour, Hugh. *The New Golden Land: European Images of America from the Discoveries to the Present Time*. New York: Pantheon, 1975.

Hough, Graham. *The Last Romantics*. London: Duckworth, 1949.

Howe, Graham, Patrick Nagatani, and Scott Rankin, eds. *Two Views of Manzanar*. Los Angeles: Frederick S. Wight Art Gallery, UCLA, 1978.

Hughes, Robert. "Images of America Before Its Fall: Retrospective at the MET." *Time* 103 (June 10, 1974): 56.

———. "Master of Yosemite." *Time* 114 (September 3, 1979): 36–44.

Hume, Sandy, and Ellen Manchester, eds. *The Great West: Real/Ideal*. Boulder: Department of Fine Arts, University of Colorado, 1977.

Hundley, Norris, jr. *Water and the West: The Colorado River Compact and the Politics of Water in the American West*. Berkeley, Los Angeles, and London: University of California Press, 1975.

———. *The Great Thirst: Californians and Water, 1770s–1990s*. Berkeley, Los Angeles, and Oxford: University of California Press, 1992.

Hurley, F. Jack. *Portrait of a Decade*. Baton Rouge: Louisiana State University Press, 1972.

———. *Industry and the Photographic Image*. New York: Dover, 1980.

Hurtado, Albert L. *Indian Survival on the California Frontier*. New Haven: Yale University Press, 1988.

Hutchings, James M. "The Yo-ham-i-te Valley." *Hutchings' Illustrated California Magazine* 1, no. 1 (July 1856): 2–8.

———. "The Great Yo-semite Valley." *Hutchings' Illustrated California Magazine* 4 (October 1859): 145–160.

———. *In the Heart of the Sierras*. Yosemite Valley and Oakland: Pacific Press, 1886.

Huth, Hans. *Nature and the American: Three Centuries of Changing Attitudes*. Berkeley: University of California Press, 1957.

Hyde, Anne. *An American Vision: Far Western Landscape and National Culture, 1820–1920*. New York: New York University Press, 1990.

Hyde, Philip. "Ansel Adams." *Sierra Club Bulletin* 56 (October/November 1971): 20–21.

"Images of Endless Moments." *New York Times Magazine*, November 8, 1965, 134–136.

"Interpreting the Primeval Scene." *American Forests* 57 (May 1951): 16–17.

Issel, William, and Robert W. Cherny. *San Francisco, 1865–1932: Politics, Power, and Urban Development*. Berkeley, Los Angeles, and London: University of California Press, 1986.

Ivins, William, Jr. *Prints and Visual Communication*. Cambridge: Harvard University Press, 1953.

Jackson, William Henry. *Time Exposure: The Autobiography of William Henry Jackson*. New York: G. P. Putnam's Sons, 1940.

Jakle, John A. *The Tourist: Travel in Twentieth-Century America*. Lincoln: University of Nebraska Press, 1985.

"James Watt's Land Rush." *Newsweek* 98 (June 29, 1981): 22–32.

Jeffers, Robinson. *Solstice and Other Poems*. New York: Random House, 1935.

———. *Such Counsels You Gave Me*. New York: Random House, 1937.

———. *The Double Axe, and Other Poems*. New York: Random House, 1948.

Jenkins, William. *New Topographics: Photographs of a Man-altered Landscape*. Rochester: International Museum of Photography, 1975.

Johnson, Marilyn S. "Urban Arsenals: War Housing and Social Change in Two California Cities, 1941–1954." *Pacific Historical Review* 60 (1991): 283–308.

Jones, Holway. *John Muir and the Sierra Club: The Battle for Yosemite*. San Francisco: Sierra Club, 1965.

Jussim, Estelle, and Elizabeth Lindquist-Cock. *Landscape as Photograph*. New Haven: Yale University Press, 1985.

Kandinsky, Wassily. *Concerning the Spiritual in Art*. 1912; New York: Wittenborn, 1955.

Karman, James. *Robinson Jeffers: Poet of California*. San Francisco: Chronicle Books, 1987.

Katzman, Louise. *Photography in California, 1945–1980*. New York: Hudson Hills Press/San Francisco Museum of Modern Art, 1984.

Kazin, Alfred. *A Writer's America: Landscape in Literature*. New York: Alfred A. Knopf, 1988.

Kazin, Michael. *Barons of Labor: The San Francisco Building Trades and Union Power in the Progressive Era*. Urbana: University of Illinois Press, 1987.

"Keeping Up with the Adamses." *Print Collector's Newsletter* 10 (January 1980): 193.

Kelley, Robert. *Gold versus Grain: The Hydraulic Mining Controversy in California's Sacramento Valley*. Glendale: Arthur H. Clark, 1959.

Kemble, John Haskell. *The Panama Route: 1848–1869*. Berkeley: University of California Press, 1943.

"Kennecott Copper and Cash." *Fortune* (November 1951): 89–96, 167–176.

King, Clarence. *Mountaineering in the Sierra Nevada*. Boston: James R. Osgood, 1872.

Kirstein, Lincoln, and Julien Levy. *Murals by American Painters and Photographers*. New York: Museum of Modern Art, 1932.

Klein, Kerwin. "The Last Resort: Tourism, Growth, and Values in Twentieth-Century Arizona." M.A. thesis, University of Arizona, 1990.

Klingender, F. D. *Art and the Industrial Revolution*. Ed. and rev. Arthur Elton. New York: Schocken Books, 1970.

Knight, Robert. *Industrial Relations in the San Francisco Bay Area, 1900–1918*. Berkeley and Los Angeles: University of California Press, 1960.

Kozloff, Max. "The Box in the Wilderness." In *Photography and Fascination*, 60–75. Danbury, N.H.: Addison House, 1979.

Kramer, Hilton. "Edward Weston's Privy and the Mexican Revolution." *New York Times*, May 7, 1972.

Krutch, Joseph Wood. *The Modern Temper: A Study and Confession*. New York: Harcourt, Brace, 1929.

Lalli, Christine. "Portrait of the Photographer as a Grand Old Man." *Esquire* 92 (September 1979): 36–38.

Lange, Dorothea, and Paul S. Taylor. *An American Exodus: A Record of Human Erosion*. New York: Reynal & Hitchcock, 1939; rev. ed., Oakland and New Haven: Oakland Museum and Yale University Press, 1969.

Langford, Nathaniel P. "The Wonders of the Yellowstone." *Scribner's Monthly* 2 (May 1871): 1–17, and 2 (June 1871): 113–128.

Lasden, Martin. "Wallace Stegner, On His Own Terms." *Stanford Magazine* (Spring 1989): 23–30.

Lawrence, D. H. *Studies in Classic American Literature*. New York: T. Seltzer, 1923.

Lears, T. J. Jackson. *No Place of Grace: Antimodernism and the Transformation of American Culture, 1880–1920*. New York: Pantheon, 1981.

Leonard, Richard M., et al. *Belaying the Leader: An Omnibus on Climbing Safety*. San Francisco: Sierra Club, 1956.

Leopold, Aldo. "Why the Wilderness Society?" *Living Wilderness* 1 (September 1935): 6.

——. "A Biotic View of the Land." *Journal of Forestry* 37 (September 1939): 727–730.

——. *A Sand County Almanac and Sketches Here and There*. New York: Oxford University Press, 1949.

Leuchtenberg, William E. *Franklin D. Roosevelt and the New Deal, 1932–1940*. New York: Harper and Row, 1963.

Lewis, Oscar. *To Remember Albert Bender*. San Francisco: Grabhorn and Hoyem, 1973.

Leydet, François, ed. *Tomorrow's Wilderness*. San Francisco: Sierra Club, 1963.

Liebling, Jerome, ed. *Photography: Current Perspectives*. Rochester: Light Impressions, 1978.

*Light Years: The Friends of Photography, 1967–1987 [Untitled 43]*. Carmel: Friends of Photography, 1987.

London, Jack. *The Call of the Wild*. New York: Gosset & Dunlap, 1903.

———. *Moon-face and Other Stories*. New York: Macmillan, 1906.

Lowitt, Richard. *The New Deal and the West*. Bloomington: Indiana University Press, 1984.

Luce, Henry. "The American Century." *Life* 10 (February 17, 1941): 61–65.

———. "Prospectus." *The Best of Life*. New York: Time-Life Books, 1973.

Luhan, Mabel Dodge. *Lorenzo in Taos*. New York: Alfred A. Knopf, 1935.

———. *Movers and Shakers*. Vol. 3 of *Intimate Memoirs*. New York: Harcourt, Brace, 1936.

———. *Edge of Taos Desert: An Escape to Reality*. Vol. 4 of *Intimate Memoirs*. New York: Harcourt, Brace, 1937.

Lynes, Russel. *Good Old Modern: An Intimate Portrait of the Museum of Modern Art*. New York: Atheneum, 1973.

Lyons, Nathan, ed. *Toward a Social Landscape*. New York: Horizon Press, 1966.

———, ed. *Photographers on Photography*. Englewood Cliffs, N.J.: Prentice-Hall, 1966.

———. ed. *Photo Notes*. Rochester: Visual Studies Workshop, 1977.

McCloskey, Michael. "Wilderness Movement at the Crossroads, 1945–1970." *Pacific Historical Review* 41 (1972): 346–361.

McConnell, Grant. *Private Power and American Democracy*. New York: Alfred A. Knopf, 1966.

McKenzie, Richard P. *The New Deal for Artists*. Princeton: Princeton University Press, 1973.

MacLeish, Archibald. *Land of the Free—U.S.A.* London: Boriswood, 1938.

Macomber, Ben. *The Jewel City: Its Planning and Achievement*. San Francisco: John H. Williams, 1915.

McPhee, John. *Encounters with the Archdruid*. New York: Farrar, Straus, and Giroux, 1971.

McWilliams, Carey. *Prejudice: Japanese Americans, Symbol of Racial Intolerance*. Boston: Little, Brown, 1944.

Maddow, Ben. *Edward Weston: Fifty Years*. Millerton, N.Y.: Aperture, 1979.

Malone, Michael P., ed. *Historians and the American West*. Lincoln: University of Nebraska Press, 1983.

"Market Interest in Adams's Work Is on the Rise." *American Photographer* 15 (December 1985): 23.

Marling, Karal Ann. *Wall to Wall America: A Cultural History of Post Office Murals in the Great Depression*. Minneapolis: University of Minnesota Press, 1982.

Marryat, Frank. *Mountains and Molehills, or Recollections of a Burnt Journal*. New York: Harper and Brothers, 1855.

Marshall, Robert. "The Wilderness as a Minority Right." *U.S. Forest Service Bulletin* 27 (August 1928): 5–6.

Marx, Leo. *The Machine in the Garden: Technology and the Pastoral Ideal in America*. New York: Oxford University Press, 1964.

Mauk, Charlotte. "Conservation in Kodachrome." In *Sierra Club: A Handbook*. San Francisco: Sierra Club, 1947.

May, Henry F. *The End of American Innocence: A Study of the First Years of Our Own Time, 1912–1917*. New York: Alfred A. Knopf, 1959.

Meine, Curt. *Aldo Leopold: His Life and Work*. Madison: University of Wisconsin Press, 1987.

Meinig, Donald, ed. *The Interpretation of Ordinary Landscapes: Geographical Essays*. New York: Oxford University Press, 1979.

Meltzer, Milton. *Dorothea Lange: A Photographer's Life*. New York: Farrar, Straus, and Giroux, 1977.

Merchant, Carolyn. *Ecological Revolutions: Nature, Gender, and Science in New England*. Chapel Hill: University of North Carolina Press, 1979.

———. *The Death of Nature: Women, Ecology, and the Scientific Revolution*. New York: Harper and Row, 1980.

Miller, Perry. "Nature and the National Ego." In *Errand into the Wilderness*, 204–216. Cambridge: Harvard University Press, 1956.

Misrach, Richard. "Documenting America's Wounded Landscape." *Earth Island Journal* 5 (Spring 1990): 28–29.

Misrach, Richard, and Miriam Weisang Misrach. *Bravo 20: The Bombing of the American West*. Baltimore: Johns Hopkins University Press, 1990.

Mowry, George. *The California Progressives*. Berkeley: University of California Press, 1951.

Muir, John. *Our National Parks*. Boston: Houghton Mifflin, 1901.

———. *The Story of My Boyhood and Youth*. Boston: Houghton Mifflin, 1913.

———. *The Thousand Mile Walk to the Sea*. 1916; San Francisco: Sierra Club Books, 1991.

Museum of Fine Arts. *Works on Paper: Edward Steichen, the Condé Nast Years*. Houston: Museum of Fine Arts, 1984.

Naef, Weston, and James N. Woods. *The Era of Exploration: The Rise of Landscape Photography in the American West, 1860–1885*. Buffalo: Albright-Knox Gallery; New York: Metropolitan Museum of Art, 1975.

Narell, Irena. *Our City: The Jews of San Francisco*. San Diego: Howell-North Books, 1981.

Nash, Gerald. *The American West Transformed: The Impact of the Second World War*. Bloomington: Indiana University Press, 1985.

———. *World War II and the West: Reshaping the Economy*. Lincoln: University of Nebraska Press, 1990.

Nash, Roderick. *Wilderness and the American Mind*. 3d ed. New Haven: Yale University Press, 1982.

"National Parks: The US's Time Dimension." *Time* (July 23, 1956): 16–22.

"The Nature of Ansel Adams." *Pageant* 17 (May 1962): 78–85.

Neel, Susan Rhoades. "Irreconcilable Differences: Reclamation, Preservation, and the Origins of the Echo Park Dam Controversy." Ph.D. dissertation, University of California, Los Angeles, 1990.

Neigle, Warta. *Santa Fe and Taos: The Writer's Era, 1916–1941*. Santa Fe: Ancient City Press, 1982.

Nelson, Bruce. *Workers on the Waterfront: Seamen, Longshoremen, and Unionism in the 1930s*. Urbana: University of Illinois Press, 1988.

Newhall, Beaumont. "Modern Photography 1934–5." *American Magazine of Art* (January 1935): 12–16.

——— , ed. *Photography: Essays and Images*. New York: Museum of Modern Art, 1980.

——— . *The History of Photography from 1839 to the Present Day*. 5th ed. 1937; New York: Museum of Modern Art, 1982.

——— . *Focus: Memoirs of a Life in Photography*. Boston: Bulfinch, 1993.

Newhall, Beaumont, and Amy Conger, eds. *The Edward Weston Omnibus: A Critical Anthology*. Salt Lake City: Peregrine Smith, 1984.

Newhall, Nancy. "The Caption: The Mutual Relationship of Words and Photographs." *Aperture* 1 (1952): 17–18.

——— . "Controversy and the Creative Concepts." *Aperture* 2 (July 1953): 43.

——— , ed. *The Daybooks of Edward Weston*. 2 vols. Millerton, N.Y.: Aperture, 1961.

——— . *Ansel Adams*. Vol. 1, *The Eloquent Light*. San Francisco: Sierra Club, 1963.

Norris, Frank. *McTeague: A Story of San Francisco*. New York: Doubleday & McClure, 1899.

Norris, Scott, ed. *Discovered Country: Tourism and Survival in the American West*. Albuquerque: Stone Ladder Press, 1994.

Norwood, Vera, and Janice Monk, eds. *The Desert Is No Lady: Southwestern Landscapes in Women's Writing and Art*. New Haven: Yale University Press, 1987.

Novak, Barbara. *Nature and Culture: American Landscape and Painting, 1825–1875*. New York: Oxford University Press, 1980.

O'Conner, Francis V., ed. *The New Deal Art Projects: An Anthology of Memoirs.* Washington, D.C.: Smithsonian Institution Press, 1972.

——. *Art for the Millions: Essays from the 1930s by Artists and Administrators of the WPA Federal Art Project.* Boston: New York Graphic Society, 1973.

Ogden, Kate Nearpass. "Sublime Vistas and Scenic Backdrops: Nineteenth-Century Painters and Photographers at Yosemite." *California History* 69 (Summer 1990): 134–153.

Ohrn, Karen Becker. *Dorothea Lange and the Documentary Tradition.* Baton Rouge: Louisiana State University Press, 1980.

Olin, Spenser, Jr. *California's Prodigal Sons: Hiram Johnson and the Progressives, 1911–1917.* Berkeley, Los Angeles, and London: University of California Press, 1968.

Olshaker, Mark. *Instant Image: Edwin Land and the Polaroid Experience.* New York: Stein and Day, 1978.

"Pacific Gas and Electric." *Fortune* 20 (September 1939): 34–41, 118, 120, 122.

Page, Christina. "The Man from Yosemite: Ansel Adams." *Minicam Photography* (September/October 1946): 75–81.

Palmquist, Peter. *Carleton E. Watkins: Photographer of the American West.* Albuquerque: University of New Mexico Press, 1982.

Park, Marlene, and Gerald E. Markowitz. *Democratic Vistas: Post Office Murals and Public Art in the New Deal.* Philadelphia: Temple University Press, 1984.

Parsons, Marion Randall. "The Twenty-Eighth Outing." *Sierra Club Bulletin* 15 (February 1930): 9–21.

Paul, Rodman. *California Gold: The Beginning of Mining in the Far West.* 1947; Lincoln: University of Nebraska Press, 1965.

Paul, Rodman W., and Michael P. Malone. "Tradition and Challenge in Western Historiography." *Western Historical Quarterly* 16 (January 1985): 27–54.

Peeler, David S. *Hope Among Us Yet.* Athens: University of Georgia Press, 1987.

Pells, Richard. *Radical Visions and American Dreams: Culture and Social Thought in the Depression Years.* 1973; Middletown, Conn.: Wesleyan University Press, 1984.

Pitts, Terence. *Photography in the American Grain: Discovering a Native American Aesthetic, 1923–1941.* Tucson: Center for Creative Photography, 1988.

Pomeroy, Earl. *In Search of the Golden West: The Tourist in Western America.* New York: Alfred A. Knopf, 1957.

Porter, Eliot. *The Place No One Knew: Glen Canyon on the Colorado.* Ed. by David Brower. San Francisco: Sierra Club, 1963.

———. *Galápagos: The Flow of Wildness.* Ed. by Kenneth Brower. San Francisco: Sierra Club, 1968.

Powell, Lawrence Clark. *Robinson Jeffers, the Man and His Work.* Pasadena: San Pasqual Press, 1940.

Pultz, John, and Catherine B. Scallen. *Cubism and American Photography, 1910–1930.* Williamstown, Mass.: Sterling and Francine Clark Art Institute, 1981.

Rakestraw, Lawrence. "Conservation Historiography: An Assessment." *Pacific Historical Review* 41 (1972): 271–288.

Reed, Allen C. "Dream Homes by the Dozen." *Arizona Highways* 30 (September 1954): 24–29, 38–39.

Reed, Susan. "Ansel Adams Takes on the President." *Saturday Review* 8 (November 1981): 32–34, 39.

Reisner, Marc. *Cadillac Desert: The American West and Its Disappearing Water.* New York: Viking, 1986.

*Report of the Director of the National Park Service . . . 1917.* Washington, D.C.: Government Printing Office, 1917.

Richardson, Elmo. *The Politics of Conservation: Crusades and Controversies, 1897–1913.* Berkeley, Los Angeles, and London: University of California Press, 1962.

———. "The Interior Secretary as Conservation Villain: The Notorious Case of Douglas 'Giveaway McKay.'" *Pacific Historical Review* 41 (August 1972): 333–345.

———. *Dams, Parks, & Politics; Resource Development and Preservation in the Truman-Eisenhower Era.* Lexington: University Press of Kentucky, 1973.

Robertson, David. *West of Eden: A History of the Art and Literature of Yosemite.*

Yosemite National Park: Yosemite Natural History Association and Wilderness Press, 1984.

Rosenberg, Edward. "San Francisco Strikes of 1901." *American Federationist* 9 (January 1902): 15–18.

Rosenberg, Emily. *Spreading the American Dream*. New York: Hill and Wang, 1982.

Rosenblum, Naomi. *World History of Photography*. Rev. ed. New York: Abbeville Press, 1989.

Rosenblum, Robert. *Modern Painting and the Northern Romantic Tradition*. New York: Harper and Row, 1975.

Rudnick, Lois Palken. *Mabel Dodge Luhan: New Woman, New Worlds*. Albuquerque: University of New Mexico Press, 1984.

Runte, Alfred. *National Parks: The American Experience*. Rev. ed. Lincoln: University of Nebraska Press, 1987.

——— . *Yosemite: The Embattled Wilderness*. Lincoln: University of Nebraska Press, 1990.

Russakoff, Dale. "The Critique: Ansel Adams Takes Environmental Challenge to Reagan." *Washington Post*, July 3, 1983, A1, A6.

Russell, Carl P. *One Hundred Years in Yosemite*. Yosemite National Park: Yosemite Natural History Association, 1968.

Russell, Terry, and Renny Russell. *On the Loose*. San Francisco: Sierra Club/Ballantine Books, 1967.

Rydell, Robert. *All the World's a Fair: Visions of Empire at American International Expositions, 1876–1916*. Chicago: University of Chicago Press, 1984.

Sanborn, Margaret. *Yosemite: Its Discovery, Its Wonders, and Its People*. New York: Random House, 1981.

Sandburg, Carl. *Steichen the Photographer*. New York: Harcourt Brace, 1929.

Sandler, Irving. *The Triumph of American Painting*. New York: Praeger, 1970.

Sandweiss, Martha, ed. *Photography in Nineteenth-Century America*. Fort Worth: Amon Carter Museum, 1991.

Sartre, Jean-Paul. *Existentialism and Humanism*. London: Methuen, 1948.

Sax, Joseph. *Mountains Without Handrails: Reflections on the National Parks*. Ann Arbor: University of Michigan Press, 1980.

Saxton, Alexander. *The Indispensable Enemy*. Berkeley, Los Angeles, and London: University of California Press, 1971.

Scharf, Aaron. *Art and Photography*. London: Allen Lane, 1968.

Scheff, D. "Fighting to Save the West, Ansel Adams Takes His Best Shot at Watt of Interior." *People* 15 (June 1, 1981): 24–29.

Schmitt, Peter. *Back to Nature: The Arcadian Myth in Urban America*. New York: Oxford University Press, 1969.

Schrepfer, Susan. *The Fight to Save the Redwoods: A History of Environmental Reform, 1917–1978*. Madison: University of Wisconsin Press, 1983.

Schudson, Michael. *Advertising: The Uneasy Profession*. New York: Basic Books, 1984.

Schwartz, Lawrence H. *Marxism and Culture: The CPUSA and Aesthetics in the 1930s*. Port Washington, N.Y.: Kennikat Press, 1980.

Scully, Julia, Andy Grundberg, Howard Millard, and Carol Squiers. "Landscape: Images and Idea." *Modern Photography* 46 (September 1982): 73–93.

Shepard, Paul, Jr. *Man in the Landscape: A Historical View of the Esthetics of Nature*. New York: Alfred A. Knopf, 1967.

"Sierra Peak Named for Ansel Adams." *Sierra Club Bulletin* 70 (May/June 1985): 78.

Simmons, Marc. *New Mexico: A Bicentennial History*. New York: W. W. Norton, 1977.

Slosson, Preston W. *The Great Crusade and After, 1914–1928*. 1930; New York: Quadrangle Books, 1971.

Slotkin, Richard. *Regeneration Through Violence: The Mythology of the American Frontier, 1600–1860*. Middletown, Conn.: Wesleyan University Press, 1973.

———. *The Fatal Environment: The Myth of the Frontier in the Age of Industrialization, 1800–1890*. New York: Atheneum, 1985.

Smith, Henry Nash. *Virgin Land: The American West as Symbol and Myth*. Cambridge: Harvard University Press, 1950.

Smith, Kirby. "A Famous Photographer Fights to Save the Environment with His Camera." *Us* 1 (May 3, 1977): 30–33.

Smith, Michael. *Pacific Visions: California Scientists and the Environment, 1850–1915*. New Haven: Yale University Press, 1987.

Snyder, Gary. *The Practice of the Wild*. San Francisco: North Point Press, 1990.

Snyder, Joel, and Neil Walsh Allen. "Photography, Vision, and Representation." *Afterimage* (January 1976): 8–13.

Sobieszek, Robert. *The Art of Persuasion: A History of Advertising Photography*. New York: Harry N. Abrams, 1988.

Soby, James Thrall. "Notes on Documentary Photography." *U.S. Camera* (November 1940): 37–39.

Sonfist, Alan, ed. *Art in the Land*. New York: E. P. Dutton, 1983.

Sontag, Susan. *On Photography*. New York: Farrar, Straus, and Giroux, 1977.

Sorenson, Thomas C. *The Word War: The Story of American Propaganda*. New York: Harper and Row, 1966.

Spaulding, Jonathan. "The Natural Scene and the Social Good: The Artistic Education of Ansel Adams." *Pacific Historical Review* 60 (1991): 15–42.

Stange, Maren. *Symbols of Ideal Life: Social Documentary Photography in America, 1890–1950*. New York: Cambridge University Press, 1989.

Starr, Kevin. *Americans and the California Dream, 1850–1915*. New York: Oxford University Press, 1973.

Starr, Walter, Jr. *Starr's Guide to the John Muir Trail and the High Sierra Region*. San Francisco: Sierra Club, 1934.

Stegner, Wallace. *The Uneasy Chair: A Biography of Bernard DeVoto*. New York: Doubleday, 1974.

———. "Ansel Adams and the Search for Perfection." *Dialogue* 9, no. 3 (1976): 33–46.

———, ed. *This Is Dinosaur: Echo Park Country and Its Magic Rivers*. New York: Alfred A. Knopf, 1955.

Steichen, Edward, ed. *The Family of Man*. New York: Museum of Modern Art, 1955.

———. *Life in Photography*. Garden City, N.Y.: Doubleday, 1963.

Stein, Roger B. *John Ruskin and Aesthetic Thought in America, 1840–1900*. Cambridge: Harvard University Press, 1967.

Steinbeck, John. *The Harvest Gypsies: On the Road to the Grapes of Wrath*. Berkeley: Heyday Books, 1989.

———. *Working Days: The Journals of* The Grapes of Wrath. New York: Viking, 1989.

Stieglitz, Alfred. "Pictorial Photography." *Scribner's Magazine* 26 (1899): 258.

Stineman, Esther Lanigan. *Mary Austin: Song of a Maverick*. New Haven: Yale University Press, 1989.

Stott, William. *Documentary Expression and Thirties America*. New York: Oxford University Press, 1973.

Strand, Paul. *Paul Strand: A Retrospective Monograph*. 2 vols. Millerton, N.Y.: Aperture, 1972.

———. "Photography and the New God." Reprinted in *Classic Essays on Photography*, ed. Alan Trachtenberg, 151. New Haven: Yale University Press, 1980.

Strand, Paul, and Nancy Newhall. *Time in New England*. New York: Oxford University Press, 1950.

Susman, Warren. "The Thirties." In *The Development of an American Culture*, ed. Stanley Coben and Lorman Ratner, 215–260. Englewood Cliffs, N.J.: Prentice-Hall, 1970.

———, ed. *Culture and Commitment, 1929–1945*. New York: George Braziller, 1973.

Szarkowski, John. *The Photographer and the American Landscape*. Garden City, N.Y.: Doubleday, 1963.

———. *The Photographer's Eye*. New York: Museum of Modern Art, 1966.

———. *Mirrors and Windows: American Photography Since 1960*. New York: Museum of Modern Art, 1978.

———. *American Landscapes*. New York: Museum of Modern Art, 1981.

Talkington, Lester. "Ansel Adams at the Photo League." *Photo Notes* (March 1948): 4–6.

Taylor, Bayard. *Eldorado, or Adventures in the Path of Empire.* 2 vols. New York: G. P. Putnam's Sons, 1850.

Taylor, Paul S., and Norman L. Gold. "San Francisco and the General Strike." *Survey Graphic* 23 (September 1934): 405–411.

Thompson, Oliver. *Mass Persuasion in History: An Historical Analysis of the Development of Propaganda Techniques.* Edinburgh: Paul Harris, 1977.

Thoreau, Henry David. *The Journal of Henry D. Thoreau.* 14 vols. Boston: Houghton Mifflin, 1949.

———. *In Wildness Is the Preservation of the World.* Selections and photographs by Eliot Porter. San Francisco: Sierra Club, 1962.

Topping, Gary. "Arizona Highways: A Half-Century of Southwestern Journalism." *Journal of the West* 19 (April 1980): 74–88.

Trachtenberg, Alan. *The Incorporation of America: Culture and Society in the Gilded Age.* New York: Hill and Wang, 1982.

Traub, Charles. "Thoughts on Photography in Conquest of the American Landscape." In *Art in the Land*, ed. Alan Sonfist, 217–224. New York: E. P. Dutton, 1983.

"Triumph of the Empire Builders." *Fortune* 45 (February 1952): 111–116.

Turner, Frederick. *Rediscovering America: John Muir in His Time and Ours.* New York: Viking, 1985.

Turner, Frederick Jackson. "The Significance of the Frontier in American History." In Turner, *The Frontier in American History*, 1–38. New York: Henry Holt, 1920.

Udall, Sharyn Rohlfsen. *Modernist Painting in New Mexico, 1913–1935.* Albuquerque: University of New Mexico Press, 1984.

"Understatement in the Southwest." *Fortune* 38 (July 1948): 114.

Van Dyke, Willard. "The Photographs of Dorothea Lange." *Camera Craft* 41 (October 1934): 461–467.

Van Nostrand, Jeanne. *The First Hundred Years of Painting in California, 1775–1875.* San Francisco: J. Howell, 1980.

Walker, Franklin. *San Francisco's Literary Frontier.* New York: Alfred A. Knopf, 1939.

Warner, Sam Bass. *Streetcar Suburbs: The Process of Growth in Boston, 1870–1900.* Cambridge: Harvard University Press, 1962.

Watkins, T. H. *Righteous Pilgrim: Harold Ickes.* New York: Henry Holt, 1990.

Watson, Steven. *Strange Bedfellows: The First American Avant-Garde.* New York: Abbeville Press, 1991.

Weart, Spencer R. *Nuclear Fear: A History of Images.* Cambridge: Harvard University Press, 1988.

Webb, Walter Prescott. *The Great Plains.* Boston: Ginn, 1931.

Weibe, Robert. *The Search for Order, 1877–1920.* New York: Hill and Wang, 1967.

Wensberg, Peter. *Land's Polaroid: A Company and the Man Who Invented It.* Boston: Houghton Mifflin, 1987.

Weston, Edward, and Charis Wilson Weston. *California and the West.* New York: Duell, Sloan, and Pearce, 1940.

White, Lynn, Jr. "The Historical Roots of Our Ecological Crisis." *Science* 155 (March 10, 1967): 1203–1207.

White, Minor. "Ansel Adams—Musician to Photographer." *Image* 6 (February 1957): 29–35.

——. Introduction. In *Ansel Adams,* ed. Liliane DeCock. Hastings-on-Hudson: Morgan and Morgan, 1972.

White, Morton. *Social Thought in America.* Rev. ed. Boston: Beacon Press, 1957.

White, Morton, and Lucia White. *The Intellectual versus the City.* New York: New American Library, 1964.

White, Richard. "Native Americans and the Environment." In *Scholars and the Indian Experience,* ed. W. R. Swagerty, 179–204. Bloomington: Indiana University Press, 1984.

————. "American Environmental History: The Development of a New Historical Field." *Pacific Historical Review* 54 (1985): 297–335.

Whitehead, Jessie M. "With the Sierra Club in 1927." *Sierra Club Bulletin* 13 (1928): 10–16.

Whitman, Walt. *Leaves of Grass.* 1855; New York: E. P. Dutton, 1912.

"Whom or What. . . ." *Village Voice* (December 8, 1975): 89.

"Wilderness Society Honors Ansel Adams." *Living Wilderness* 44 (June 1980): 40–41.

Williams, Raymond. *Culture and Society: 1780–1950.* London: Chatto & Windus, 1958.

————. *The Country and the City.* New York: Oxford University Press, 1973.

Williams, William Carlos. *In the American Grain.* New York: A. & C. Boni, 1925.

Wilmerding, John, ed. *American Light: The Luminist Movement, 1850–1875.* Washington, D.C.: National Gallery of Art, 1980.

Wilson, Charis. "The Weston Eye." In *E.W. 100: Centennial Essays in Honor of Edward Weston,* 117–123. Carmel: Friends of Photography, 1986.

Winkler, Allan W. *The Politics of Propaganda: The Office of War Information, 1942–1945.* New Haven: Yale University Press, 1974.

Witkin, Lee, and Barbara London. *The Photograph Collector's Guide.* Boston: New York Graphic Society, 1979.

"Wizards of the Coming Wonders." *Life* 36 (January 4, 1954): 93–94.

Wolfe, Tom. *The Electric Kool-Aid Acid Test.* New York: Farrar, Straus, and Giroux, 1968.

Worster, Donald. *Nature's Economy: A History of Ecological Ideas.* Cambridge: Cambridge University Press, 1977.

Wright, Cedric. "Trail Song, Giant Forest and Vicinity: 1927." *Sierra Club Bulletin* 13 (1928): 20–23.

Wright, Jack. "The Work and Ideas of Ansel Adams, FPSA." *PSA Journal* 16 (December 1950): 756–762.

"Yosemite." *Life* 47 (July 25, 1949): 53–57.

# Index

Abbott, Berenice, 173

Abstract expressionism, Adams's response to, 237–238, 256–258

Acoma, New Mexico, 71

Adams, Anne (daughter): birth, 107, 138; mentioned, 139; schooling, 150, 231

Adams, Ansel

architecture, childhood fascination with, 14

articles: *Arizona Highways*, 273–276; *Camera Craft*, 87, 122–123; *Creative Art*, 104–105; *Fortune*, 214–216, 253, 264; *Life*, 272–273, 276–278; *Modern Photography*, *1934–1935*, 123–124; *Sierra Club Bulletin*, 97, 189, 217–218, 384 n.35; *Victory*, 212–214

birth, 2

books: as long-term projects and public outreach, 163–164; *Basic Photo* series, 124, 219–220; *Born Free and Equal*, 205, 207–210; *Death Valley*, 292; *Fiat Lux*, 335 n. 41; *Illustrated Guide to Yosemite, An*, 247; *Images: 1923–1974*, 354, 360; *Land of Little Rain, The*, 255; *Making a Photograph*, 124–125, 171, 175, 219; *Michael and Anne in Yosemite Valley*, 246–247; *Mission San Xavier del Bac*, 292; *My Camera in the National Parks*, 255–256, 328, 354; *My Camera in Yosemite Valley*, 255; *Pageant of Photography, A*, 174; *Photographs of the South-*west, 354; *Portfolios of Ansel Adams, The*, 354; *Sierra Nevada: The John Muir Trail*, 161, 163, 169, 322; *Taos Pueblo*, 69–73, 79–82; *Tetons and the Yellowstone, The*, 349–350; *These We Inherit: The Parklands of America*, 328; *This Is the American Earth*, 292–293, 298, 307–315, 328, 329, 330, 333–335; *Yosemite and the High Sierra*, 254–255; *Yosemite and the Range of Light*, 354, 355; *Yosemite Valley*, 292

childhood, 1–19

communism, views on, 127–128, 249–252

counterculture, views on, 326–328

critics, 82, 323–324, 354–355

curator, 172–174, 177–178

darkroom fire, 155–156

"darkroom monkey," first job, 28–29

death, 366

education, 13–19

environmentalism and humanism, 290–291, 358–359

exhibitions: An American Place, New York, 133, 138–140, 143–145, 170, 173, 178; *Ansel Adams and the West*, 355; Arts Club, Washington, D.C., 138; Delphic Studios, New York, 104; *Eloquent Light, The*, 322–324; *I Hear America Singing* (aka *Nation of Nations*), 302–307; Katherine Kuh Gallery, Chicago, 138; *Manzanar, Photo-*

graphs of *Loyal Japanese American Relocation Center*, 208–209; *Photographs of America by Ansel Adams*, 190–192; *Pictorial Photographs of the Sierra Nevada Mountains*, 90; *This Is the American Earth*, 284–285, 289–292, 298

family life: ambivalence toward, 138–139, 143–145; new appreciation for, 150–151; artistic, eccentric, and middleclass "success," 231

finances, 68, 93, 96, 137, 138–139, 142–145, 230–231

gallery and studio, 105–106

gregariousness, 324, 361–362

Guggenheim fellowship, photography on, 218, 222, 223, 226–240

health, physical and emotional, 13, 32–33, 50, 142–145, 146, 147–161, 259–261, 308–309, 318, 320; heart troubles, 349; hypochondria, 363; triple coronary bypass, 363

jokes and pranks, 54–55, 96, 99, 187–188, 361–362

Medal of Freedom, 360

modernism, artistic, introduction to and adoption of, 17, 58–65, 75–78, 81, 92–93

mountain climbing, 54

moves: to Berkeley, 146–147; to Carmel, 320–321; back to San Francisco, 259; to Yosemite, 150

mural project, Interior Department, xi–xiii, 181, 184, 186–190, 193–194, 217–219

Museum Set, 363

music: career, 44, 48–49, 65–66; continues for pleasure, 192, 321; influences in photography, 84, 171; Milvani trio, 65; training, 14–15, 29–30

nature and society, ideas on, 63, 205–206, 227–228, 313–315, 355–356

parents, relationship with, emotional effects of, 13–14, 144, 259–261, 320

photographic career: acquires business manager, 351–352; creative rhythms of, 267–268; in Depression, 93; turn toward, 65–66, 68

photographic education, 27–29

photographic style, changes in, 81, 154, 188–190, 234–237, 318–320, 324

photographic technique, 28–29, 46–48, 67–68, 108, 122–125, 171–172, 229–230, 234–236, 365. *See also* Zone system

photographs: *Aspens, Northern New Mexico*, 318–320, 353, 354; *Boards and Thistles*, 91, 147; *Burnt Stump and New Grass, Sierra Nevada*, 307; *Clearing Winter Storm, Yosemite National Park*, 360; *Detail, Interstadial Forest, Glacier Bay*, 236; *Diamond Cascade*, 34; *Fern in Rain, Mount Rainier*, 310; first, 21–22; *Freedom of Speech, Freedom of Religion, Freedom from Want, Freedom from Fear*, 212; *Frozen Lake and Cliffs*, 90–91, 353; *Golden Gate, The*, 147; *Graffiti, Abandoned Military Installation*, 364–365; *Monolith, the Face of Half Dome*, 66–68, 322, 353; *Moon and Mount McKinley*, 234–235; *Moonrise, Hernandez, New Mexico*, xi–xiii, 188, 207, 305, 353, 354; *Mount McKinley and Wonder Lake*, 235–236; *Mount McKinley*

*National Park*, 247; *Mt. Robson*, 89; *Mount Williamson, the Sierra Nevada from Manzanar*, 206, 300–301, 307; *On the North Farm at Manzanar*, 205; *Pine Cone and Eucalyptus*, 147; *Self-Portrait in a Victorian Mirror*, 144; *Surf Sequence*, 175; *Tetons and the Snake River, The*, 311; *Thunderstorm, the Teton Range*, 304; *Vernal Falls, Yosemite National Park*, 247; *White Tombstone*, 140; *Winter Sunrise, the Sierra Nevada from Lone Pine*, 206–207, 310, 314, 354; *Woman Winnowing Grain*, 81

photographs, marketing of, 241–242, 246–247

photography and popular persuasion, 167–168, 189–190, 282–284, 297–298, 313–315

photography, color, 275, 329

photography, commercial: Bank of America, 265; Bell Telephone, 272; conflicts with art and preservation, 137, 141–142, 144–145, 157–158, 170, 200, 265–266; Curry Company, Yosemite Park and, 97–98, 134–136, 147, 157–158, 265; Eastman Kodak, 229–233; first assignments, 44–46; Hasselblad, 272; high-technology clients, 271–273; IBM, 272; Kennecott Copper Corporation, 264–265; Pacific Gas and Electric, 265; Polaroid, 265, 270–272; Southern Pacific, 233; Standard Oil, 247–248, 264–266; University of California, 335–336; U.S. Potash, xiii, 141; Varian Associates, 272

photography, documentary: African-American education, 211; Manzanar project, 201–210; Office of War Information, 211–214; Richmond shipyards, 217–219

photography, European, reaction to, 178

photography, landscape: new directions in, reaction to, 356–358; nineteenth-century, influence of, 37–38

political activism, 179–181

political beliefs, 127–128, 165–166, 179–181, 210, 238, 250–252

portfolios: *Parmelian Prints of the High Sierras*, 57–58, 240; *Portfolio I*, 240–242; *Portfolio II*, 433 n.91

portraits: early, 68; in Manzanar, 204; in Richmond shipyards (*Trailer Camp Children*), 215; of "Juan," 79–80; of Mary Austin, 71–72; of O'Keeffe, 157; of self, 144; of women, 152–153

sexuality, 152–153, 239–240

social activism and art, 108–115, 217, 238, 251–252, 255–259, 283–284

teaching, 121–122, 171, 199–200, 218–219

technology, fascination with, 17–19, 137, 272–273

tourism, development, and preservation, views on, 137, 141, 217–218, 232–233, 242–248, 252, 264–266, 276, 278–279, 295–297, 355–356

visualization in photography, 67–68, 171

youth: growing maturity and self-reliance, 40–42; lack of discipline in, 13–15

wartime service, 191, 198–200

West, American, people of, attitude toward, 278

wilderness: attitude toward, 50, 217–
218, 355–356; ideal and reality,
282–283; popular identification
with, 354–355

women, relationships with, 153, 238–
240

Adams, Charles (father): anti-
Communism, 127; assumes family
business, 6; Astronomical Society of
the Pacific, secretary of, 13; astron-
omy, 6; business failures, family ten-
sions, 11–13; death, 259–260; old age,
223; relationship with Ansel, 13–14,
41–42, 259–260; youth and marriage,
5–6

Adams, Elizabeth (aunt), 39

Adams, Henry, 8–9

Adams, Jeanne Falk (daughter-in-law),
352

Adams, Michael (son): born, 106–107;
mentioned, 138; schooling, 150, 231;
travels with his father, xi, 186–187,
233–234

Adams, Mount Ansel, dedication of,
366–368

Adams, Olive Bray (mother): attitude
toward photography, 84; death, 259;
effects of family financial failure, 13;
family background, 6; marriage to
Charles Adams, 6; old age, 223; rela-
tionship with Ansel, 259, 389 n. 64;
Yosemite visits, 20–22, 30–31

Adams, Robert, 358

Adams, Virginia Best (wife): Ansel's
affair, 142–145; Ansel meets, 43–45;
Ansel postpones engagement, 48–49;
Ansel renews relationship, 65–66;
marriage proposal and wedding, 68–
69; mentioned, 105, 133, 138, 141,
182, 184; Michael and Anne born,

107; moves to Berkeley, 146–147, to
Yosemite, 150, back to San Francisco,
259, to Carmel, 320–321; publishing
ventures, 239, 246–247, 255, 292;
relationship with Ansel, 238–240;
retires from Sierra Club board of
directors, 107; travels with Adams
and Newhalls, 228; travels with Ansel
to New York, 98–102; visitors, love
of, 361–362

Adams, William (uncle), 6

Adams, William James (grandfather):
birth and youth, gold rush experi-
ences, 3–4; death of, 12; Unadilla,
home in Atherton, California, 4, 10–
11, 12; Washington Mill Company, 5,
11, 12–13

African-American education, Adams-
Newhall project on, 211, 298–299

Agee, James, 117

Agriculture, United States Department
of, 129

Ahwahnee Hotel, 95

Ahwahneeche, Yosemite tribe, 23

Alaska National Interest Lands Conser-
vation Act, 360

Albright, Horace, 129, 141, 296

Alinder, James, 364

Alinder, Mary, 363, 391 n.77

*American Photographs* (Evans), 165–166

*Americans, The* (Frank), 325

Anspacher, Carolyn, 153

*Aperture* magazine, founding of, 268–270

Applegate, Frank, 79

Arbus, Diane, 324–325

Archer, Fred, 171–172

*Arizona Highways*, 273–276, 292

Armes, William, 52

Art Center School (later Art Center Col-
lege of Design), 171–172, 199–200, 218

*Art of Edward Weston, The* (Weston), 104–105

Ashcan school, 75

Ashkenazy, Vladimir, 365–366

Aspen Conference on Photography, 268–269

Atget, Eugène, 173, 178

Austin, Mary, 69–77, 153, 189, 238; collaborates with Adams on *Taos Pueblo*, 79–82

Ayres, Thomas, 24

Baer, Morley, 352

Ballantine Books, 330

Baltz, Lewis, 357

Barr, Alfred, 148, 177–178, 185

Bauhaus school, 88, 195

Bayer, Herbert, 195, 303

Bender, Albert: Adams's gratitude toward, 82, 92, 112; Adams meets, 56–57; correspondence with Mary Austin, 72–73; death of, 182; introduces Adams to artists and writers of California and New Mexico, 56–65; sponsors Adams's first portfolio, 56–58; suggests Adams collaborate with Mary Austin, 69

Bergson, Henri, 75

Berlin, Irving, 179

Berry, Philip, 344, 347

Best, Harry, 42, 106, 107, 139

Best, Virginia. See Adams, Virginia Best

Best's Studio, 107, 141, 144, 150, 320, 351

Bierstadt, Albert, 188–189

Bissantz, Edgar, 352

Boone, Daniel, 233

Borglum, Solon, 16

Born, S. A., 14

Boulder Dam. See Hoover Dam

Bourke-White, Margaret, 119, 162, 173, 179

Bracebridge Dinner, Yosemite National Park, 95–96

Bradley, Cornelius, 53

Bradley, Harold, 243–245, 287, 296

Brand, Stewart, 327

Brant, Irving, 130

Bray, Mary (aunt), 6, 20; attitude toward Charles Adams, 13

Bray, Olive. See Adams, Olive Bray

Breton, André, 257

Bridges, Harry, 125–126

*Britain at War* (MoMA), 185

Brower, David: "anti-science bias," 316; conflicts over publishing and nuclear power, 340–349; contributions to *This Is the American Earth*, 307, 309; Curry Company publicity manager, 98; dedication of Mount Ansel Adams, 367–368; Dinosaur campaign, 278–283; early years at Sierra Club, first efforts at public persuasion, 261–263; executive director of Sierra Club, 279; exhibit format series, 313, 328–335; Grand Canyon campaign, aggressive tactics in, 337–340; joins Tenth Mountain Division, 191; on *Aspens*, 319–320; photography in conservation campaigns, 297–298; publishing and advertising, 293–294; Sierra excursion with Adams and Weston, 152; "Young Turks" reshape Sierra Club, 243–245

Brown, Edmund G., 336

Bullock, Wynn, 352

Bunche, Ralph, 306

Bunnell, Lafayette, 23

Burford, Anne, 361

Burlew, E. K., 180–181, 184, 191, 193

Burton, Philip, 359
*Business Week*, 265
Butler, Marie, 15
Bynner, Witter, 64–65

Cahill, Holger, 112
Caldwell, Erskine, 162, 179
California: environmental damage to,
    51–52; environmental protection in,
    52; literary and artistic heritage, 58–
    63; love of outdoors in, 22; postwar
    society, 215–216; urban and subur-
    ban development, 1, 10, 137, 146–
    147, 342
*California and the West* (Weston), 151
California Conservation League, 135
California School of Fine Arts, 218–219,
    223–224, 237–238
*Camera Craft*, 122–125
*Camera Work*, 75, 100, 103, 221
Cammerer, Arno, 129
Canyon de Chelly, 156–157, 186–187,
    274
Carlsbad Caverns National Monument,
    141–142
Carlson, Raymond, 273
Carlyle, Thomas, 49
Carmel Highlands, Adams builds home
    in, 320–321
Carpenter, Edward, 40–50, 54–55, 85,
    255
Carson, Rachel, 315–316
Carter, Jimmy, 360
Cartier-Bresson, Henri, 119, 258, 324
Catlin, George, 312
Central Arizona Project, 337
Cézanne, Paul, 75
Chapman, Oscar, 263–264
*Chrysanthemum Specialist* (Miyatake), 205
Church, Frederick, 189

Civil Rights movement, 298–299
Clark, Nathan, 262
Clark, Reuben, 277
Clemens, Samuel, 58
*Co-Evolution Quarterly* (Brand, ed.), 327
Colby, William E., 33, 243–244, 266,
    321, 338
Cole, Thomas, 36–37
Colorado River Storage Project (CRSP),
    263–264, 279–283
Colorama, Adams photographs for
    Kodak, 229–233
Communism, 126–128, 238
Connell, Arthur, 352
Conservation Associates, 341
Conservation movement, origins and
    early legislation, 52
Coolbrith, Ina, 58
Cranston, Alan, 359–360, 367
*Creative Art*, 104–105
Cunningham, Imogen, 87, 89, 133, 152,
    185, 352
Curry, David, 21, 94
Curry, Jennie, 94
Curry Company, Yosemite Park and,
    93–98, 134–136, 152, 157–158, 218,
    261, 262, 265, 292, 296

Darwin, Charles, 286
Dasmann, Raymond, 342
Dassonville, William E., 79
Dater, Judy, 362–363
Davis, Stuart, 113
De Cock, Liliane, 352
De Kooning, Willem, 257
de Young, M. H., Museum, 107, 322
Death Valley National Monument, 186,
    226
Deaver, Michael, 360
Delphic Studios, 104

Demaray, Arthur, 141, 169
DeMille, Cecil B., 186
Depression, Great, 93, 98–99, 112–115
DeVoto, Bernard, 253–255, 263, 283, 291, 293–294
Diablo Canyon nuclear power plant, Sierra Club conflicts over, 341–345
Dinosaur National Monument, 263–264, 279–283, 293–294, 333
Dittman, Frank, 28–29
Dixon, Daniel, 277
Documentary photography, 116–121, 155, 162–163, 164–165
Dominy, Floyd, 338
Donohue, Phyllis, 363
Dougherty, William, 255–256
Douglas, William O., 313
Dove, Arthur, 221
Dresser, Rod, 363
Du Bois, W. E. B., 211

Eastman House, George, 329
Easton, Ansel, 12–13
Echo Park Dam, 279–283
Ecology: deep, 358–359; influence on Adams and Sierra Club, 286–287
Ecotactics: The Sierra Club Handbook for Environmental Activists, 348–349
Edgerton, Harold, 173
Edwards, John Paul, 87
Edwards, Jonathan, 311
Eisenhower, Dwight, 264
Eisenstein, Sergei, 120
Eissler, Frederick, 341
Emerson, Peter Henry, 35
Emerson, Ralph Waldo, 63
English, Patricia, 138
Environmentalism, rise of, 285–289
Evans, Walker, 119, 163, 165–166, 218
Existentialism, 257–258

Family of Man, The (Steichen), 300–302, 303
Farm Security Administration (FSA), 137, 163, 173, 211
Farquhar, Francis, 262
Farquhar, Marjory, 280
Farr, Fred, 359
Farr, Sam, 359
Federal Arts Project, 112
Ferris, Milton, 269
Field Workers Hoeing Corn, Manzanar (Lange), 205
Firth, Francis, 311
Flaherty, Robert, 71, 116
Ford, Gerald, 360
Forest Service, United States, 130, 135, 168, 245, 254, 286–287
Fortnightly, 85
Fortune, 117, 214–216, 253, 264, 265, 275–276
Four Freedoms project with Lange, 211–213
Four Seasons in Yosemite, The, 157
Frank, Robert, 324–325
Fraser, James Earl, 16
Fried, Alexander, 323
Friends of Photography, 352
Frontier: Adams's reinterpretation of, 313–315; cult of, 25–27
Frugé, August, 333–334

Gaspar, Reiko, 210
George, Henry, social critiques of, 7
Glacier National Park, 233
Glen Canyon Dam, 281
God Bless America (Berlin), 179
Gold rush, California: literature of, 58; social and cultural legacy, 4–5
Gonne, Maude, 72

Gorky, Arshille, 257
Grand Canyon National Park, 186, 226–227, 229–230; Sierra Club campaign for, 337, 346
Grierson, John, 116
Grinnell, Joseph, 94
Group f/64: founding of, 87; modernism and, 88–91, 92, 113, 115, 124, 154, 189, 236, 268
Gruening, Ernest, 233–234
Grunsky, Frederick, 289, 297–298
Guggenheim Foundation, 154, 218, 220, 222, 293, 324, 326

Haeckel, Ernst, 286
Halcyon, Theosophical Society colony in Oceano, California, 272
Hall, Ansel, 42
Halsman, Philippe, 250–251
Hamlin school, 231
*Harper's*, 253–254
Harriman, E. H., 233
Harris, Morgan, 152
Harte, Bret, 58
Hasselblad Corporation, 272
Hayden, Ferdinand, 38
Henri, Robert, 78
Hetch Hetchy Valley, 263, 281–282
Hildebrand, Alexander, 266, 295, 316
Hildebrand, Joel, 131, 316, 340
Hills, Cassandra, married to W. J. Adams, 4
Hine, Lewis, 117–118, 306
Hodel, Donald, 366, 367
Holman, Francis, 31–32, 38–40
Holme, C. P., 124
Hoover Dam, 137, 186
Houghton Mifflin Company, 239, 254–255
*How the Other Half Lives* (Riis), 162
Huber, Walter, 266

Hughes, Robert, 354–355
Hutchings, James M., 20, 24
Hyde, Philip, 282–283

Ickes, Harold, 129–130, 134, 168–169, 180–181, 184, 193, 210, 217–218, 238, 366
*Image of Freedom* (MoMA), 180, 184–185
*In Wildness Is the Preservation of the World* (Porter), 329–330, 333–334
Interior, United States Department of, xi, 129, 134, 193, 264, 327, 337
International Business Machines (IBM), 272

Jackson, William Henry, 38, 129, 193–194
Japanese American Citizens League, 210
Japanese Americans, internment of, 201–209
Jeffers, Robinson, 60–63, 145, 331–332
Jeffers, Una, 60–61
Jenkins, William, 357
Johnson, Hiram, 134
Johnson, Mildred, 65
Johnson, Robert Underwood, 52
Jordan, David Starr, 53
Jukes, Thomas, 316

Kandinsky, Wassily, 76
Keith, William, 52
Kennecott Copper Corporation, 264–265
Kennedy, John F., 315, 316
Kerouac, Jack, 325
Kerr, Clark, 336
Kertész, André, 185
Kesey, Ken, 326–327
Kings Canyon: Adams lobbies for park, 130–134; Adams's travels in, with LeContes, 46; national park estab-

lished in, 168–169; roads in, 243–244, 262

Kino, Eusebio, 275

Kirstein, Lincoln, 165–166, 178, 324

Klein, William, 324

Knopf, Alfred, 293

Kodak, Eastman: Adams makes coloramas for, 229–233, 270; first roll film cameras, 27

Kodani, Fumiye, 363

Kriebel, Richard, 271

Kuh, Katherine, Gallery, 139

Lamar, Edwin, 17

Land, Edwin, 153, 270–272

Land of the Free (MacLeish), 162–163, 180, 274

Landscape: painting, influence on Adams, 35–37, 188–189; photography, influence on Adams, 37–38, 356–357

Lange, Dorothea, 113–115, 116, 118, 119, 121, 128, 163, 352; Fortune collaboration with Adams on Richmond shipyards, 214–216, 227, 238, 251, 269; Four Freedoms project, 211–213; Life collaboration with Adams on "Three Mormon Towns," 276–278; Manzanar photographs, 204–205, 209

Last Redwoods, The (Sierra Club), 334–335

Lawrence, D. H., 73

LeConte, Joseph N., 52

LeConte, Joseph N., II, Kings Canyon excursions with Adams, 46

LeConte Memorial Lodge: Adams's custodial duties, 31–33; This Is the American Earth exhibition, 284–285, 291–292

Lee, Russel, 163

Leonard, Richard, 191, 243–245, 279, 293, 296, 340, 343, 345, 347

Leopold, A. Starker, 331

Leopold, Aldo, 131; influence in environmental movement, 287–289, 331

Life, 117, 157, 173

Lincoln, Abraham, 208–209

Little, Brown and Company, 353–354

Litton, Martin, 337, 342

London, Jack, 59–60

Look, 117

Lorentz, Pare, 120–121, 162

Losh, William J., 289

Louie, Ernest, 269

Luce, Henry, 117

Luhan, Mabel Dodge, 73–74, 76, 112

Lujan, Antonio, 73–74

Lunn, Harry, 360

McAgy, Douglas, 218–219, 224

McAlpin, David: Adams discusses commercial work for Polaroid, 270; Adams meets, 132–133; books as vehicles for meaningful projects, 163; buys Adams prints, 143; founding department of photography, MoMA, 176–177; Image of Freedom show, MoMA, 184–185; on Stieglitz, 170; outrage at hiring of Steichen, 220–221; phases of Adams's career, 267–268; travels with Adams, O'Keeffe, and Rockefellers in New Mexico, 156–157; travels with Adams, O'Keeffe, and Rockefellers in Yosemite, 159–160

McCarthy, Joseph, HUAC hearings, 250–251

McCloskey, Michael, 341, 347

McConnell, Grant, 342

McDuffie, Duncan, 266

McFarland, Horace, 244

McGraw, Dick, 320

McGraw, Max, 309, 320

MacGregor, Francis, 179

McKay, Douglas, 264, 294

MacLeish, Archibald, 162–163, 180, 274

Maloney, Thomas, 177, 220

Manzanar Relocation Center, 201–210

Marc, Franz, 76

Marin, John, 76–78, 112, 201, 221, 241

Marshall, George, 331–332

Marshall, Robert, 131, 288–289, 331

Mather, Stephen, 244–245

Matisse, Henri, 75

Mauk, Charlotte, 243, 255

Mazzeo, Rosario, 352

Merriam, Frank, 126

Merritt, Ralph, 202–203

Meyer, Eugene, 58, 134

Michael, Charles W., 94–95

Miller, Joaquin, 58

Misrach, Richard, 357

Miyatake, Toyo, 201–205

Modernism, artistic, influence on
    Adams, 60–63, 70–91, 111–113, 155

Moe, Henry Allen, 220, 293

Moholy-Nagy, László, 88, 173

Mooney, Tom, 18, 93

Moore, Benjamin, 30

Moore, Jean Chambers, 57

Moran, Thomas, 189

Morgan, Barbara, 177, 269

Morgan, Willard, 177

Morris, William, 49

Mortensen, William, 87

Mount Ansel Adams, dedication of, 367–368

Mount McKinley, 234–236

Muir, John: Adams and, 50, 254–255,
    367–368; conservation ideas and
    activism of, 50–52, 261; founding of
    Sierra Club and, 52–53; Hetch Het-
    chy and, 263, 281–282; mentioned,
    63; revival of influence, 254–255;
    Sequoia and Kings Canyon National
    Parks and, 130; use and preservation in
    the parks, ideas on, 232–233, 243–
    244

Museum of Modern Art, New York:
    Adams's association with, 147, 175–
    180, 183, 184–185, 190–192, 200,
    220–221, 250, 268; *Ansel Adams and
    the West* exhibition, 355; Beaumont
    Newhall joins, 147–148; Beaumont
    Newhall resigns from, 220–221;
    Diane Arbus exhibition, 325; found-
    ing of Department of Photography,
    175–180; *Image of Freedom* exhibition,
    184–185; Manzanar exhibition, 208–
    210; Minor White and, 223; Nancy
    Newhall, acting curator, 190–192;
    *Road to Victory* exhibition, 195–198;
    Steichen and, 103, 220–221; Stieglitz
    and, 158–159; Walker Evans and,
    165; Weston retrospective, 225

Muybridge, Eadweard, 173

Mydans, Carl, 163

*National Geographic* magazine, 258

National Park Service: dams and, 263;
    Kings Canyon legislation, 168–169;
    Leopold Report, 331; mentioned,
    135; Mission 66 program, 294–297;
    Organic Act, 295; renews Best's Stu-
    dio permit, 141; tourism and devel-
    opment in the parks, 243–246, 355–
    356; under Ickes and FDR, 129–130

Nature, landscape art and, 77–78

New Deal, 112–113, 127–128, 137, 163,
    186, 238

New Frontier, 315

*New Republic*, 167

*New Topographics: Photographs of a Man-altered Landscape* (Jenkins, ed.), 357

*New West: Landscapes Along the Colorado Front Range, The* (Robert Adams), 358

*New York Times*, 345

Newhall, Beaumont: Eastman House, 239; education and training, 147; exhibition style, 301; finds *Four Freedoms* series in Italy, 213; first visit to California, 173–178; 5 Associates, publishing, 292; founding of *Aperture*, 269; Friends of Photography, 352; *Image of Freedom* exhibition, 185; Minor White and, 223; joins MoMA, 148–149; Photo League and HUAC, 252; *Road to Victory* exhibition, 197–198; Steichen and, 103, 220–221; Stieglitz and, 159, 222; travels with Adams on Guggenheim, 227–230; urges Adams to social activism in his art, 284; wartime service, 191; Weston retrospective at MoMA, 225

Newhall Fellowship, 350

Newhall, Nancy: acting curator, MoMA, 191–192; Adams's psychology, 260–261; Adams worries about her overwork, 308; African-American education, 211, 298–299; *Arizona Highways* collaborations with Adams, 273–276; art and the postwar world, 258–259; background, marriage to Beaumont, 148–149; biography and retrospective exhibition of Adams, *The Eloquent Light*, 322–324, 350; comparisons of Adams and Weston, 236–237, 269; Eliot Porter and, 329; environmentalism, 289–291; *Fiat*

*Lux* project, 335–336; first visit to California, 173–178; 5 Associates, publishing, 292; Friends of Photography, 352; *I Hear America Singing* exhibition, 302–307; *Image of Freedom* exhibition, 180; joint projects with Adams, 238–240; Manzanar exhibition at MoMA, 207–211; *Photographs of America by Ansel Adams*, 190; physical decline, death, 349–350, 352; relationship with Adams, 238–240; Steichen and, 220–221; Stieglitz and, 222; *Tetons and the Yellowstone, The*, 349–350; *This Is the American Earth*, exhibition, 289–292, book, 307–315; "Three Mormon Towns," 277; travels with Adams on Guggenheim, 227–230; Weston retrospective, MoMA, 225

*Newsweek*, 265

Nipomo Dunes, 341

Norman, Dorothy, 143, 222–223

Norris, Frank, 59–60

Noskowiak, Sonja, 87

*Not Man Apart* (Jeffers), 331–332, 334

Nuclear power, conflicts between Adams and Sierra Club over, 340–345

Office of War Information (OWI), 191, 209, 211, 213, 227, 302

O'Keeffe, Georgia: Adams meets, 76–78; Adams portrait of, 153; Adams visits in New York, 132–133; sells despite Depression, 112; Stieglitz's death and, 222; travels with Adams in New Mexico, 156–157; travels with Adams in Yosemite, 159–161

Olmstead, Frederick Law, Jr., 95

Olney, Warren, 52

Omaha, Ben, 210

*One Flew Over the Cuckoo's Nest* (Kesey), 326
*One World* (Wilkie), 300
*On the Loose* (Russell and Russell), 343–344
O'Sullivan, Timothy, 147
Outerbridge, Paul, 173
Oye, Harry, 201–203

Pacific Gas and Electric Company (PG&E), 265, 340–342
Page, Christina, 227
Panama Pacific International Exposition, 15–19
*Park City* (Baltz), 357
Parsons, Marion Randall, 309
*Partisan Review*, 167, 257
Partridge, Roi, 152
Partridge, Ron, 152, 185
Photography, landscape: new directions in, 356–358; nineteenth-century, 37–38
Photography, "street," 324–325
Photo League, 173; Adams, McCarthy Hearings, and, 250–252
Picasso, Pablo, 76
Pictorialism, 35
Pillsbury, Arthur, 22, 30
Pinchot, Gifford, 130, 254, 287
*Place No One Knew, The* (Porter), 337
*Playboy*, 360
*Plow That Broke the Plains, The* (Lorentz), 120–121
Plueger, Timothy, 172–173
Plumb, Stanley, 261
Polaroid Corporation, 265, 270–272
Pollock, Jackson, 257
Pond, Charles, 38
Pond, Elizabeth, 38
Pope, Bertha, 63–64
Porter, Eliot, 185; *In Wildness*, 329–330;

Sierra Club conflicts, 345, 347; *The Place No One Knew*, 337
*Posters for National Defense* (MoMA), 185
Pound, Ezra, 88
Progressivism: influence on Adams, 8–10, 18–19, 127, 137; photography and reform, 117

Rahv, Philip, 167
Rainier, Chris, 363
Ray, Man, 164, 173
Reagan, Ronald, 360–361, 366
Reclamation, United States Bureau of, 264, 279–283, 338
*Redes* (Strand), 120
Reed, Alma, 104
Riis, Jacob, 162
*River, The,* (Lorentz), 121
Rivera, Diego, 128, 257
*Road to Victory, The* (Steichen), 195–198, 274
Robinson, Bestor, 246, 295, 338
Robinson, Gerald, 352
Rockefeller, Godfrey, 157, 159
Rockefeller, Helen, 157, 159
Roosevelt, Eleanor, 179
Roosevelt, Franklin Delano, 98, 125–130, 169, 210, 238, 366
Roosevelt, Theodore, 9–10, 26, 129
Ross, Alan, 353
Rothstein, Arthur, 163
Ruskin, John, 55
Russell, Renny, 343–344
Russell, Terry, 343–344

Sacks, Paul, 147
Sandburg, Carl, 196, 300
*Sand County Almanac, A* (Leopold), 288
San Francisco: Adam's reaction to development in, 137; Art Association, 218; earthquake and fire, 11–12; General

Strike, 1934, 125–127; gold rush society and culture, 4–5; Golden Gate Exposition, 1940, 172–174; Museum of Art, 256; Panama Pacific International Exposition, 15–19; turn-of-the-century society and economy, 2–3

Sartre, Jean-Paul, 258

*Saturday Evening Post*, 265

Save-the-Redwoods League, 136

*Say, Is This the USA* (Caldwell and Bourke-White), 179

*Seasons, The* (Porter), 329

Shahn, Ben, 163

Sharpe, Geraldine, 319, 352

Sheeler, Charles, 173, 192, 229

Sheeler, Musya, 192

Sierra Club: Adams declines participation on *This Is Dinosaur*, 282; Adams encourages growth and activism of, 279–280; Adams joins board, 107; Adams's introduction to, outings with, 31, 53–54, 78–79, 106; Adams lobbies for Kings Canyon National Park, 130–134; Adams opposes Tioga Road expansion, 295–297; Adams resigns from board of directors, 349; biocentrism and environmentalism in, 285–289, 316–317, 331–332; Brower, publishing, and nuclear power, conflicts over, 340–349; confrontation as political method, 337; development, recreation, and preservation, conflicts over, 242–246, 266, 339; Dinosaur campaign, 279–283; founding of, 52–53; Grand Canyon campaign, 337; growth and political activism, conflicts over, 279–280, 332–333; High Trip and outings, 53–54, 78–79, 90–91, 106; Ickes lobbies, 168–169; Kings Canyon park pro-

posal, 13–131; leadership, conflicts among, 340–349; leadership, new, 243–244; leadership as "men of influence," 266; loyalty oath, 248; mentioned, 179, 183, 272; Mission 66 and Tioga Road, 295–297; public outreach and persuasion, 98, 261–263, 297–298; publishing, 309–310, 327, 328–335, 337, 340–349; racial exclusion, Los Angeles chapter, 248–249; recreational orientation of 1920s and 1930s, 97; tax deductions, loss of, 339–340; wilderness conferences, 285–286

*Sierra Club Bulletin*, 97, 106, 217–218, 261–263, 287

Sierra Nevada: Adams's excursions in, 20–22, 30–32, 38–40, 46–48, 53–54, 68, 78–79, 90–91, 106; Adams's excursion with O'Keeffe, McAlpin, and friends, 159–161; Adams's excursion with Weston and friends, 151–156; environmental damage to, 51–52; gold rush in, 23

*Silent Spring* (Carson), 315–316

Sill, Richard, 345

Simon, Richard, 293

Siri, William, 333

Siria, Judy, 363

Siskind, Aaron, 185

*Sixty Photographs: A Survey of Camera Aesthetics* (MoMA), 177–178

*Sky-Land Trails of the Kings* (Brower), 262

Sloan, John, 78

Smith, Joseph, 58

Smith, Kate, 179

Smith, Martin, 129

Smithsonian Institution, 302, 329

Snyder, Gary, 358

Soby, James Thrall, 164–165, 178, 185, 190, 221

Southwest Regional Water Plan, 337

Spencer, Eldridge T., (Ted), 96, 218, 227–228, 292, 321

Spencer, Jeanette, 96, 292

Spurr, Stephen, 331

Stalin, Joseph, 128, 257

Starr, Walter, Jr., 149

Starr, Walter, Sr., 149, 161, 266, 291–292

*Starr's Guide to the John Muir Trail*, 149

Stegner, Wallace: edits *This Is Dinosaur*, 294; environmental concerns, 316; meaning of wilderness to culture, 330; on Adams, 326, 361–362, 367; on David Brower, 346; on counterculture, 326–327; on Robinson Jeffers, 332; Sierra Club publications committee, 334

Steichen, Edward: Adams meets, 103; Adams's antipathy for, comparisons with, 103–104, 258, 300–302; department of photography, MoMA, 177, 220–221, 223; *Family of Man* exhibition and book, 300–302; *Road to Victory* exhibition, 195–198, 274

Stein, Gertrude, 75

Stern, Rosalie Meyer, 58, 112, 242

Stern, Sigmund, 58

Stieglitz, Alfred: Adams's American Place exhibition, 138–140, 143–145; Adams dedicates portfolio to, 240–241; Adams exhibition, offer of, 132–133; Adams's independence of, 170, 190, 181–182, 239; Adams's relationship with, 93; Adams visits, 98–103; art as the "affirmation of life," 326, 350; art and commerce, discusses with Adams, 158–159; art and social responsibility, discusses with Adams, 107–109; artistic circle, 77–78, 112; *Camera Work*, 75; death of, 221–223; does not offer Adams another show,

170; Eliot Porter exhibition at American Place, 329; "equivalents," 274; influence on Adams, 105–106, 222–223; on Adams's *Making a Photograph*, 124–125; on Adams's *Sierra Nevada: The John Muir Trail*, 161; on Steichen, 220; Paul Strand and, 83; reaction to Department of Photography at MoMA, 176–177; World War II and, 200–201

Still, Clifford, 257

Stoddard, Charles Warren, 58

Strand, Paul: Adams meets, 83–84; art and science in modern photography, views on, 88–89; color work, 229; communism, 128; criticizes Adams for low prices, 241–242; documentary film work, 120–121, 162; exhibitions, 173, 178; influence of, 83–84, 124, 190; on Manzanar exhibition, 209

Strand, Rebecca, 83

Strauss, Levi, 58

Stryker, Roy, 209

Swift, Henry, 87

Szarkowski, John, 355, 446 n.3

Taylor, Bayard, 51

Taylor, Paul, 276–278

*This Is America* (Roosevelt and MacGregor), 179

*This Is Dinosaur: Echo Park Country and Its Magic River* (Stegner, ed.), 282, 334

Thoreau, Henry David, 50, 329–330

*Time*, 117, 265, 354–355

*Time and the River Flowing* (Sierra Club), 337

Tourism: Adams's attitudes toward, 232–233; in California, 22–25; in the West, 24–25; in Yosemite, 22–25

Tresidder, Donald, 95, 134–136, 157–158, 167–168
Trotsky, Leon, 128, 257
Turnage, William, 351–354
Turner, Frederick Jackson, 26; Turner thesis, Adams, Newhall, and, 313–315

Udall, Stewart, 316, 330
United States Army, Signal Corps, 198–199
United States Film Service, 162
United States Information Agency (USIA), 302–303
United States Potash Company, Adams's commercial work for, xiii, 141
University of California, 135; Adams assignment for, 335–336
U.S. Camera, 171, 177, 210, 220

Van Dyke, Willard, 87, 119, 121, 128, 131, 137, 162
van Gogh, Vincent, 148
Varian, Agnes, 272
Varian, John, 272
Varian, Russell, 272–273
Varian, Sigurd, 272–273
Victory magazine, 212–213
Visualization, in photography, Adams's principal of, 68–69, 171

Wagner, Robert, 126
Walcott, Marion Post, 163
Wall, Vivienne, 65
Wallace, Henry, 129–130
Walpi, Arizona, 186
War Relocation Authority (WRA), 203–204, 210
Warren, Dody, 269
Wasatch Academy, 231
Washington Mill Company, 5, 51

Watkins, Carleton, 38, 129
Watt, James, 360–361, 367
Wayburn, Edgar, 313, 348
Weed, Charles, 24
Weston, Brett, 85, 173, 185, 308, 352
Weston, Charis Wilson, 151–156, 224–225
Weston, Cole, 308, 352
Weston, Edward: Adams and Newhalls visit, 175; Adams meets, reviews exhibition, discusses photography and abstraction, joins in founding Group f/64, 84–88; Adams portrait, 200; Adams reviews Art of Edward Weston, 104–105; Armco Steel, Ohio, 89; art and social responsibility, 119–120; color work, 229; compared with Adams, 133, 190, 152–154, 226, 236–237; death, 308; divorce, MoMA retrospective, Parkinson's disease, last photographs at Point Lobos, 224–226; exhibitions, 173, 178, 352; My Camera on Point Lobos, 255; Sierra excursion with Adams, 151–156; on women and sexuality, 153, 239–240
Weston Gallery, 363
Wheeler, Monroe, 185, 195
White, Minor, 223–224, 269, 308, 352
White Angel Breadline (Lange), 114–115, 124
Whitman, Walt, 49–50, 303–307, 314, 325, 368
Whole Earth Catalogue, The (Brand, ed.), 327
Wild Cascades, The, 335
Wilderness, American culture and, 35–37, 330–331
Wilderness Act, 297, 330
Wilderness Conferences, 285–286, 297, 316, 330
Wilderness Society, 280, 297

Wildflower Festival (aka Conservation Forum), 135–136
Wilkie, Wendell, 300
Willard, Merriam, 221
Williams, William Carlos, 88
Winogrand, Garry, 324
Wirth, Conrad, 294
Witham, Bruce, 363
Wolfe, Linnie Marsh, 254
*Words of the Earth* (Wright), 328
Work, Hubert, 94
Works Progress Administration (WPA), 112–113
Worth, Don, 319
Wright, Cedric, xi, 54–56, 143–145, 150–151, 173, 186, 187, 328
Wright, George, 12–13

Yale University, 79; Chubb Fellowship, 351
Yellowstone National Park, 193–194
Yosemite National Park: Adams's first trip to, 20–22; Adams moves to, 150; Adams's portrayal of, 168, 232–233; Adams's summers in, 30–33;

Bracebridge Dinner, 95–96; commercialization of, 94–98, 158; crowding in, 94; deeded to California as park, 24; development vs. preservation, 136, 186, 355–356; exploration of, 23; identification of Adams with, 354–355; impact on Adams, 21, 27, 368; photography in, 24; Tioga Road controversy, 244–246; tourism in, 22–25, 243–248; United Nations World Heritage Site, named, 366–368; visitation figures, 24–25, 243–248, 356
Yosemite Park and Curry Company. *See* Curry Company
*You Have Seen Their Faces* (Caldwell and Bourke-White), 162
Young, Ella, 72

Zahnizer, Howard, 280, 297
Zech, Frederick, 29–30
Zion National Park, 186
Zone system: development of, 171–172; teaching of, 219, 223–224; use of, xi, 235–236, 365

The author and publisher wish to thank the following individuals and institutions for permission to quote from copyrighted materials:

The Aperture Foundation, Inc., Paul Strand Archive, for quotations from texts by Paul Strand. Copyright © Aperture Foundation, Inc., Paul Strand Archive.

Center for Creative Photography, for quotations from texts by Edward Weston. Copyright © 1981 Center for Creative Photography, Arizona Board of Regents.

Mrs. David McAlpin, for quotations from letters by David McAlpin. Copyright © 1985 by David McAlpin.

The Museum of Modern Art, for quotations from publications and press releases. Copyright The Museum of Modern Art.

The Beaumont and Nancy Newhall Estates, for permission to quote from texts by Beaumont Newhall and Nancy Newhall. Courtesy David Scheinbaum, co-executor, the Beaumont and Nancy Newhall Estates.

Random House, Inc., for quotations from *Selected Poems* by Robinson Jeffers. Copyright © 1935 and renewed 1963 by Donnan and Garth Jeffers. Reprinted by permission of Random House, Inc.

Regional Oral History Office, The Bancroft Library, University of California, Berkeley, for quotations from oral history interviews in the Bancroft Library.

Ms. Barbara M. Van Dyke, for permission to quote from texts by Willard Van Dyke.

The Minor White Archive, Princeton University, for permission to quote from excerpt from "Memorable Fancies" 9 [10] July, 1946. Courtesy The Minor White Archive, Princeton University. Copyright ©

Designer: Jacqueline Gallagher-Lange
Compositor: Wilsted & Taylor
Text: 10/16 Janson Text
Display: Janson Text
Printer: Malloy Lithographing
Binder: John H. Dekker & Sons